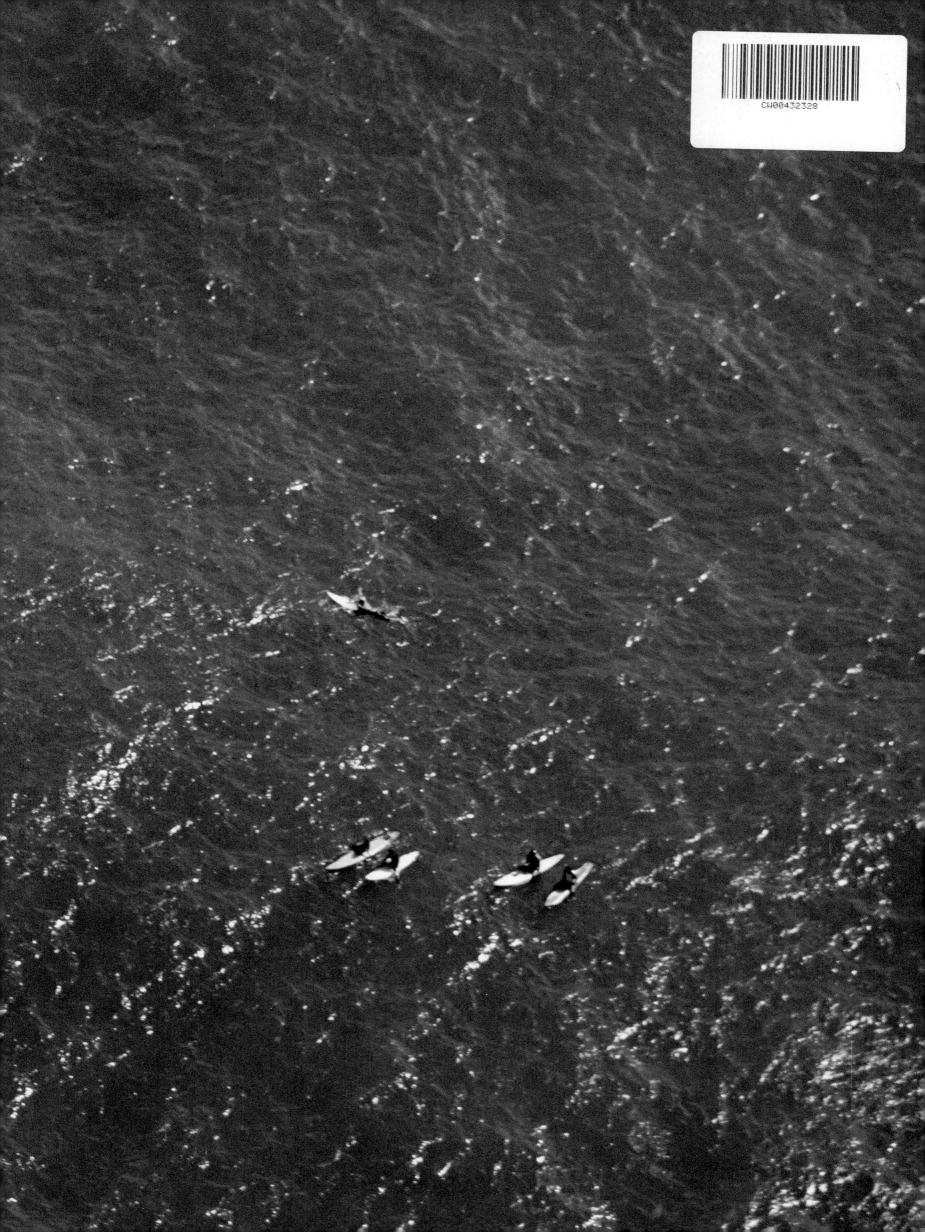

SURFING
1778-TODAY

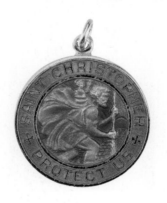

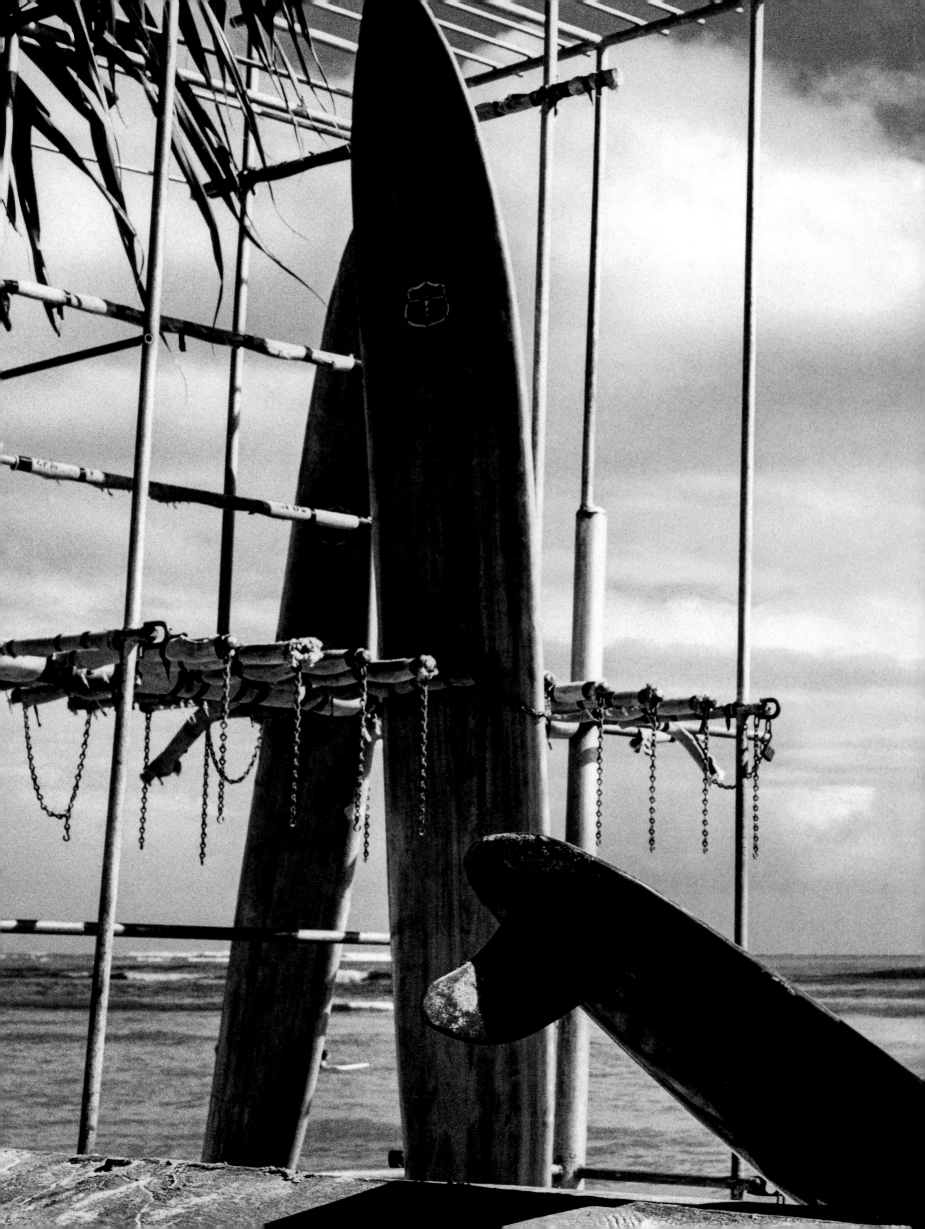

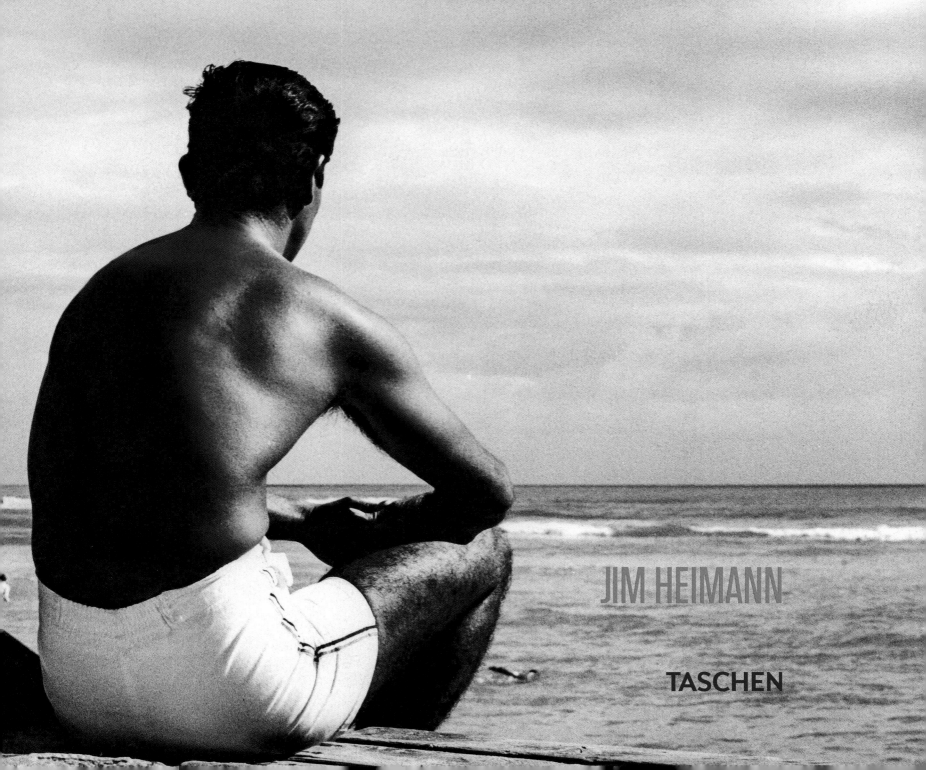

SURFING
1778–TODAY

JIM HEIMANN

TASCHEN

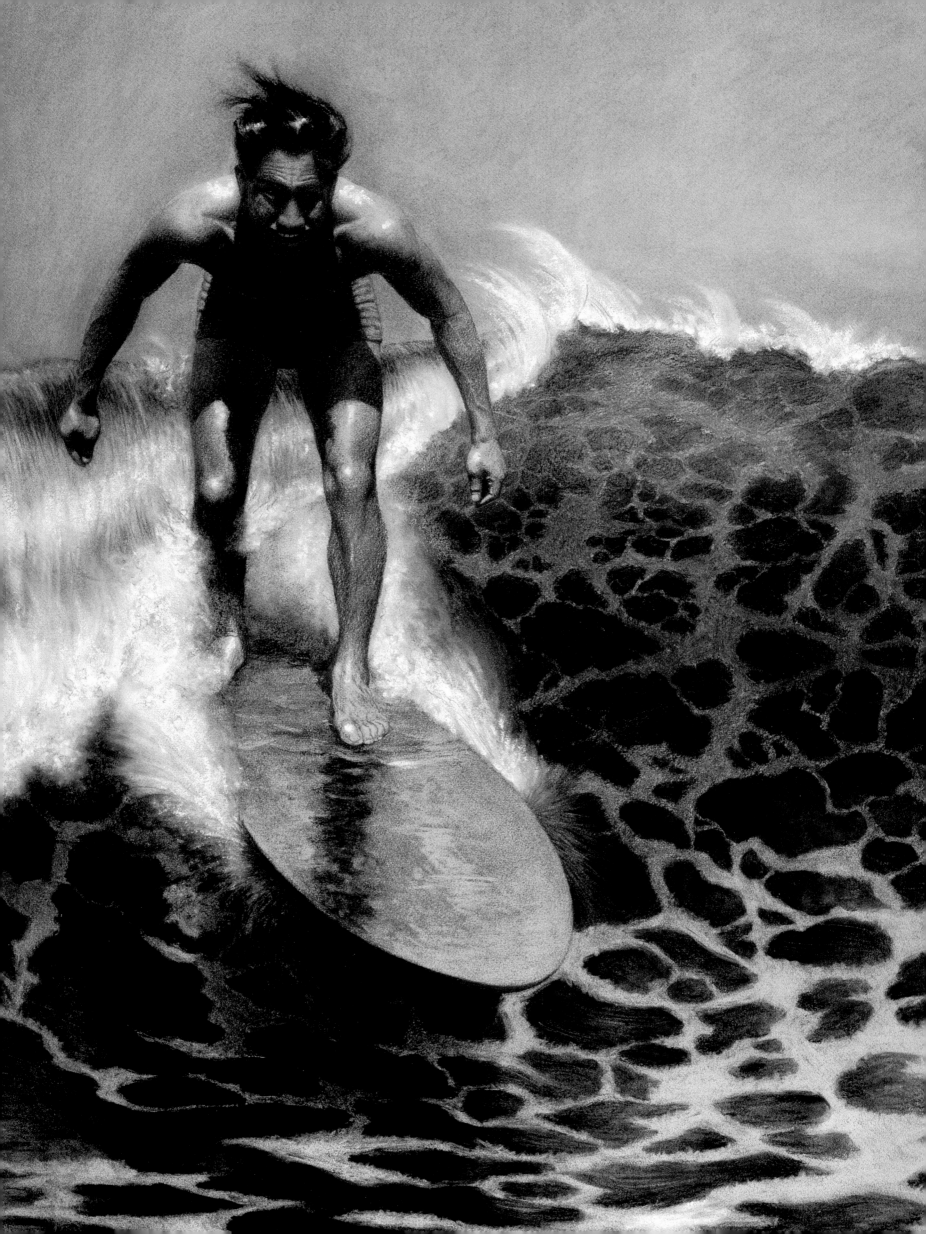

CONTENTS

DEUTSCHE ÜBERSETZUNG
TRADUCTION FRANÇAISE

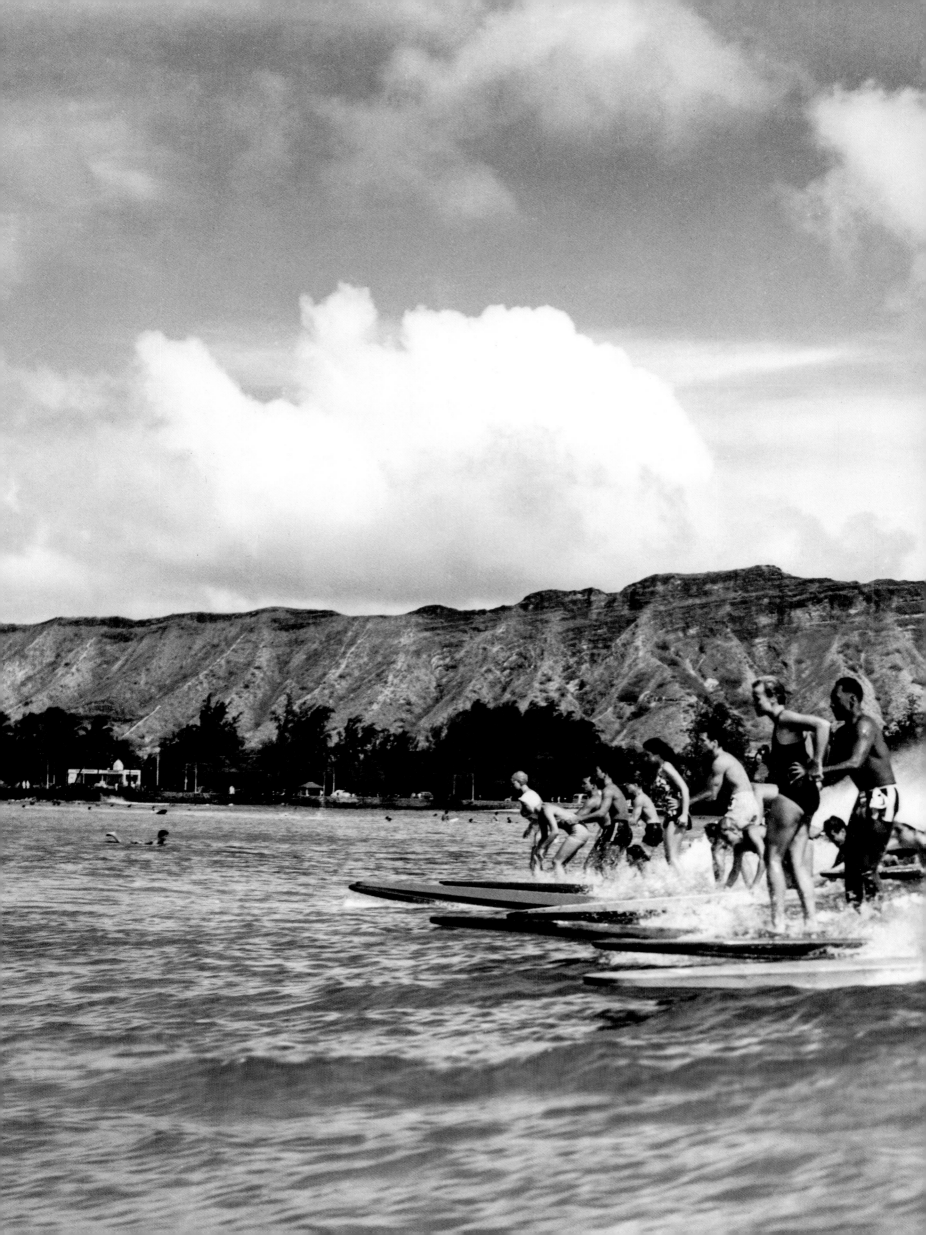

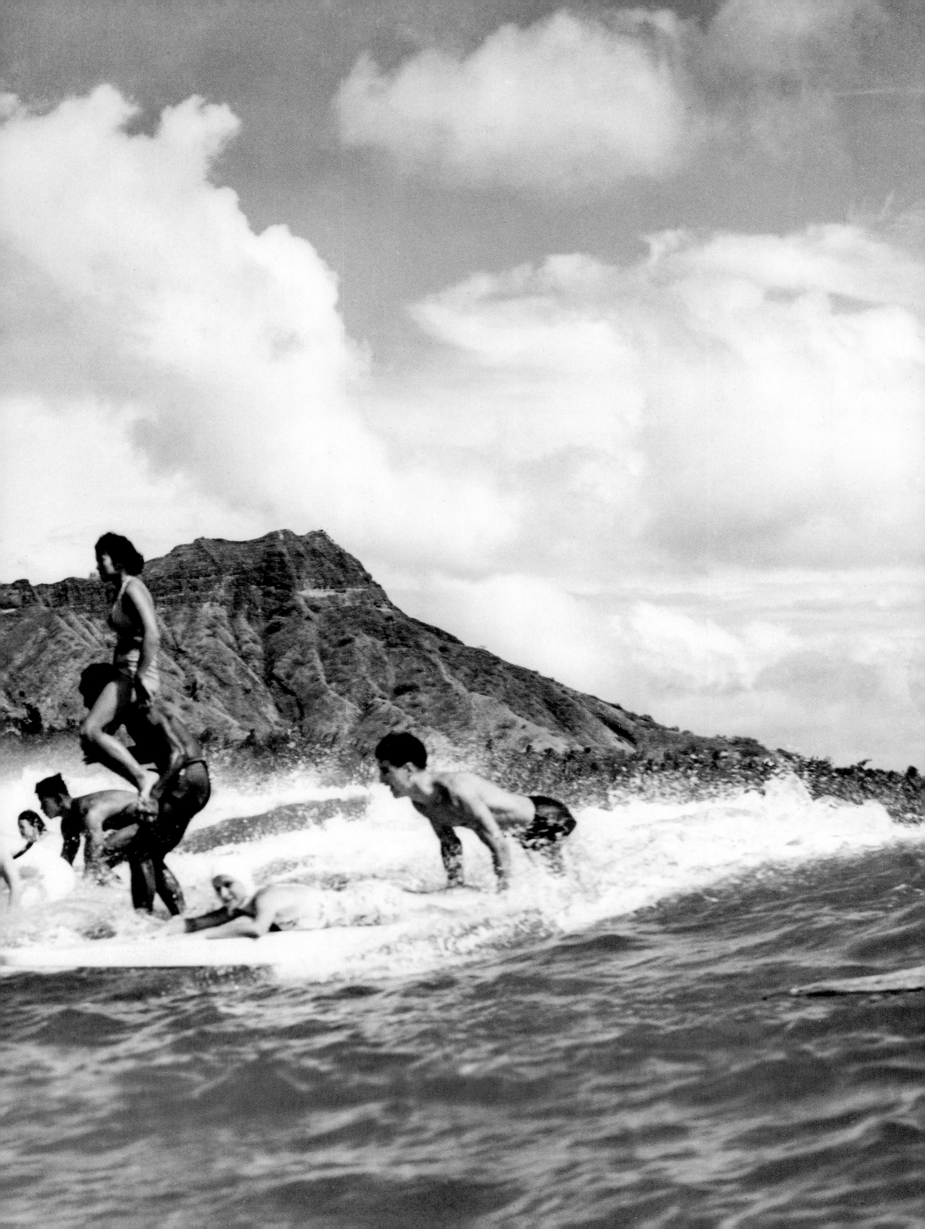

A VIEW FROM THE BEACH

JIM HEIMANN

Surfing is a complex and unique sport. Its evolution from the crude ability to hang on to a floating piece of wood and be propelled on the face of a wave to today's contest-infested international community is a labyrinth of places, personalities, and emotions. It can be competitive or pursued for sheer pleasure. It can be can be experienced alone or with a group. It can be unpredictable and lethal, benign and thunderous, ecstatic and satisfying. Nothing in the world of sports quite compares to it.

Growing up near the beach in Southern California during the 1960s, I eagerly absorbed the cultural aspects of that early surf scene. I didn't own a board—it was economically unfeasible for me, and with two working parents, taking one on the bus to the beach would have been nerdy and awkward—so I bodysurfed. I hung out with a crowd that hit the beach every day, bought my *SURFER* magazine at the local drugstore, wore my Pendleton, and became well versed with the terms and conditions of this coastline sport. The Beach Boys were crosstown rivals, mostly with the car crowd, but I did cruise up and down "the same old strip" (Hawthorne Boulevard) and distinctly remember them getting egged on the base-ball field at a Loyola University homecoming concert. Dennis Wilson had a new "Vette" and the local guys knew he was showing off. Adding to the rising resentment was new band member Al Jardine replacing David Marks in the lineup. The crowd thought they were get-ting gypped and the eggs were launched.

I drew "Murphy" on my canvas school binder and I became a hard-hit fan of the artist. After years of following his work, I wanted to follow suit and majored in art in college. When an opportunity at school arose, I organized Griffin's first solo show and finally got to meet and spend some time with him. Always cordial, he knew I was a fan and treated me accord-ingly, though he did turn me on to some of the more "mysterioso" aspects of his life. We traded some pieces and I became the proud owner of some key Griffin work. Sadly his prolific art came to an end when he was killed in a motorcycle accident, but his inspiration continues to fuel me to this day. Post-college I moved on to other interests in the arts, history, and publishing worlds but always clung to and kept up with the coastline craze I grew up with. This book is an extension of that.

To attempt to encapsulate this history in a single volume is an impossible task. The richness of the sport in terms of visual imagery and depth of subject matter would require multiple volumes to do it justice. Unique in its influence on music, fashion, lifestyle, and language, surfing embraces and integrates these and other cultural elements to further enhance the sport. Thus the task of putting together one book that would reflect all of these aspects was a daunting one.

The job of creating a survey of "the sport of kings" was based on a narrative that started with a broad stroke and then was fine-tuned. Experts in the field, surf legends, captains of the surf industry, seasoned photographers, "groms" and pros, along with the surfers who just paddle out on the weekend, were solicited. Their guidance and contributions to this process provided the book with an authentic perspective. Eventually the countless stories and a stockpile of images were assembled for consideration. The most grueling task was to cull the best ones from the approximately 7,000 images to fit this book.

After assembling a rough cut of the book, I came to the realization that I couldn't include all of the elements I wanted to. So rather than try to incorporate every photo, event, and personality, it became apparent that some dutiful editing needed to happen. There were some tough decisions to make. I was very aware of the lapses and exclusions of material from previous publications and made a stab at compensating for those shortcomings. I also wanted to work in some surprises and "I have never seen that!" moments. What you have in your hands is a result of that effort.

A book, an article, or blog can only give a glimpse of what the world of surfing is all about. Ultimately the sport demands more. What it delivers cannot be found in something as tangible as a book. It is the satisfaction that surfers and non-surfers alike get from communicating so closely with nature, be it with a herd at Rincon, an early morning paddle out in Biarritz, attacking a monster at Teahupo'o, or sitting on the sand reveling in the mantra of repetitive breaking waves. The act of being in concert with mother ocean, despite other obvious distractions, is what brings one back again and again to this world. The clothes, the boards, the music, the contests, the rivalries, and friendships all exist in supporting roles to the water.

At the end of the day, as John Severson so aptly put it many decades ago, "In this crowded world, the surfer can still seek and find the perfect day, the perfect wave, and be alone with the surf and his thoughts."

I hope all of you do.

—Jim Heimann, Los Angeles

MEDALLION, 1963 *(Page 1)*
St. Christopher—patron saint of mariners, boatmen, and travelers—was adopted by surfers in the early 1960s.

GEORGE SONODA, WAIKIKI, HAWAII, C. 1955 *(Pages 2–3) Photo, Clarence Maki*

PAINTING, DUKE KAHANAMOKU, 1914 *(Page 4) Art, E.H. Steel*

WAIKIKI, HAWAII, C. 1950 *(Pages 6–7)*

INTERNATIONAL SURF FESTIVAL; MANHATTAN BEACH, CALIFORNIA; 1965 *(Page 8) Photo, Ralph Crane*

PETE PETERSON; SANTA MONICA, CALIFORNIA; 1928 Peterson, right, grew up on the Santa Monica Strand. By age nine he was surfing, and over the next half-century swam competitively, bodysurfed, and became known as the consummate waterman's waterman.

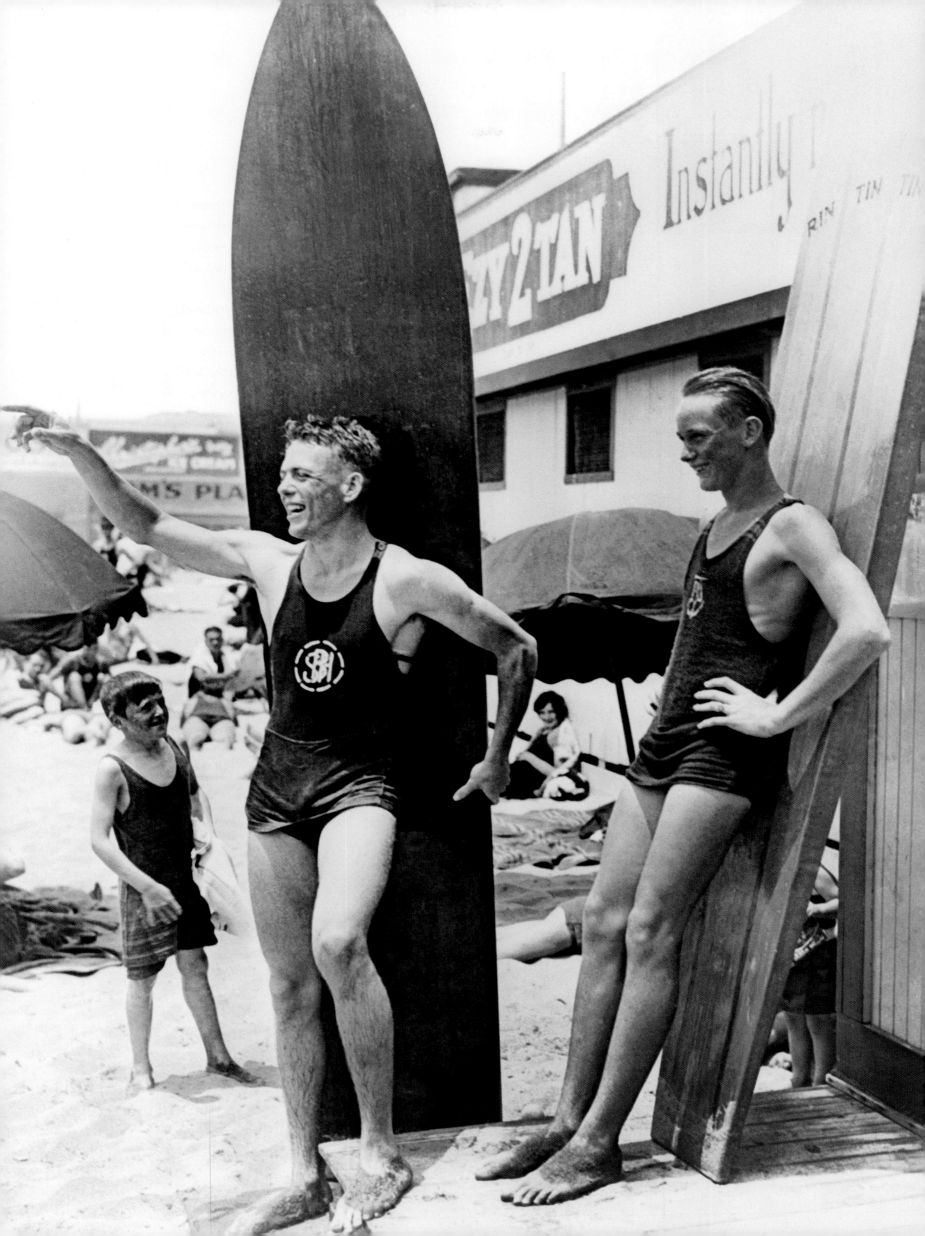

1778-
1945
THE EMERGENCE OF A SPORT

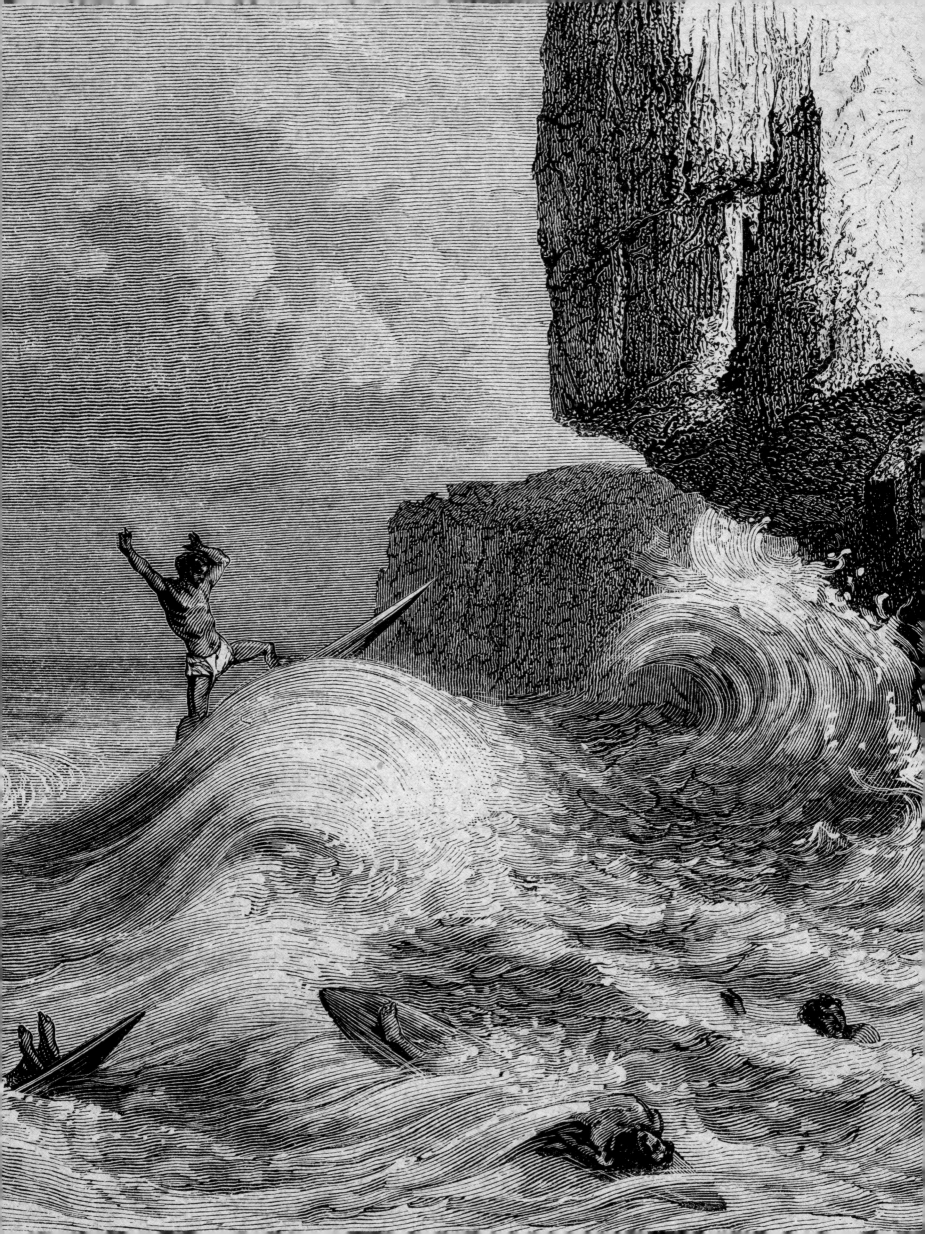

1778-1945
OUT OF THE BLUE

MATT WARSHAW

It's easy to imagine that wave-riding of one kind or another likely took root on antediluvian beaches from Brazil to Senegal, Lebanon to Borneo. For any society living on a temperate coastline, riding waves would likely be a natural, if not intuitive act. Dolphins and pelicans and other animals seem to do it purely out of enjoyment, after all. When did the very first human wade into the shorebreak and try to imitate a dolphin? Or put another way — when did bodysurfing start? That probably goes back millions of years, not thousands.

One version of surf history begins in the coastal salt marshes west of Trujillo, Peru, among the tall chlorophyll-green stalks of *Schoenoplectus californicus* — California bulrush to English-speakers, *totora* to Peruvians. Traders used *caballito* reed boats, probably invented around 3000 BC, to move goods short distances along the coast, while fishermen used them as a roving nearshore platform. In short, the *caballito* was designed for the serious, tedious business of feeding the community. At some point, though, the fluttery thrill of riding a wave on a *caballito* became its own reward, removed from the daily work routine and pursued for its own sake. A form of surfing began. Possibly the original form.

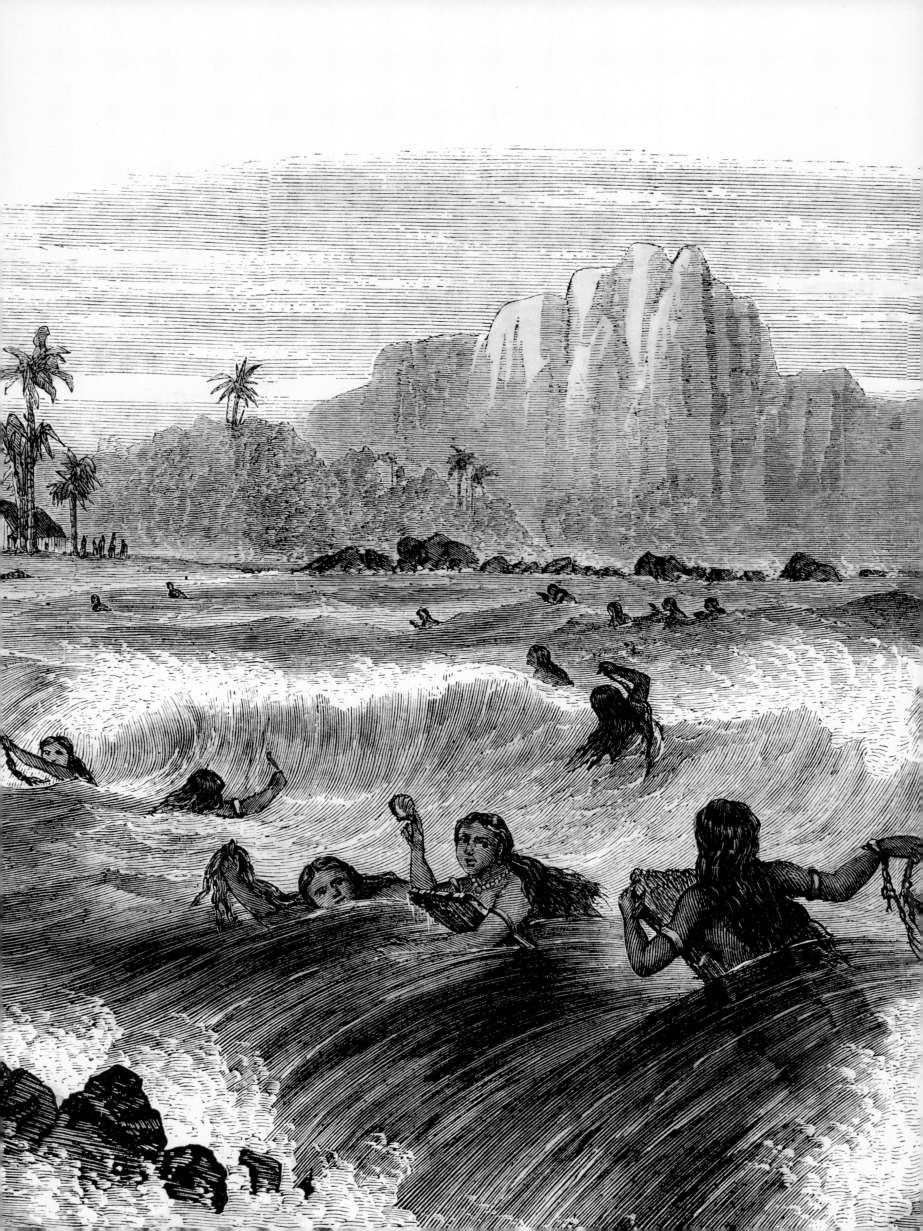

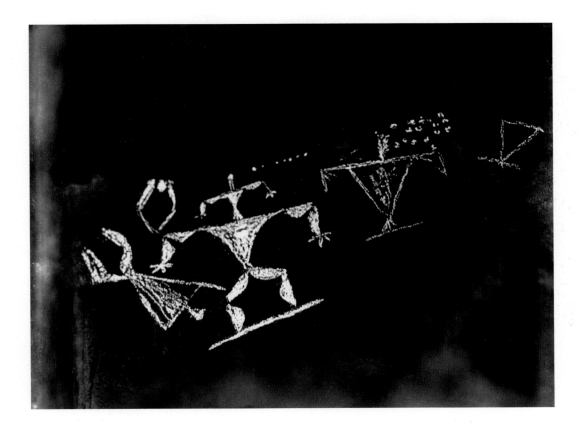

A more accepted version of early surf history connects the sport directly and organically to ancient Polynesia. Almost everything now thought of as innately Hawaiian actually originated in Tahiti—surfing included. Hawaii's first inhabitants probably sailed up from Polynesia's Marquesas Islands around 300 AD, and 800 years later, Tahitians conquered and resettled the Hawaiian Islands, bringing not only their animals, fruit, and animism to the islands, but also surfing. Before this, we can only guess at the start date for some rudimentary proto-Polynesian form of surfing, which may have begun as far back as 2000 BC. Only on the main islands of what is called East Polynesia (Hawaii, the Marquesas, Tahiti, the Cook Islands, and New Zealand) was surfing practiced by adults as well as children. Of this group, just the Tahitians and Hawaiians used full-length boards and rode while standing. And of these two, only the Hawaiians, probably beginning around 1200 AD, developed the sport into a communal obsession. This original surf lust, as much as the islands' accrued developments in board design and riding technique, is what marks Hawaii as surfing's birthplace.

A WAY OF LIFE

Surfing in Hawaii was both recreational and universal. The ruling class had special boards and exclusive breaks, but even so, the sport was the island nation's great common denominator. Surfing was practiced with equal enthusiasm (and class-leveling nudity) by farmers, warriors, fishermen, children, grandparents, and chiefs. As one early Western visitor wrote, "The entire population of a village would at certain hours resort to the seaside to indulge in, or to witness, this magnificent accomplishment."

The average Polynesian peasant-surfer likely banged together his new surfboard with no more godly thoughts than a woodcrafter making a door. At the royal level, however, boardmaking was a serious matter, filled with rituals. High-end boardmaking from start to finish took about a week, and more rites and prayers were made over the finished product before it was launched into the water. Hawaiians developed three basic types of surfboard: the paipo, the olo, and the alaia. The round-nosed paipo was the smallest of the three, and it was used mostly by children in nearshore surf.

The showpiece of ancient Hawaiian surfing was the royal olo, the wiliwili-made colossus used exclusively by the ruling *alii* class. Specs for the olo surfboard were almost cartoonish: 20 feet long by two feet wide, 200 pounds, and domed along both the deck and bottom. There are

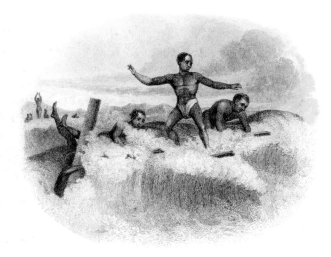

WAIKIKI, C. 1890 *(Pages 12–13)* Waikiki, in its pre-high-rise halcyon era, was a native gathering place and late-19th-century haole cottage resort. The surfer is holding an alaia board used for riding upright across gentle rolling Waikiki waves. *Photo, Frank Davey*

ENGRAVING, 1874 *(Page 14)* *Art, Emile Bayard*

ETCHING, 1866 Wave-riding spanned class, age, and gender of ancient Hawaiian society: from commoner to king. "There are no people more accustomed to the water than the islanders of the Pacific; they seem almost a race of amphibious beings." —Reverend William Ellis, English missionary and adventurer, 1823

PETROGLYPH, C. 1500 Hawaiian petroglyphs are usually found etched into fossilized lava fields throughout the islands, but have recently been uncovered on beaches facing now famous surf breaks. Surfing was a popular motif.

ENGRAVING, 1831 The frontispiece from William Ellis's *Polynesian Researches*, vol. 4, "Sandwich Island Surf-Riders" is reputed to be one of the first printed images of surfing action, wipeouts and all.

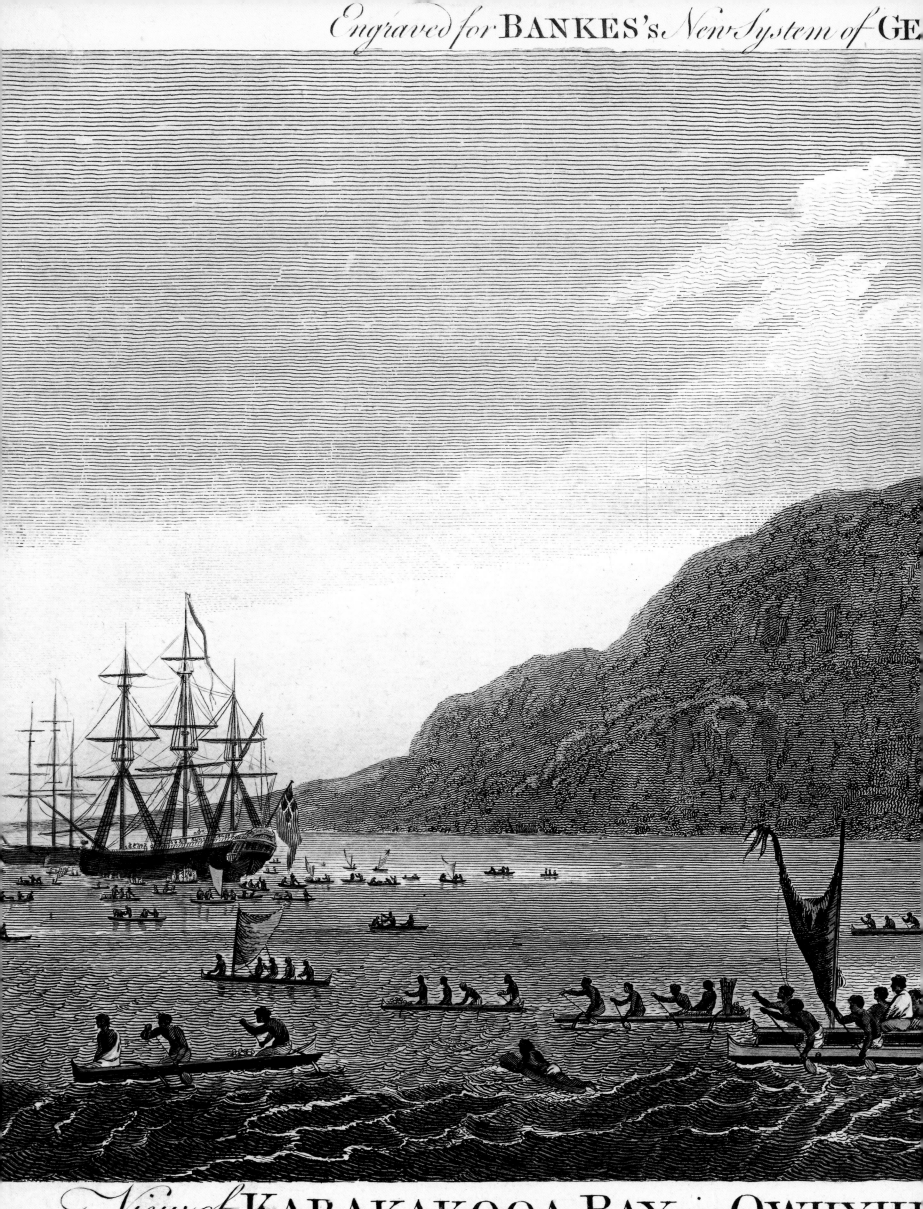

View of KARAKAKOOA BAY in OWHYHI

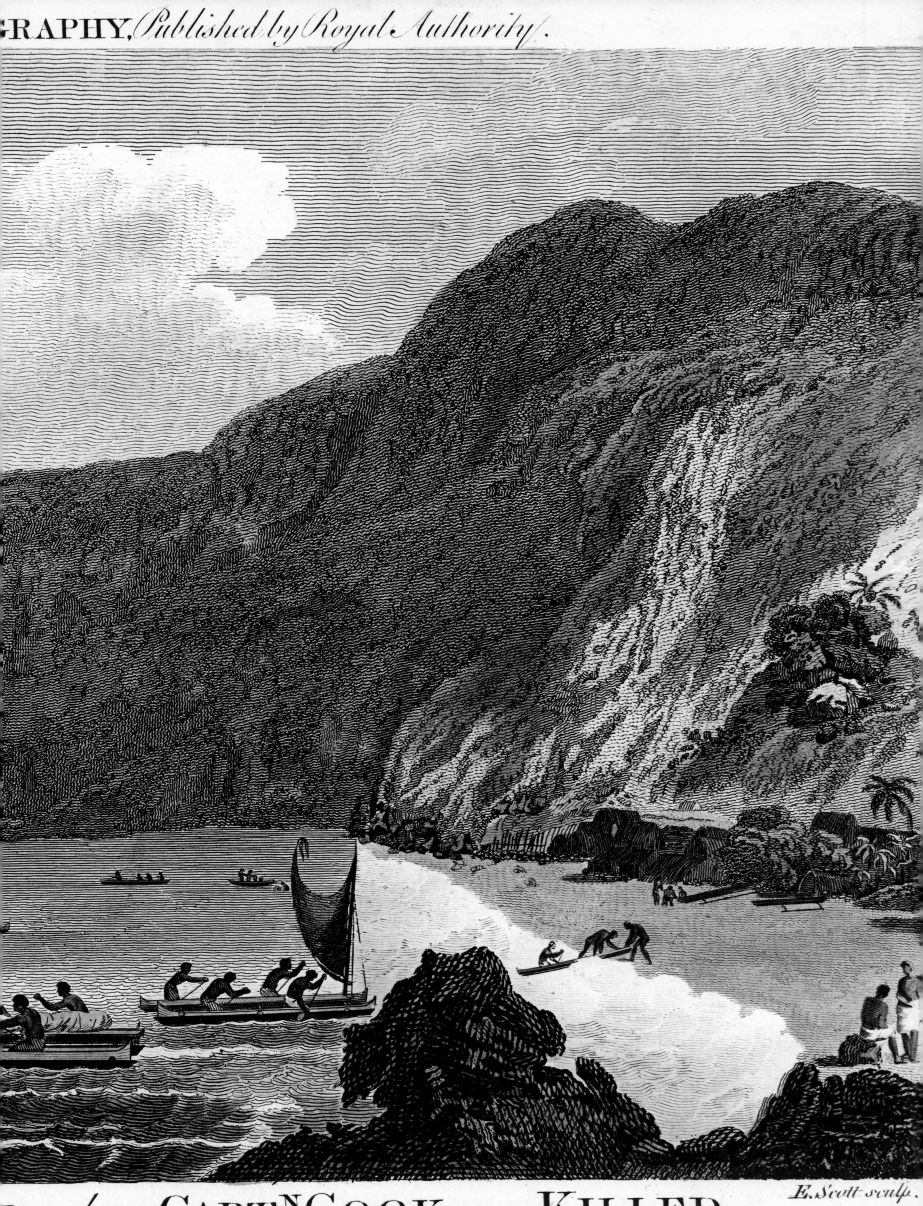

E. Scott sculp.

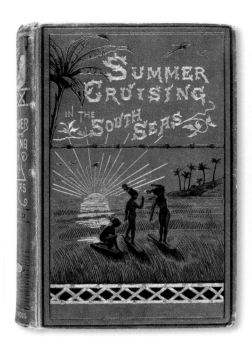

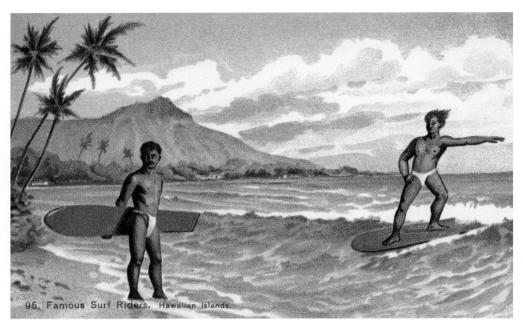

95. Famous Surf Riders. Hawaiian Islands.

no eyewitness accounts of olo surfing, but it seems likely that the boards were used for the sole purpose of riding unbroken waves. Another theory surf historians have suggested is that the olo may have been designed for big surf. Large waves move faster through the ocean and are much harder to catch than small waves, and the olo had a great paddling advantage over other types of boards. It's a more prosaic idea, and there's nothing in the records saying as much, but it may be that the Hawaiians regarded the olo as more of a paddleboard than a surfboard.

Surfing as the world knows it—stand-up riding on a wave that curls and breaks—was for all practical purposes invented on the alaia, a thin, midsize board about half the size of an olo. The alaia was the Hawaiian standard, used by monarchs and villagers alike; it paddled well enough to catch unbroken swells on the intermediary offshore reefs, but was responsive and maneuverable enough to let the surfer ride in the steep, fast, curling section of the wave. Unlike the hulking olo, an alaia board could be paddled directly through the wave zone to the lineup—the surfer's ready area, located just beyond the breaking waves. Once in the lineup, the surfer either sat on his board or remained prone, eyes to the horizon, and watched the incoming swells for a likely wave. When it came, the board was quickly wheeled around and aimed shoreward, centered beneath the rider—some knee-paddled into waves, but most went prone—and with a few churning strokes the wave was caught. Timing, more than speed, was essential. The idea wasn't so much to match the wave's speed as to be positioned on the swell's upper slopes just as it tilted up, allowing gravity to do the work.

THE ARRIVAL OF "LONO"

It was late 1778 that British explorer Captain James Cook was nearing the end of his third and final Pacific voyage. He had been crisscrossing the Pacific Ocean in an attempt to discover the fabled Northwest Passage. Having failed, yet again, to find a watery link from the Pacific to the Atlantic, Cook directed his HMS sloops *Resolution* and *Discovery* away from the Alaskan coast and set a south-southeast course for the tropics. Ten months earlier, in January, Cook and his 150-plus crew had become the first Westerners to make contact with Hawaii, spending three days ashore on the islands of Kauai and Niihau, where natives had worshipfully dropped to their knees in greeting, filled the ships' holds with pigs and breadfruit and water in exchange for a handful of sixpenny nails and a few pieces of iron, and tended fully to the visitors' sexual needs.

ENGRAVING, 1784 *(Pages 18–19)* "View of Karakakooa Bay in Owhyhee, where Captn. Cook was Killed" depicts the setting where angry Hawaiians killed Cook on February 14, 1779. What's notable is the islander in the foreground paddling out on a surfboard. *Art, John Webber*

BOOK COVER, *SUMMER CRUISING IN THE SOUTH SEAS*, 1873 San Francisco author Charles Warren Stoddard first traveled to Hawaii in 1864, the first of four trips to the South Seas over the next decade. *Art, Wallis Mackay*

POSTCARD, C. 1904

ADVERTISEMENT, 1908

TRAVELOGUE POSTER, C. 1920

WINTER SPORT IN HAWAII

CHARMIAN LONDON, WAIKIKI, 1907
The Hawaiian Islands were the first port of call in
1907 for Jack and Charmian London aboard *Snark*,
their 45-foot ketch. The celebrated literary couple
spent five months cruising the islands where Jack
tried surfing for the first time in Waikiki. He was so
enthralled with surfing he wrote a magazine article
that essentially introduced the English-speaking
world to wave-riding.

SOUVENIR PHOTO ALBUM, C. 1900

BOOK COVER, *HAWAII: OUR NEW
POSSESSIONS*, 1898 Promoting Hawaii as
a tourist destination accelerated after the turn of
the century by dedicated boosters who appealed
to mainlanders in publications like *National
Geographic*.

Now, having sailed directly from Alaska to Hawaii, Cook meandered around the islands
without going ashore for nearly eight weeks. He eventually circled the Big Island, where the
Makahiki festival was underway, and when Cook finally ordered the *Resolution* and *Discovery*
to drop anchor in the north end of Kealakekua Bay, the event was likely interpreted by the
Hawaiians as nothing less than the return of their mythological deity Lono himself. A group of
priests immediately draped Cook in red cloth and escorted him to a skull-lined platform at a
waterfront temple, while gathered onlookers, prostrate with foreheads touching the ground,
chanted "Lono." The goodwill, however, didn't last. A few weeks later, Cook was mobbed by
natives in the shallows of Kealakekua Bay, clubbed, and stabbed to death.

Cook has long been credited with the first written description of wave-riding,
which appeared in a 1777 journal entry that was published, posthumously, in *A Voyage
to the Pacific Ocean*:

> He went out from the shore till he was near the place where the swell begins to take its rise;
> and, watching its first motion very attentively, paddled before it with great quickness, till
> he found that it overlooked him, and had acquired sufficient force to carry his canoe before it
> without passing underneath. He then sat motionless, and was carried along at the same swift
> rate as the wave, till it landed him upon the beach. Then he started out, emptied his canoe,
> and went in search of another swell.

But historians later determined that the passage in fact belongs to *Resolution* surgeon
William Anderson, who summarized in an almost poetic voice: "I could not help concluding
that this man felt the most supreme pleasure while he was driven on so fast and so
smoothly by the sea." No description of surfing that followed over the next hundred
years would match Anderson's lovely "supreme pleasure" observation. Of the few dozen
descriptions of the sport that were published during this period, mild bombast and polite
disbelief were the rule.

From the moment Westerners "discovered" it, surfing took on the status of an outsider
activity. In every surf-related log entry, journal passage, travelogue, and monograph, the
division between the surfer and nonsurfers is always implied and often explicit. But just as
Western newcomers to Hawaii granted themselves a race-based intellectual and cultural
superiority, the natives were understood to have a huge congenital advantage in the water.
The visitors knew their place. And it was on the beach, dry and fully dressed.

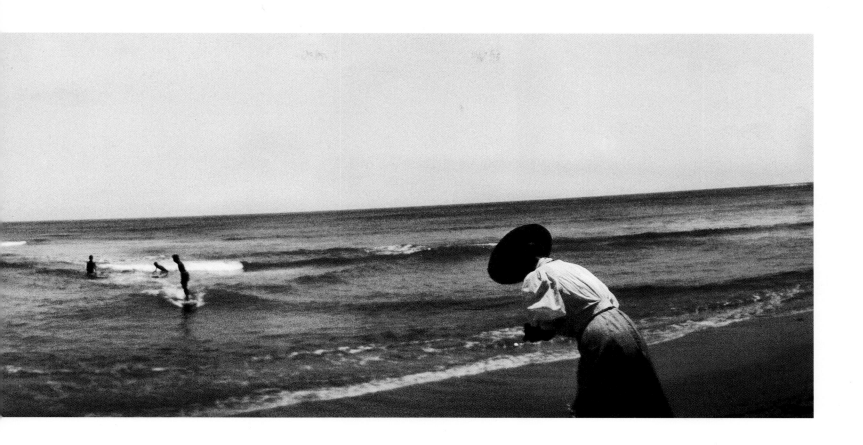

At the time of Cook's arrival, an estimated 400,000 Hawaiians lived on the islands. By 1896 the number had been reduced to just over 30,000. Most of the decline was from imported sickness and disease. After centuries of mid-Pacific isolation, the Hawaiian immune system was defenseless against the assorted germs, pathogens, and viruses brought by the first Westerners. It wasn't just the terrible new diseases that reshaped Hawaii. Native custom and culture were under attack as well, particularly with the arrival of American missionaries.

THE DARK AGES

On a brisk late-October afternoon in Massachusetts in 1819, seven evangelical "Pioneer Company" Calvinists and their church-matched wives left Boston Harbor on the brig *Thaddeus*. Their assigned task was to both "civilize and save" the natives—or "savages," to use the missionaries' preferred term—and to "cover those islands with fruitful fields and pleasant dwellings, and schools and churches." Five months and 8,000 miles later, *Thaddeus* arrived on Hawaii's Kona Coast, not far from where Captain Cook had landed 40 years before. Missionary leader Hiram Bingham wrote in his journals that the boat was immediately surrounded by an oceangoing throng "of every age, sex, and rank, swimming, floating on surfboards, sailing in canoes." Bingham continued: "The appearance of destitution, degradation, and barbarism, among the chattering and almost naked savages, was appalling… Can these be human beings?" Bingham's moralizing tone largely defined the entire missionary experience.

Their influence on island policy and culture was so immediate and significant that islanders soon made reference to the "missionary monarchy." Protestantism briefly became the nation's religion. Meanwhile, a new code of missionary-backed laws and decrees were passed. Hula dancing was banned. Surfing itself was never made illegal, but it was tightly hemmed in by "blue laws" against gambling and nudity, both of which had been nearly as important to the sport as riding itself. Bingham saw this as a noble improvement, writing: "The decline and discontinuance of the use of the surfboard, as civilization advances, may be accounted for by the increase in modesty, industry, or religion." Hawaiians, for the most part, adapted or acquiesced to the missionary values. But they were also enthusiastic backsliders. Hawaiians and the arrayed newcomers spent a lot of time locked in a cultural standoff.

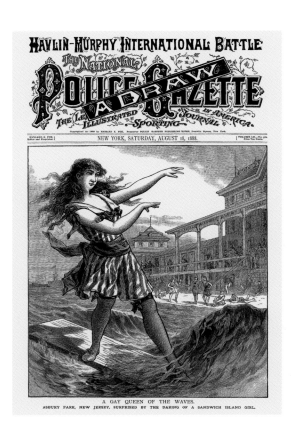

MAGAZINE COVER, *POLICE GAZETTE*, 1888 Fact or fiction? An idealized maiden frolics in the East Coast surf in what could have been an imagined event or early pinup art.

GEORGE FREETH, WAIKIKI, C. 1907 Freeth, left, started surfing in 1902 at a point when surfing was at its lowest ebb. He insisted on riding upright rather than prone, and angling across the wave rather than going straight in with the foam. When Jack London saw him riding in Waikiki a few years later he wrote that Freeth was "… a brown Mercury… calm and superb." *Photo, Ray Jerome Baker*

SANTA MONICA, CALIFORNIA, C. 1880 While a few trendsetting Angelenos ventured into the Pacific by the end of the 19th century, the majority kept their corsets, ties, and bonnets securely fastened. Note the singular Hawaiian-style alaia board, likely ridden prone in the Santa Monica shorebreak.

HAWAIIAN PRINCES; SAN MATEO, CALIFORNIA; C. 1885 The teenage sons of a Kauai king—princes Jonah Kuhio Kalanianaole, David Kawananakoa, and Edward Keliiahonui—paddled out in July 1885 to try the chilly waves at the Santa Cruz river mouth while on school holiday. They rode redwood boards they had shaped themselves and were a big hit with the Santa Cruz locals. It was the first recorded instance of board surfing in the United States.

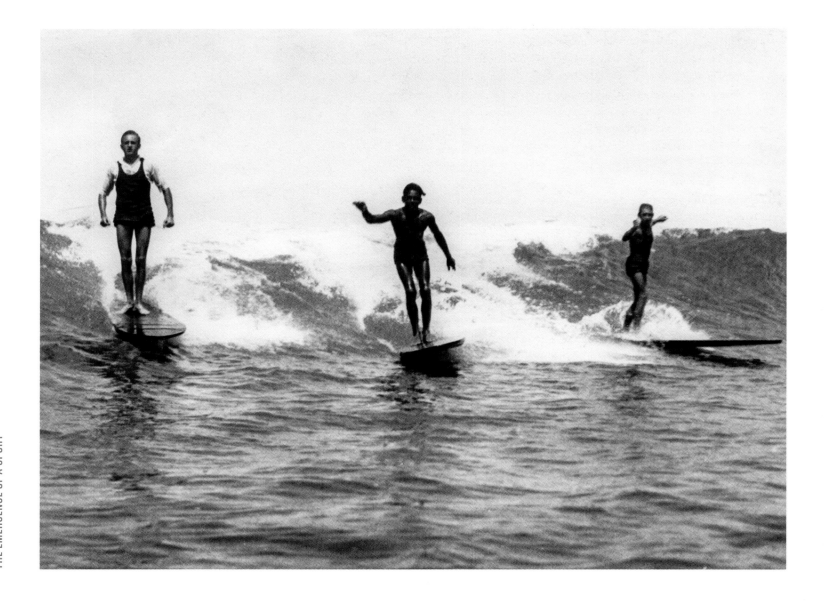

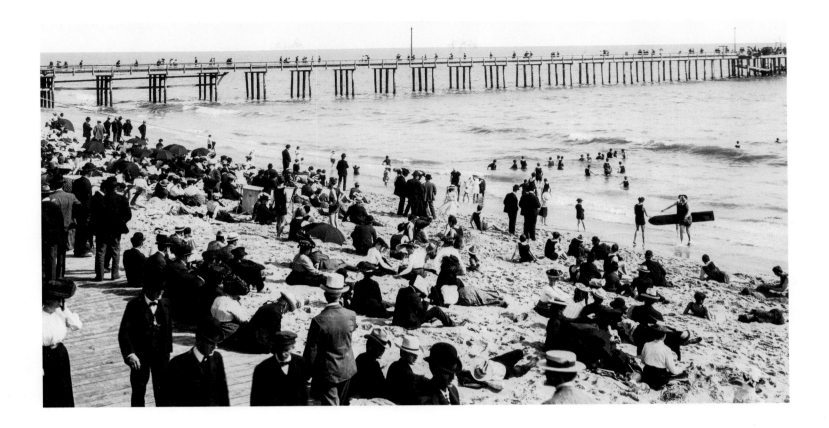

Later in the 19th century, as church influence waned, American-led business interests took over the Hawaiian economy. Young and ambitious entrepreneurs, speculators, and merchants, along with their families, flocked to Hawaii from the U.S. mainland and Europe. In Hawaii's new wage-based plantation economy, you either worked or went hungry—another reason not to surf. Syphilis and cholera, new laws and prohibitions, endless work hours, overthrow and annexation—all these things conspired to remove wave-riders from Hawaiian lineups throughout the 19th century; the era came to be known as surfing's own Dark Ages.

Surfing never "vanished," as later accounts would have it. But the sport indeed suffered a grievous loss in raw numbers. The Native Hawaiian population was cut by 90 percent in just over a hundred years, and the number of surfers was no doubt reduced by a similar amount and then some. By any measure, the 19th century was a disaster for surfing. By 1890, however, the worst was over. The Hawaiian immune system had toughened up. The missionaries were all but gone. Surfing now entered a quiet but sustaining period. The sport and its practitioners looked different somehow—at least to the world at large. Surfing had been described by Bingham in 1820 as the pastime of "chattering savages." Now it was about to be reintroduced by swashbuckling writer Jack London as nothing less than "a royal sport for the natural kings of earth."

SPREADING THE SURFING GOSPEL

Surfing's revival in the early 20th century made perfect sense. As wealthy American and European globetrotters scanned the world for suitably exotic getaways, their attention naturally gravitated to Hawaii, which was pulsatingly tropical and yet both English speaking and American run. Honolulu had by then eclipsed the Big Island to become Hawaii's political, cultural, and business hub, and it included the veranda-lined beachfront neighborhoods of Waikiki.

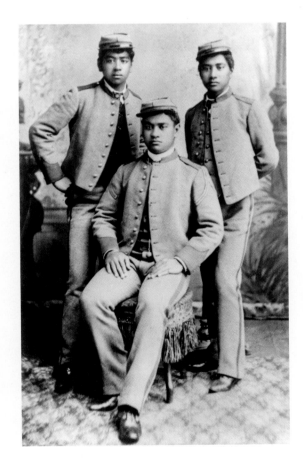

During the first few years of the new century, tourism's benefit to surfing—and vice versa—was fast and direct. This "uniquely Hawaiian water sport," as it was often described, was a calling card like no other. Local governors, plantation owners, and hoteliers immediately recognized that island romance and excitement were distilled in the act of wave-riding, and surfing imagery was soon printed, stamped, embossed, and etched onto pretty much anything connected with the islands—from postcards and travel brochures to china teacups and hotel wine glasses. The public-relations campaign worked. Surfing was now on a growth trajectory that, apart from a short-lived dip or two, remained unbroken into the 21st century.

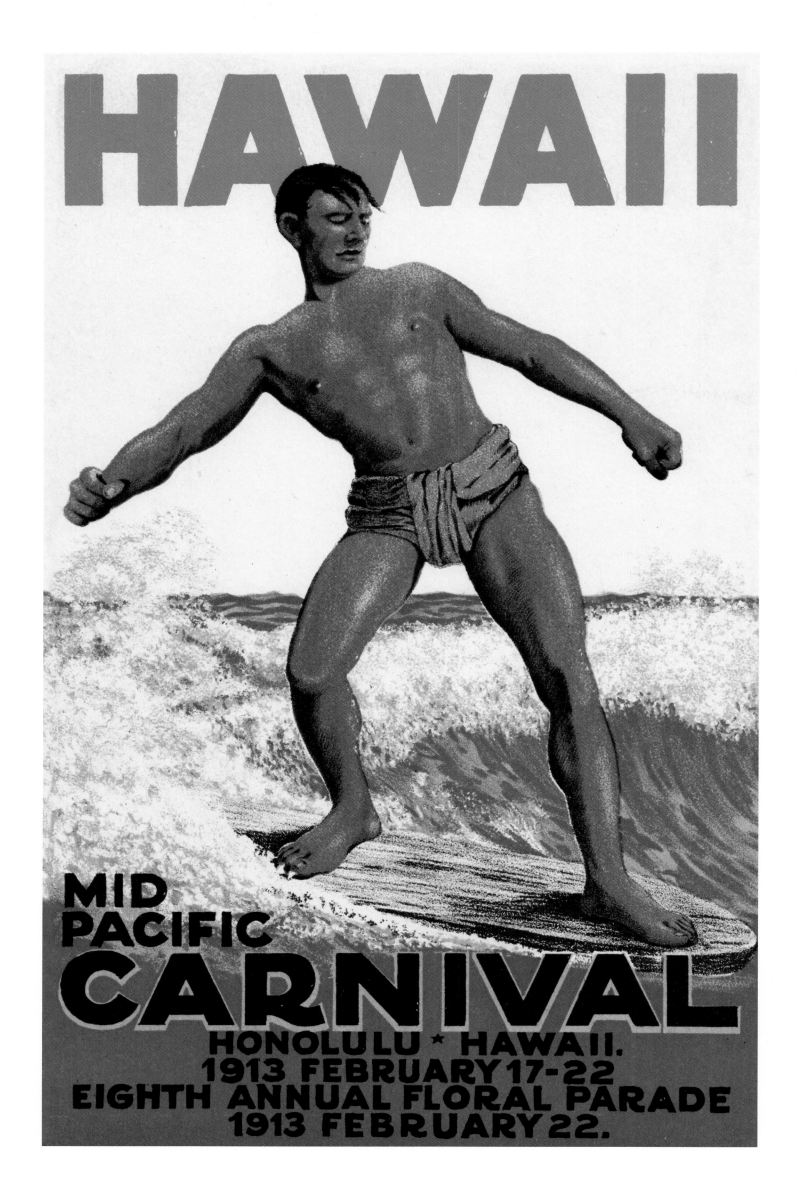

And when 30-year-old writer Jack London, living high on royalties from his adventure novels like *Call of the Wild* and *White Fang*, sailed his home-designed ketch *Snark* from San Francisco to Honolulu, he'd soon bring surfing to the public's attention like never before. There he met 39-year-old Alexander Hume Ford, a small, pointy-bearded Honolulu gadabout and surfing promoter, who is credited with introducing London to the sport, even taking the writer surfing for the first time. Not long after, London wrote his 4,000-word essay on his Waikiki surfing experience for *Women's Home Companion*, which was published on the mainland in October 1907 and reprinted as a chapter in London's 1911 travelogue *The Cruise of the Snark*.

Class and wealth also played a part in Waikiki's burgeoning surf scene. In 1908, Ford founded the Outrigger Canoe and Surfboard Club, surfing's first organization, for the purpose of "developing the great sport of surfing in Hawaii." The club had two or three dozen hardcore surfers and canoeists, but its membership roll was filled with hundreds of wealthy white-skinned surf dilettantes who mostly used the club for weekend brunching.

Twenty-three-year-old Waikiki local George Freeth, a quiet and well-bred, part-Hawaiian grandson of a British shipping magnate, befriended the local Hawaiians and began riding waves in the mid-1890s. Freeth became known from Hilo to Honolulu as an expert swimmer and the islands' best surfer. It was inevitable Ford and Freeth would meet, and in less than two months after they teamed up in 1907, Freeth gave London his first surfing lesson. Later that year, Freeth set out to promote the sport on the mainland. He sailed from Honolulu to San Francisco in California, and then almost immediately headed south to Los Angeles.

Los Angeles would try anything. This was the only place in early 20th-century America where surfing might be embraced as something more than a curiosity. Henry Huntington, land baron and Pacific Electric Railway owner, was a master at promoting Southern California land development. When he discovered Freeth and his surfing ability, he immediately put Freeth to work as an attraction for his subdivision.

In the summer and fall of 1907, twice each weekend afternoon, at 2 p.m. and 4 p.m., visitors were invited to the water's edge in front of the Hotel Redondo, in Redondo Beach, where a megaphone-wielding announcer introduced George Freeth as "the Hawaiian wonder" who could "walk on water." He'd wheel his heavy eight-foot redwood plank around,

SURF-RIDERS, HONOLULU, C. 1919
(Pages 26–27) Art, Charles William Bartlett

POSTCARD, MID-PACIFIC CARNIVAL, 1913 The Mid-Pacific Carnival, brainchild of tireless Hawaii booster Alexander Hume Ford, ran from 1910 to 1917. Surfing exhibitions were a sure homegrown crowd-pleaser alongside hula dancing, parades, and assorted sideshows.

POSTCARD, WAIKIKI, C. 1906

PROMOTIONAL BROCHURE, 1903 The outrigger canoe was often a substitute for the surfboard to entice Hawaii-bound tourists.

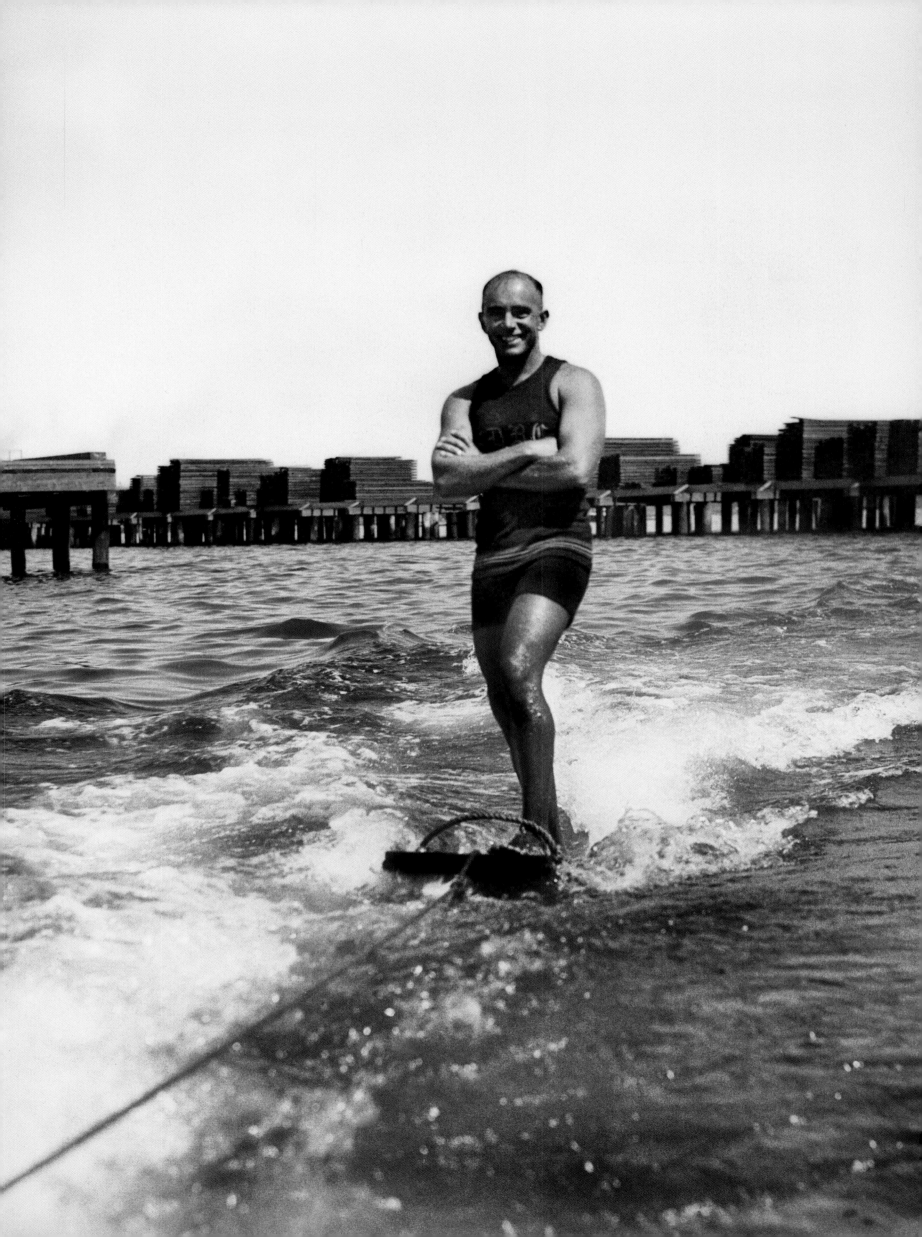

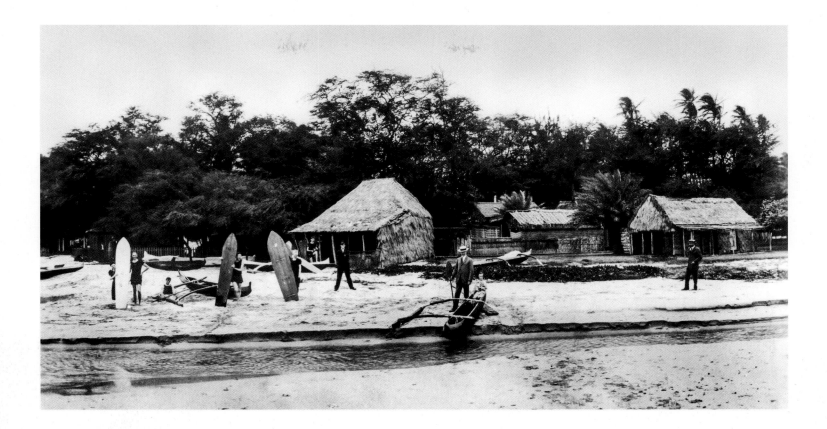

paddle for a wave, jump to his feet, glide toward shore, then paddle back out and do it again. Freeth was a loner and never married. He lived in hotels and boardinghouses, politely turned down invitations to social events, and in 1919, at age 35, died alone in a hospital in the coastal city of San Diego, a victim of the Spanish Flu pandemic. Still, he brought surfing to California at a critical juncture.

THE RISE OF THE DUKE

While Freeth spread the surfing gospel in California, Waikiki became packed with true believers. After Jack London departed aboard the *Snark*, surfing's popularity in Hawaii shot up rapidly, and in 1908, Alexander Hume Ford wrote that "at times there are hundreds in the surf with their boards." Hawaiian surfers formed small clusters beneath the shade trees and elegant verandas of the Moana Hotel, and later the Royal Hawaiian, and these groups of surfers, mostly in their 20s and 30s, were collectively known as "beachboys." All earned money by befriending tourists and serving in whatever capacity was required: island guide, surf instructor, lifeguard, babysitter, serenader, gigolo. It was an informal, tips-only, cash-based business. For better and worse, the beachboys of Waikiki established the particular value system that surfing became known for. Surfing was as important to these barefoot troubadours as their sexed-up, easygoing, empty-pocket deviancy. By combining the two, beachboys laid the foundation for what would later be called the surfing lifestyle.

Surfing had its glamour-generating force in Duke Kahanamoku, who, by the start of World War I, was globally recognized as wave-riding's grand patriarch. Kahanamoku began surfing at age eight, just before the turn of the century, and he may have been informally mentored by Freeth, who was seven years older and had been surfing at least a year or two longer. Kahanamoku cofounded the Hui Nalu ("Club of the Waves") surfing and canoe club in 1911, which had a small, talent-based membership, in contrast to Ford's Outrigger Canoe and Surfboard Club, which was mostly used for socializing by its primarily well-to-do members, who numbered in the hundreds. Though known as one of Waikiki's best surfers, Kahanamoku put most of his energy into swimming. He won a gold medal and set a world record in the 100 meters at the 1912 Olympics in Stockholm, Sweden, and returned to Waikiki an international sports hero.

GEORGE FREETH; SAN DIEGO, CALIFORNIA; C. 1915 Freeth's many skills in the ocean made him the consummate waterman.

OUTRIGGER CANOE CLUB, WAIKIKI, C. 1908 Shortly after Jack London's visit to Hawaii in 1907, Alexander Hume Ford formed the Outrigger Canoe Club on a prime beachfront lot leased for $10 a year from the estate of Queen Emma. Part surf club, part health club, its stated purpose was to provide a place where "men and boys could ride upright on the crest of waves." *Photo, Ray Jerome Baker*

PRINCESS KAIULANI, C. 1895 Kaiulani, heir apparent to the Hawaiian throne, was cultured, English-educated, and by all accounts a surfer. In her short 23 years, she campaigned tirelessly for the United States to restore her stolen kingdom and advocated the return of traditional Hawaiian culture.

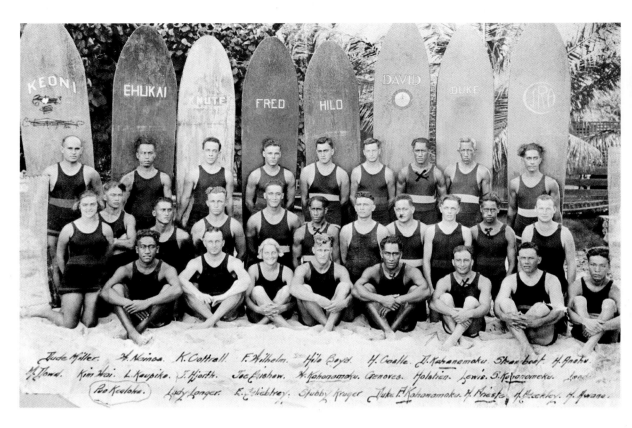

Surfing in Hawaii, and for a few devotees in California, may have been the activity of choice, but to the masses it remained nothing more than a fringe recreational activity. Kahanamoku changed this. Surfing would have caught on without him, but not as quickly, and not with the same opening bolt of style and élan. The athlete was famous and well traveled, eager to try new waves, and happy to pass on instruction. Kahanamoku was so at ease on a board that the ocean itself appeared less dangerous. All that, plus, he was tall and broad-shouldered, with high cheekbones, a radiant, full-lipped smile, and a brushed-back crown of thick black hair—one admirer fairly described him as "the most magnificent human male God ever put on earth." For 60 years, the "Duke" was the unofficial ambassador and the face of the sport.

REVOLUTIONIZING THE BOARD

Meanwhile, the Southern California surf scene developed quickly in the 1920s, and in many ways independently of Hawaii. In the 1920s, nearly everyone in the region wanted access to Malibu. In the fall of 1927, Santa Monica lifeguards Tom Blake and Sam Reid loaded their boards into Blake's Essex roadster and drove a few miles north to surf at Rancho Malibu, where they were greeted with a locked gate and a "No Trespassing" sign. But that didn't stop them from hitting the water. The two quickly stripped down to their swim trunks, unloaded the boards, and jumped in the water. Paddling north they zeroed in on Malibu point, made the lineup, and paddled for their first wave. "We caught it together," Reid said, "not a yard apart, and turned into a steep, parallel slide to try and beat the continuous wall rising ahead 300 yards to the beach. That was the game!"

Another popular surfing spot was Corona del Mar, a break next to the Newport Harbor jetties, in Orange County, about 90 minutes south of Los Angeles. Waves here were gentler, not so acutely angled, and better suited to the plank boards in use at the time. And it became the site of the inaugural Pacific Coast Surf Riding Championships, held in 1928.

The competition was an odd paddle-surf hybrid, held on a warm midsummer Sunday afternoon. A dozen or so riders lined up on the sand berm facing the surf, and at the sound of a starter's gun, they picked up their boards, sprinted for the water, paddled 500 yards out to a buoy, turned, and came back to the wave zone, where they had to ride, not paddle, for the shore and the finish line. Tom Blake was the inaugural winner, and that would just be the start of him making surfing history.

HUI NALU SURF CLUB, WAIKIKI, C. 1921
In response to the Outrigger Canoe Club, which became the social hub for Hawaii's white ruling elite, local Hawaiian surfers formed Hui Nalu, which translates to "Club of the Waves." Membership was open to all races and both sexes but surfing talent was prized above all.

STATIONERY DETAIL, HUI NALU, C. 1912

DUKE KAHANAMOKU, C. 1910 Kahanamoku, born August, 24, 1890, grew up a block off Waikiki Beach with five brothers, three sisters, and more than 30 cousins. He was named after his father, Duke, a Honolulu policeman, who had been named after Prince Alfred, Duke of Edinburgh.

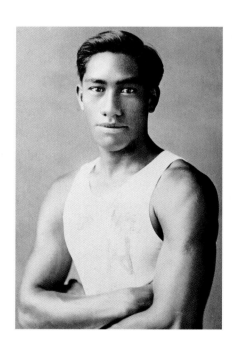

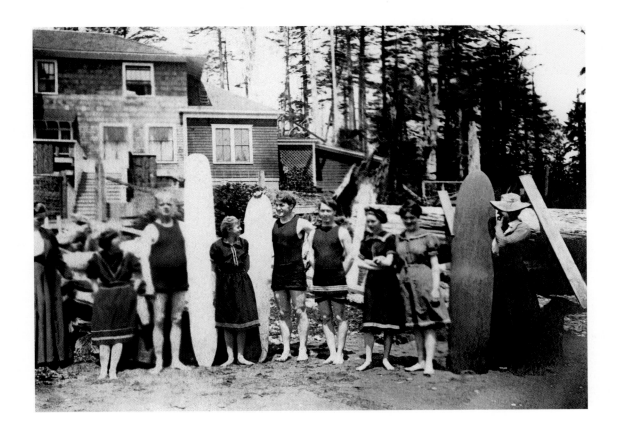

The Wisconsin-born Blake, restless and nearly humorless, became the sport's great innovator: He redesigned the surfboard, transformed wave-riding into something broader, changed the way surfers looked, and helped develop what later generations would call the "surfing lifestyle."

Blake had tried acting when he first arrived in Los Angeles, and then took a Santa Monica lifeguarding job and began to surf. In 1924, still a novice wave-rider but consumed by the sport, he caught a steamer for Hawaii, not returning to the mainland until years later. Boardmaking at the time was essentially a do-it-yourself job performed in the garage or backyard; the process usually took three days to a week. The average adult-size board, in keeping with a trend started by Duke Kahanamoku, was now longer, thicker, and wider than it had been, but board construction hadn't much changed in centuries. Blake was about to do something about that.

During his second visit to Hawaii, Blake built himself a 15-foot solid-redwood olo replica in 1926. Finding it too heavy, he drilled hundreds of holes from deck to bottom, and then covered both sides with wood veneer. Blake's hollow paddleboards quickly evolved into lethal-looking "cigar" models, first chambered, then rib-braced like an airplane wing.

He developed "riding" boards in line with his longer paddleboards, reducing the weight of a 10-footer to an airy 40 pounds. For the first time, surfers had a choice between two board construction styles. Blake's hollow style board was the main reason that California surfing's first real population spike came during the Depression, when the number of surfers doubled, then doubled again. Yet Blake's real gift to the surfboard was the introduction of a stabilizing fin in 1935—the design advance upon which virtually all future advances were built. "Never before had I experienced such control and stability," Blake said, recalling his first wave using a finned board. With this breakthrough, all the traction and bite a surfer needed was now available.

Blake's second big accomplishment of 1935 was the publication of his 95-page photo-illustrated *Hawaiian Surfboard*, the sport's first full-length book. It earned good reviews in the Honolulu press, but it failed to sell through its initial 500-copy press run. Blake was an earnest and deeply knowledgeable surfing source, but a flat-toned writer; what impressed reviewers the most was the book's photography.

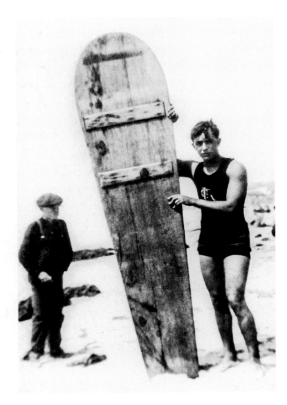

BEACH HOUSE; JOE CREEK, WASHINGTON; C. 1910 Surfing made its way to the Pacific Northwest via surfing descendants of the Dole family of Hawaii who built a sawmill and shingle factory near the Washington coast. They called it the "Aloha Shake Company."

GEORGE FREETH; REDONDO BEACH, CALIFORNIA; 1915 In his own quiet way Freeth was responsible for embedding Hawaiian surfing and surf culture on the beaches of California. Traveling alone along the Southern California coast, he would stop into small beach towns and give free surfing lessons to anyone who asked.

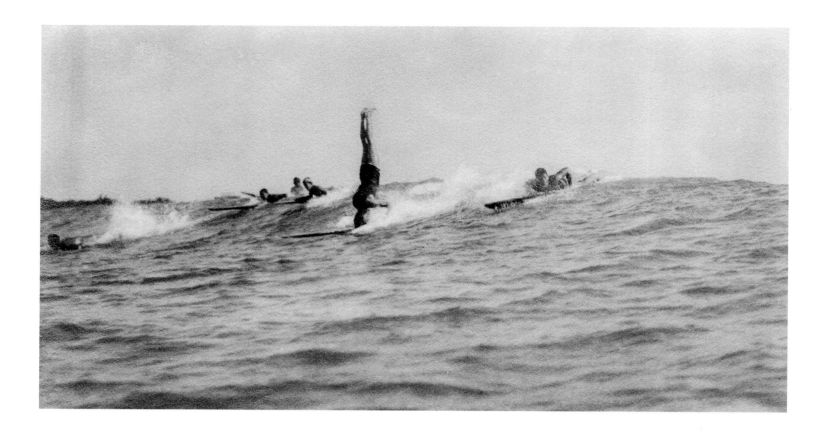

THE BUSINESS OF SURFING

The popularity of surfing continued to grow in coastal areas, despite the Depression. Being poor on the beach in Southern California was a lot better than being poor in the Nebraska plains or on a New York street corner—or anywhere else in the country, for that matter. Surfers were already familiar with living on the cheap: They made their own trunks and surfboards, pulled lobsters and abalone from the sea, gathered wood for their own fires, and could build an evening's entertainment around a ukulele, a guitar, and a passed-around bottle of jug wine. Riding waves didn't make up for being jobless or underemployed, but it was a nice way to pass the time if you were.

Outside of the United States, surfing pioneer work was underway during the 1930s in Lima, Peru; Durban, South Africa; Rio, Brazil; and a few other coastal cities. But the surf world remained for the most part tri-cornered—practiced in Australia, Hawaii, and California by fewer than 3,000 people total. Over the previous 35 years, maybe a dozen surfers had circulated between California and Hawaii. Even fewer went from Australia to Hawaii, or vice versa, and surf travel between California and Australia didn't exist.

During the Depression, Australia was truly a surfing land unto itself. Despite Duke Kahanamoku leaving his sugar pine surfboard behind after his visit in 1915, the locals pretty much invented their own version of the sport. For all of Australia's ingenious surfing equipment developments, the sport remained very much an auxiliary pastime of the powerful Surf Life Saving Association of Australia (SLSA). A sports organization and social network as much as it was a lifeguard service, the all-volunteer SLSA, by 1935, had nearly 10,000 bronzed, muscled, highly disciplined members who were the beachfront pride of the British Empire. Given the SLSA's beachfront dominance, surfing Down Under was bound to come of age as a much different sport than it did elsewhere. Virtually all first-generation Australian surfers were lifesavers first and wave-riders second. Surfing was something you did during off-duty hours. Surfing in Australia wasn't the "sport of kings," as it was in Hawaii, and had little or none of the early onset cult panache that was developing in California. While Australia was destined to become the world's most exciting surf nation, first it would have to make a clean break from the SLSA.

Hawaii invented surfing, and Waikiki remained by far the easiest and most agreeable place in the world to ride waves. Yet by the 1930s, Southern California was uniquely

WAIKIKI, 1912 *Photo, A.R. Gurrey*

POSTCARD, MID-PACIFIC CARNIVAL, 1914

MAGAZINE COVER, *THE GRAPHIC*, C. 1915

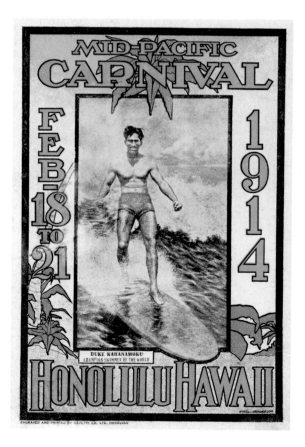

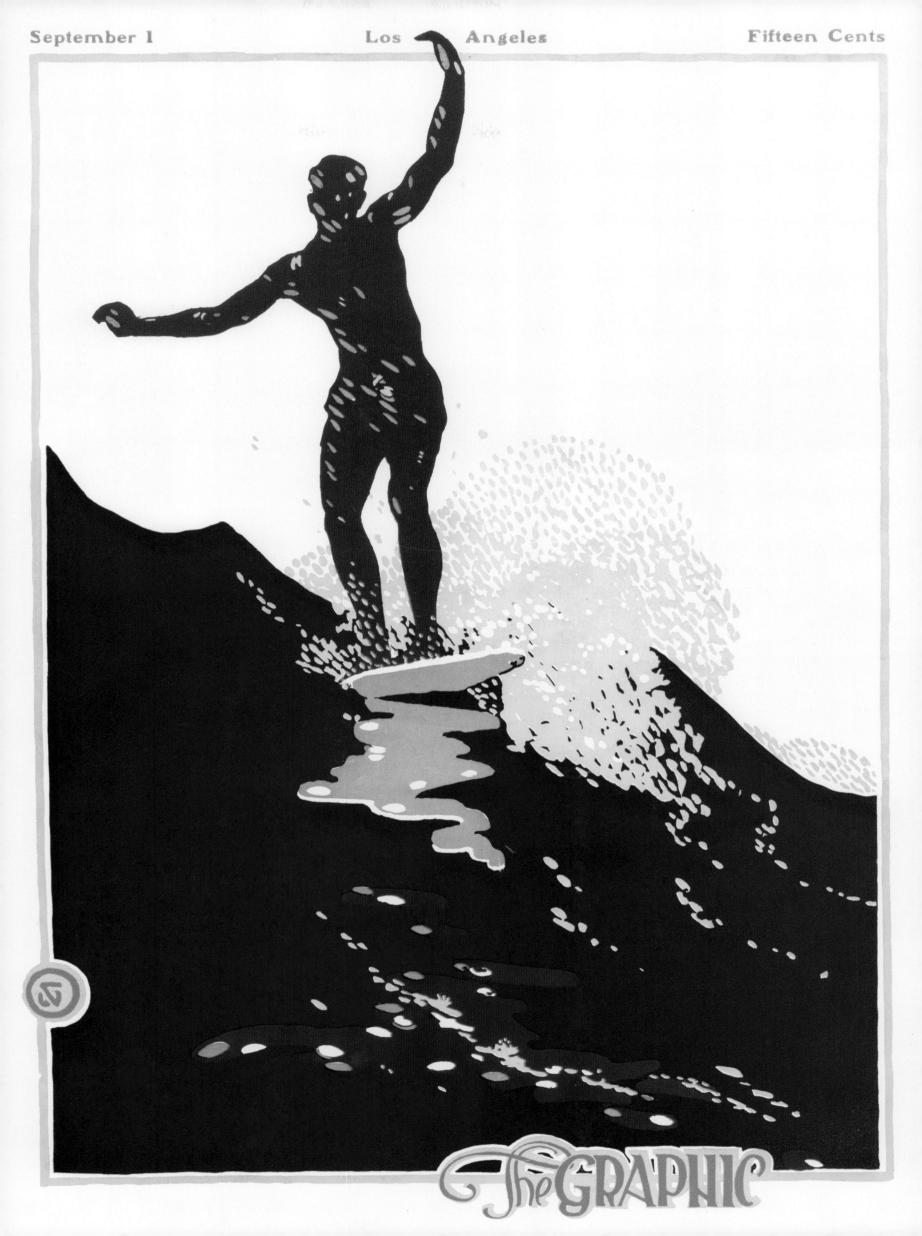

The GRAPHIC

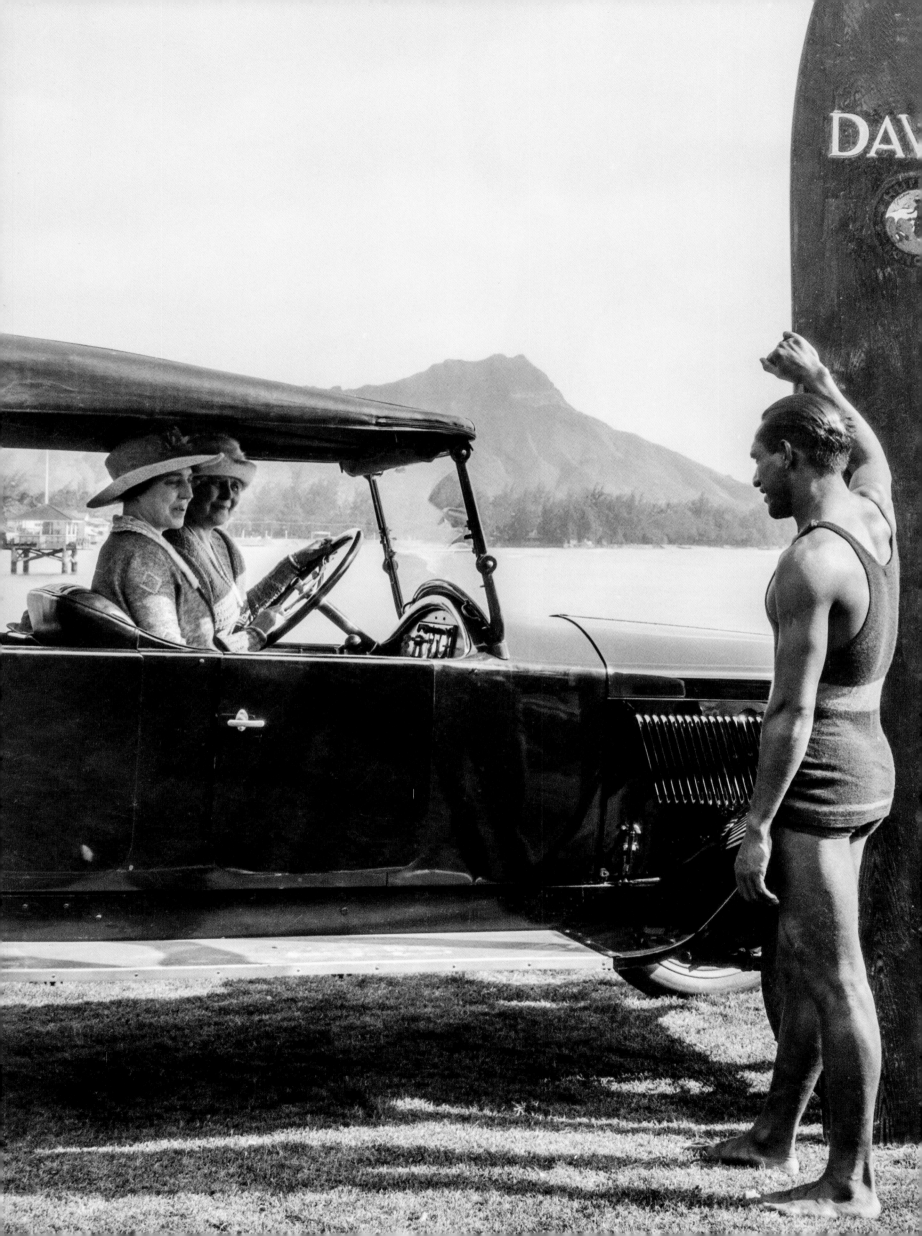

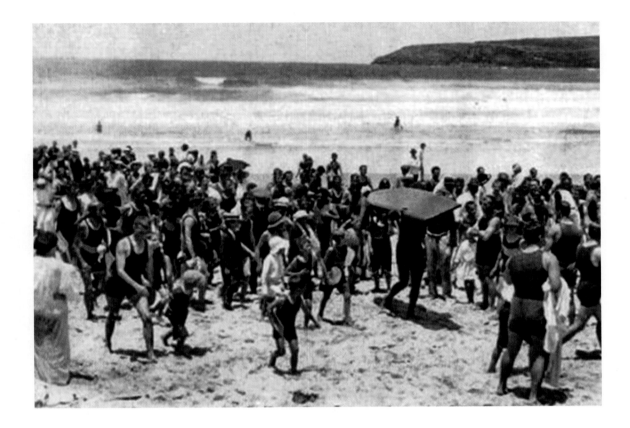

qualified to begin reinventing the sport. The first commercially made surfboards were built, stored, packaged, advertised, and shipped by Pacific System Homes, a light industrial company founded in 1908. Meyers Butte was the son of the company cofounder, and he convinced his father that building surfboards might be a profitable Pacific System sideline. The subsidiary interest he organized was called the Swastika Surf-Board Company—in 1930 the hooked-cross design was recognized, if at all, as an obscure good luck symbol.

Butte hired top Southern California surfer-craftsmen, such as Pete Peterson, Lorrin "Whitey" Harrison, and Calvin "Tulie" Clark, to make his line of boards, which were built to preset dimensions and sold in sporting goods stores, beach clubs, and department stores. The first Pacific System boards were finless single-slab redwood planks weighing 70 pounds. Butte knew this was too heavy, so in 1932, Pacific System boards had a balsa core and redwood on the sides, nose, and tail. To promote the line, Butte spent freely on surfboard advertising and promotions, and he was an expert at getting his boards into the hands of celebrities, including Duke Kahanamoku and Shirley Temple.

At the same time, Tom Blake secured a patent on his hollow surfboard—or "water sled." He then entered into the first of a series of licensing agreements to manufacture, market, and sell his signature line of boards, almost all of which were assembled by professional woodworkers of one kind or another.

Where Pacific System boards were designed and marketed primarily as wave-riding craft, the Blake hollow was offered as a paddleboard, a rescue board, a tow-board, and a water polo board. None of it much effect on the bottom line. The problem was that the worldwide surfing population in the 1930s remained below 5,000. The sales figures are long lost, but Blake said his semiannual royalty checks rarely topped $100 and were often below $40. Pacific System Homes did no better: Just 15 boards were made in a given batch, and the boardmaking operation shut down completely after America entered World War II. Surfing wasn't yet big enough to support even a cottage industry.

"SANO" SOCIALIZING

Surf club membership wasn't mandatory for California surfers, but by the late 1930s you could have driven some 450 miles from San Diego to Santa Cruz, and had a hard time loading a car up with nonaffiliated surfers. Unlike the surf-based organizations in Hawaii

DAVID KAHANAMOKU, WAIKIKI, C.1918
David Kahanamoku, younger brother of Duke, chats with tourists at Waikiki Beach. He, along with Duke and their brother Sam, all qualified for the U.S. swim team to compete in the 1924 Summer Olympics in Paris, France.

DUKE KAHANAMOKU; FRESHWATER BEACH, SYDNEY, AUSTRALIA; 1915 Though Kahanamoku's "surfboard shooting" performance at Freshwater Beach may not have been the first instance of surfing in Australia, it remains a celebrated moment for the sport.

MAGAZINE COVER, *SCIENTIFIC AMERICAN*, 1912 The cover story on "Artificial Surf Baths" featured a strained, tamed, and heated ocean, as well as an early example of a wave machine that a mostly non-swimming Edwardian populace could relate to.

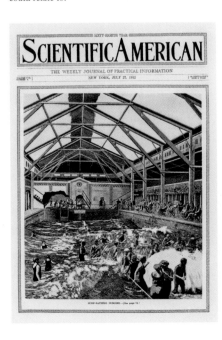

WAIKIKI, 1914

TOURIST BROCHURE, C. 1918

MAGAZINE COVER, *PARADISE OF THE PACIFIC*, 1918 *Paradise of the Pacific* was founded in 1888 by King David Kalakaua to promote Hawaii businesses and overseas tourism. *Art, P. J. Rennings*

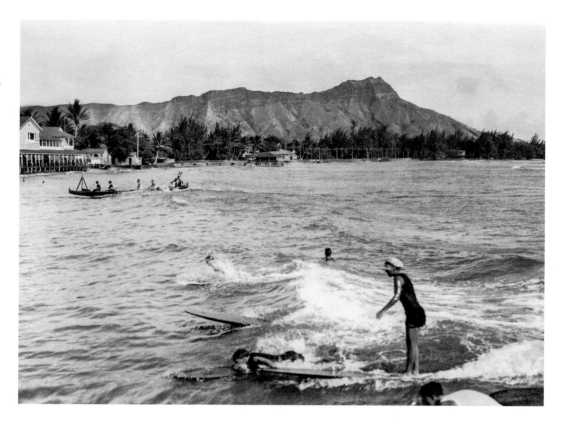

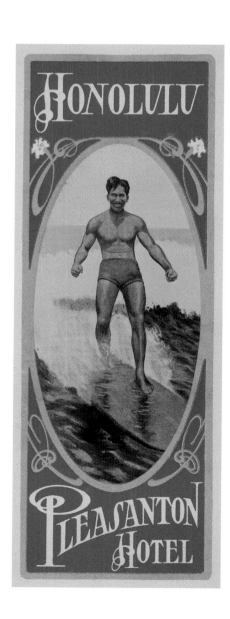

and Australia, these new clubs were focused on surfing, and a bit of paddling, and nothing else. California's best-known and best-organized group was the Palos Verdes Surf Club (PVSC), founded in 1935 by a surfing dentist named John "Doc" Ball. Fewer than 30 surfers took the club oath and became PVSC members during the 1930s. A dozen other similar clubs were formed up and down the coast, everyone filled with young gung-ho middle-class surfers, roughly half of them college students. The surf club movement said a lot about how the sport was developing in America. Surfers now had the numbers and confidence to join together in organizations having little or nothing to do with extraneous things like lifeguarding or canoeing. Wave-riding was enough.

In the 1930s and early 1940s, San Onofre was the sweet and easy low-simmering crucible of American surfing. Tiny pod-like surfing communities took root in California, from San Diego's Mission Beach all the way up to Pacifica in the San Francisco Bay Area; Virginia already had three decades of surf history; and Florida had enough riders by the end of the Depression that Daytona Beach was able to host an annual contest. But San Onofre, located between Los Angeles and San Diego, was where the mainland version of the sport shined brightest.

The San Onofre wave was perfectly engineered to work with a 40-pound wooden surfboard. A telescoping set of reefs produced a long stretch of beginner's surf near the beach, and a more concentrated peak further offshore—like Waikiki, but at one-third the scale. The best thing about San Onofre, surf-wise, was that it could conjure waves from nothing. Beaches to the north and south might be completely flat, but there was always something to ride here.

What made San Onofre unique had as much to do with what happened on the beach as what took place in the water. On any given warm weekend, 25 or so "Sano" regulars and another 50 to 75 fellow travelers—assorted friends, siblings, and girlfriends—came together informally into a kind of self-contained surf cooperative. For the first time in its modern era, the sport had a space in which it could develop on its own. Over the course of a few thousand Depression-era days at San Onofre, surfing socialized itself.

The San Onofre pioneers also developed many of the protocols for what it meant to be a surfer, in and out of the water. Travel was part of it, and self-reliance. They were the first to imbue the sport with the pride and knowingness of an exclusive secret society.

Paradise of the Pacific

HAWAII'S ILLUSTRATED MONTHLY MAGAZINE

Volume XXXI Number XII HONOLULU, HAWAII, U. S. A. Price Fifty Cents

DECEMBER, 1918

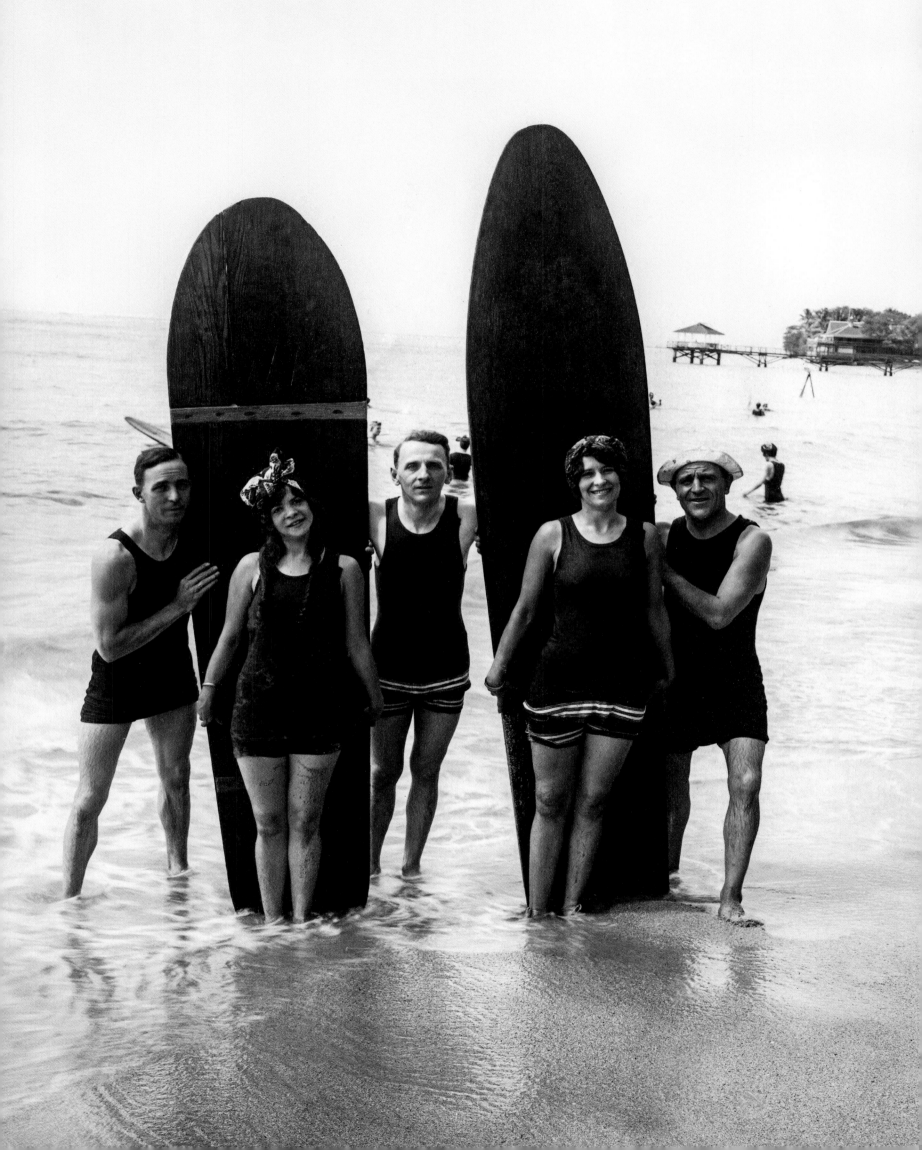

THE EMPTY LOT BOYS

Meanwhile, island life was getting more attention: In the years between the world wars, Hawaii discovered that its most valuable export was itself. Movies, newsreels, magazines, newspapers, and radio flung Hawaiian images and songs across the Pacific to the mainland like free candy. Hawaii was still too distant and too expensive for all but leisured rich. Not until after World War II would tourism become Hawaii's perpetually top-ranked industry. But the Depression-era promotion of the Hawaii fantasy helped make that happen.

Surfing continued to develop in its waters during this time, with a group of young surfers looking to take the sport to new heights. One of them was John Kelly, the son of a San Francisco artist, who was learning how to surf on a miniature redwood plank shaped by David Kahanamoku, Duke's brother. The younger Kelly soon made friends with two other local haole surfers, a chalk-white scrapper named Wally Froiseth and a quiet, slender, well-dressed boy named Francis "Fran" Heath. They rode all the Waikiki breaks and even discovered another half dozen spots within paddling distance of Kelly's house at Black Point, on the east side of Diamond Head. When they weren't surfing, they hung out in an overgrown beachfront lot not far from the Moana Hotel; people started calling them the Empty Lot Boys. Kelly, Froiseth, and Heath watched and learned from the top beachboy surfers at breaks like Queen's and Publics, but by the time Kelly and his friends entered high school, they looked upon the Waikiki surf scene with a more critical eye. The older surfers didn't much care about advancing the performance standard, while the new kids cared about little else.

The Empty Lot Boys didn't like longer boards. They didn't like hollow boards, either—too buoyant and tippy. Heath was the best surfer of the group, from a wealthy family, and at age 18, he had a beautiful new Pacific System Homes Swastika model board freighted over from Los Angeles. On a summer morning in 1937, Heath and Kelly paddled out to a Diamond Head reef called Browns, located near Kelly's house, to try and ride some overhead waves. On wave after wave both surfers kept "sliding ass"—spinning out—as they tried to hold an angle across the steep faces. Kelly stared down at his plank during a backyard lunch break that afternoon and came to what now seems like an obvious design appraisal: too much planing surface in the tail section. On the spot, Kelly convinced Heath to hand over his still-new Swastika. After setting the board on a pair of sawhorses, he stood for a

MAINLAND TOURISTS, WAIKIKI, 1914
Photo, Ray Jerome Baker

SHORT STORY ILLUSTRATION, 1920
Surfing, swimsuits, and sex... what happens in Waikiki, stays in Waikiki. *Art, Stockton Mullard*

MAGAZINE COVER, *POPULAR MECHANICS*, 1927 "Weighing but 30 pounds and constructed so that it cannot sink or capsize," *Popular Mechanics* highlighted a fanciful, fish-shaped metal surfboard from California made of duraluminium.

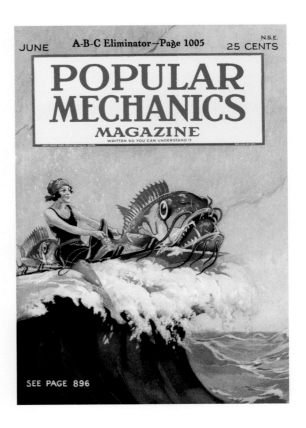

JANUARY 27, 1923 ★ Down South Number PRICE 15 CENTS

JUDGE

WITH WHICH IS COMBINED LESLIE'S WEEKLY

A Gulf Streamline Model

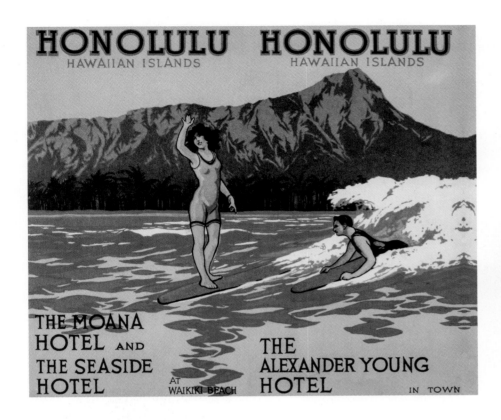

moment looking down at the board's stern, and with a determined overhead swing, buried the ax blade three inches into the rail. Both surfers then got to work, transforming the squared-off tail section into something that resembled the tail section of a jet fighter.

Later that afternoon, with the new varnish coat still tacky, the two surfers paddled back out to a still-humping Browns lineup. Kelly had the new board, and on his first wave it bit into the wave face, and he was able to draw a high, fast angle toward the deep-water channel. Froiseth shouted out, "These things really get you in the hot curl!" With that, the new narrow-tail design had a name.

Kelly's new board was one of those developments that, in hindsight, seems both wildly modern and woefully overdue. Modern surfing begins at the turn of the century with George Freeth and Jack London, Alexander Hume Ford, and the Outrigger Canoe Club. Lagging by a full 30 years, modern surfboard design begins with the hot curl.

BIG WAVE-RIDING

Wave-riding in Hawaii during the late 1930s was still done almost exclusively at Waikiki, where the surf was generally biggest from May to September. Everyone on the beach had a vague understanding that the waves on the north and west sides of the island came up during fall and winter, and that they were often bigger, much bigger, than anything that hit the southwest-facing reefs at Waikiki. Before long, a few surfers began directing their attention toward Makaha, on Oahu's west side. With a moderate swell running, three distinct takeoff areas are in play at Makaha, each one good for a playful if somewhat meandering right-slide that terminates, just a few feet off the beach, in a spectacular backwash-generated shorebreak. The hot curl surfers enjoyed riding on these kinds of small and midsize days. But what they really hoped to find after the long drive from Honolulu is something called Makaha Point Surf, where waves are twice as powerful as anything found in Waikiki.

When Kelly and Froiseth began riding Makaha, they did so believing they were the first. They eased into it. Full-size Point Surf was too much for the early hot curl prototypes, but the Empty Lot Boys were confident in their new equipment and pumped to the gills with immortal teenage swagger. They understood that new big surf techniques were theirs to invent; three or four years later, they were confidently paddling into waves bigger than

MAGAZINE COVER, *JUDGE*, 1923
TOURIST BROCHURE, C. 1919
LUGGAGE LABEL, C. 1925
MAGAZINE COVER, *SUNSET*, 1926

ALOHA HAWAII
FROM

SEASIDE HOTEL *and* BUNGALOWS
On the Beach at Waikiki—HONOLULU

anything they'd ever seen in Waikiki. Froiseth, Kelly, and a few others also began making day trips out to the North Shore, after hearing stories from visiting California surfers Whitey Harrison and Gene "Tarzan" Smith about a powerful reef break near Haleiwa Town. The North Shore was a different world compared to Makaha.

The two surfing environments were different as well. As terrifying a big-wave break as Makaha could become at times, its location was actually protected from much of the year's biggest surf and heaviest weather. The North Shore squared up directly against both incoming waves and storms, which meant bigger waves, mixed-swell combinations, plenty of rain and stronger, less predictable winds. Sunset Beach quickly revealed itself as the North Shore's most consistent break.

Sunset was the first North Shore wave Wally Froiseth, Fran Heath, and the rest of the hot curl gang rode. They liked it well enough, and were awed by the sheer number of breaks along the North Shore. Makaha, though, remained their favorite surf-travel destination. Chasing bigger waves was a thrill, but it was also time-consuming and intense; by focusing more on one break—Makaha—instead of roaming the coast from Haleiwa to Sunset, the whole operation was a bit more grounded.

At Queen's in Waikiki, a beachboy named Albert "Rabbit" Kekai was an early addition to the Makaha crew, joining Froiseth, Kelly, and Heath. Another newcomer was Woodbridge "Woody" Brown, a 28-year-old New Yorker and record-holding glider pilot who sailed for Honolulu in 1940. The first friend he made in Hawaii was Froiseth. Brown had built his own gliders, and rightly believed that much of what he knew about aerodynamics might be applied to surfboards, so he jumped right into the ongoing hot curl revolution. Froiseth and the others thought Brown was a bit of an odd duck but he was smart and enthusiastic, and just as ready as they were to paddle into big surf. Brown rode Makaha like he was born there, and it wasn't long before his sleek boards were getting noticed as well.

Through the fall of 1941, the Empty Lot Boys and their hot curl converts lived at a nearly surreal remove from the rest of the world, both geographically and psychologically. The winter wave season had just arrived, and Hawaii's surfing vanguard spent the first three weeks in December riding Makaha, or making plans to do so, and talking a lot about who had a faster board, Froiseth or Brown. These were the important things, until December 7.

Los Angeles to Honolulu
ON UNITED STATES GOVERNMENT SHIPS

Los Angeles Steamship Company
Operators for United States Shipping Board

SURFERS GO TO WAR

On December 7, 1941, a California surfer named Don James set the auto timer on his camera and took a photo of himself and two friends standing with their boards in front of a rented bungalow at Topanga Beach, near Malibu. "Right about then, news came over the radio about Pearl Harbor, and suddenly everything changed. We all looked at each other, and we all knew we were going off to war."

Nearly every able-bodied surfer over the age of 17 enlisted, and within six months, American lineups were close to empty. Hawaii, in particular, was transformed. Martial law was declared across the islands. Razor wire was unspooled around the beach perimeter at Waikiki and Makaha to guard against the expected amphibious landing of Japanese forces, and gun emplacements were built on the slopes of Diamond Head.

In California, surfboard production came to a near halt as building materials of every kind were claimed by the military. The Coast Guard built a station at Malibu, put a barbed-wire fence around the point, and was off-limits for the duration. More than half of Rancho Santa Margarita y Los Flores, including San Onofre, was unceremoniously requisitioned by the United States Marines, cleared of all civilians, stocked with barracks and training fields, and renamed Camp Pendleton. Rationing made surf travel a lot harder: Government-issued coupon books allowed most civilians just four gallons of gas a week, and a lightly enforced but still annoying "Victory Speed Limit" was set at 35 miles per hour.

And for those few hundred GI surfers in foxholes, barracks, tents, tanks, mess halls, and airfields around the world, surfing and all its attendant pleasures became a daydream— a favorite subject for homesick can't-wait-to-get-back letters to friends and family. In these letters, soldier-surfers often touched on noble aims like freedom and democracy. But they lingered on things that were less ideological, more immediate and personal—a speedy return to Bondi, or Waikiki, or Malibu, and a mad dash for the surf. This was a form of patriotism, too; a longing for the everyday pleasures that peace and free society allowed.

—Adapted from *The History of Surfing*, 2010

WAIKIKI, C. 1921
MAGAZINE COVER, *THE STOWAWAY*, 1919
MAGAZINE COVER, *PARADISE OF THE PACIFIC*, 1923

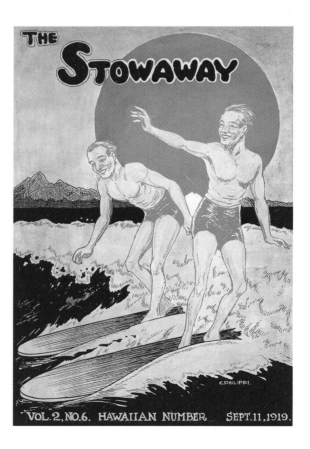

Paradise of the Pacific

HAWAII'S ILLUSTRATED MONTHLY MAGAZINE

VOL. XXXVI. HONOLULU, OCTOBER, 1923 NUMBER 10

PRICE 30 CTS.

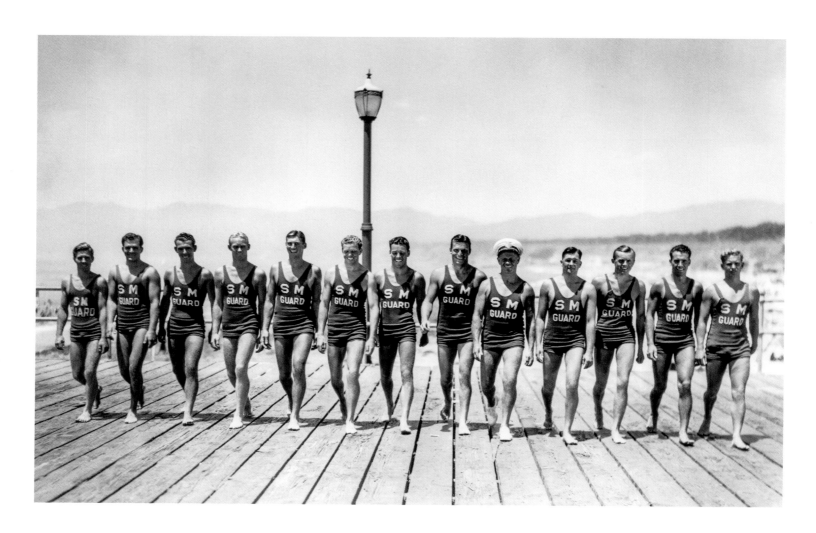

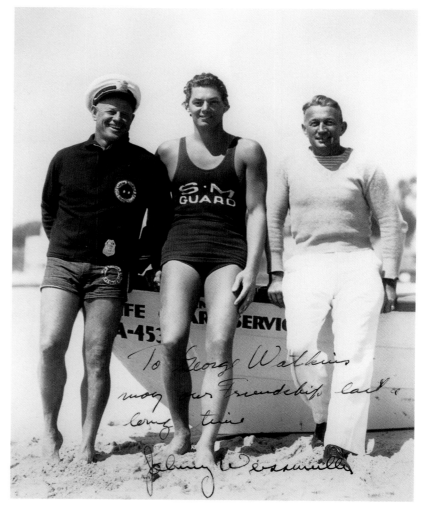

SANTA MONICA LIFEGUARDS, 1933

GEORGE "CAP" WATKINS AND JOHNNY WEISSMULLER; SANTA MONICA, CALIFORNIA; C. 1932 Watkins, left, was instrumental in creating one of the world's first modern professional lifeguard services on the beaches of Santa Monica. Weissmuller, center, was an Olympic gold medal–winning swimmer and rising Hollywood star who was made an honorary Santa Monica lifeguard.

ADVERTISEMENT, VALSPAR, 1920
Duke Kahanamoku was a rare example of a surfer endorsing a product line, a practice that would become commonplace several decades later.

Valspar—the Varnish of countless uses—

DUKE KAHANAMOKU of Hawaii, famous athlete, expert on the surf-board and world champion 100-metre swimmer has discovered still another use for Valspar. Duke Kahanamoku writes:

Honolulu, T. H., May 3, 1921
"Have used Valspar on my surf-boards for several years, and find that it preserves the wood, because it is waterproof and prevents the water from soaking in. No matter how long the board is used in the water, the Valspar is not affected and does not change color." DUKE KAHANAMOKU.

Valspar is durable, easy to apply, weatherproof and *waterproof*— "the Varnish that won't turn white."

Valspar's well-known uses—on floors, furniture, woodwork, linoleum, airplanes, boats and railroad trains—are supplemented by countless others such as

Baby Carriages	Golf Clubs
Window-Screens	Tents
Trunks	Fishing Rods
Hand Luggage	Tennis Rackets
Wicker Furniture	Oilskins
Refrigerators	Gun Stocks
Fireless Cookers	Snow Shoes
Draining Boards	and Skis
Boots and Shoes	Etc., etc.

In fact, anything that's worth varnishing is worth Valsparring.

Don't overlook the coupon below.

VALENTINE & COMPANY

Largest Manufacturers of High Grade Varnishes in the World—Established 1832

New York Chicago Boston Toronto London Paris Amsterdam
W. P. FULLER & Co., Pacific Coast

VALENTINE'S VALSPAR

The Varnish That Won't Turn White

The famous Valspar boiling water test

This coupon is worth 20 to 60 cents

VALENTINE & COMPANY, 456 Fourth Ave., New York

I enclose dealer's name and stamps, amounting to 15c for each 35c sample can checked at right. (Only one sample of each product supplied at this special price. Write plainly.)

Dealer's Name...........................

Dealer's Address........................

Your Name..............................

Your Address...........................

Valspar . . . ☐
Valspar Stain . ☐
State color...........
Valspar Enamel ☐
State color...........

Lit. Dig. 4-1-22

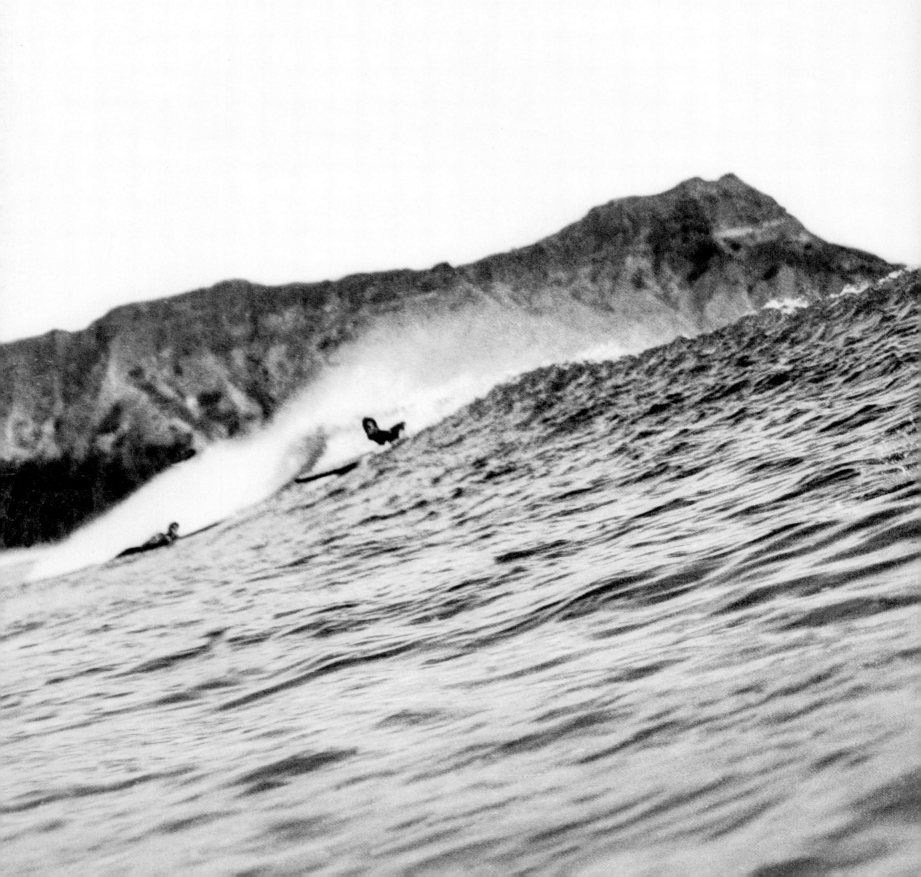

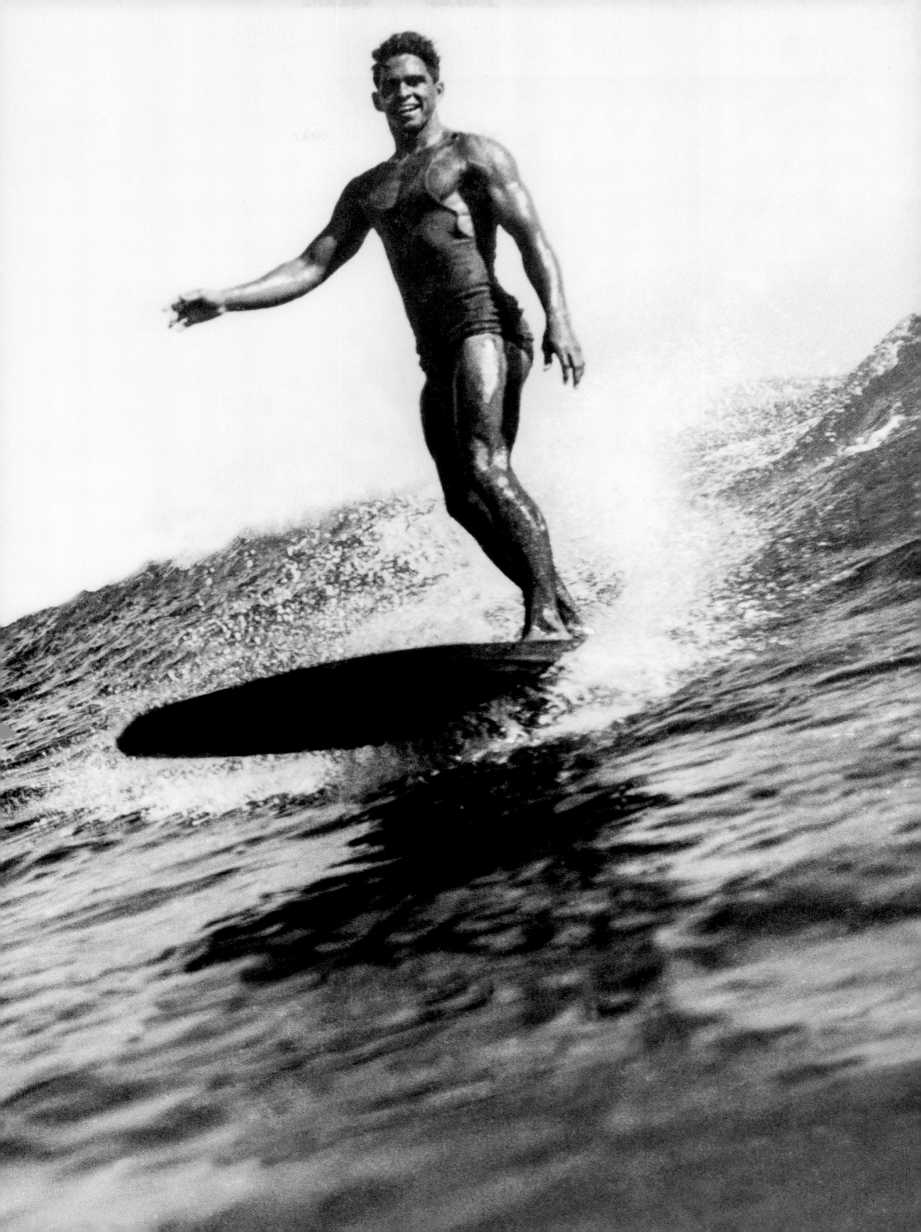

HARRY FIELDS, WAIKIKI, C. 1932
(Pages 50–51) Tom Blake designed and built the first camera water-housings to take close-up surf photographs. He would wade out and stand on the shallow reef at Waikiki or take a canoe out to deeper water. A surfer himself, Blake had a natural eye for framing the wave and the rider in a way that caught the peak of the action. *Photo, Tom Blake*

DECAL, C. 1939

BOOK COVER, *KIMO*, 1928 Author Alice Cooper Bailey was the daughter of Judge Henry Cooper, one of the men responsible for the overthrow of the Hawaiian monarchy in 1893. *Kimo* was about the grandson of Hawaii's deposed Queen Liliuokalani. *Art, Lucille Webster Holling*

PUZZLE, C. 1931 Offered at Richfield gasoline stations, novelty puzzles were given away as a premium to repeat customers. *Art, Feg Murray*

TOURIST BROCHURE, 1932 *Art, Maurice Loran*

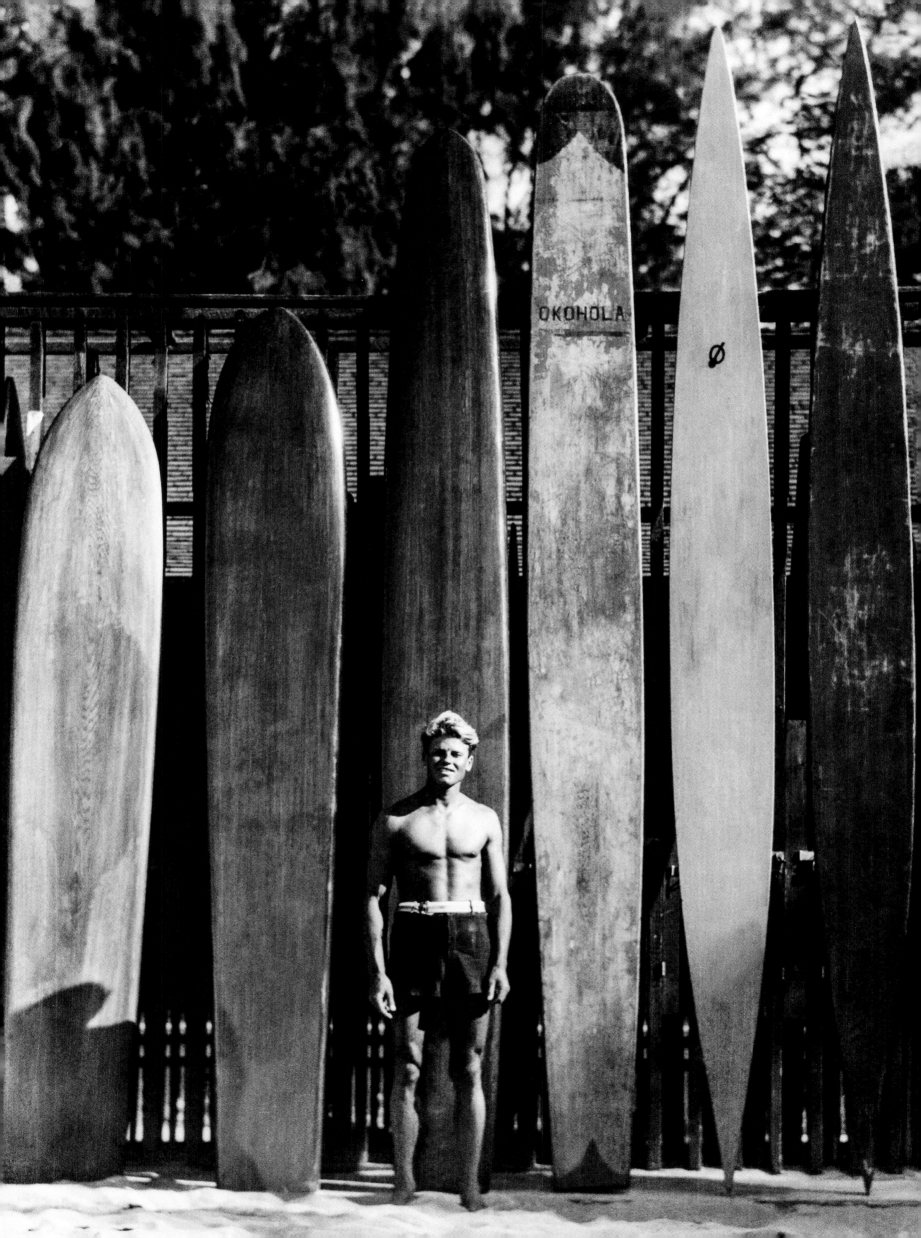

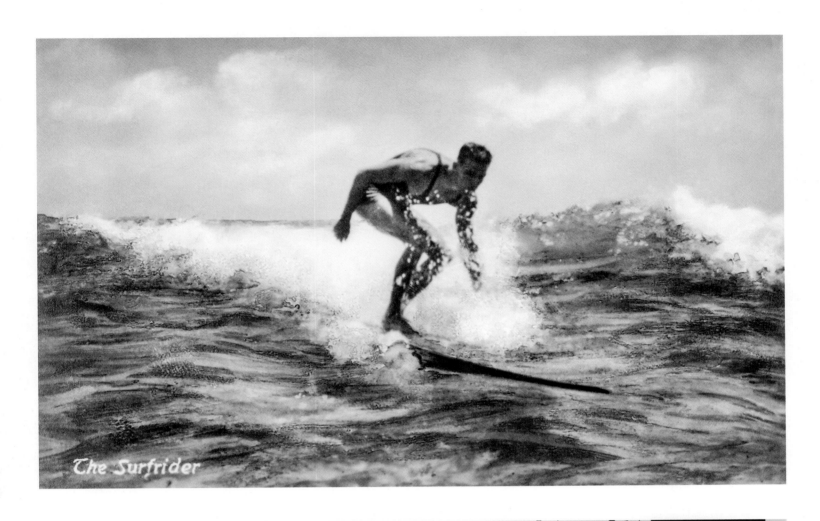

The Surfrider

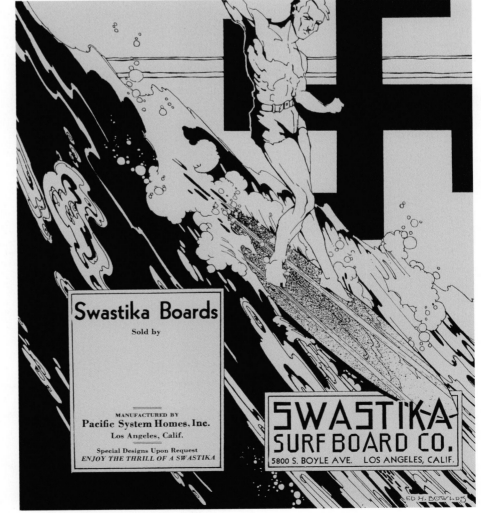

Swastika Boards

Sold by

MANUFACTURED BY
Pacific System Homes, Inc.
Los Angeles, Calif.

Special Designs Upon Request
ENJOY THE THRILL OF A SWASTIKA

SWASTIKA
SURF BOARD CO.
5800 S. BOYLE AVE. LOS ANGELES, CALIF.

TOM BLAKE, WAIKIKI, 1929 Blake took this self-portrait with his "quiver" of self-made boards that he used for a wide range of wave sizes and swell conditions. *Photo, Tom Blake*

POSTCARD, C. 1932

PROMOTIONAL BROCHURE, PACIFIC SYSTEM HOMES, C. 1932 Swastika Surf-Boards, manufactured by Pacific System Homes, borrowed the Hindu symbol for God and energy, which implied a deified good ride. After the Nazis appropriated the swastika as a symbol of Aryan purity in the 1930s, the boards were rebranded as "Waikiki Surf-Boards."

Riding the Breakers!

on this

HOLLOW HAWAIIAN Surfboard

It's built like a boat, with deck and bottom planking over frames, and is so light that one person can handle it either ashore or afloat

By TOM BLAKE

YOU'LL get plenty of thrills when you try this speedy hollow surfboard, either riding the waves of the open ocean, freeboard aquaplaning in the wake of a speedboat, sailing or just paddling about on fresh-water lakes. It's nothing more or less than a shallow pontoon, light, structurally strong and virtually unsinkable. So great is the safety factor that it has been officially adopted in many localities as standard lifesaving equipment.

Size and Framing: For a person of 125 to 200 lbs. weight, the standard-size board is desirable. This is 12 ft. 10 in. long, in width 22 in. maximum, and in depth 5⅝ in. maximum. For lakes and rivers it may be made of lighter material than specified, for this model is more for heavy duty in the ocean surf and will weigh from 70 to 75 lbs. The entire board may be made of any wood desired, spruce for frames and African mahogany for planking being first choice. See Figs. 1 and 2 for general details and sizes of stock. The framework

consists of transverse braces or ribs, a bow and stern block and sides or rails to hold all these parts in place, Figs. 3, 4 and 5. Two lateral battens extend down the center of the frame to form a seat for the center seams. The ribs are fastened to the side rails with headless copper nails, Fig. 4, countersunk and covered with putty. This allows ribs to pull free from the sides of the board when expansion of the decks takes place after seasoning a few weeks in the water. The expansion of the decks amounts to about ⅜ in. on each side, and therefore the rib must be free to leave the rail that much. This makes it wise to omit the deck screws through to the ribs transversely, until expansion has occurred in the water, otherwise the screws may pull loose. However, by deeply countersinking and covering the screws, they will tend to bend with expansion of the decks and not show from the outside of the board. Due to the structural features, however, the former procedure is recommended. Sides take the curve of the board without steaming. Clamps easily bring them into position. The grain of the bow and stern blocks should run with that of the decks. This is important as it allows all

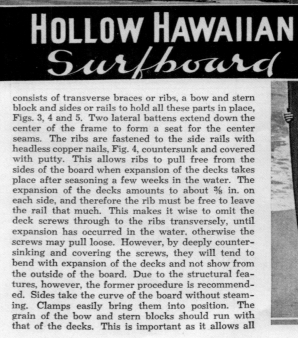

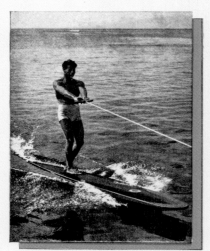

parts to swell equally in all directions. Sides are fastened to bow and stern blocks with 2-in. flat-head brass screws.

Decks: Decks (top and bottom of board) can be cut from a plank 12 in. wide,

14 ft. long, and ¾ in. thick. Using stock of this width, it is necessary to select each plank very carefully. Decks should be fastened to the frame with flat-head brass screws spaced 2 in. apart. The center batten seam and the rail joints are taped and coated with marine glue when assembling. Screws should be countersunk and the holes plugged to make a neat job. Use a waterproof casein glue under the screw-hole plugs. A hole to drain the water is located near the stern, and each rib is notched to form limber holes on each side of the center batten. The stern handle is made of ½-in. brass tubing bent to shape by packing with sand and using a vise. Packing the tube with sand prevents flattening at the bend. The ends are flattened, let into the stern flush and fastened with screws. The bend extends about 4 in. past the stern.

Now a few precautions to observe: Special care must be taken in fitting decks. For instance, the line down the center battens is straight, but due to the convex shape of the top and bottom of the board the seam edge of the planking describes an arc. One way to get the proper curve is to clamp one plank to the frame, leaving both ends in proper position. This will

leave the middle of the plank out of plumb. Now fasten a chalk line at both ends of the plank and snap it to mark the curve. Without a form on which to assemble your board the difficulty of bending deck and bottom planking to the frame, transversely, can be overcome by using the clamp and caul method shown in Fig. 5. First, you set

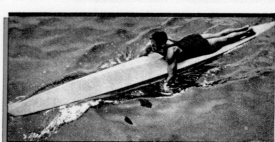

the clamp and drive home a few screws, then advance the clamp and repeat the same operation. It's well to examine the planks carefully before you clamp them in place. Look out for surface checks or any irregularity in the grain that might cause the plank to split under pressure of the clamp or later on when seasoning. Another thing to watch is the equal spacing of the screws and nails. Uniformity in spacing tends to equalize stresses on both planking and framing during the period of seasoning.

Finish: Decoration of the board with scrollwork or designs offers an outlet for

one's artistic talent, although some leave their boards plain, considering the grain of the wood to be decoration enough. If you're careful in selecting the individual planks you can usually match the grain to form a pleasing figure. This should be done when placing decks in position to band-saw to the curve of the board. Waterproofing paint may be used to protect the inside of the board, while three coats of spar varnish finish the outside, leaving the board ready for the water.

DIMENSIONS GIVEN IN INCHES AND EIGHTHS ②													
STATIONS	0	1	2	3	4	5	6	7	8	9	10	11	12
HEIGHT OF SIDES & ENDS OF RIBS	6¾	1	1½	1⅞	2⅛	2⅜	2⅝	2¾	2⅞	3	3	3	3
LENGTH OF RIBS	15	17⅛	18⅛	19⅞	20⅛	20⅛	19⅛	17¾	14¾	11⅛	7½		
TOP CROWN OF RIBS	⅜	4½	⅝	¾	¾	¾	¾	¾	⅝	½	⅜		
BOTTOM CROWN OF RIBS	½	1	1⅜	1½	1½	1¼	1⅜	1¼	1¼	½	⅜		

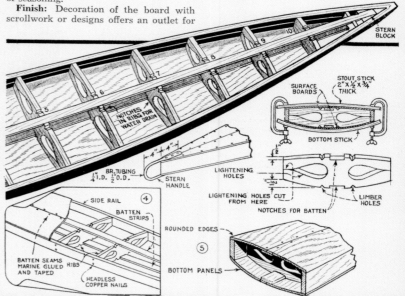

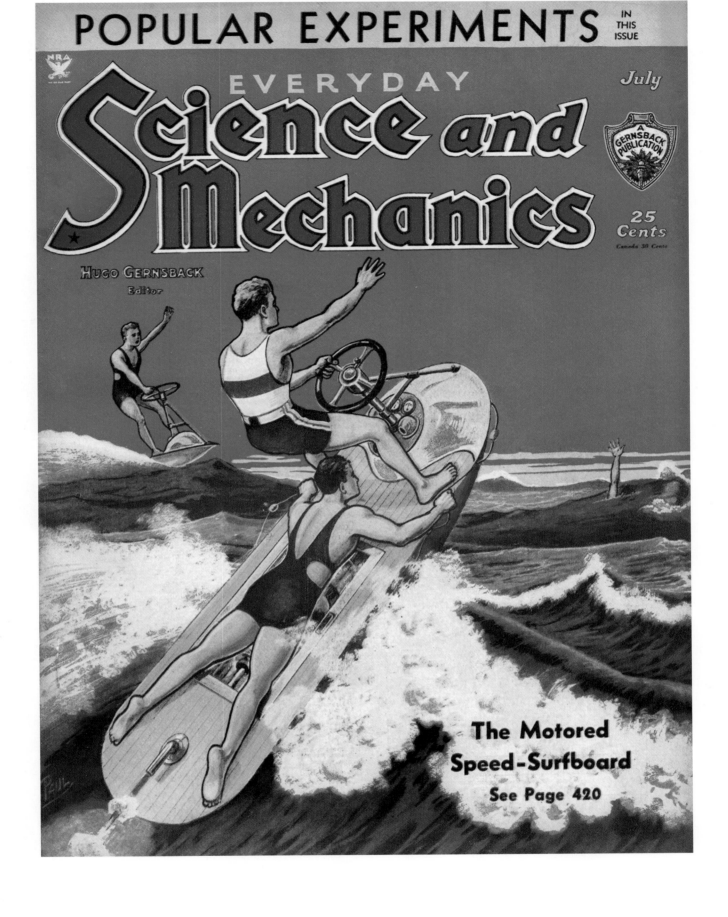

POPULAR EXPERIMENTS IN THIS ISSUE

EVERYDAY

Science and Mechanics

July

A GERNSBACK PUBLICATION

HUGO GERNSBACK
Editor

25 Cents
Canada 30 Cents

The Motored
Speed-Surfboard
See Page 420

MAGAZINE INTERIOR, *POPULAR MECHANICS*, **1937** Based on the Hawaiian royal olo board, Tom Blake created a lightweight surf-rescue board using modern boatbuilding materials and techniques. His design, dubbed the "cigar box," proved highly popular, especially in Australia.

MAGAZINE COVER, *SCIENCE AND MECHANICS*, **JULY 1934** Patents for motorized surfboards stretch back to the 1920s, although few if any were actually built until the mid-'50s.

CALIFORNIA, C. 1938 Surfing in Southern California was a homegrown sport spawned in backyards and garages along the coast.

TOURIST BROCHURE, C. 1936

MAGAZINE INTERIOR, *MODERN MECHANICS*, 1933 An earlier iteration of Tom Blake's "cigar box," this do-it-yourself surfboard was to be constructed from marine-grade plywood and spruce.

MAGAZINE COVER, *PICTORIAL CALIFORNIA AND THE PACIFIC*, 1930 *Pictorial California and the Pacific* featured handsome sepia prints that promoted the virtues of California and the Western United States. This lineup of women was meant to entice visitors to the southland.

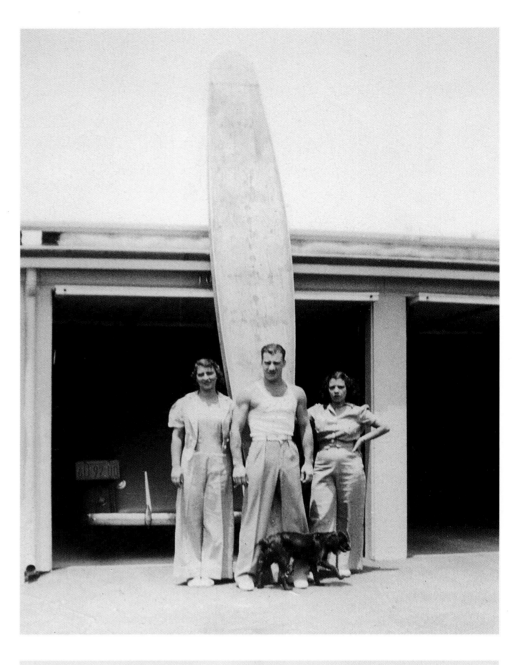

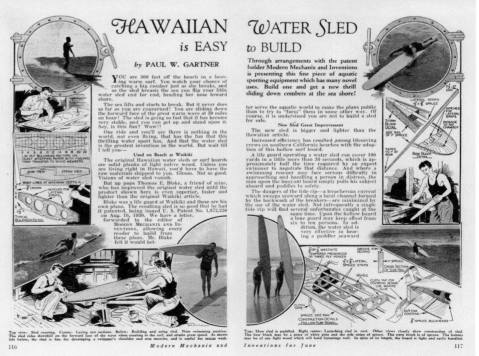

Pictorial California

and the
PACIFIC

July ·· 1930
VOL · 5
NO · 7
25¢

ON A PACIFIC BEACH

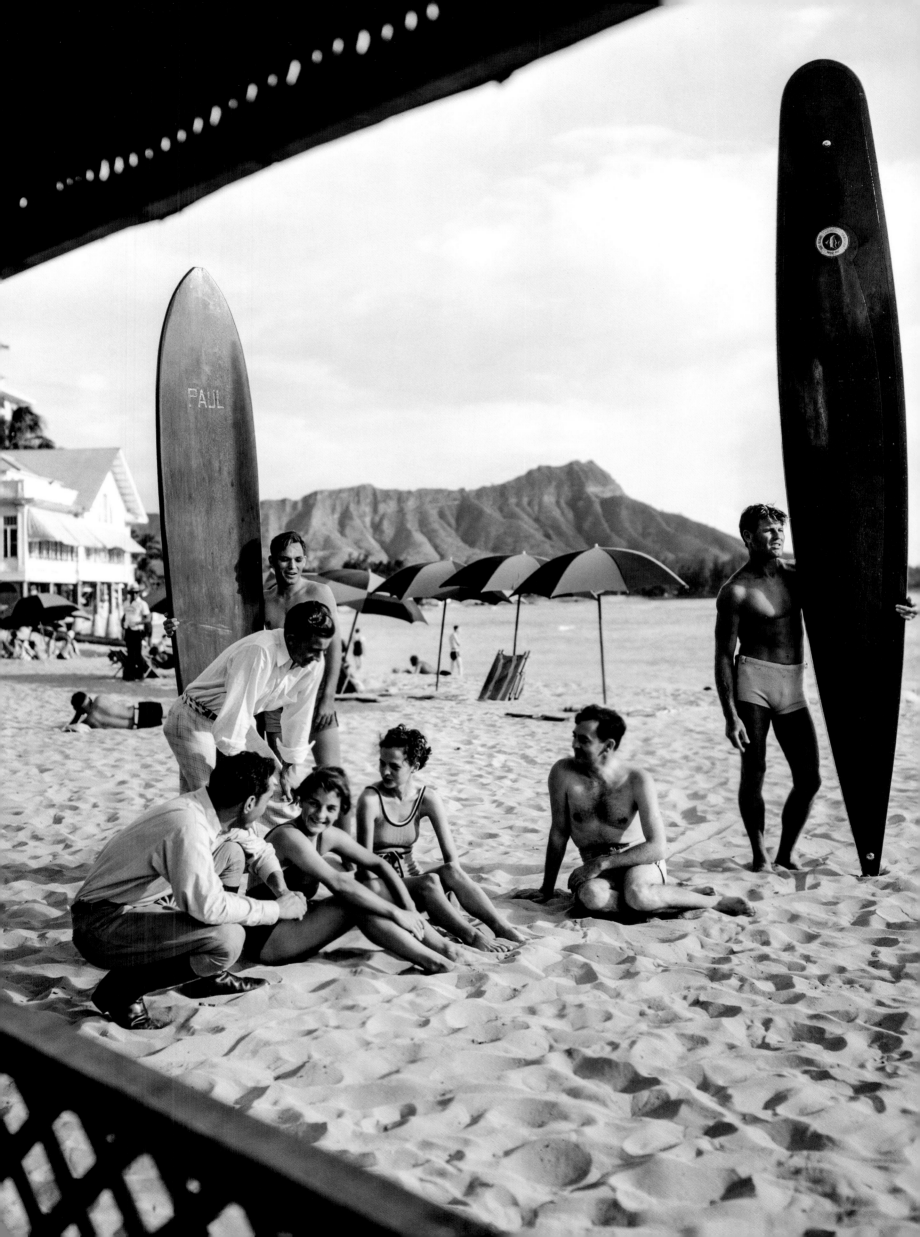

TOM BLAKE AND BEACHGOERS, WAIKIKI, C. 1935 Blake, far right, was friendly and photogenic, but a confirmed loner who was better appreciated in silhouette at a distance. *Photo, N.R. Farbman*

ADVERTISEMENT, DOLE, 1936
Art, James N. Doolittle

SURFBOARD WATER POLO, WAIKIKI, C. 1937 Paddleboard games, initiated by Waikiki hotels, were a substitute for the more challenging sport of wave-riding.

WAIKIKI, C. 1937 *(Pages 62–63)*
Photo, Richard Hewitt Stewart

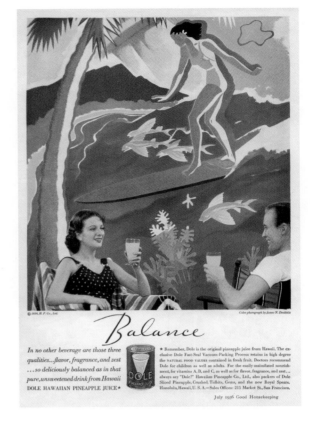

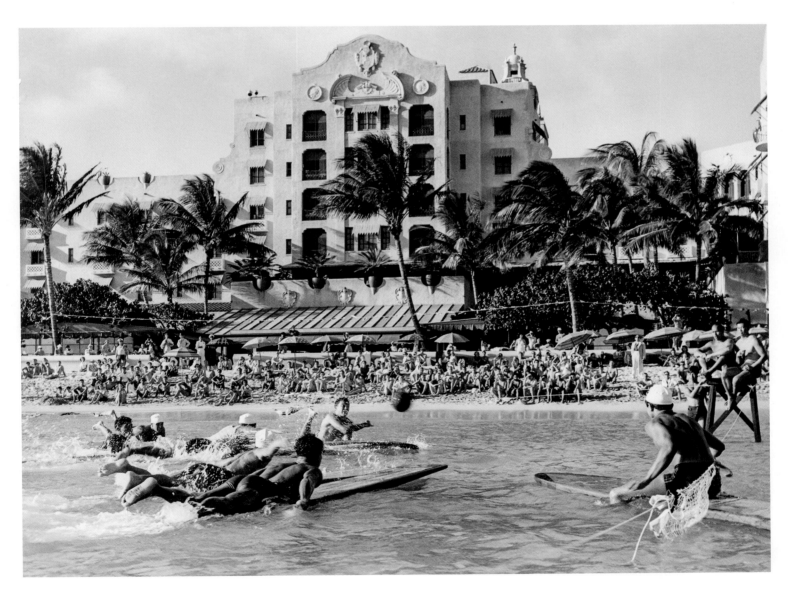

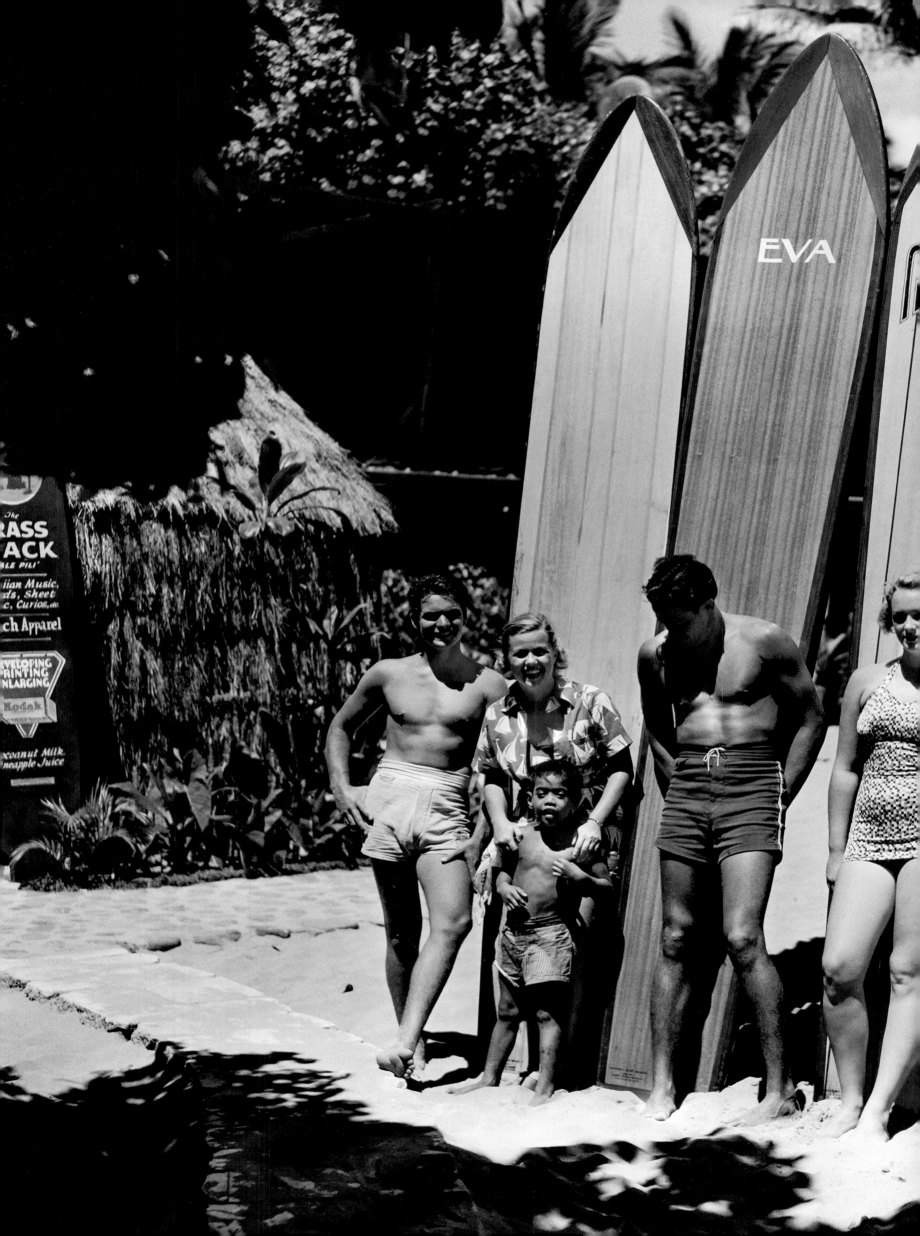

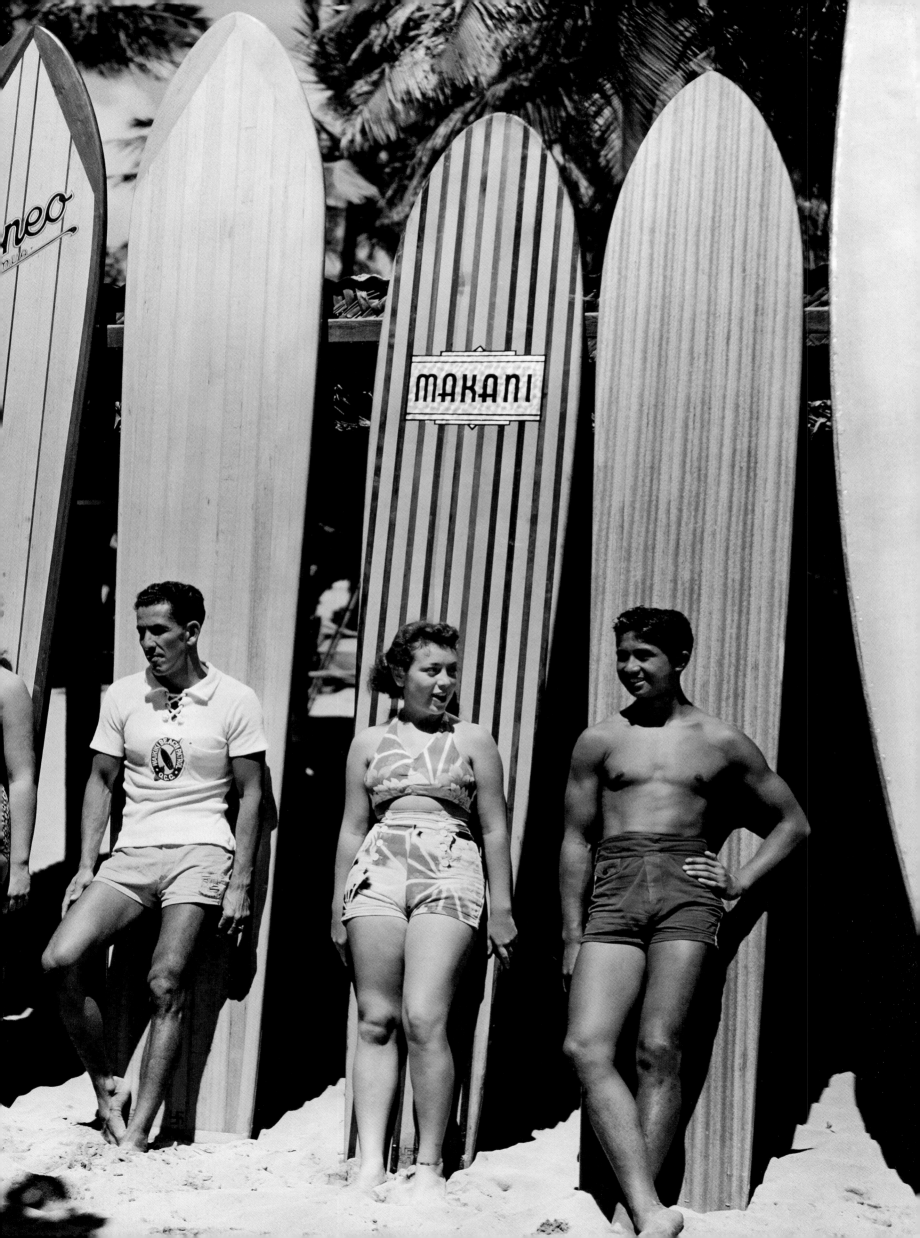

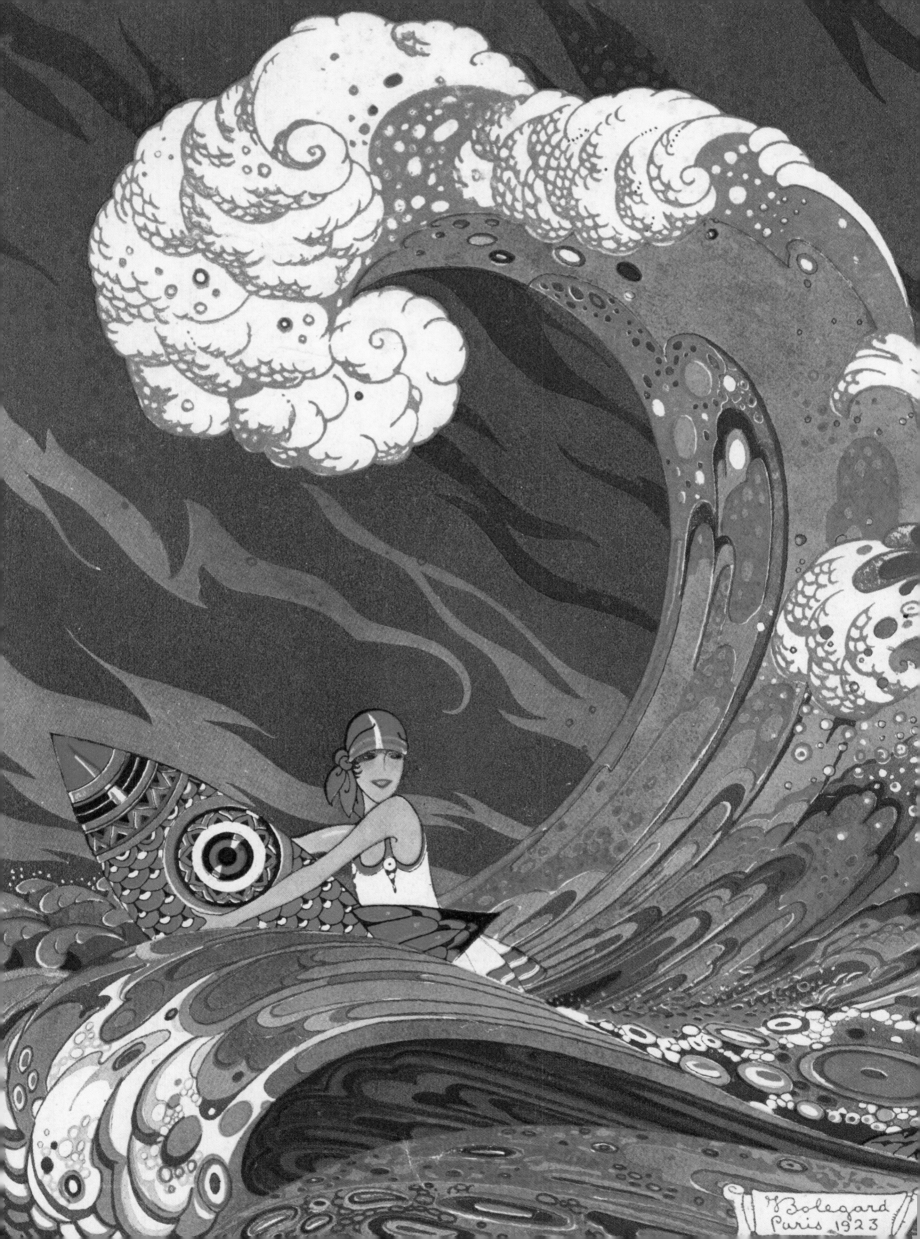

MAGAZINE COVER DETAIL, *FASHIONS OF THE HOUR,* 1923

MEN'S SWIMSUITS *(Clockwise from top left)* Moana Hotel, c. 1922;
Gantner Wikies, c. 1935; Jockey, c. 1943; c. 1944; c. 1938; c. 1938

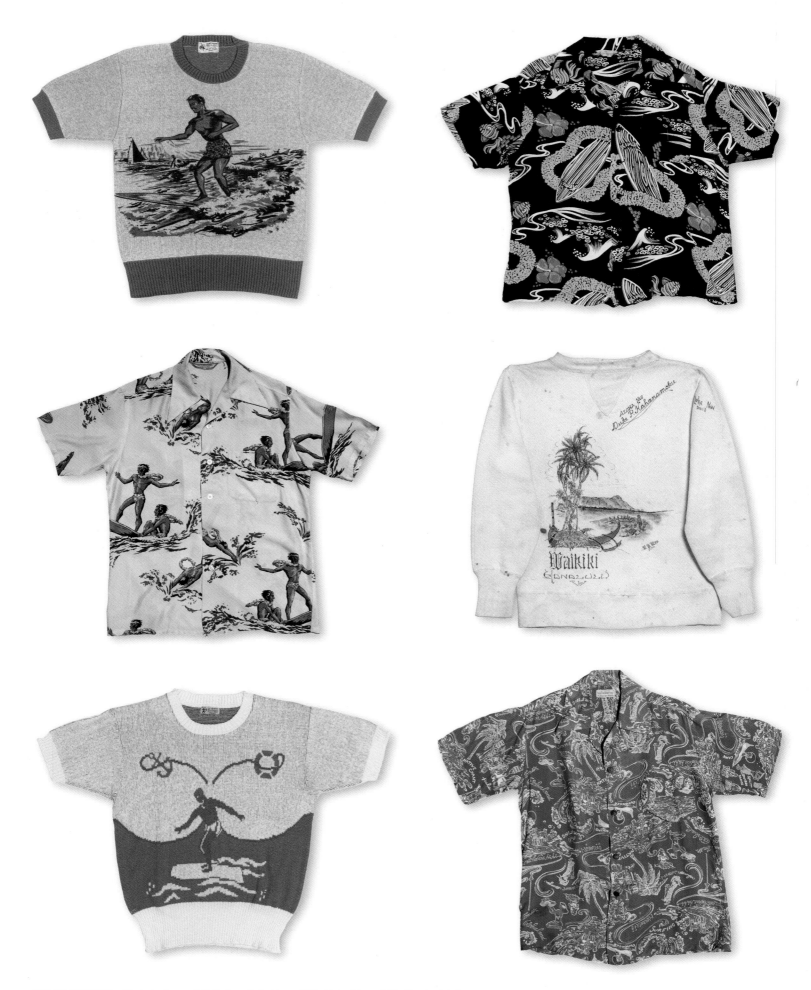

MEN'S APPAREL *(Clockwise from top left)* Pullover knit shirt, c. 1943; Aloha shirt, c. 1939; Hand-painted sweatshirt, c. 1929, autographed by Waikiki's famed beachboys, this was a one-of-a-kind souvenir; Aloha shirt, c. 1945; Pullover knit shirt, c. 1942; Aloha shirt, c. 1940

FABRIC DETAIL, WAIKIKI BEACHBOYS PATTERN, C. 1948

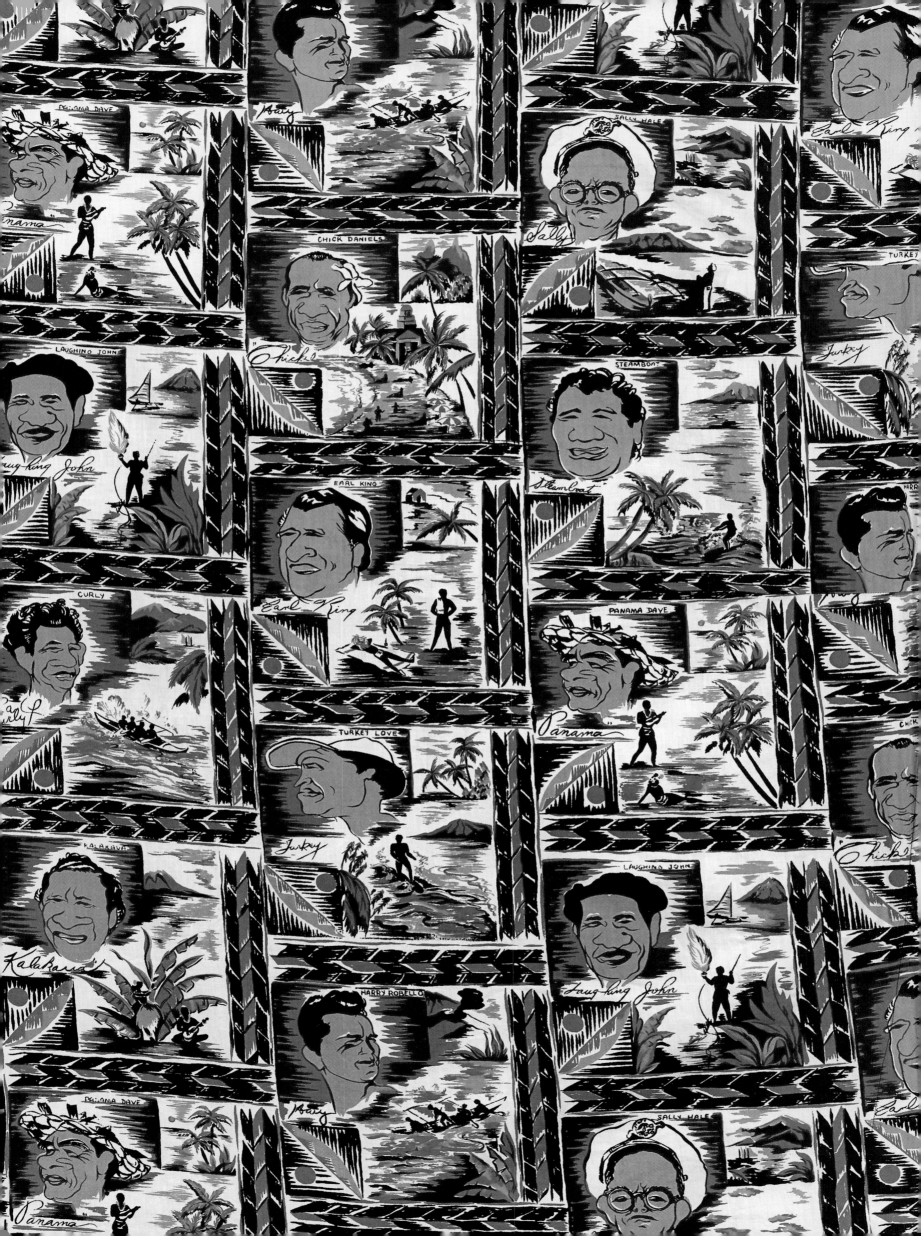

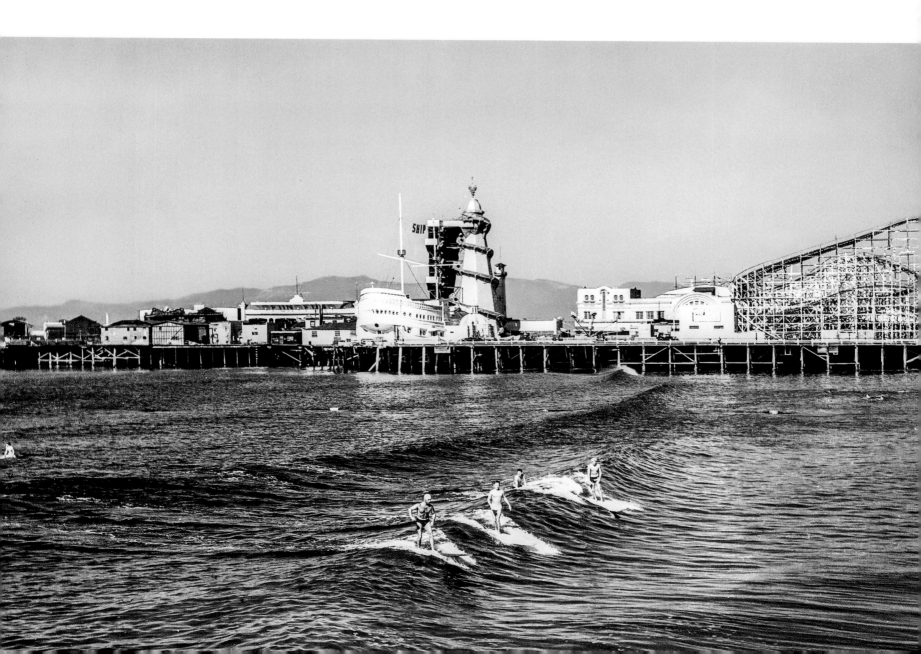

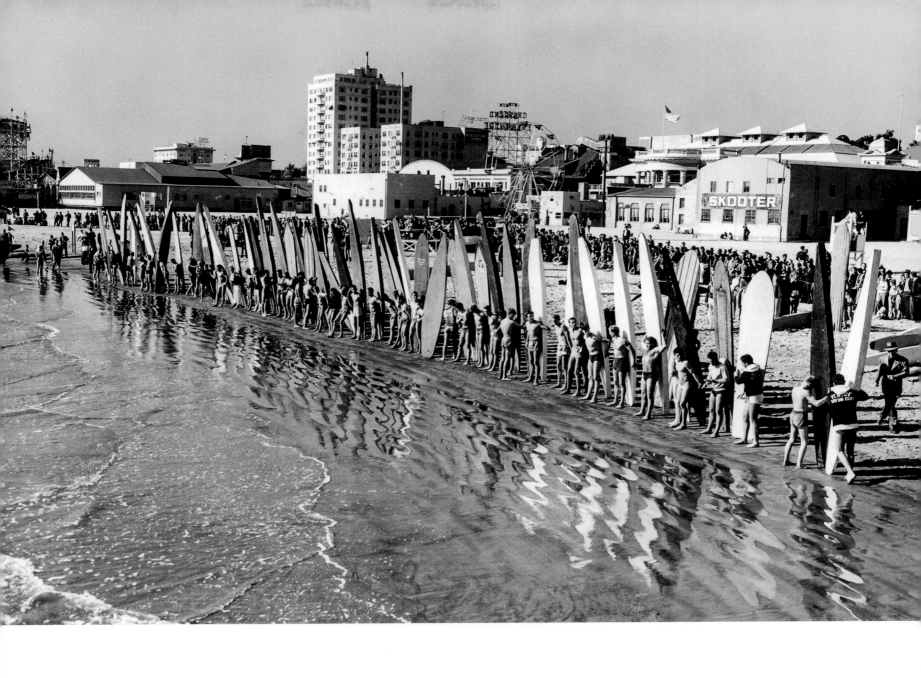

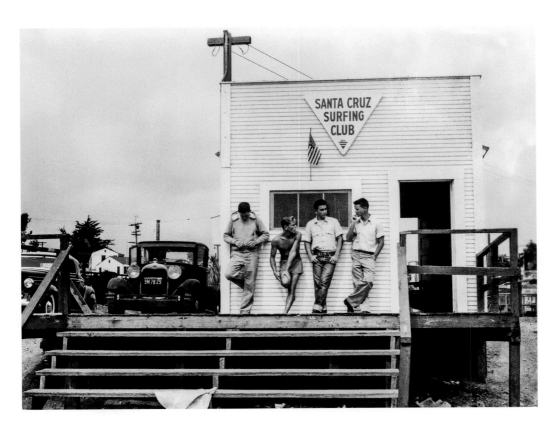

SURFERS, CALIFORNIA, C. 1938
A jury-rigged trailer was often the most practical solution for transporting heavy boards to the beach. *Photo, Doc Ball*

VENICE BEACH PIER; VENICE, CALIFORNIA; C. 1937 Prior to World War II, Venice Beach was home to several amusement centers and was a popular surf spot.

INAUGURAL NATIONAL SURFING AND PADDLEBOARD CHAMPIONSHIPS; LONG BEACH, CALIFORNIA; 1938

SANTA CRUZ SURFING CLUB; SANTA CRUZ, CALIFORNIA; 1940 A crew of teenage surfers started the Santa Cruz Surfing Club in 1936. Their clubhouse was a former hamburger stand at Cowell's Beach, a spot with gentle rolling waves that many local surfers call "Cowell-ikiki." *Photo, Doc Ball*

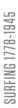

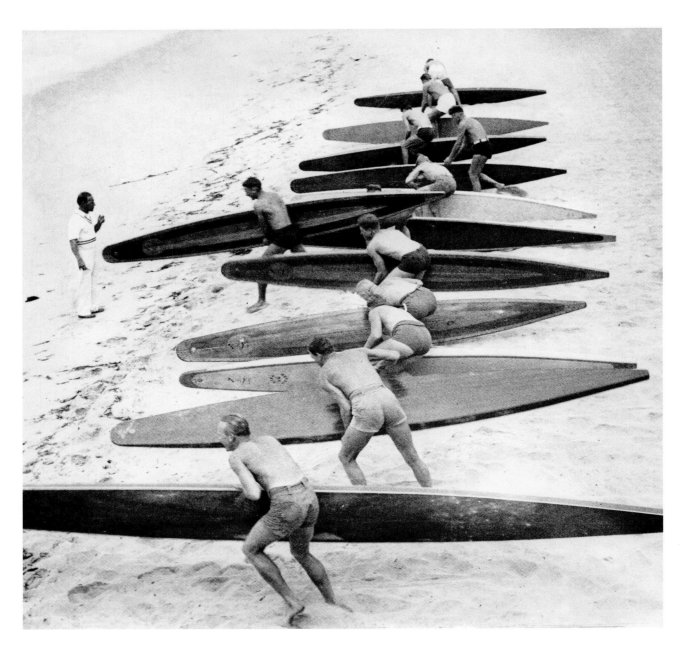

PADDLEBOARD RACE; SANTA MONICA, CALIFORNIA; C. 1931 Early surf contests were as much about paddling prowess as wave-riding.

SANTA MONICA LIFEGUARDS, C. 1931

LIFEGUARD HEADQUARTERS; SANTA MONICA, CALIFORNIA; C. 1931

LOS ANGELES COUNTY LIFEGUARD, C. 1935

SANTA MONICA, CALIFORNIA, C. 1931

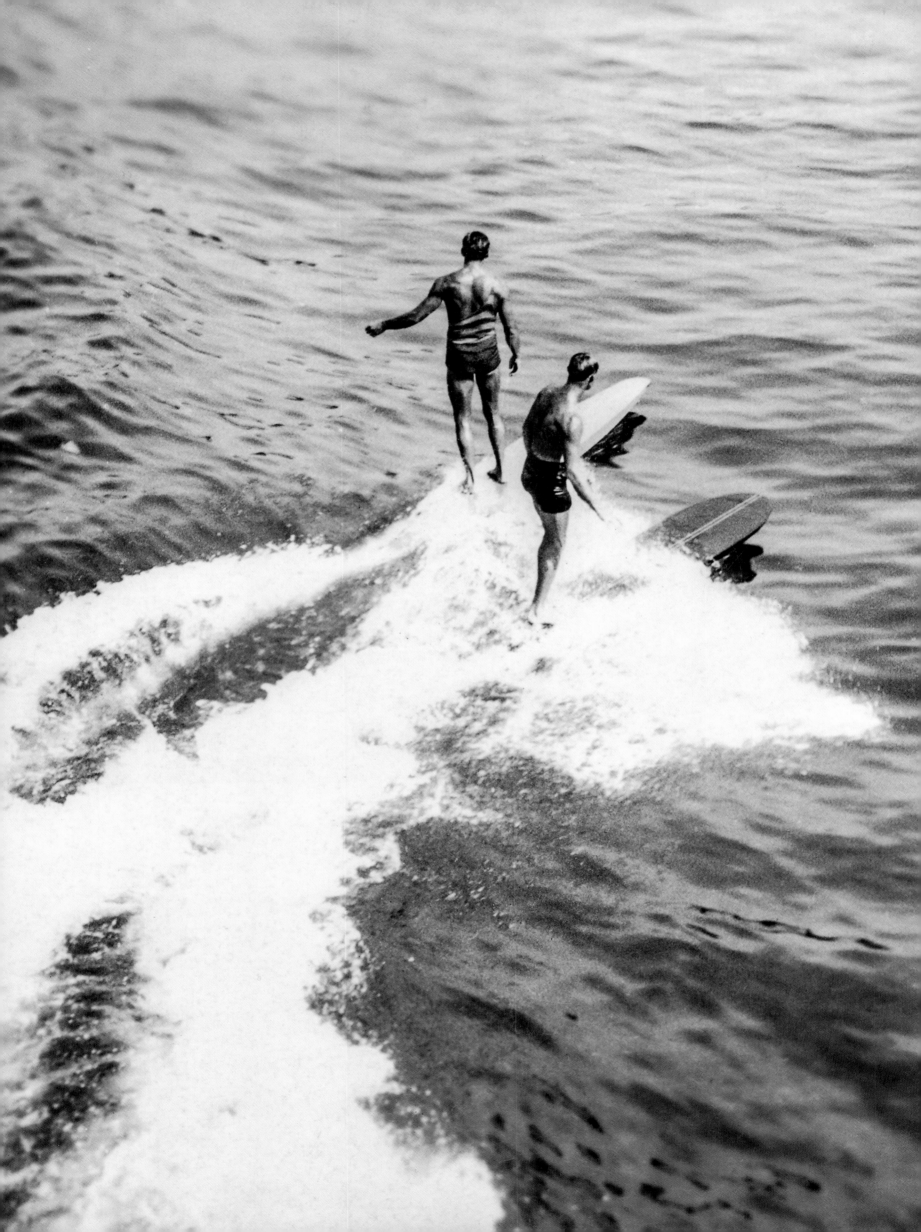

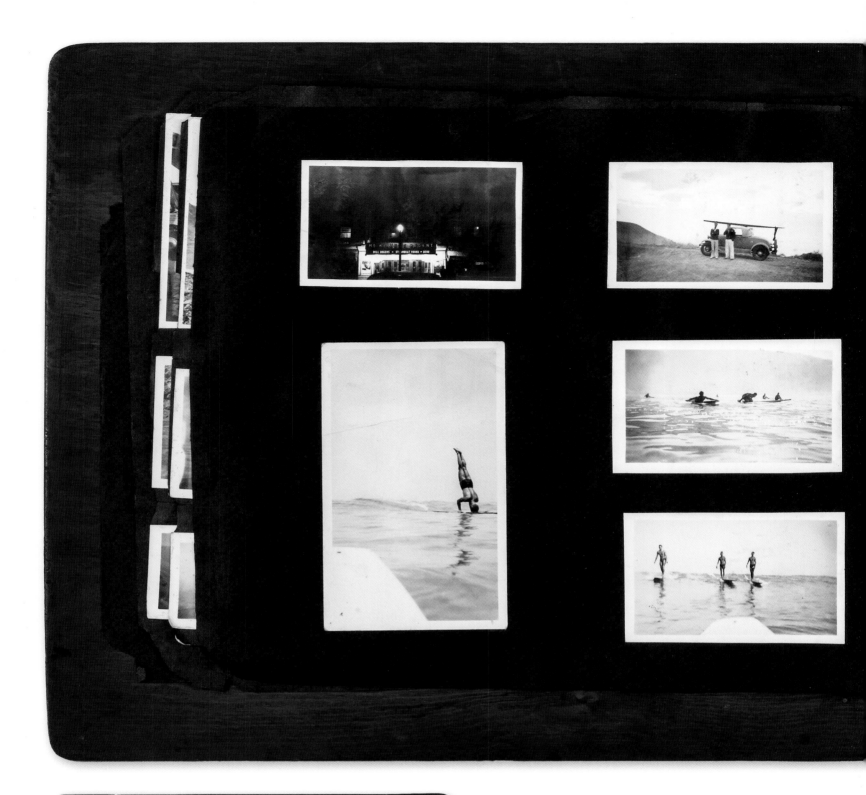

SCRAPBOOK COVER AND INTERIOR, PALOS VERDES SURFING CLUB, C. 1935 The personal photo album of surf photographer Doc Ball showcases the Palos Verdes Surfing Club in a rare document of Southern California's nascent surf culture of the 1930s. Deeded to his protégé LeRoy Grannis, Ball was also Grannis's best friend.

PALOS VERDES SURFING CLUB MEMBERS, C. 1935 Back row, left to right: Dutchy Lenkeit, Jim Reynolds, Doc Ball, E.J. Oshier, and Tulie Clark. Front row, left to right: Gene Hornbeck, Patty Godsave, and unidentified. *Photo, Doc Ball*

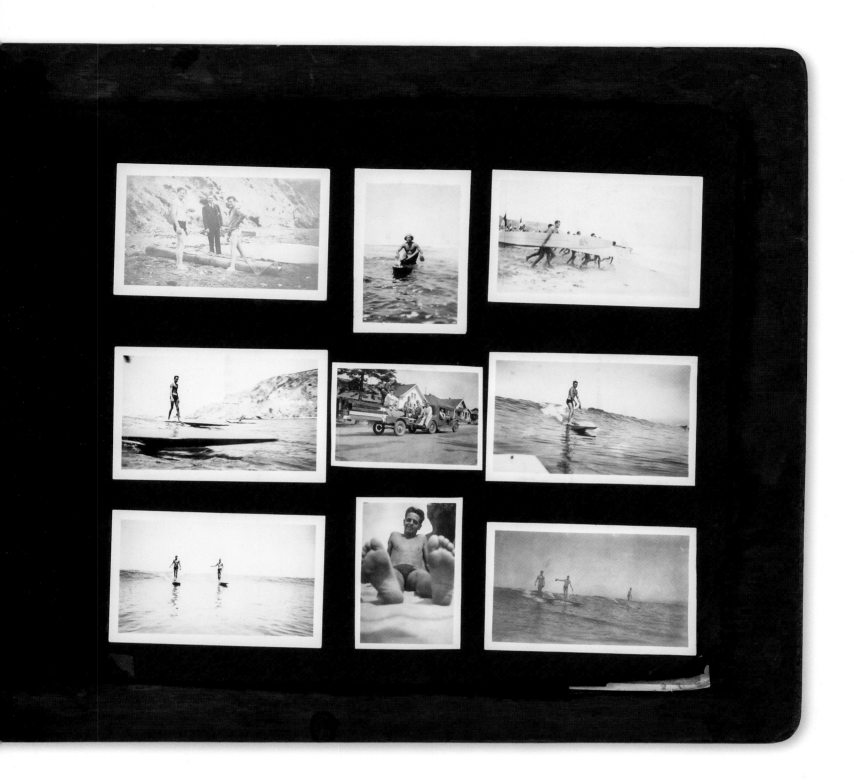

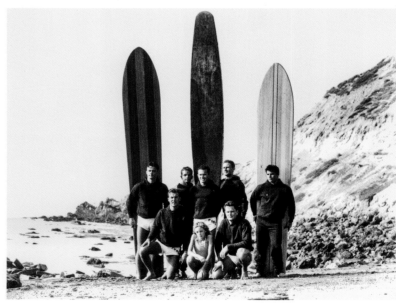

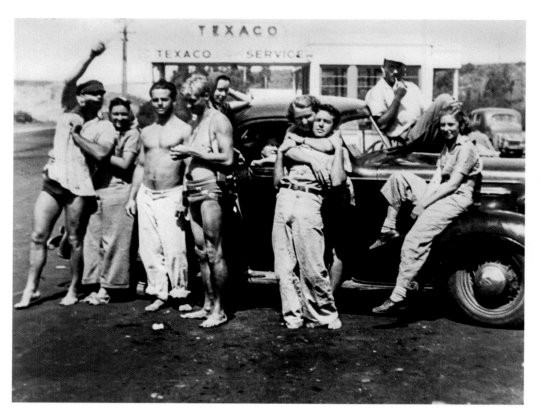

SAN ONOFRE, CALIFORNIA, C. 1939 A group of surfers and their girlfriends make a gas station pit stop while roaming the coast. *Photo, Don James*

MARY ANN HAWKINS; REDONDO BEACH, CALIFORNIA; 1938 Hawkins was a champion swimmer, paddleboarder, and surfer who combined movie-star looks with an innate sense of showmanship, as evidenced in the wake of the infamous 1938 Los Angeles flood. *Photo, Doc Ball*

PARTY INVITATION, PALOS VERDES SURFING CLUB, 1940

PALOS VERDES SURFING CLUB, LOS ANGELES, C. 1935 The Palos Verdes Surfing Club had monthly meetings that included minutes, progress reports, and often a formal sit-down dinner at a local Los Angeles restaurant. *Photo, Doc Ball*

PALOS VERDES SURFING CLUB INDUCTION CEREMONY, LOS ANGELES, C. 1935 Part fraternity, part boys' club, early surfing clubs were where surfers developed their own code and culture separate from the mainstream. *Photo, Doc Ball*

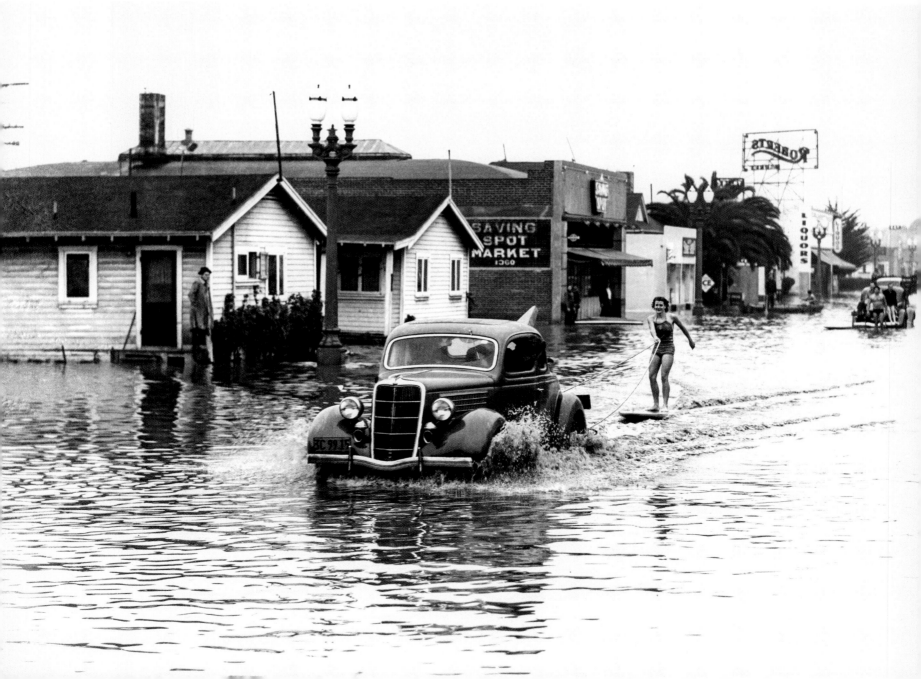

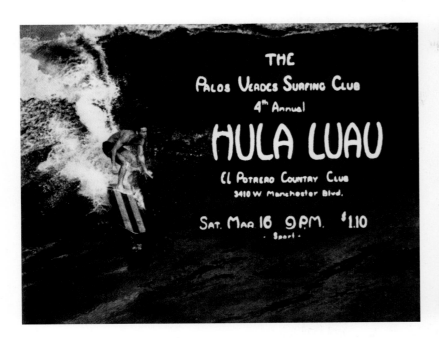

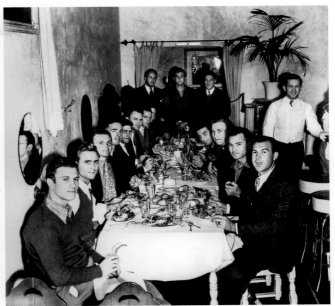

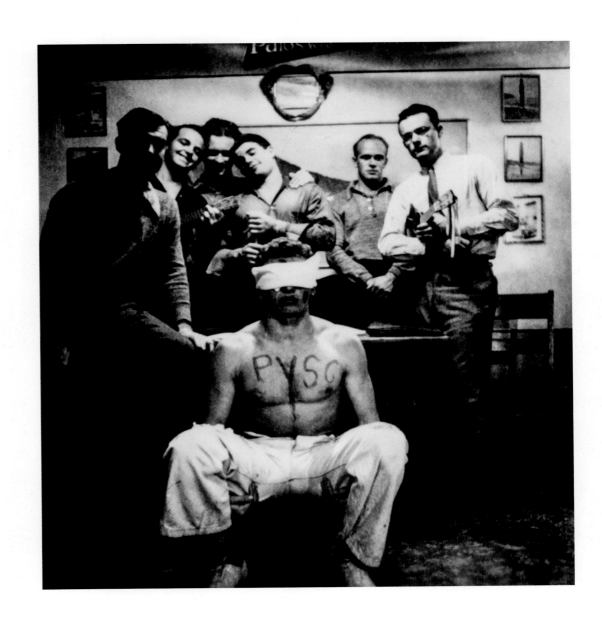

PAINTING, *SURFER*, 1931
Art, Phil Dike

SURF CAMP; SAN ONOFRE, CALIFORNIA; C. 1937 By the 1930s, San Onofre featured a small fishing camp with a gas station and little else. Surfers wanting to ride "Sano" had to bring most of the essentials and be prepared to rough it. *Photo, Don James*

SAN ONOFRE, CALIFORNIA, C. 1936 Consistent waves and a sheltered cove made Sano the ultimate prewar surf spot. *Photo, Bob Johnson*

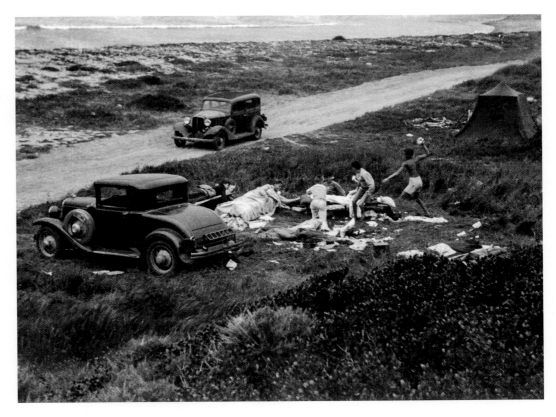

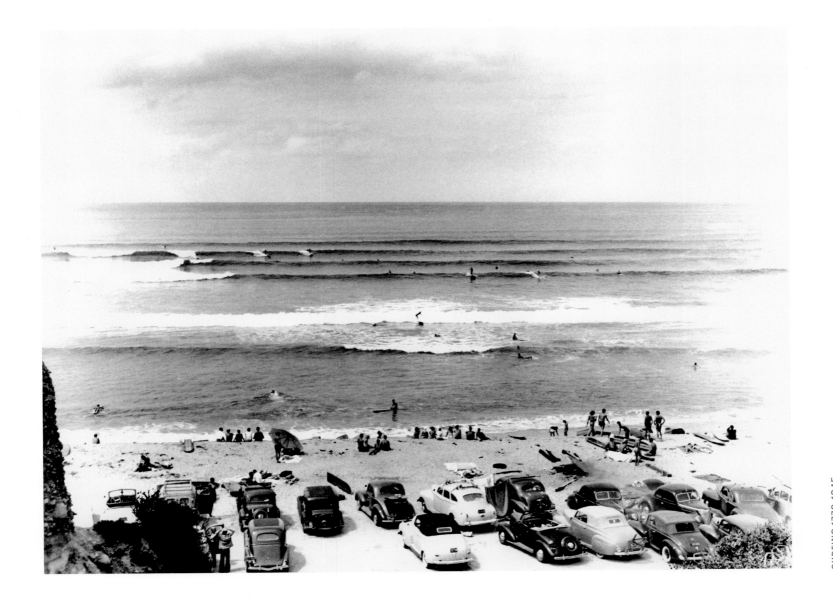

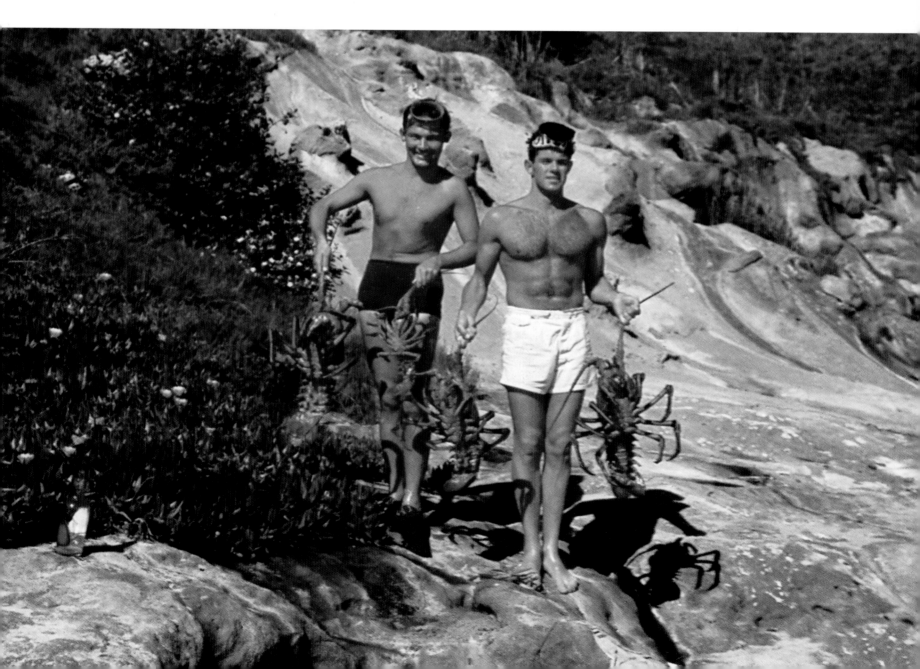

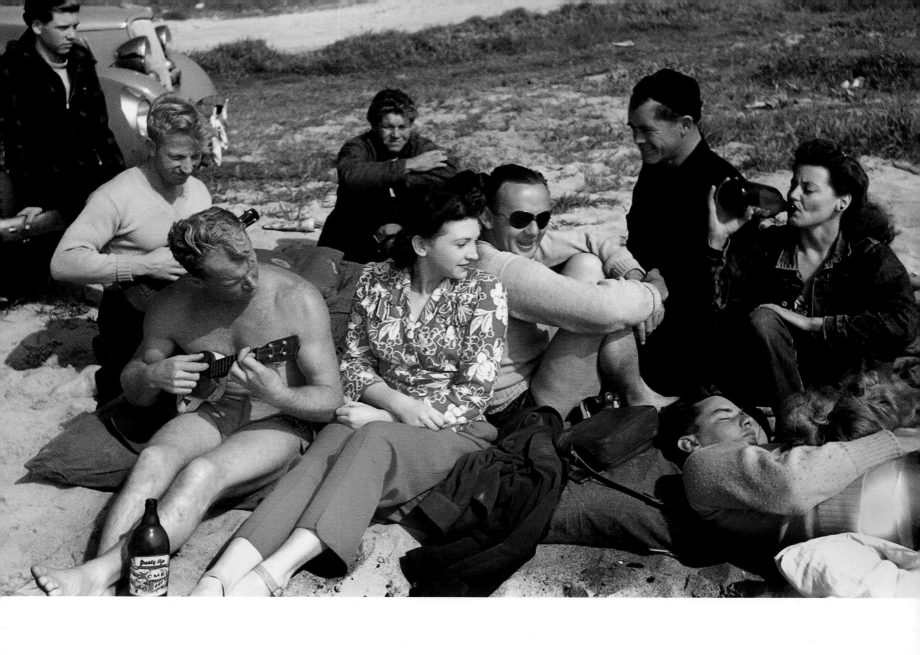

TULIE CLARK; PALOS VERDES, CALIFORNIA; C. 1935 Surfers of this era often created their own beach access whether by trail, boat, car, or bolt cutters. *Photo, Doc Ball*

DON JAMES, CALIFORNIA, C. 1936 Southern California's uncluttered coast provided surfers easy access to the Pacific's bounty, as James, right, and a surf friend display their "bugs" (lobsters) plucked from the sea. *Photo, Don James*

SAN ONOFRE, CALIFORNIA, C. 1938 As surfing evolved into small, contained groups, weekend campouts would oftentimes include drinking, dancing, and "weenie bakes."

SAN ONOFRE, CALIFORNIA, C. 1939 From left to right: Eleanor Roach (dancing), Barney Wilkes, Katie Dunbar, and Bruce Duncan. *Photo, Don James*

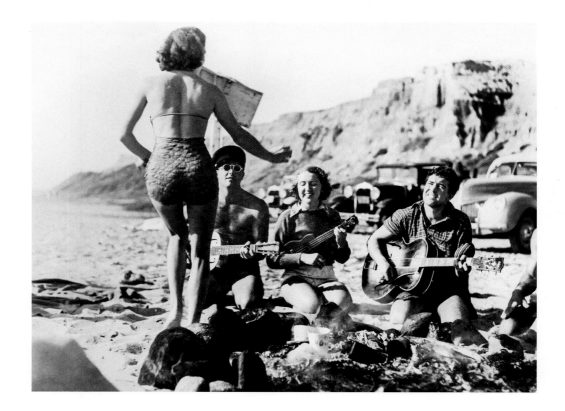

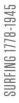

79

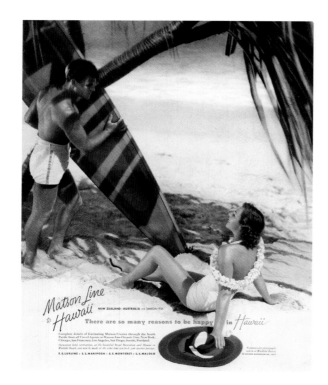

ADVERTISEMENT, MATSON LINE, 1937

SANTA MONICA, CALIFORNIA, C. 1935
Surfboards and models were a convenient device for press agents who wanted to promote a relaxed California lifestyle.

MAGAZINE COVER, *TRAVEL*, 1939

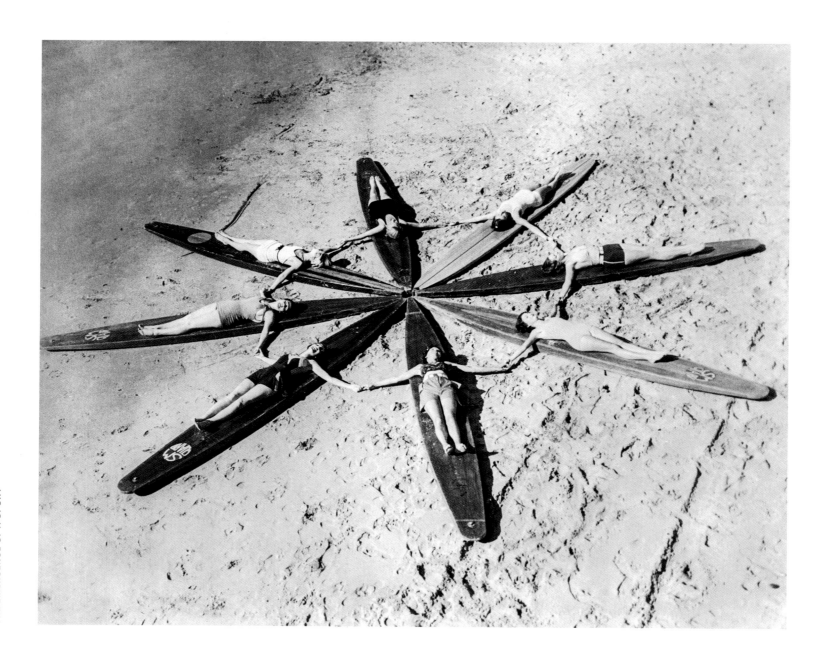

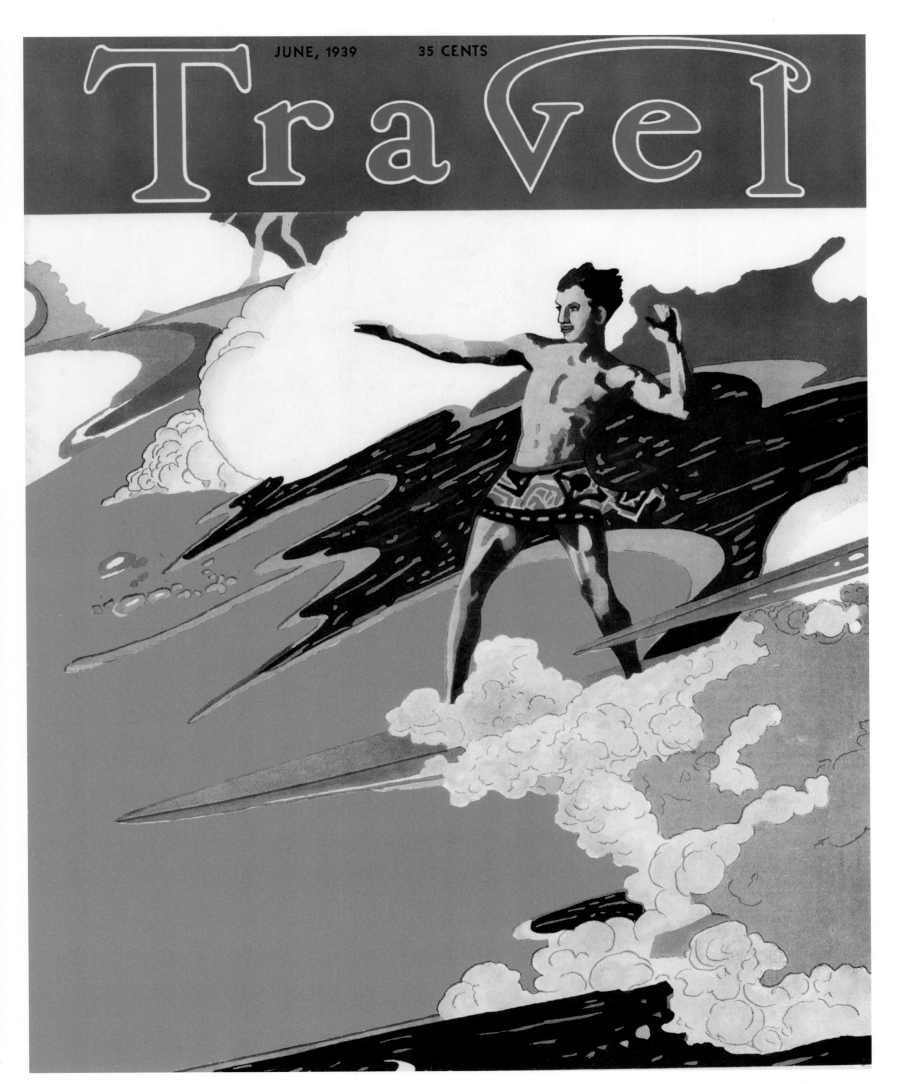

JUNE, 1939 35 CENTS

TraVel

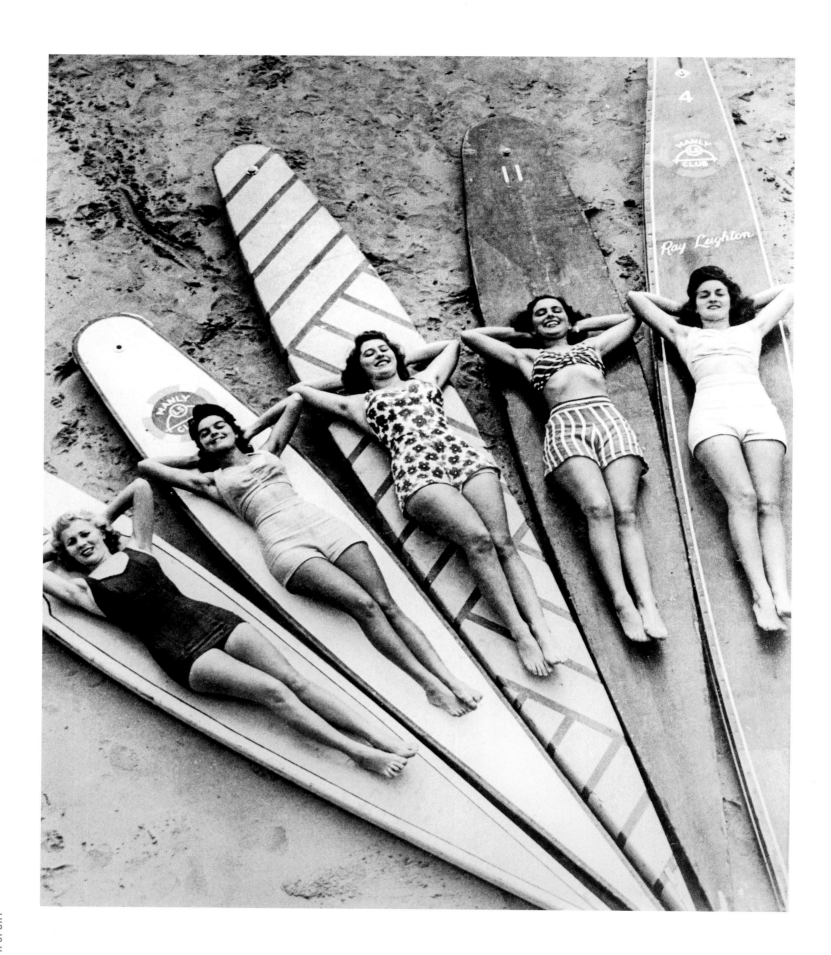

SURF SIRENS; MANLY BEACH, SYDNEY,
AUSTRALIA; C. 1937 *Photo, Ray Leighton*

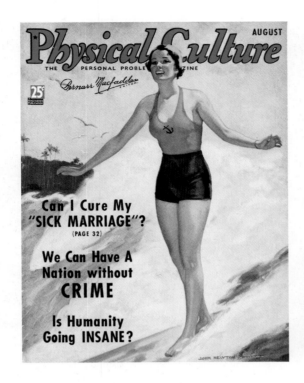

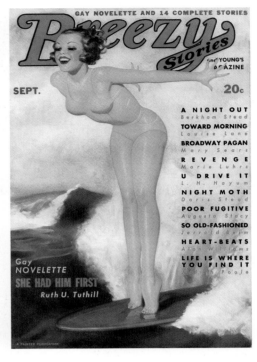

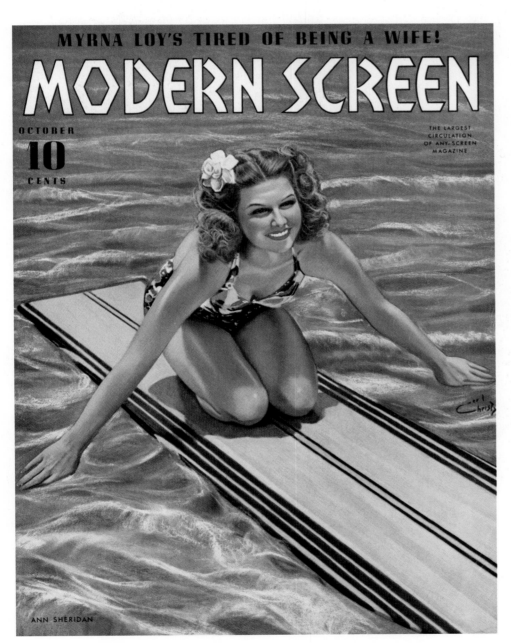

MAGAZINE COVER, *PHYSICAL CULTURE*,
1936 *Art, John Newton Howitt*

MAGAZINE COVER, *BREEZY STORIES*,
C. 1938 *Art, Enoch Bolles*

MAGAZINE COVER, *MODERN SCREEN*,
1938

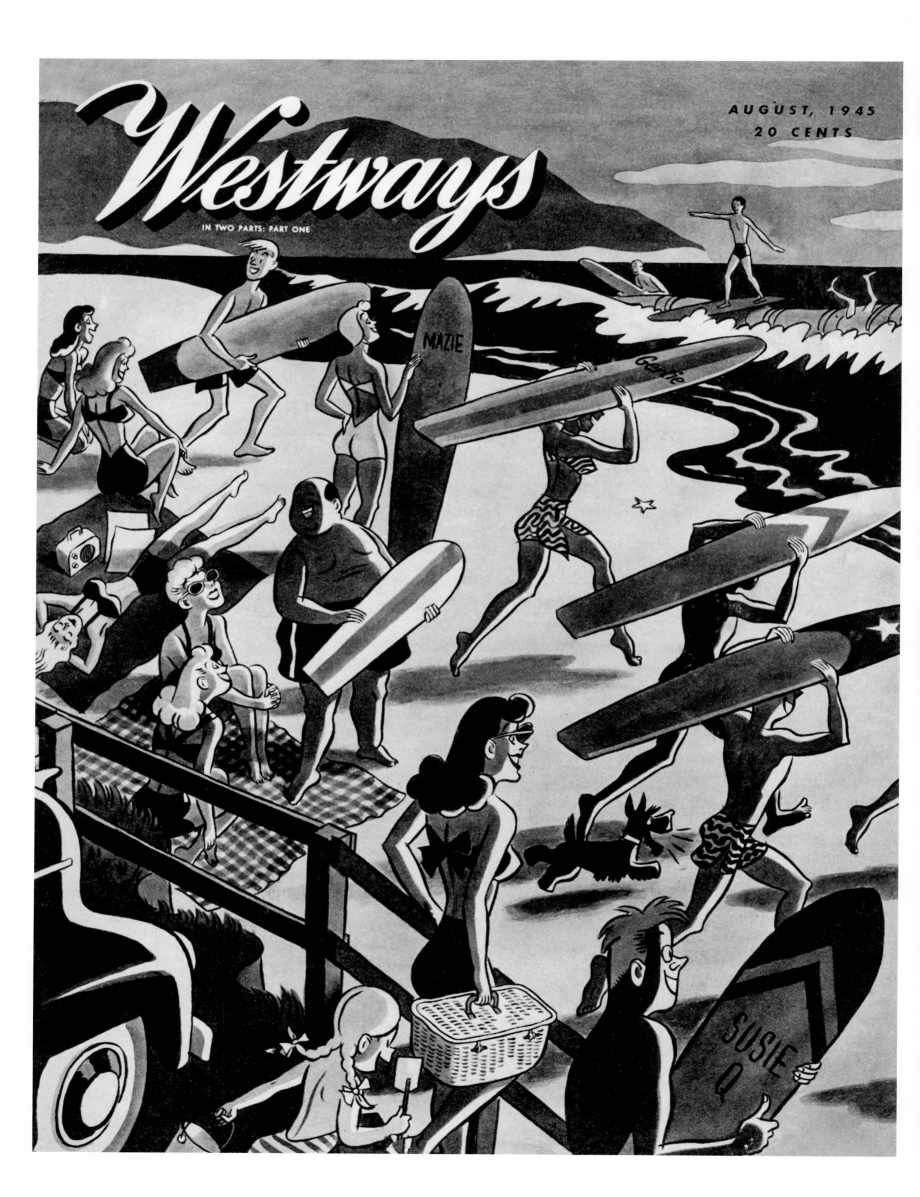

MAGAZINE COVER, *WESTWAYS*, 1945
Surfing's rising popularity is lampooned on the cover
of the Auto Club of Southern California's monthly
magazine. *Art, Dillon Lauritzen*

ADVERTISEMENT, JANTZEN, 1938
Art, George Petty

ILLUSTRATION, *SITTING PRETTY*, 1944
Art, Alberto Vargas

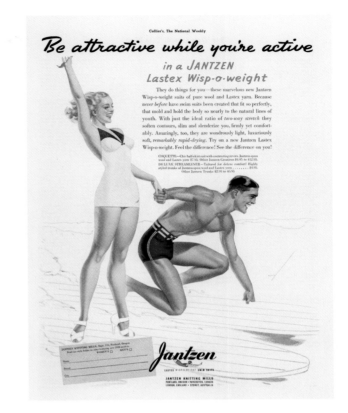

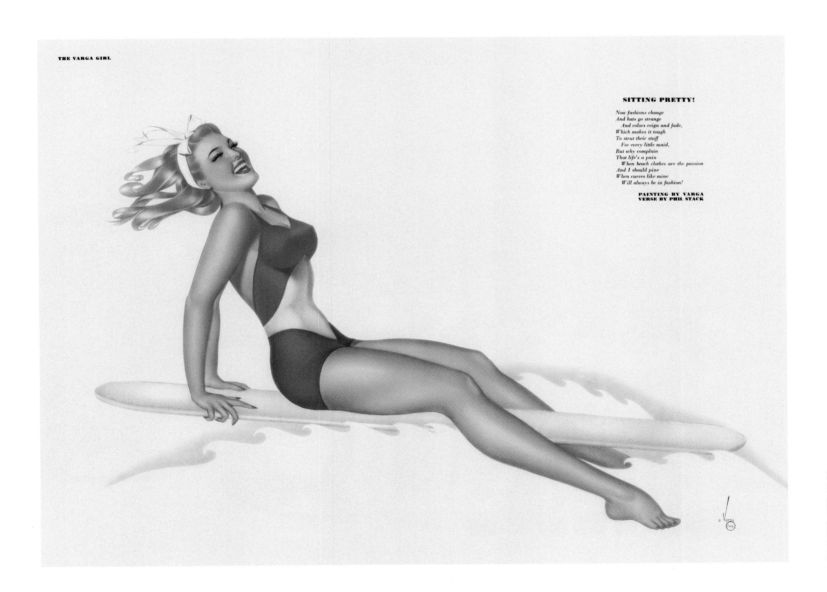

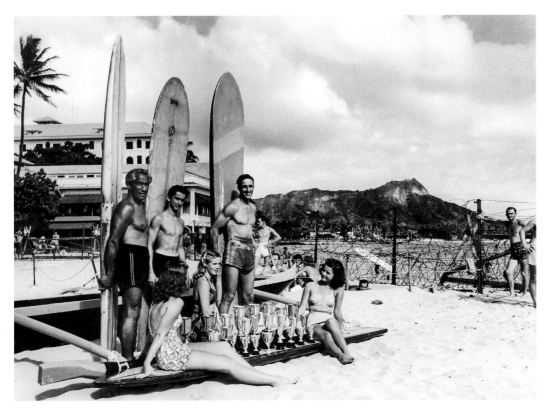

DUKE KAHANAMOKU AND TARZAN SMITH, WAIKIKI, C. 1944 During World War II, Hawaii fell under martial law, its beaches bristling with barbed wire. Kahanamoku, left, and Smith, far right, pose in front of the Ala Moana Hotel with a display of trophies for an aquatic contest.

MAKAHA, HAWAII, C. 1940 As American mainland surfers drifted to Hawaii, the promise of endless waves and an island lifestyle would prove to be irresistible for the hundreds who would follow. From left to right: unidentified, Bud Browne, Walter Hoffman, Jim Fisher, and Don James

HAWAII, C. 1946 An idealized Hawaiian setting advertises a postwar paradise for tourists.

MAKAHA, HAWAII, C. 1939 *(Pages 88–89)*

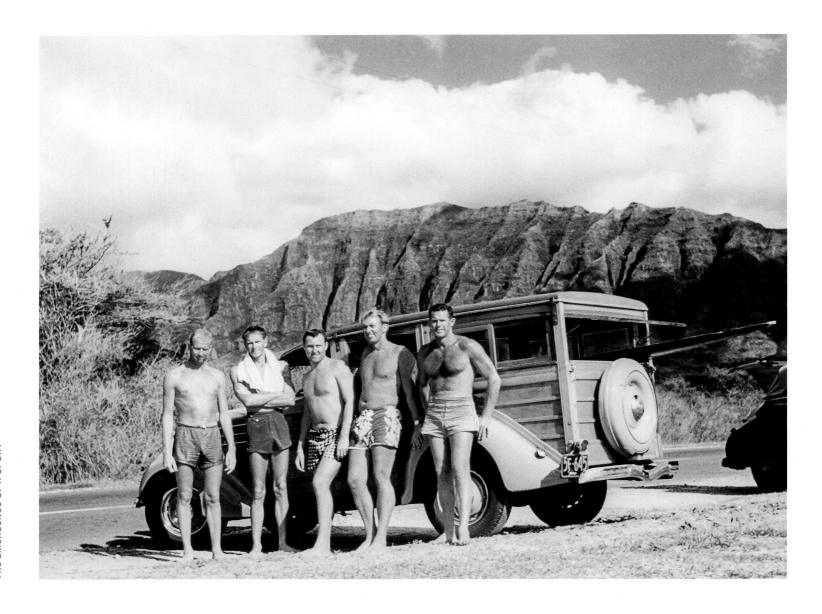

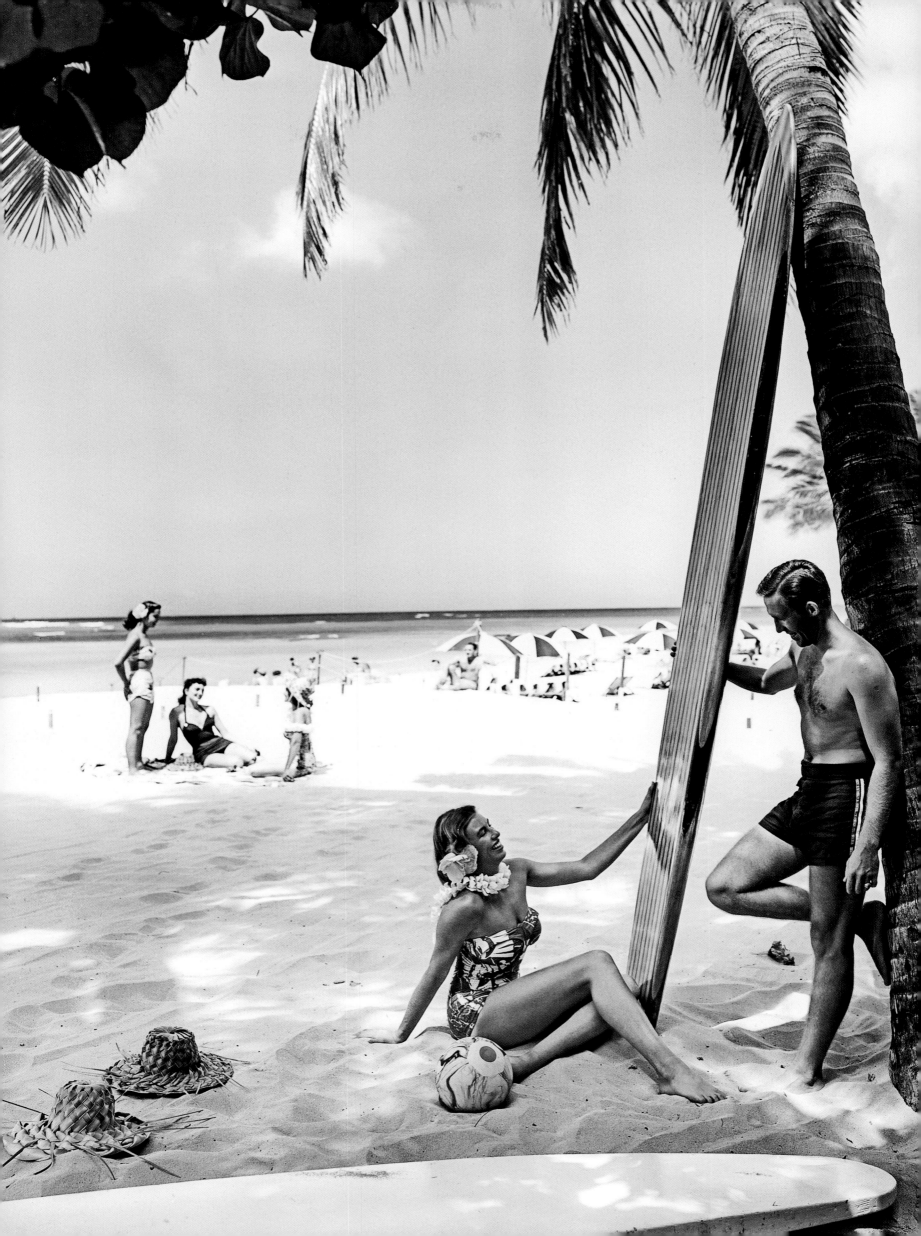

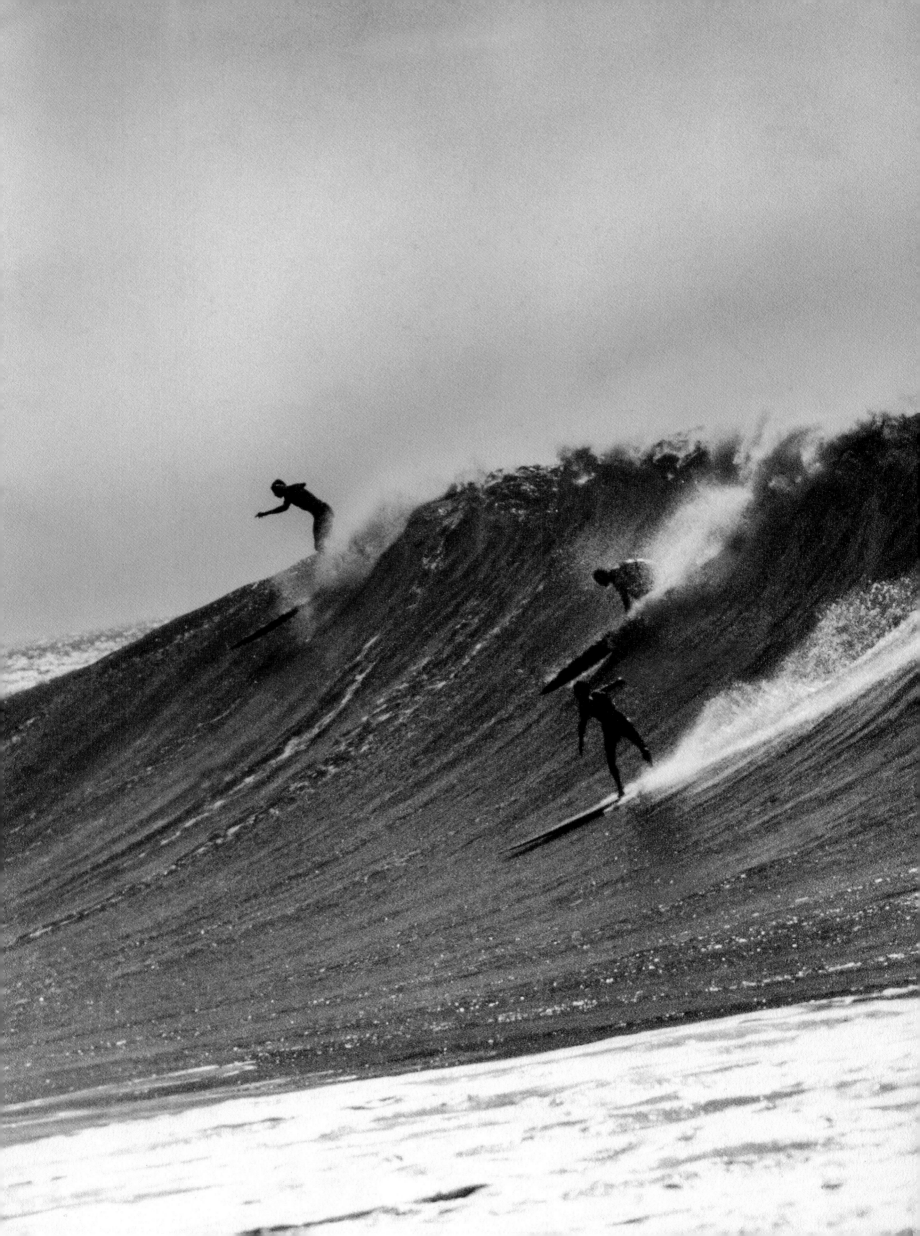

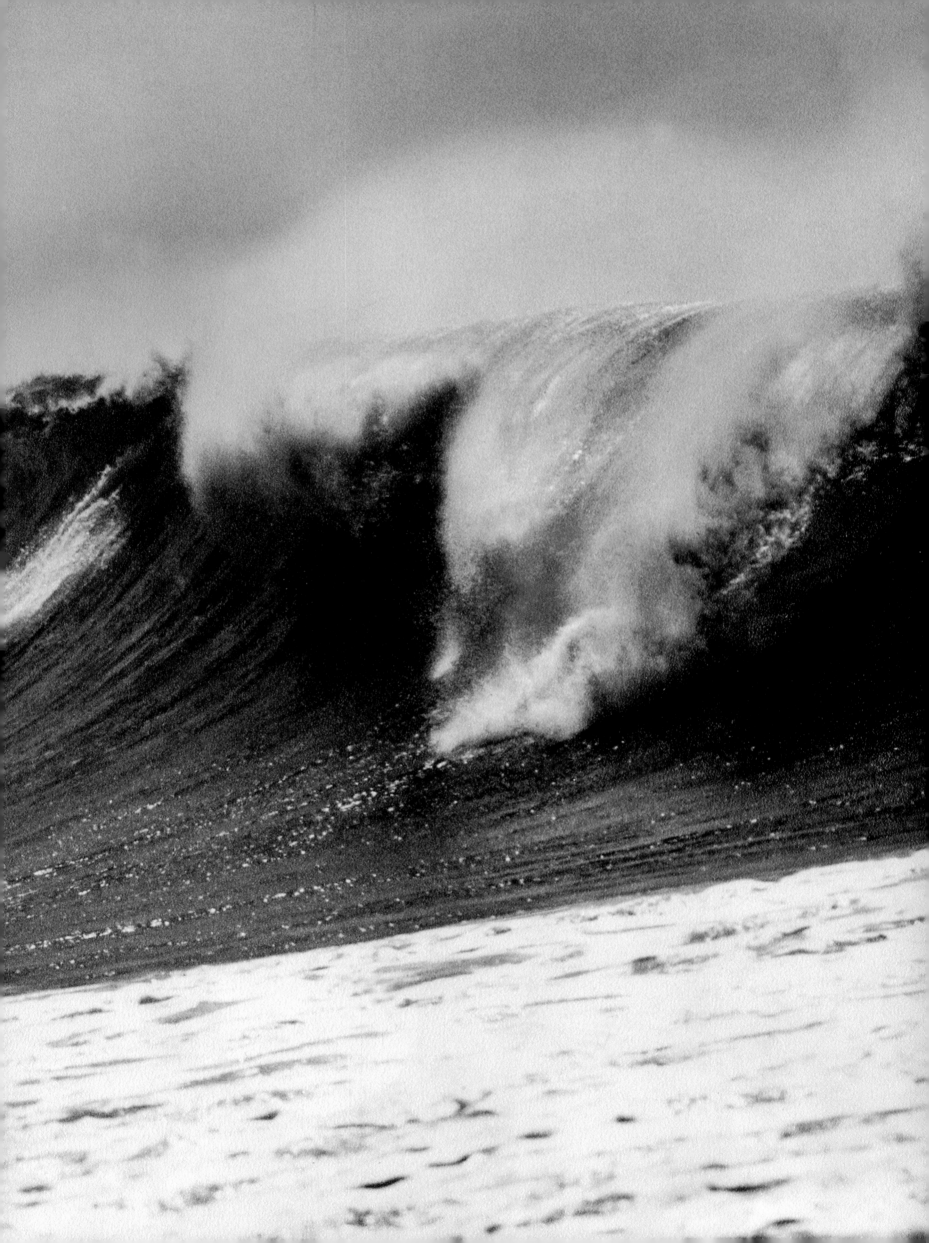

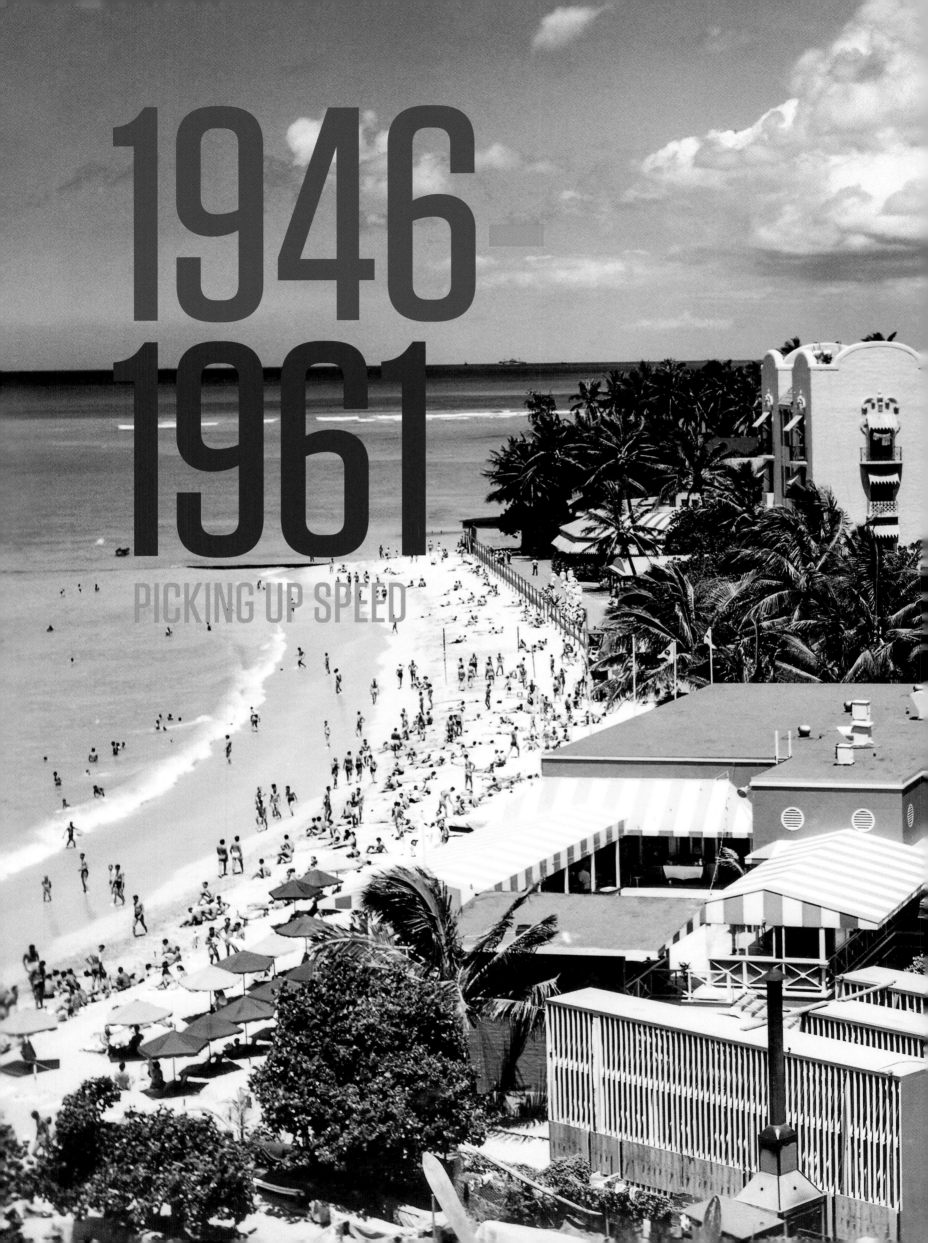

1946-1961

PICKING UP SPEED

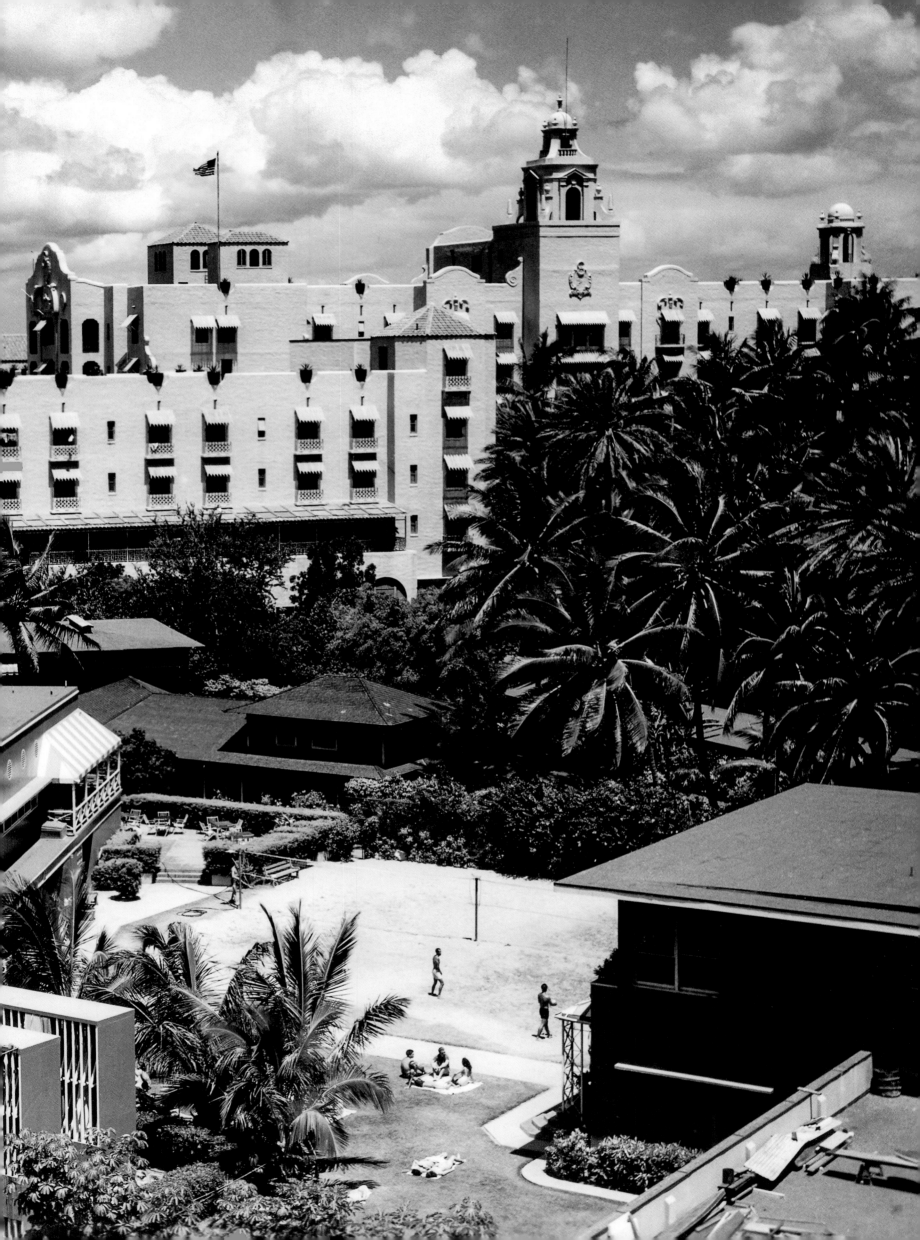

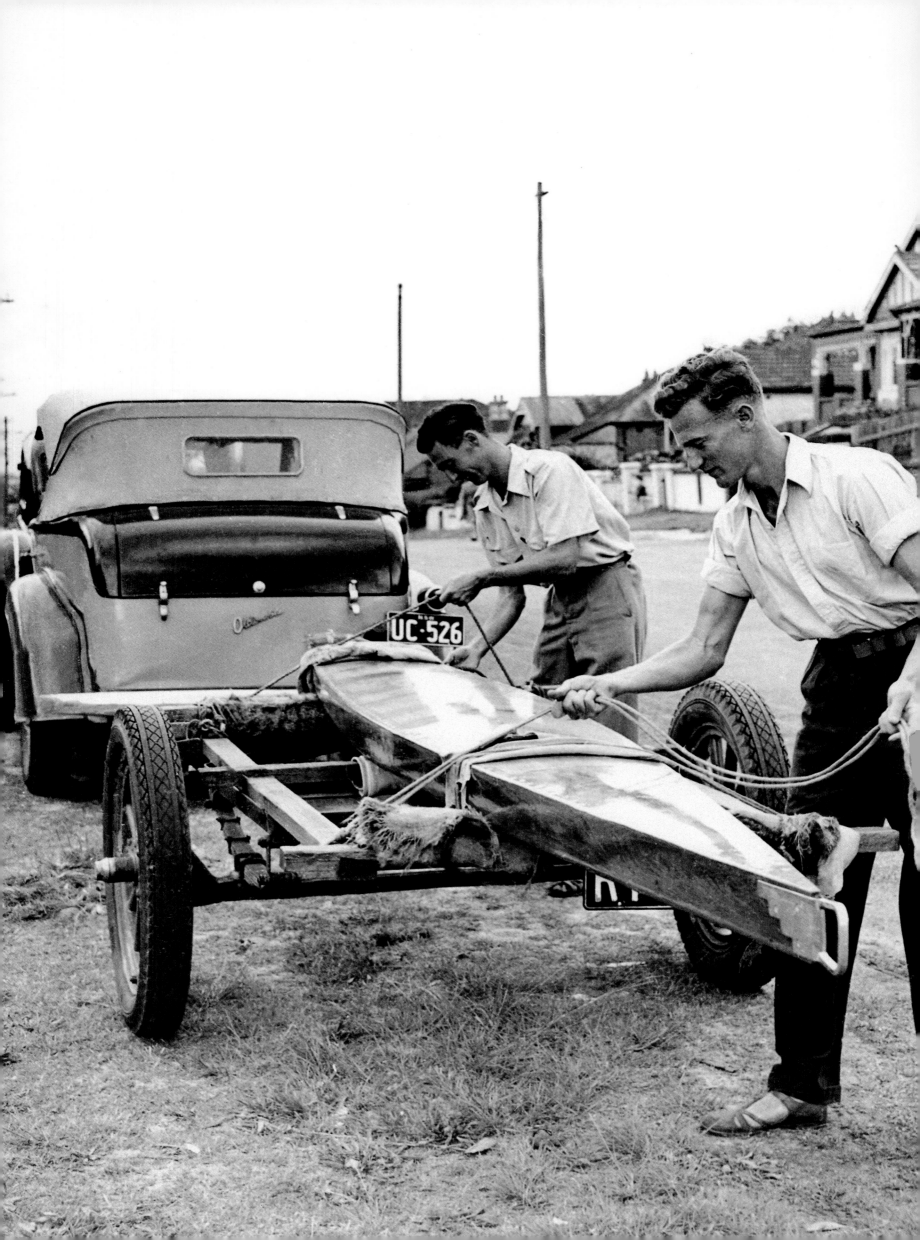

1946-1961
WAR, PLASTICS, AND THE PAN-PACIFIC STOKE

STEVE BARILOTTI

It's unlikely that Minoru Nii, the Hawaii-born son of a Japanese plantation worker, ever intended to create the core product of a multibillion-dollar surf-fashion industry. Born with a withered leg, he didn't surf and by all accounts was afraid of the ocean. His wife and partner, Florence, a tiny Japanese woman who herself had lost a leg to diabetes, was a nonsurfer as well. The Niis eked out a modest trade doing repairs and producing workaday sewn goods for the people of Waianae, a sleepy town of 3,000 on Oahu's dry leeward side. But by the winter of 1955, the 48-year-old tailor was handcrafting the best, and arguably the first, pair of modern purpose-built surf trunks constructed expressly to survive large Hawaiian waves. Nii's clientele included an eclectic squad of young big-wave adventurers as well as Hollywood A-listers and a future U.S. president.

The Makaha Drowners, named for the popular West Side surf break three miles up the highway from Nii's small tin-roofed shack in Waianae, were cut mid-thigh from sturdy cotton twill, double stitched, and cinched just below the navel with a snug fitted waistband. At the surfers' request, Minoru added a small wax pocket that allowed the surfer to touch up his board in the water as needed, when the waves were up and good traction was critical.

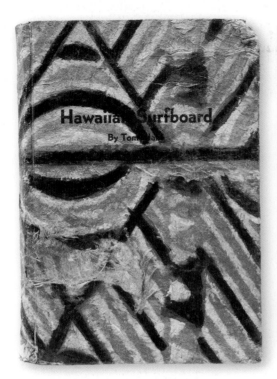

WAIKIKI, C. 1946 *(Pages 90–91)* By the end of World War II, Hawaii's civilian tourist industry was poised for a huge growth spurt. Enabled by new air routes, a war-weary nation was ready to relax on the beach and learn the hula.

SANTA CRUZ, CALIFORNIA, 1946 *(Page 92)* First designed by Tom Blake in the early 1930s, the hollow board's minor popularity peaked by the mid-'40s. But with the introduction of shorter all-balsa boards after World War II, these stately 16-foot mini yachts were soon regarded as museum relics.

POSTER, PAN AM, C. 1960

BOOK COVER, *HAWAIIAN SURFBOARD* **BY TOM BLAKE, 1935**

BROCHURE DETAIL, OUTRIGGER CANOE CLUB, C. 1947

TOMMY ZAHN, OUTRIGGER CANOE CLUB; WAIKIKI; C. 1947 Zahn, born 1924 in Santa Monica, California, became a stylish surfer, lifeguard, and champion paddleboard racer. He made his first extended trip to Hawaii in 1947 and returned many times over the next decade.

The design criteria were basic but essential. First, they simply had to stay attached during the most brutal washing-machine wipeouts imaginable. Off-the-rack poolwear had proven short-lived in even moderate Hawaiian waves—often tearing to shreds in the neck-snapping Makaha Beach backwash—leaving the luckless surfer to make a furtive bare-ass run up the beach. Second, they had to be comfortable, nonbinding, and would protect the inner thighs from wax chafing while straddling a board for hours. Third, they had to look cool. Forget the tight beefcake bunhuggers or the belted hands-on-hips pose of a Jantzen swimwear model, these trunks were meant to be lived in and tell the world you were a surfer: worn gunslinger low with a touch of insolence. Returning to the mainland wearing a salty tan, an aloha shirt, and a pair of faded, wax-impregnated custom trunks marked you as a made man.

For surfers, the Drowners were yet another shack-built tool advancing the surfing equivalent of the space race. Early 1950s big-wave surfing was still in its toddler phase, but even prior to the war, Hawaii-born and mainland surfers had left the gentle rollers of Waikiki and were regularly challenging Makaha Point Surf in towering fast waves topping 15-foot or more. New lightweight balsa boards were foiled into 10-foot spearheads for maximum speed in an attempt to outrun the fearsome Makaha Bowl, a Godzilla-sized ellipse of hungry water that gobbled up nine out of 10 surfers racing for the channel. Greg "The Bull" Noll first went to Makaha as a skinny 17-year-old in 1954 and recalls the abrupt gear change transitioning from small California waves. "For years these guys were talking about big Makaha and 'when it comes, buddy, you're gonna know it!' And I thought, 'Bullshit.' Then it happened … giant walls that just kept on going forever. I never saw a place that put the fear of God in me like Makaha."

COASTAL NONCONFORMISTS

The Eisenhower-era surfers living up at Makaha were, for the most part, in their early 20s, Californian, white, and upwardly middle class. They were born during an auspicious gap—late 1920s to early 1930s—too young to remember much of the Depression and, as high schoolers, missed being called up following the 1941 Pearl Harbor attack. This generation reached adolescence during a prosperous wartime economy, and following the war were gifted a limitless future and a garage to build it in. Many, like the Hoffman

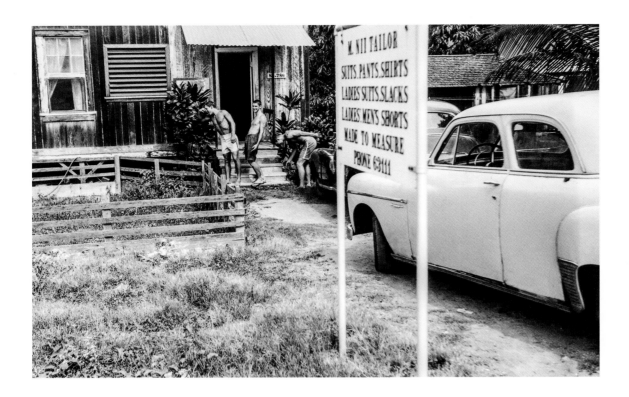

brothers Phillip ("Flippy") and Walter, came from well-off families with enough discretionary income to afford cars, college, and second homes at the beach.

They were in many ways the world's first modern teenagers. Raised on Mark Twain and superhero comics, this generation of young American princes took a decidedly do-it-yourself approach to life lifted straight from the pages of *Popular Science*. Their bare-bones man Eden at Makaha—surfing all day, camping on the beach, freediving for lobster for dinner, chasing girls, brewing washtub swipe (a deadly grog made from pilfered pineapples), and occasionally tussling with the locals—had the trappings of a romantic quest, part Jack London expedition, part mildly subversive *Boys' Life* adventure. This played well to postwar heartland America as a Sunday supplement novelty, as long as it was kept as a weekend lark and everyone was back to work come Monday morning. But following the war a small but growing cadre of young people, mostly men, were beginning to define themselves and their lives by their passions—skiing, climbing, hot rods, motorcycles, music—rather than the regimented role models imposed by society. By its random, often nonlinear nature, surfing was fundamentally individualistic and counterculture, more stylized dance than sport. A healthy outdoor coastal life, one that revolved around tides and wrestling storm-bred swell, held a strong laissez-faire allure over a gray existence spent inside an office oiling the cogs of corporate America.

"I think for a lot of the surfers of the late '50s, their parents were children of the Depression," says Steve Pezman, publisher of *The Surfer's Journal*. "And so, like my father, our parents were conditioned to get a good job and keep it at all costs. And life was about being white-knuckled to an income. Well, as a surfer it became apparent to us that those rules and that paranoia might not necessarily be worth worshiping for the rest of our lives."

SHACK DAYS

Along the California coast, from San Diego to as far north as San Francisco, small pods of surfers clustered around a handful of surf spots—Windansea, San Onofre, Palos Verdes, Malibu, Santa Cruz—to ride waves and to assert allegiance to a bigger tribe that crossed American middle-class utopianism with an ancient Polynesian maritime culture. The San Onofre surfers, especially, embraced a romantic ideal of Hawaii, which, if somewhat makeshift in authenticity, was genuine in its pure enthusiasm.

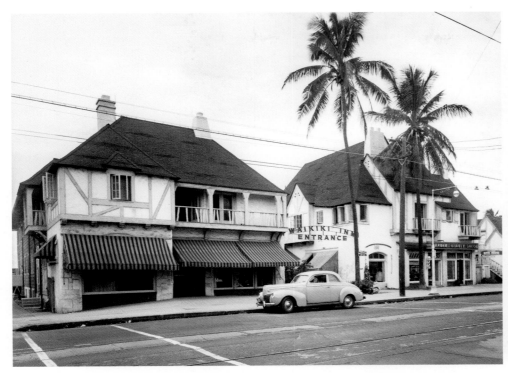

Prior to the war, surfers had been congregating at San Onofre, an isolated stretch of sere coastal bluffs an hour's drive north of San Diego, which produced easy-breaking rolling waves that mimicked Waikiki. On the beach, hidden from easy view, up to a hundred surfers with their friends and families would surf and car camp over a long weekend. The few who had actually been to Hawaii made it as tropical as possible—palm-frond shacks, crudely carved tikis, hand-plaited palm sunhats, and ubiquitous ukulele plinking around a night bonfire to take the chill off the encroaching fog.

While it's easy to dismiss the San Onofre scene as little more than genteel, mostly white suburbanites having a weekend romp, the reality was that many were looking at ways to make surfing a full-time lifestyle and identity. This, in effect, created a separate beach-based culture free from the conservative Midwest values that had migrated to the coast with the flood of wartime factory workers. It wasn't quite a rebellion, but at the same time these young people were of a prime age to enter the work force, make babies, and keep the juggernaut of American hegemony rolling. And they couldn't seem to care less.

The mainstream press took a friendly but paternalistic tone in covering this new/old fringe sport that was captivating a growing number of Americans (an estimated 5,000 on both coasts and Hawaii in 1946). A 1956 article in Long Beach's *Independent Press-Telegram* on the San Onofre scene examined surfers as a fun-loving cult of amphibians where most "... keep up the appearances of normal human beings." While the author gives a fairly credible account of surfing basics and "surfboarders," he couldn't help signing off with a wholesome cautionary quote from a San Onofre veteran: "You need a strong will to surf ... otherwise you'll turn into a bum. You get a feeling that nothing but surfing is important."

POISED FOR A BOOM

Walter Hoffman, the youngest son of successful Los Angeles textile merchant Rube Hoffman, first traveled to Oahu as a teenager in 1948 where he surfed Waikiki on a large south swell. Two years later as a Navy seaman, he had the good fortune to be stationed at Pearl Harbor running computers and the base surf and swim team. Hoffman's off-duty hours were spent mostly at the beach, living in a Waikiki apartment or a rudimentary cottage an hour's drive up the West Side at Makaha. After his discharge in 1953, Walter went to work for the family business, returning to Hawaii regularly to surf, but also to source exquisite

MINORU NII'S TAILOR SHOP; WAIANAE, HAWAII; 1959 From this humble little West Side shack came surf trunks built tough enough for big-wave surfers, but stylish enough for movie stars and a future American president. John F. Kennedy, then a Massachusetts senator, found out about M. Nii custom trunks from his brother-in-law, Peter Lawford. Popular lore has it that Kennedy was a notoriously slow pay. *Photo, Tom McBride*

TOURIST BROCHURE, 1952

WAIKIKI TAVERN, WAIKIKI, 1945 The venerable Waikiki Tavern on Kalakaua Avenue became the unofficial hangout for "coast haoles" from California in the 1940s and '50s. Its "merry-go-round" bar was infamous for frequent fights and many called it "the boxing ring." *Photo, Ray Jerome Baker*

MENU, WAIKIKI TAVERN, C. 1946 Located a short walk from the beach, the tavern's main draws for cash-strapped surfers were cheap cocktails and a $1 all-you-can-eat salad bar.

RIDE OUT THE HEAT WAVES!

Peso Pluma **tailored by Sagner...Lightest Dacron-Worsted Suit Ever!**

Cool as the surf . . . light as a feather! That's Pacific's new sea breeze tropical. 55% Dacron* polyester gives it the power to ward off wrinkles indefinitely . . . 45% fine worsted lets it "breathe" . . . lets the air circulate around you . . . gives it superb tailoring qualities. Praise Pacific for the fabric . . . Praise Sagner for the styling and tailoring. Combined they present you with your coolest, best dressed summer yet! Suits, from $55. Sport Coats, at $37.95. Slacks, from $12.95. *Slightly higher in the West.*

At Jordan Marsh, Boston & Miami; John David, New York & Wash.; Maison Blanche, New Orleans; Donaldson's, Minneapolis; Frankenberger's, Charleston. For names of other stores, write Pacific, 261 5th Avenue, New York 16, N.Y.

Pacific Burlington
PACIFIC MILLS WORSTED COMPANY
A Division of Burlington Industries

*DUPONT'S T.M.

THE NEW YORK TIMES MAGAZINE

ADVERTISEMENT, BURLINGTON, 1961

DECAL, MOANA HOTEL, C. 1953

WAIKIKI, C. 1950 The early missionaries frowned heavily on surfing because it promoted "lewd displays" and encouraged "mixing of the sexes" among the natives. A hundred years later, the missionaries' suntanned descendants would do most of the mixing.

BEACHBOYS, WAIKIKI, C. 1946
(Pages 100–101) Duke Kahanamoku, far right, with his brother David and other Waikiki beachboys welcome the deluge of postwar tourists.

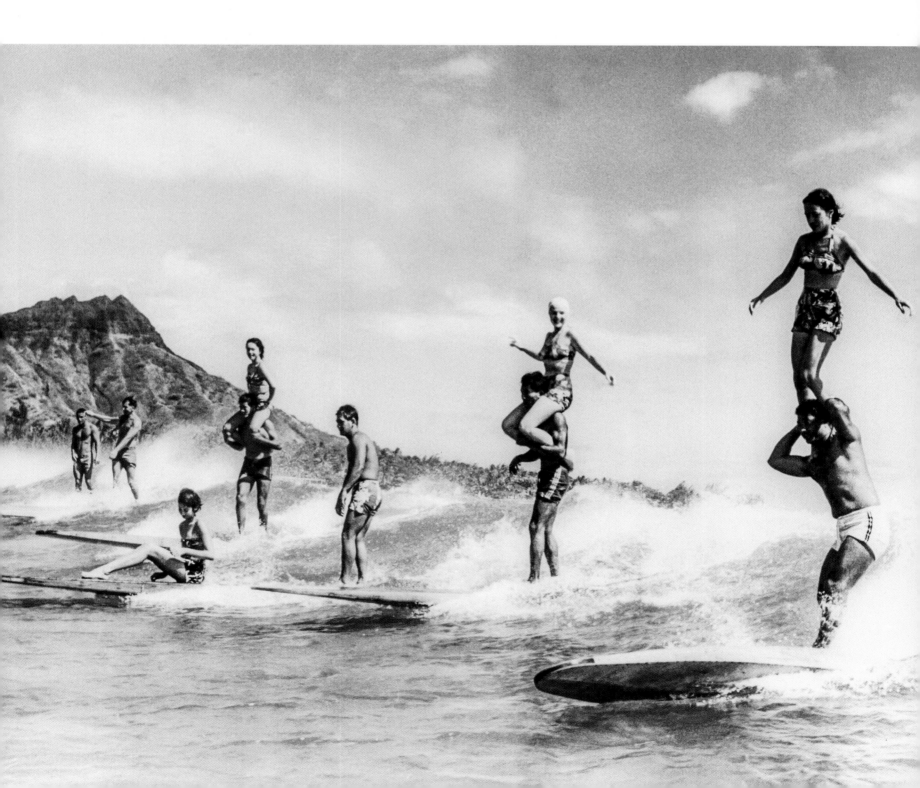

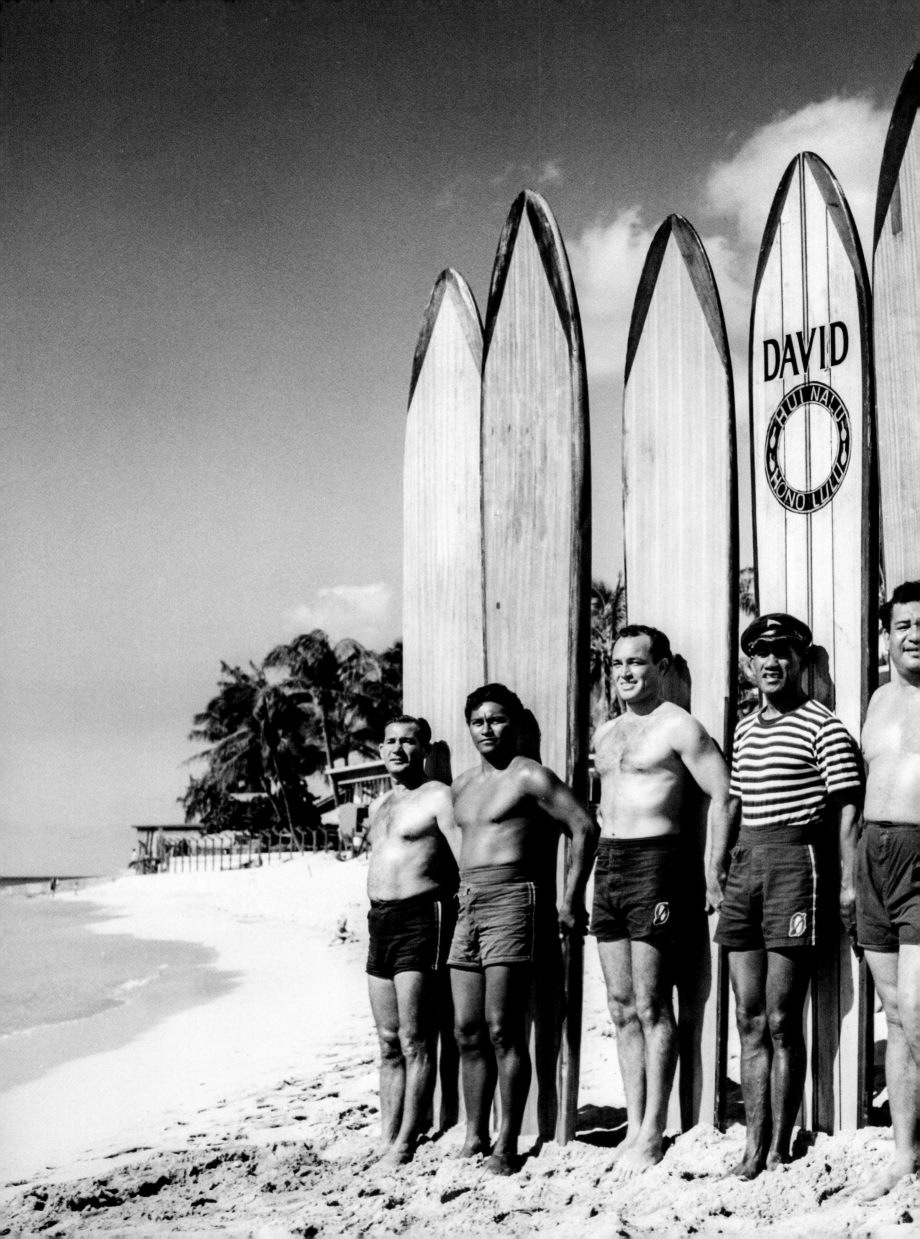

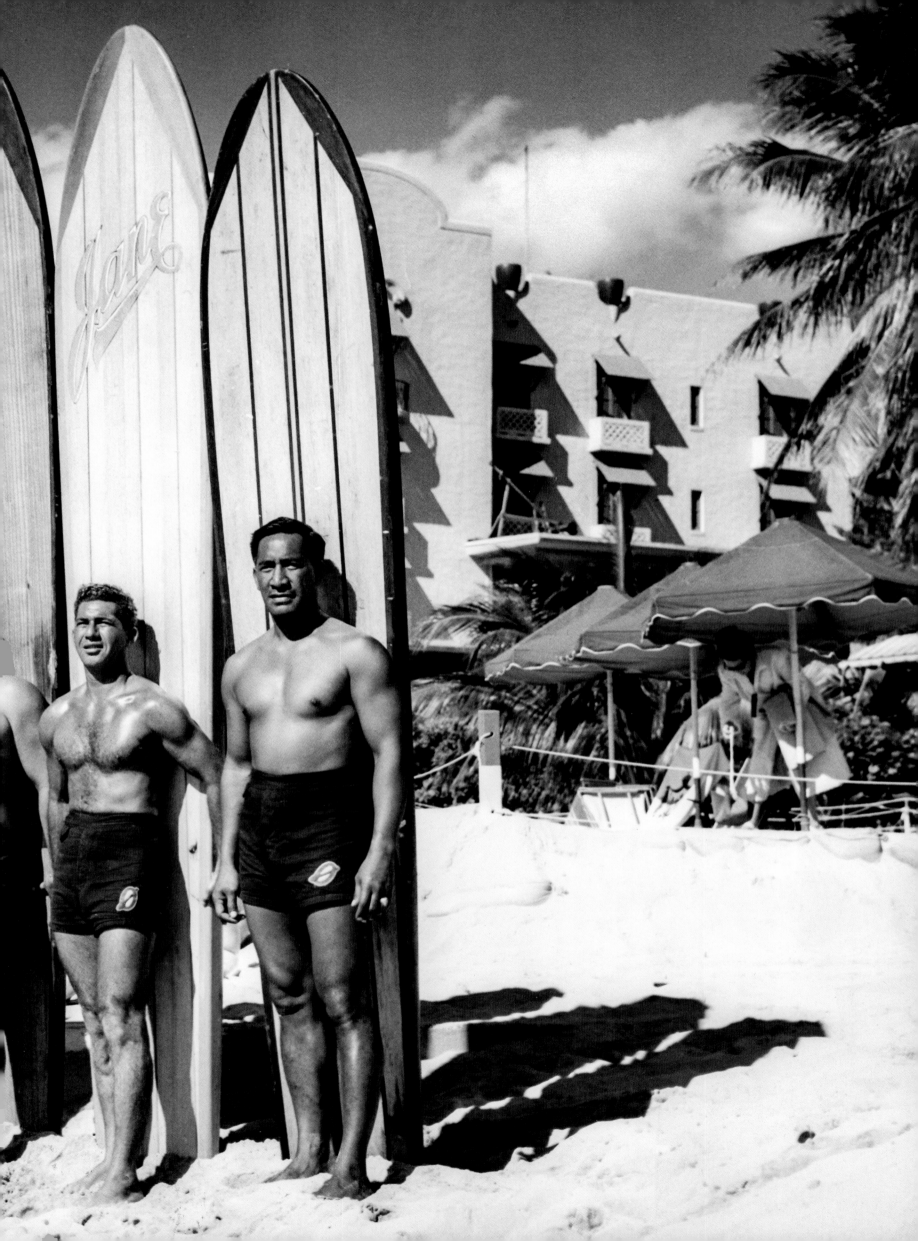

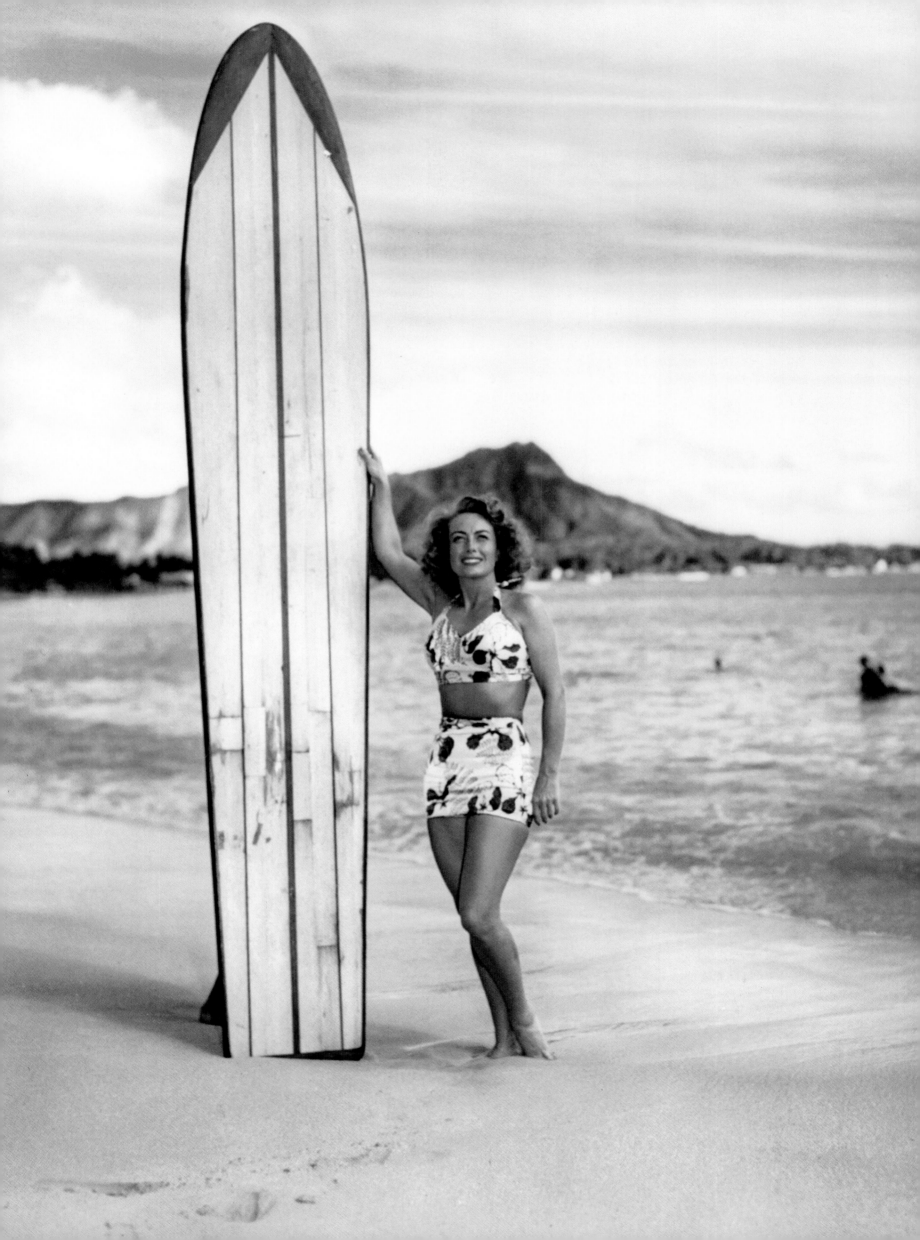

Japanese-made floral prints used in the burgeoning aloha-shirt industry based in Honolulu. Japan's renowned textile industry, which had been flattened by the war, was quickly rehabilitated by America with trade subsidies and a glut of American cotton stockpiled for the war effort. Between surf sessions Walter would collect samples and ship them back to Hoffman Fabrics in California. New fabrics would be designed, manufactured in Japan, and exported to shirtmakers in Hawaii and the mainland, eventually making their way to small tailor shops like the Niis'.

When surfing boomed as a totemic lifestyle in the early 1960s, the Hoffmans were in the enviable position as textile-savvy surfers supplying Hawaiian-styled prints to the bulk of surfwear start-ups and the mainstream fashion industry eager to exploit the international fad. Duke Boyd, an early Makaha surfer and budding beach entrepreneur, reverse-engineered a pair of M.Nii trunks that he marketed in 1960 under the name Hang Ten. Boyd's new brand quickly became a hit with surfers, eventually filtering out to the inland masses and beyond. By the end of the '60s, Hang Ten sales eventually topped $100 million. They became the seminal surf brand archetype for future global surfwear giants such as Quiksilver and Billabong that shared similar humble beach-garage beginnings in the 1970s.

In retrospect it's fairly easy to trace modern surfing's rapid journey from arcane fringe sport to leading aspirational lifestyle. America emerged victorious from World War II as the new Rome with its infrastructure untouched, industrial base expanded, and teeming new export markets made up of its allies and recent enemies alike. At home, a rejiggered war industry turned consumer-good manufacturers were about to drop the green light on a revved-up domestic economy redlining on four years of good wages and pent-up demand.

As the war ended with a blinding atomic flash over Japan's Hiroshima, America's focus — and to a large extent its future — shifted decidedly westward. The Hawaiian Islands, equidistant between California and Japan, represented a new coastal America that had more in common with the Pacific Rim nations of Asia and Australia than the American heartland. California, with more than half its economy driven by aerospace, oil, mass media, and international shipping, became a sovereign nation of tomorrow. Its surfers were literally poised along America's leading edge, drifting across the Pacific on airborne Silk Roads created in the wake of fast-shifting and momentous geopolitics. As Harvard University historian H. Stuart Hughes wrote of Californians in his 1956 essay "California — The

JOAN CRAWFORD, WAIKIKI, C. 1946
Surfboards provided a convenient prop for glamorous Hollywood movie stars visiting Hawaii.

JOE QUIGG, MATT KIVLIN, AND TOMMY ZAHN; 1948 A trio of now-legendary coast haoles returns to California aboard the Matson Line steamship *Lurline.* Even though air travel to the islands was freely available by the late 1940s, many surfers chose the longer, cheaper six-day ocean route that included deck games, pretty coeds, and generous dining privileges.

MATCHBOOK COVER, 1957

PAINTING; WAIKIKI BEACH, HAWAII; C. 1952 *(Pages 104–105) Art, Fred Ludekens*

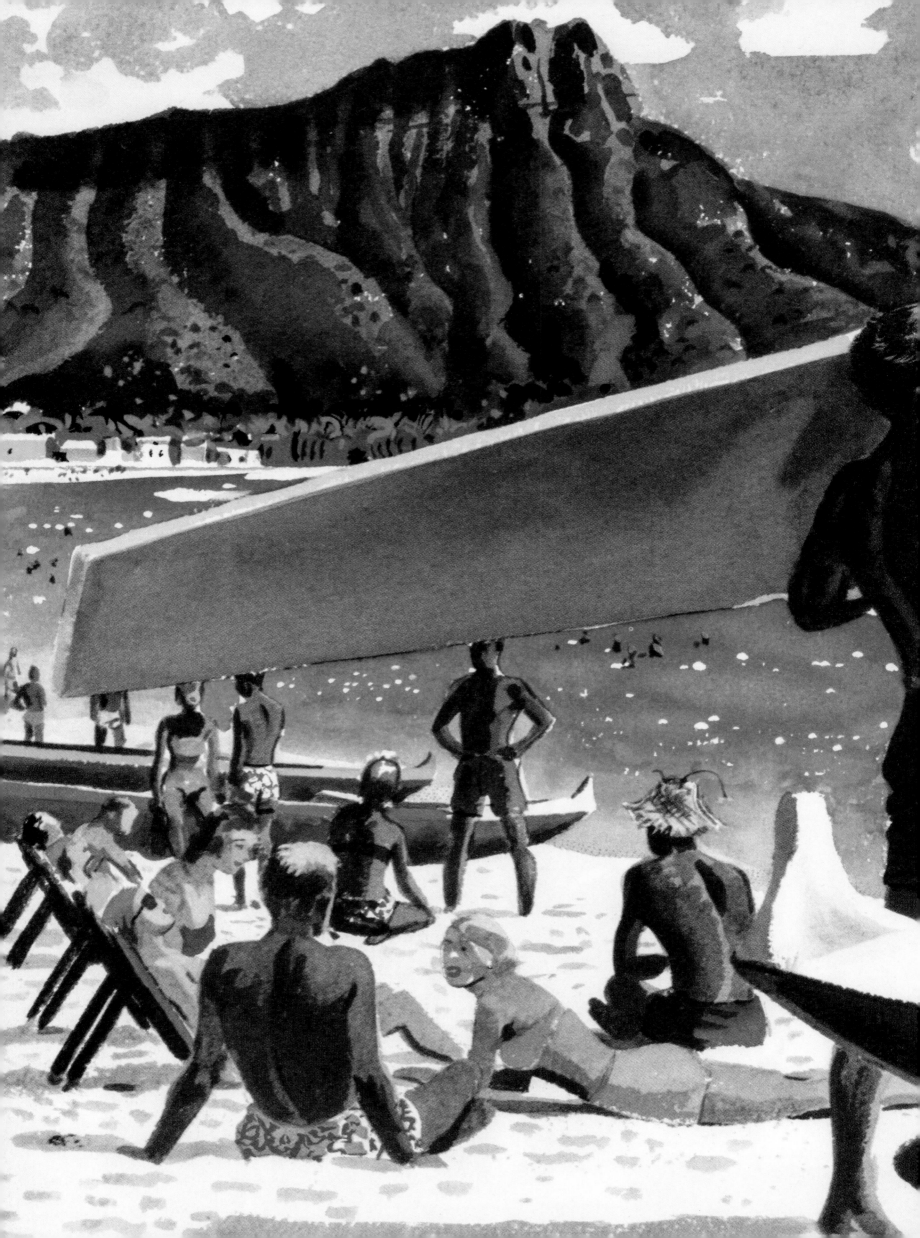

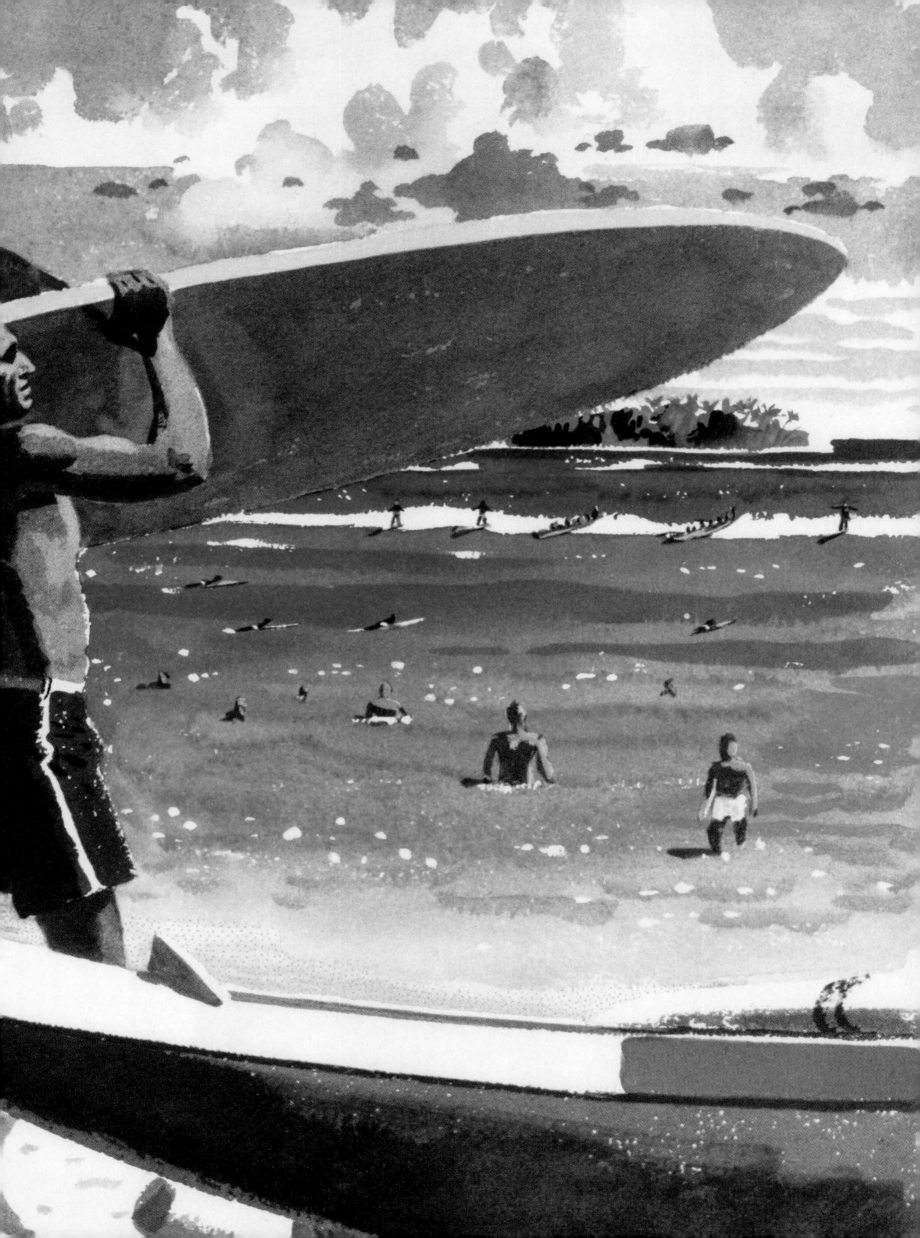

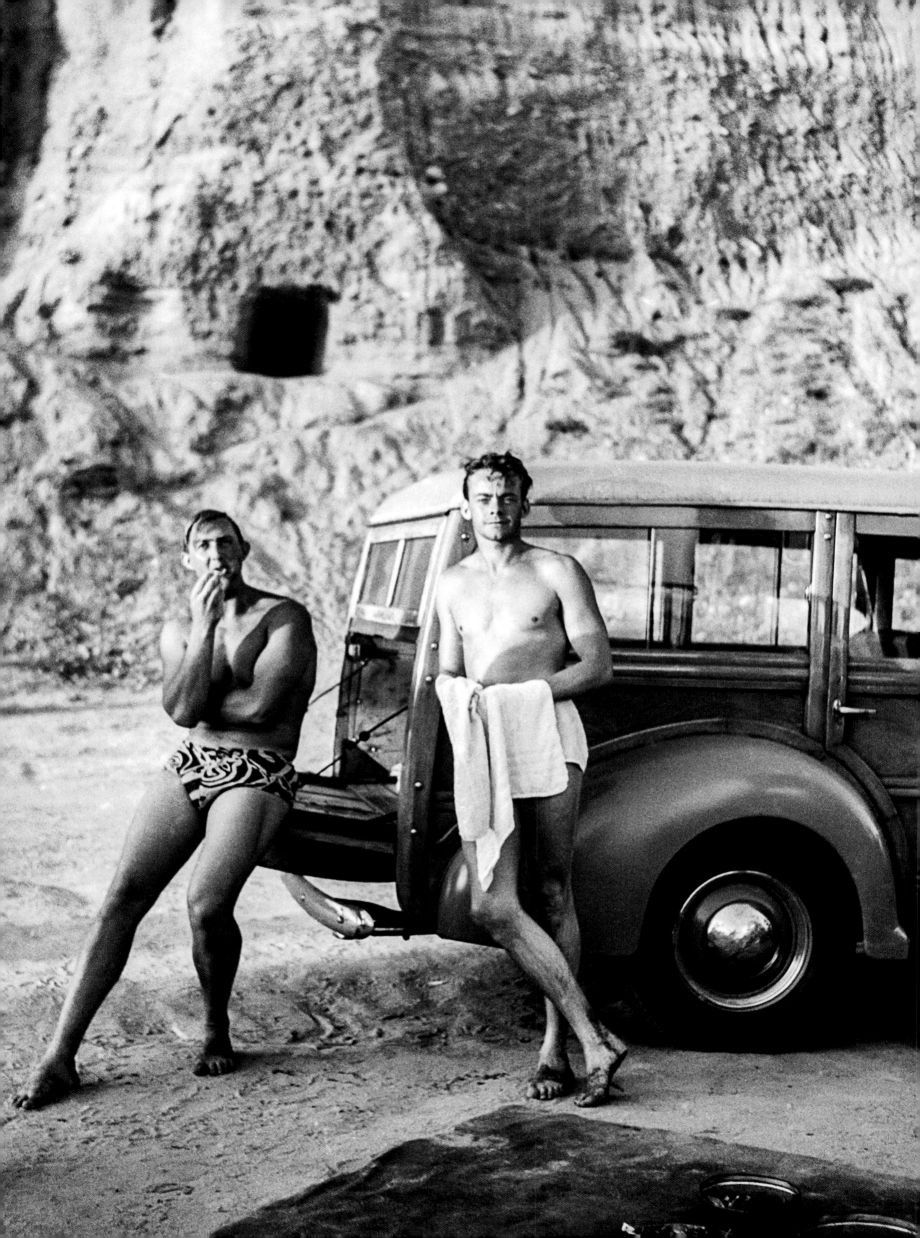

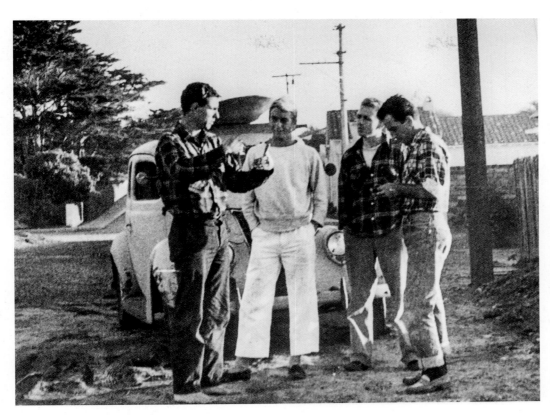

SAN ONOFRE, CALIFORNIA, 1950
The "Woodie" was introduced in the late 1920s as a roomy vehicle to transport passengers and luggage from the train station. But 20 years later the wood on most had deteriorated badly. They sold for as cheap as $75 to surfers who found them ideal for hauling 10-foot surfboards and sleeping rent-free next to the ocean. *Photo, Loomis Dean*

BOB SIMMONS; LA JOLLA, CALIFORNIA; C. 1949 Simmons, left, explored California waves solo in a rusted-out '37 Ford where he kept a sleeping bag, a bag of oranges, cans of baked beans, and hydrographic charts. "Simmons was like a missionary who traveled the coast promoting his ideas," said Joe Quigg. *Photo, John Elwell*

BOB SIMMONS SURFBOARD, 1949 While the plane shapes of Simmons boards were similar to earlier redwood planks, their design, construction, and materials were practically space-age. By using a polystyrene core laminated with a mahogany veneer and sealed with fiberglass and resin, the result was an instant halving of the weight and a quantum leap in performance.

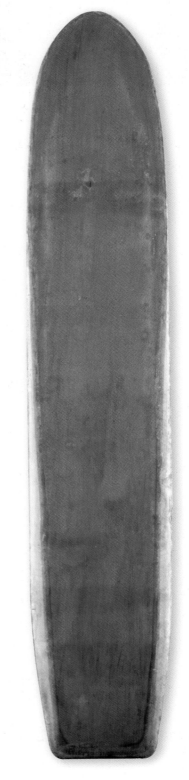

America to Come," "They have reached the point of extreme advance, both geographically and socially: only the ocean and the huge riddle of Asia lie beyond."

TRANSPACIFIC TECHNOLOGY TRANSFER

In August 1949, Hawaiian surfers Wally Froiseth, George Downing, and Russ Takaki sailed from Honolulu to San Diego aboard the transpacific racing yacht *Flying Cloud*. The crossing, a standard yacht delivery, took 15 days and was a working vacation for the three young men ranging from 19–28. Symbolically, however, it connected the final dots of a Polynesian technology left a thousand years earlier with the Tahitian sailing canoes arriving in Hawaii and offloading—among pigs, gods, and a rigid class structure—long, carved, wooden surfboards.

Lashed to the deck were three redwood-laminate hot curl boards—over 10 feet long, finless, and weighing upward of 65 pounds apiece. Originally designed in the late '30s by Oahu surfers Froiseth and John Kelly to hold an acute angle while speeding across forgiving Diamond Head peelers, the hot curl's heft, V-tail, and dagger-like silhouette proved the X factor, negotiating the fast treacherous walls of Makaha in the 10-foot range. Once the thick blunt rail (the surfboard's lengthwise edge) was locked in to the wave face, the hot curl overcame its considerable mass and transformed from a heavy, unwieldy plank into a point-to-point guided missile that allowed slight course corrections as the rider blew down the line. The speed it generated, however, could be breathtaking.

Joe Quigg, the 1940s Malibu virtuoso and prescient surfboard designer, recalls seeing his first hot curls in Waikiki in the late '40s as he paddled out on his lightweight balsa Malibu chip board: "…as I'm about to punch through, I looked down and there was Georgie [Downing] standing there smiling, going faster than hell on his redwood. He was just streaking along in impossible situations and making it because of positioning and all that inertia. Downing pioneered the riding of really big, nasty waves."

After disembarking in San Diego, the trio bought a $25 junkyard Ford Model A, strapped their boards to the roof, and headed up Pacific Coast Highway. Through Signal Hill and Huntington Beach, they would have no doubt noted a forest of oil derricks and refineries looming over the ocean; the trophy fields of a huge—if toxic and unsightly—state industry that supplied 15 percent of the United States.

SIMMONS'S DESIGN BREAKTHROUGH

Surfing-wise, the trip was a bust. The summer waves proved small, the water unseasonably cold, and the hot curl boards lumbered like swamped battleships in the slow, gutless conditions. However, on rolling up to Malibu, the Hawaiians reconnected with their mainland surf buddies Pete Peterson, Matt Kivlin, Dave Rochlen, Goodwin "Buzzy" Trent, and others. The "coast haoles," as the mainland surfers were known in Hawaii, were mostly surfing broad, agile balsa-core boards shaped by Kivlin, Quigg, and a brilliant if prickly 29-year-old former Douglas Aircraft mathematician named Bob Simmons.

Since the war's end, Simmons had been obsessed with creating the fastest surfboard in the world. Adapting recently released naval warfare planing-hull research used for designing fast-attack gunboats, Simmons had been relentlessly churning out a series of boxy speed machines, experimenting with balsa, plywood, and Styrofoam composites to reduce weight without sacrificing buoyancy in California's often underpowered waves. His garage-built prototypes weren't pretty—often looking dingy and unfinished—but like the hot curls, once set on a straight trajectory they were rocket sleds down the line. Malibu, with its predictable machine-like waves that hit the gas on a big swell, became Simmons's laboratory and drag strip.

Simmons, along with Quigg, Kivlin, Peterson, and a handful of other multitalented surfer-shapers, were early adopters of fiberglass and polyester resins for board building. These new synthetics were first developed by American and German chemical industries in the 1930s, but fast-tracked during the war to replace strategic natural materials made scarce by the conflict. In the United States, oil was cheap and readily available, and through petrochemical alchemy could be transformed into the base matter of all manufactured goods, including weapons.

THE MAGIC OF PLASTIC

Plastics themselves had a checkered, sometimes covert past, with most formulas and curing techniques kept closely guarded industrial secrets. During the war, British spies stole the latest plastics technology from Nazi-controlled chemical companies such as IG Farben (who produced the Zyklon B deathcamp gas) and Bayer, and turned them over to the American military. They in turn gave the formula to American aircraft and boatbuilding companies to mass-produce critically needed parts and coatings. During the war, Simmons likely encountered plastics as a young California Institute of Technology student working as a night-shift

TOMMY ZAHN, DARRYLIN ZANUCK, AND PETE PETERSON; SAN ONOFRE, CALIFORNIA; C. 1947 Both Zahn, left, and Peterson, right, were all-around watermen and lifeguards who could surf, paddle, dive, fish, and sail all manner of watercraft.

DARRYLIN ZANUCK AND TOMMY ZAHN; SANTA MONICA, CALIFORNIA; C. 1947 Zanuck, eldest daughter of 20th Century Fox studio head Darryl F. Zanuck, began dating Tommy Zahn as a high schooler in the late 1940s. Her athletic good looks combined with Zahn's natural surfer charisma made them Malibu's gilded couple.

machinist at Douglas Aircraft, where the newly formulated plastics were being used to make custom tools, radar cowlings, and machine-gun ammunition chutes, among other things.

When Downing smashed the nose of his prize hot curl "Pepe" against a Malibu pier piling, Simmons offered to repair the damage using fiberglass and resin from his carefully hoarded stash. Fiberglass-reinforced plastics, recently declassified as a strategic material by the War Department, were being slowly filtered into the consumer market, sold by a handful of Los Angeles chemical supply houses such as Thalco, a small operation made up of Ted Thal and Brant Goldsworthy. Goldsworthy, a pioneering composites engineer, worked at Douglas during the war and was an avid San Onofre surfer who freely shared his expertise with his surfer friends, including Pete Peterson, renowned lifeguard and part-time Hollywood stuntman. In 1946, Peterson fully glassed his balsa and redwood "Pete" board, becoming the first verified boardmaker to use fiberglass tech.

Downing, who even at 19 had embarked on a lifelong holistic, even meditative, inquiry of waves and wave-riding, took note. He couldn't have missed, however, Simmons's prolific use of glassed-in fins to help stabilize and steer his wide, tongue-depressor-shaped boards. While surfboard fins dated back to the '30s and had gained traction on the West Coast by the mid-1940s, Hawaiian surfers on the whole had been slow to embrace them, considering the rigid knife-like projections slicing through the water to be potentially dangerous (rightly so) to the surfer and other people in the waves. Traditional surfing in gentle Waikiki rollers allowed for multiple riders on finless boards to safely share a wave to the beach in a gentlemanly side-by-side manner (derided by younger surfers as the "Straight-Off Adolf" style).

ROCKET THROUGH THE BOWL

Downing knew from surfing mid-size Makaha that the existing hot curl boards, as fast as they were, effectively tapped out in waves taller than 10 feet (the low end of true Point Surf); performance became erratic, even disastrous. As the hot curls approached terminal velocity in large waves, their V-shaped tails would often break free, leading to a barely controlled side-slip or a wholesale "sliding-ass" wipeout. But by the time Downing flew back to Oahu a month later, he was holding all the critical components to build a modern lightweight surfboard that would enable a few select surfers to break surfing's big-wave sound barrier. The goal: 20-foot Point Surf. He quickly set about modifying the existing

TOMMY ZAHN, DARRYLIN ZANUCK'S HOUSE; SANTA MONICA, CALIFORNIA; C. 1947 Zanuck was quick to learn surfing and asked Zahn, right, to make her a board she could paddle easily. He sought the lightest balsa available and handed the job to Joe Quigg, who shaped Zanuck a featherlight 10'2" that was dubbed the "Darrylin board."

MAGAZINE COVER, *THE HOME WORKSHOP*, C. 1947

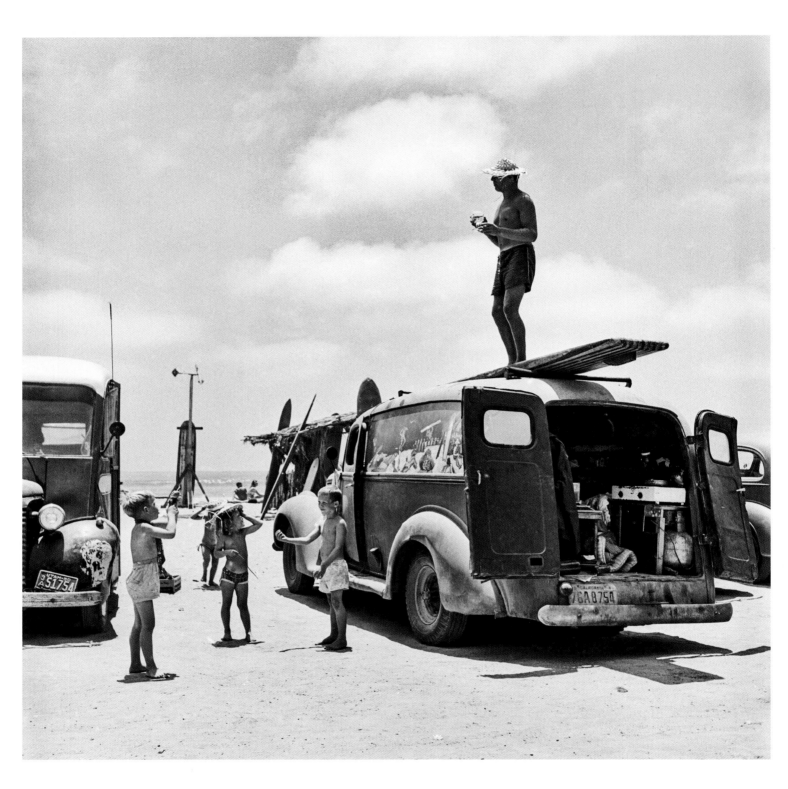

hot-curl template, keeping the length and narrow profile but adapting the materials and tech gained from his California sojourn. Working with hand planes on a balsa core glued up with three slender redwood "stringers" for strength, Downing sculpted a 10-foot, 35-pound golden missile he named, appropriately enough, "The Rocket." The chunky V-tail was gone, flattened out and replaced with a repurposed waterski fin. Downing also fashioned a rudimentary fin box, another first, that allowed him to switch out fins and dial in placement in increments.

His first test flight at Makaha was a revelation. The Rocket was not only a bullet down the line, it also felt dead solid underfoot. Further, the fin allowed for definitive direction change, allowing the rider to climb and drop across the huge wave face at will by weighting and unweighting the rail, much in the same way a skier will traverse a steep mountain pitch. "I had had so much confidence in this board," Downing said, "…that never once, if I got it trimming right, did I feel like I couldn't make it to the end of the curl line."

Downing built a series of Rockets from 1950 to 1953; each one used in increasingly larger Makaha waves, with occasional exploratory probes out to Sunset Beach on the North

BOB "HAMMERHEAD" GRAVAGE; SAN ONOFRE, CALIFORNIA; 1950
Photo, Loomis Dean

WENDE WAGNER AND TOM CARLIN, HAWAII, 1957 Director Billy Wilder spotted Wagner while she was swimming near the Coronado, California set of *Some Like It Hot* in 1958. Struck by her exotic good looks, he offered Wagner a screen test, but her parents forbade it until she finished high school. She went on to become an international fashion model, movie actress, and underwater stuntwoman. *Photo, Bev Morgan*

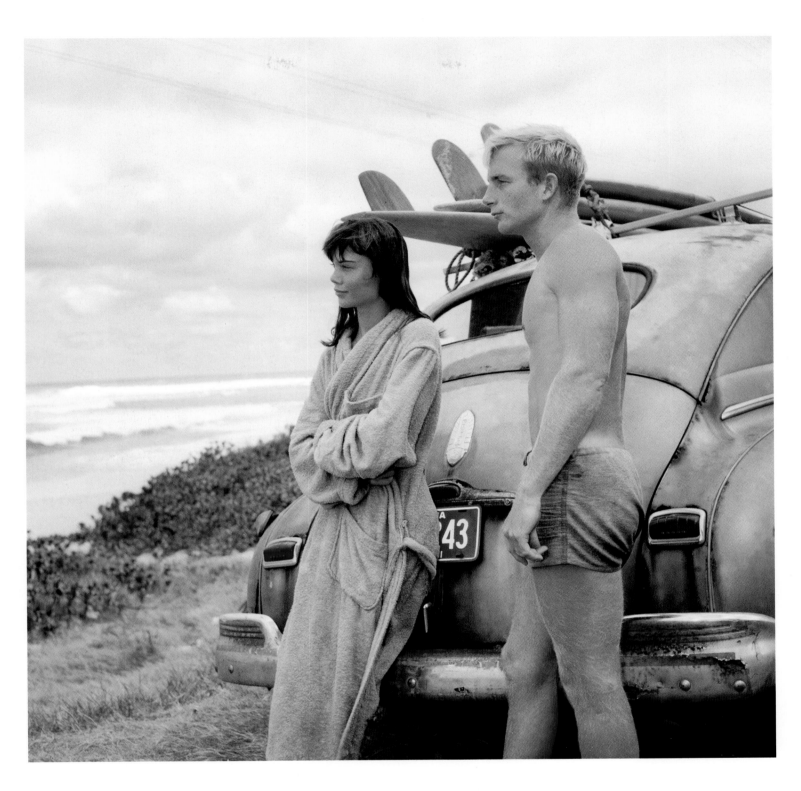

Shore. By 1952, surfing 20-foot Point Surf was, if not commonplace, done enough to estab-
lish a sequence of reasonable steps up the big-wave ziggurat.

In 1953, Associated Press stringer Thomas "Scoop" Tsuzuki snapped a stunning
black-and-white photo of George Downing, Buzzy Trent, and Woody Brown gliding in
formation down a fearsome but friendly looking 12-footer that had been tilted to appear bigger.
Regardless, it was impressive. The shot went international and sparked a seasonal surfer
migration to Hawaii. For a brief span in the 1950s, Makaha was the ultimate surfing destination
for a small but fast-growing community of surfers drawn from around the Pacific Rim.

Fred Van Dyke, a 22-year-old schoolteacher and surfer from Santa Cruz, who braved
the hypothermic waves of Northern California without a wetsuit, was prepping for his class in
the teachers' lounge when the school superintendent walked in with the morning *Santa Cruz
Sentinel*. On the front page, sharing real estate with local school board bickering, a New York
longshoremen walkout, and post-peace talks arguments over Korean POWs, was Scoop's shot.

"And that was it," said Van Dyke. "I quit my job the next day and headed for Hawaii."

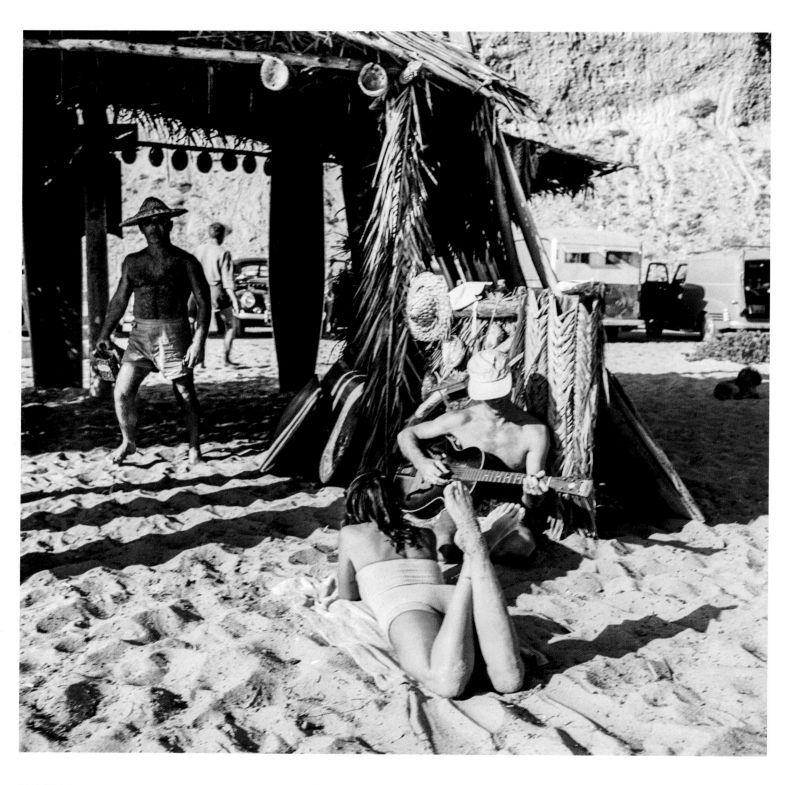

SAN ONOFRE, CALIFORNIA, 1950
Photo, Loomis Dean

THE GIDGET FACTOR

Popular history renders the film premiere of *Gidget* in April 1959 as surfing's big bang, the lone cataclysmic event that transformed surfing overnight from a singular communion with the ocean into a wholesale gold rush by the inland hoards to the coast. Viewed at ground level the numbers would bear that out, as the number of surfers on all American coasts increased exponentially (estimated at close to 100,000 from a postwar total of 5,000) within two years following the film's release. The cause and effect, however, is a bit more tangential.

While the film, dubbed a "mild little Columbia (Pictures) frolic" by *The New York Times*, was a decent enough domestic earner at the time to justify a European summer release, it was strictly a one-off teen exploitation film from a studio renowned for screwball comedies and drive-in fare like *Attack of the Crab Monsters*. After all, the book (published in 1957) and the film itself were not really so much about surfing as a teen girl's first summer crush set against the thriving mid-'50s Malibu scene.

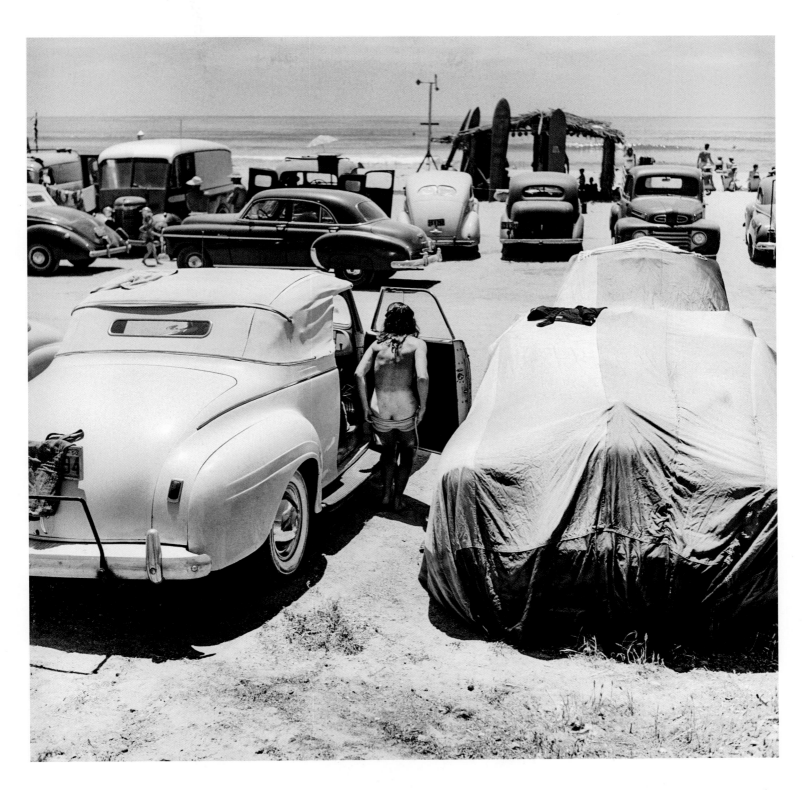

SAN ONOFRE, CALIFORNIA, 1950
Photo, Loomis Dean

But despite its slangy concocted enthusiasm—or maybe because of it—*Gidget*'s lush cinescopic blend of surf, romance, implied sex, and sanitized Beat rebellion caught fire with a burgeoning war-baby population (approximately 24 million) well into an affluent teenhood by 1960. By hiring top young Malibu surfers, including Miki Dora, Mike Doyle, and Mickey Muñoz, as surfing doubles, the film retained a thread of credibility and sold the ideal of surfing, at least Hollywood's version of it, to the world. But rather than a direct cause of surfing's seeming overnight popularity, the film was more an accelerator, feeding a perfect storm of youth-fueled cultural fission coupled to a small but tooled-up surf industry more than 10 years in the making.

FROM A RUMBLE TO A ROAR

For surfing to accommodate a huge influx of beginners, however, the equipment had to change radically. The new surfers coming to the sport were, for the most part, spindly adolescents who demanded a lightweight maneuverable board that was within their allowance.

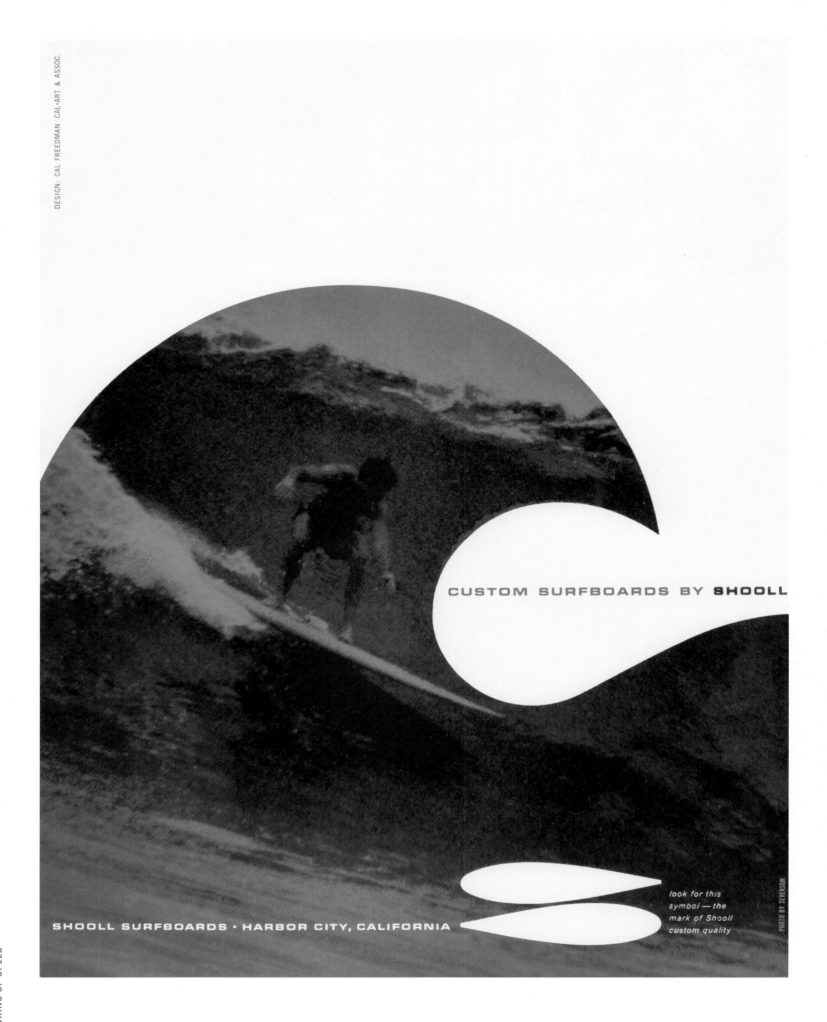

CUSTOM SURFBOARDS BY SHOOLL

SHOOLL SURFBOARDS · HARBOR CITY, CALIFORNIA

*look for this
symbol — the
mark of Shooll
custom quality*

ADVERTISEMENT, SHOOLL SURFBOARDS, 1961

FABRIC DETAIL, C. 1951

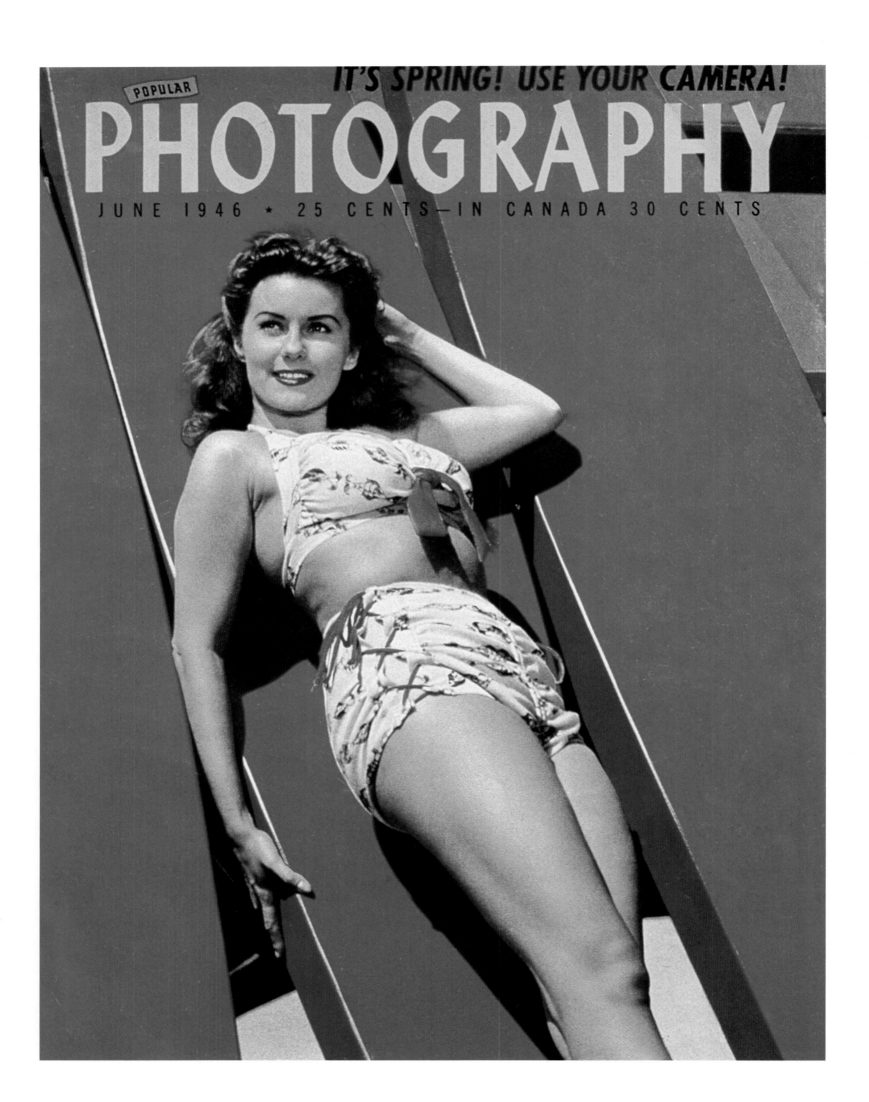

IT'S SPRING! USE YOUR CAMERA!

POPULAR

PHOTOGRAPHY

JUNE 1946 ★ 25 CENTS—IN CANADA 30 CENTS

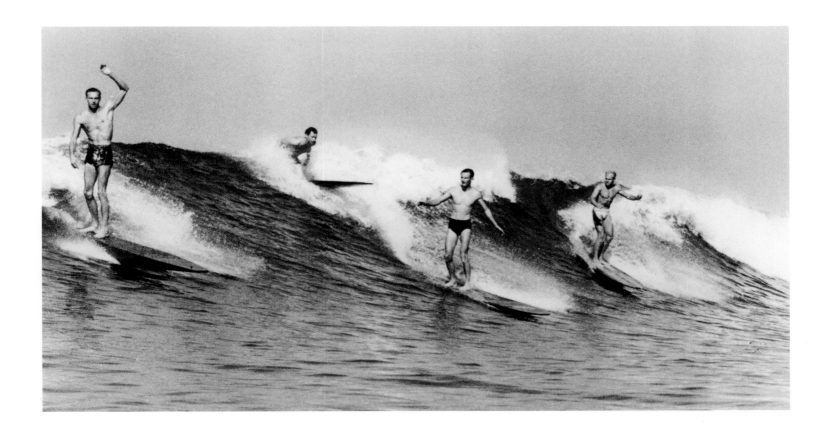

A heavy slab of polished timber, no matter how expertly crafted, was cumbersome on land, a pain to transport, and took months to master the basics of paddling and safely navigating through even relatively benign waves.

Progressive Malibu shapers such as Joe Quigg and Matt Kivlin had shown a better, lighter future as early as 1951 by creating 25-pound balsa boards as short as seven feet for their girlfriends, with one of the main criterion that it had to fit in the back of a Town & Country convertible. When the male surfers borrowed the "girlfriend boards" for a lark, they were amazed at their agility and the responsiveness, allowing for quick top-to-bottom banking turns, radically changing the style from chesty upright gliding to a fluid series of connected maneuvers that allowed the surfer to explore the entire face of the breaking wave at will. "What they did, as far as I'm concerned, busted the whole surfing thing right open," recalled a then-teenaged Greg Noll, "…it was the beginning of the end for old-fashioned and crude surfing."

By the mid-'50s, however, the world's balsa wood output, most of it grown and hand-harvested in Ecuador, had become in increasingly short supply. Like rubber and oil, balsa had been classified a strategic resource during World War II. After the war, boatbuilders and the shipping industry consumed the bulk of prime lightweight balsa, leaving a handful of Southern California surfboard builders scrapping over dwindling stockpiles of erratic quality. The top shapers such as Hobart "Hobie" Alter and Dale Velzy were struggling to keep up with board orders and already experimenting with rudimentary production streamlining on the way to full mass production. But with balsa, 35 pounds of laminated 50-pound blank was ending up on the shop floor as shavings and offcuts. Clearly an alternative was needed.

Expanded polystyrene, the same large-bead foam (aka Styrofoam) used for packaging and cheap beer coolers, had proved nominally functional but would melt like butter when catalyzing resin or any other reactive chemical was applied. The plywood/foam "sandwich" boards also proved highly susceptible to heat delamination. Alter, who had started shaping and glassing balsa boards in 1950 in the garage of his parents' Laguna Beach summer home, an hour's drive south of Los Angeles, recalled that after a day in the sun the composite boards would fall part and rattle like dried peas in a jar.

Polyurethane foam, invented in 1937 by Otto Bayer at IG Farben (and likely one of the secret formulas stolen by wartime British intelligence) seemed a much better fit; it was

MAGAZINE COVER, *POPULAR PHOTOGRAPHY*, 1946

HERMOSA BEACH, CALIFORNIA, C. 1946
Photo, Doc Ball

ADVERTISEMENT, JANTZEN, 1947
Jantzen swimwear began as the Portland Knitting Company in 1910, and by the late '50s was actively marketing to surfers, eventually becoming *SURFER's* mainstay advertiser.

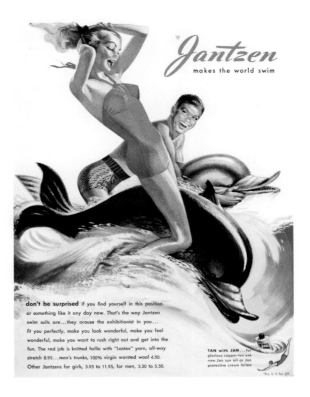

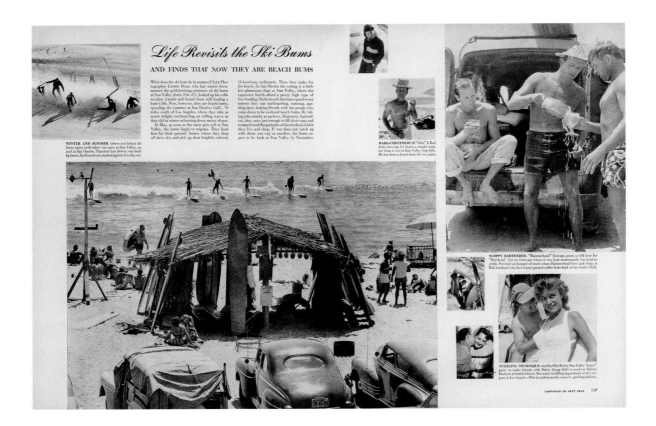

feather light but dense, could be readily rough cut with a handsaw, fine-shaped quickly with wood-grade sandpaper, and, most important, remained absolutely inert when coated with multiple layers of hot resin.

Its main drawback was that even though polyurethane was available in pint-sized amounts for small modeling projects, nobody by the mid-'50s had dialed in the intricate multipart chemical "blowing" process for creating a uniformly dense sculpted product as large as a surfboard blank. Early attempts by budding surfer-chemists at producing a blank under pressure in heavy coffin-like molds had resulted in near disasters. The fast-mushrooming mass blew out seams, threatened to catch fire, and spewed mounds of toxic off-gassing foam across the garage floor.

THE FUTURE IS FOAM

But for those who saw surfing as their future—and this included a beach-based livelihood beyond lifeguarding—this was the literal core product of a future billion-dollar industry. Without a cheap, easily replicated lightweight board and an efficient surf industry to produce, market, and distribute the essential equipment, the global surfing craze of the early '60s would likely have fizzled on the launch pad and become a regional fad at best.

By late 1957, two rival Southern California surfboard makers, Hobie Alter of Dana Point and Dave Sweet of Santa Monica, were in a low-budget technological arms race to develop and control blank production. Both, however, worked unaware of the other. Sweet, who had started experimenting with polyurethane foam in 1953, had the early lead with financing from future *Gidget* star Cliff Robertson. By 1956, Sweet was offering a foam-core board to a select Malibu clientele. But Alter had a scientific mind, some money in the bank, unlimited drive, and critical chemical expertise in his employee-turned-partner Gordon "Grubby" Clark, a onetime oilfield worker who had earned an engineering degree at Pomona College. In early 1958, Alter and Clark set up a top-secret skunkworks in a ramshackle garage on the outskirts of Laguna Beach. For the next five months they worked nonstop behind blacked-out windows amid choking fumes to perfect the foam-blowing process using steel-reinforced concrete molds.

By that summer, however, they emerged from the gloom with a viable blank ready for mass production. Alter scrapped his balsa operation and went 100 percent into an all-plastic

MAGAZINE INTERIOR, *LIFE*, 1950
"*LIFE* Revisits the Ski Bums," with photos by Loomis Dean, heralded surfing's visibility into the mainstream.

SURFBOARD RACE, MALIBU, 1949
Tommy Zahn won the inaugural Malibu surfboard race on September 11, 1949. The short-lived contest only ran until 1952.

SUNSET SPECIAL, HAWAII, 1960
John Severson, future founder of *SURFER*, was stationed on Oahu after being drafted to the U.S. Army. He wrangled a spot on the Army surf team and spent his off-duty hours surfing, painting, and shooting 16mm film. He also hand-decorated his surf car, dubbed the "Sunset Special." *Photo, John Severson*

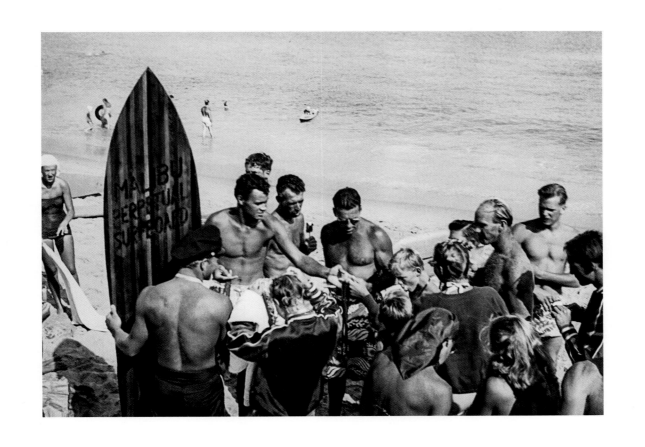
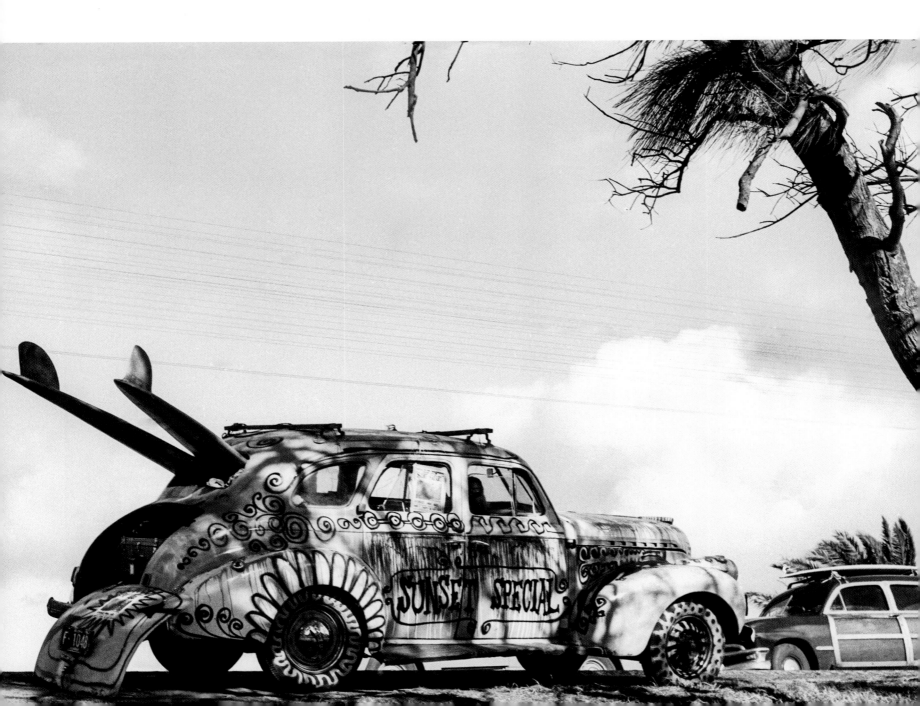

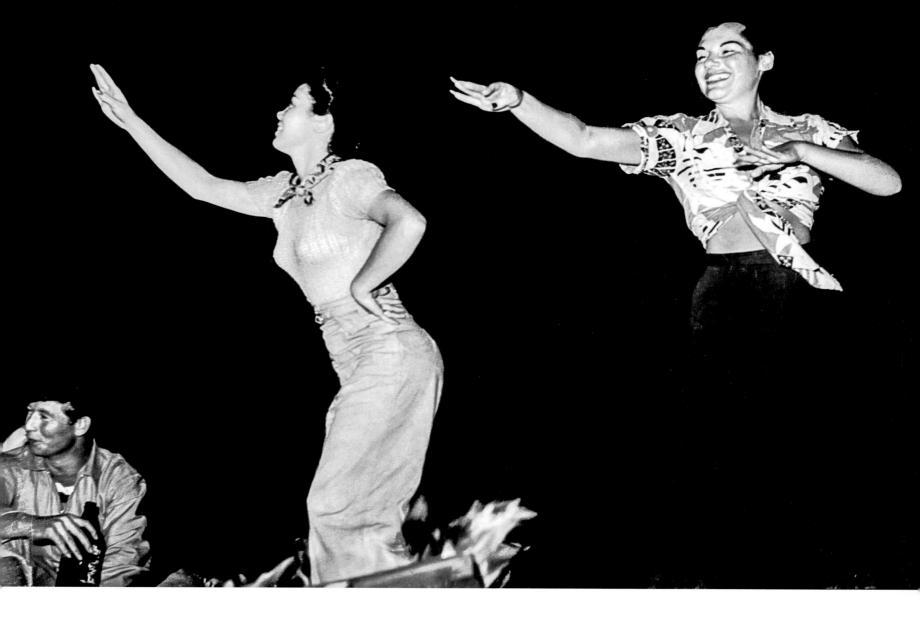

board. "Now, suddenly, a new era had begun," said Alter. "The foam boards were unlimited. We could, in shaping them, put rocker effects on them and give them flying shape. And, man, what a difference. After balsa, it was like shaping a stick of butter."

In short order the remaining pieces of an informal surfing infrastructure fell into place. By 1961 at least a dozen new boardmaking shops popped up in Southern California that included Greg Noll, Reynolds "Renny" Yater, Herbert "Bing" Copeland, and David "Dewey" Weber. With a fast-expanding market, other blank makers appeared, so Clark sheared off amicably from Alter in 1961 to create Clark Foam, which supplied blanks to the whole market but reserved a hefty discount for Hobie.

INDIGENOUS SURF MEDIA

A tenfold increase in any population does not go unnoticed — especially one driven by teenagers driving beater cars sporting gleaming new candy-colored boards. Mainstream media attention ramped up accordingly with a flurry of newspaper and magazine articles about the new "surfing bug" captivating America's youth along with the Twist and Limbo Rock. *Gidget*'s box-office success spawned a franchise that included five novels, two sequels, and a TV series starring Sally Field.

But more profound was the growth of a grassroots surf media driven by surfers themselves. John Severson published the first issue of *The Surfer* in 1960 as an adjunct to his surf films that he'd been making and showing since 1958. It proved a hit and within a year he switched to publishing the renamed *SURFER* as a quarterly. The magazine — which functioned as equal parts club newsletter, travelogue, and photo dream book — had a folksy but utterly genuine feel to it. Produced for and by surfers, it became a clearinghouse for the fledgling surf culture to critique and define itself apart from the mainstream. It also created a star-making machine — not only for the surfers, but also the waves.

Contained within the dozen or so ads was essentially a dramatis personae setting up surfing's main players — and to a great extent its economic ecology — for the next two

BEACH PARTY, CALIFORNIA, C. 1946
Surfers imported the luau from Waikiki to the foggy beaches of California where a car radio, campfire, and bottle of "dago red" zinfandel was all that was needed for a night's entertainment. *Photos, Jack Huff*

PAINTING, 1946 *Art, Billy DeVorss*

120

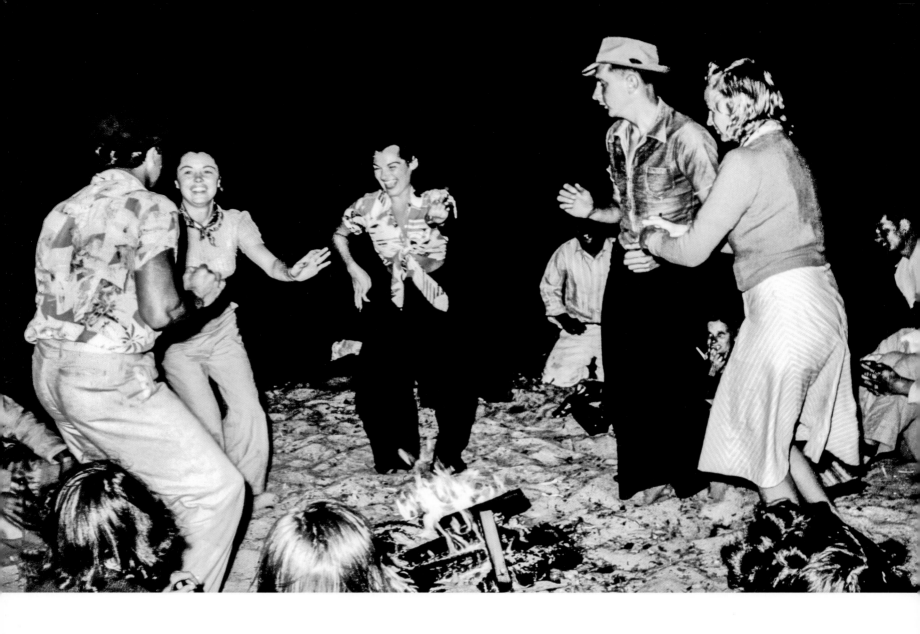

decades or more. It was here that the California Dream was codified, popularized, and marketed for mass consumption via a loose cartel of surfer entrepreneurs who came to be known, only half jokingly, as the Dana Point Mafia. Many of the original advertisers such as Hobie went on to become huge multinational brands. The prosaically named Surf Shop company of Santa Cruz was in fact pioneering wetsuit designer and marketer Jack O'Neill. The same goes for brothers Bill and Bob Meistrell's South Bay Dive N' Surf shop that marketed their custom wetsuits under the logo Body Glove.

Also featured in the debut issue was a small-wave hotdog gallery Severson shot at Secos, aka Leo Carrillo State Beach in Malibu, where incidentally *Gidget* had been filmed a year earlier. It spotlighted the diminutive Mickey Muñoz (5'4", 130 pounds) demonstrating a handful of showy poses that included the now-iconic and much-imitated Quasimodo squat. It should also be noted that Muñoz served as the stunt double for *Gidget* star Sandra Dee's surfing scenes by donning a blond wig and a bikini.

SURFING'S MOON SHOT

Although Muñoz, nicknamed "Mongoose," was fast becoming one of surfing's most mediafriendly stars (shown in an early wetsuit ad intoning a Gumpian Zen proverb, "It is better to be warm than cold."), he had an early introduction to Hawaiian wave power as a vacationing high schooler in 1954. On November 7, 1957, the 20-year-old Muñoz paddled out to thundering 18-foot Waimea Bay with Pat Curren, Greg Noll, Fred Van Dyke, Mike Stange, and others to become the first modern surfers to successfully challenge and ride the ominous North Shore break. If Makaha was the suborbital space shot of big-wave surfing, Waimea, at least for the foreseeable future, was the lunar landing. To ride, and more importantly survive, a certified man killer of a wave not only set the new standard of high-performance surfing but gave the world an incredible, highly photogenic avatar that rebooted the outer limits of human achievement.

PAINTING, *SURF'S UP*, 1948 *Art, Bill Medcalf*

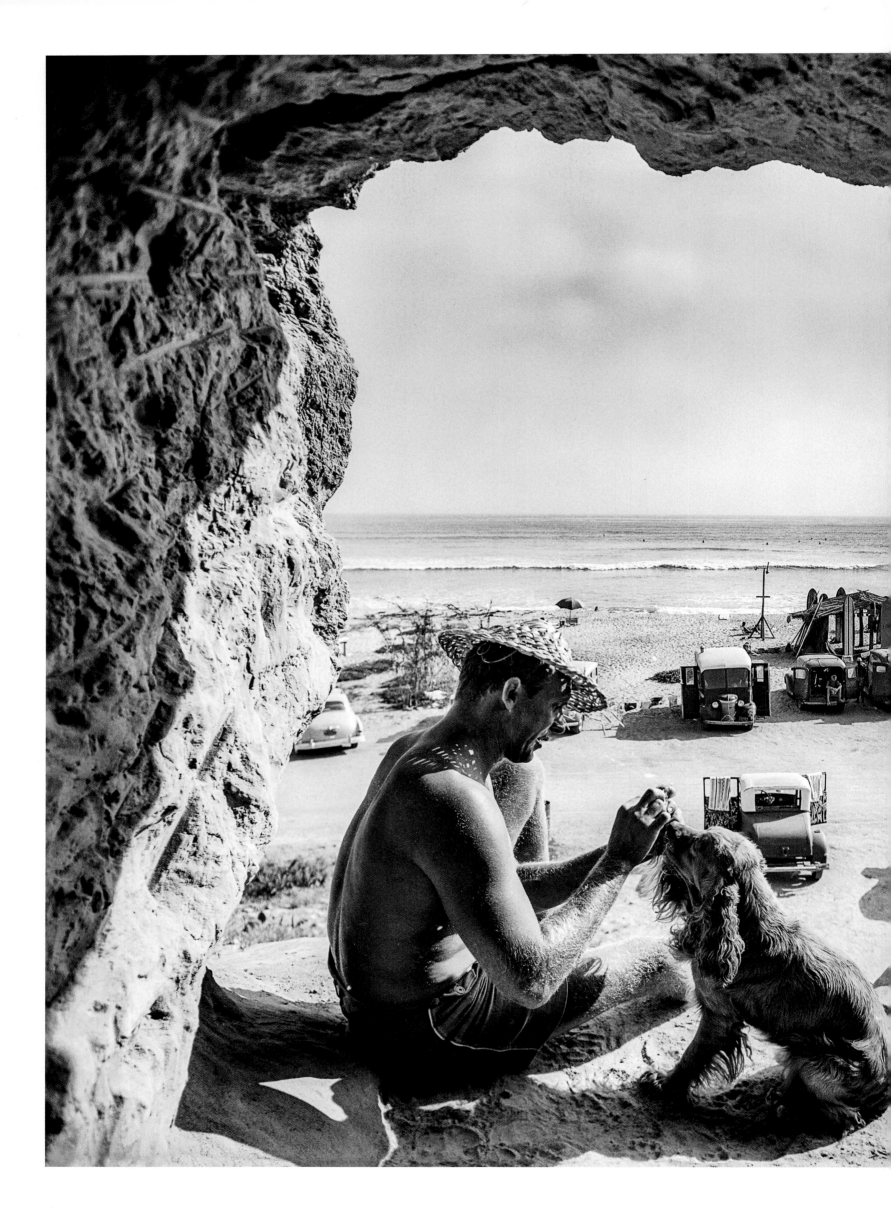

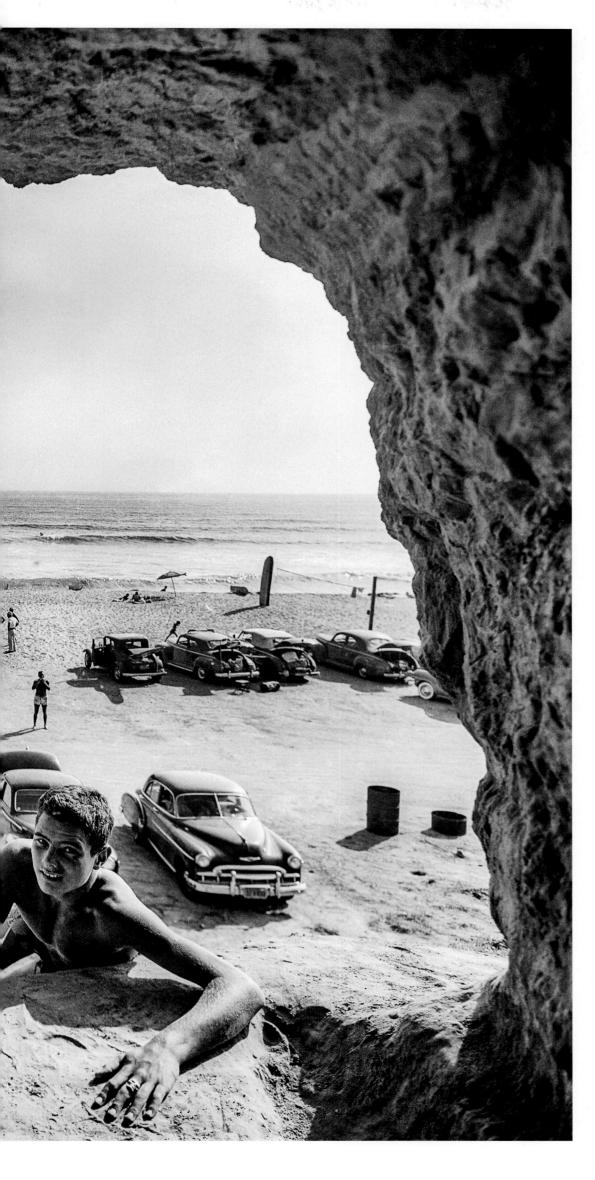

SAN ONOFRE, CALIFORNIA, 1950
The sandstone bluffs lining "Sano" are full of caves, canyons, and eroded gullies. Before restrooms were installed in the 1950s, surfers would use one particular canyon called "Kukae Canyon" as a crude toilet. *Kukae* is the Hawaiian word for "shit." In later years, "kuk" or "kook" came to mean an inexperienced or rude surfer. *Photo, Loomis Dean*

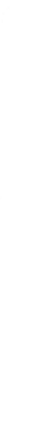

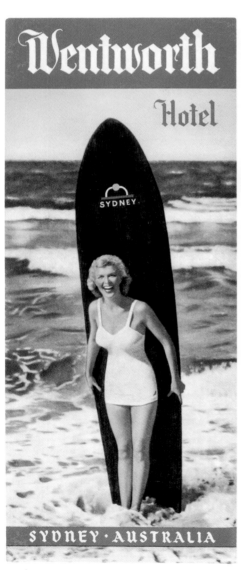

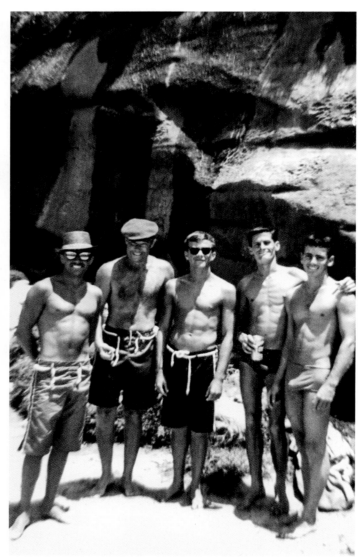

By late afternoon that day the wind had come up and all the other surfers except for Muñoz and Stange had gone in. The sky clouded over with intermittent rainsqualls and they sat out in the huge swell screaming lines from *Othello* to each other in the howling maelstrom. Finally, after being lashed by stinging spray for more than an hour, a definitive 20-foot set rounded the outer bay. Within seconds the swell felt the boulder-lined bottom and pitched up in Waimea's distinctive fishhook profile, a warehouse-sized slab of heaving parabolic cement. Both surfers went for it, Muñoz at the apex and 20 feet deeper than Stange. As the resulting photo by Don James shows, Muñoz negotiated the initial drop but does a full flying leap into the wave face an instant before he is annihilated under tons of grey unforgiving water. The wipeout was predictably horrific, but survivable, and as Muñoz related recently, "Waimea made me bigger."

Muñoz emerged from the pounding shorebreak, board and swimsuit intact. His trunks, white with blue stripes and a matching wax pocket, were laced around the middle in a distinctive X pattern. They have no apparent label but sewn into the inner waistband is a small graphic of a surfer.

—M. Nii, Waianae, Oahu

PADDLEBOARD RACE; LAGUNA BEACH, CALIFORNIA; 1955 The Brooks Street Surf Classic, started in 1955, is the world's longest-running surfing contest. *Photo, Dick Metz*

BROCHURE, C. 1946

SYDNEY, AUSTRALIA, C. 1958 From left to right: Stu Ford, Scotty Dillon, Noel Ward, Kevin Holland, and Andy Cochrane

MALIBU, C. 1950 By the early 1950s Malibu had evolved into its own unique beach scene complete with movie stars and pretty girls. *Photo, Richard Miller*

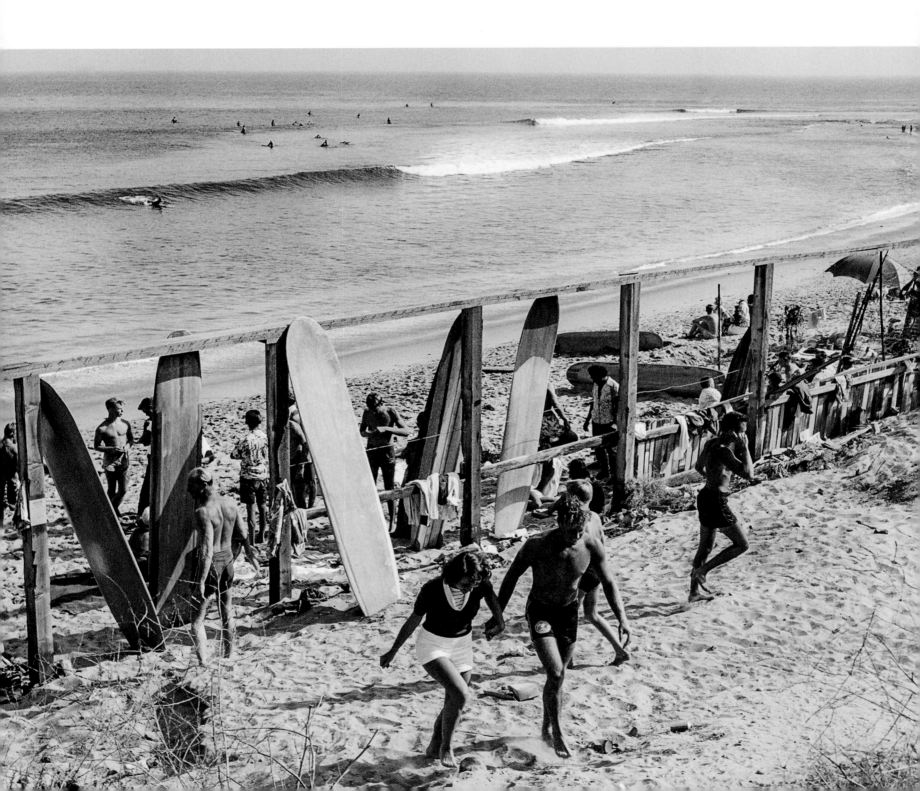

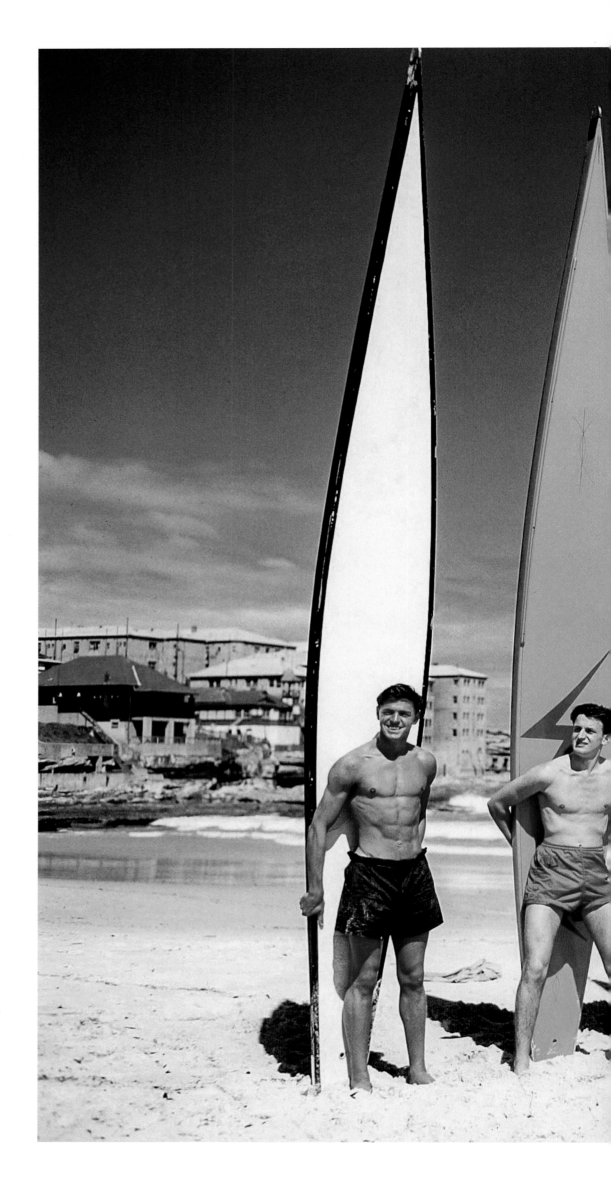

BONDI BEACH; SYDNEY, AUSTRALIA; 1948 Prior to the 1960s, Australian surfers were world-champion swimmers and paddlers, but their surfing equipment stagnated under the lifesavers' regime until the late 1950s.

JERSEY SURFBOARD CLUB, BAILIWICK OF JERSEY, 1960 *(Pages 128–129) Photo, John Houiellebecq*

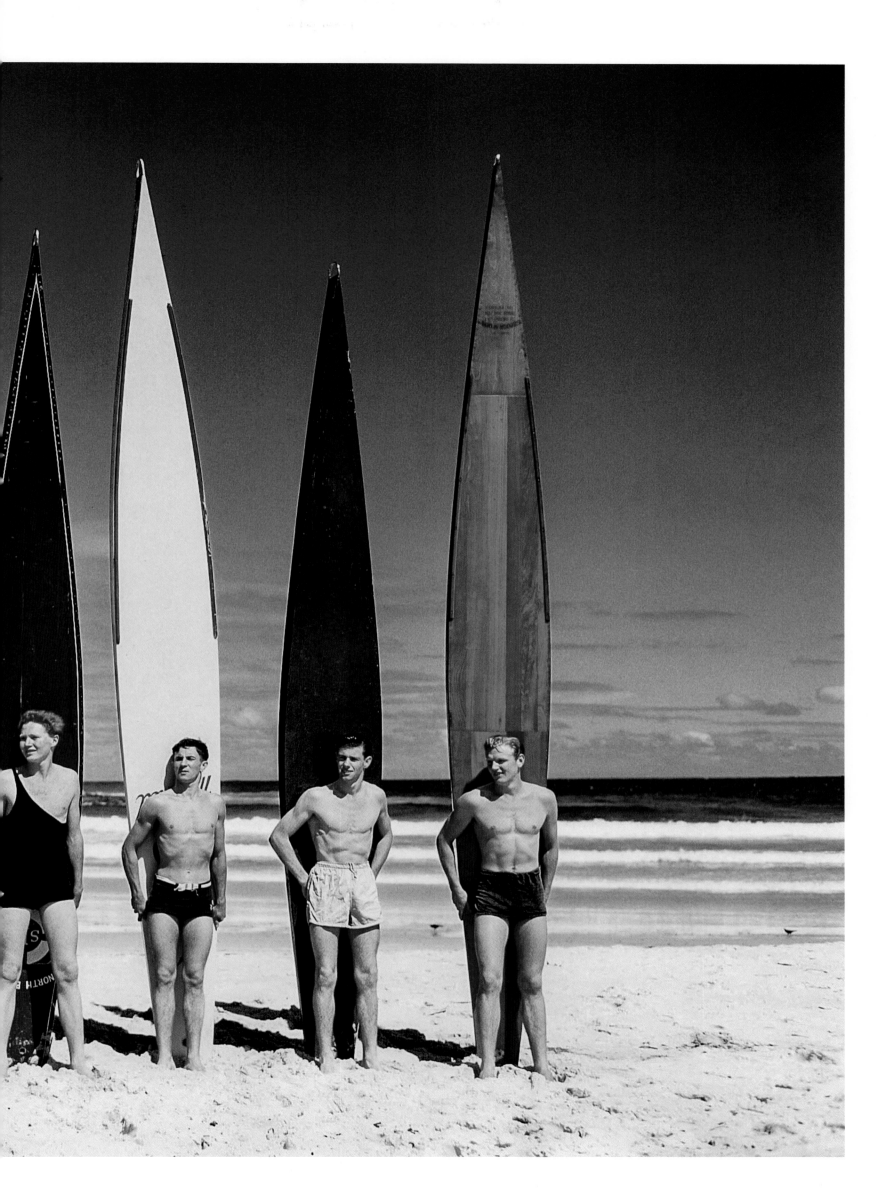

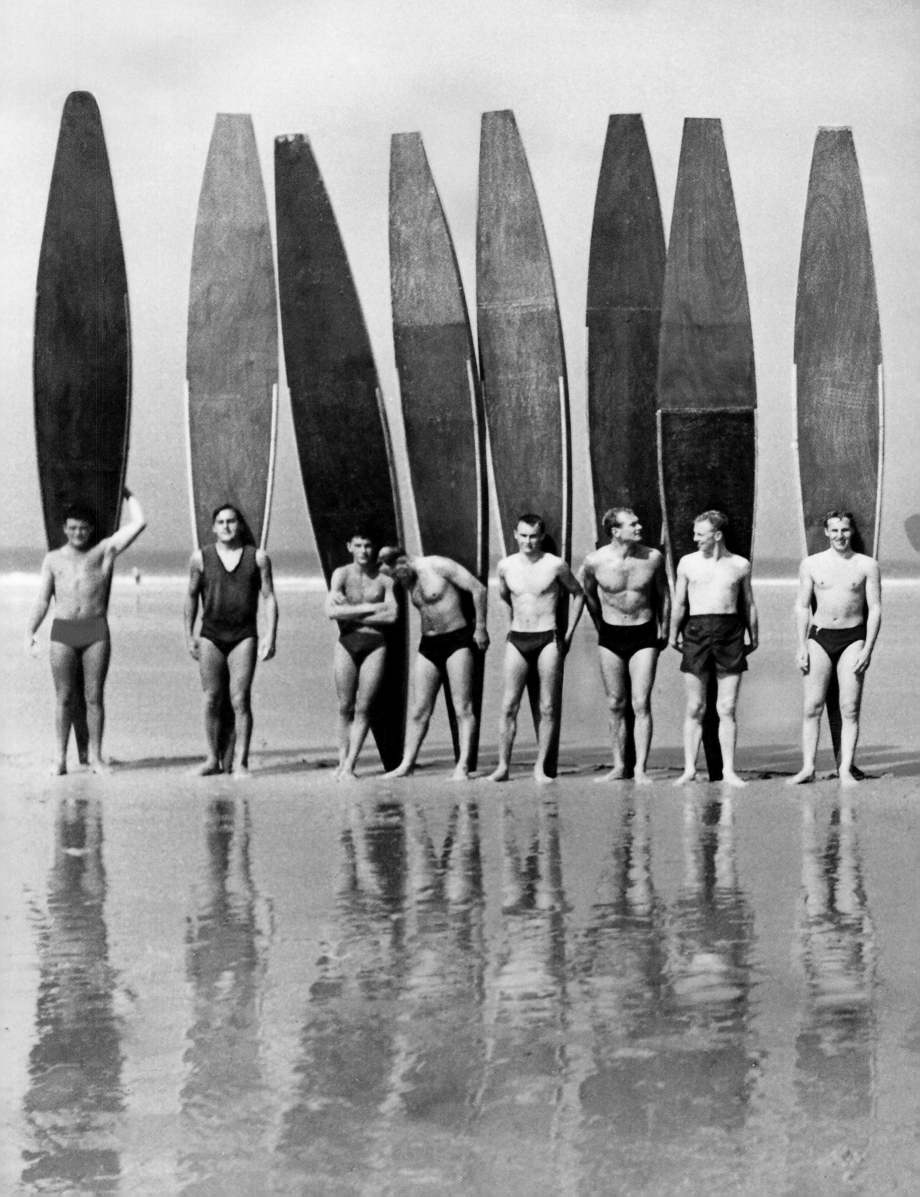

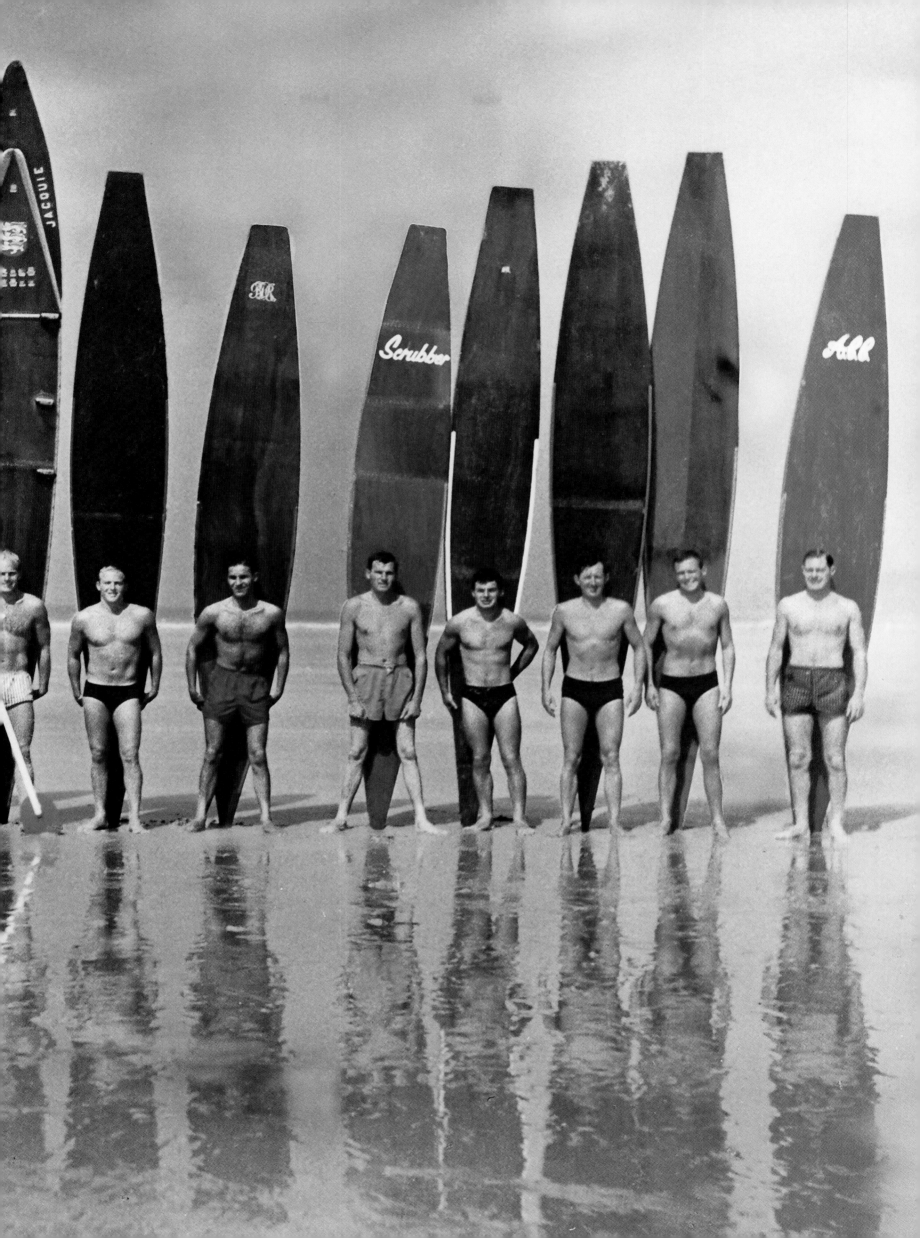

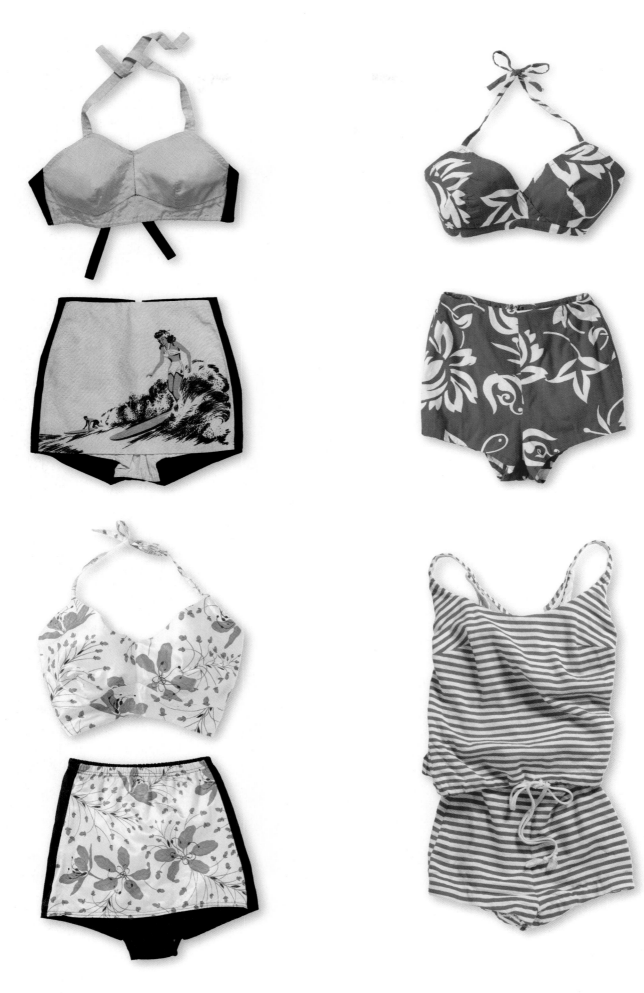

CATHERINE AND HER SURFBOARD, BIARRITZ, 1959
Photo, Georges Dambier

WOMEN'S SWIMSUITS *(Clockwise from top left)*
c. 1946; Alfred Shaheen, c. 1961; c. 1947; c. 1949

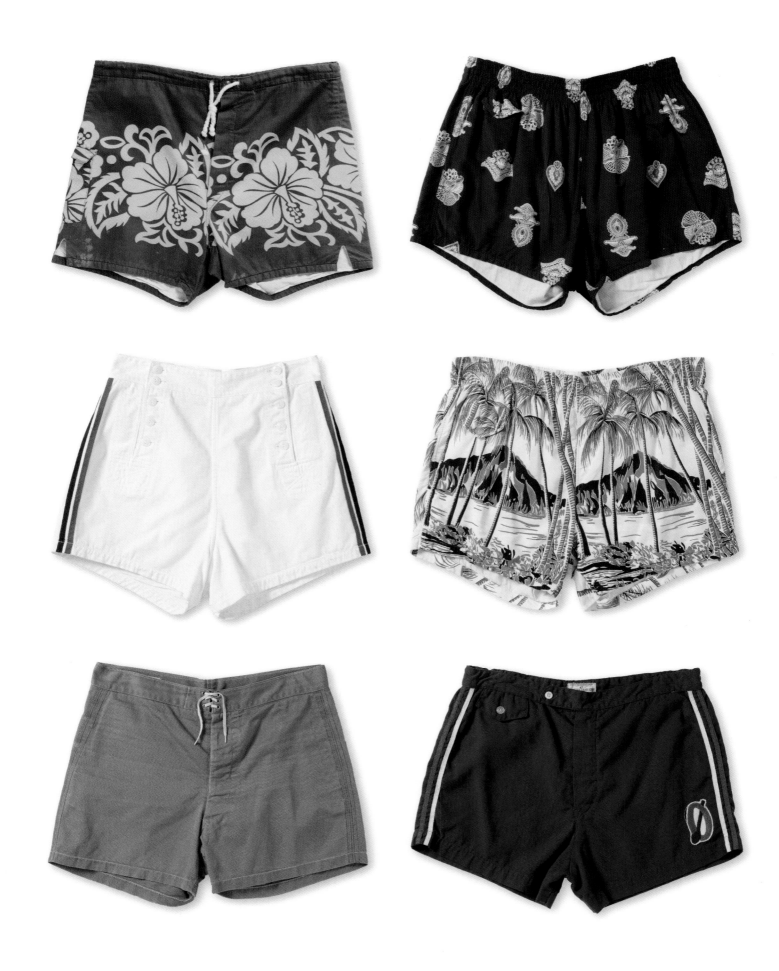

MEN'S SWIMSUITS *(Clockwise from top left)* c. 1960; Duke Kahanamoku, c. 1947; Duke Kahanamoku, c. 1948; Outrigger Canoe Club, c. 1954; M. Nii, c. 1958; c. 1953. Swimsuits were needed for beach recreation that allowed free movement for swimming but retained a modicum of modesty. Surfers were the first to demand sturdy, purpose-built surf trunks that looked as good as they felt.

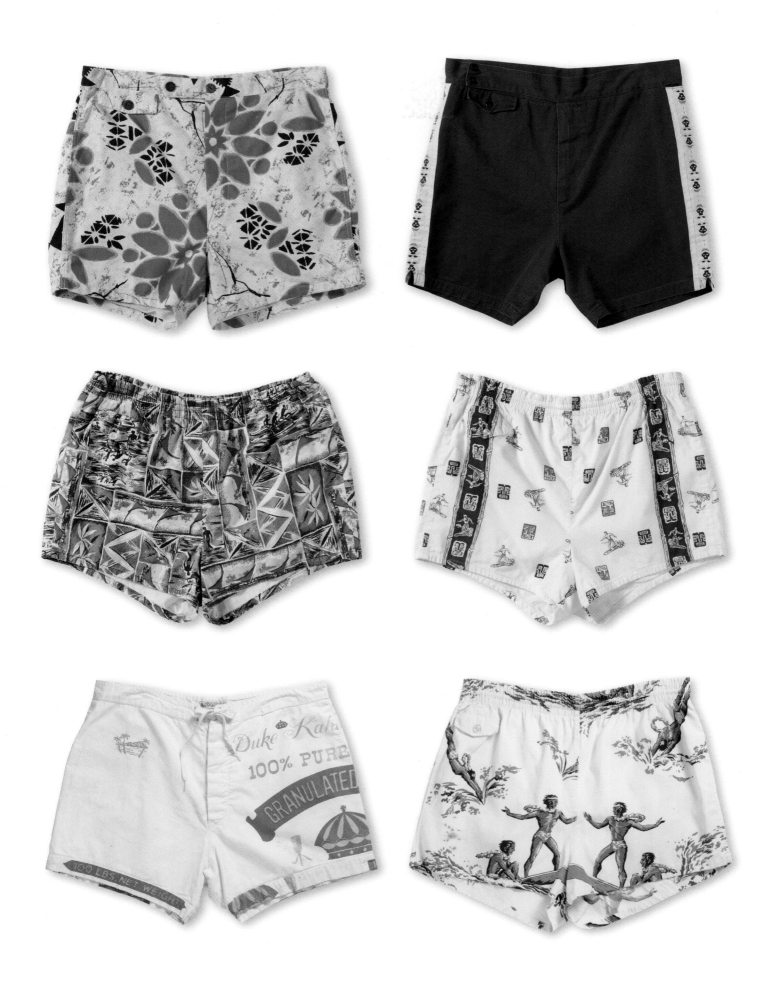

MEN'S SWIMSUITS *(Clockwise from top left)* Duke Kahanamoku by Catalina, c. 1958; Take's of Waikiki, c. 1952; c. 1950; McGregor, c. 1948; Duke Kahanamoku, c. 1957; c. 1954.

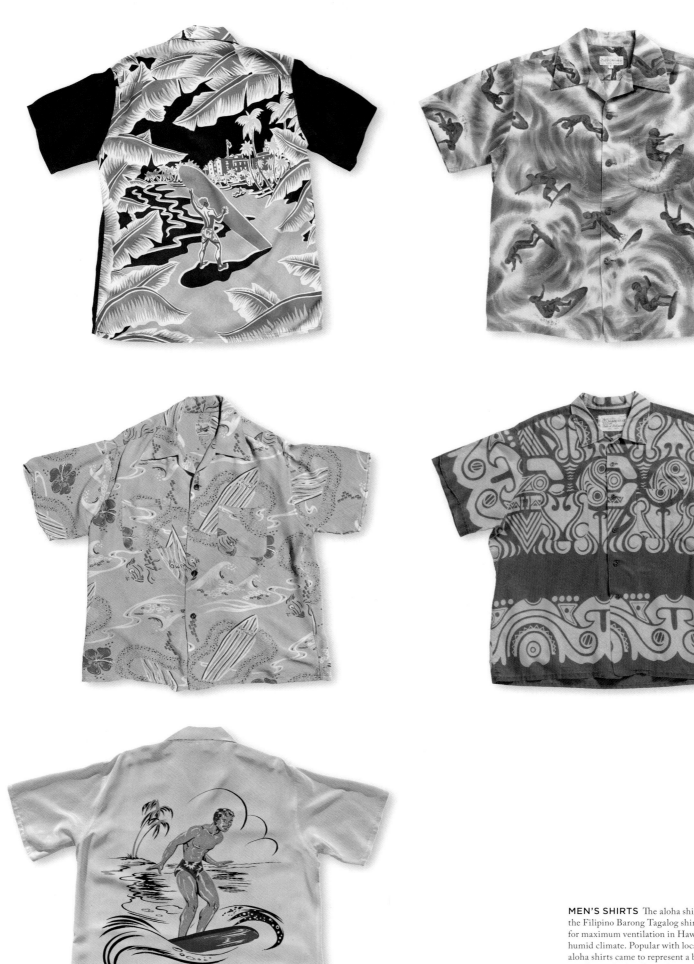

MEN'S SHIRTS The aloha shirt, adapted from the Filipino Barong Tagalog shirt, was cut wide for maximum ventilation in Hawaii's often hot and humid climate. Popular with locals and tourists, aloha shirts came to represent a barefoot attitude of comfort and relaxed social mores. *(Clockwise from top left)* Aloha shirt, c. 1950; Aloha shirt, Duke Kahanamoku, c. 1960; Aloha shirt, Waikiki Wear by Duke of Hollywood, c. 1958; Novelty shirt, c. 1946

ALOHA SHIRT DETAIL, C. 1952

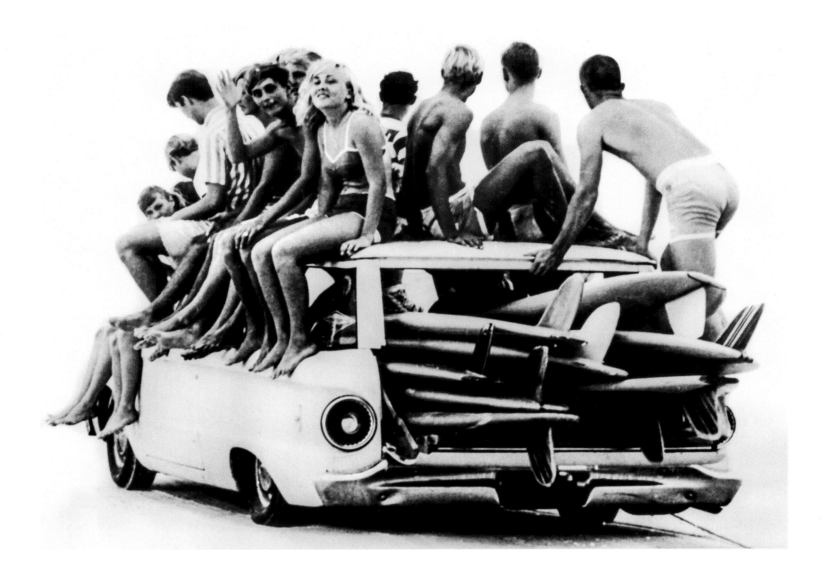

The well-ordered Pontiac for '61
trims width outside the wheels for better balance

Balance is the big factor in pleasant, comfortable travel!

It's achieved by distributing as much weight as possible directly between the wheels.
Pontiac '61 has more of its weight between the wheels than any other car.
You have the feeling of sitting erect even when swinging around curves and corners.
If you travel a lot . . . or just want to enjoy your travel a lot more . . . try new Wide-Track
at any of our fine Pontiac dealers. PONTIAC MOTOR DIVISION • GENERAL MOTORS CORPORATION

THE ONLY WIDE-TRACK CAR

PONTIAC '61—It's all Pontiac! on a new Wide-Track!

CALIFORNIA, 1961 The teenage propensity for performing exaggerated stunts is displayed in this jammed Ford Falcon wagon.

ADVERTISEMENT, PONTIAC, 1961

ADVERTISEMENT, DAN RIVER, 1962

MAGAZINE COVER, *ROAD & TRACK*, 1959

KAENA POINT, HAWAII, C. 1960
Photo, Bev Morgan

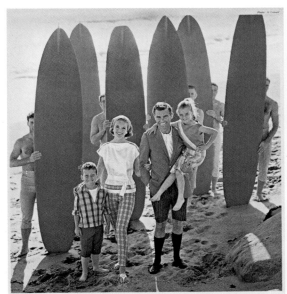

Discover *New Horizons in color*

Hop aboard and ride the new wave of color! The whole family shines in the sky blues, sea blues, rainbow hues of Dan River Wash & Wear Cottons. Born aquanauts, they wash and dry ready to don. Surface so smooth, most people don't even bother ironing them at all. Below the surface the answer is 'WRINKL-SHED' by DAN RIVER WASH & WEAR COTTONS

ALFA SUPER SPIDER

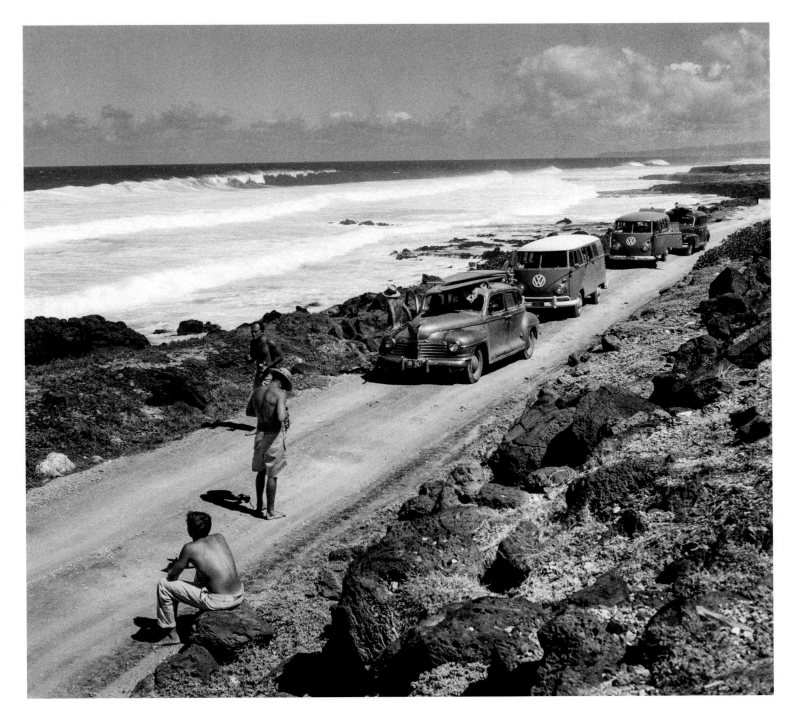

138

JACK O'NEILL, C. 1956 O'Neill, right, was a surf-wetsuit innovator, who was low-key in life but had a genius flare for marketing. His sales tools included a catamaran, a sand yacht, and a giant hot-air balloon, all piloted by him and emblazoned with the distinctive O'Neill logo.

JACK O'NEILL, SAN FRANCISCO, C. 1953 O'Neill opened one of the world's first surf shops in 1952 out of his beachfront garage in San Francisco, where the freezing local waters of Northern California inspired him to develop a functional surfing wetsuit.

WETSUIT PROTOTYPE, O'NEILL, C. 1953 Jack O'Neill's original surf vest was inspired by neoprene sheets he saw being used as carpet subflooring in a DC-3 passenger plane.

SIZING CHART, DIVE N' SURF, C. 1952

BOB AND BILL MEISTRELL, C. 1948 Identical twins, the Meistrell brothers were good surfers and fanatical divers. In the early 1950s they helped develop custom-fitted wetsuits for California's chilly winter waters. The Dive N' Surf wetsuit, eventually named Body Glove, caught on with surfers in the 1960s and created a multimillion dollar business.

ADVERTISEMENT, DIVE N' SURF, 1958 The small Dive N' Surf shop still sells wetsuits and surfing supplies in its original location more than half a century later.

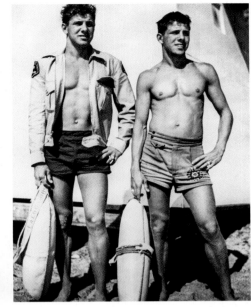

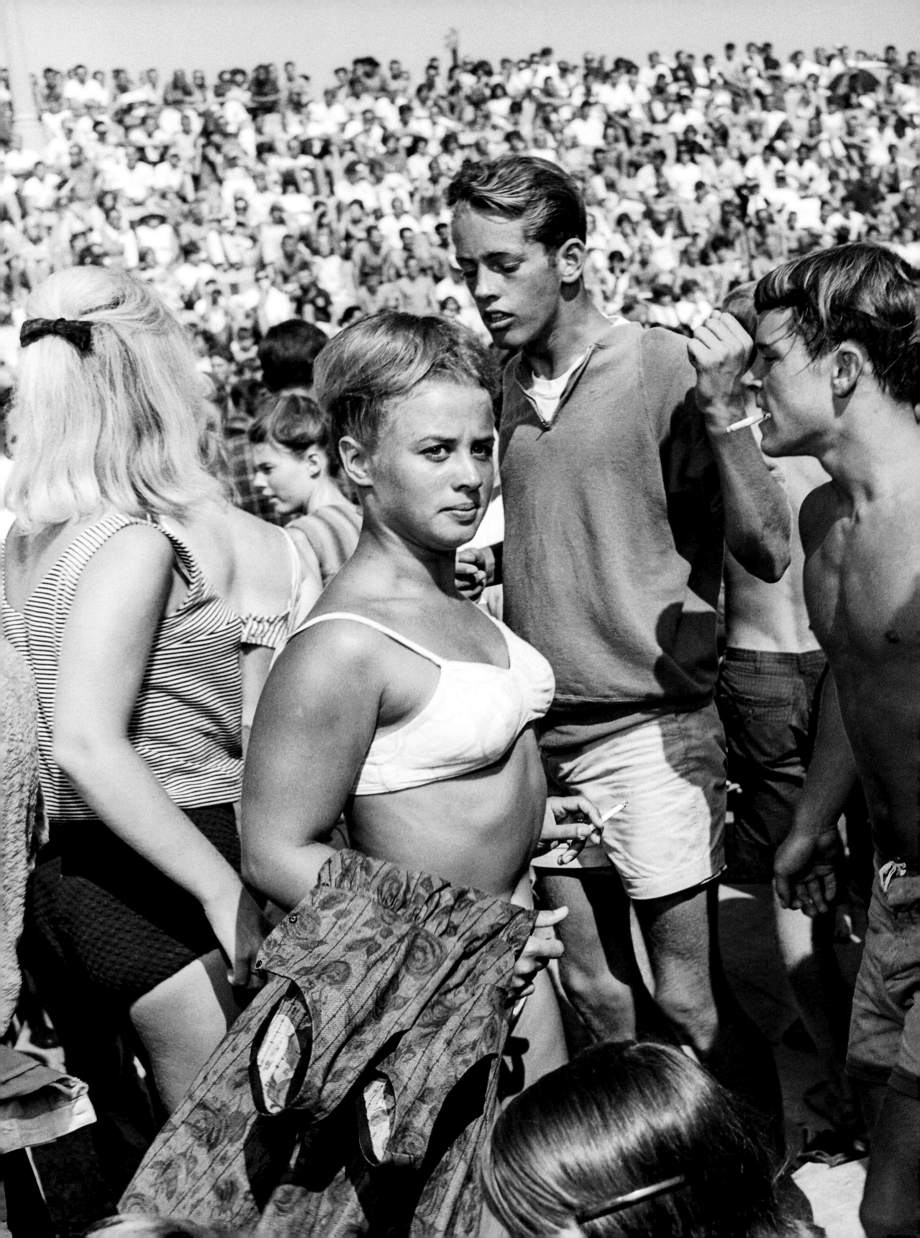

SURFER STOMP; HUNTINGTON BEACH, CALIFORNIA; 1961 *Photo, Ron Church*

HERMOSA BEACH, CALIFORNIA, C. 1955
Surfers have always been tribal by nature, forming small, protective groups centered on a specific wave or locale.

SURF SHOP; SANTA CRUZ, CALIFORNIA; C. 1961 Originally selling surfboards, Jack O'Neill's simply named Surf Shop quickly discovered a far greater demand for his newly developed wetsuits.

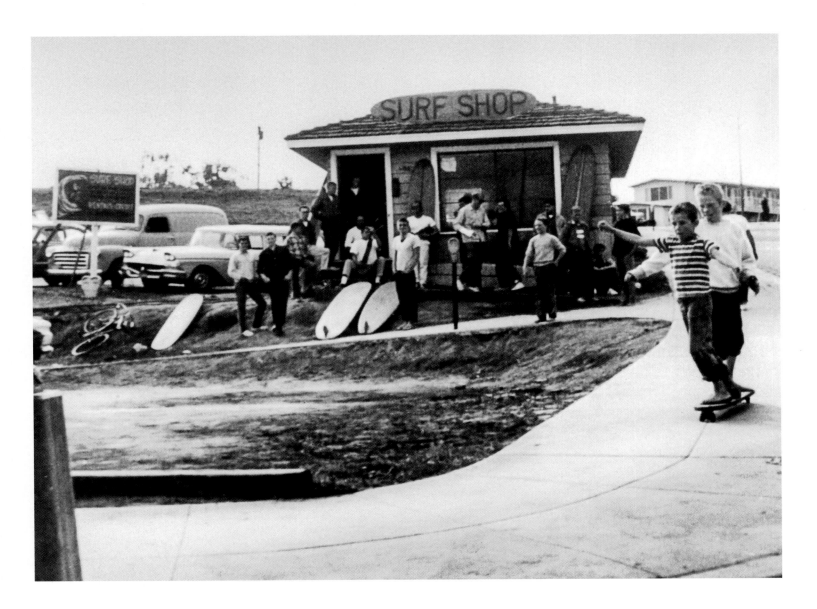

SURFING 1946-1961

141

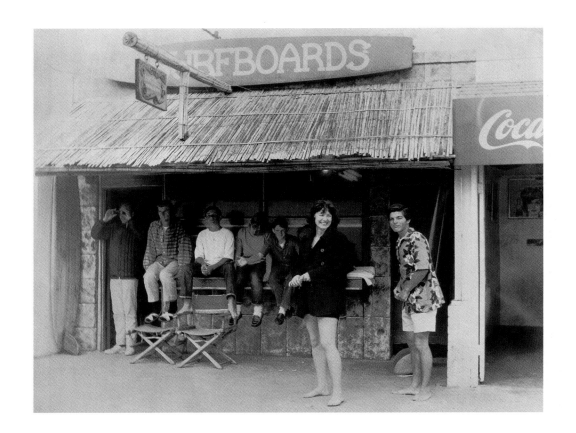

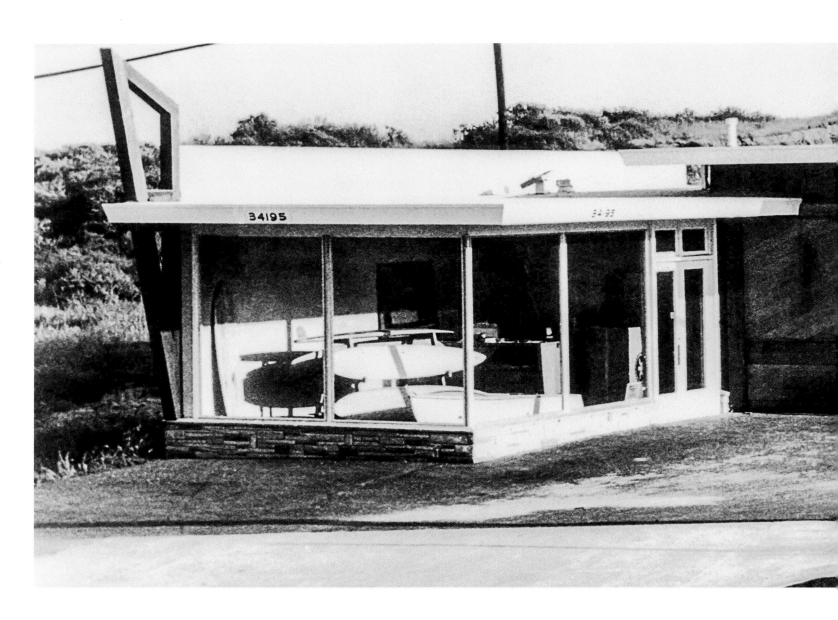

BING SURFBOARDS; HERMOSA BEACH, CALIFORNIA; C. 1961 Bing Copeland grew up in Manhattan Beach, California, and as a teen worked for surfboard maker Dale Velzy. In 1959, after serving in the U.S. Coast Guard and sailing the South Pacific in his own boat, Bing returned to Hermosa Beach to open his first shop on the Hermosa Strand. *Photo, Lester Dietz*

HOBIE SURFBOARD SHOP; DANA POINT, CALIFORNIA; C. 1956 After Hobie Alter's expanding surfboard business outgrew his parents' Laguna Beach garage, the 20-year-old opened his first shop in nearby Dana Point, where coastal property along Highway 1 was still inexpensive.

DALE VELZY'S SHOP; MANHATTAN BEACH, CALIFORNIA; 1952 Dale Velzy began shaping balsa boards on a pair of sawhorses under the Manhattan Beach Pier in the late 1940s. He later rented this converted garage just up from the pier to launch a small but highly lucrative surfboard empire. *Photo, Don Guild*

PAT CURREN, 1959 Curren was a master craftsman who regularly built his own big-wave equipment, including this balsa glue-up for a 12-foot "rhino gun" that he would use to ride 20-foot Waimea Bay in Hawaii. *Photo, Bev Morgan*

SAN ONOFRE, CALIFORNIA, 1950
Shapers were not limited to indoor garages but took advantage of a temperate climate to build their surfboards. *Photo, Loomis Dean*

DECAL, GREG NOLL SURFBOARDS,
C. 1959

ADVERTISEMENT, SURFBOARDS BY
VELZY, C. 1960 Dale Velzy had expanded to
three California locations by the early '60s with a
fourth in Honolulu.

POSTER; CAT ON A HOT FOAM BOARD,
BUD BROWNE; 1959

ADVERTISEMENT, GORDON & SMITH,
C. 1960 Larry Gordon and Floyd Smith, two
surfers from San Diego, California, parlayed their
garage-based shaping business into a thriving inter-
national surf brand.

ADVERTISEMENT, JACOBS SURFBOARDS,
1961

THE BEST DRESSED SURFERS PREFER...

SURF BOARDS
by
JACOBS

* ORDER A DOZEN FOR CHRISTMAS

422 PACIFIC COAST HWY.
HERMOSA BEACH, CALIF.
FR 9-8366

RICK HATCH
HERMOSA BEACH

147

PAINTING, SEAL BEACH LOCALS, 1956
Inspired by a Beat aesthetic, John Severson created one of the first surf culture paintings.
Art, John Severson

POSTER, NORTHWEST ORIENT AIRLINES, C. 1955

MAGAZINE INTERIOR, *ESQUIRE*, 1949
"Riding the Big Combs" featured photos by Doc Ball that were at least 10 years old, showing equipment and styles that were fast disappearing by the late 1940s.

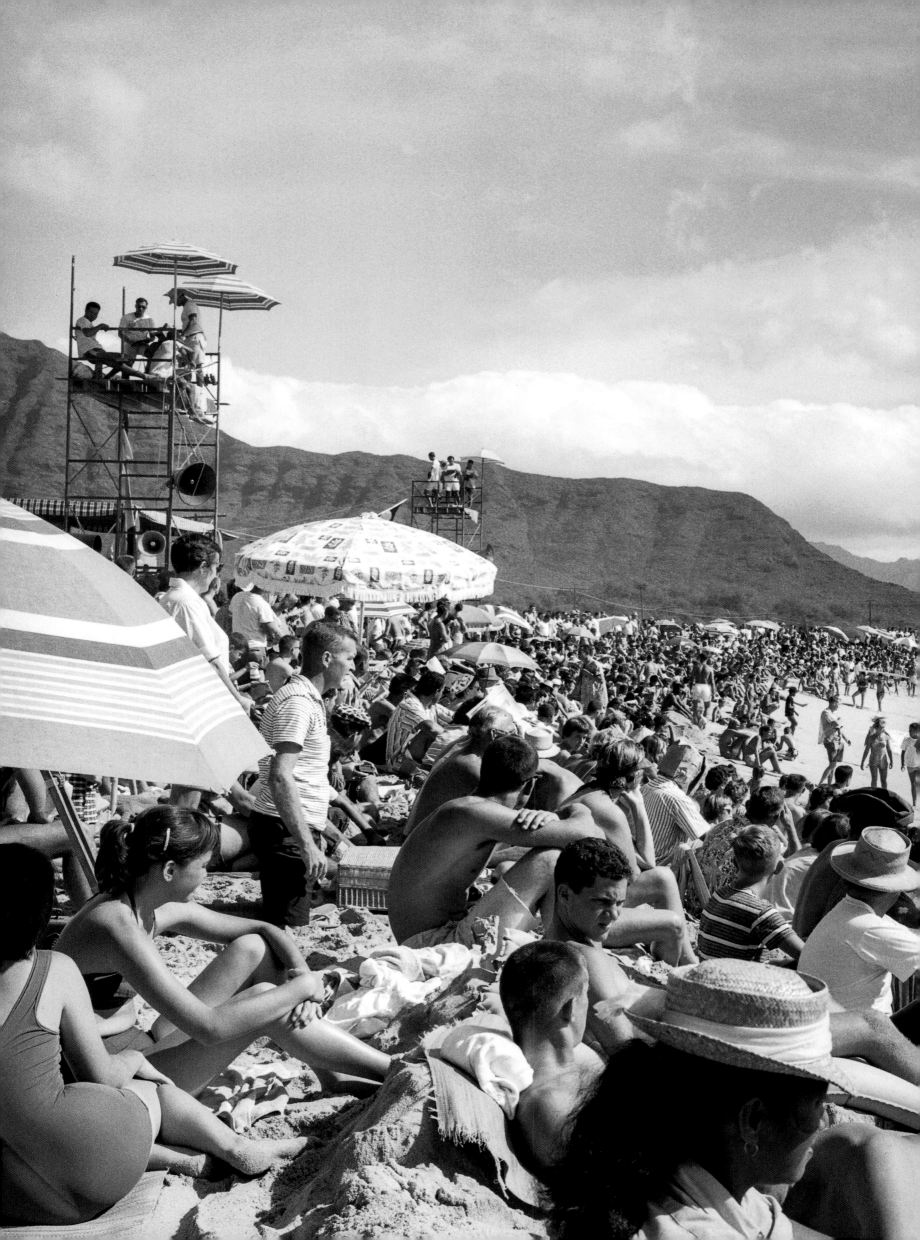

The annual Makaha contest, which ran from 1954 to
1971, was the de facto world championships from its
start until the early 1960s. *Photo, Robert Butterfield*

DECAL, C. 1950

SURFING AT WAIKIKI

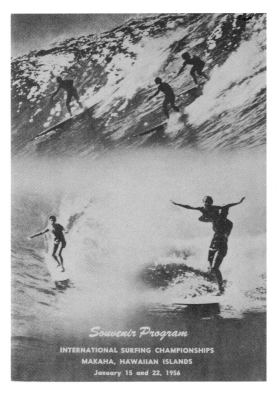

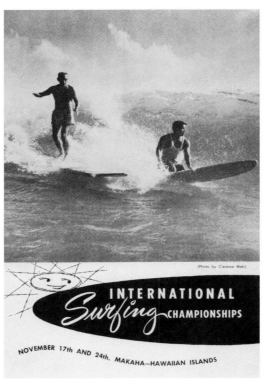

DON JAMES AND BUZZY TRENT; SUNSET BEACH, HAWAII; 1957 As a Hollywood dentist, with many celebrity patients that included film studio executives, James, foreground, had access to state-of-the-art lenses and cameras used in big-budget filmmaking. This advanced optics technology coupled with his surfing expertise gave James's photos incredible depth, clarity, and an unequaled professional look. *Photo, John Elwell*

MARGE CALHOUN; MAKAHA, HAWAII; C. 1958 Calhoun won the women's Makaha contest in 1958. *Photo, Don James*

SURF CONTEST; MAKAHA, HAWAII; 1959 From left to right, standing: George Downing, Albert "Rabbit" Kekai, and Ed Whaley. *Photo, Don James*

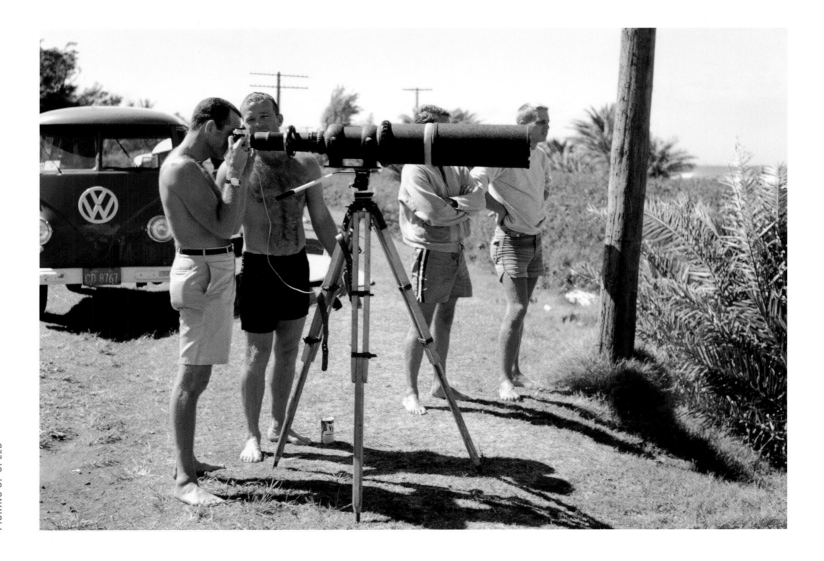

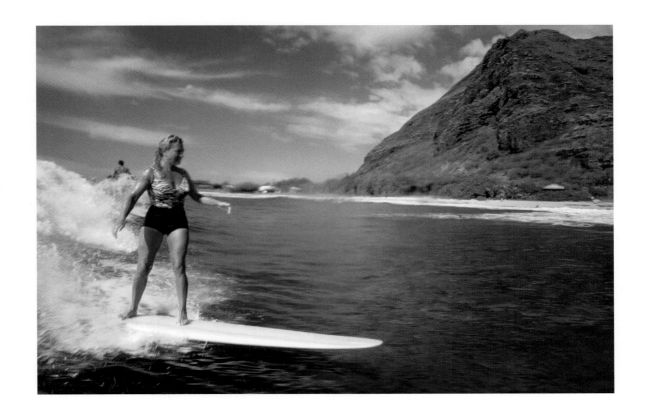

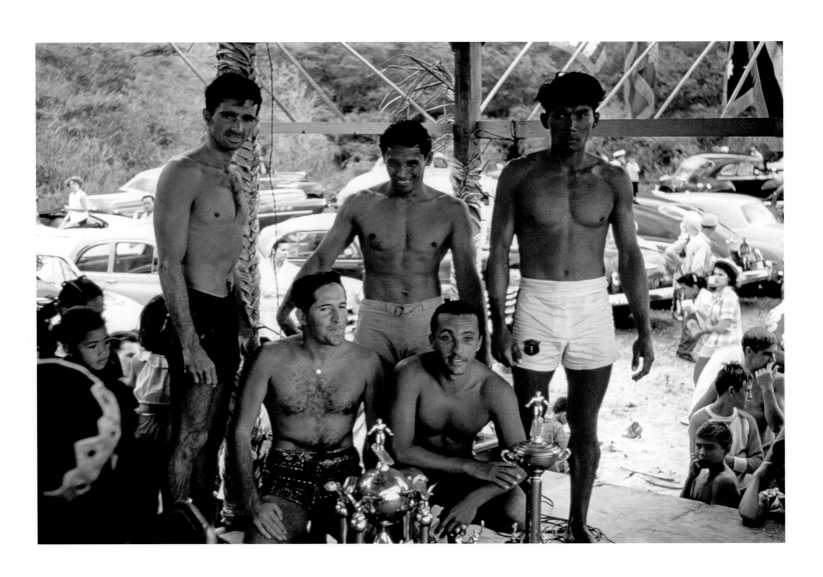

BOOK COVER, *GIDGET*, 1957

KATHY AND FREDERICK KOHNER; BRENTWOOD, CALIFORNIA; 1957 To get teenage surf slang correct, Frederick would eavesdrop on his daughter's private phone conversations.

KATHY KOHNER, MALIBU, C. 1957 *(below and opposite top)* Kohner was 15 years old when she showed up on the beach wanting to surf. Having no board, she traded peanut butter and radish sandwiches with the likes of Mike Doyle and Kemp Aaberg for the use of their equipment until she got her own board.

For two summers, Terry "Tubesteak" Tracy lived rent-free on the beach at Malibu in a self-made shack. The funny, well-liked, and respected surfer nicknamed the five-foot-tall Kohner "Gidget" by combining the words girl and midget.

DIARY, KATHY KOHNER, 1957 Kohner kept a detailed account of her first summer at Malibu, surfer-boy crushes and all, which her father used as the foundation for *Gidget*, his novel published in 1957.

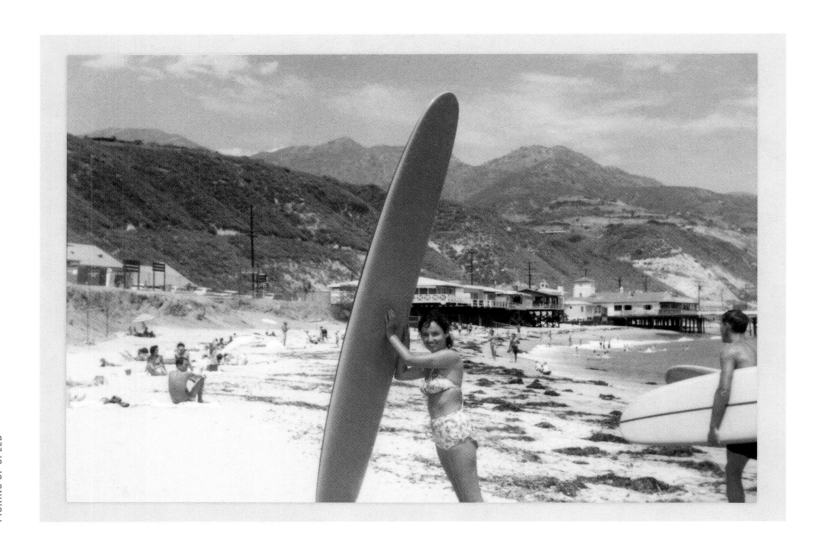

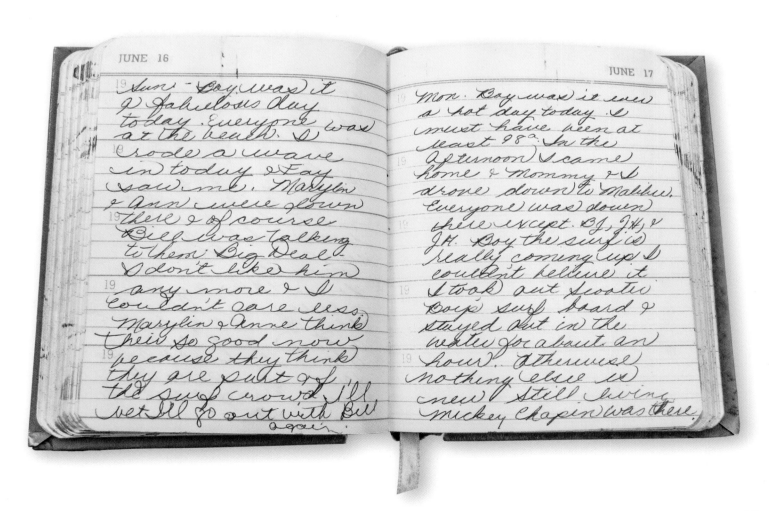

KATHY KOHNER, MALIBU, C. 1956

FILM STILL, *GIDGET*, **1959** The first *Gidget* was shot at Leo Carrillo State Beach, aka "Secos." The production hired Malibu surfers Miki Dora, Mickey Muñoz, and Mike Doyle to double for the actors. Muñoz, wearing a blond wig and women's bathing suit, doubled as Sandra Dee in the film.

POSTER, *GIDGET*, **1959** The first *Gidget* starring Sandra Dee proved to be popular, profitable, and long-lived, spawning two sequels, a television series (starring Sally Field), and a TV movie.

WATCH OUT
BRIGITTE...
HERE
COMES
GIDGET!

COLUMBIA PICTURES
presents

GidGET

co-starring

SANDRA DEE **CLIFF ROBERTSON** **JAMES DARREN**

ARTHUR O'CONNELL with **MARY LaROCHE** **JO MORROW** and **THE FOUR PREPS**

The
joyous movie
based
on
that
book!

Screenplay by GABRIELLE UPTON • Based on the novel by FREDERICK KOHNER

CINEMASCOPE Produced by LEWIS J. RACHMIL • Directed by PAUL WENDKOS EASTMAN COLOR

POSTER, *BLUE HAWAII*, 1961

FILM STILL, *BLUE HAWAII*, 1961
Elvis Presley had a long love affair with Hawaii going back to his first tour of the islands in 1957.
Although "the King" didn't really surf, over the next 20 years Presley would make three Hawaii
films, several shows, and the landmark *Aloha from Hawaii Via Satellite* world telecast in 1973.

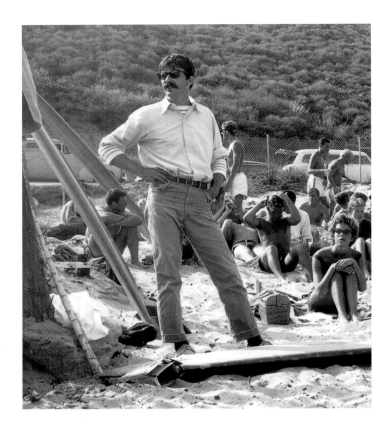

BILLY AL BENGSTON, MALIBU, C. 1956
As an art student in Los Angeles in the 1950s, Bengston surfed Malibu consistently and took the name "Moondoggie" from avant-garde composer Louis "Moondog" Hardin. Frederick Kohner named Gidget's love interest after Bengston in his novel. *Photo, Hal Conway*

KEMP AABERG; RINCON, CALIFORNIA; 1959 Aaberg had a precise yet flamboyant style that defined California class while his lean blond looks made him an early '60s surf star in both magazines and film. *Photo, John Severson*

RENNY YATER; SANTA BARBARA, CALIFORNIA; 1960 The boards Yater shaped were sought out by the best surfers of the era, and he was renowned as a boardmaker's boardmaker. *Photo, John Severson*

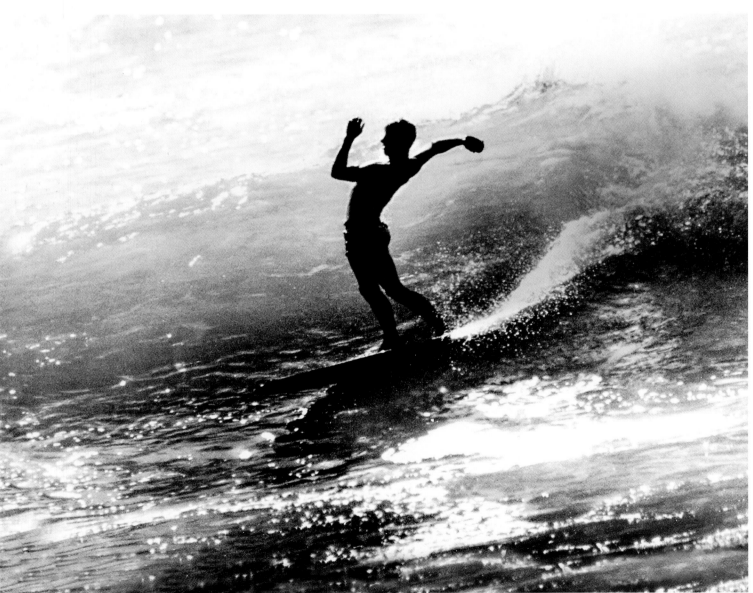

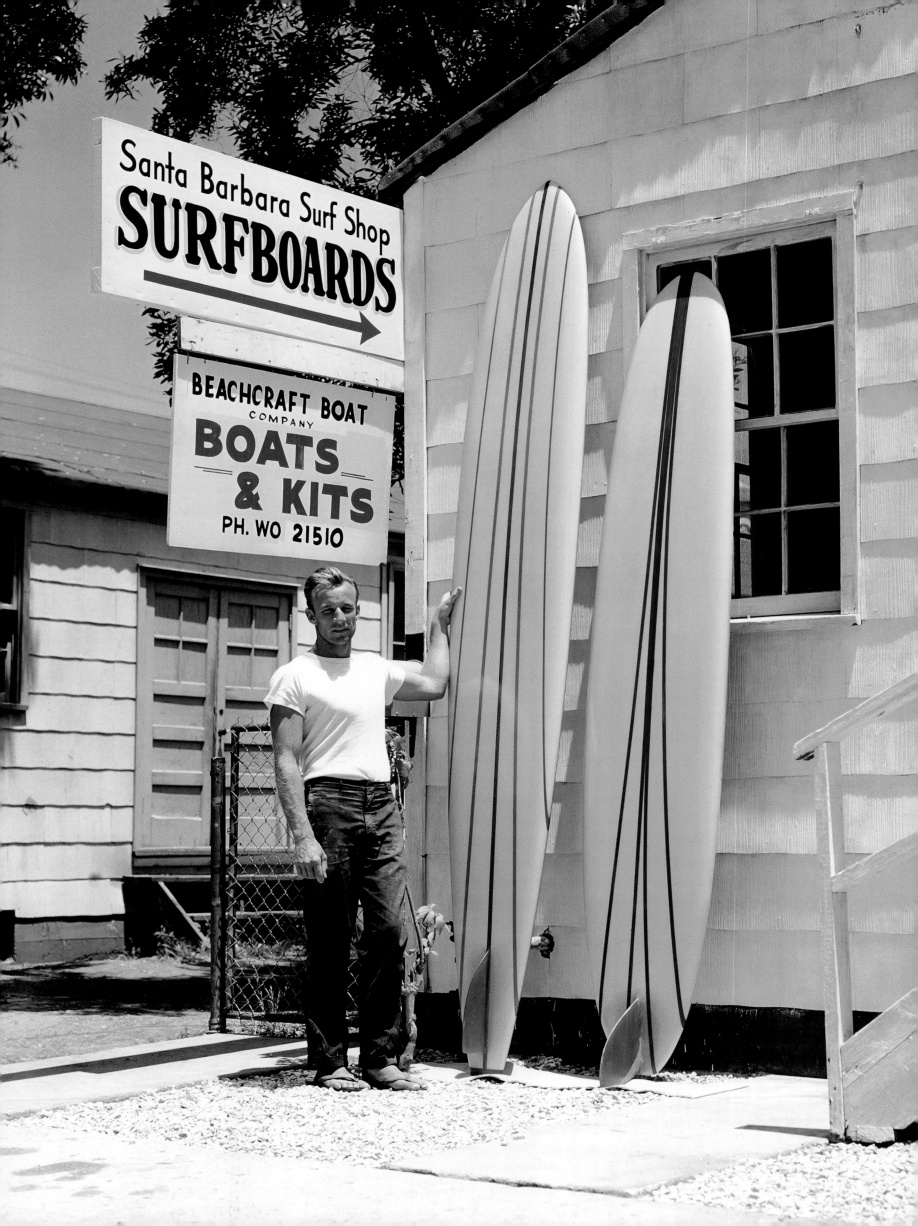

SURFING MOVIE

John **SEVERSON** **PRESENTS**

"SURF FEVER"

All New 1960 Color Surfing Adventure
filmed in HAWAII · CALIF · MEXICO · and NEVADA!

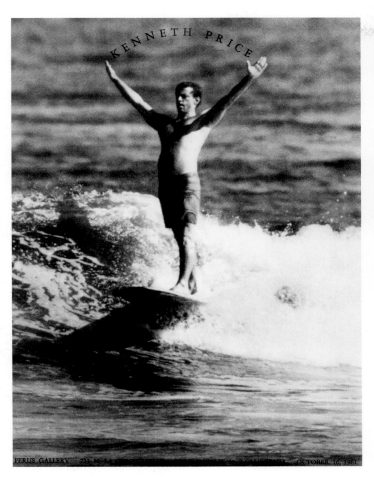

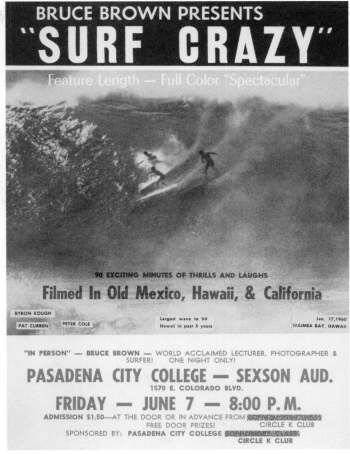

POSTER, *SURF FEVER*, 1960 By the late '50s there were enough surfers on both coasts and Hawaii to support a small but bustling surf-film circuit. They were hard-core documentaries made for and by real surfers that were essentially glorified home movies— low on production values but high on genuine stoke. *Photo and design, John Severson*

ANNOUNCEMENT, FERUS GALLERY, 1961 Ken Price, one of Ferus Gallery's "Cool School" artists and a dedicated surfer, brought surf culture to the hip world of Southern California fine art.

POSTER; *SURF CRAZY*, BRUCE BROWN; 1959

BRUCE BROWN, C. 1958 While Brown is renowned for *The Endless Summer*, most people outside the surfing realm don't realize that he had previously made five feature-length surf documentaries, starting with *Slippery When Wet* in 1958. *Photo, Ron Church*

NORTH SHORE, HAWAII, 1957 (Pages 164–165) *Photo, John Severson*

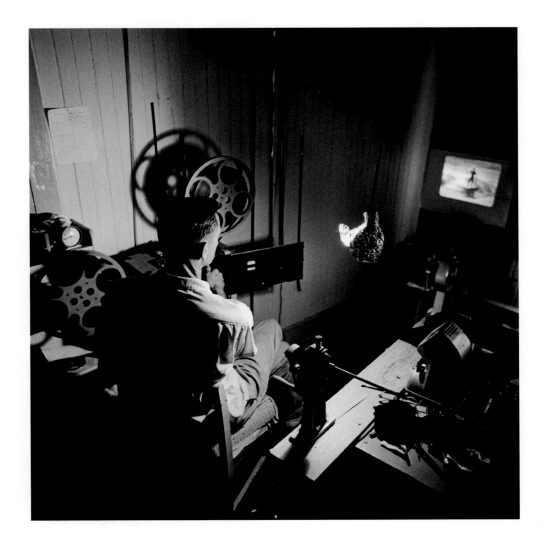

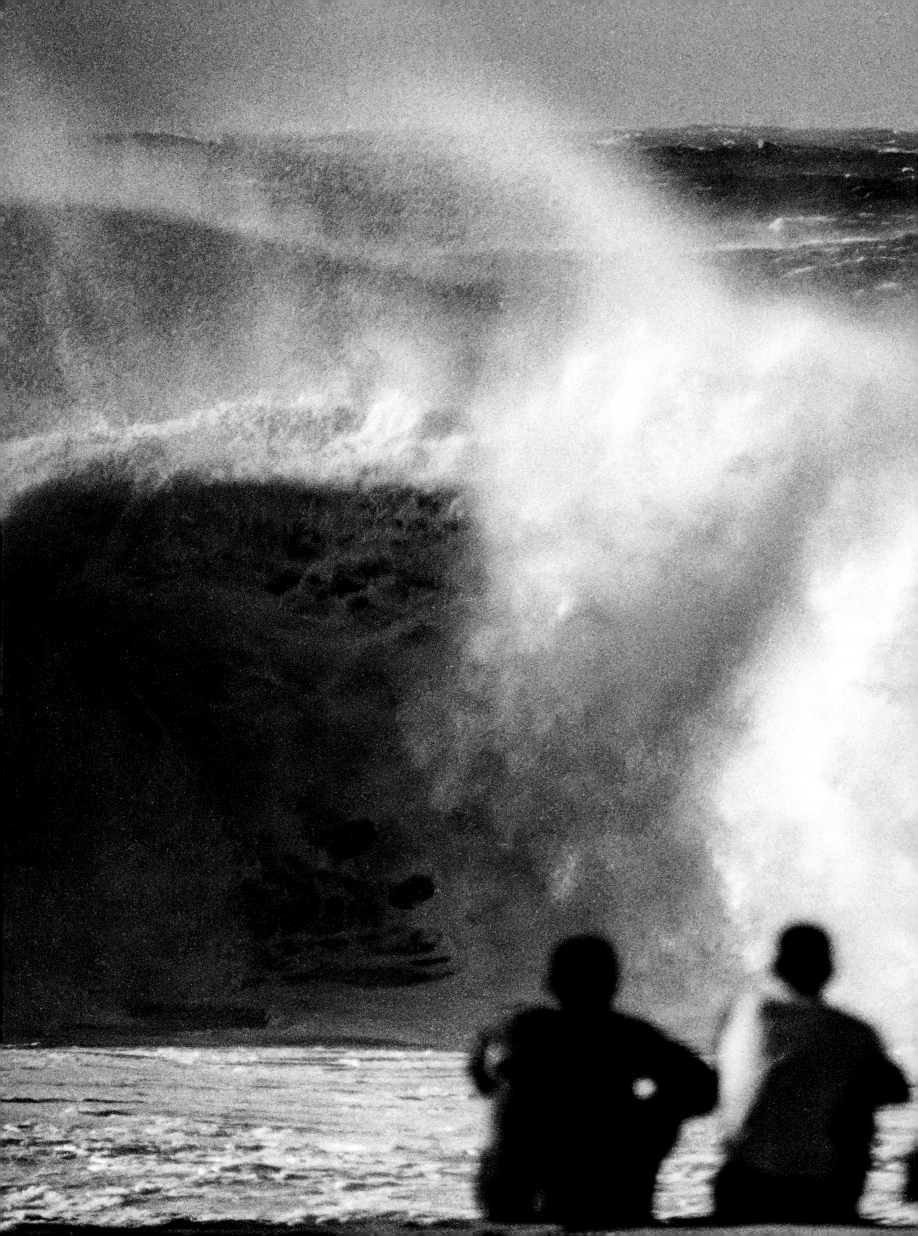

MAGAZINE COVER; *THE SURFER*, VOL. 1, NO. 1, JANUARY; 1960 John Severson created the first issue of *The Surfer* as a photo booklet to sell for extra cash at showings of his new film, *Surf Fever*, and crafted the magazine himself on the floor of his apartment. "The first one was different from all the others," Severson noted, "and actually came out pretty much as I hoped… It was trying to be an art piece, really. But total surfing." *Photo and design, John Severson*

PROGRAM, INTERNATIONAL SURFING CHAMPIONSHIP; MAKAHA, HAWAII; 1960

MAGAZINE COVER; *THE SURFER QUARTERLY*, VOL. 2, NO. 4, WINTER; 1961 *Photo and design, John Severson*

MIKI DORA, MALIBU, 1961 *(Pages 168–169)* Dora's relationship with Malibu, while amazing to watch, was often one-sided and obsessional. Far from an all-around waterman, his non-surfing time was spent as a vindictive prankster, manipulator, and minor league criminal. *Photo, LeRoy Grannis*

THE SURFER QUARTERLY

A John Severson Production

75¢

VOL. 2. NO, 4 - WINTER

RM
aff

SURFER EXTRAS SAN ONOFRE
YOKAHAMA BLASTERS·HUNTINGTON CONTEST
BODY SURFING

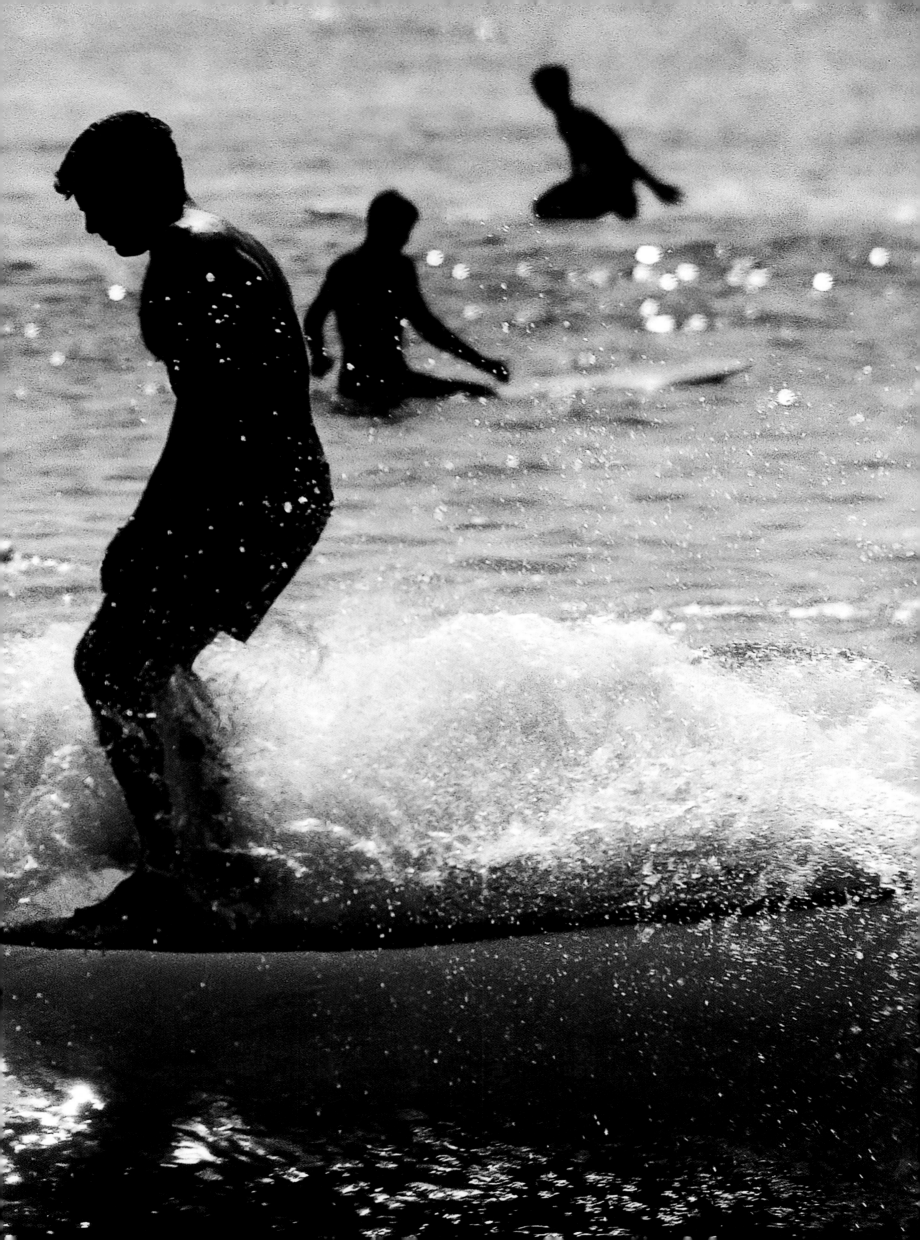

SPORTSMAN

Beautiful FULL COLOR Automotive Showcase

AUGUST 1953 · 35c

**THE END OF
A LEGEND**

School for Speed

INSURE IT!

TRAVEL

SPORTSWEAR

MAGAZINE COVER, *AUTO SPORTSMAN*, 1953 Surfing's infiltration of mass media, or vice versa, goes back to the turn of the century. The results have been mixed, ranging from fanciful to clever. One reason is that most of the advertisers and the art directors who work for them don't surf. As one surf pundit put it, "surfing makes its own anti-bodies and will always reject outside foreign bodies."

THE BEACH BOYS, C. 1961 *(right and below)* From left to right: Dennis Wilson, Mike Love, Brian Wilson, Carl Wilson, and Al Jardine. Clad in Pendletons and white T-shirts, the Beach Boys rehearse in the studio. From left to right: Mike Love, Brian Wilson, Carl Wilson, Dennis Wilson, and David Marks

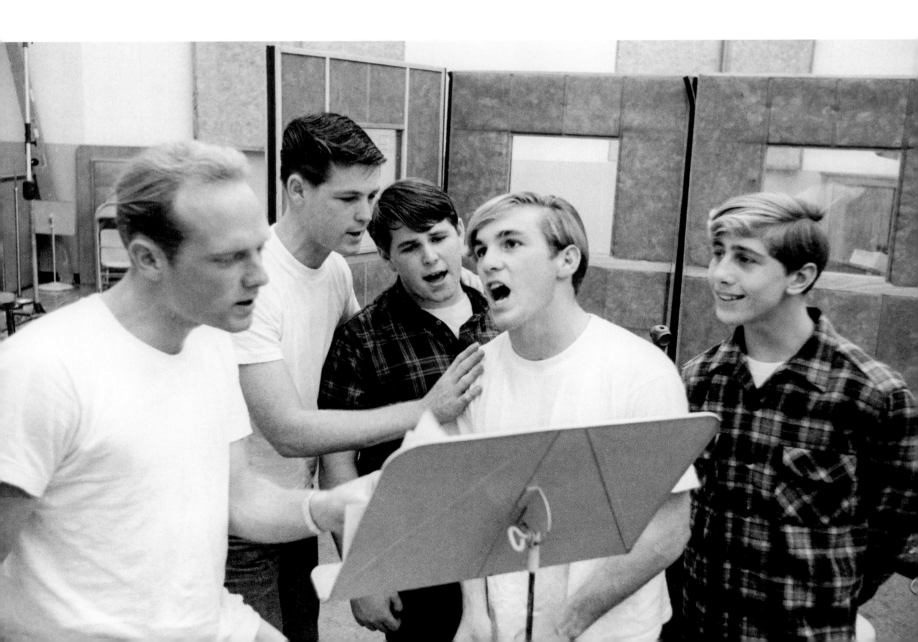

REDONDO BEACH, CALIFORNIA, C. 1954
Lifeguarding has traditionally been the first and best job for any committed young surfer: flexible hours, ready surf, and no shoes. From left to right: Bing Copeland, Mike Bright, Sonny Vardeman, and Bob Liff.

CALIFORNIA, C. 1961 The postwar baby boom spawned a generation of surf rats who found a suburban garage the ideal space for their nascent lifestyle.

LINDA BENSON; MAKAHA, HAWAII; 1959
Benson grew up surfing in Encinitas, California, and was considered one of the best surfers, male or female, in the state. At age 15 she won the women's division at the 1959 Makaha International Surfing Championships, making her the youngest champion in contest history. *Photo, John Severson*

BEACH, HAWAII, 1960 *(Pages 174–175)* Sunset Beach is considered one of the "big three" of epic North Shore surf breaks, along with Waimea and Pipeline. While deceptively easy to paddle to because of a fast-running current, it's perhaps the most complex of all the Hawaiian waves to position and ride well. *Photo, John Severson*

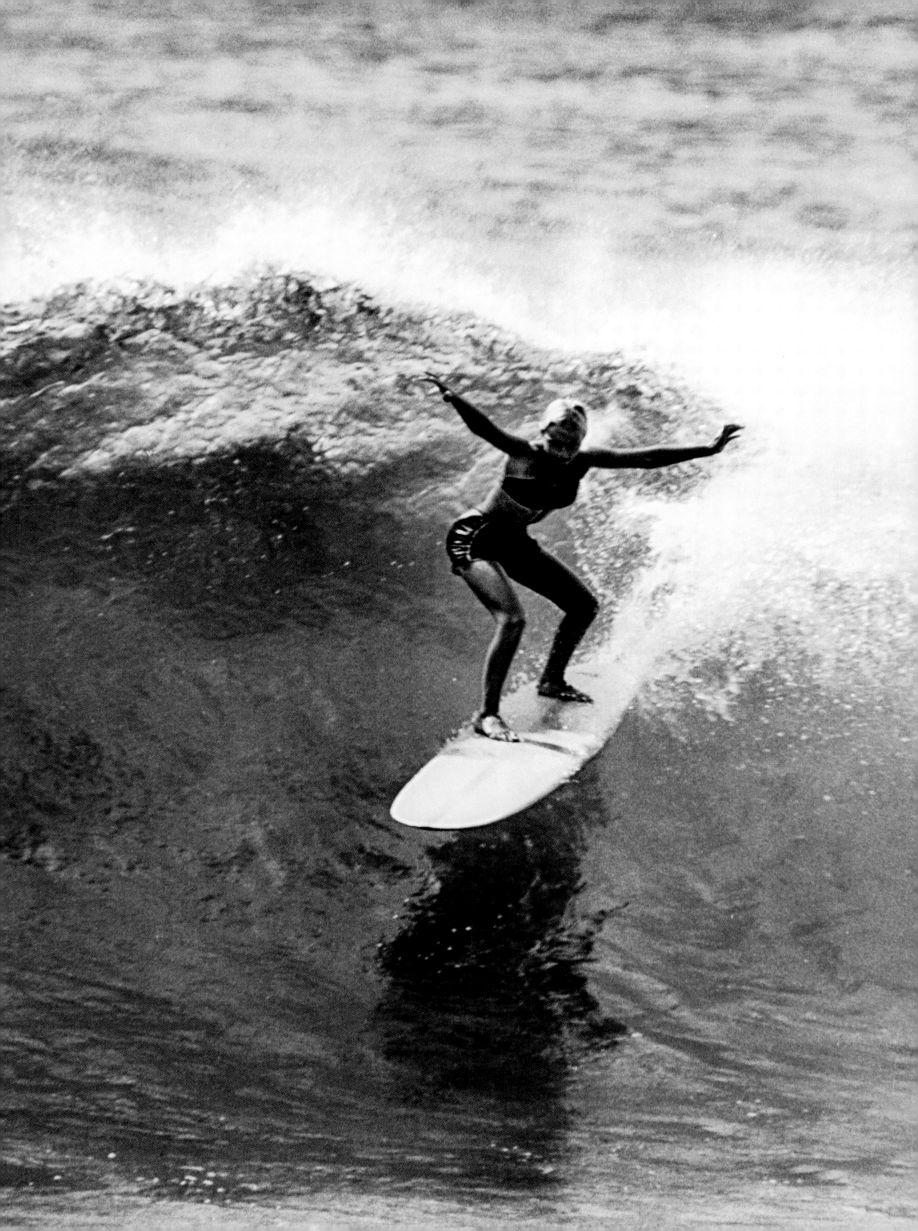

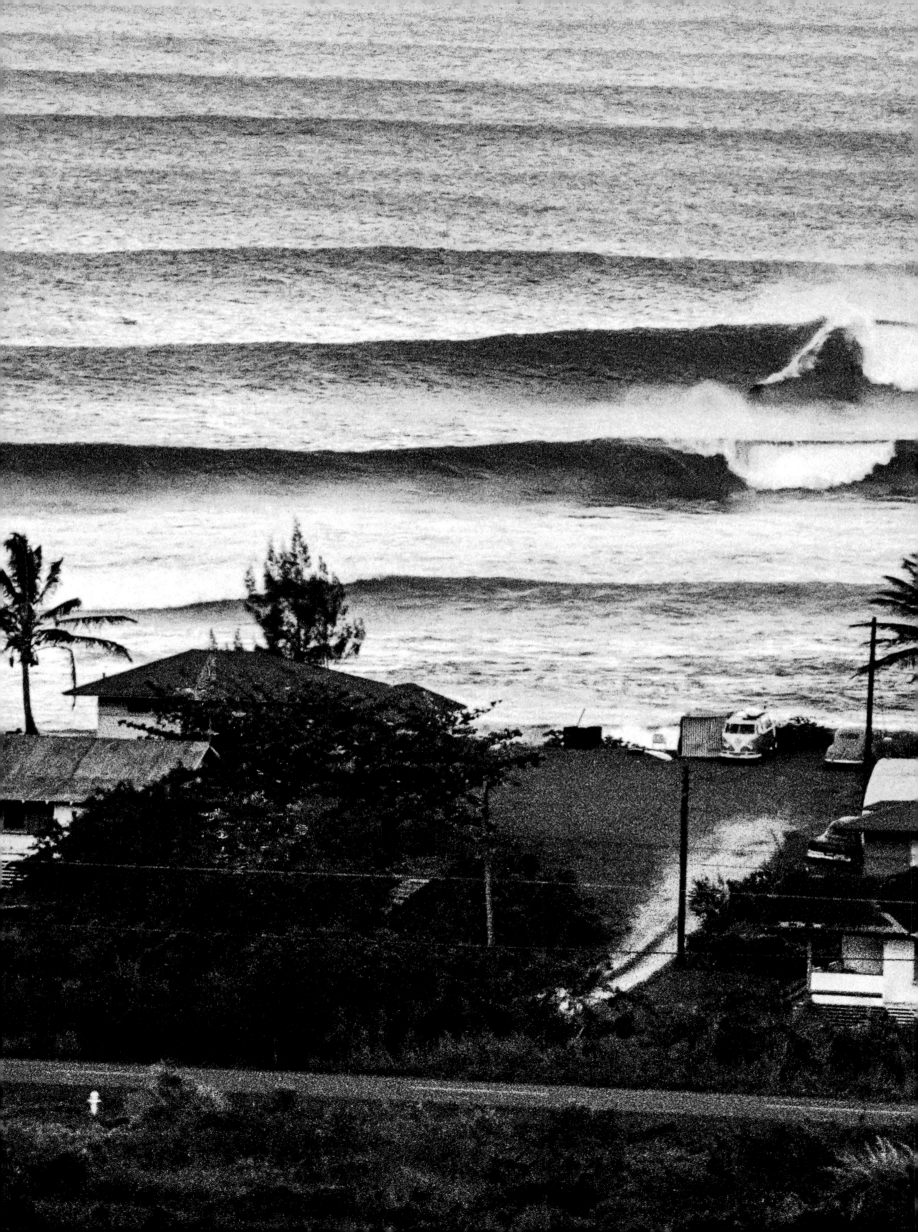

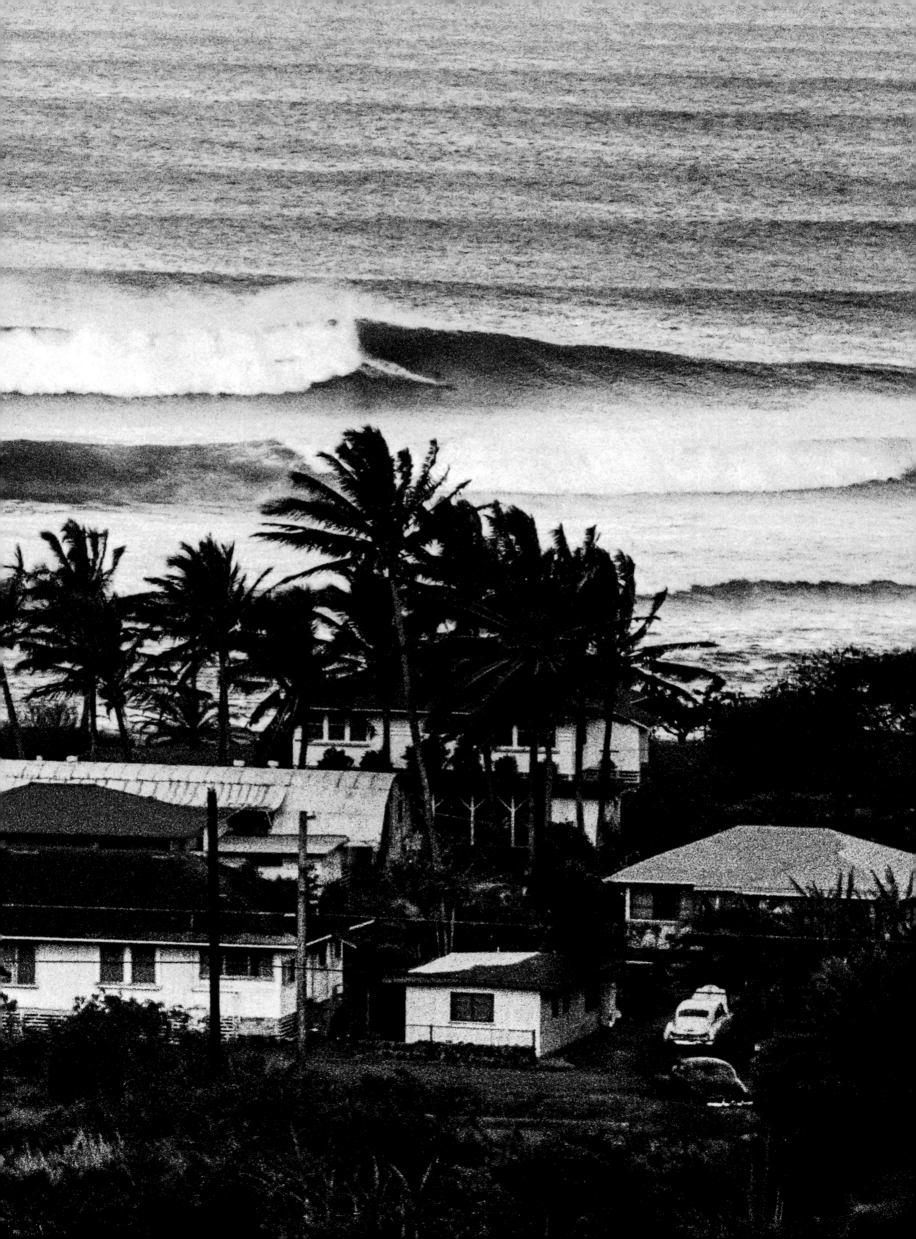

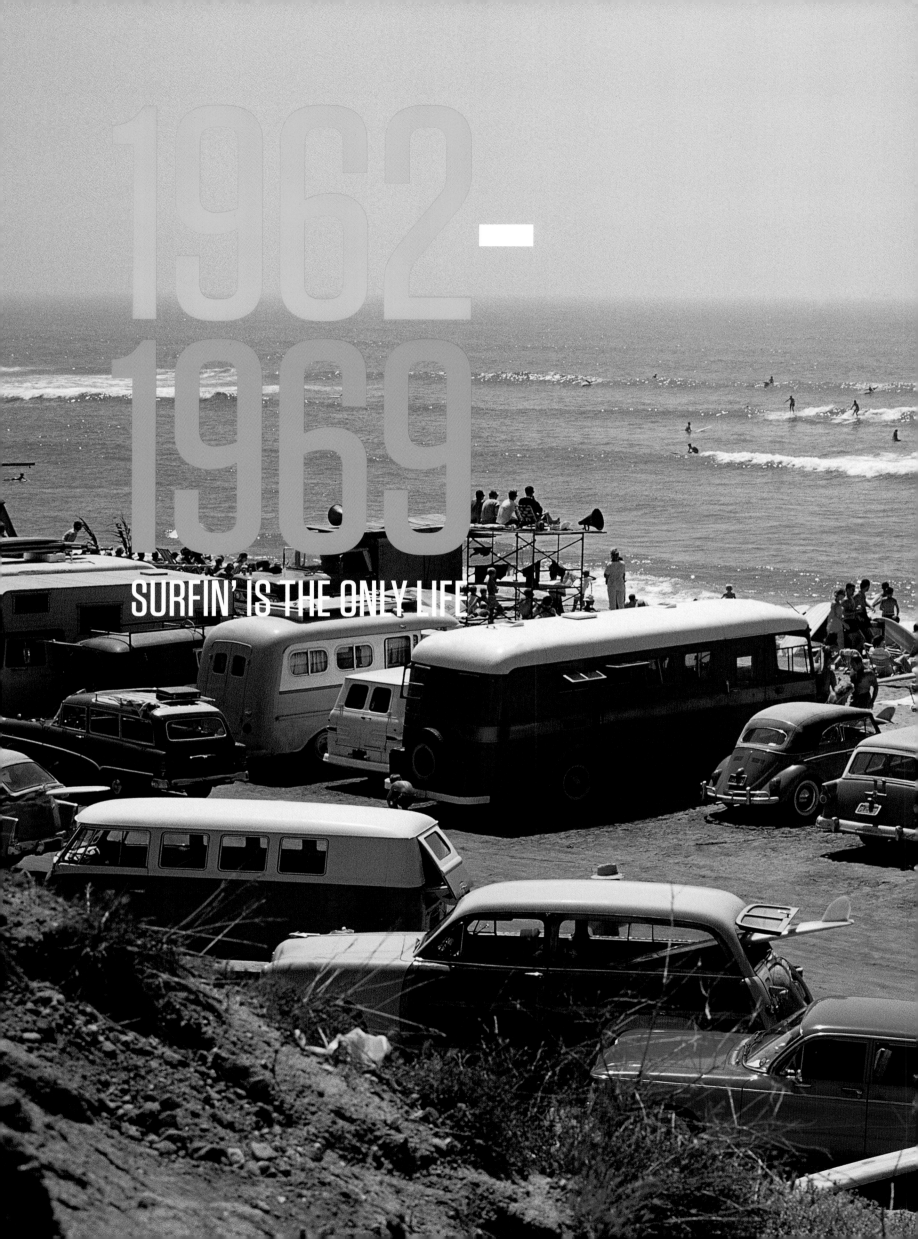

1962–1969

SURFIN' IS THE ONLY LIFE

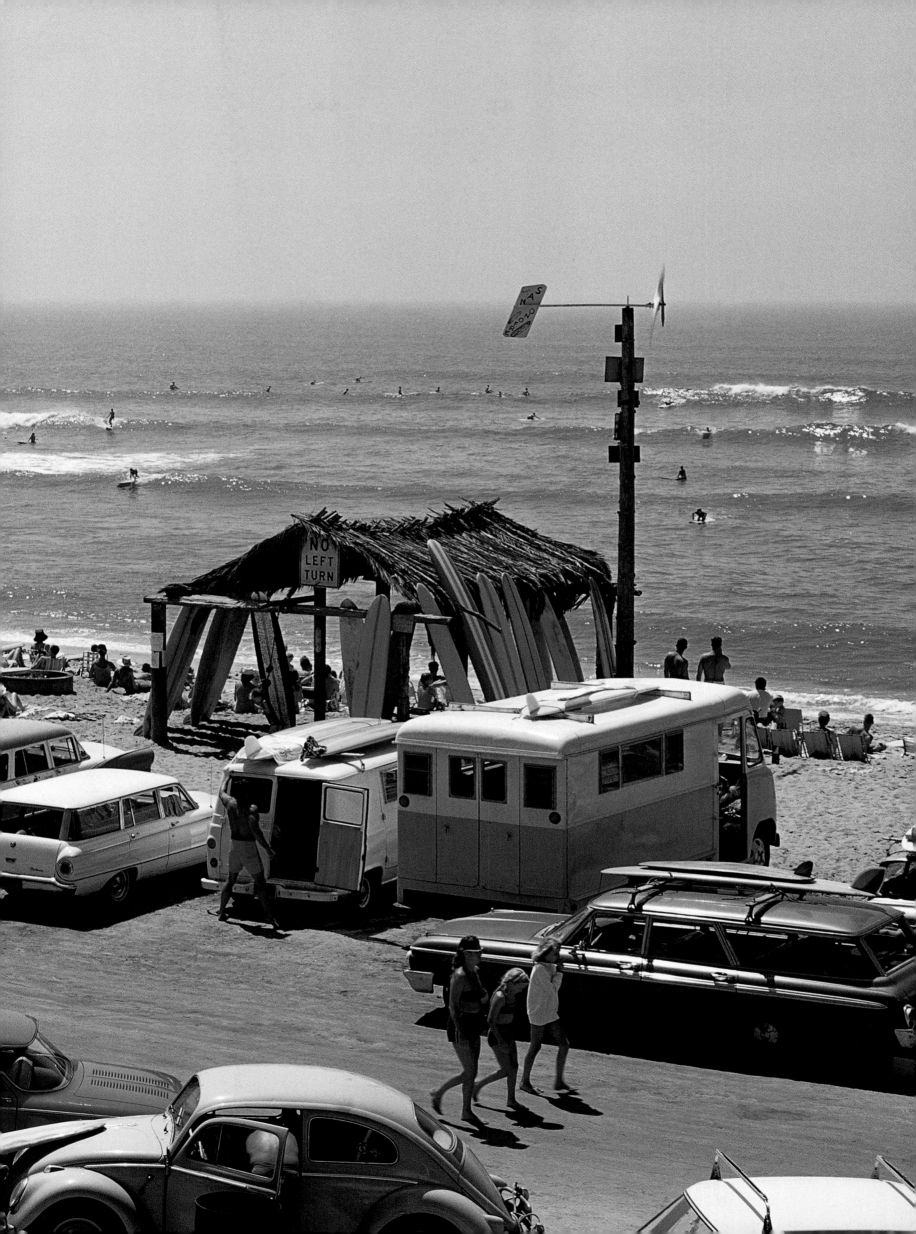

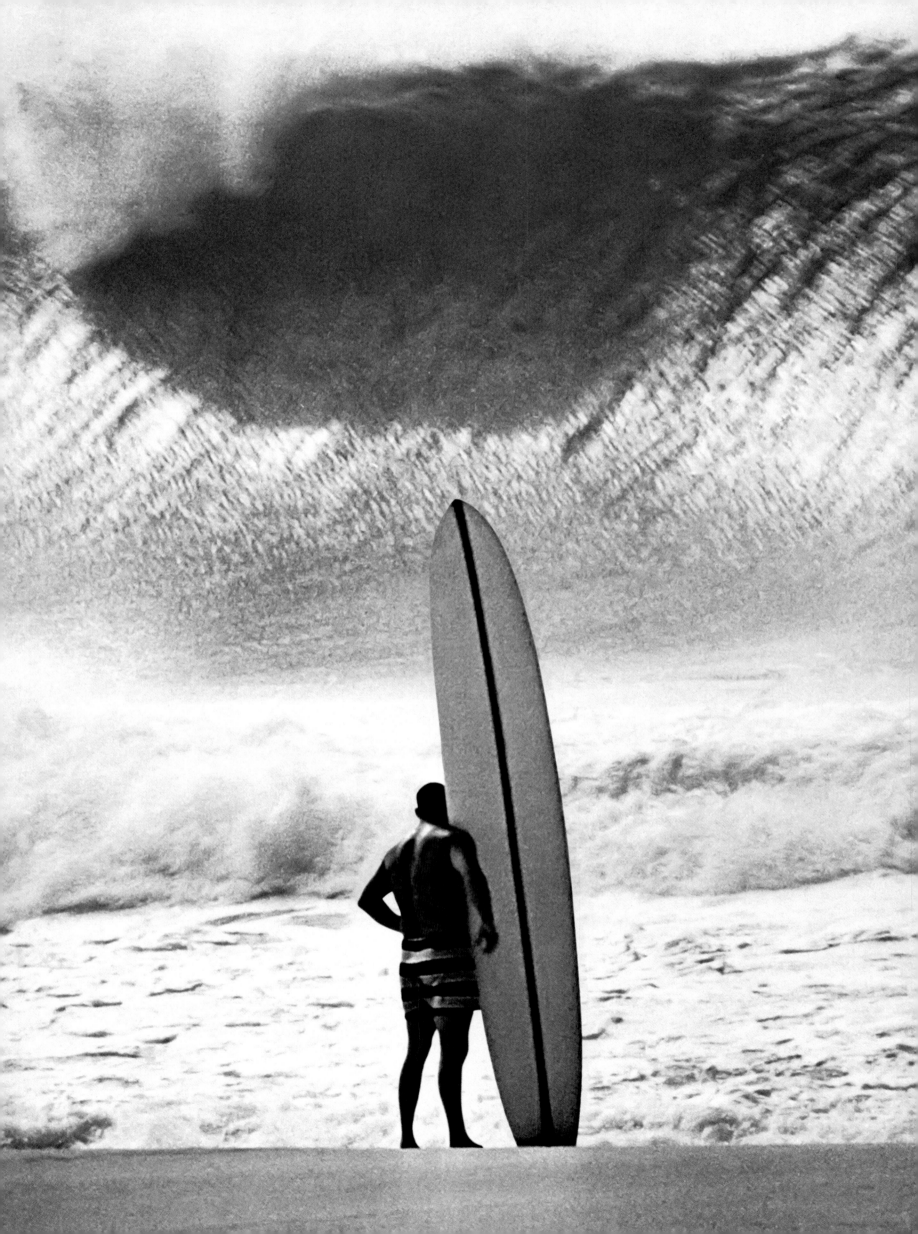

1962-1969
IF EVERYBODY HAD AN OCEAN

CHRIS DIXON

It's a warm, cloudless autumn morning in Southern California. South of Los Angeles in Huntington Beach, the air is crackly dry and the perfume of chaparral and Orange County citrus groves waft through town, thanks to a Santa Ana breeze blowing down from the high desert. These Santa Ana winds blow directly out to sea, and they've groomed a healthy south swell into dreamy, head-high waves with trails of rainbow mist blowing off their backs. It's 1963 and California surfers are pondering the seismic shifts that have shaken the surf world they knew but a few years ago. Back in '58, surfing was known to perhaps 5,000 Californians, and Huntington Beach was in its waning days as a beachfront oil-well boomtown. If a car passed with surfboards on the roof, you stopped to talk. If you arrived at the pier solo, you often had to wait some time before another surfer would even show up. To the relatively small circle of people who freely roamed the glorious beach and point breaks from La Jolla in San Diego, to Trestles at San Onofre, "Killer Dana" in Orange County, Malibu in Los Angeles County, and Rincon by Santa Barbara, this fertile coastal desert crescent—full of waves, fish, abalone, and endless mountain views—was Xanadu.

Then, seemingly overnight, surfing's small tribe would come to understand the sobering, transformative power of America's pop-culture media machine after a cute little brunette surfer girl named Kathy Kohner dropped into Malibu bearing a giantess named Gidget on her slight shoulders. The eponymous book, written by her father, had outsold Jack Kerouac's *On the Road* in its initial 1956 printing, and turned a generation of baby boomers onto California's nascent beach culture. But it would be the 1959 release of the eponymous film that spawned a tsunami of mixed media that would sweep from California, through the Rocky Mountains, across rural Kansas, down the eastern seaboard, and out over the vast oceans via airwaves and movie theaters.

Then, in 1961, a middling South Bay surfer named Dick Dale blew open a genre of instrumental rock called "surf music" with a series of raucous concerts at Newport Beach's Rendezvous Ballroom and the release of his album, *Surfer's Choice*. Hitching a ride to Dale's wagon was a band of brothers from the inland Los Angeles suburb of Hawthorne who combined Chuck Berry riffs and Dale-inspired chords with Four Freshman-style harmonic crooning. They called themselves the Beach Boys, though only one actually surfed. No matter, with the 1962 release of the LP *Surfin' Safari* and 1963's *Surfin' USA*, the band converted millions of landlocked teens into "surfers," and paved the way for acts like the Ventures, Minnesota's Trashmen ("Surfin' Bird"), and Indiana's Rivieras ("California Sun"). A Los Angeles vocal duo named Jan and Dean picked up on the hot-rod and skateboarding crazes with "Sidewalk Surfin'" and songs like "The Little Old Lady from Pasadena" and "Dead Man's Curve." It would become impossible to miss one of these acts weekly on *American Bandstand*, or to drive Pacific Coast Highway (PCH) for more than a few minutes without hearing surf music on Southern California's ubiquitous KRLA radio station. Pepsi even decided to get in on the act by sponsoring the 1962 West Coast Surfing Championships and becoming the first multinational corporation to back a wave-riding contest. Madison Avenue ad men were now using surfing to sell everything from cars to tampons to cigarettes.

As if Pepsi and cigarettes weren't enough to choke American pop culture on surfing, American International Pictures unleashed another shot across *Gidget's* bow in August of 1963. *Beach Party* was a cornball and cringeworthy piece of surf cinema that featured Dick Dale alongside a surfer couple—the pale, buxom, brunette, and ex-Mouseketeer, Annette Funicello, and her weed-toking beau, Frankie Avalon. Loosely based on a cultural anthro-

pologist's quest to study the rites and rituals of the modern California teenager, *Beach Party* drew sneers from real surfers, but overjoyed its producers. It cost $500,000 to film, yet earned over $6 million, spawned seven sequels and one-upped *Gidget* in popularizing "the surfer look," a look that was making nascent mainstream surfwear manufacturers, like Hang Ten's Duke Boyd, suddenly very wealthy.

At best, longtime surfers took a dim view of all this contrived excitement. *Beach Party* in particular made it painfully clear how skewed and exploited surfing had become as a mass-market phenomenon. For every nonsurfer kook who cruised PCH or a Kansas City main drag using a surfboard as a prop, thousands of others, now clad in warm, comfy wetsuits and buoyed by lightweight fiberglass surfboards became instantly and hopelessly addicted to surfing's rush. The stronghold was still Southern California, but surfing had a firm footing up the coast in Santa Cruz and was spreading north into Oregon and Washington and south along the most desolate reaches of the Baja peninsula. With a critical mass of devoted apostles, and *SURFER* magazine as its bible, surfing's subculture began to evolve artistically, aesthetically, economically, and even politically—at warp speed.

When the 1962 August/September issue of *SURFER* hit the stands, surfers, particularly those from Huntington Beach, were amazed to find a cover drawing by their own regular

surf rat, Rick Griffin, a talented and driven young pen-and-ink impresario and understudy of *SURFER*'s founder, John Severson. Griffin's illustrations would come to fill the magazine's advertisements and white spaces in a manner modeled after *Mad* magazine's Don Martin and Sergio Aragonés. His simple drawing of "Murphy" a towheaded gremmie (an avid young surf kid) navigating a right-hand slide—a caricature of Griffin himself—would become one of the most iconic *SURFER* covers of all time and a mascot for a generation.

RISING SWELL

Half an ocean away in surfing's ancestral promised land, minds were blown when, after staring long and hard at the waves exploding onto a jagged lava reef 50 yards off Ehukai Beach on Oahu's North Shore, a preternaturally talented Californian named Phil Edwards gathered the nerve to paddle out, be swallowed alive, and spat out by a tornadic barrel. Bruce Brown scored a coup over competing filmmakers, capturing Edwards at the Banzai Pipeline for the first time. The moment appeared in Brown's 1961 film *Surfing Hollow Days* and was seared into the retinas of hollering wave-riders in high schools and veterans hall-sacross Hawaii, California, Florida, and even Australia, whose own exploding surf culture was almost unknown in California.

Yet a hotly talented crew was indeed bubbling up from Down Under. In 1962, in the wake of a slew of small-time startups, Australian surfing launched its first mainstream answer to *SURFER*, in the form of *Surfing World*—a title still published today. In Hawaii, Bernard "Midget" Farrelly, a diminutive 17-year-old Aussie, would win the 1962 Makaha International Surfing Championships in Hawaii, a contest generally considered the world championship of the day. Two years later, Farrelly cemented his reputation by winning the first official World Surfing Championships at Australia's Manly Beach. That same year, the arrival in Malibu of a lanky, brash Aussie named Robert "Nat" Young highly impressed Miki Dora and crew, taking advantage of the entire wave face with tight cross-steps and lightning-fast top turns.

If California's surf hegemony was already beginning to wane, it was also becoming easy to recognize a Golden State not portrayed in saccharine film or musical creations. Out beyond the southland coast, a layer of brown smog typically smudged the horizon 30 miles away to Catalina Island. California's manufactured idyll was luring a half million

THE SURFER

BI-MONTHLY
A John Severson Production

75¢

VOL. 3 NO. 3 AUG. – SEPT.

RM aff

THE INTERNATIONAL SURFING MAGAZINE

MORE OF MURPHY

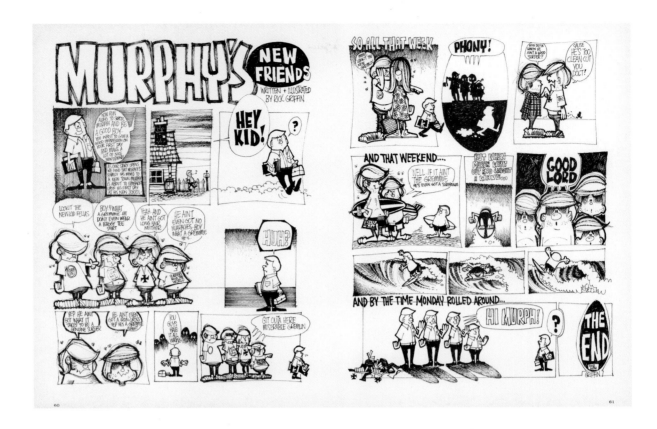

new residents every year, but the 17 million already here by 1962 packed freeways with fume-belching, tailfinned cars while their subdivisions and industrial parks gobbled up the beautiful landscapes and seascapes that had attracted them in the first place. A few miles from the headquarters of Greg Noll and Dale Velzy's exploding surfboard businesses, the Montrose Chemical Corporation was in the middle of a decades-long run of dumping over a hundred tons of toxic DDT and PCB's into the ocean.

Surfing, too, was nowhere near the wholesome pastime that marketers wanted parents to believe, though young surfers themselves were surely no less filled with vice than any other youth of the era. At this time, Steve Pezman, the future editor of *SURFER*, was making a living selling marijuana. But surfers had developed their own impenetrable culture, and even a provocative language filled with nonsensical-sounding words like *hodad, gremmie, bitchin'*, and of course, *stoked*. "Miki Dora had to go to the Santa Monica court," recalls Noll. "And the judge literally said, 'I don't understand what this man is saying. You're gonna have to get an interpreter.'"

American mass culture, says Noll, filtered surfing through its own funhouse mirror. "They ended up kind of creating this culture, around this thing that people did—called *surfing*," he says. "And most of it had absolutely nothing to fucking do with what was actually going on. Really, it was good-lookin' gals and guys drinking wine, smoking weed, fucking up, screwing, and rebelling against society and anything you're supposed to do. That's what we were doing—that's the truth of it."

HOT RODS, FINKS, AND IRON CROSSERS

Perhaps more in tune with surfing's actual zeitgeist were Ed "Big Daddy" Roth, a nonsurfing cartoonist and hot-rod icon, and Tom Wolfe, a skinny, pale, bespectacled New York journalist. Wolfe not only stumbled onto Roth and Dick Dale while researching his iconic car culture *Esquire* article "There Goes (Varoom! Varoom!) That Kandy-Kolored (Thphhhhhh!) Tangerine-Flake Streamline Baby (Rahghhh!) Around the Bend (Brummmmmmmmmmmmmmmmm) … ," he also attempted to infiltrate surf culture directly in a flawed, but famed 1966 essay on the surfers of La Jolla, who he called "The Pump House Gang," which would be republished in a book with the same title.

When he first showed up asking questions of local surfers at San Diego's Windansea Surf Club in his trademark seersucker suit, garrote-tight tie, and sneakers, Wolfe, a

MAGAZINE COVER AND INTERIOR, *SURFER*, 1962 *(opposite and top)* Sixteen-year-old Rick Griffin began contributing cartoons and illustrations to *SURFER* in 1961. By the third issue, he had created his most famous character, Murphy, who caught the excitement, fun, fears, and frustrations of the thousands of new teen surfers coming into the sport, and quickly became its beloved mascot. *Art, Rick Griffin*

RICK GRIFFIN; HUNTINGTON BEACH, CALIFORNIA; 1964 Griffin barely survived a near-fatal car accident in late 1963 while hitchhiking up to San Francisco. After the accident, Griffin grew a beard to hide the fresh scars and wore an eye patch over his heavily damaged left eye. *Photo, Ron Stoner*

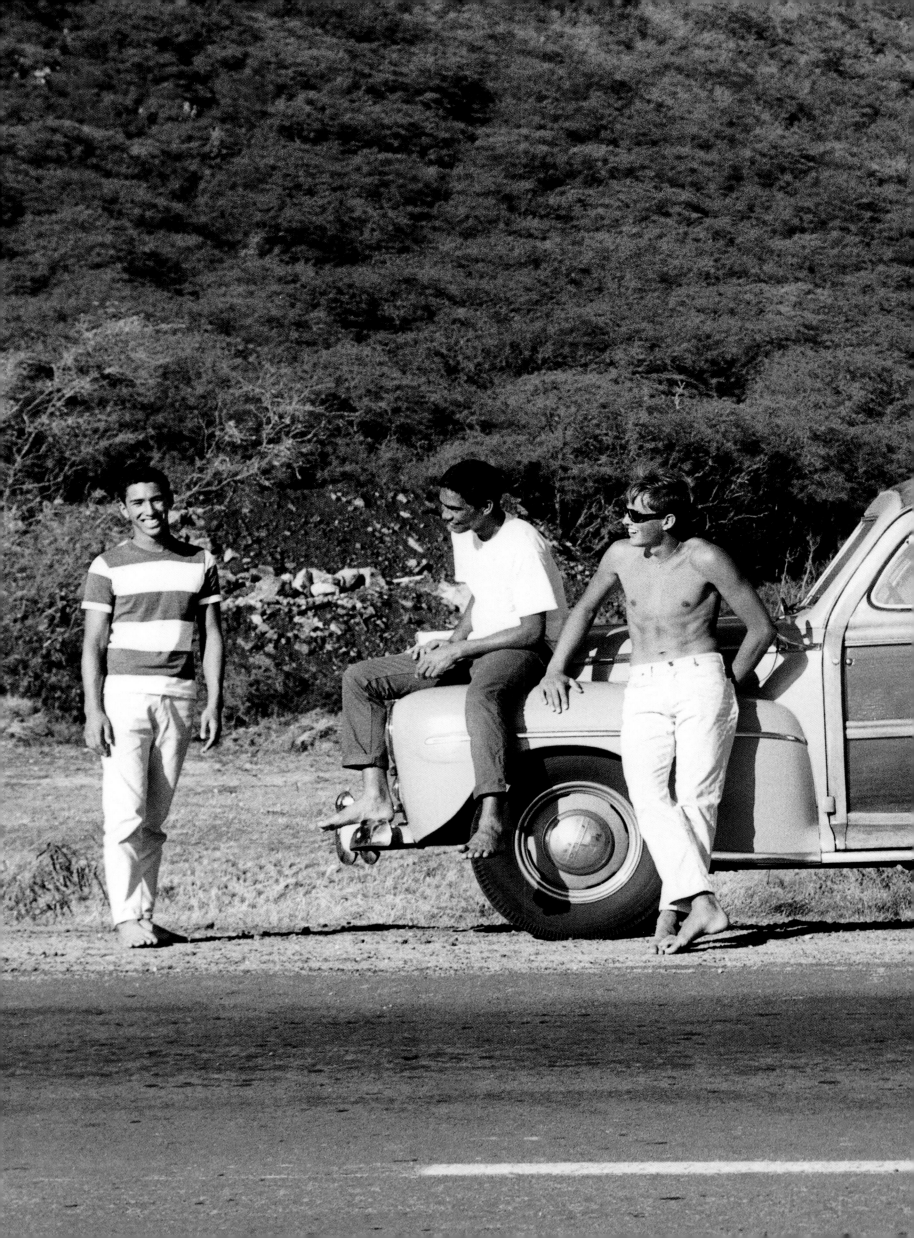

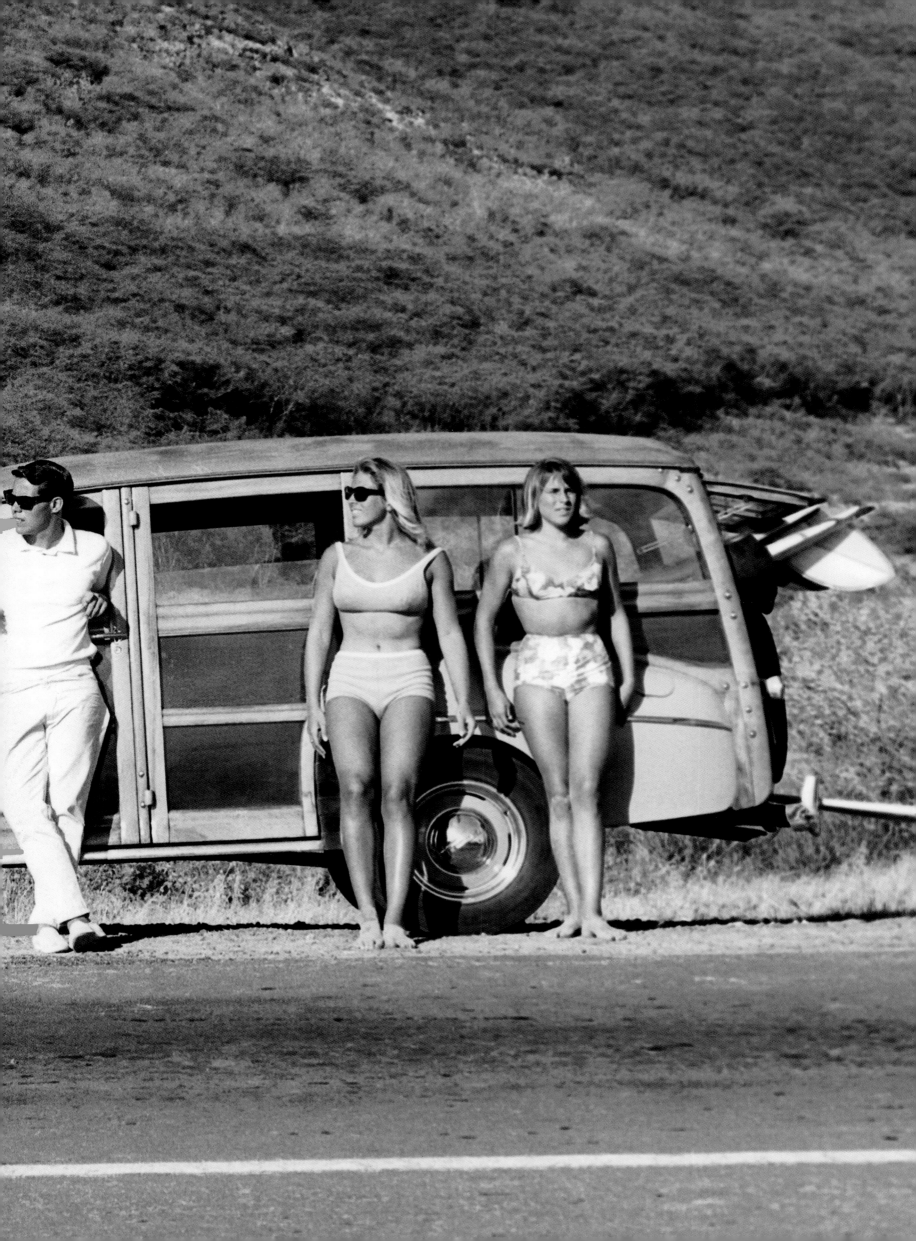

Virginia-raised, Manhattan dandy, was viewed with equal parts disdain and curiosity. Yet he managed to insinuate himself, particularly among the younger La Jolla surfers, so that he could wind up his observational engine.

"They had very little sense of resentment toward their parents or 'society' and weren't rebels," Wolfe wrote. "Their only 'alienation' was the usual hassle of the adolescent, the feeling that he is being prodded into adulthood on somebody else's terms. So they did the latest thing. They split off—to the beach, into the garages!—and started their own league, based on the esoterica of surfing. They didn't resent the older people around them; they came to pity the old bastards because they couldn't partake of this esoteric statusphere." He would get some aspects of surf culture around the La Jolla sewer pump wrong: almost entirely missing is the booming and destructive drug culture (despite publishing his drug-fueled book, *The Electric Kool Aid–Acid Test*, on the same day), seemingly fabricating a toga party, and mangling surf lingo (calling a "kick-out" a "kick-up," for example). Yet Wolfe also cast an unflinching light on some hard truths. California, he wrote, was less overtly about racial segregation as it was age segregation. Surfing provided an ideal representation of this. Indeed, one young couple, it seems, blew their brains out in front of the pump house, rather than live past the age of 25.

Wolfe met Dale and Roth at a car show around 1964 while writing *The Kandy-Kolored Tangerine-Flake Streamline Baby*. Roth was a surreal illustrator, creating a series of semipsychedelic, hot-rod culture-tuned creatures like Rat Fink, described by author Matt Warshaw as "Roth's hairy-middle-finger answer to Mickey Mouse." And later Surf Fink, a literal Jekyll and Hyde version of Griffin's "Murphy," made three-dimensional with a Revell model kit. There was plenty of tension between landlocked hodad car customizers and surfers, yet also plenty of Roth-fueled cross-pollination. Wolfe wrote in this book, "The surfers—surfboard riders—are a cult much admired by all the kids. They have their own argot, with adjectives like 'hang ten,' meaning the best there is." But he got the meaning of hang ten wrong; it refers to the terribly difficult but highly rewarding act of getting one's toes completely over the nose of your board. Though he did get surfing's connection with cars—further represented by the Beach Boys' "Little Deuce Coupe" and "409"—just about right.

Roth built an amazing custom surfboard-equipped car, the Surfite, which would briefly appear in the film *Beach Blanket Bingo* in 1965, the same year Noll opened the biggest surfboard factory in the world. Roth followed the Surfite with a cheap metal pendant he called

MAKAHA, HAWAII, 1962 *(Pages 188–189)* From left to right: unidentified, Ivan Vanetta, Frank Grannis, Paul Strauch, Candy Calhoun, and Robin Calhoun. *Photo, LeRoy Grannis*

HERMOSA BEACH, CALIFORNIA, 1962 The family station wagon was by far the most popular surf car of the early 1960s. *Photo, LeRoy Grannis*

HUARACHE SANDALS, C. 1962

MICKEY MUÑOZ AND TINA TRUNICK; DANA POINT, CALIFORNIA; 1964 *Photo, Don Trunick*

WEST COAST SURFING CHAMPIONSHIPS; HUNTINGTON BEACH, CALIFORNIA; 1962 *(Pages 192–193)* Winners of the West Coast Surfing Championships pose with their trophies. *Photo, LeRoy Grannis*

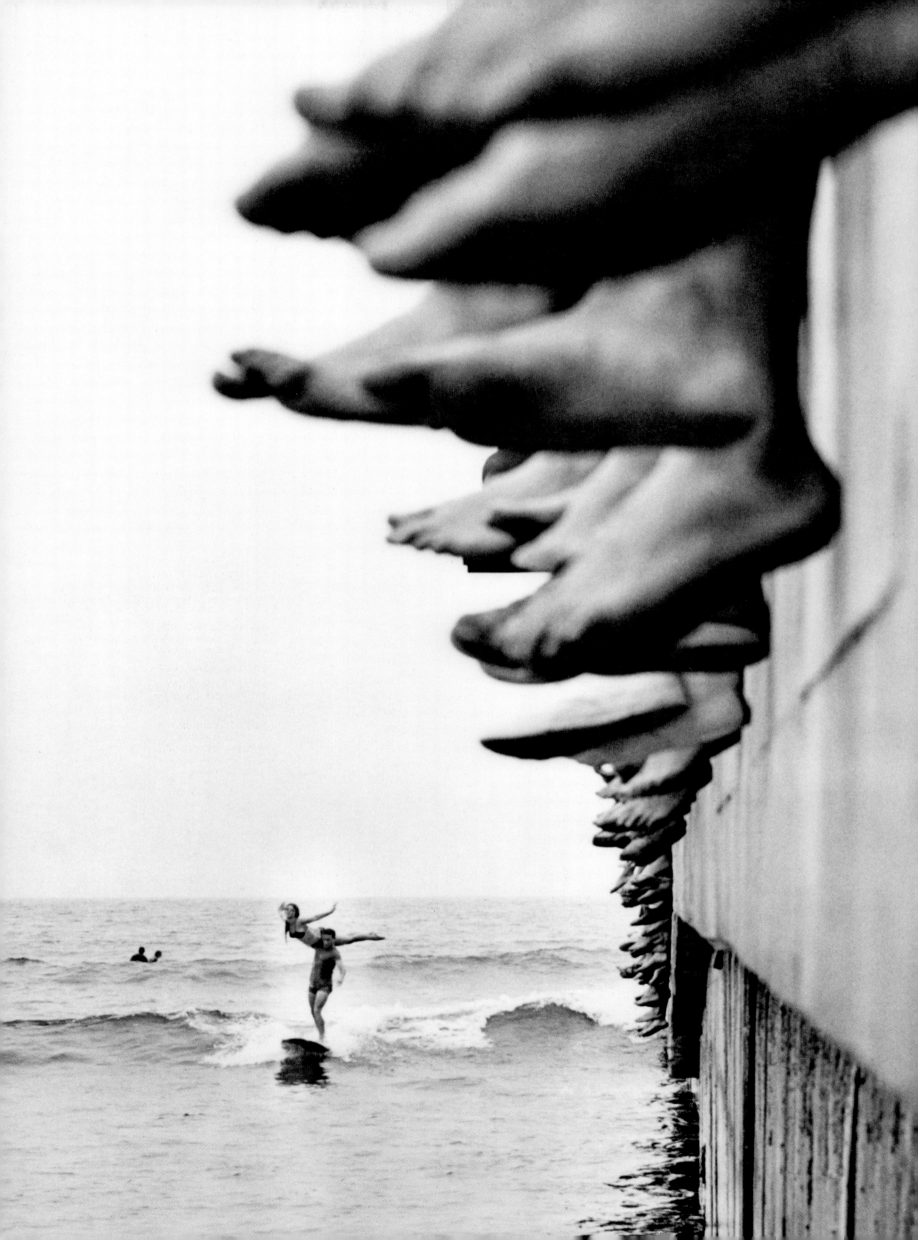

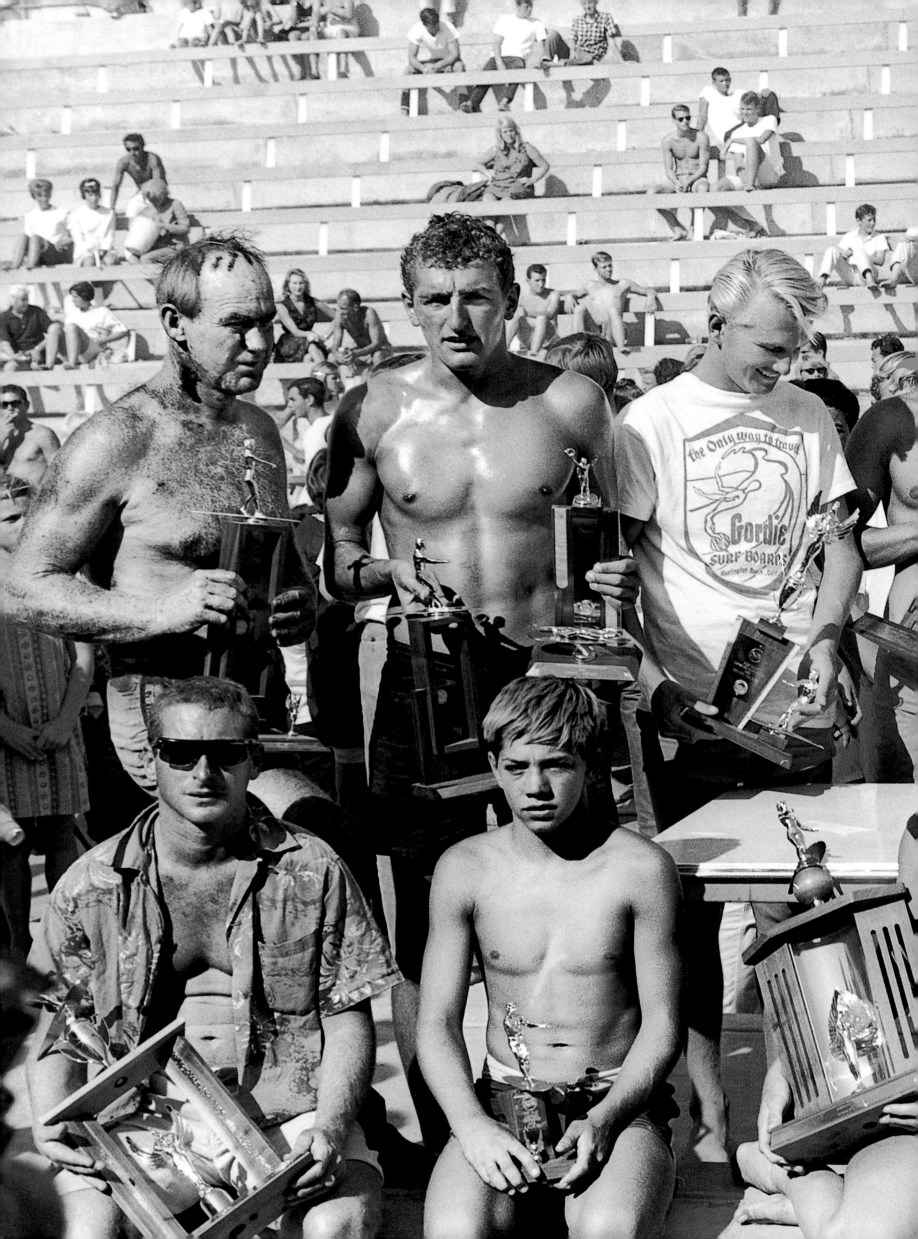

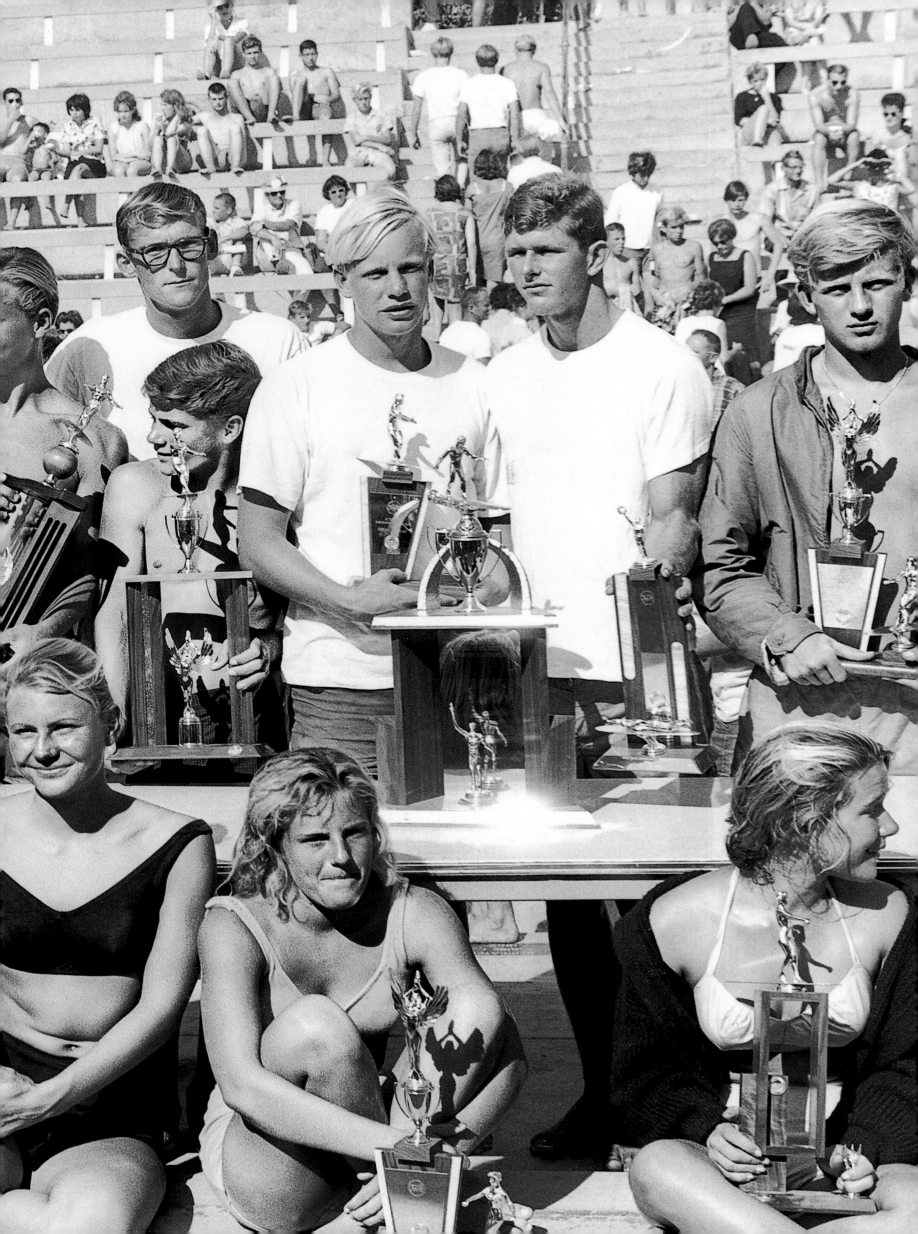

"The Surfer's Cross," essentially a replica of the Nazi Iron Cross with a surfer in the middle. Within half a year, Roth was selling 24,000 of these *a day* across the country. Parents were outraged, but Roth lapped it up, telling *Time* magazine, "that Hitler did a helluva public relations job for me."

This wouldn't be the first—or last—time that surfing would flirt with Nazi imagery. In Noll's film *Search for Surf*, a group of young La Jolla surfers dressed in Nazi outfits flew a Nazi flag and blasted down a storm drain on flexible flyer land sleds. But as Noll put it, despite the fact that a good many young California surfers surely had Aryan looks, the whole Nazi thing didn't go much beyond ignorant teenage rebellion. "We'd paint a swastika on something, for no other reason than to piss people off," he once told Warshaw. "Which it did. So the next time we'd paint *two* swastikas, just to piss 'em off more."

By the mid-'60s, surfers had plenty of bigger things to worry about. In between Beach Boys songs and Sally Field's TV *Gidget*, news broadcasts of communist takeover, nuclear standoff, race riots, and assassinations brought the world outside close enough to distance any one from sunshine daydreams. And now on the heels of an unwinnable war in Korea, came the thunder of another Asian conflagration, this time in a tiny backwater jungle nation called Vietnam. There, in a horrifyingly incomprehensible act of protest, a Buddhist monk had burned himself alive in front of cameras in protest of a corrupt, United States–backed government. As Bob Dylan would sing a few months on, "the times they are a-changin'."

EXPLORATION AND COLONIZATION

Driven by already disaffected West Coasters, soldiers and explorers like Peter Troy—a nomadic Aussie who brought surfing to England, Brazil, and Morocco—spread surfing's tentacles far beyond the West Coast, Hawaii, and Australia. In 1957, Jewish physician Dorian "Doc" Paskowitz gave up nearly all his worldly goods, moved to an Israeli kibbutz, and turned Tel Aviv locals onto Mediterranean surfing—and by the mid-'60s, that community was thriving. In 1959, San Diego surfer-sailors Harrison Ealey, Bob McClane, and Lee Dendiger probably became the first to surf the named and unnamed reefs off Tuamotus, Marshall Islands, and Tahiti. A year later, Ealey and his good friends Wayne Schafer and Phil Edwards sailed from Mazatlan in Sinaloa, Mexico, to California, exploring jaw-dropping point breaks along the Islas Tres Marías, whose biggest island, Maria Madre, was one big penal colony.

HAWAII, C. 1962 More act of teenage rebellion than following Hitler's dogma, the surf Nazi was a hyper-dedicated surfer who loved challenging authority. "We just did things like that to be outrageous," says Greg Noll. "You paint a swastika on your car and it would piss people off. So what do you do? You paint on two swastikas." *Photo, Tom Keck*

HANG TEN ADVERTISING SHOOT, 1965 Looking for a way to make extra money in college, California surfer Duke Boyd made some surf trunks to sell in his spare time. His seamstress asked what the surfing equivalent of a hole in one was. Boyd replied, "Hang ten," and a multimillion-dollar surfing brand was born. From left to right: Greg Noll, Bettina Brenna, and Phil Edwards. *Photo, LeRoy Grannis*

MALIBU, C. 1963 During one summer weekend at Malibu in 1963, a lifeguard counted more than 300 surfers on the water scrapping for waves. *Photo, LeRoy Grannis*

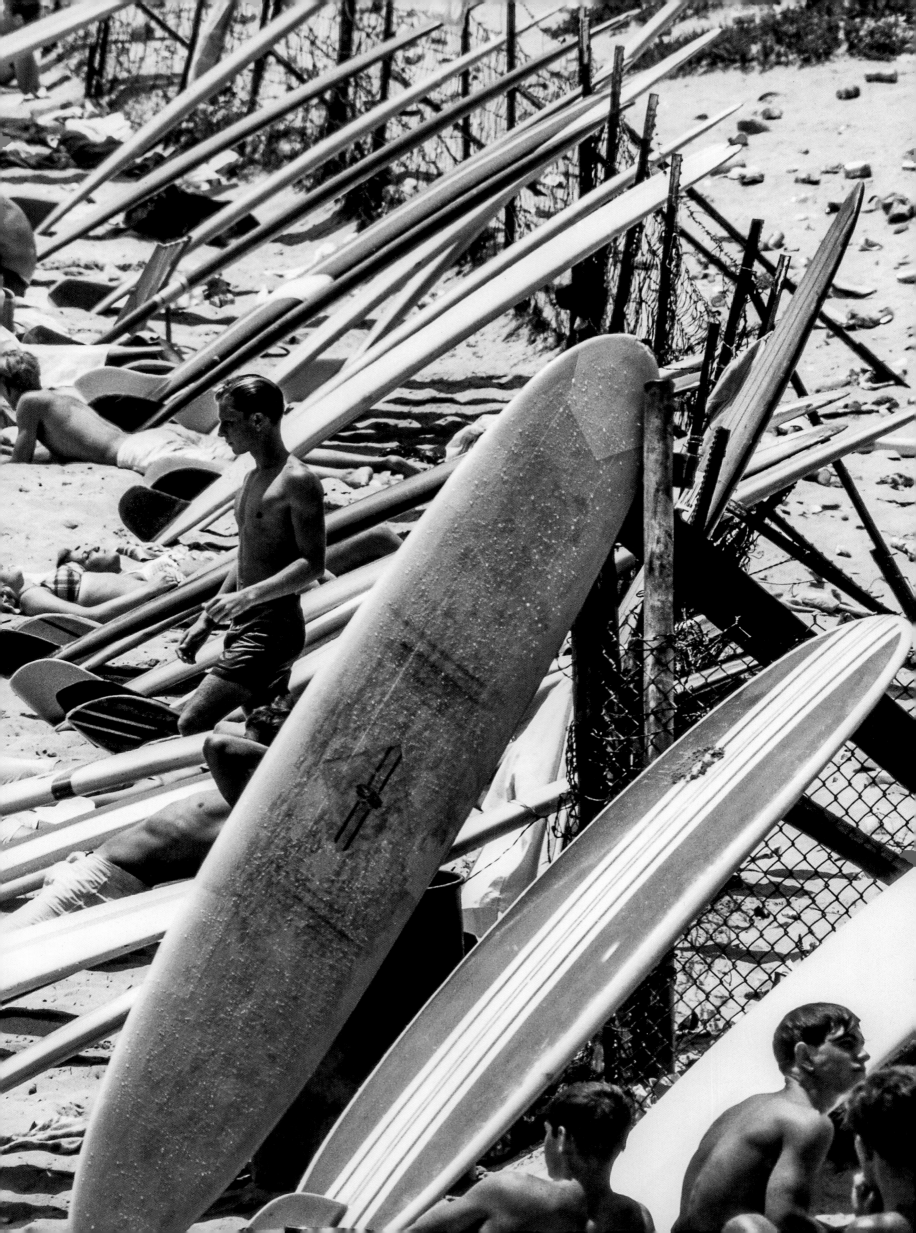

In the winter of 1961, Ealey ferried Edwards to Hawaii for the winter (a few weeks later, Edwards would surf the Banzai Pipeline). After scaring the hell out of himself at Waimea Bay and Makaha, Ealey returned home on a summertime route that carried him past a six-foot-deep seamount a hundred miles west of San Diego called the Cortes Bank. Because no one said he couldn't, he paddled his Makaha gun out into this utter wilderness and rode a big south swell by himself. "I'd been surfing Makaha and Waimea, so it didn't look scary," Ealey stated matter-of-factly. "But then again, it wasn't 50 feet either."

Three thousand miles away, Puerto Rico, Eleuthera in the Bahamas, and hundreds of islands that ringed the Caribbean Sea were undergoing surfer colonization. In Jamaica, Cecil Ward, Billy "Mystic" Wilmot, and a handful of youth from its capital, Kingston, were rock-steadying to the Wailers' first big hit, "Simmer Down." Some, like Wilmot, knew nothing of California, and rode their first waves on bellyboards made from the chunks of cottonwood harvested from fishermen's rotting boat hulls. But after a few wealthy kids drifted through Kingston's Cable Hut Beach with 9'6" boards, Ward and crew shaped blanks with foam from used refrigerators, gussied them up with electric-tape racing stripes, plopped on a primitive layer of cloth made from discarded window curtains, and nearly asphyxiated themselves pouring over layers of primitive resin. Soon a dedicated crew was sliding down the sapphire rollers off Kingston's Palisadoes peninsula.

Back on the Eastern mainland, surfing wafted into North Carolina's Outer Banks, and genteel antebellum towns like Wilmington, North Carolina; Savannah, Georgia; and Charleston, South Carolina; on the first curls of Jamaican and Columbian ganja smoke, ferried north and east by fishermen and surfers who'd been exploring the wilds of mainland Mexico and beyond. Surfing marines stationed at the swampy South Carolina hell base known as Parris Island were invariably drawn to a beautiful stretch of coastal jungle called Hunting Island. Those at the Charleston Naval Base headed to an oak-shaded Civil War battlefield called Folly Beach. In 1963, a sixteen-year-old Folly beach rat named Foster Folsom watched a Navy man all the locals knew simply as "Sarge" Bowman wax his California Hobie with a candle. "I said, you can't surf on this coast, there's no waves," he recalls with a Charleston drawl. By 1969, Folsom's Revolution Number Nine was one of three surf shops that had sprung up on Folly Beach. If the Carolinas were surfing's backwater, entrepreneurial Californians saw Florida as their next promised land. With 700 miles of white sand beach

RINCON, CALIFORNIA, C. 1964 Located 60 miles up Pacific Coast Highway from Malibu, Rincon is the wilder, colder, more powerful big-sister surf break. But when it gets a big northwest swell, it produces the fastest, longest rides on the West Coast. *Photo, LeRoy Grannis*

MAGAZINE COVER, *SURF GUIDE*, **1963**

MAGAZINE COVER, *INTERNATIONAL SURFING*, **1964** Started by Richard Graham and LeRoy Grannis, *International Surfing* emerged from a cluster of early 1960s surf magazines to become *SURFER*'s chief rival.

and a burgeoning, moneyed population, the state was as ripe as a Sunkist orange, a fact noted by a peripatetic violin virtuoso and friend of Phil Edwards named Jack Murphy. Murphy had grown up with Edwards in Carlsbad and Oceanside in San Diego County, but became smitten with the Sunshine State in the late 1950s and opened Murph's Surf Shop in Cocoa Beach around 1960. "I had hitchhiked up from Miami to Cape Canaveral," says Murphy. "Got to Indialantic and walked down to the beach. The waves were absolutely spectacular. Four to six feet, offshore wind, blue water, peaking everywhere. I'm thinking, 'Where am I?' And the water was so warm. That's why more surfing champs have come out of the Cocoa Beach area than anywhere: Bruce Valluzzi, Jeff Crawford, Gary Propper, Mike Tabeling, then later Frieda Zamba, brothers C.J. and Damien Hobgood, and Kelly Slater. A kid could go out at 6 a.m. and come home at 8 p.m.—just staying out all day long and never getting cold like in California."

Hobie's East Coast team—Crawford, Tabeling, and the mouthy but preternaturally talented noserider Propper—were soon traveling from Miami, Florida, to New York City,

PETER TROY; LAS PALMAS, CANARY ISLANDS; C. 1963 While *The Endless Summer* was shot over four months in late 1963, Troy spent more than a decade wandering the globe to 130 countries searching for perfect waves. *Photo, Rennie Ellis*

ROBERT AUGUST, MIKE HYNSON, AND BRUCE BROWN; LOS ANGELES; 1963 Brown's fifth film, *The Endless Summer*, was born out of reports by Dick Metz that there were good waves in South Africa. Brown had talked with a travel agent who told him it would cost $50 less to keep going around the world from Cape Town rather than flying back to California the same direction. *Photo, R. Paul Allen*

POSTER, *THE ENDLESS SUMMER*, 1966 *Art, John Van Hamersveld*

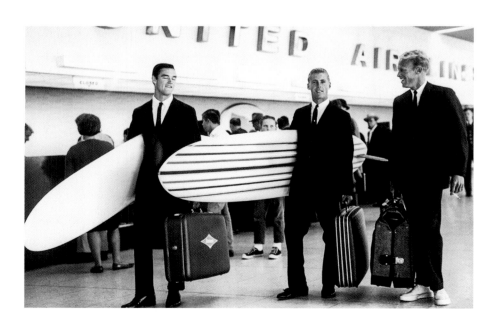

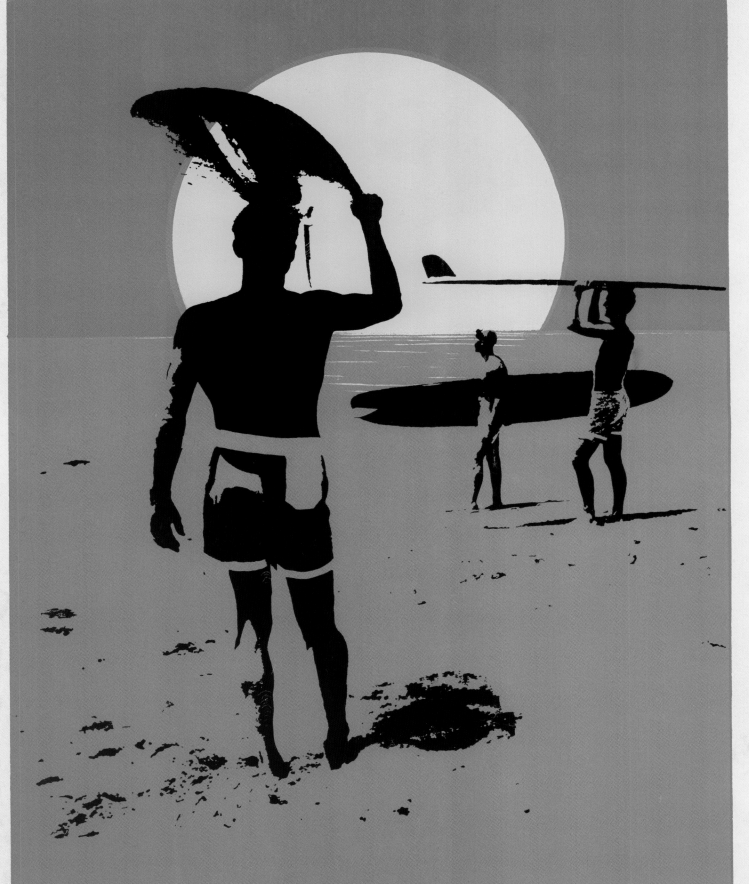

Endless Summer

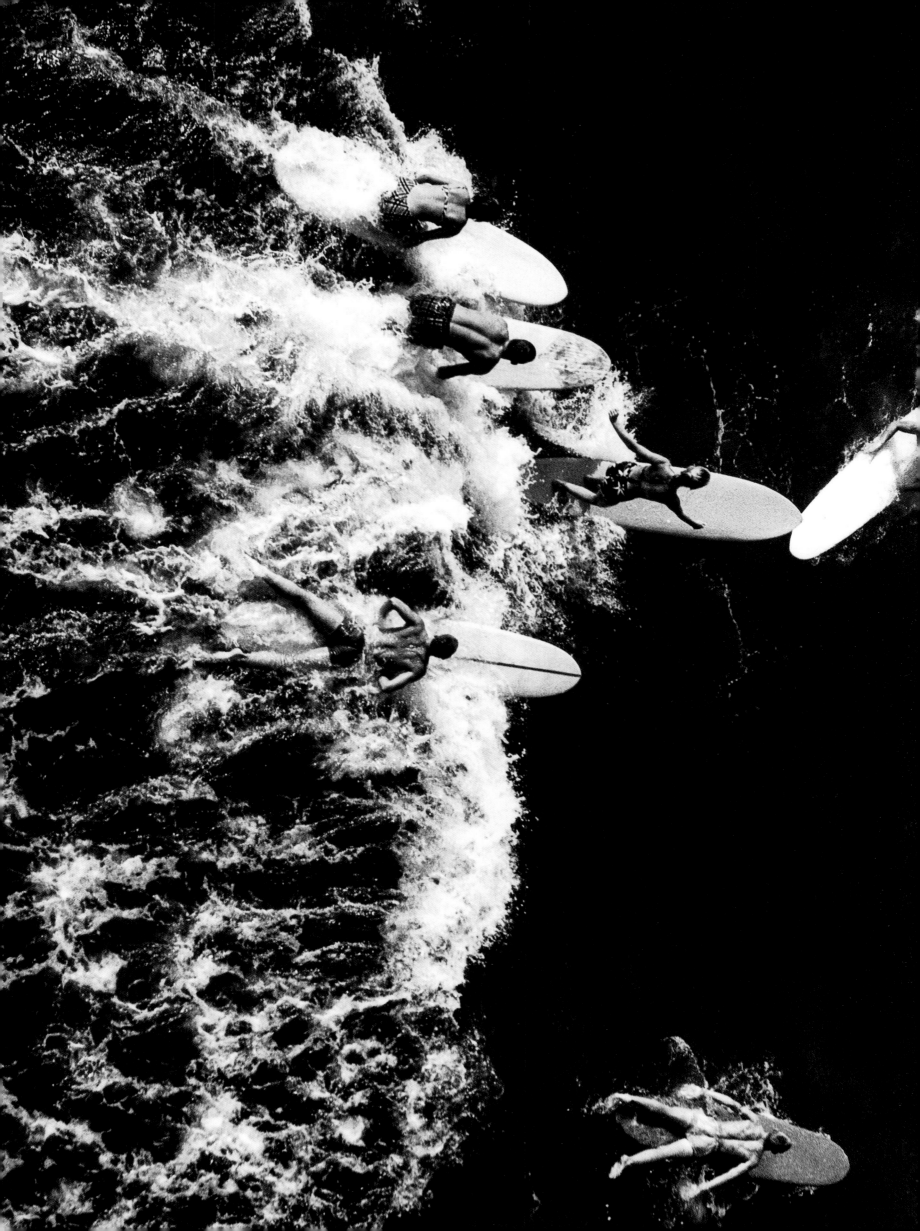

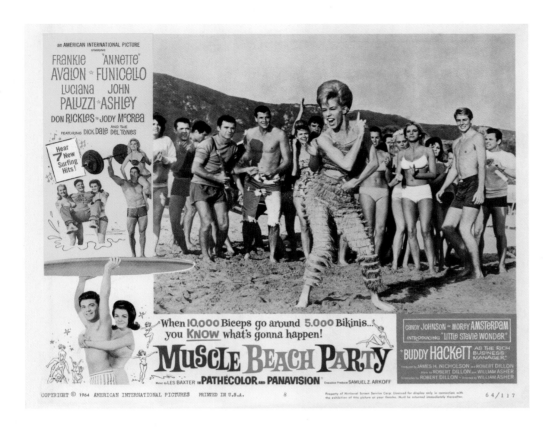

CALIFORNIA, C. 1964 *Photo, Allan Grant*

POSTER, *MUSCLE BEACH PARTY*, 1964

even racking up victories over California's legendary Dewey Weber surf team. Propper's Hobie model would go on to become the best-selling Hobie surfboard *in the world*—its 6,000 annual sales almost entirely on the East Coast. "When Tabeling or Crawford would go out and whip everybody in California they were *our* champions," says Murphy. "You could cut the pride with a knife."

A DISTANT WAR HITS HOME

In Hawaii, a high schooler named Gerry Lopez was taking in surfing's explosion contemplatively.Lopez's father was a surfing Honolulu newspaperman who took his young son to see a Grant Rohloff surf film sometime in 1961—around the time Lopez also saw his first copy of John Severson's *SURFER*. On one hand, Lopez lived on the most remote island in the Pacific. Onthe other, the guys who were appearing in *SURFER* and the films of Rohloff, Severson, Bruce Brown, and Greg Noll were the same guys he saw every day. Indeed, the roster of Lopez's classmates and educators reads like a Hawaiian who's who: Jeff Hakman, Paul Strauch, and Jay "Jaybird" Clark were classmates; Peter Cole (algebra); Ricky Grigg (summer school) and Fred Hemmings (science), his teachers. It was as if they were moonlighting as surf movie stars.

Yet, unlike many Californians, Lopez and his friends saw Hawaii's media exposure more as a vindication of a noble pursuit and a healthy addiction than a career opportunity. "We looked at surfing as a means to have a sense of identity and self respect," says Lopez. "That's really hard when you're a teenager asking 'who am I?' and trying to define yourself. But surfing wasn't anything that anybody in our group was serious about. I thought I would be an architect."

In Ventura, California, a Hawaiian-born contemporary of Lopez named Rick Thomas was rooming with a motley crew of hard partying transient surfers on the point at California Street, several of whom had been smoking weed and even experimenting with a then-legal CIA-invented pharmaceutical called LSD. When Vietnam flared into a full conflagration in 1965, some bailed with surfboards to parts unknown. Some married to avoid service. Some, like Thomas, signed up. Thomas had steered clear of drugs until he was handed a joint on the train ride to San Francisco for his shakedown Navy cruise. That night, a different sort of shakedown occurred in the city's Haight-Ashbury district, where an introduction to

psychedelics, free love, and the budding counterculture went down in a beatnik commune. "There was just this counterculture explosion," he says. "It was going on down south too in places like Laguna Beach, with the Brotherhood of Eternal Love, among the avant-garde of the surf culture. Guys like David Nuuhiwa and Rick Griffin" (who would begin to surreptitiously slip in references to drugs and the counterculture into *SURFER* right under the nose of publisher Severson).

ENDLESS SUMMER — ENDLESS BUMMER

To Lopez and Thomas, the cognitive dissonance of the mid-'60s was surreal. In Honolulu, one surfer might be departing Schofield Barracks for a potentially fatal deployment to Vietnam. Another might be dropping acid for the very first—or last—time. Yet another might have just plopped down a dollar to sit in Waikiki's air-conditioned Varsity Theater to watch *Beach Blanket Bingo.* By the time Thomas found himself along the periphery of the Cua Viet River, staring at achingly perfect waves from behind a machine-gun post on a patrol boat, he was having serious doubts about this undeclared war.

And then, into this increasingly insane world, dropped a beacon of sanity and escape. Bruce Brown's *The Endless Summer* opened in June of 1966, and was to be his—and surfing's—cinematic magnum opus. Brown sheepishly declared that he was simply making a movie that he liked, but the seemingly simple yet brilliantly nuanced travelogue of a pair of hot young surfers following summer around the world in 1963 in search of (and finding) the perfect wave, shows a filmmaker at the top of his game. The movie produced record crowds across America's landlocked heartland.

"Bruce Brown comes out with *The Endless Summer*—a free-loving, funny, goofy, corny, racist travelogue," says *SURFER*'s former editor and filmmaker Sam George. "But at the end there's that one line: 'Think of the thousands of waves that had gone to waste, and the waves that are going to waste right now at Cape St. Francis [in South Africa].' Then turn back to that first issue of *SURFER*. It showed everyone having fun *together*, surfing the Makaha shorebreak, eight guys dropping in at Waimea. Cartoons. Maps of surf spots—then Severson's coda at the end of the magazine: 'In this crowded world the surfer can still seek and find the perfect day, the perfect wave, and be alone with the surf and his thoughts.' Brown and John Severson had combined to create this culture of fantasy within surfing. That fantasy carried surfers through the last years of the 1960s—when it became imperative to

STARRING

BOB
CUMMINGS
DOROTHY
MALONE
FRANKIE
AVALON
ANNETTE
FUNICELLO
HARVEY
LEMBECK
JODY
McCREA
JOHN
ASHLEY

ALSO STARRING
MOREY
AMSTERDAM
AND EVA SIX
And Featuring
DICK DALE
AND THE DEL TONES

It's what happens
when 10,000 kids meet
on 5,000 Beach Blankets!

in AMERICAN INTERNATIONAL'S

BEACH PARTY

IN PATHECOLOR AND PANAVISION

Directed by WILLIAM ASHER Written by LOU RUSOFF Produced by JAMES H. NICHOLSON and LOU RUSOFF Executive Producer SAMUEL Z. ARKOFF Music by LES BAXTER

BEACH PARTY 63-261

SURFING 1962-1969

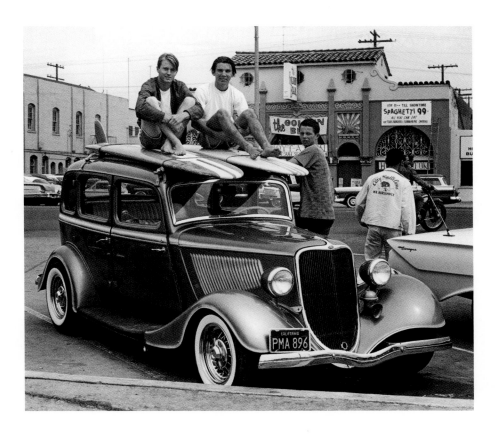

turn your back on what was going on. It was not so much to march to end the war, though some surfers did that, but to go off to South Africa, Mexico, Australia, or Southeast Asia and smuggle Thai sticks—just so you could go be alone and surf."

Thanks to a case of childhood asthma and what he reckons was the intervention of his vehemently antiwar pediatrician, Lopez was declared unfit for service in 1967. By now, surfers were doing whatever they could to avoid the war. Dressing up in women's underwear and makeup to feign homosexuality, or acting batshit crazy. Many early draftees, including eventual *SURFER* publisher Steve Pezman, were declared unfit because of "surfer's bumps," golfball sized calluses that appeared on the knees and feet of surfers who constantly kneeled atop their boards to avoid the chilly water. Now wiser, recruiters simply offered crestfallen draftees the chance to have them sliced off. "They were drafting surfers like crazy," Lopez says. "And everybody who went in, whether they saw combat or not, they came back fucked up. Wounded. Traumatized. Maybe strung out on heroin. Nobody got out of Vietnam totally alive."

The obvious alternative was the counterculture. Rick Griffin simply disappeared into it, reappearing in 1966 as the designer of seminal concert posters for the Grateful Dead, Jimi Hendrix, and Jefferson Airplane, and the logo for a new magazine called *Rolling Stone*. Even *SURFER*'s publisher, John Severson, embraced Griffin's transformation via herbal remedy. Fueled by Griffin's mesmerizing art, *SURFER* began its own long, strange trip, while Griffin became one of the preeminent psychedelic artists of the 1960s.

Rather than pharmaceuticals, Gerry Lopez concentrated on the mind-altering drug provided by the Banzai Pipeline and the fantastical right-handers at Maui's Honolua Bay. Aboard a thin 9'6" Dick Brewer rocket called a Pipeliner, he would become known for Zen calm while the world was exploding around him; the model cosmic rider for an emerging mystical age.

THE SHORTBOARD REVOLUTION

Five thousand miles away, Australia's surfing diaspora was also evolving. Aussies had always concentrated far more heavily along their coastline (around 85 percent of the country lives near the ocean) than Americans, and thanks to the country's surf life-saving clubs that had proliferated for generations, they considered surfing as much a national pastime as soccer or cricket. Yet, they were also just as keen on Dick Dale, Dale Velzy,

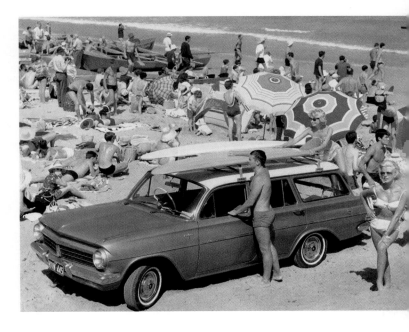

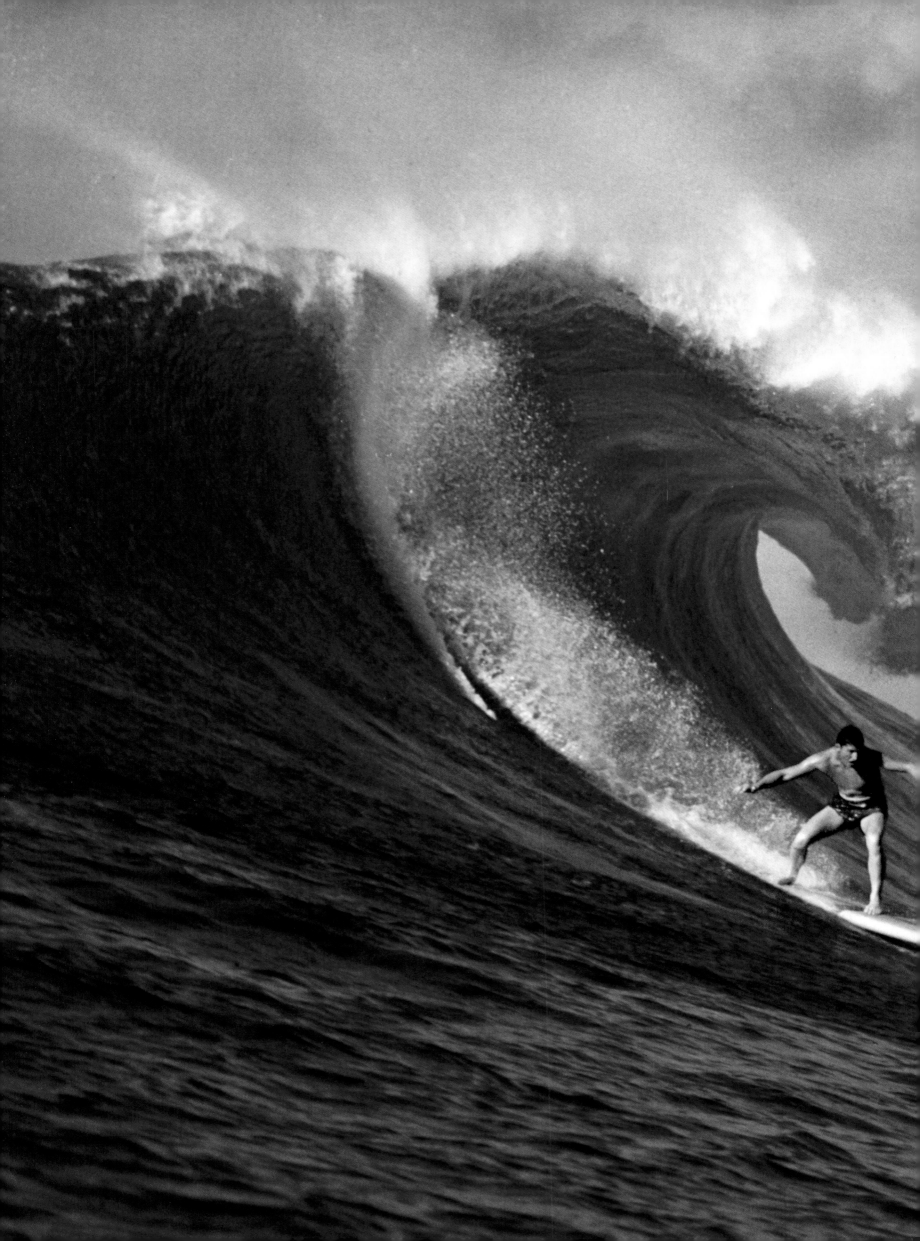

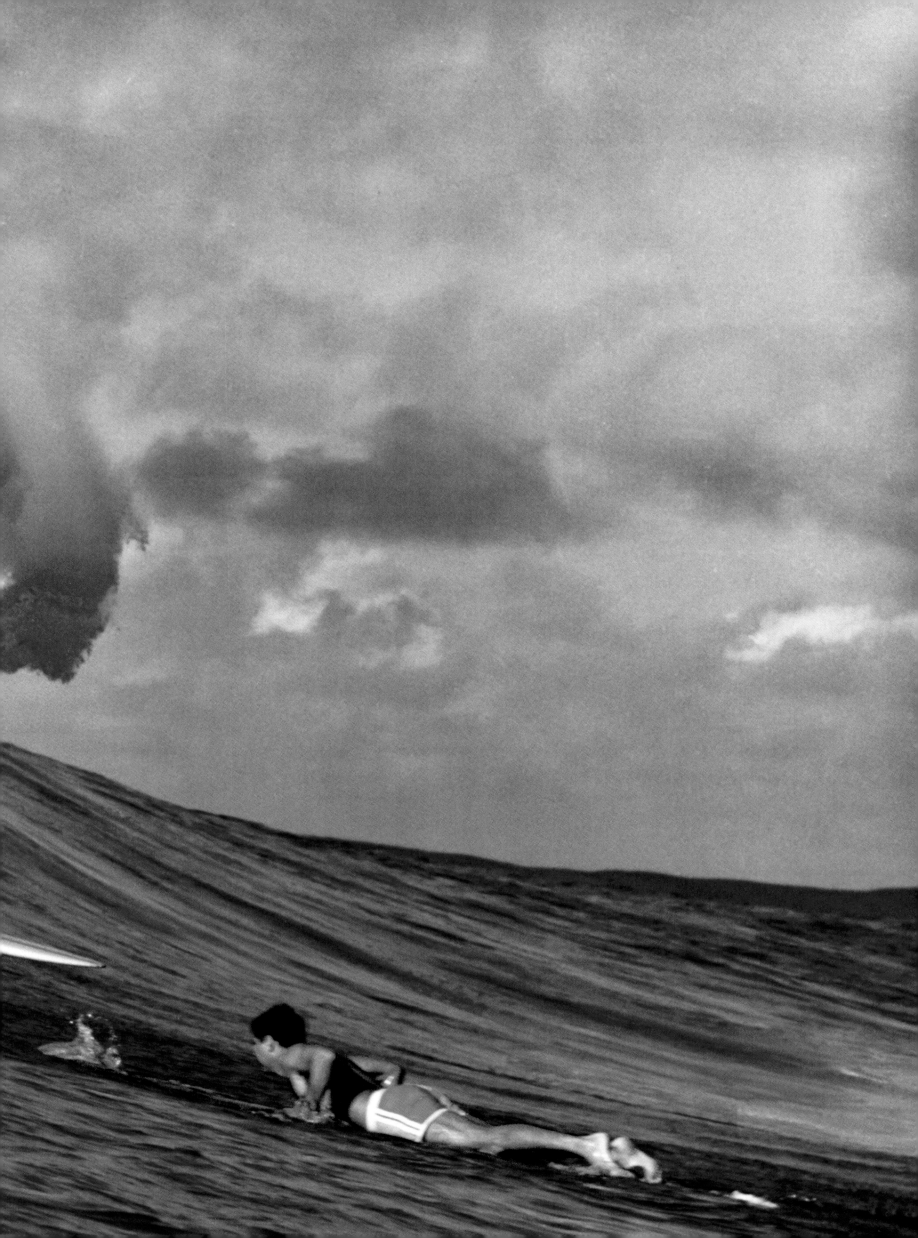

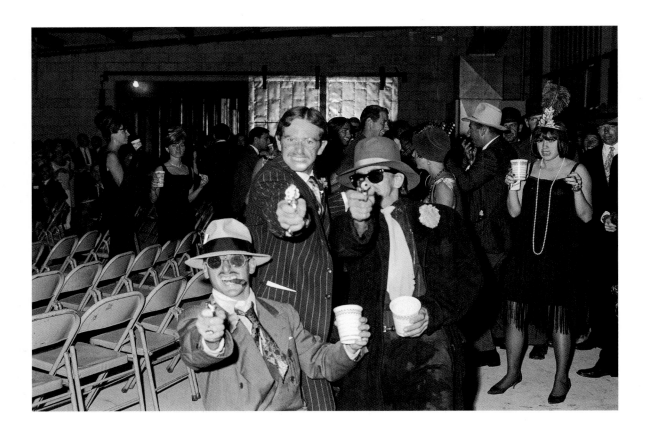

Bruce Brown, and *SURFER* magazine as the Californians. "Surf culture took off," says revered Australian shaper Bob McTavish. "We started wondering what was around the next headland. And we started traveling and discovering beautiful point breaks. We had this wonderful huge coastline, clean air, and clean beaches. It was mecca. Many, many guys threw away careers and futures and jobs and university and just went surfing."

As Vietnam escalated, Australia marched in lockstep with America, and in 1965, instituted a draft. McTavish believes that by 1967 Aussie surfers were even more politically opposed to the war than Americans. "We were the full-on antiestablishment," he says. "I was writing in the magazines 'Make Waves Not War,' and promoting mind-expanding drugs, traveling to the States each year—running in the counterculture world. And as a writer, I was transmitting what was happening in California. Australia was so much like California then. We were a total brotherhood, mate."

Yet that brotherhood would be tested. At the 1966 World Surfing Championships in San Diego, Nat Young displayed a powerful repertoire of turns and noserides on a thin McTavish board, decimating a field that included David Nuuhiwa and Jock Sutherland—a Pipeline idol of Gerry Lopez. Young did little in an ensuing interview with *SURFING Magazine* to endear himself to the Americans, insulting Nuuhiwa's noseriding and women in general by saying "Girls shouldn't surf, they make fools of themselves."

After what he perceived as a lack of American recognition of Young's victory, Australian firebrand journalist John Witzig, younger brother of filmmaker Paul Witzig, penned a 1967 article for *SURFER* titled "We're Tops Now." "How much a shock has it been to see the idols, the graven images, fall so unceremoniously to the ranks of also-rans," he wrote. "Everything the pedestal of California surfing is built upon means—nothing!"

Another salvo was launched via a quiver of radical new Australian surfboards. Shorter and lighter than anything currently ridden, and bearing flexible skegs modeled after the fins of tuna fish, the boards were designed by McTavish and George Greenough, a Santa Barbara iconoclast who had blown McTavish's mind in 1965 with deep carving rollercoasters on a short, stubby kneeboard. Using Greenough's principles, McTavish and his compatriots like Midget Farrelly had in turn, blown the minds of visiting California pros Mickey Muñoz and Harry "Skip" Frye in 1967 at a competition in Sydney. There, the Californians found locals riding these radical boards in lengths as short as 7'6".

RUSTY MILLER AND MIKI DORA; SUNSET BEACH, HAWAII; 1963 *(Pages 206–207)* The original photo for Hamm's ad campaign had Miki Dora paddling in foreground. *Photo, Don James*

PARTY AT GREG NOLL SURFBOARDS; HERMOSA BEACH, CALIFORNIA; 1965 A small cartel of surf industrialists in South Orange County were dubbed the "Dana Point Mafia" because of their lopsided influence on the fast-growing surf culture. From left to right: Mickey Muñoz, Jeff Logan, and Ronald Patterson. *Photo, LeRoy Grannis*

SKIP FRYE; PACIFIC BEACH, CALIFORNIA; 1963 Frye, the epitome of classic California surf cool, demonstrates his tip-riding technique for the local San Diego newspapers. In the background is Crystal Pier. Photo, Ron Church

REDONDO BEACH, CALIFORNIA, 1963 *Photo, LeRoy Grannis*

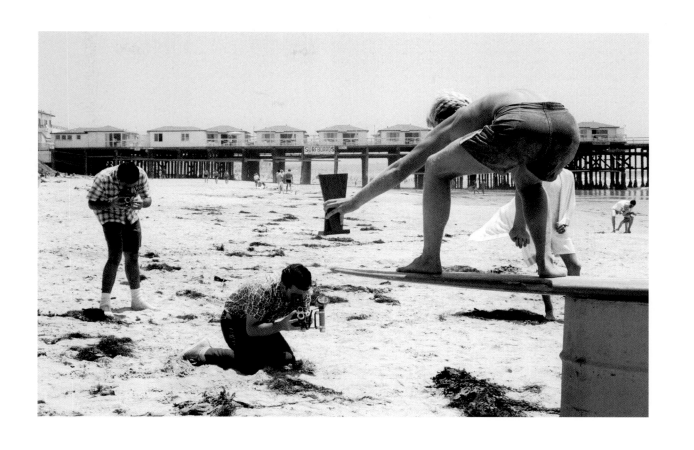

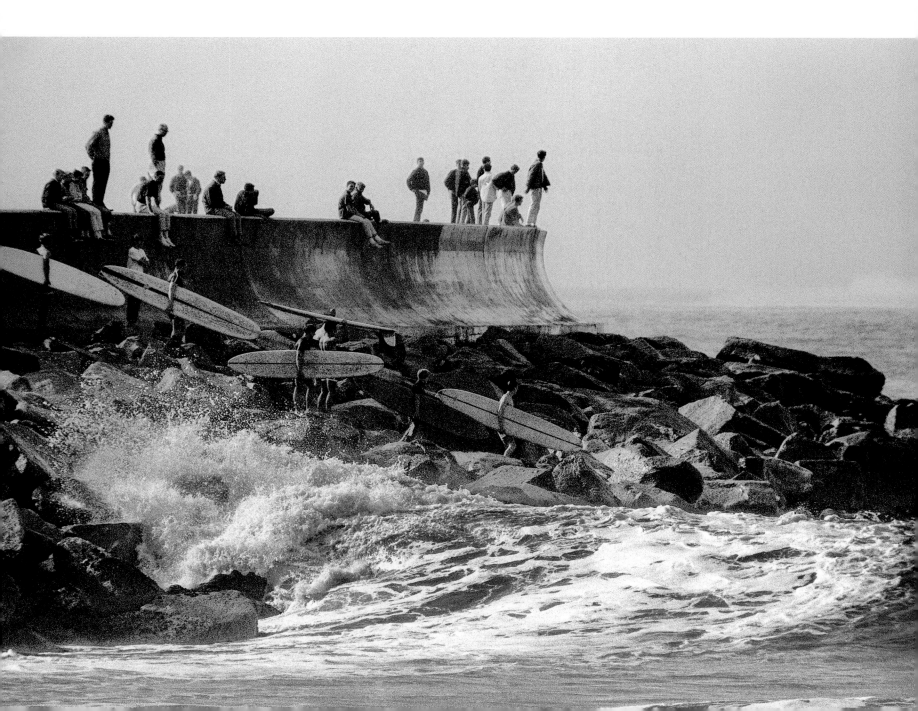

McTavish and Greenough reached Hawaii with a film crew in late '67 to test these "Plastic Machines." The boards were shaped something like a boat, with vee-shaped hulls and much more volume toward the tail. They would basically list over on one side or the other during a ride, and would thus always be ready to turn from one edge to the other. They weren't meant to be ridden in traditional longboard cross-step style. "The walking's cut out," McTavish says in the film *Fantastic Plastic Machine*, "You haven't got to walk to the back of the board to maneuver it. You stay right where you are and just go 'whammy.'"

McTavish made an inauspicious debut on a nine-foot Plastic Machine at the 1967 Duke Kahanamoku Invitational at Sunset Beach in Hawaii, where his wide board spun out in the big surf. But its potential was revealed when McTavish dropped to the bottom of a wave, cranked a turn, and drove straight back up the face before being hurled over the falls. He cursed his wipeout. "But everybody else saw that bottom turn and just said, 'Holy shit,'" says Lopez. "Nobody's board at the time would even *make* a turn like that."

McTavish then traveled to the island of Maui to trade ideas with an emerging North Shore guru shaper named Richard "Dick" Brewer. "I was raving about vertical surfing down in Australia. But at the same time the beauty of Dick's templates was just outstanding compared to my ugly Plastic Machines. By the end of the week, we'd meshed together our designs. Brewer had the templates, I had the length."

On December 20, 1967, newly minted Brewer riders Gerry Lopez and his friend Reno Abellira were hanging out at "LSD," Brewer's Lahaina Surf Designs surfboard factory in Maui, when a veritable who's who of Australian surfing rolled up. "Nat (Young), (George) Greenough, Ted Spencer, John and Paul Witzig, Russell Hughes, and McTavish drive up with this big stack of boards," says Lopez. "They said they were shortboards. But they weren't really *that* short."

All the Aussies drifted off toward the ocean except McTavish, who joined Lopez and Abellira in Brewer's shaping room. Brewer had crafted Lopez's foam blank into a beautiful 9'6" gun—ready for its coat of fiberglass. "It was a classic," says McTavish. "Brewer asks, 'What do you think of this?' I go, 'It's beautiful, Dick.' But then I pulled the handsaw off the wall, and located it one foot from the tail. I said, 'But, Dick…' and I held the saw there and looked him in the eye, and he looked at me, and a smile crept across his face. Not a word was said, just this smile, and I handed Dick the saw."

DICK METZ, HOBIE STORE; HONOLULU; 1964

NORTH SHORE, HAWAII, 1965 From left to right: Paul Strauch, George Downing (sitting), Fred Hemmings, Joey Girard, and Bobby Cloutier

BUZZY TRENT; NORTH SHORE, HAWAII; C. 1962 *Photo, Don James*

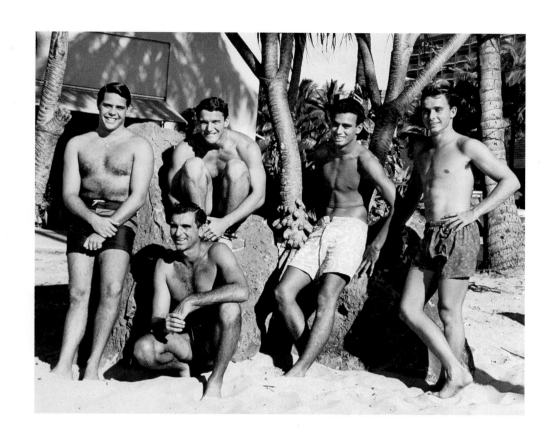

"Then he starts sawing on my blank," says Lopez. "I go, 'Shit, R.B., I want a 9'6"! What the fuck are you doing, man? The blank's down to 8'6"? Nobody's heard of a board that short.' He says, 'Just flow with it, man, I got an idea.' And I go, 'Well, fuck, I guess I don't have any choice.' Reno's over there laughing in the corner 'cause his 9'6" is already shaped."

The board would come to be called a "mini gun." It was wide up front and tapered toward the tail. Lopez tested it out alongside the Aussies at big Honolua, then Kahana Lefts, "and I'm thinking, wow, this board is working pretty good," he says. "It turned so much better and quicker, accelerated faster and fit the wave better. Then we drove over to Papaula outside Kahului Harbor. It's eight feet, *perfect*. *Everybody* wanted to borrow it. When I rode it at Pipeline, it's the board that made me think, holy shit, you've got a chance out here."

The possibilities of the shortboard were first widely revealed to American audiences by way of Nat Young, Midget Farrelly, McTavish, and a wildly talented Aussie crew in Paul Witzig's 1967 film *The Hot Generation.* The film ended with a mind-bending exchange of waves at Honolua Bay by Young and McTavish. Surfers were mesmerized by the swooping turns and deep, surreal barrels these short surfboards delivered. Surfing suddenly shifted as if on a giant fulcrum. Longboard shapers sitting on huge inventories pleaded with publishers like John Severson to hold off on covering the shortboard explosion until they could pare down.

Greg Noll learned of the revolution early when his Hawaiian dealer Charlie Galanto ordered 150 short boards. "I remember [fellow shaper] Don Hansen coming to my shop to have lunch and bullshit," says Noll. "He kept trying to get in the backroom to see what I had going on. I had to step away, and he opens the door and lets out this bellow. 'What the fuck's going on?' I had 75 boards all laid out on the shaping racks. None of 'em over eight feet."

To make matters worse, surfers started jumping ship from established shapers to build their own boards or ride models from garage shapers. Film and print extended the shortboard fantasy. "The perception now was that surfers were tripped out mind travelers seeking nirvana in the mystic eye while riding the crystal cathedral," says surfer and journalist Sam George. "But very few people were doing anything like that. We idealized this fantasy—that surfers were trying to find something—looking at waves and thinking, where can we ride that we've never ridden before? Really, most of the boards were terrible and guys just started

JACK'S SURFBOARDS; HUNTINGTON BEACH, CALIFORNIA; 1964 Jack Hokanson opened one of the first surf shops in Huntington Beach in 1957 and sponsored early skateboard competitions. Skateboarding, a by-product of surf culture, accelerated beyond fad status to become a sport of its own. *Photo, LeRoy Grannis*

PROGRAM, WORLD SURFING CHAMPIONSHIPS, 1968

POSTER, U.S. SURFING CHAMPIONSHIPS, 1966 *Art, Earl Newman*

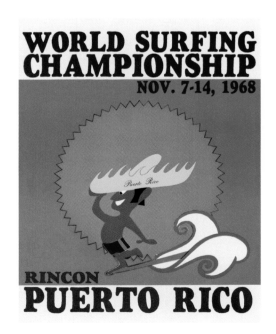

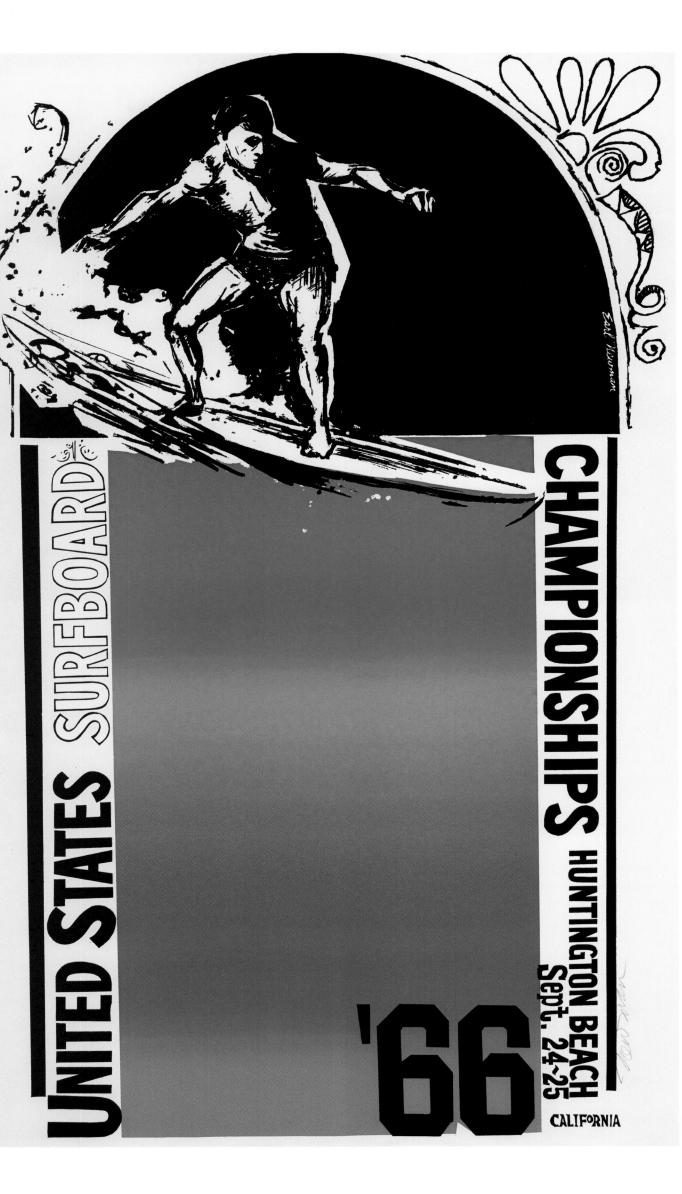

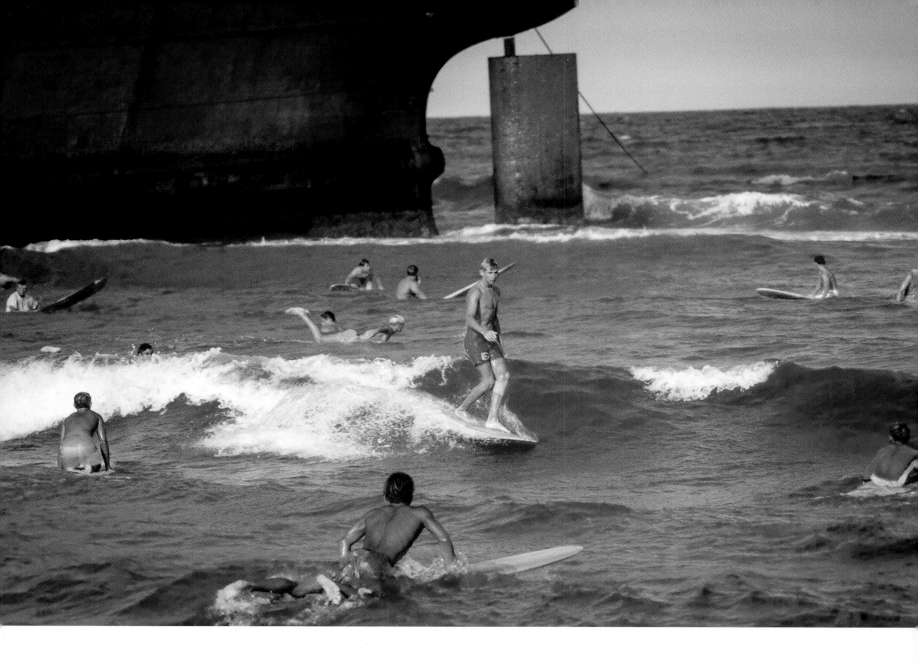

surfing awful, wagging and spinning around." It was bad surfing due to the learning curve everybody took to get there, coupled with new, shorter equipment that looked cool but was experimental in nature.

In a more practical sense, the shortboard dealt surfing a heavy blow in places where the water was too damn cold to sit half-submerged waiting for a wave. Furthermore, older surfers who didn't want to transition to newer, more difficult to ride boards, simply quit. Matt Warshaw figures that from late 1967 through the early 1970s, the surfing population in the United States probably dipped 10 to 20 percent — perhaps 50 percent in New England. McTavish reckons the same was true in Australia.

SURFER GOES COSMIC — AND CORPORATE

Back in Dana Point, California, John Severson and his motley crew of editors were flowing with the times, and soon enough, shorter boards. Severson hired a brilliant, cosmically tuned young editor from Santa Cruz named Drew Kampion to shepherd *SURFER* through the Age of Aquarius. Kampion in turn, launched *SURFER*'s longtime environmental column "Our Mother Ocean" and a litany of hallucinogenically enhanced stories. By late 1969, Huntington Beach local Steve Pezman had turned his considerable intellect away from marijuana dealing and toward shaping and writing for magazines like *Petersen's Surfing* in Los Angeles. When Severson offered "Pez" a *SURFER* job, he happily took a desk alongside Kampion. "*SURFER* became the most creative, freeform expression of youthfulvalues and culture in the United States," says Pezman. "Bob Dylan was Drew's hero. He kind ofunpeeled surf culture with a Dylanesque point of view and he totally raised the bar at *SURFER*.

"Kampion touched a nerve with everyone," says Severson. "He wrote what we were thinking, and he had a good grip on the artistic presentation of the magazine. Before Drew,

JOHNNY SENNETT; PALM BEACH, FLORIDA; 1965 On September 7, 1965, the freighter *Amaryllis* lost rudder control and was driven ashore at Singer Island, creating an instant wave to the delight of local Palm Beach surfers. *Photo, M. E. Gruber*

FIRST BEACH; NEWPORT, RHODE ISLAND; 1965 *Photo, Ed Greevy*

SOUTH PADRE ISLAND, TEXAS, C. 1966 Despite generally small and crumbly Gulf Coast waves, South Padre Island quickly became a hotbed of Texas surfing in the 1960s. *Photo, Ron Stoner*

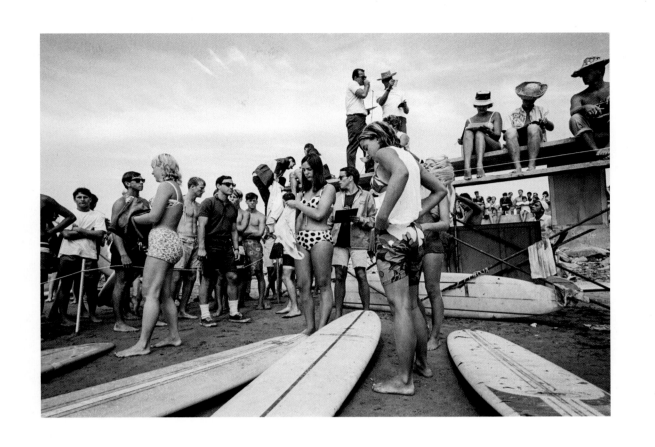

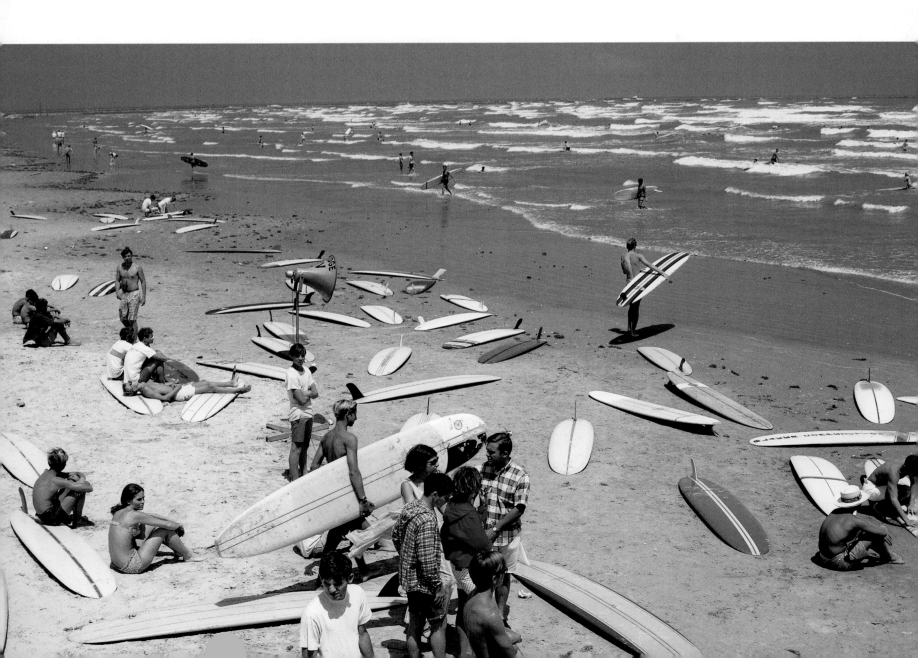

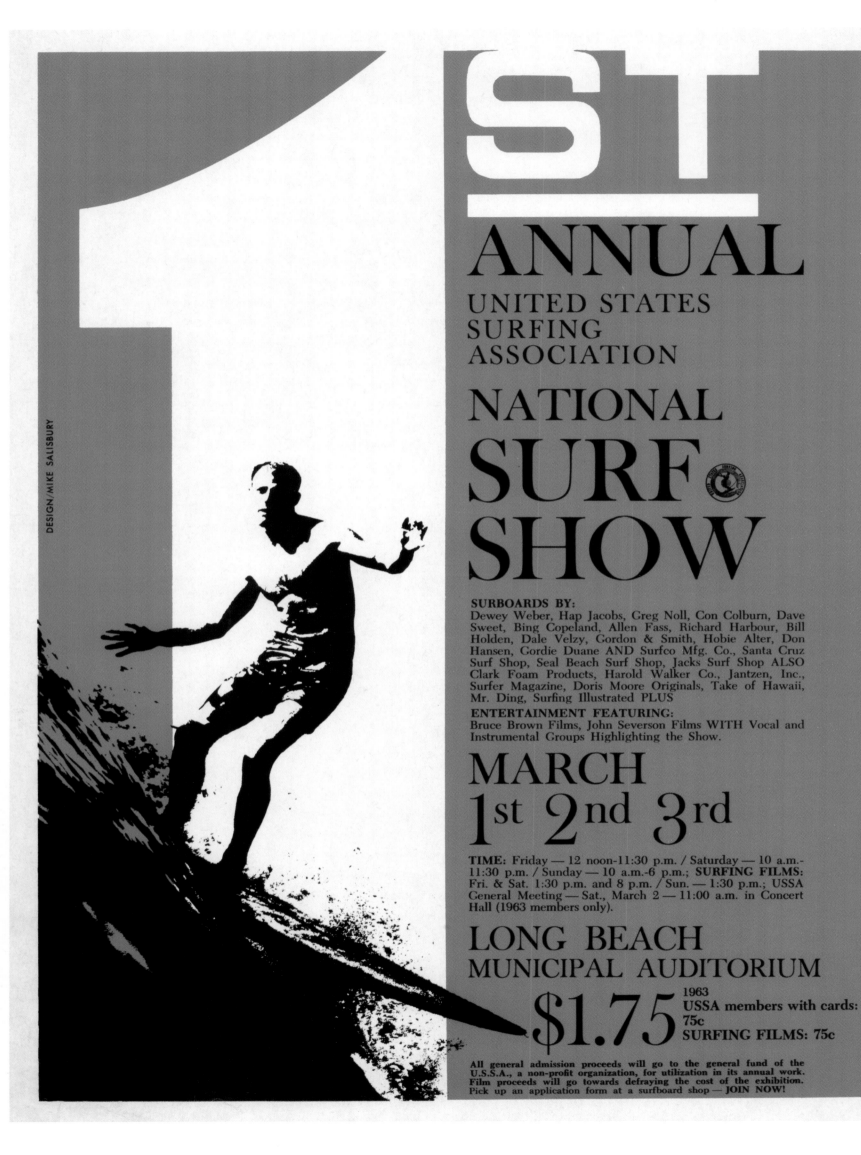

our words didn't seem to reflect the youth and rebelliousness and the larger culture. Drew put it all together. If you go back and read those issues from the late '60s, I don't know if they make much sense today—but back then they sounded pretty good."

Yet all was not well in Severson's world. At the end of 1969, he faced the ultimate antiestablishment nightmare when President Richard Milhous Nixon established his beach-front "Western White House," literally next door to Severson in San Clemente's Cypress Shores neighborhood, south of Laguna Beach. While Severson was regularly welcoming psychedelic wanderers of all stripes, the devil incarnate was doddering around next door in a bathrobe and slippers. Severson's mother-in-law started dating a Secret Service agent who relayed that Nixon's men were eavesdropping on everything that went on at the Severson home, and even noting Nixon editorial slaps in *SURFER*. Matters weren't helped when artist Rick Griffin pulled into the Severson driveway behind the wheel of Motorskill, the quintessential hippie bus Severson and Griffin had painted, nor when Kampion was arrested by military police for surfing at Trestles, the then off-limits waves just south of Cypress Shores on Camp Pendleton Marine base. "We were not friends of the administration," says Kampion. "John got really nervous."

In 1970, Severson released his own pièce de résistance by way of a beautiful medita-tion on surf life called *Pacific Vibrations*. In full psychedelic splendor, the film reeled from Edenesque Hawaiian lineups, to bucolic California ranchland, to depressing shots of factories, war, and sardine-can packed beaches. He followed iconoclasts like Miki Dora, who said, "I think we're having a nervous breakdown in this country."

Surfer Laird Hamilton's father, Bill, told Severson from atop the Huntington Beach Pier, "I'm just trying to stay one step ahead of the man's progress, you know? I'd give it another three, four years the way it's going now."

"And then where?" asked Severson.

"Well, there are about a thousand islands down in the Pacific," said Hamilton. "Take your choice."

One day, Pezman and Kampion were surprised to answer the queries of a small team of suited bean counters who had infiltrated the old airplane hanger that doubled as *SURFER*'s headquarters. Shortly thereafter, Severson promoted a bemused Pezman to publisher and announced the sale of *SURFER* to For Better Living Incorporated, a company that made

ADVERTISEMENT, 1ST ANNUAL SURF SHOW, 1963 *Design, Mike Salisbury*

BRUCE BROWN, SURF-O-RAMA; SANTA MONICA, CALIFORNIA; 1963 The Surf-O-Rama was part trade show, part swap meet, and part tribal gathering. Although it eventually died off, the idea became part of a multibillion-dollar action-sports industry. *Photo, LeRoy Grannis*

JACK HALEY SHOP; SEAL BEACH, CALIFORNIA; 1963 Nicknamed "Mr. Excite-ment" for his charismatic style, Haley later opened a popular restaurant called Captain Jack's in nearby Sunset Beach. *Photo, LeRoy Grannis*

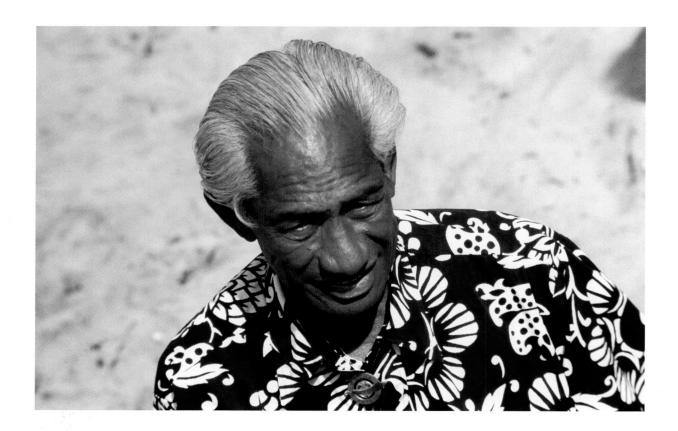

concrete highway overpasses. He sold his home in Cypress Shores and disappeared to one of Hamilton's islands.

"I watched with great interest as Nixon's train eventually went off the tracks," says Severson. "He deserved it all."

THE LAST WAVE

The 1960s ended with an astonishing burst of human achievement, violence, and optimism. In 1969, Led Zeppelin would release their first album, the Beatles would play their last concert, Creedence Clearwater Revival would sing "Bad Moon Rising," and later that summer, Neil Armstrong would walk on the moon. In August, followers of Charles Manson would brutally murder a pregnant actress named Sharon Tate and four of her friends in the Hollywood Hills. A week later, a famed concert kicked off in Woodstock, New York. By December 1, as American students anxiously listened on the radio to learn whether thedraft lottery would match their birthday, a vast low pressure system beneath the Aleutian Islands had rendered the entire North Pacific a cauldron of storm and swell. By December 4, the biggest waves in living memory were hammering Hawaii.

Greg Noll had taken in the latter '60s with equal measures of awe and disdain. He understood that the changes wrought in surfing the previous few years had been the result of decades of pent-up social upheaval and a groundswell of youth. But Noll was no flower child. "I kind of came from the culture of spit on 'em and punch 'em in the face," he chuckles. "If someone tried to hand me a flower, it didn't usually turn out too well."

On the morning of December 4, Noll studied the hazy swells detonating outside of Makaha. The swell was still rising, and he wondered just how damn big Makaha could get. Heart in his throat, Noll was never more certain that he was a big-wave lifer. "I woke up that morning sure I was gonna surf 'til my arms won't work anymore," he says. By late that afternoon, Makaha was as big as anyone could recall, with the waves exploding with such power that the droplets of water on Noll's board sizzled. With his fretful wife, Laura, and his good friend Richard "Buffalo" Keaulana trying to make him out far up the point, Noll realized that even if he managed to catch a wave, the currents, rocks, and boiling whitewater inside left him at best a 50 percent chance of survival. Catching a wave, though, was his only means back to the land of the living.

DUKE KAHANAMOKU; SAN DIEGO, CALIFORNIA; 1966 Duke was able to attend the first three contests named in his honor. He died January 22, 1968, in Honolulu at the age of 77. *Photo, Ron Stoner*

MAGAZINE COVER, *SPORTS ILLUSTRATED*, 1966 *Sports Illustrated* embraced surfing early on as a legitimate sport worthy of thoughtful features and surfer profiles. Phil Edwards, generally considered the best surfer in the world at the time, made the cover.

UNDERWATER VIEW; MAKAHA, HAWAII; 1962 *Photo, Don James*

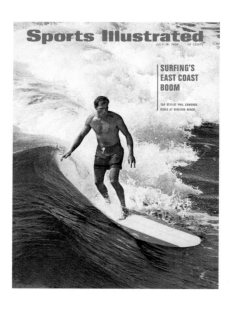

PIPELINE, HAWAII, C. 1965
Photo, LeRoy Grannis

MALIBU, 1963 Surf photographer LeRoy Grannis
was also a Boy Scout troop leader for his son Frank
and he would often load up his truck with boards for
a weekend surfari. *Photo, LeRoy Grannis*

When the biggest damned set that he'd ever seen from the water loomed, he windmilled his big arms and jumped to his feet atop his bouncing 11-foot-long "rhino chaser." Noll never estimated how big the wave was himself, but those on the beach said it was in the neighborhood of 50 feet. Set against the speeding water, his skeg resonated like a gothic pipe organ. Buffalo and Laura watched his approaching wake and gasped when the wave reared up into a monstrous closeout. Noll leapt off, got beat to absolute hell, and staggered up onto the sand, where Buffalo promptly handed him a beer.

"I went to bed that night with some confusion," he says. "I didn't have that feeling—didn't feel I had to prove myself anymore. I realized I'd accomplished what I'd wanted. I'd ridden a good-sized wave. At that point, I could enjoy myself and my family and the ocean, and dive and fish and surf and realize that there are other things in life besides catching some stupid big wave."

More than anything, Noll says, he came away from that day, and from the 1960s, with a profound reverence for the seemingly simple, but life-affirming act of surfing and what it can do for your soul. Surfing changed plenty from the dawn of the decade to Noll's big-wave curtain call, but for scores of people like Noll, surfing became the rock—the only source of stability in a mad, mad, mad, mad world. In the ensuing years, he has struggled to explain this concept to countless nonsurfers. "Inevitably they ask, 'Greg what is it about surfing? Blah, blah, blah,'" he says. "I got so tired of answering, that I just told 'em, 'People that do it, people who surf, you don't have to ask them that question. They know. The rest of you poor bastards are never gonna know and I feel sorry for you.' The more I've tried to explain why guys will give up their families, jobs, everything just to surf—you can't do it. People see this devotion, they know something's there, and they want a piece of it, but they can't buy it. It's not packaged like a steak. You can't get it at a bar. You either have it in you, or you don't."

PARADISE BAY; NORTHLAND, NEW ZEALAND; 1964 Because of its isolation, New Zealand was, for the most part, off the world surfing map until it was featured in *The Endless Summer* in 1966. *Photo, Neville Masters*

CAPE ST. FRANCIS, SOUTH AFRICA, C. 1966 The perfectly peeling waves of Cape St. Francis as seen in *The Endless Summer* drew surfers from around the world to South Africa. From left to right: Ron Perrott, Ian Harwood, Jim Pike, and Tony Burgess

HOUT BAY, CAPE TOWN, SOUTH AFRICA, C. 1966 Cape Town's scenic coastline proved to be a bounty of new surf breaks explored and first ridden in the early 1960s. *Photo, Ron Perrott*

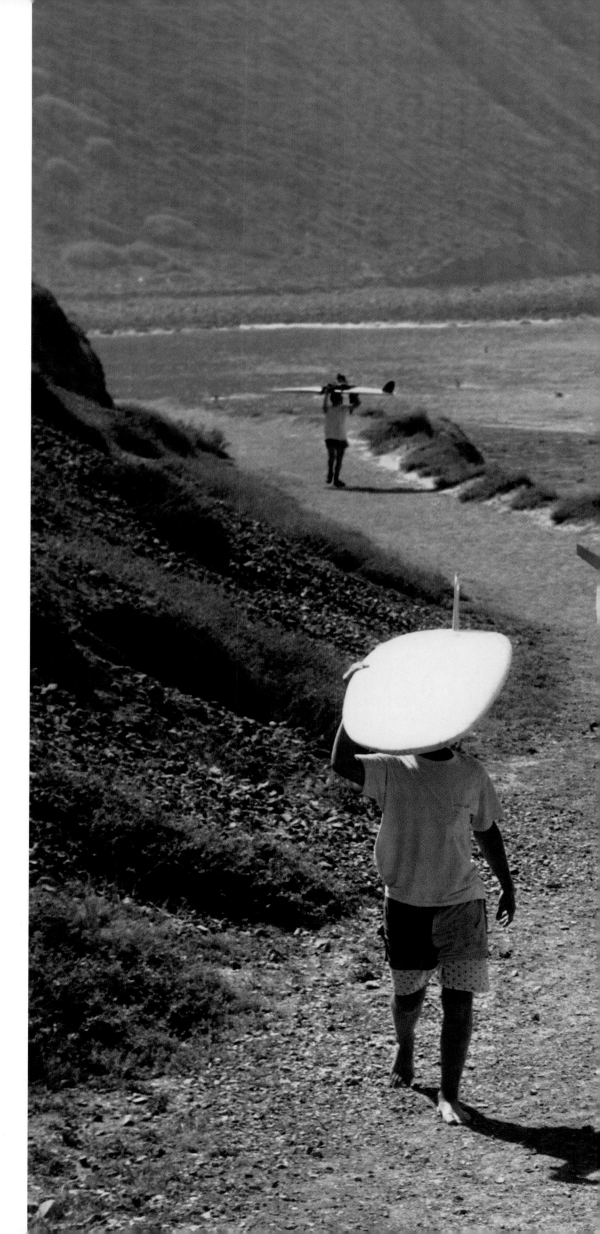

PALOS VERDES, CALIFORNIA, 1964
With lightweight foam boards and a flood of new surfers coming into the sport, Palos Verdes Cove went from Depression-era secret spot to '60s beginner's break. *Photo, LeRoy Grannis*

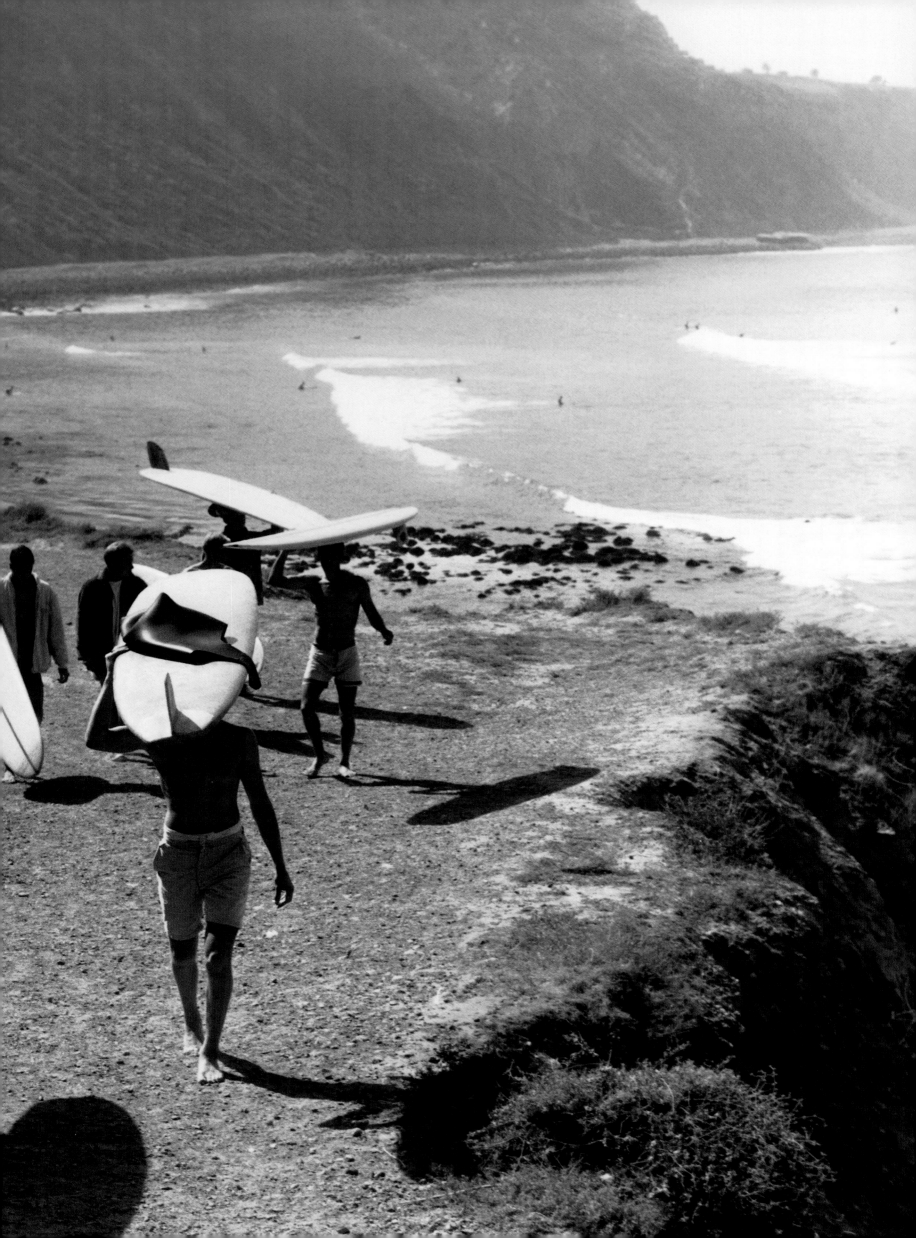

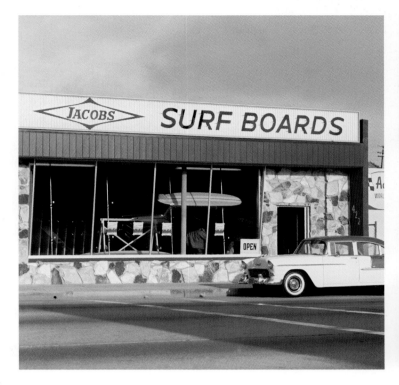

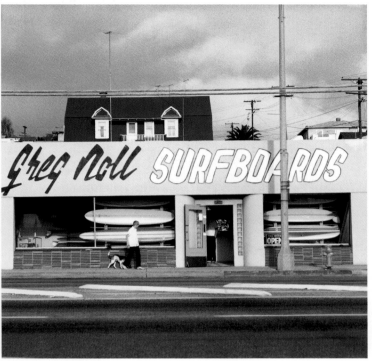

GREG NOLL'S DISPLAY ROOM; HERMOSA BEACH, CALIFORNIA; 1961 *Photo, LeRoy Grannis*

JACOBS SURFBOARDS; HERMOSA BEACH, CALIFORNIA; 1963 *Photo, LeRoy Grannis*

GREG NOLL SURFBOARDS; HERMOSA BEACH, CALIFORNIA; 1963 Behind the shop was a 20,000-square-foot surfboard factory where Noll and his workers "blew foam," then shaped, glassed, and sanded up to 200 boards per week for the booming surf market. *Photo, LeRoy Grannis*

DEWEY WEBER SHOP; VENICE, CALIFORNIA; 1968 *Photo, LeRoy Grannis*

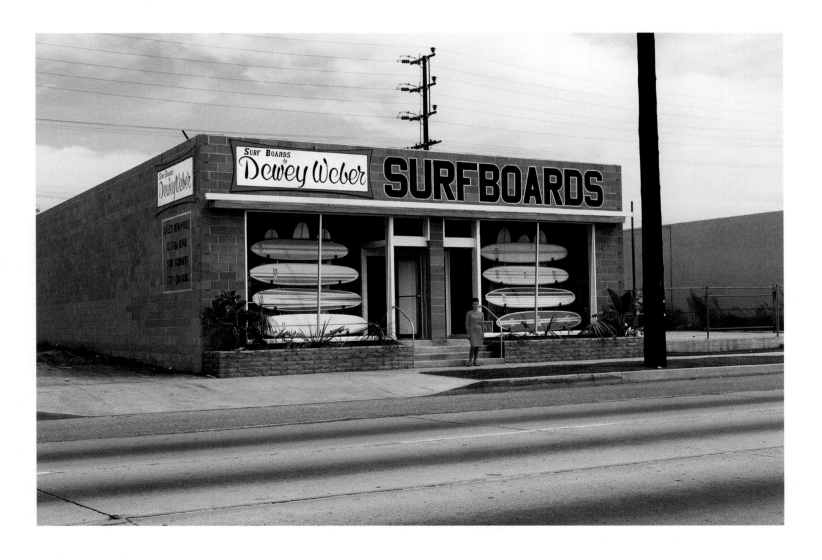

JACOBS SURFBOARDS; HERMOSA BEACH, CALIFORNIA; 1965 Dudley "Hap" Jacobs approached surfboard making as an Old World craft that combined ultimate function with impeccable form. His showroom was called "the Notre Dame of surf shops." *Photo, Steve Wilkings*

HAP JACOBS; HERMOSA BEACH, CALIFORNIA; 1963 *Photo, LeRoy Grannis*

JACOBS SURFBOARDS ADVERTISEMENT, 1963 Resin pigment tints and pinstriping is where the "Kustom Kulture" car aesthetic and surfing met beautifully on the beach. *Photo, LeRoy Grannis*

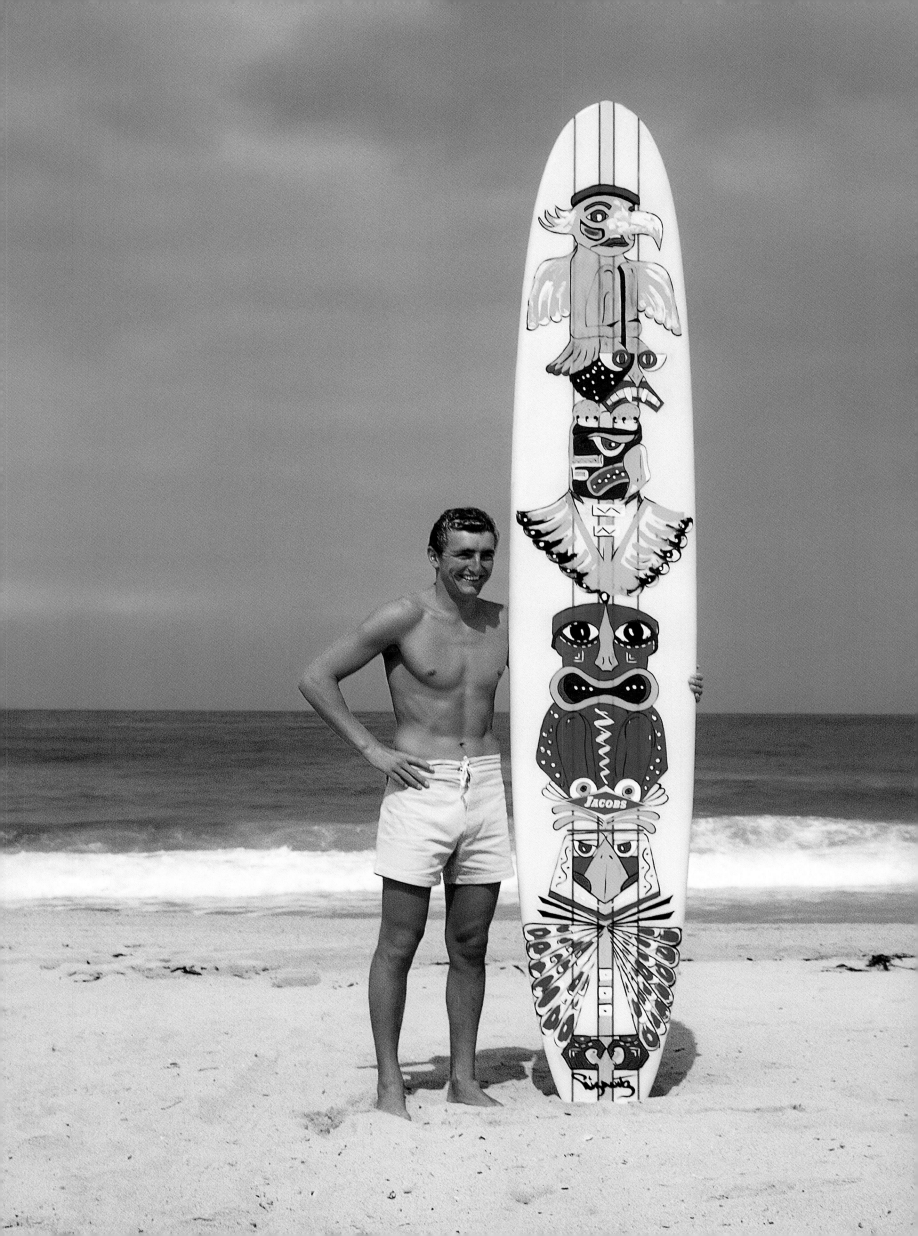

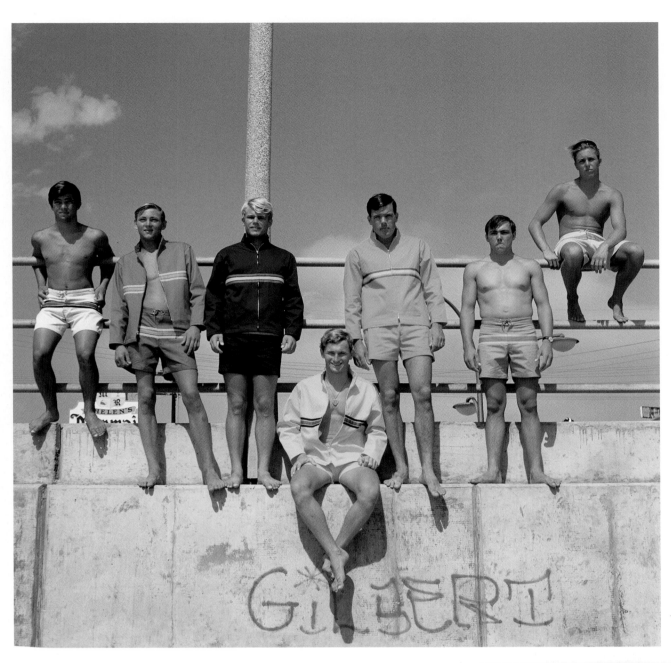

MIKE DOYLE; MANHATTAN BEACH, CALIFORNIA; 1963 Doyle, nicknamed "Tiki Mike," was a self-taught artist who loved to decorate his surfboards, cars, and room with colorful motifs. *Photo, LeRoy Grannis*

LAGUNA SWIMWEAR ADVERTISING SHOOT; OCEAN BEACH, CALIFORNIA; 1966 In his 1966 essay, "The Pump House Gang," Tom Wolfe wrote of nylon swimming trunks: "pretty soon every kid in Utica, N.Y., is buying a pair of them." *Photo, LeRoy Grannis*

ADVERTISEMENT, HANG TEN, 1965 Hang Ten was the first surf brand to break out of surf culture and into department stores, and Phil Edwards was an early entry into the endorsement game.

SCRAPBOOK INTERIORS, WINDANSEA SURF CLUB, 1964 *(opposite and top)* Thor Svenson, a Windansea Surf Club member, meticulously documented a trek to Hawaii in a scrapbook filled with newspaper clippings, photos, and his personal drawings inspired by Rick Griffin's comic-strip character "Murphy."

WINDANSEA SURF CLUB; MAKAHA, HAWAII; 1964 *Photo, LeRoy Grannis*

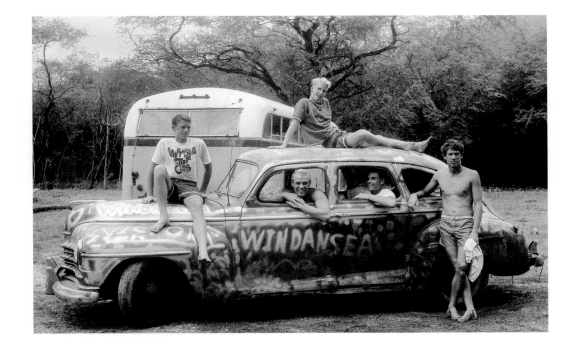

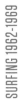

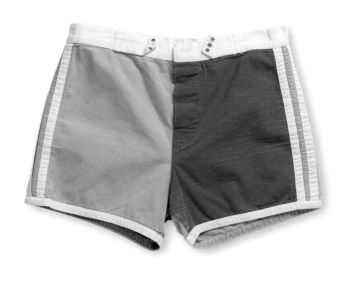

MEN'S SURF TRUNKS *(Clockwise from top left)* Catalina Surfers, c. 1966; Birdwell, c. 1968; c. 1964; Kanvas by Katin, c. 1968; Laguna, c. 1968; Hawaiian Holiday Sports Wear, c. 1964

ADVERTISING SHOOT, CALIFORNIA, C. 1962

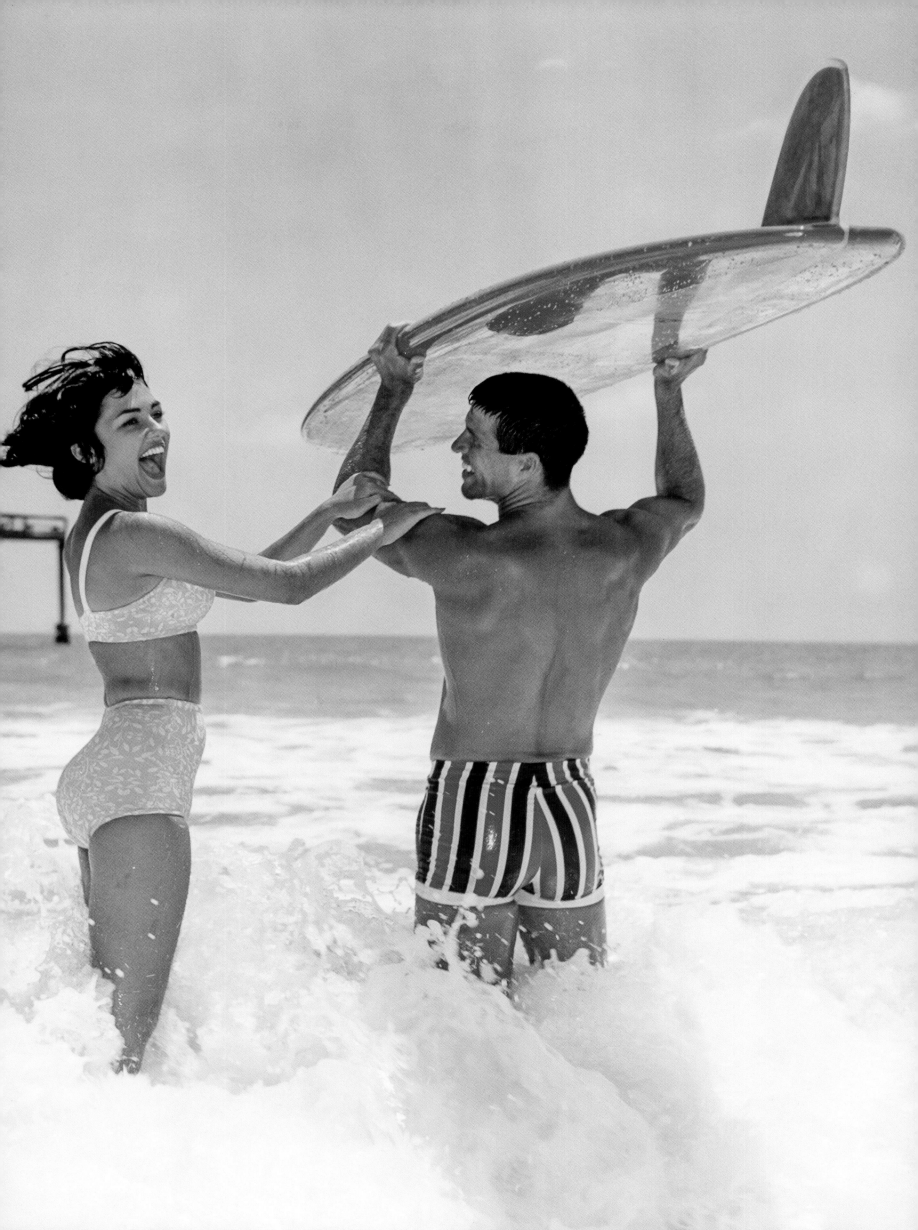

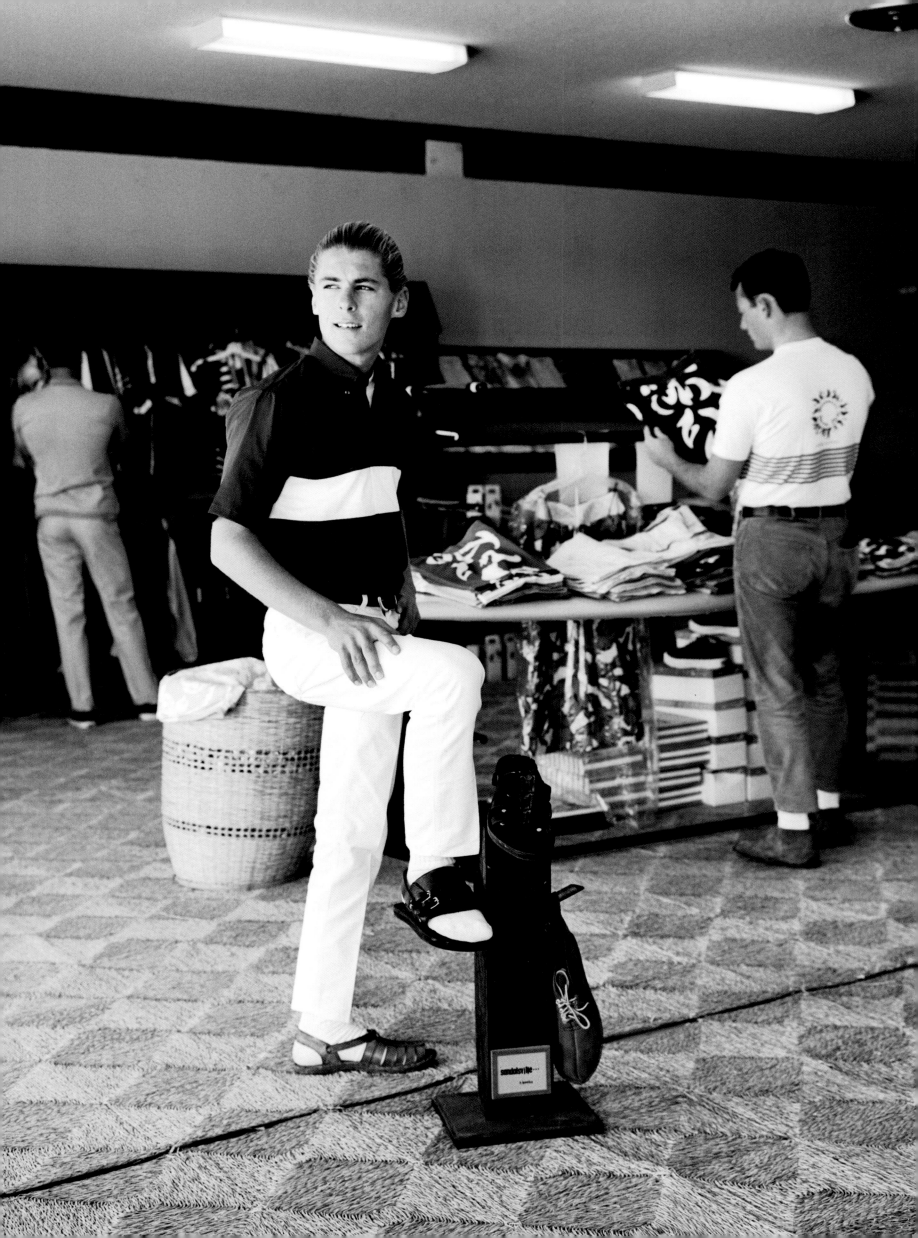

MIKE HYNSON; PACIFIC BEACH, CALIFORNIA; 1964 By the mid-1960s, many surf shops started carrying aloha-wear and "surf clothing" as a sideline. This quickly grew into full-blown industry. *Photo, Ron Church*

MEN'S SHIRTS *(Clockwise from top left)* Arrow "Surf-rider," c. 1968; Hang Ten, c. 1968; c. 1962; Surf Line Hawaii, c. 1966; Hang Ten, c. 1968; McInerny, c. 1965

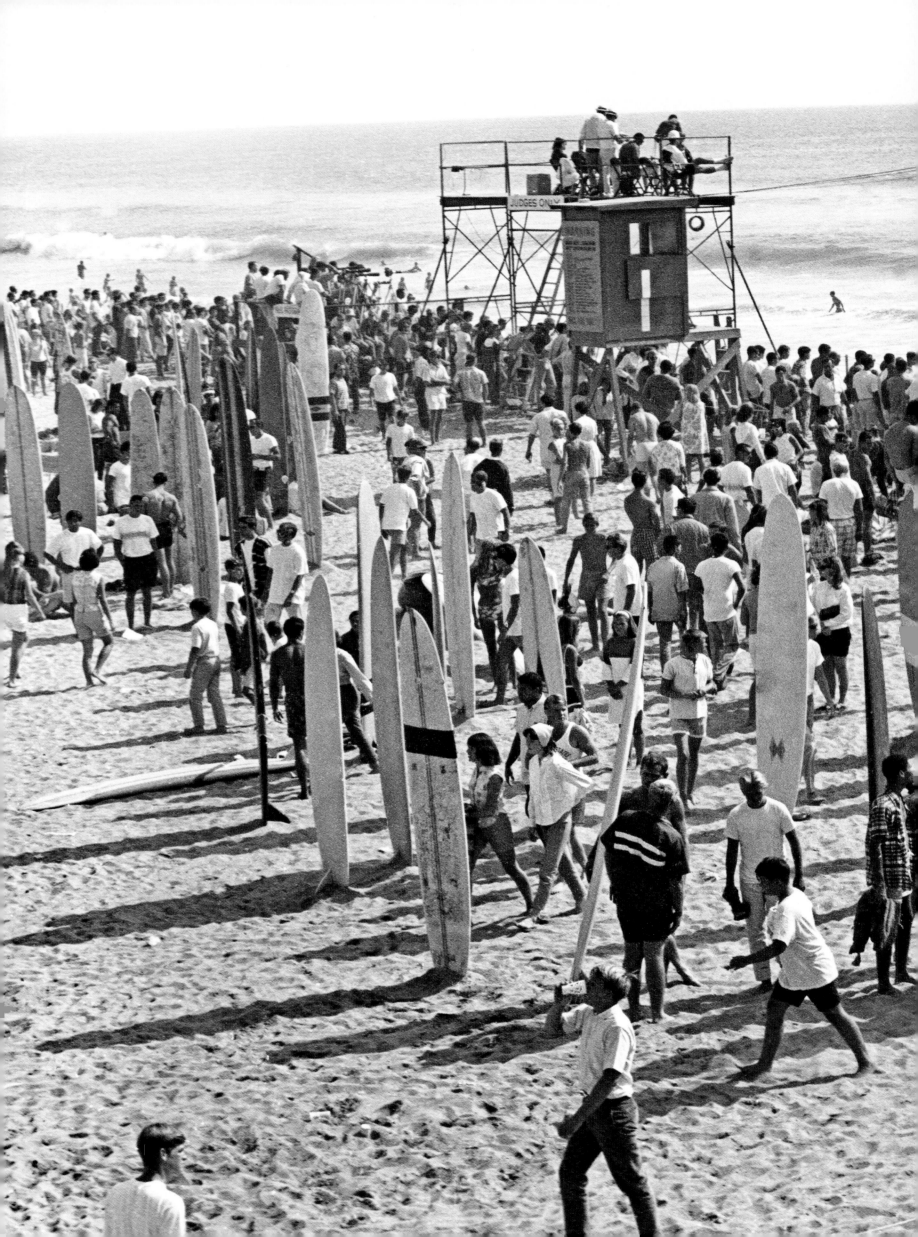

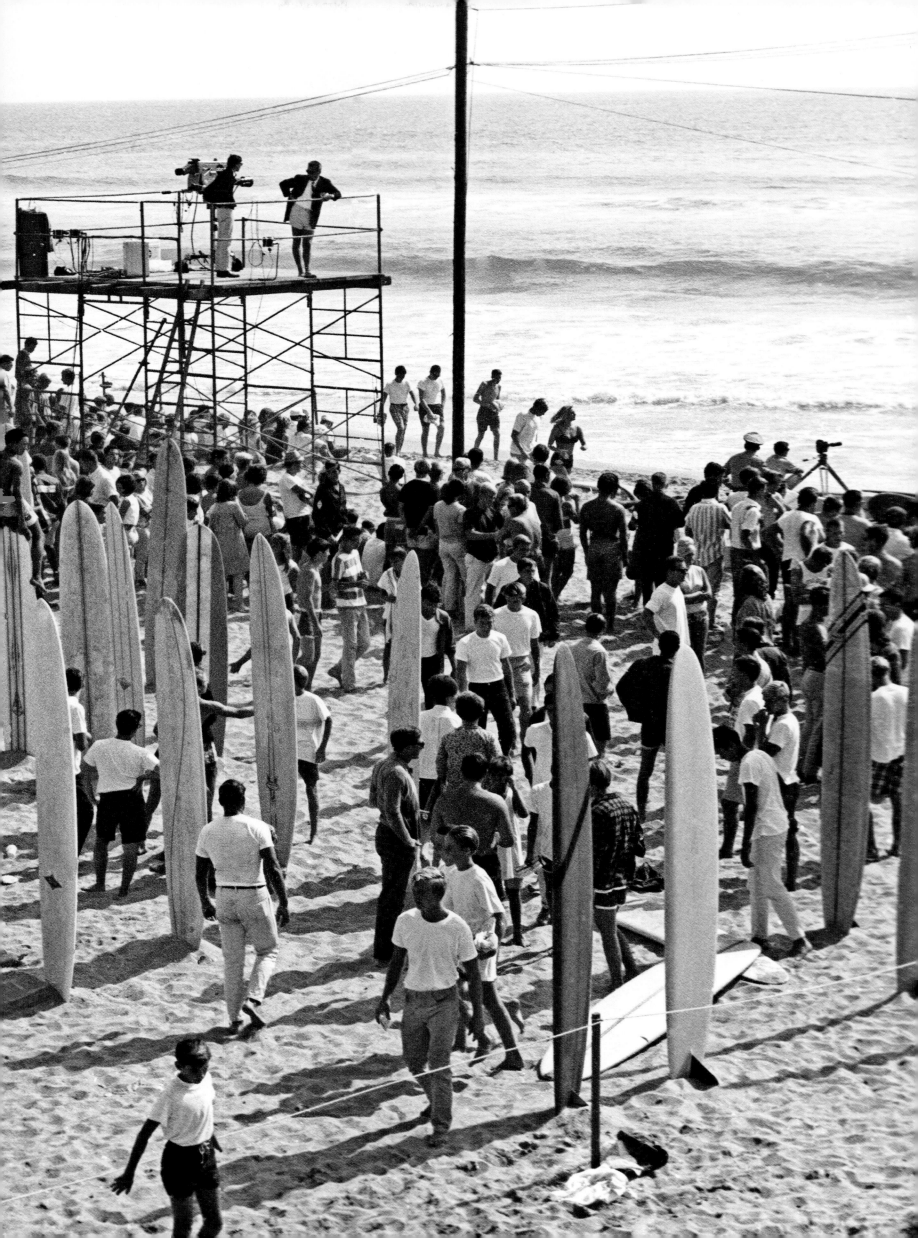

U.S. SURFING CHAMPIONSHIPS; HUNTINGTON BEACH, CALIFORNIA; 1964 *(Pages 238–239)* The United States Surfing Championships, known as the West Coast Surfing Championships from 1959 to 1963, were held in Huntington Beach until 1972. It then became a floating venue throughout the coastal United States. *Photo, Tom Keck*

MIKE DOYLE, U.S. SURFING CHAMPION-SHIPS; HUNTINGTON BEACH, CALIFORNIA; 1964 Doyle was an avid competitor who was one of the first surfers to train seriously for contests. With good looks that personified the California style, he quickly received full sponsorship from major swimwear company Catalina. *Photo, Ron Church*

U.S. SURFING CHAMPIONSHIPS; HUNTINGTON BEACH, CALIFORNIA; 1964 *Photo, Ron Church*

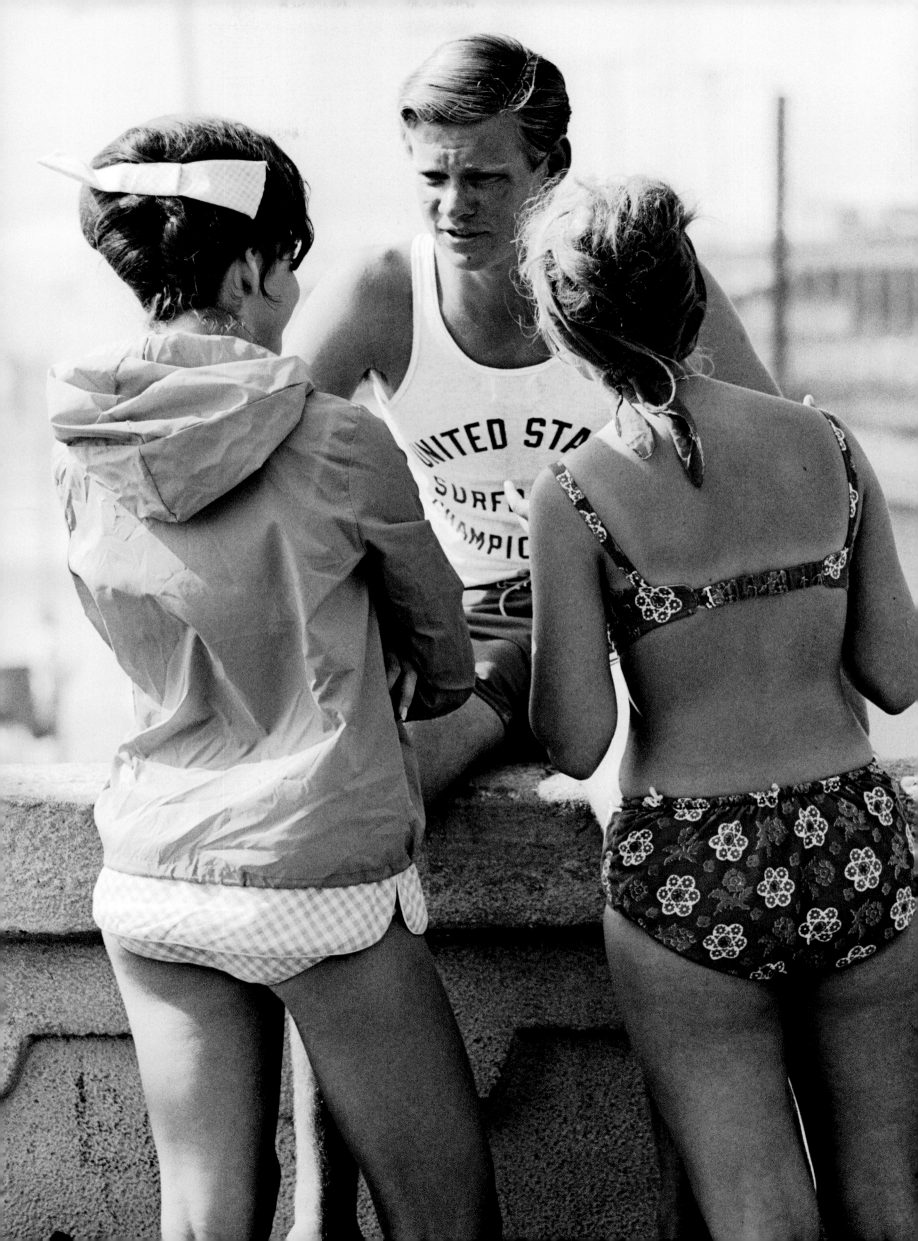

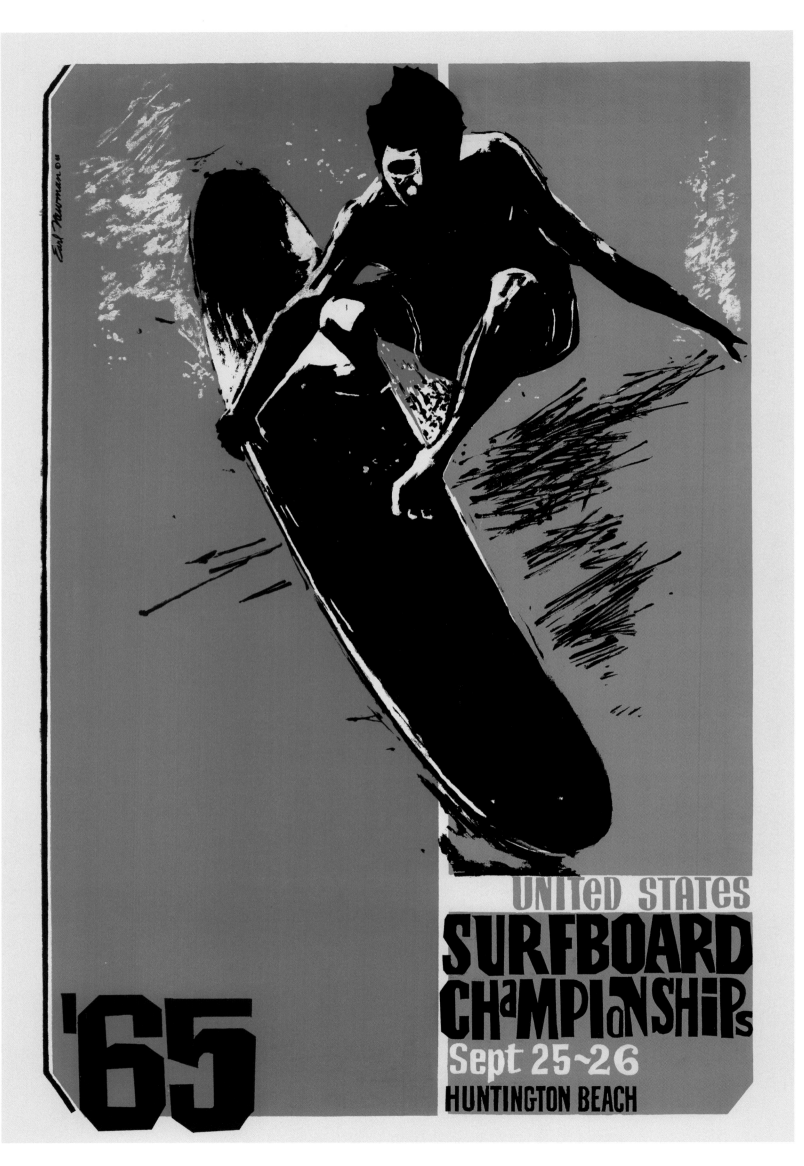

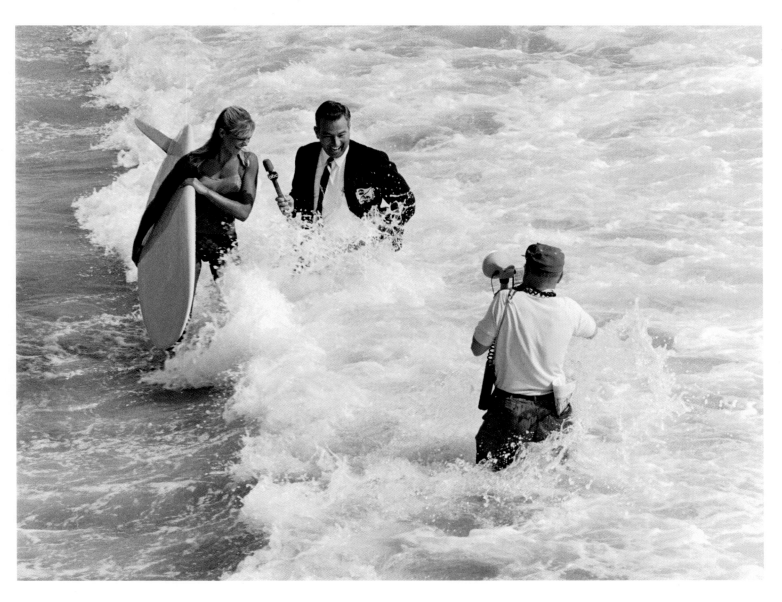

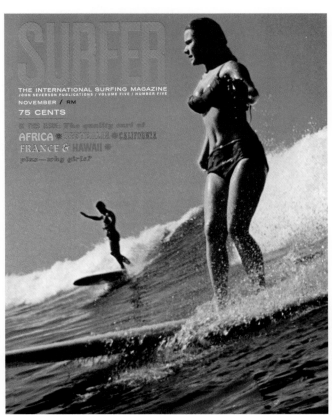

U.S. SURFING CHAMPIONSHIPS;
HUNTINGTON BEACH, CALIFORNIA; 1964
(Pages 242–243) An unlucky competitor is caught
between the pilings after a wipeout during the
annual U.S. Surfing Championships. *Photo, LeRoy
Grannis*

POSTER, U.S. SURFING CHAMPIONSHIPS,
1965 *Art, Earl Newman*

JOYCE HOFFMAN, U.S. SURFING
CHAMPIONSHIPS; HUNTINGTON BEACH,
CALIFORNIA; C. 1966 Hoffman, adopted
daughter of big-wave pioneer and surf-fabric manufac-
turer Walter Hoffman, grew up riding waves among
California surf royalty. She was a fierce competitor
who won a dozen championships, including the 1965
and '66 World Championships. *Photo, Ron Church*

MAGAZINE COVER, *SURFER*, 1964 Raised
in Southern California by a surfer dad, Linda Merrill
was stylish, smooth, and highly photogenic. She later
won the tandem event at the 1965 World Surfing
Championships with Mike Doyle, but *SURFER* still
had to ask, "Why Girls?" *Photo, Bev Morgan*

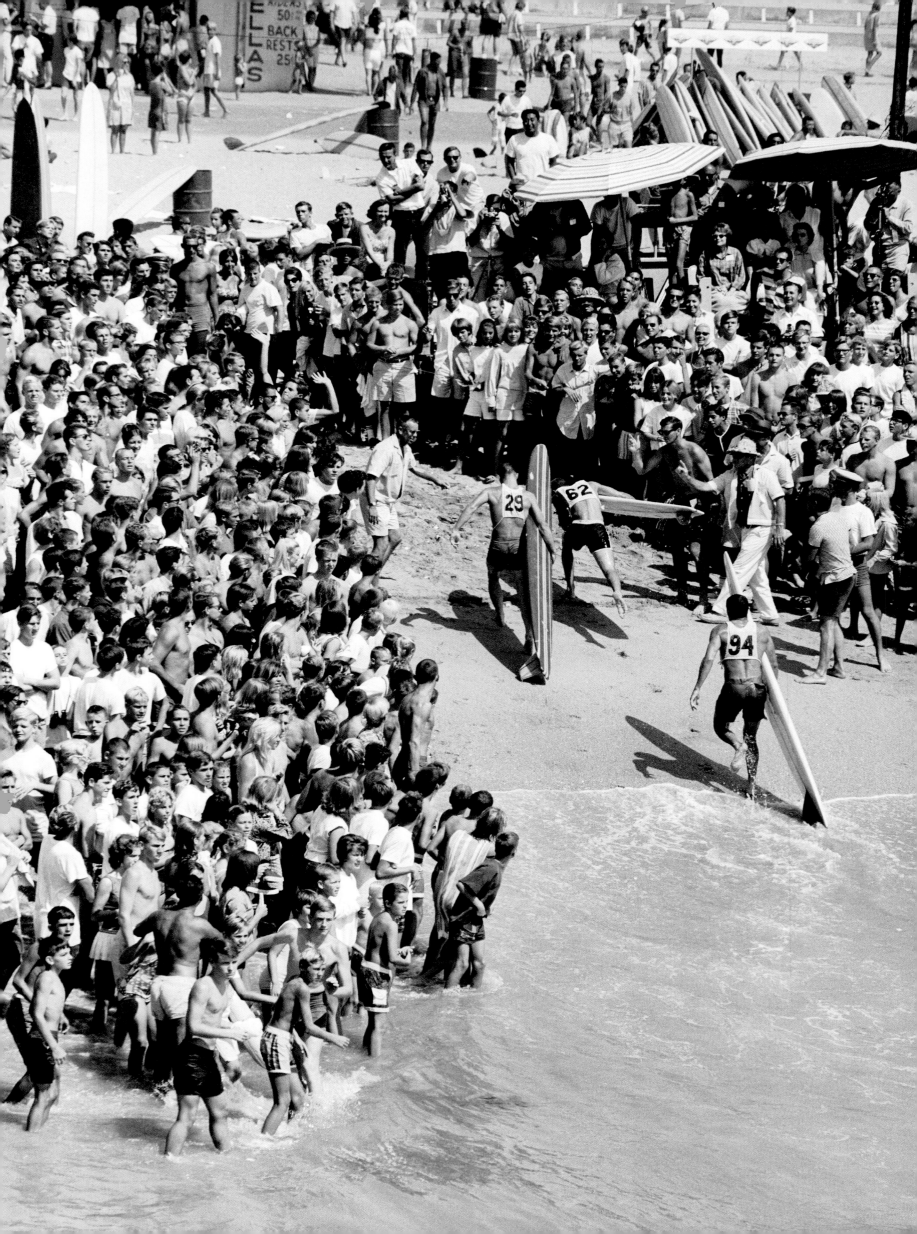

RELAY RACE, U.S. SURFING CHAMPION-
SHIPS; HUNTINGTON BEACH, CALIFORNIA;
1964 *Photo, Ron Church*

HUNTINGTON BEACH, CALIFORNIA, 1964
"Board-perching" required climbing skills, balance,
and a hardy groin. *Photo, Ron Church*

WORLD SURFING CHAMPIONSHIPS; SAN DIEGO, CALIFORNIA; 1966 From left to right: Corky Carroll, third place; Nat Young, first place; and Jock Sutherland, second place. *Photo, Ed Greevy*

WORLD SURFING CHAMPIONSHIPS; SAN DIEGO, CALIFORNIA; 1966 More than 40,000 gathered for the weeklong event held in small waves at Ocean Beach, California. *Photo, Ed Greevy*

LIFE **SWIMSUIT PICTORIAL, 1965** Malibu surfer Dave Rochlen moved to Honolulu in 1962 where he founded Surf Line Hawaii with Dick Metz and created a line of colorful and comfortable beachwear he called "Jams." They were a huge hit and were soon selling in major department stores across the United States.

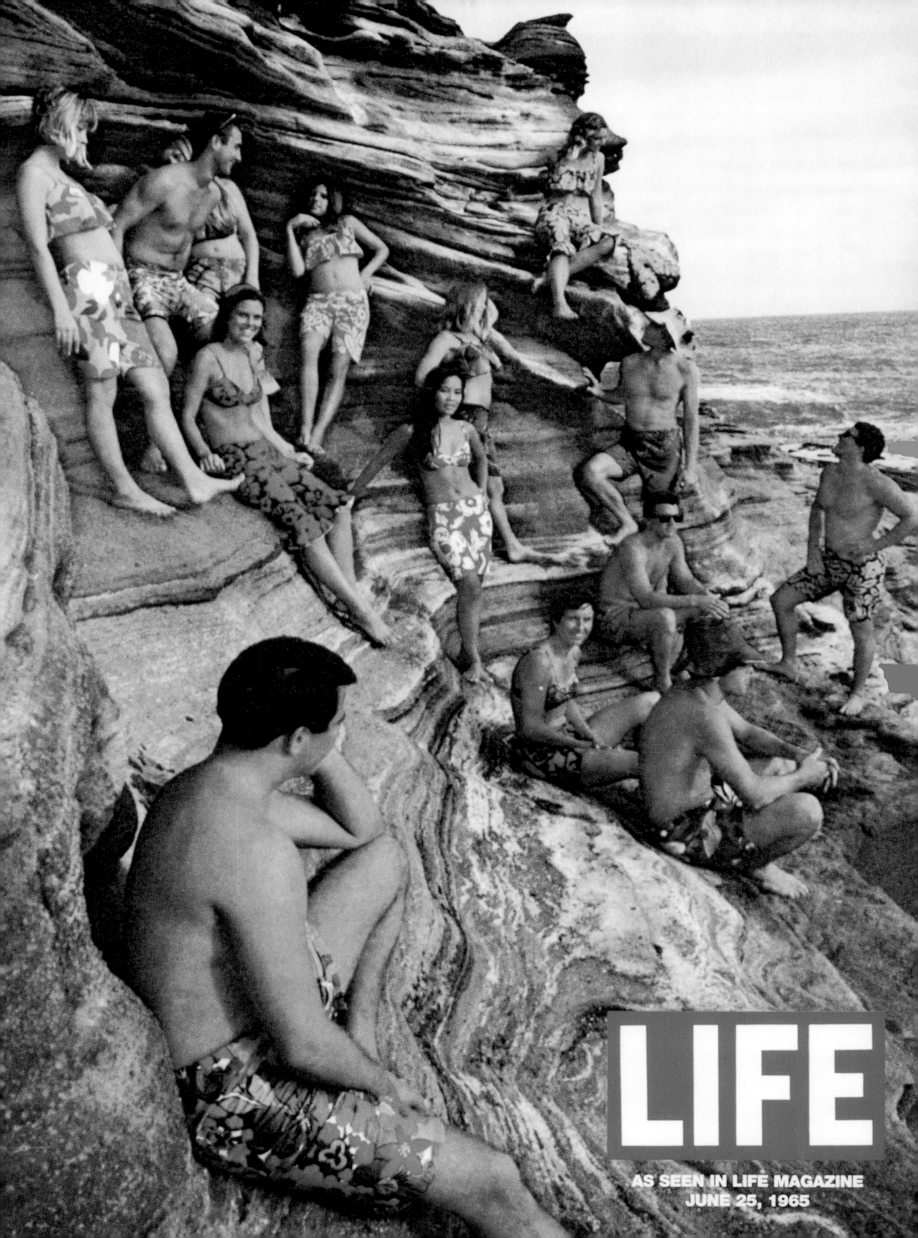

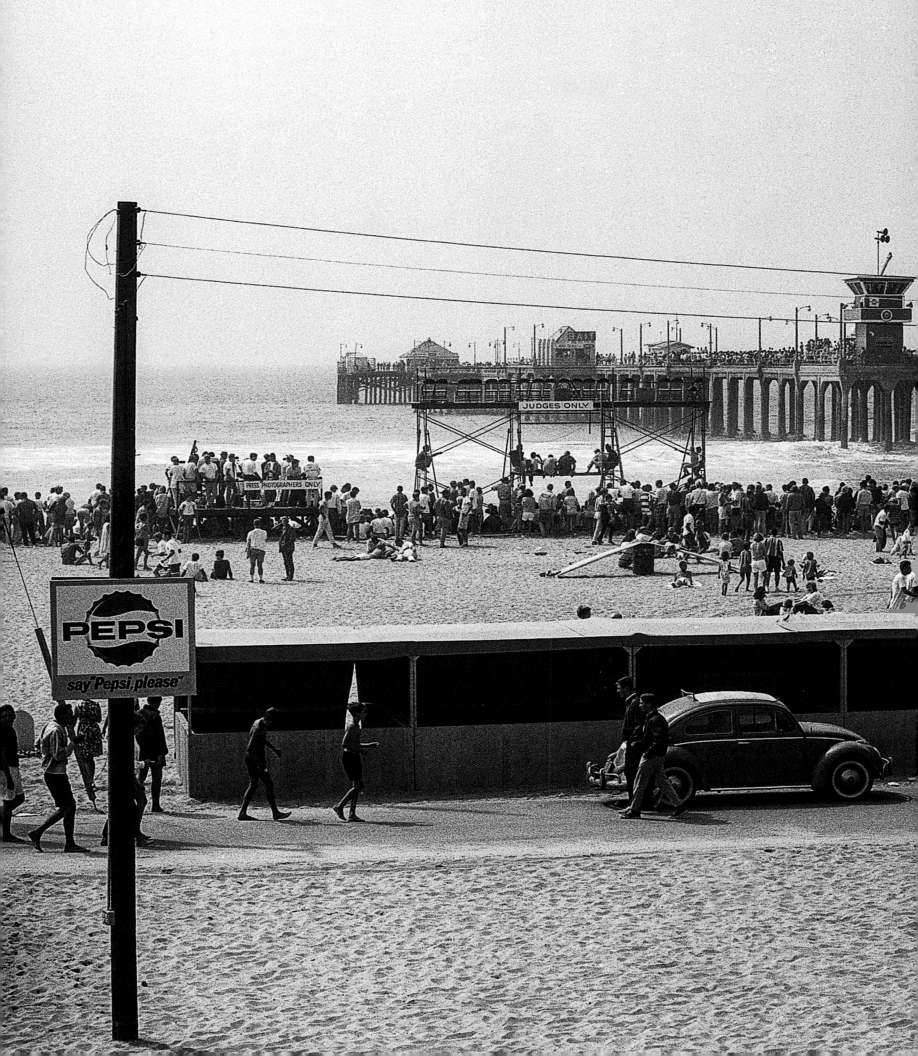

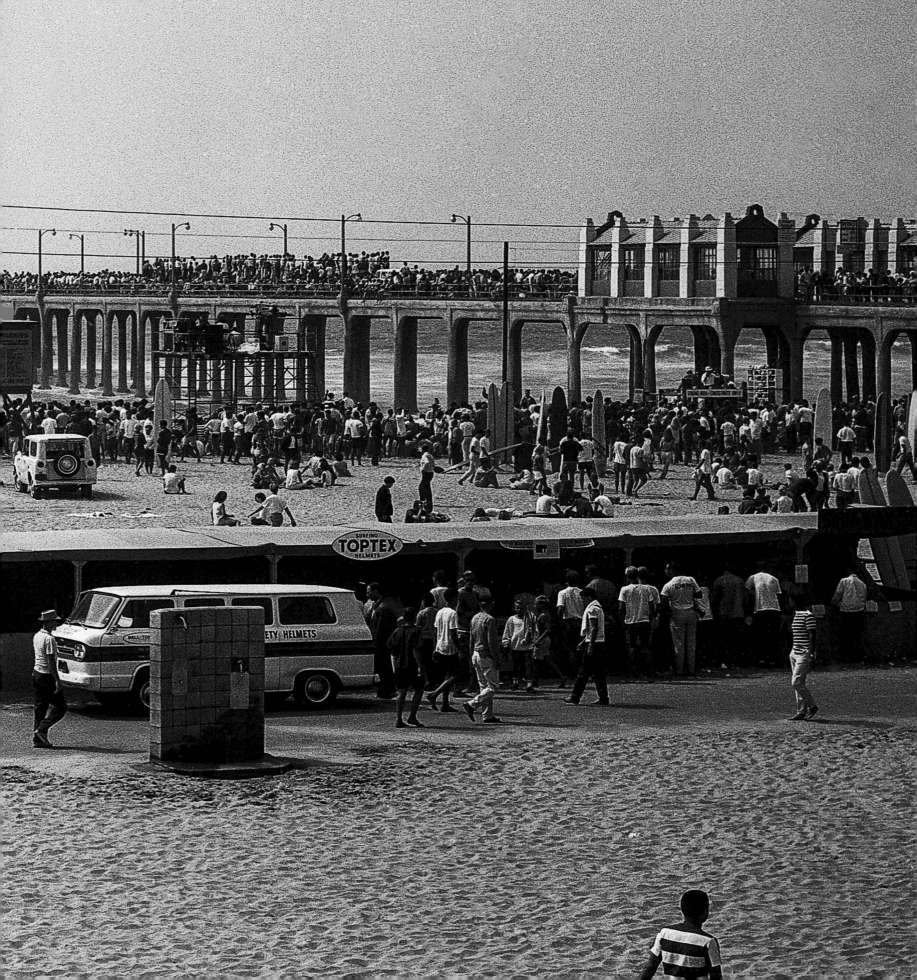

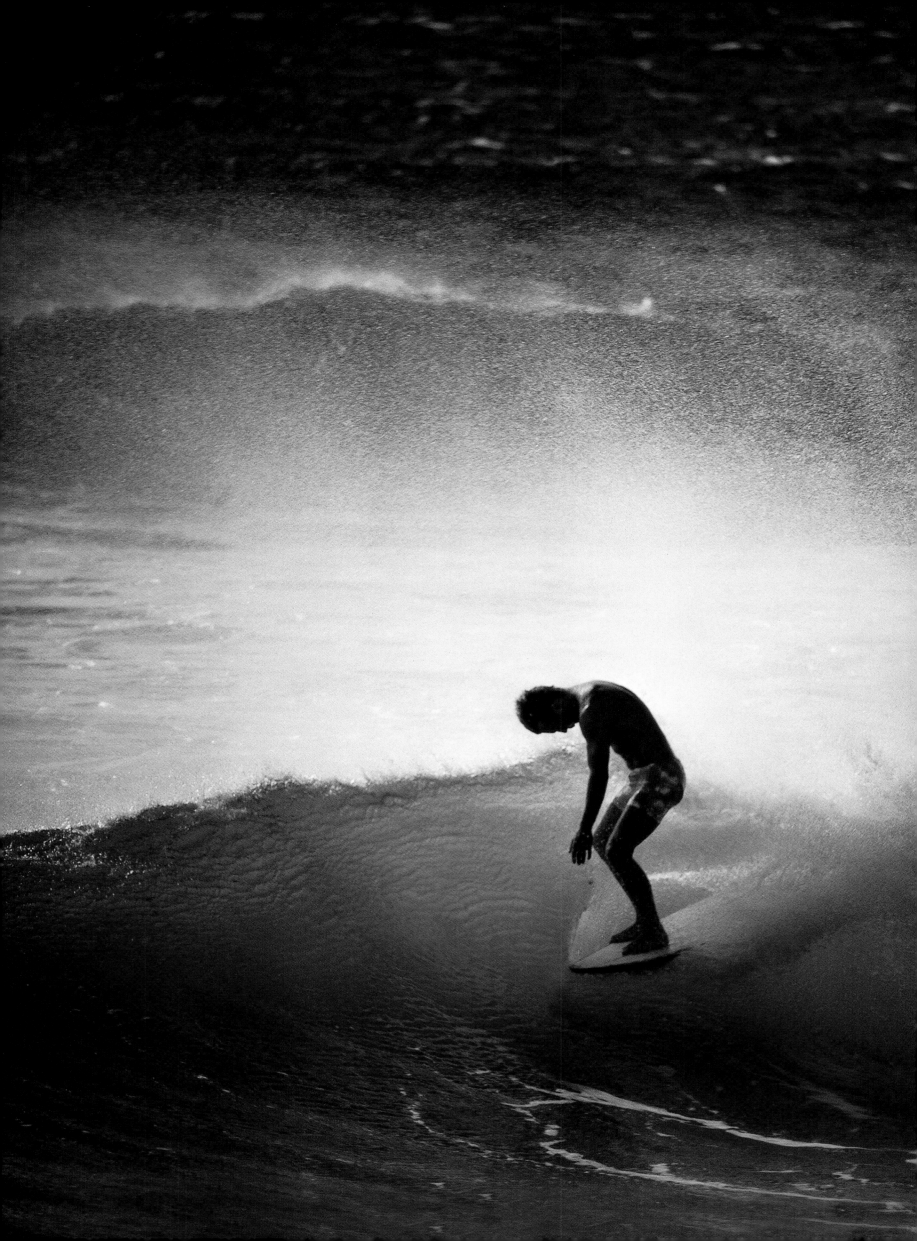

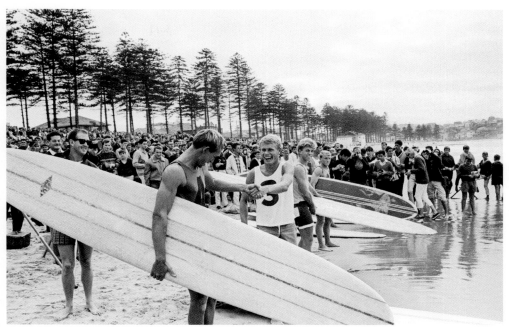

U.S. SURFING CHAMPIONSHIPS; HUNTINGTON BEACH, CALIFORNIA; 1964 *(Pages 250–251)* The annual championships were held in late September and drew more than 10,000 people to "Surf City." *Photo, LeRoy Grannis*

MIDGET FARRELLY; MAKAHA, HAWAII; 1968 Farrelly, along with Nat Young, was part of a small vanguard of Australian surfers competing internationally in the early 1960s. He was the first non-Hawaiian to win the Makaha International Surfing Championships in 1962, and two years later he won the first world championships at Manly Beach, Australia. *Photo, LeRoy Grannis*

MIDGET FARRELLY, WORLD SURFING CHAMPIONSHIPS; MANLY BEACH, SYDNEY, AUSTRALIA; 1964 Born in Sydney in 1944, Farrelly started surfing at age nine. Renowned for his smooth, polished style, Farrelly won the inaugural 1964 World Championships and went on to become a patriarch of Australian surf culture.

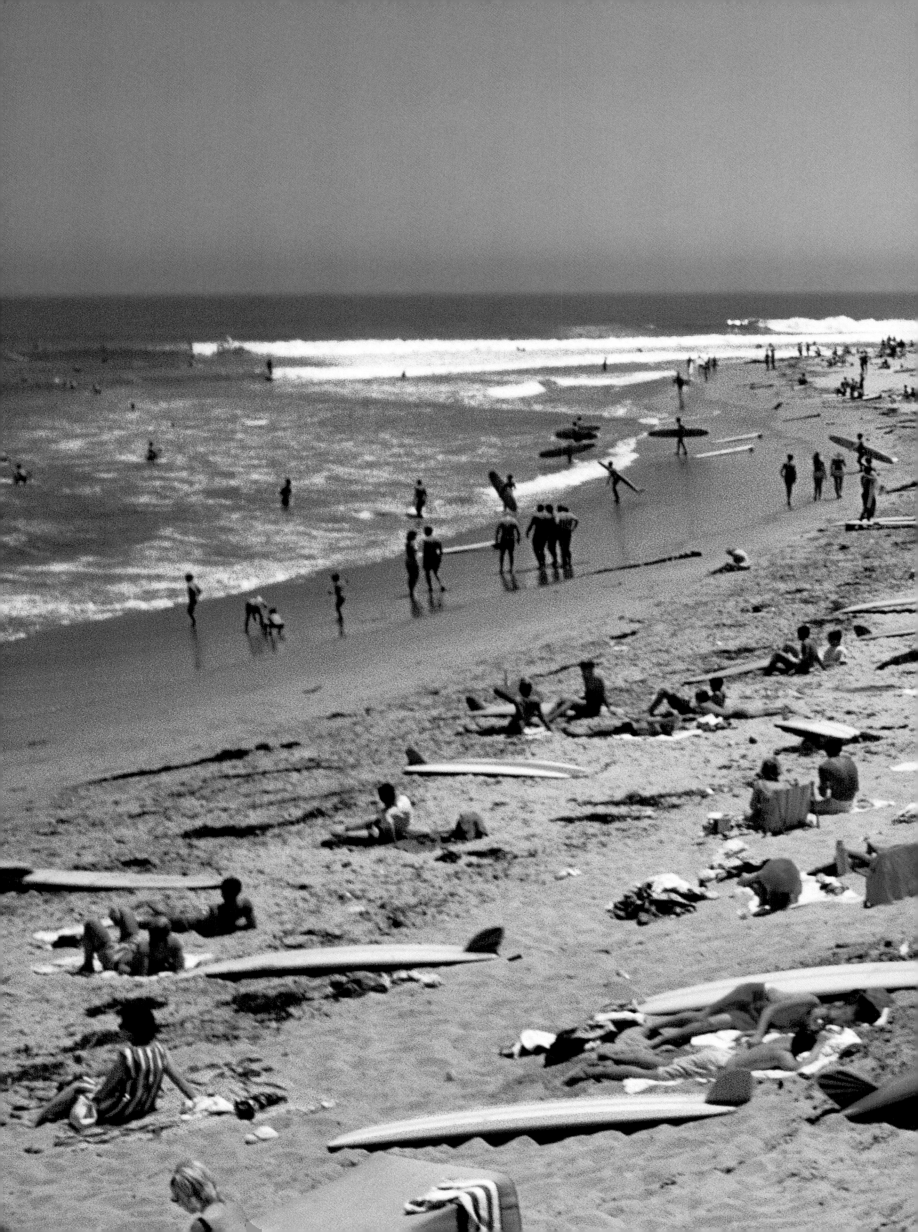

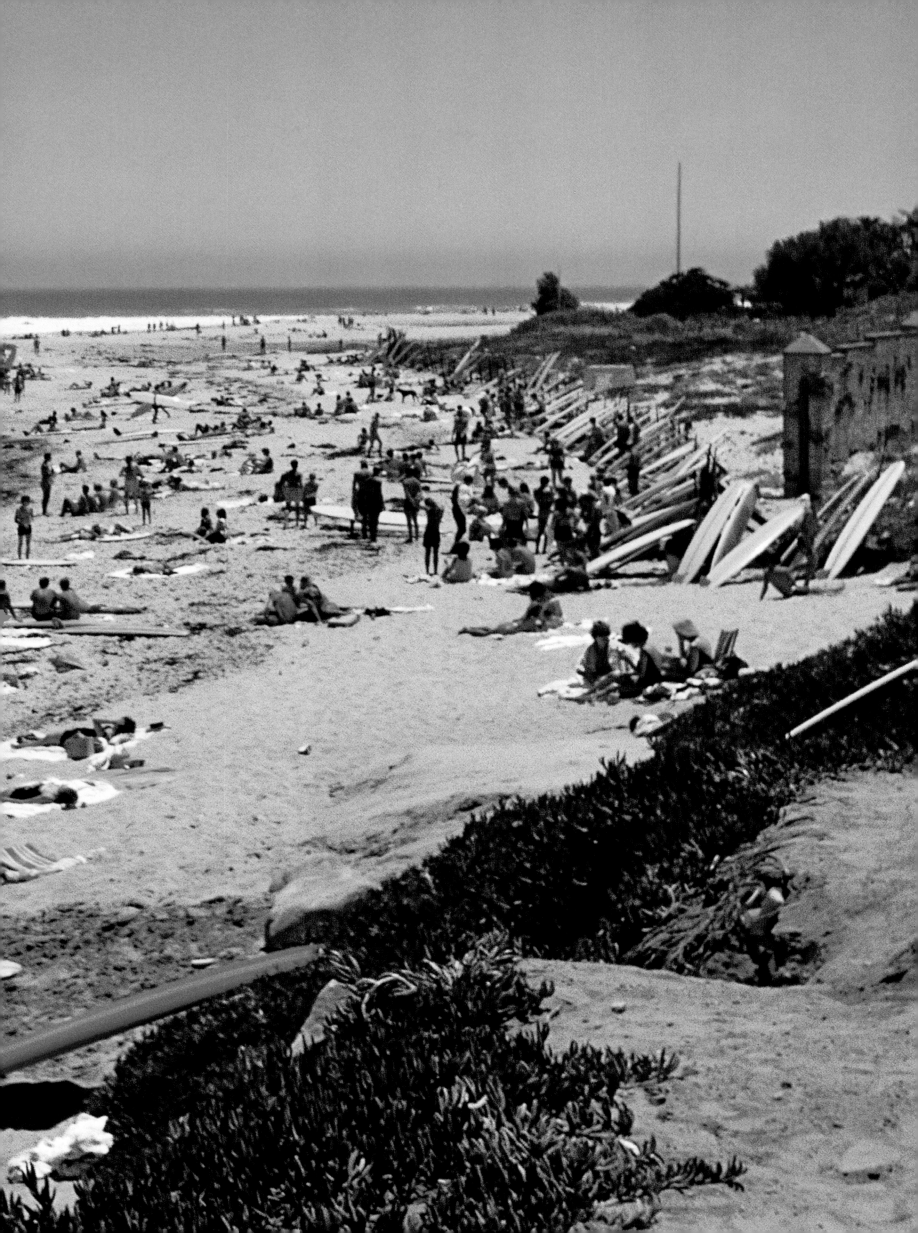

MALIBU, C. 1965 *(Pages 254–255)*
Photo, LeRoy Grannis

POSTER, *SURF'S UP*, 1961

RICKY GRIGG; LA JOLLA, CALIFORNIA;
1961 "Other surf photographers of the era were just aiming their shore-bound 'telephotos' at whatever moved," said *SURFER*'s former photo editor, Brad Barrett, "… while Ron was thoughtfully composing photographs as he floated around in the impact zone." *Photo, Ron Church*

HUNTINGTON BEACH, CALIFORNIA,
C. 1965 "Shooting the pier" on a large wave was thrilling, photogenic, and occasionally fatal.
Photo, LeRoy Grannis

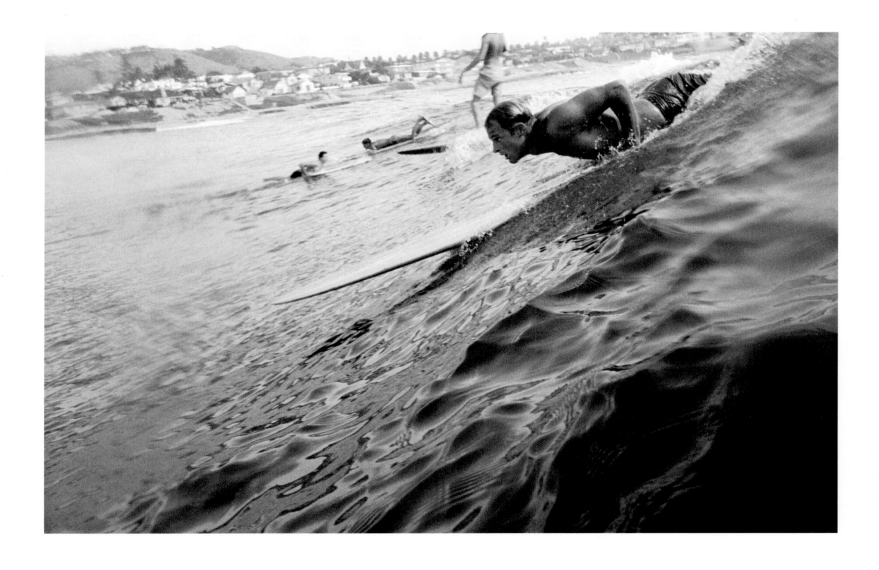

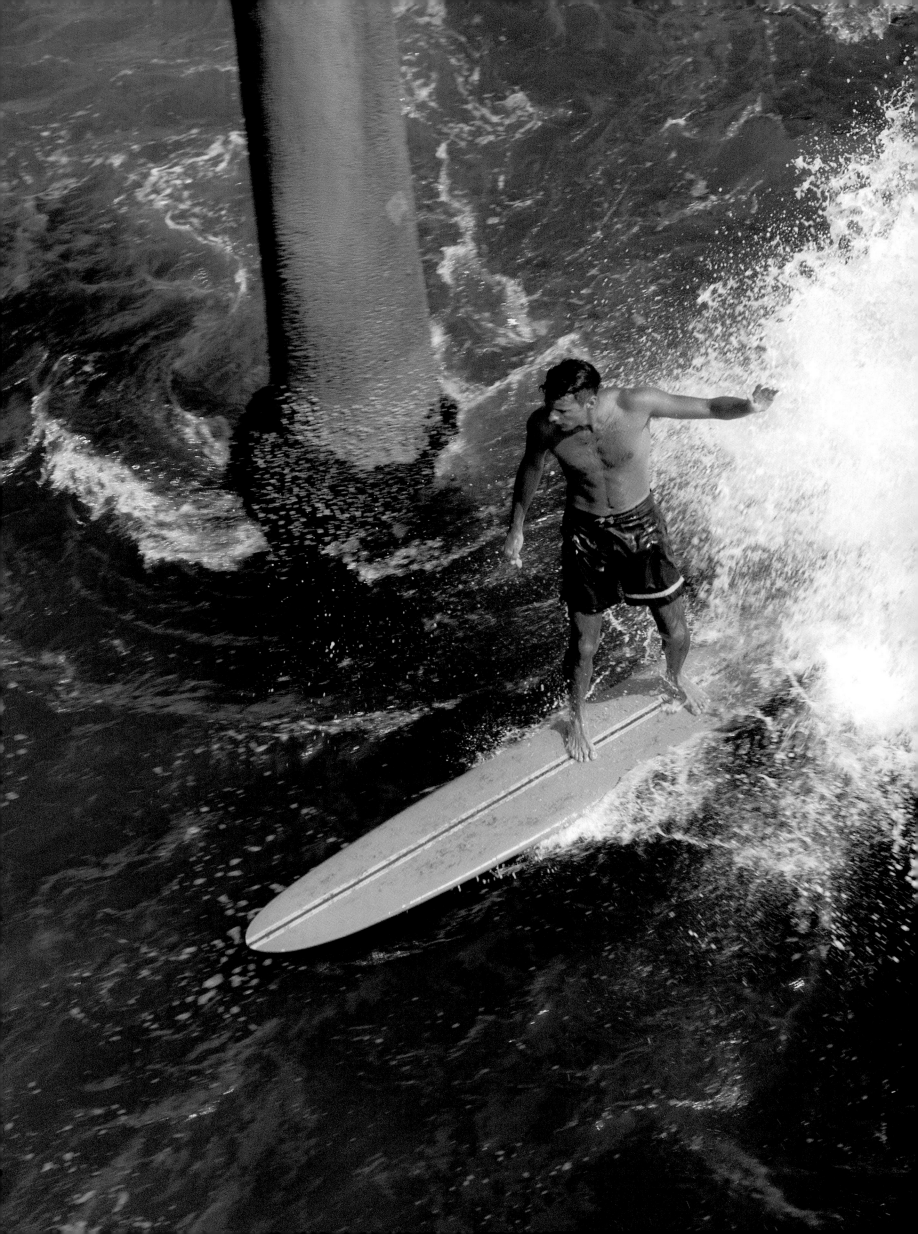

JOHN SEVERSON

PRESENTS

FEATURING SURF IN MEXICO, CALIFORNIA, AND HAWAII ■ PHOTOGRAPHED BY JOHN SEVERSON & RON CHURCH ■ IN COLOR ■ NARRATION BY JOHN SEVERSON

THE GREAT SURFING MOVIE OF 1963

THE ANGRY SEA

NEXT SHOWING

Orangecoast College

THURSDAY, & FRIDAY, APRIL 25 & 26

8:15 P. M. ADMISSION $1.50 DOOR PRIZE

POSTER, *THE ANGRY SEA*, 1963
Art, John Severson

POSTER, *ONCE UPON A WAVE*, 1963

ROXY THEATER; PACIFIC BEACH, CALIFORNIA; 1963 John Severson made his sixth film, *The Angry Sea*, with photographer Ron Church. With the exception of 1970's *Pacific Vibrations*, none of Severson's films still exist in their original form. *Photo, Ron Stoner*

Walt Phillips presents his all-color surfing movie

once upon a wave

admission price
$1.50
all tickets at door
night of showing

For this year's movie "Once Upon a Wave" I've taken shots of "Sunset Beach" with top riders like Peter Cole, Ricky Grigg, Fred Van Dyke, and many more. "Banzai Pipeline" with riders like Butch Van Artsdalen, who tore Banzai apart this year, Midget Farrelly, Mick Mahan, and many others. The heavy's "Waimea Bay" with Gregg Noll, Mike Stang, Mickey Dora, Jose Angel, plus the others who rode Waimea at its biggest in five years. These were truly giant waves with great rides and horrible wipeouts.

"Hammonds Reef" with Henry Ford, Ricky Irons, and other top coast surfers on a hot, size day. All up and down the coast of California and Mexico—edited down from thousands of feet to the best, choicest rides. Then—I've gone back through five years of surfing footage and taken the very best from all of that film to bring you this movie, tieing it together with all the best comedy from my other movies and making 90 minutes of surfing, wipeouts, and sometimes hilarious comedy. See you, "Once Upon a Wave."

VAN NUYS HIGH SCHOOL
Thurs., Aug. 15th 7:15 & 9:00

TWO SHOWINGS
ONE NIGHT ONLY

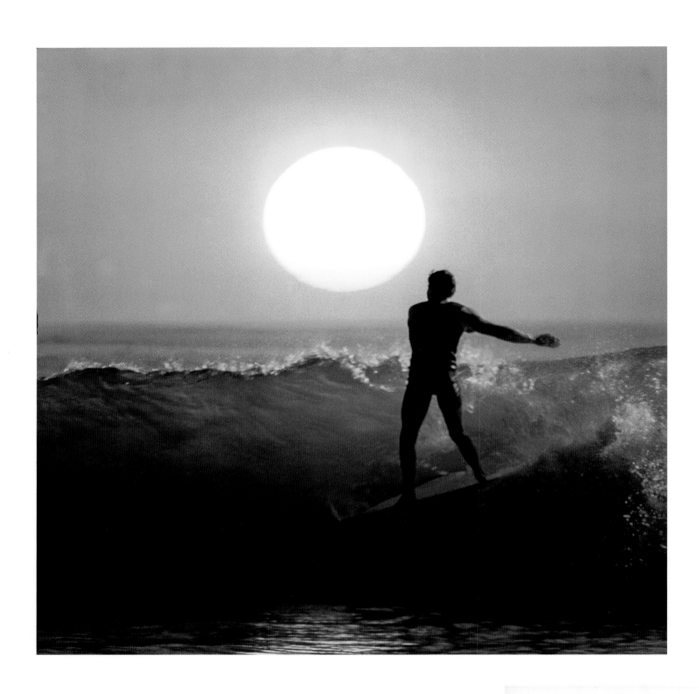

**LANCE CARSON; RINCON, CALIFORNIA;
1967** The iconic August 1967 cover of *SURFER*
was created by superimposing two photos—Ron
Stoner's shot of Carson at Rincon and a sunset photo
by John Severson. *Photo, Ron Stoner and John Severson*

MAGAZINE COVER, *SURFER*, 1963
Art, Leo Bestgen

**PAINTING, *SURF'S UP ON A GOLDEN DAY*,
C. 1962** *Art, Rex Brandt*

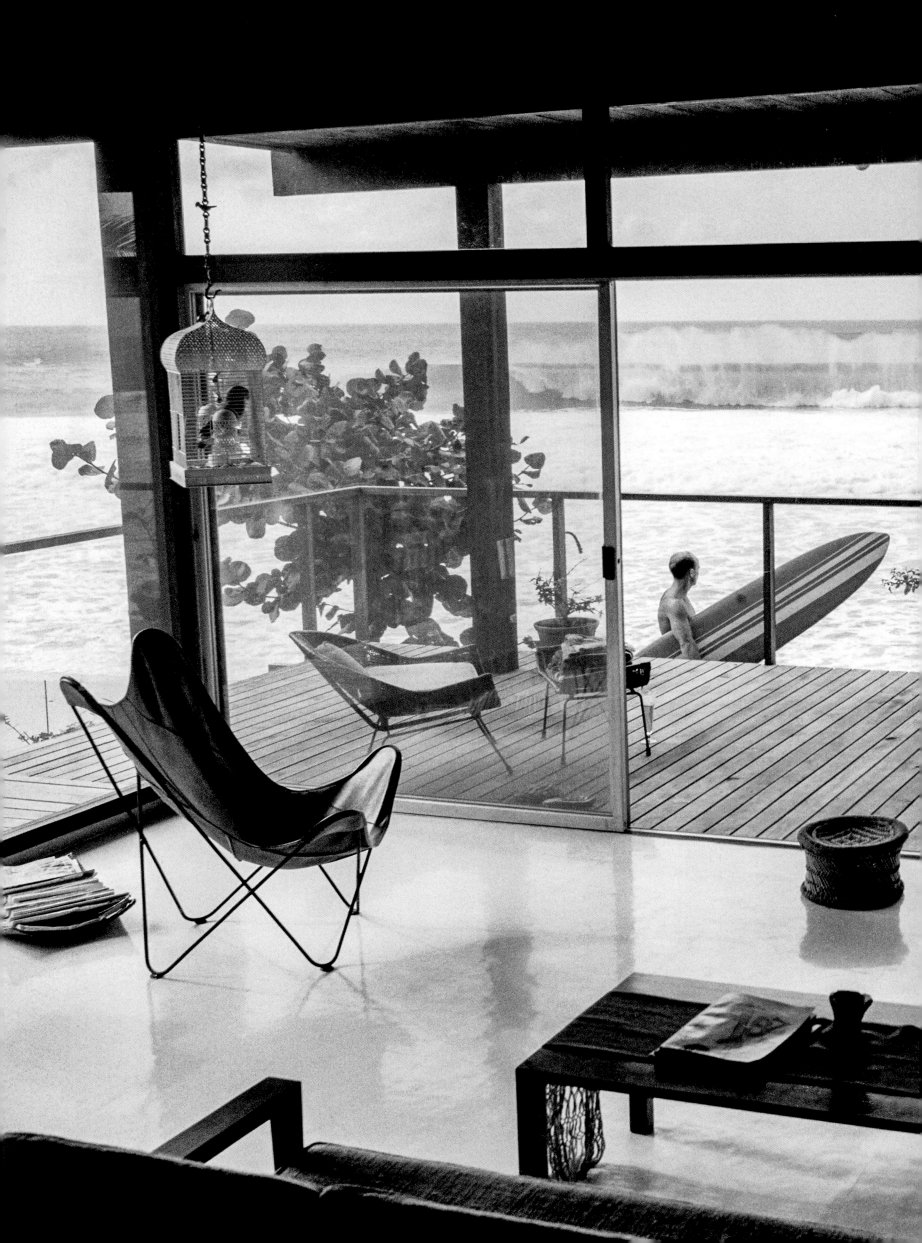

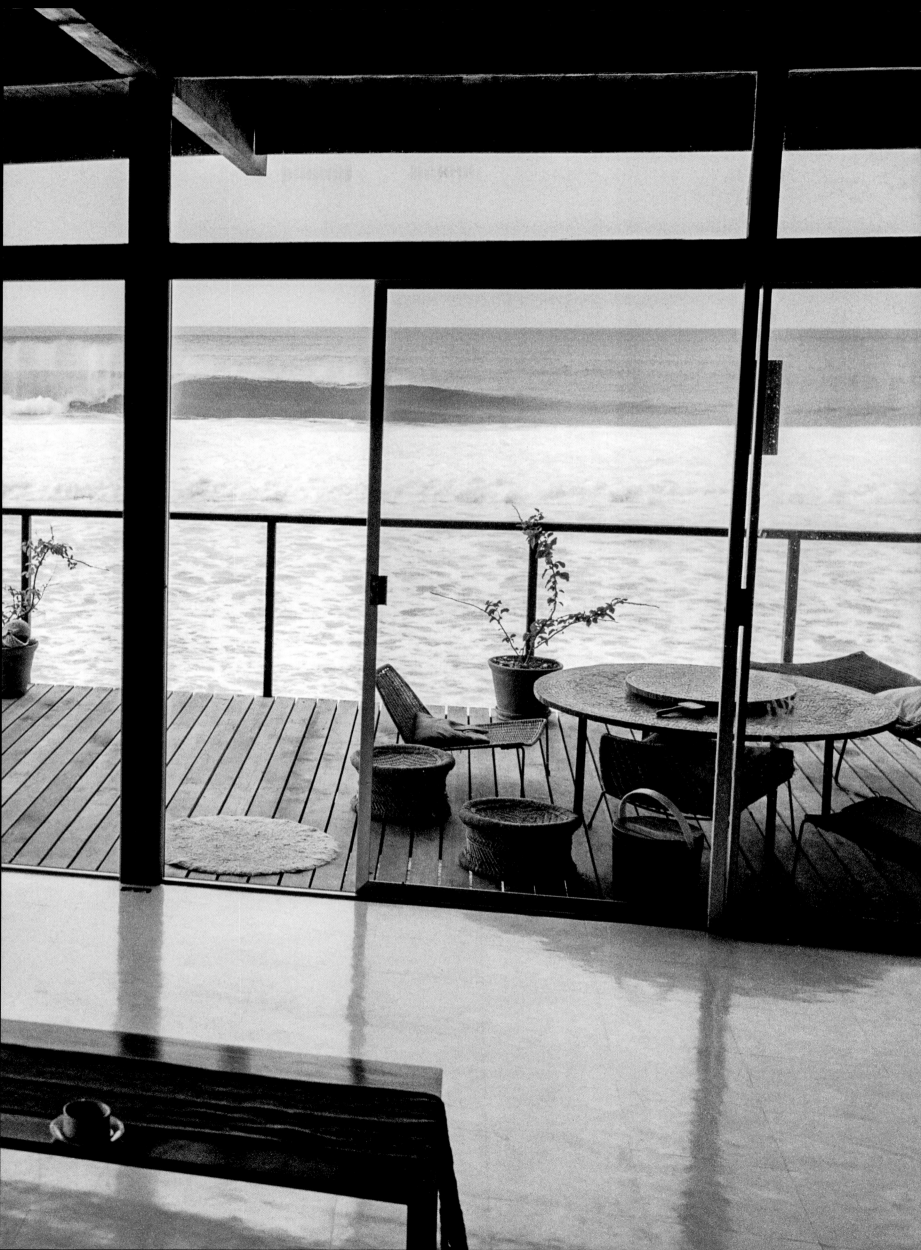

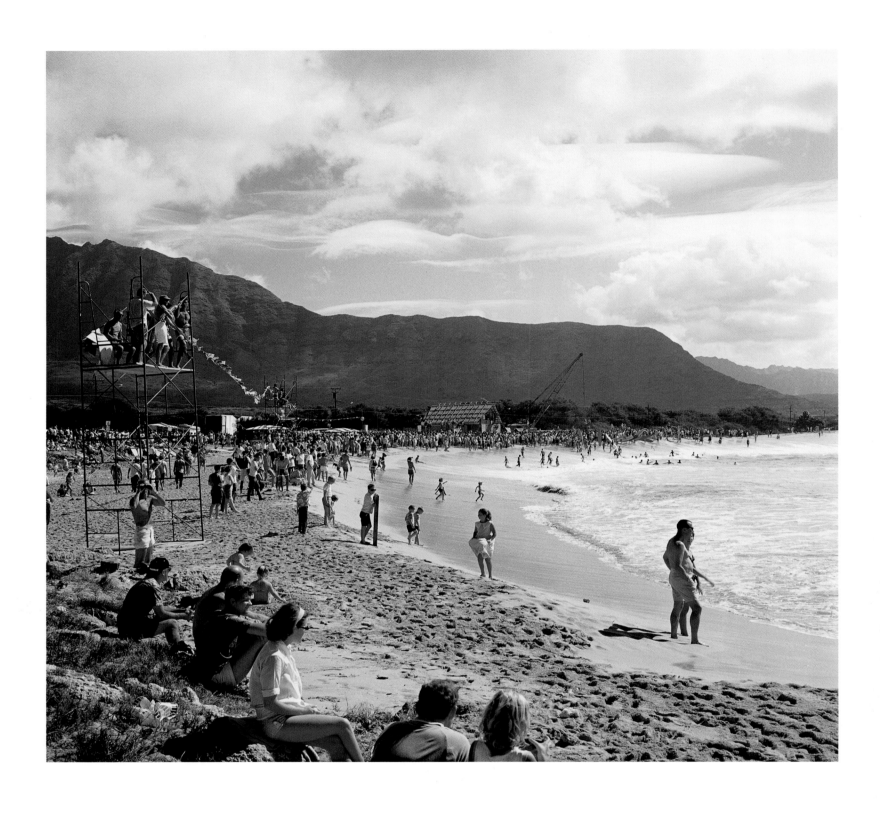

NORTH SHORE, HAWAII, 1962
(Pages 262–263) Mid-century modern meets the
beach at the home of Hawaiian big-wave legend
Warren Harlow. *Photo, Ron Church*

**MAKAHA INTERNATIONAL SURFING
CHAMPIONSHIPS; MAKAHA, HAWAII;
1963** *Photo, LeRoy Grannis*

MAKAHA INTERNATIONAL SURFING CHAMPIONSHIPS; MAKAHA, HAWAII; 1966 A pre-drone news helicopter captures an aerial view of George Downing, left, and Mike Doyle. *Photo, Ed Greevy*

MAKAHA INTERNATIONAL SURFING CHAMPIONSHIPS; MAKAHA, HAWAII; 1963 *Photo, Tom Keck*

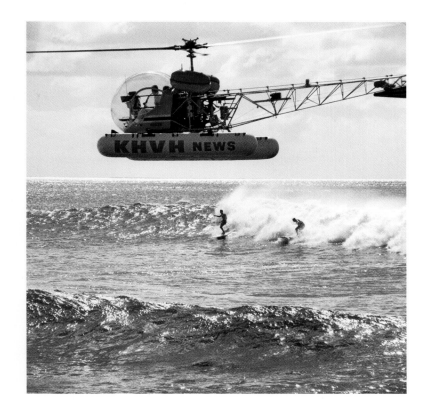

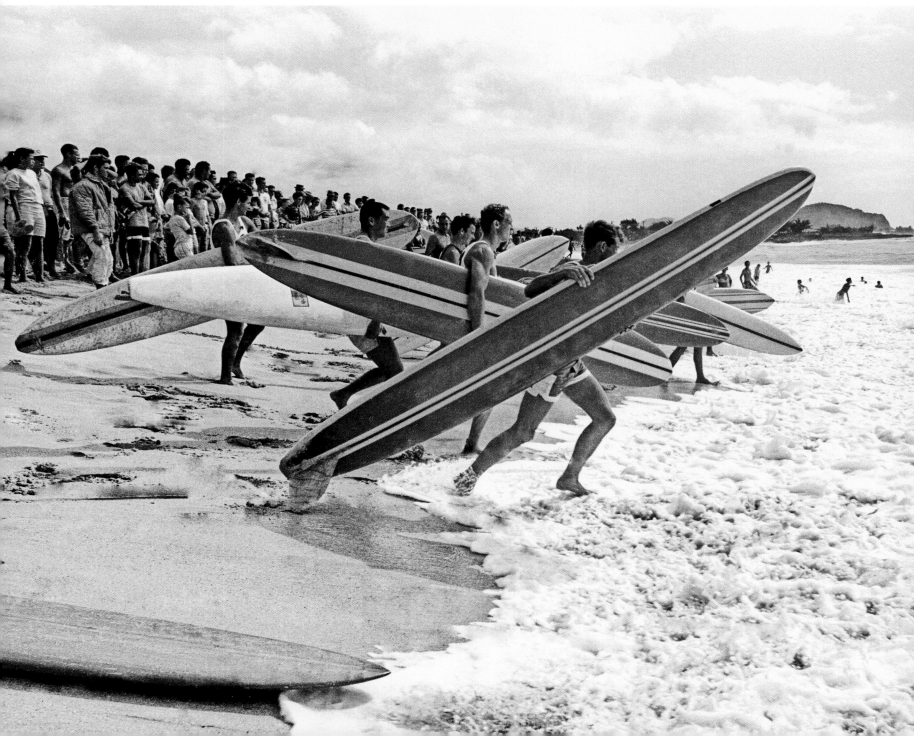

MAKAHA, HAWAII, 1966 The steep beach at Makaha produces a spectacular and often dangerous backwash that snaps boards and occasionally bodies. *Photo, LeRoy Grannis*

WAIMEA BAY, HAWAII, 1966
(Pages 268–269) Photo, LeRoy Grannis

PROGRAM, MAKAHA INTERNATIONAL
SURFING CHAMPIONSHIPS, 1963

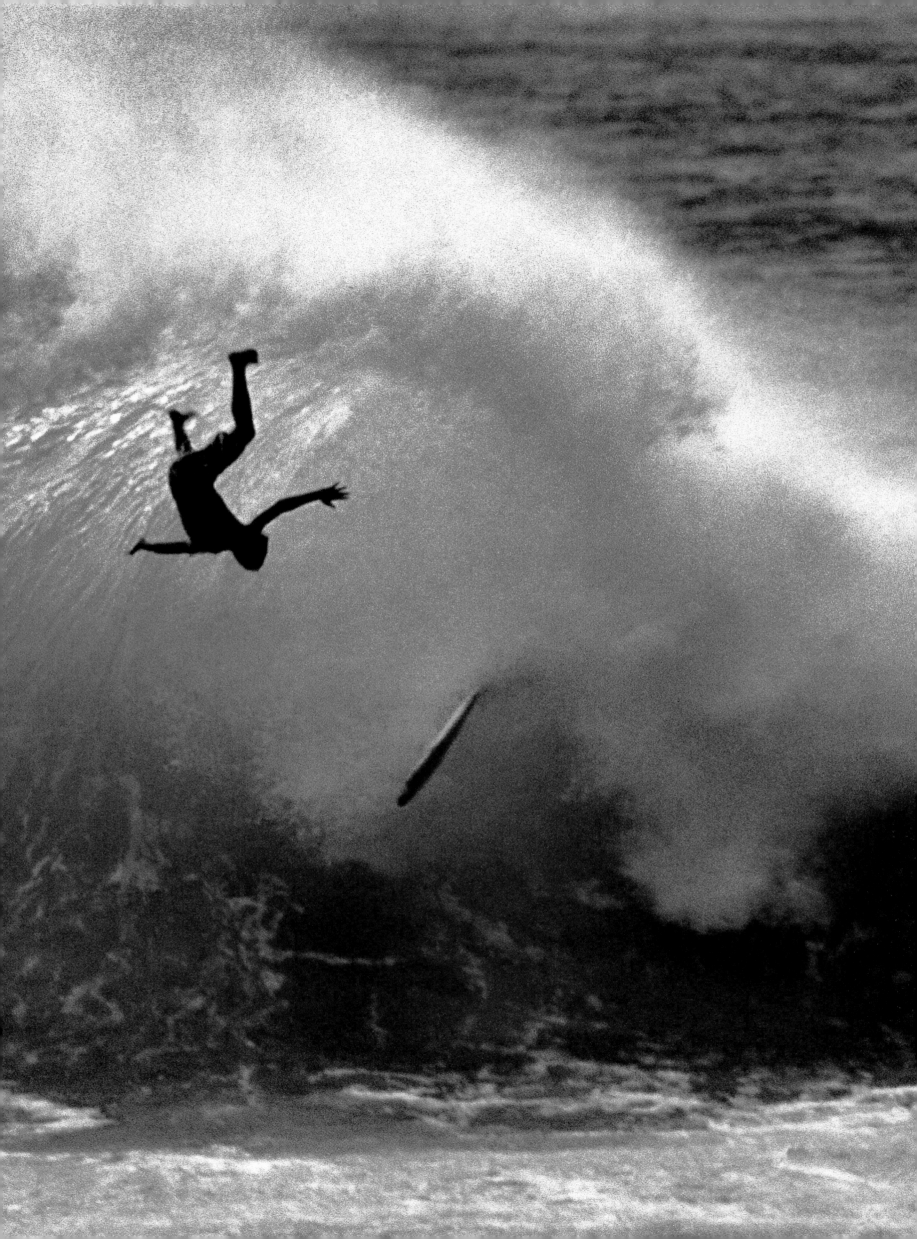

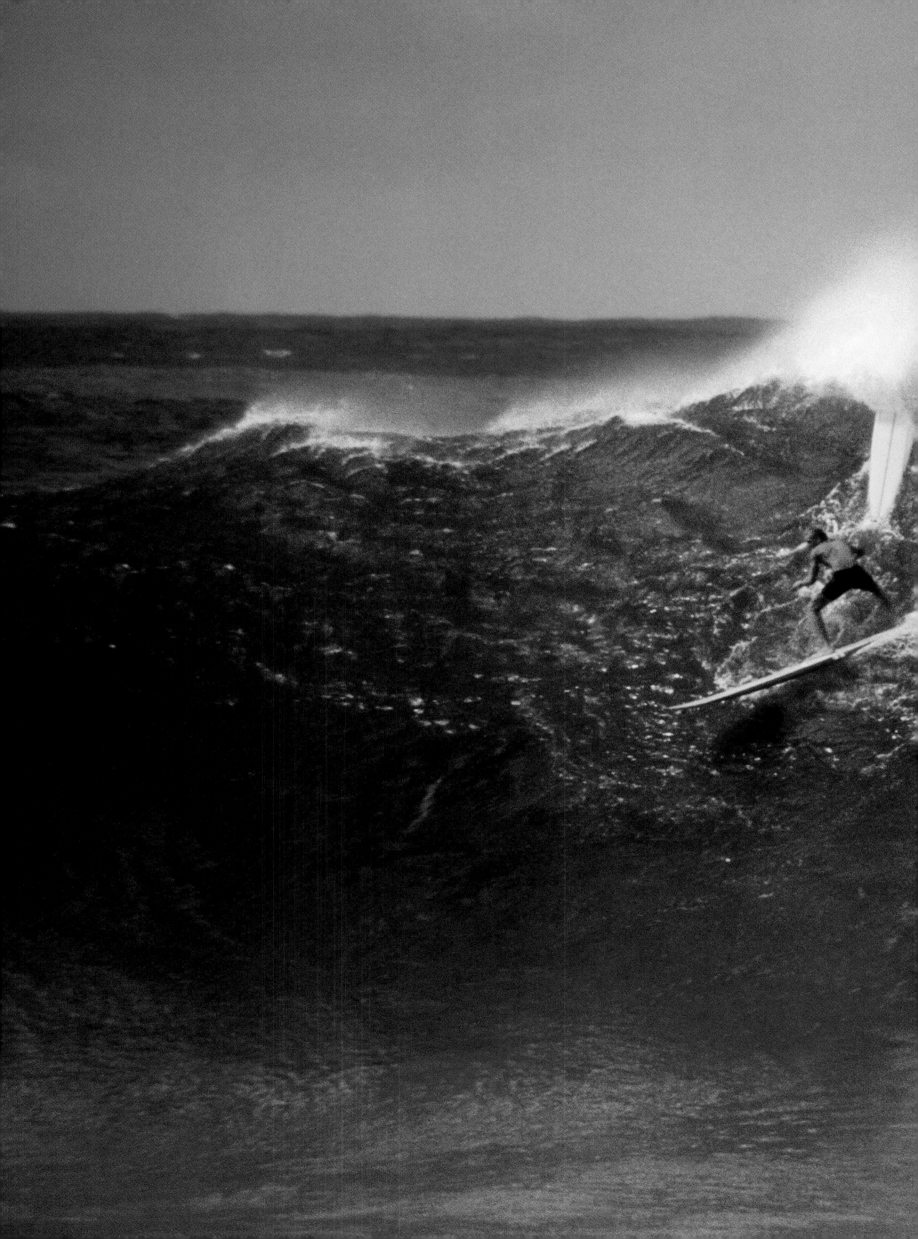

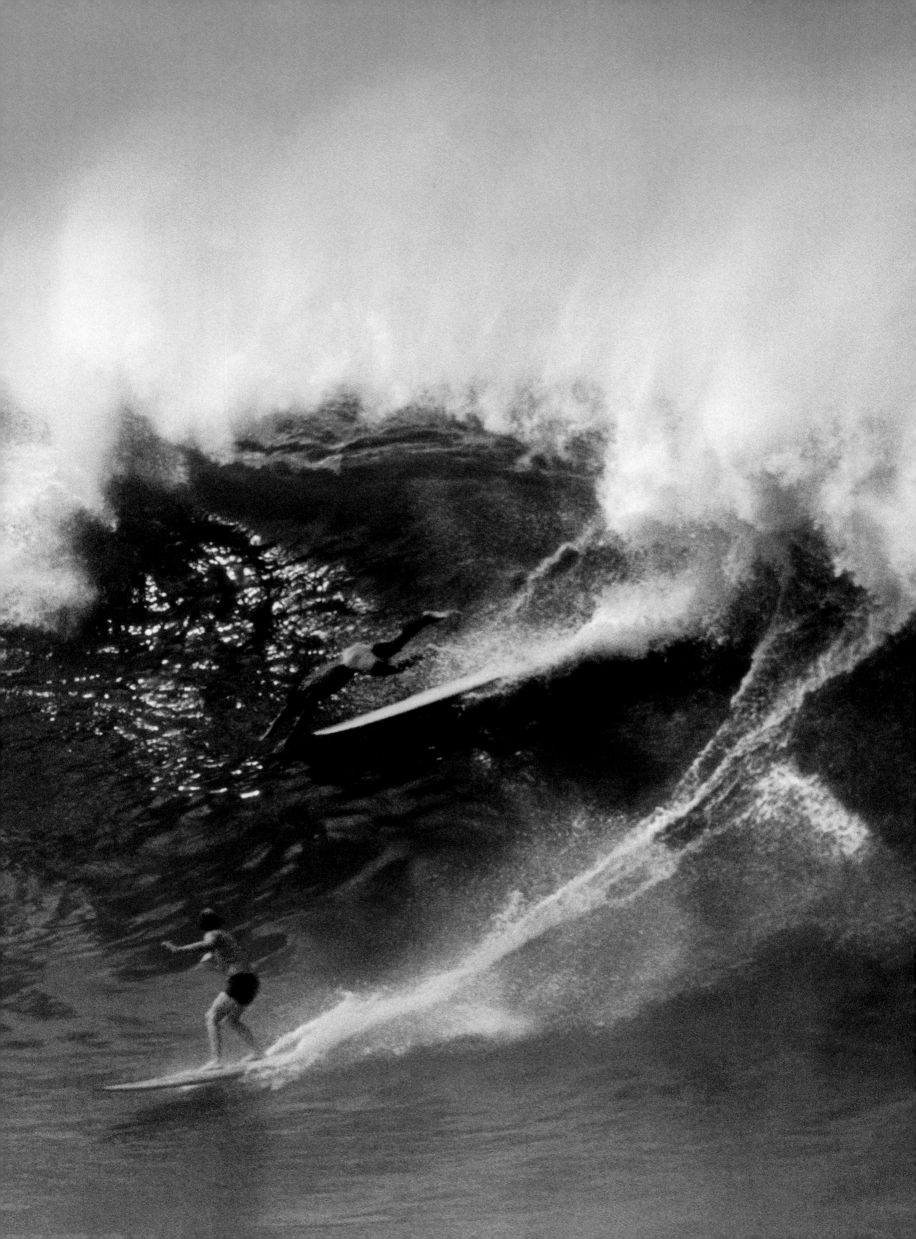

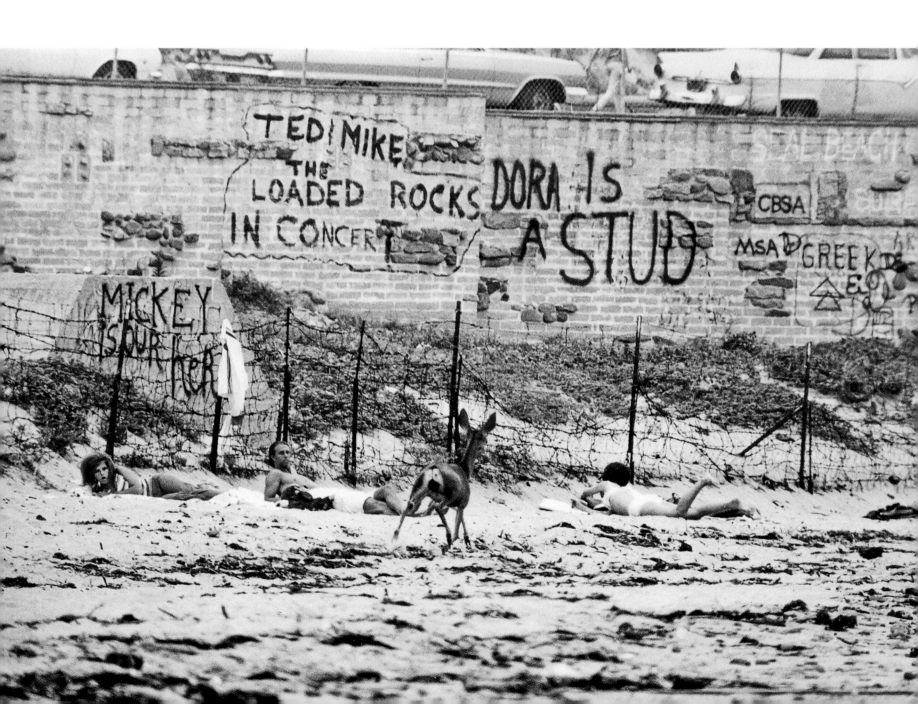

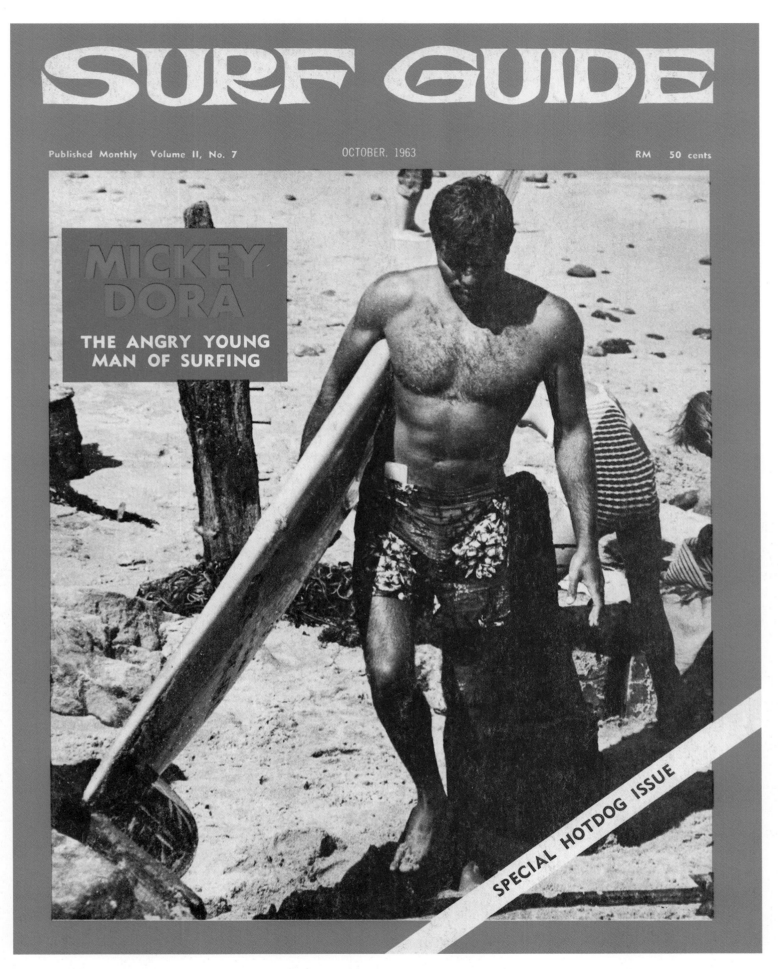

SURF GUIDE

Published Monthly Volume II, No. 7 OCTOBER, 1963 RM 50 cents

MICKEY DORA
THE ANGRY YOUNG MAN OF SURFING

SPECIAL HOTDOG ISSUE

MIKI DORA, DA CAT ADVERTISING SHOOT, 1966 Dora saw himself as equal parts playboy, prankster, prophet, and martyr. He railed against the hordes who invaded his Malibu, calling them "kooks of all colors, fags, finks, ego heroes, amen groupies, and football-punchy Valley swingers." *Photo, Pat Darrin*

ADVERTISEMENT, GREG NOLL SURF-BOARDS, 1966 Miki Dora briefly partnered with Greg Noll to produce a signature model called Da Cat, Dora's nickname.

MALIBU, C. 1966 For years after Miki Dora left Malibu, people spray-painted "Dora Lives!" Meanwhile, Dora was on a 30-year global "surfari" financed, in part, by credit-card fraud.

MAGAZINE COVER, *SURF GUIDE*, 1963

THE AIKAU FAMILY, DUKE KAHANAMOKU INVITATIONAL; SUNSET BEACH, HAWAII; 1967 The Aikau brothers, Eddie and Clyde, were raised in a Honolulu graveyard where their family served as the caretakers. Both brothers became legendary big-wave surfers and watermen. Shown watching Eddie compete at Sunset, from left to right: his father, Solomon "Pops" Aikau; his mother, Henrietta; and his sister, Myra. *Photo, LeRoy Grannis*

WAIMEA BAY, HAWAII, 1968 From left to right: unidentified, Mike Doyle, and Eddie Aikau, who charged big waves in a distinctive wide-legged "bully" style. *Photo, LeRoy Grannis*

MAZATLÁN, MEXICO, 1966 Surf photographer Ron Stoner made several trips to Mexico in his Ford Falcon station wagon. He discovered a number of new surf breaks, including a classic right point near San Blas now called Stoner's Point. *Photo, Ron Stoner*

GREG NOLL AND BOBBY CLOUTIER; WAIMEA BAY, HAWAII; 1967 Caught inside the wave, Eddie Aikau abandoned his big-wave gun and swam to safety through the wave face. *Photo, LeRoy Grannis*

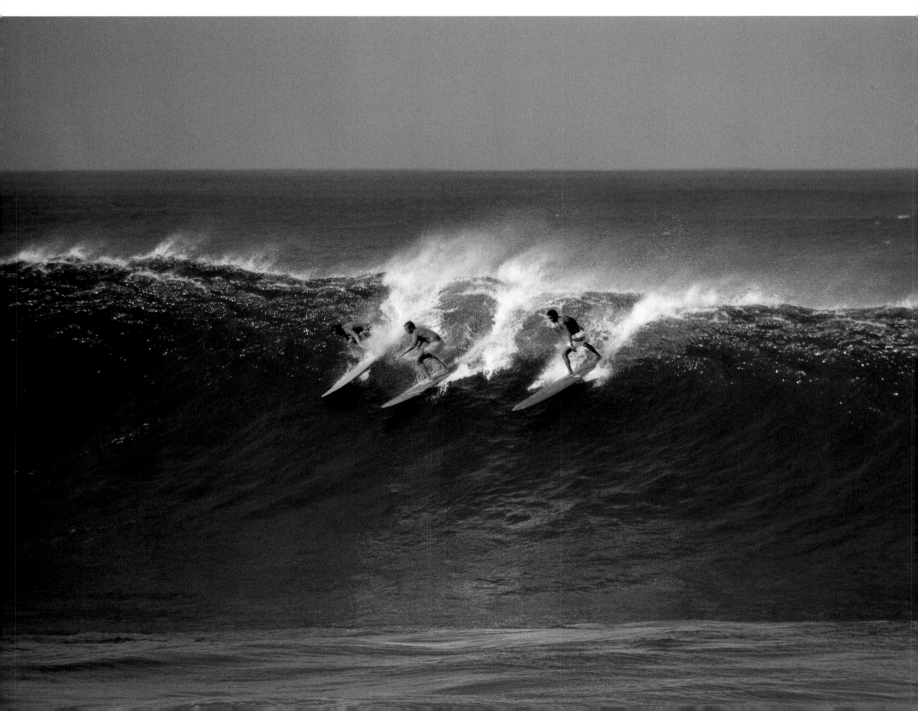

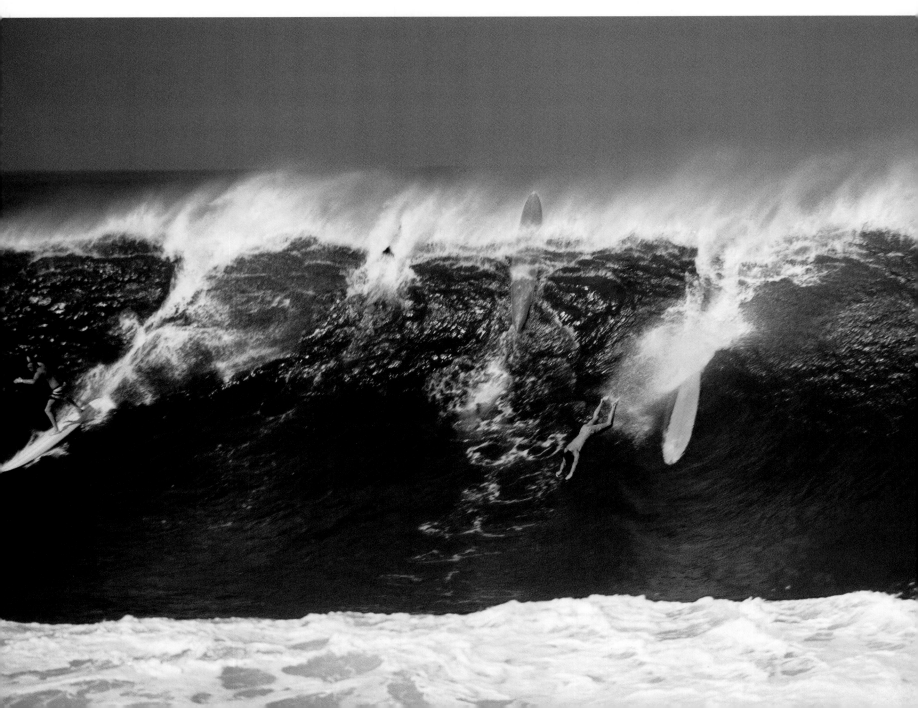

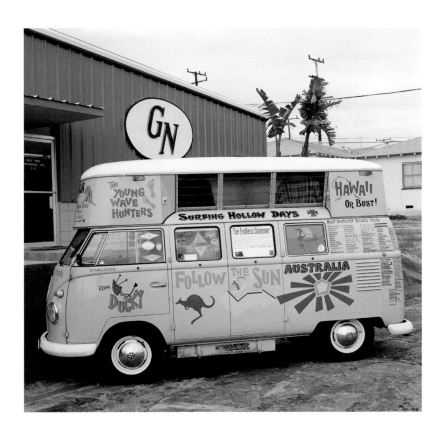

GREG NOLL SURFBOARDS FACTORY; HERMOSA BEACH, CALIFORNIA; 1965
Visiting Australian surfers camped for a couple nights at the Noll factory. *Photo, LeRoy Grannis*

SURF WOODY, HAWAII, C. 1965
Part dragster, part beach cruiser, the George Barris-designed Surf Woody featured a Ford Cobra engine, racing slicks, walnut paneling, stereo sound, and two portable TV sets. *Photo, George Barris*

MAGAZINE COVER, *CAR CRAFT*, 1963
Southern California car culture absorbed the free-wheeling lifestyle that surfing projected.

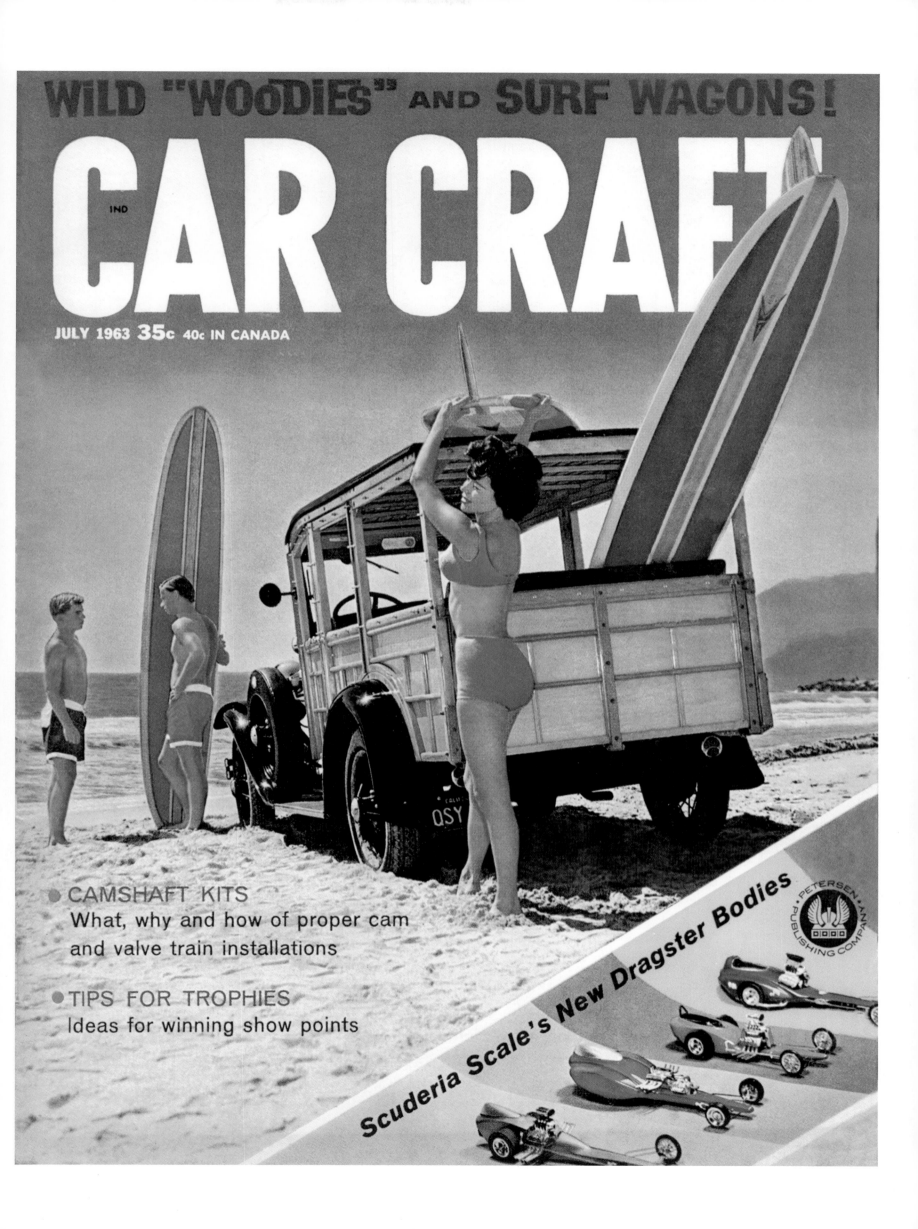

WILD "WOODIES" AND SURF WAGONS!

CAR CRAFT

IND

JULY 1963 35c 40c IN CANADA

● CAMSHAFT KITS
What, why and how of proper cam
and valve train installations

● TIPS FOR TROPHIES
Ideas for winning show points

Scuderia Scale's New Dragster Bodies

PETERSEN
PUBLISHING COMPANY

PULP COVERS *Surfside Sex*, 1966; *The Sex Surfers*, 1968; *Surf Broad*, 1965

MAGAZINE COVER, *TRUE DANGER*, 1964
Surfing's impact on popular culture was filtered down to the exaggerated literary genre of pulp fiction.

FOR MEN ONLY MAGAZINE, 1969

SURFER GRAFFITI; SAN FRANCISCO, CALIFORNIA; C. 1966 *(Pages 278–279)*
Photo, Kelly Hart

THE HELL SURFERS

"A weirdo gang of thrill-seekers on a sin and crime rampage..."—The Record

JULY

FOR MEN ONLY

IND ◇

40¢

From the $5.95 Shocker

"I Am A 'For Millionaires Only' Call Girl"

COMMANDER "BULLETS" HAYS

LONE WOLF ACE THE NORTH VIET CAN'T SHOOT DOWN

Yank Who Raided The Island Of **"PASSION HOSTAGES"**

PROFITS: $4 BILLION TAXES: $0

Sickening Scandal Of Our Fat, "Free Ride" Oil Companies

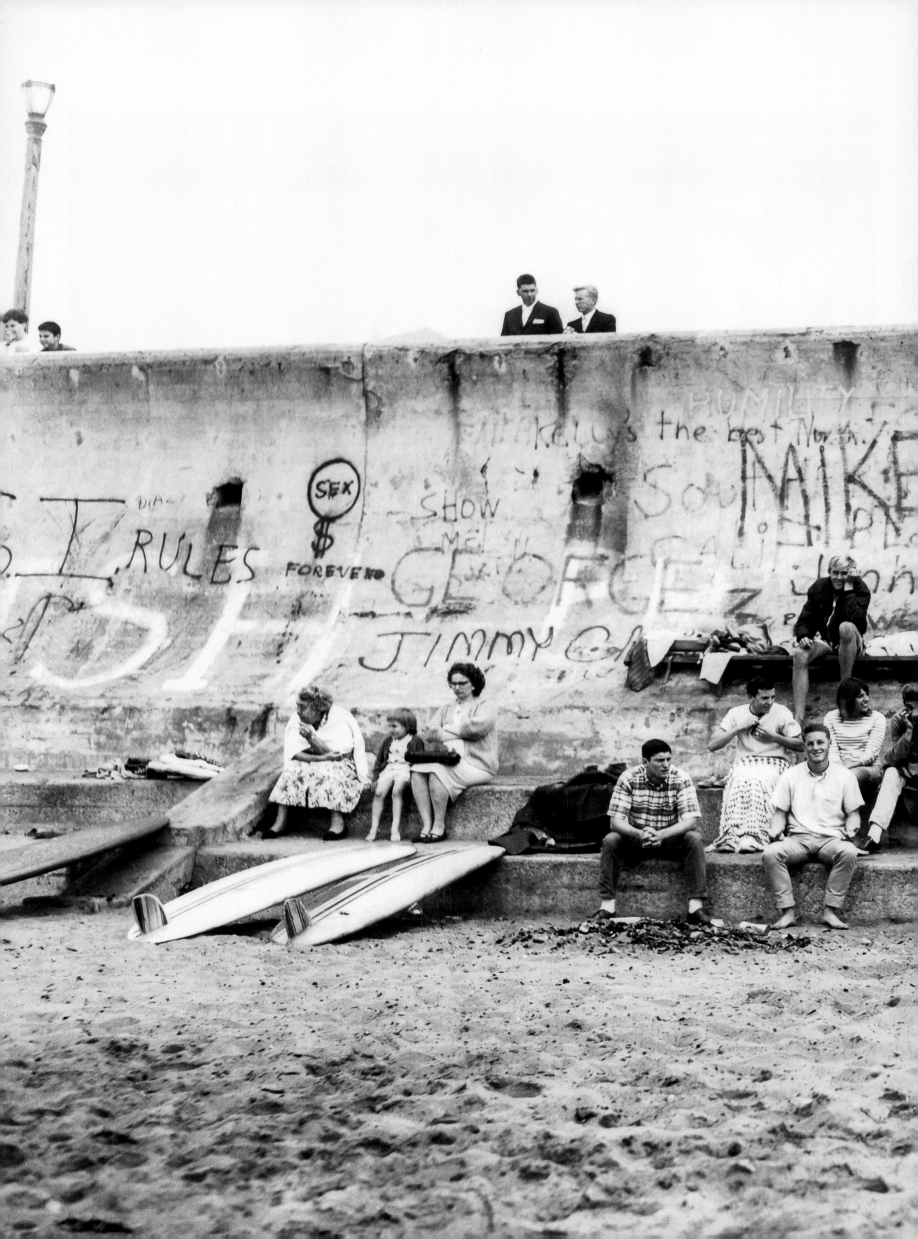

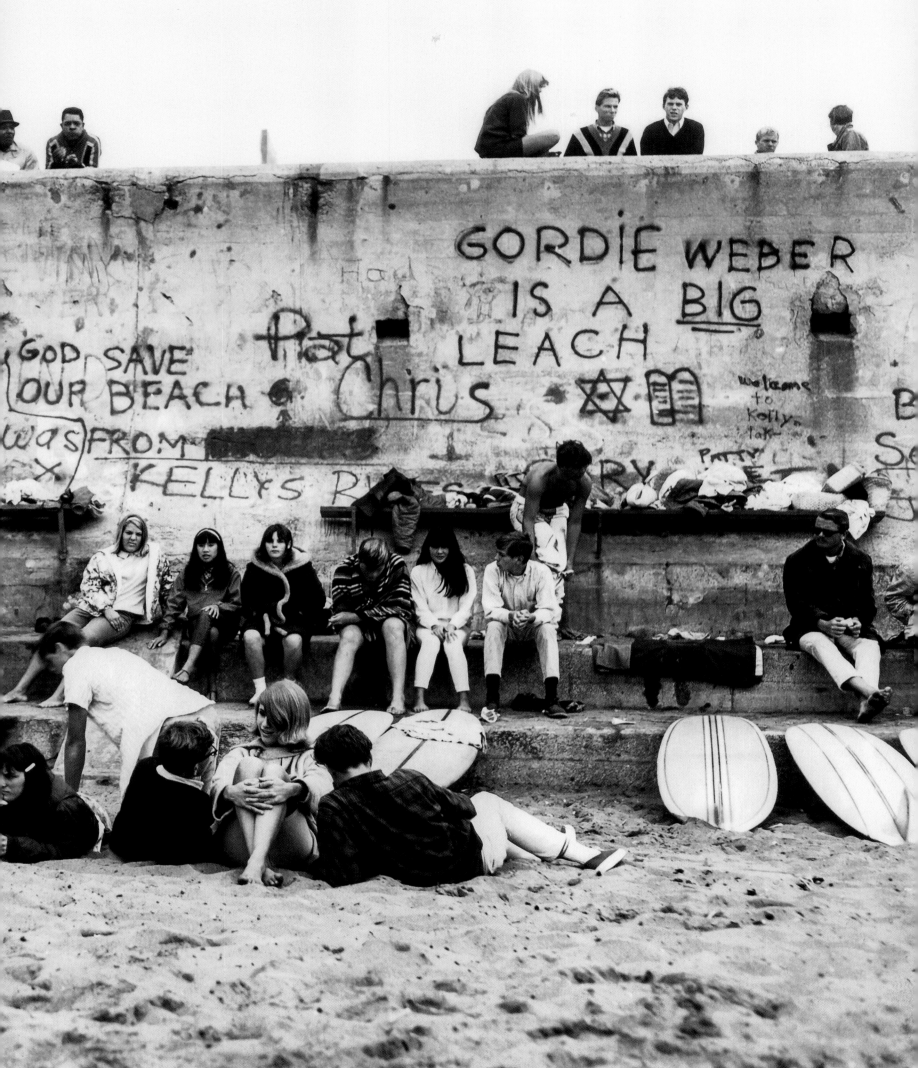

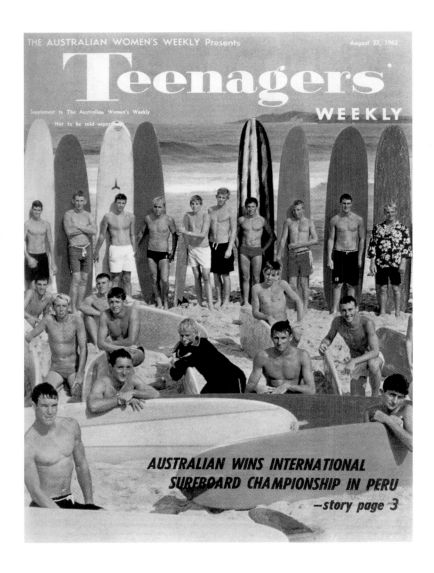

MAGAZINE COVER, *TEENAGERS' WEEKLY*, 1962

HERMOSA BEACH, CALIFORNIA, 1967
During the summer, the Hermosa Beach boardwalk becomes a nonstop parade of bikes, skateboards, and roller skates. *Photo, LeRoy Grannis*

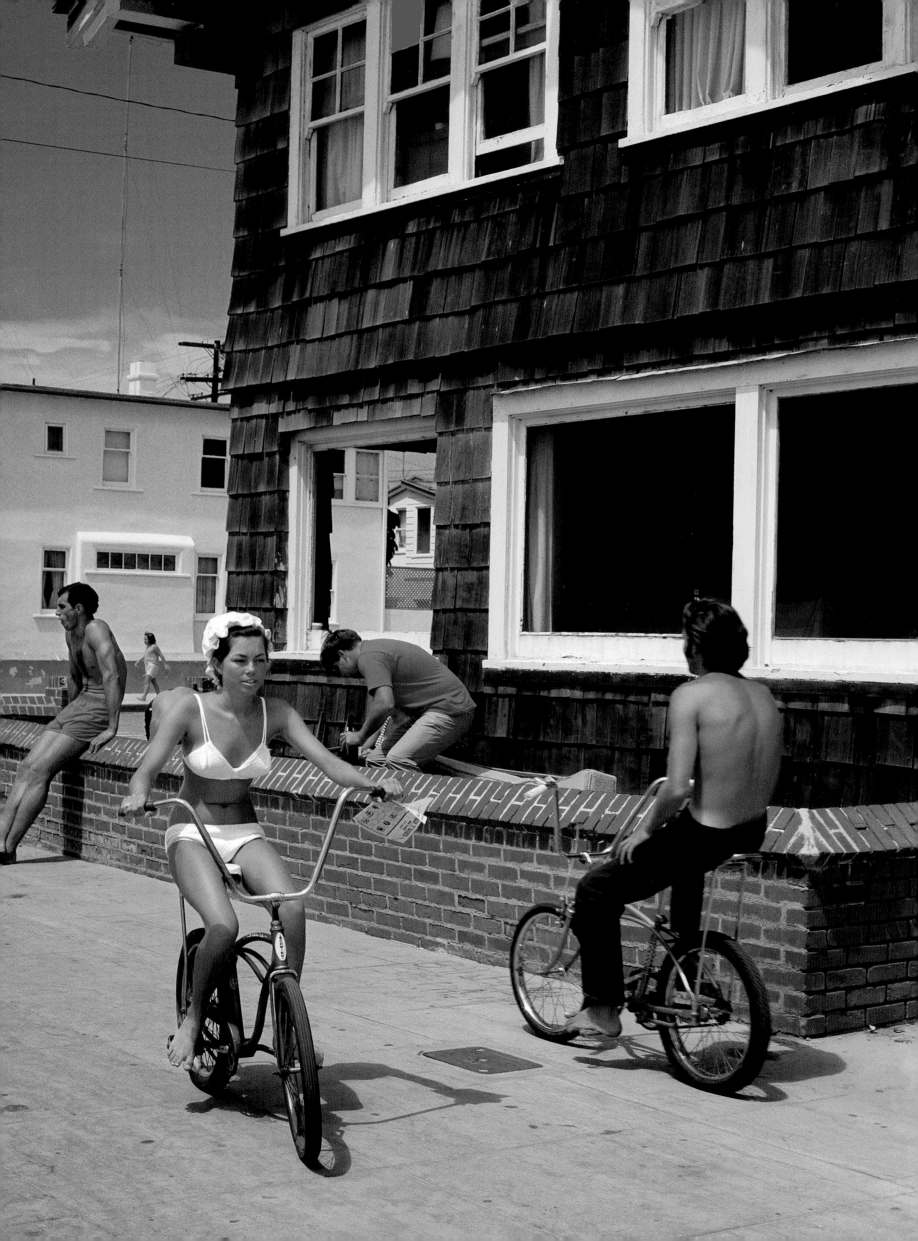

NEW TANFASTIC DARK-TANNING OIL

Wildest suntan stuff ever invented!

Gives you the fastest, darkest, sleekest, shiniest, best-looking <u>real</u> suntan on the beach!

This is THE suntan oil! The one that lets in all the dark-tanning rays you can take while it blocks out burning rays. The one that tans you really deep really dark, capital D-A-R-K! The one that works fast! So don't mess with fake tans, get a real dark suntan real <u>fast</u>! Get with new Tanfastic Dark-Tanning Oil! P.S. Comes in lotion, too!

Join the tan-ables . . . get the best of the sun

Sharon Tate
Co-starring in Martin Ransohoff's "Don't Make Waves" says

"Coppertone gives you a better tan"

(—it's enriched to give extra protection, too!)

Post-haste Prose by Montag

In the swim of this fast-moving modern world, a gal has to make every minute count . . . so post haste she pens a bit of hot news or cool chit-chat to a friend on Post-A-Cards or French Notes. There's a choice of designs and colors and papers . . . all dashing. Post-A-Cards are a mere 59c and 69c for a box and French Notes just a little ole dollar.

At Stores Where You'd Expect to Find the Newest Ideas in Notes.

Montag
Atlanta–New York–Dallas

LEOPARD'S SPOTS ADVERTISING SHOOT, 1967 Sherry Haley, wife of Huntington Beach surfer Mike Haley, was the queen of surf models. She manufactured, sold, and modeled her own line of bikinis called Leopard's Spots. *Photo, Ron Stoner*

ADVERTISEMENT, TANFASTIC, 1965 Before the cancerous effects of prolonged sun exposure was fully known, a deep tan was considered healthy and sexy.

ADVERTISEMENT, COPPERTONE, 1967 Model and actress Sharon Tate regularly appeared in advertisements and magazines. She would be brutally murdered years later by members of Charles Manson's "family."

ADVERTISEMENT, MONTAG STATIONERY, 1967

Make It!

International Surfing stars make it with Catalina. Mike Doyle, number one in Surfer Magazine's reader poll, right, wears the "Waimea," Australia's Queensland Champion Ken Adler, left, wears "Ole Verde," and Robert August, one of California's best, center, wears "Surf Beach." The best from the originators of authentic Surfer® jackets and trunks. All of 100% Du Pont Nylon.

▲— Catalina, Inc. • Another Fine 🔷 Kayser-Roth Product *Catalina*®

INSTANT KICKS FROM SCRIBBLE-YOUR-OWN
Grapefruit G's
NEW FROM SANDCOMBER

sandcomber

ADVERTISEMENT, CATALINA SWIMWEAR, 1966 Catalina was a mainstream swimwear company that hired surfers like Mike Doyle as their surfing spokesmen, but they made a shoddy department-store product. "When authentic surfwear companies started popping up out of garages all over Southern California pushing tough, creative, innovative beachwear," Doyle said, "Catalina got eaten alive."

ADVERTISEMENT, SANDCOMBER, 1966 Noted South Bay surfer Henry Ford's pose was a take on a favorite surfer prank of dropping their baggies and "bare-assing" unsuspecting citizens.

ADVERTISEMENT, FALSTAFF BEER, 1965

ADVERTISEMENT, CHESTERFIELD, C. 1965 Not skipping a beat, the cigarette industry used the rugged surfer look to sell their product.

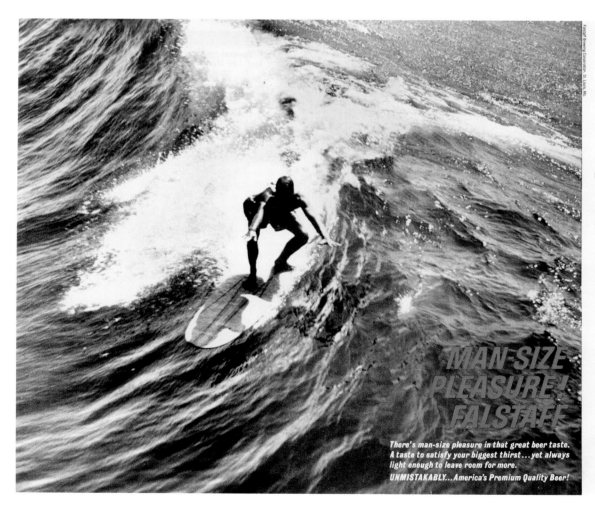

MAN-SIZE PLEASURE! FALSTAFF

There's man-size pleasure in that great beer taste. A taste to satisfy your biggest thirst...yet always light enough to leave room for more.
UNMISTAKABLY...America's Premium Quality Beer!

FALSTAFF *Beer*
America's Premium Quality Beer

SURFIN' IS THE ONLY LIFE

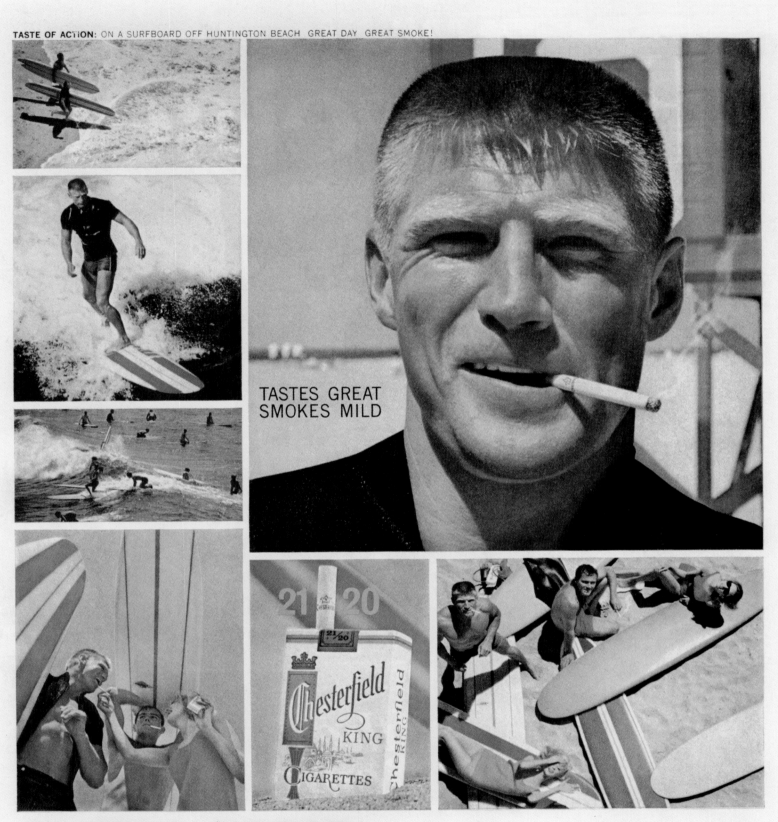

TASTE OF ACTION: ON A SURFBOARD OFF HUNTINGTON BEACH. GREAT DAY. GREAT SMOKE!

TASTES GREAT
SMOKES MILD

TASTES GREAT because the tobaccos are!

21 great tobaccos make 20 wonderful Chesterfield Kings...vintage tobaccos grown mild, aged mild, blended mild and made to taste even milder through longer length. Have a great smoke!

CHESTERFIELD KING

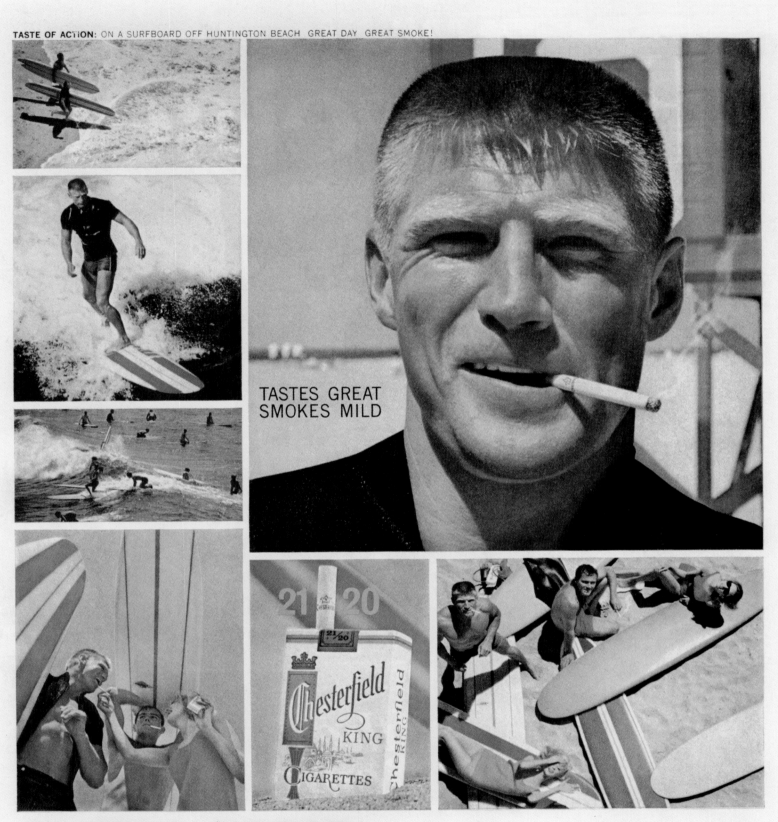

285

(use colored pencils, pens, etc., to add designs not shown)

Take this to your local Weber Dealer

Redwood Stringers
1/16" redwood
1/8" redwood
1/4" redwood
3/8" redwood
1/2" redwood
3/4" redwood

Balsa Stringers
1/4" balsa
1/2" balsa
1" balsa
2" balsa
3" balsa
4" balsa

Foam Stringers
1" foam bordered by 1/4" redwoods
1/4" foam bordered by 1/8" redwoods
1/4" foam unbordered

Foam Stringers colors
blue, yellow, red, orange, white, black

Combination Stringers
Wood t-bands — (redwood-balsa-redwood)
Wood reverse t-bands — (balsa-redwood-balsa)

Fin colors
Black

Transparent fin colors
White
Red
Yellow
Blue

Colors
Red
Blue
Baby Blue
Royal Blue
Green
Lime Green
Olive Green
Transparent Green
Yellow

More Colors
Pale Yellow
Transparent Yellow
Orange
Apricot
Maroon
Chocolate Brown
Beige
White
Black

EXCLUSIVE WEBER DEALERS
B. J. Surf Shop
Houston, Texas
Hang Ten Surf Shop
Santurce, Puerto Rico
Monmouth Surf Shop
North Long Branch, N. J.
Spyder Surf Shop
Ocean City, Maryland
South Shore Surfer
Hull, Mass.
Western Auto
Burgaw, N. Carolina

Dewey Weber
Built with Quality
WALKER FOAM

NON EXCLUSIVE DEALERS
Bikini Surf Shop
York Beach, Maine
Berts Beach Service
Ocean City, New Jersey
Dewey's Surf Shop
Folly Beach, S. Carolina
Emilio's Ski Shop
Forest Hill, N.Y.C., N.Y.
Emilio's Ski Shop
Levitown, L.I., N.Y.
Felix Marina
Grand Haven, Michigan
Goldie's Surf Shop
Cranston, Rhode Island
Hixon Surf Shop
Neptune Beach, Florida
Island Surf Shop
Port Aransas, Texas
Will Jacobs
Hartford, Conn.
Juno Surf Shop
Juno, Florida
Mogul Ski Shop
Clifton, New Jersey
Pleasure Point Surf Shop
Santa Cruz, Calif.
RanJon Surf Shop
Pawleys Island, S. Carolina

RanJon Surf Shop
Cocoa Beach, Florida
RanJon Surf Shop
Ship Bottom, New Jersey
The Ski Shop—
Streeter & Quarles
Boston, Mass.
Surfboards Galore
Daytona Beach, Florida
Surfline
Honolulu, Hawaii
Surf Scene
La Jolla, Calif.
Surf Sun 'n Fun
Fort Lauderdale, Florida
Southern Water Sports, Inc.
Mobile, Alabama
Troy Surf Shop
Portland, Oregon
Valley Surf Center
Tarzana, Calif.
Western Auto
Virginia Beach, Va.
Willburgers Ski Shop
Philadelphia, Pa.
Jasper's Surf Shop
Cape Cod, Mass.

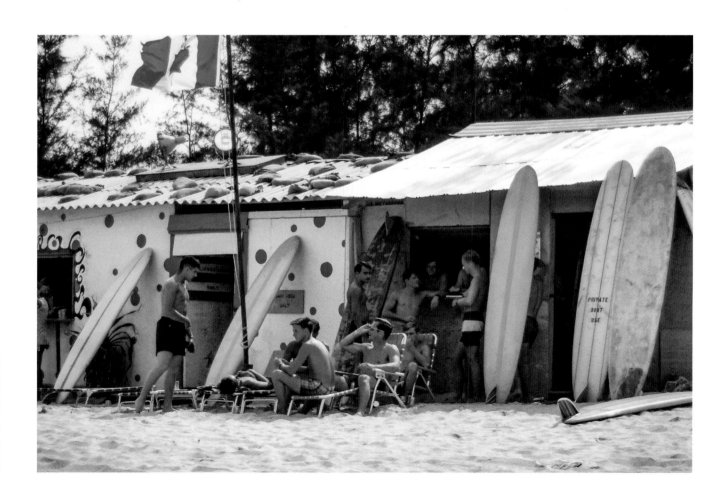

SURFIN' IS THE ONLY LIFE

286

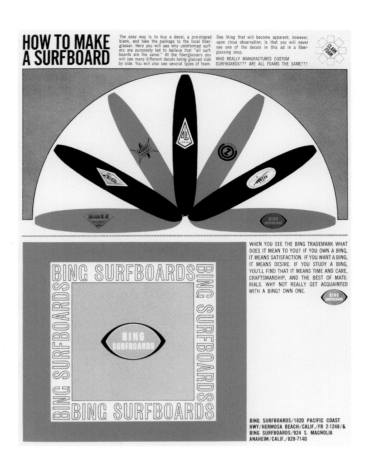

ADVERTISEMENT, DEWEY WEBER SURFBOARDS, 1967 As the surf industry matured it began to take cues from cutting-edge advertising agencies for a more sophisticated pop-art approach to marketing, in this case offering off-the-rack customizing similar to buying a new car from the factory.

CHINA BEACH SURF CLUB; DA NANG, VIETNAM; C. 1969 "One of the most poignant things of the film is how many California surfers went to Vietnam, and how many didn't come back. One of the reasons I put surfing in *Apocalypse Now* was because I always thought Vietnam was a California war."—John Milius, cowriter of *Apocalypse Now* and director of *Big Wednesday*

ADVERTISEMENT, BING SURFBOARDS, 1963

ADVERTISEMENT, DEWEY WEBER SURF-BOARDS, 1967 By the mid-1960s, psychedelic drug culture was infiltrating surf culture as these flower-power boards attest.

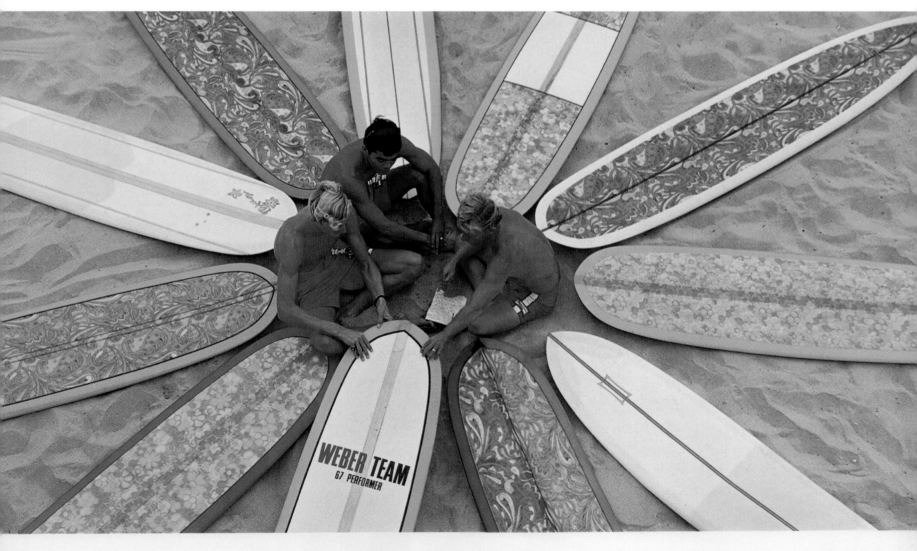

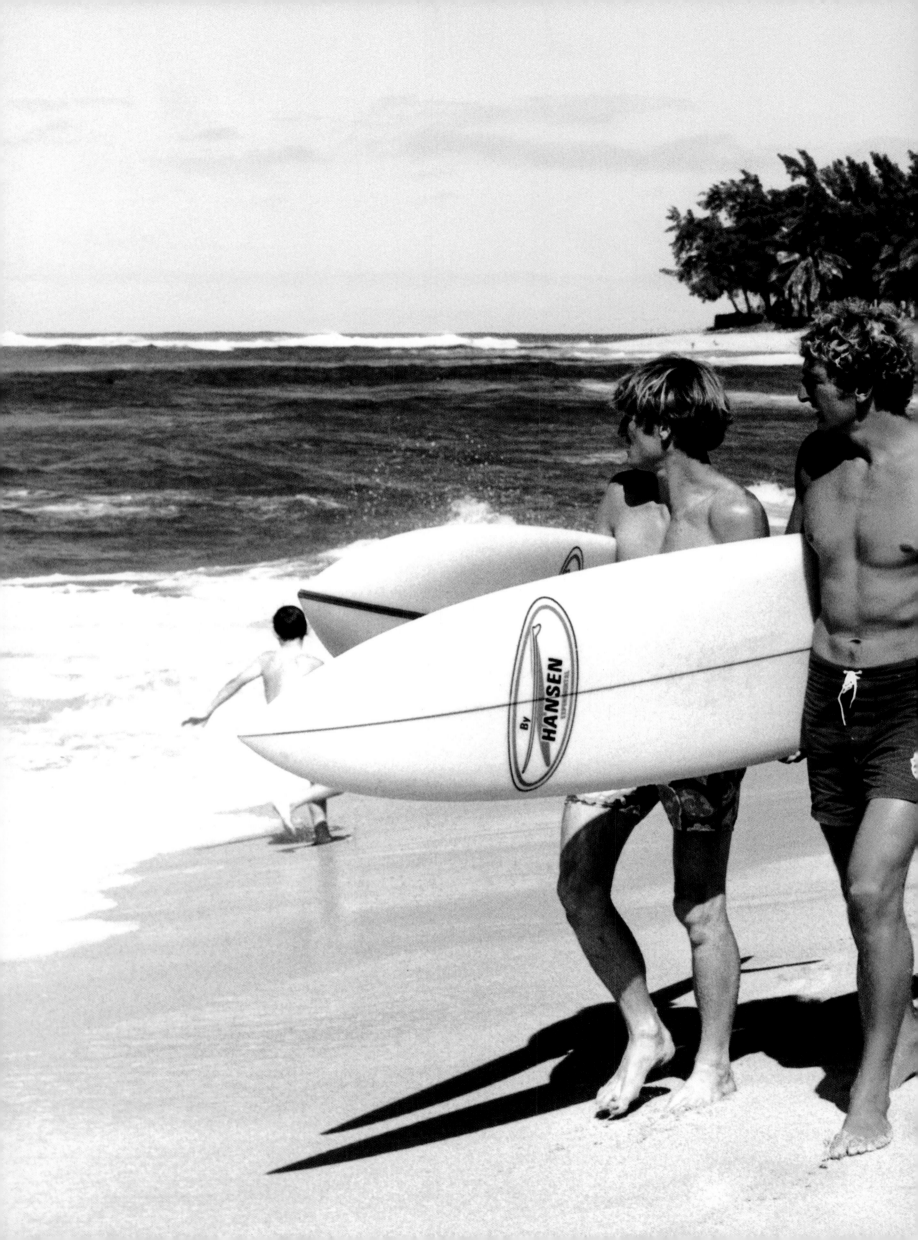

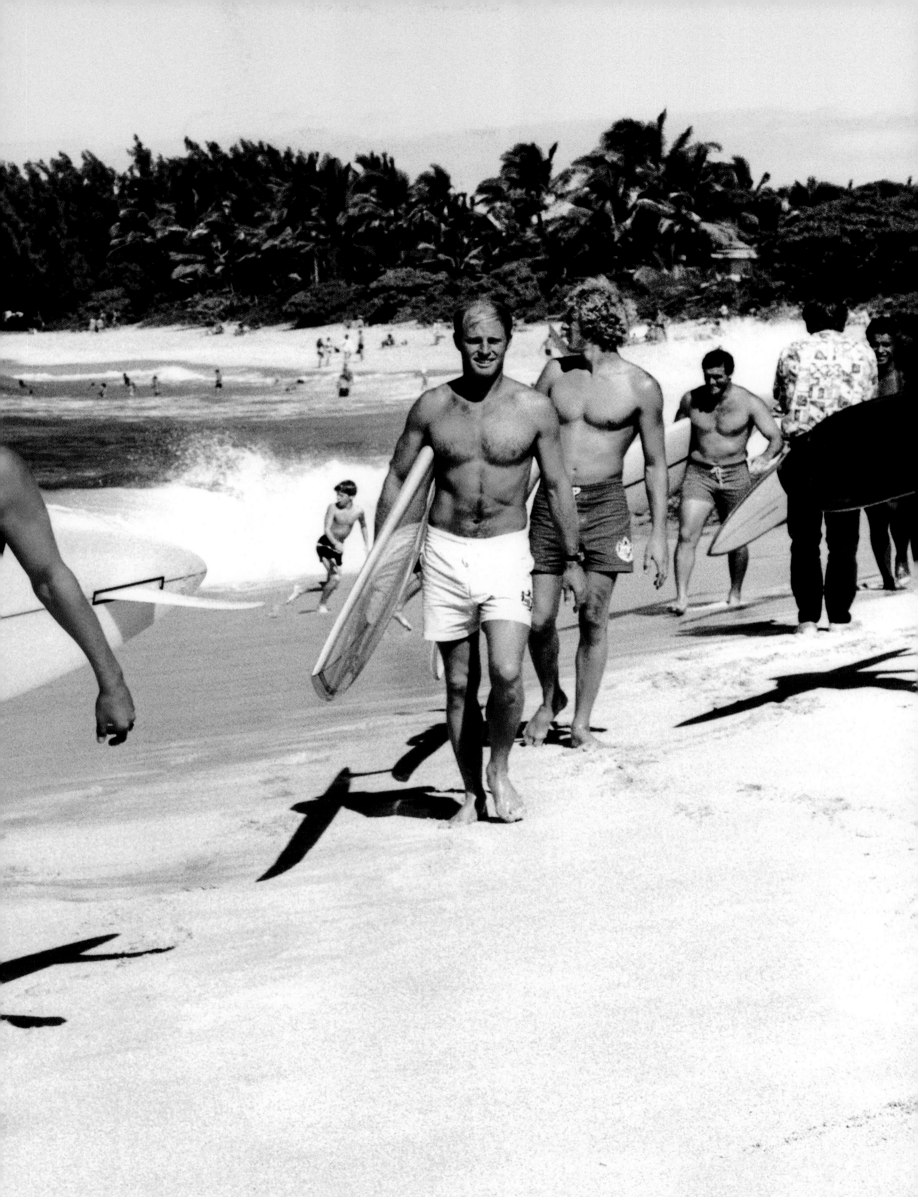

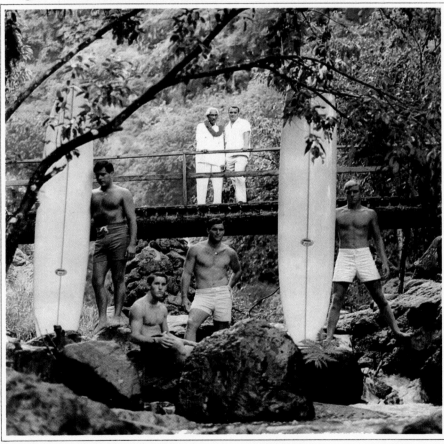

DUKE KAHANAMOKU INVITATIONAL FINALISTS; SUNSET BEACH, HAWAII; 1968
(Pages 288–289) "The Duke" was a prestigious big-wave contest held from 1965 to 1984. The invite-only event was held at Sunset Beach in fearsome waves that often topped 20 feet. From left to right: Rusty Miller, Mike Doyle, Ricky Grigg, Nat Young, and Fred Hemmings. *Photo LeRoy Grannis*

DUKE KAHANAMOKU INVITATIONAL FINALISTS; SUNSET BEACH, HAWAII; 1967
The 1966 Duke Classic had to be held on February 1, 1967 due to poor surf conditions in the winter of '66. Among those in attendance were Fred Hemmings, Miki Dora, Paul Strauch, Eddie Aikau, Rick Grigg, Mike Doyle, Corky Carroll, Greg Noll, and Mike Hynson. *Photo, Tim McCullough*

ADVERTISEMENT, GREG NOLL SURF-BOARDS, 1968

POSTER, CONTINENTAL AIRLINES, C. 1968

Hawaii

CONTINENTAL

THE PROUD BIRD WITH THE GOLDEN TAIL

SURFING 1962-1969

GERRY LOPEZ; PIPELINE, HAWAII; 1969
Lopez started surfing at Waikiki and was a champion
junior competitor. But it was at the North Shore's
Pipeline where Lopez rose to fame as the best tube-
rider in the world. *Photo, Art Brewer*

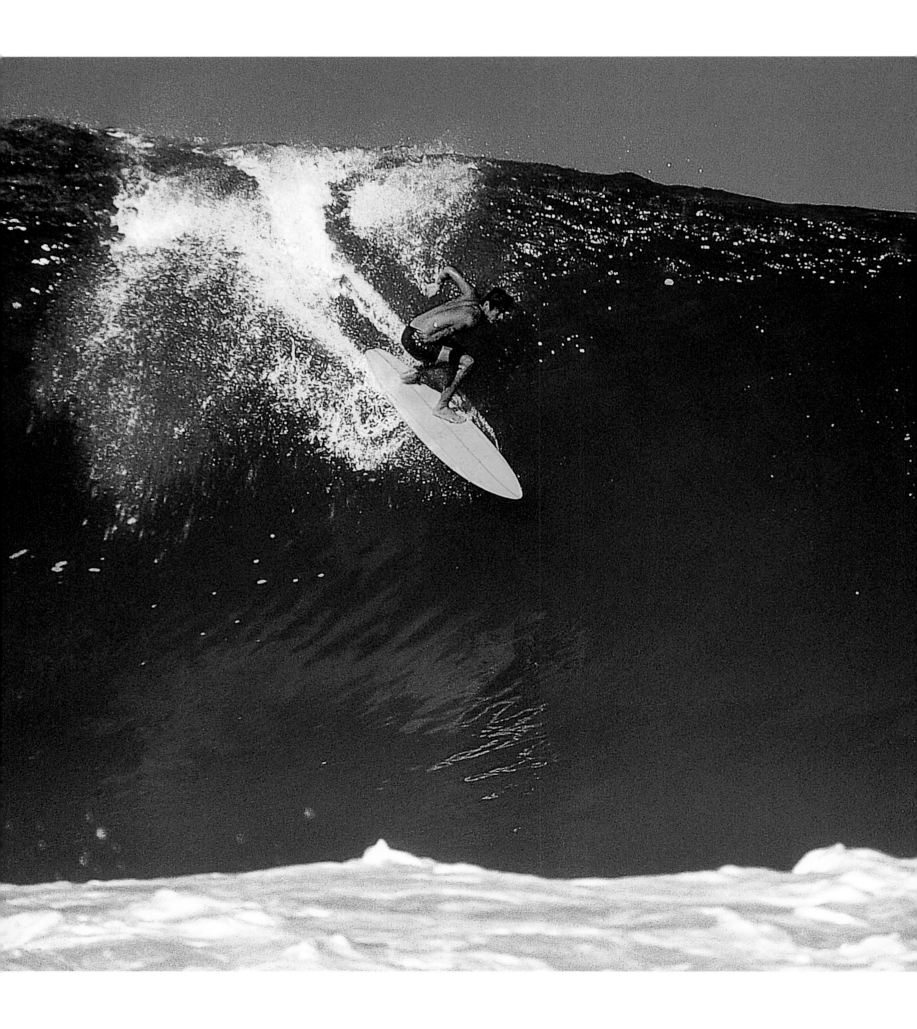

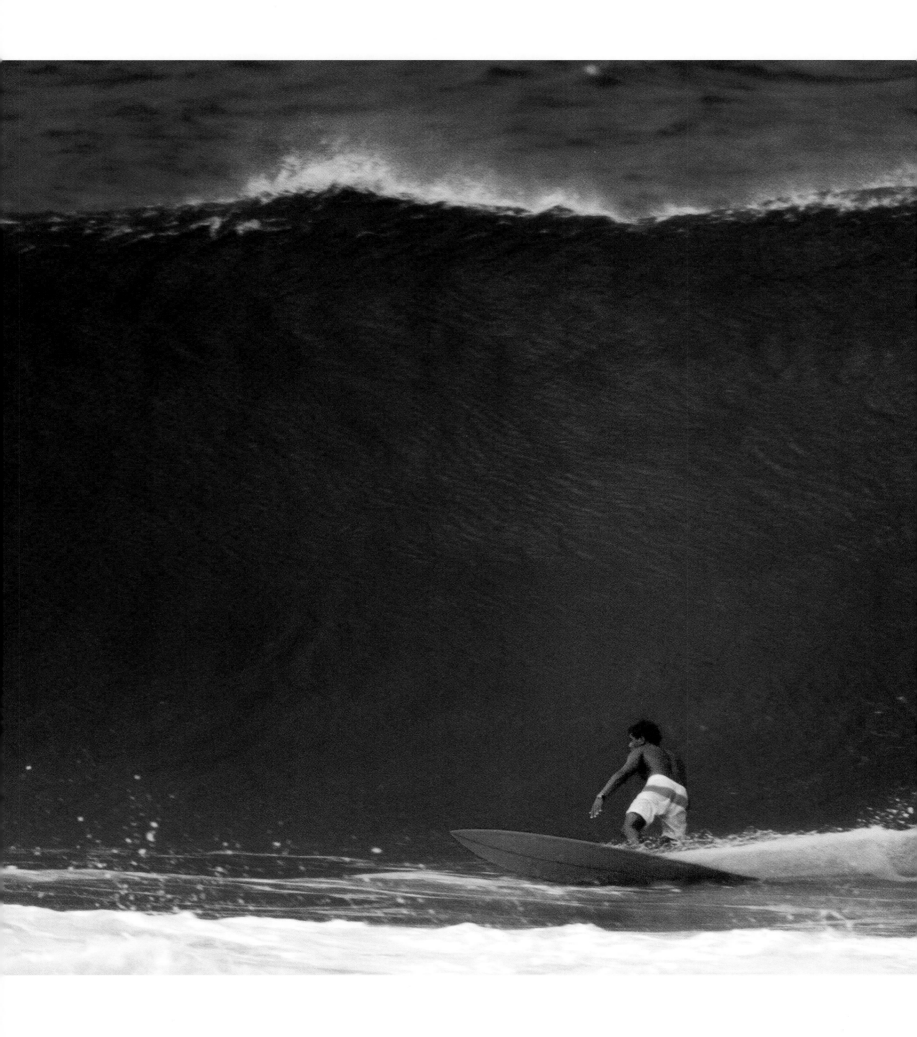

Paul Witzig Presents

the hot generation
FROM AUSTRALIA

POSTER, *THE HOT GENERATION*, 1967

POSTER, *FREE AND EASY*, 1967
Greg MacGillivray and Jim Freeman made the most well-crafted and sophisticated surf films of the era, employing the latest in film cameras, lenses, equipment, and techniques.

POSTER, *THE PERFORMERS*, 1965

POSTER, *THE FANTASTIC PLASTIC MACHINE*, 1969 *The Fantastic Plastic Machine* was Hollywood's attempt at a big-budget "real" surf film patterned after *The Endless Summer*. It failed on most levels except accidentally capturing key moments of the impending shortboard revolution brewing in Australia.

SURFING 1962–1969

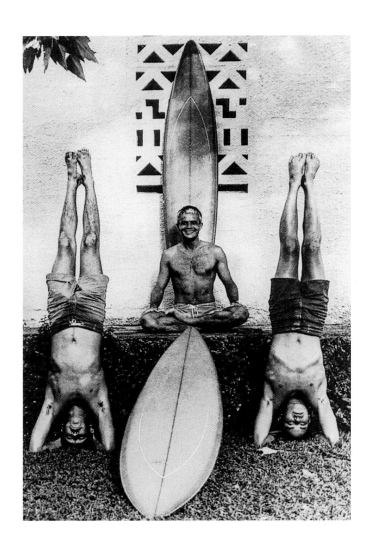

GERRY LOPEZ, DICK BREWER, AND RENO ABELLIRA; HONOLULU; 1969 From the late 1960s through the '70s, Brewer, center, was known as the guru of progressive shortboard design. Top Pipeline riders Lopez, left, and Abellira, right, pose as New Age disciples for a Brewer surfboard advertisement. *Photo, David Darling*

ANGOURIE BEACH; NEW SOUTH WALES, AUSTRALIA; C. 1969 Australian surfers mirrored their Hawaiian and American West Coast counterparts and were looked upon with suspicion by local farmers and citizens of New South Wales's rural beaches. *Photo, John Witzig*

RICK GRIFFIN; DANA POINT, CALIFORNIA; 1969 When Severson returned to filmmaking in 1969 to make *Pacific Vibrations*, he hired Rick Griffin to create the film's poster and the psychedelic bus called *Motorskill*. From left to right: Chuck Edwell, Rick Griffin, and John Severson. *Photo, Art Brewer*

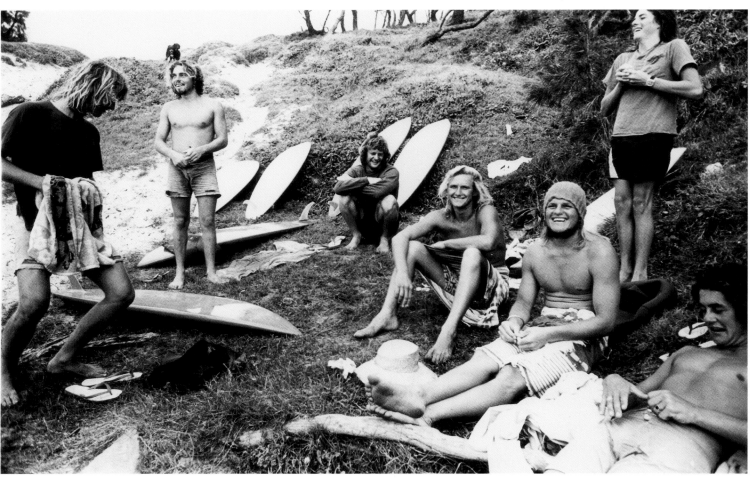

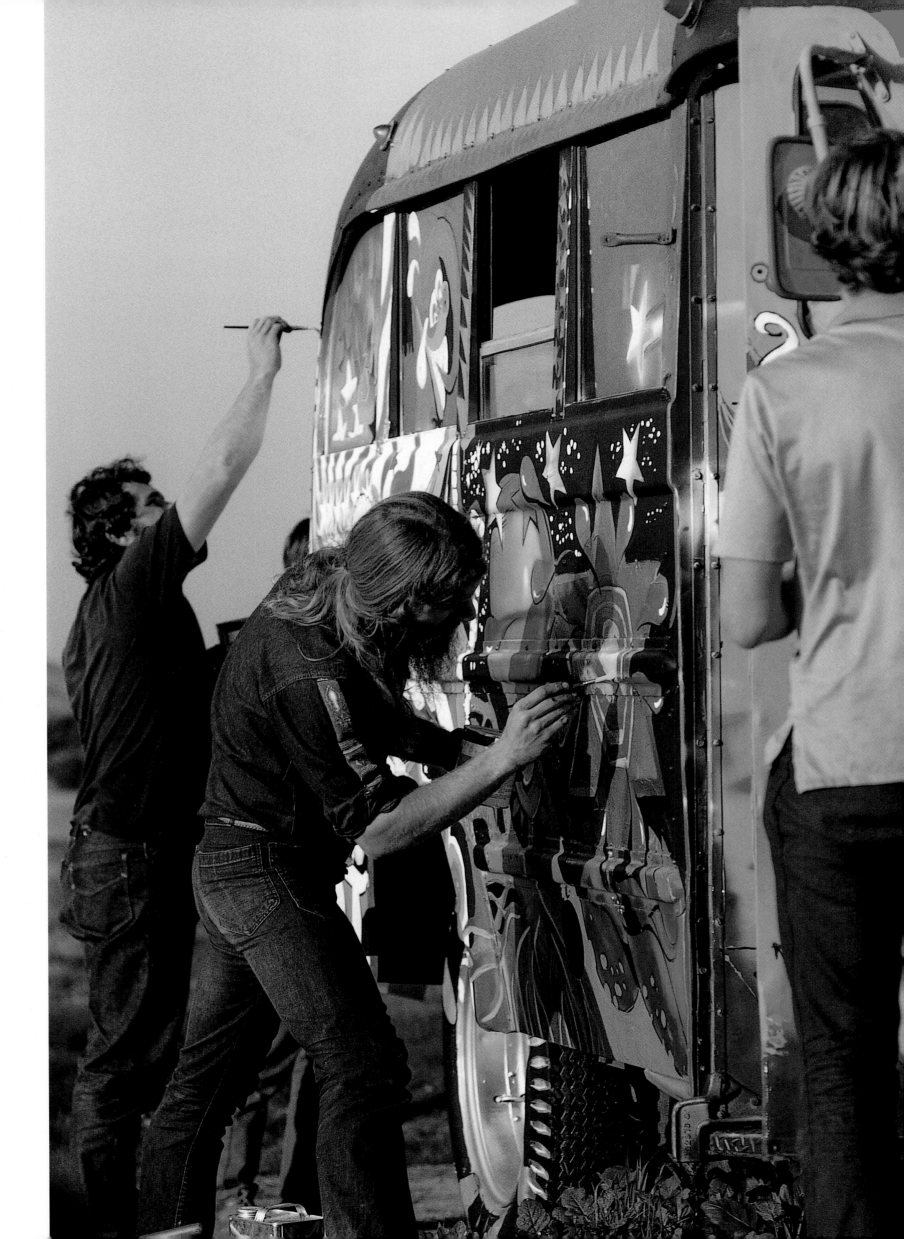

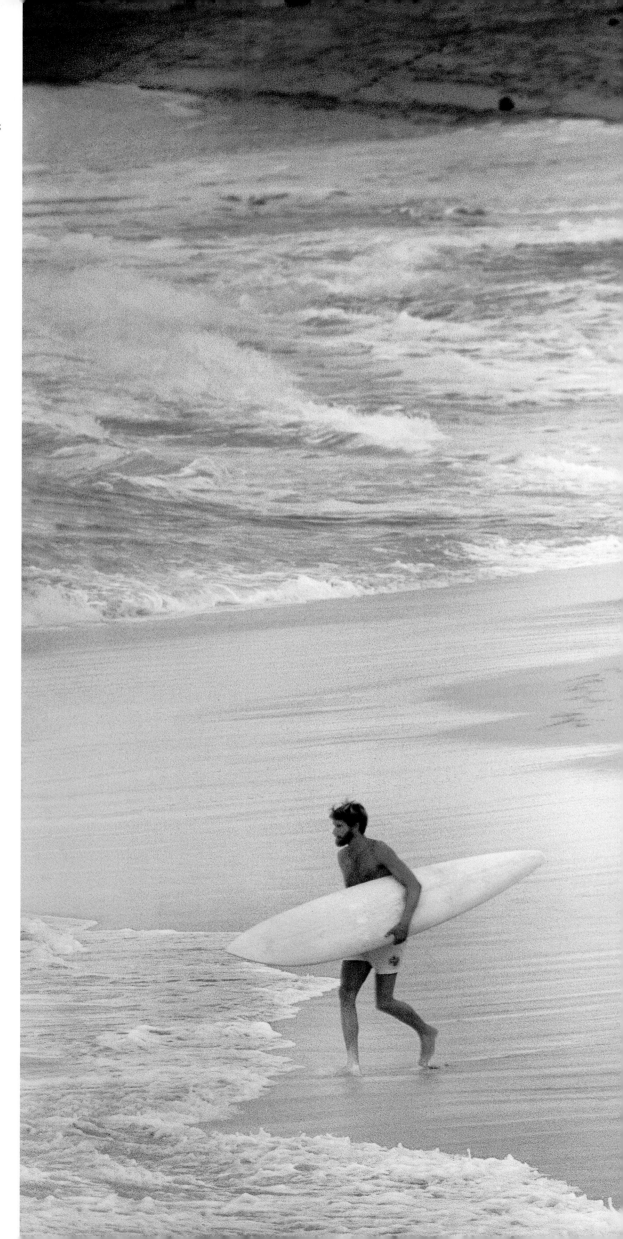

SURFIN' IS THE ONLY LIFE

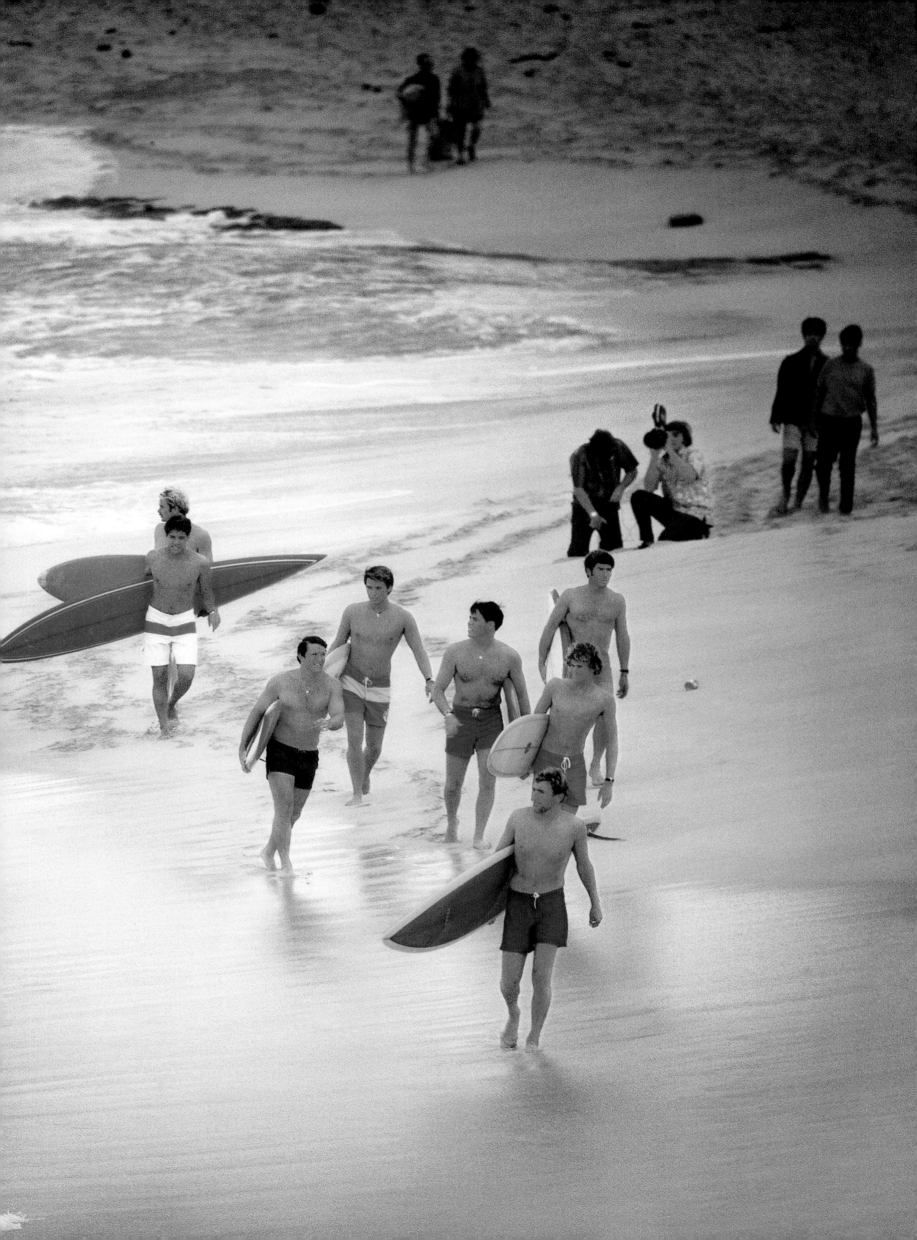

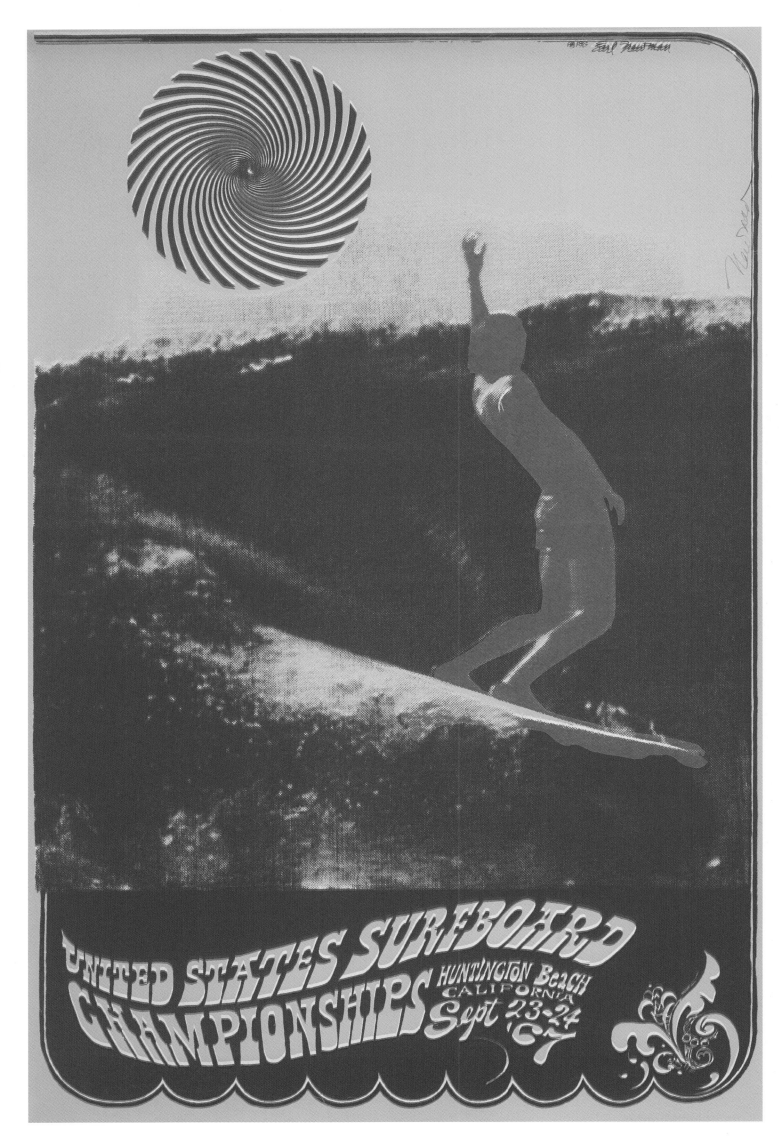

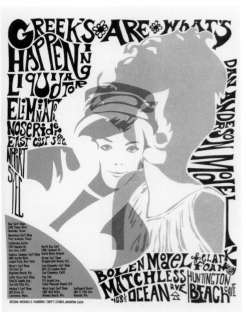

**BIG SURF WAVE POOL; TEMPE,
ARIZONA; 1969** *(Pages 300–301)* Wave pools
actually date back to the early 1900s, but weren't
built for wave-riding until the late '60s. Big Surf was
funded by the hair-care giant Clairol, and featured
a two-foot wave and a 20-acre Polynesian-themed
complex. *Photo, LeRoy Grannis*

**POSTER, U.S. SURFING CHAMPIONSHIPS,
1967** Artist Earl Newman created a series of rare
silkscreened posters for the annual surf competition.
Art, Earl Newman

ADVERTISEMENTS *(Clockwise from above left)*
Shane Surfboards, 1969; Con Surfboards, 1969;
Greek Surfboards, 1967; Bing Surfboards, 1969

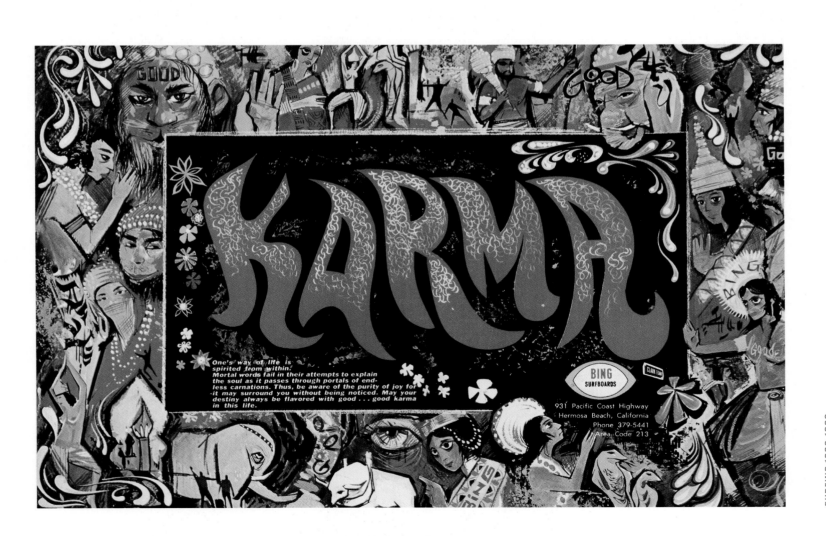

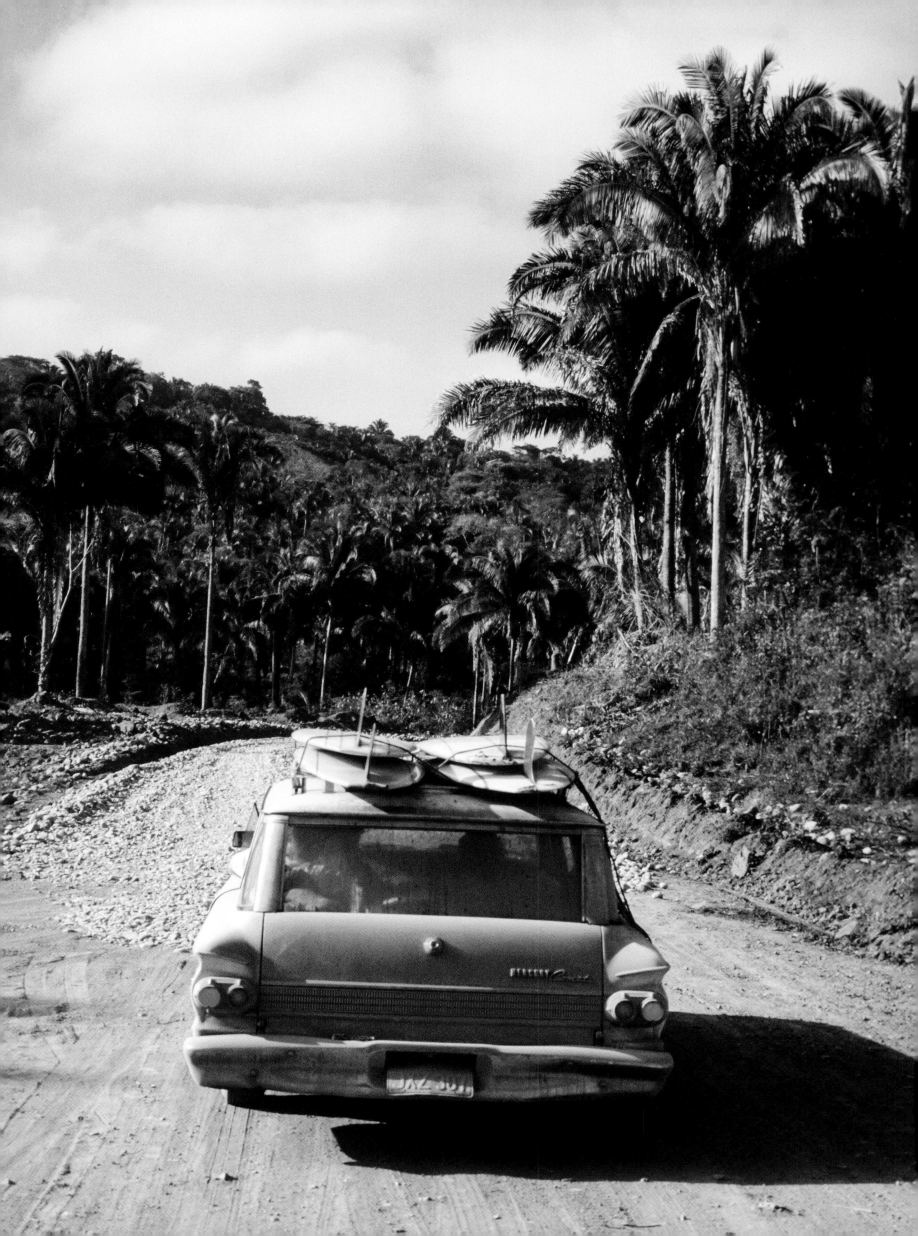

MEXICO, 1966 *Photo, Ron Stoner*

POSTER, FIRST NATIONAL TOURNAMENT, 1967

MEXICAN TEAM, WORLD SURFING CHAMPIONSHIPS; RINCÓN, PUERTO RICO; 1968 From left to right: Ignacio Felix Cota, Rocky Changala, David Zarate, and Carlos Hernandez. *Photo, LeRoy Grannis*

BARRY KANAIAUPUNI; SUNSET BEACH, HAWAII; 1969 *(Pages 306–307)* Kanaiaupuni, known as "BK," was a fast, powerful surfer and all-time master of big Sunset Beach. He rode narrow knife-like "pocket rockets" that he shaped himself. Jeff Hakman called BK "reckless … but amazing!" *Photo, Art Brewer*

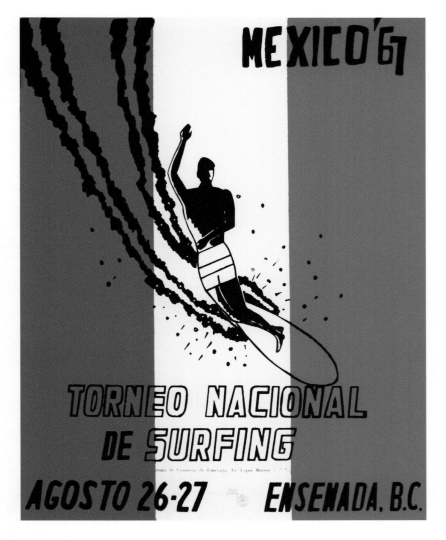

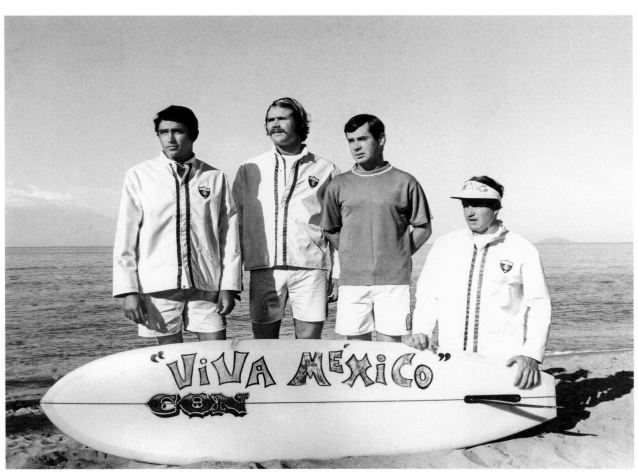

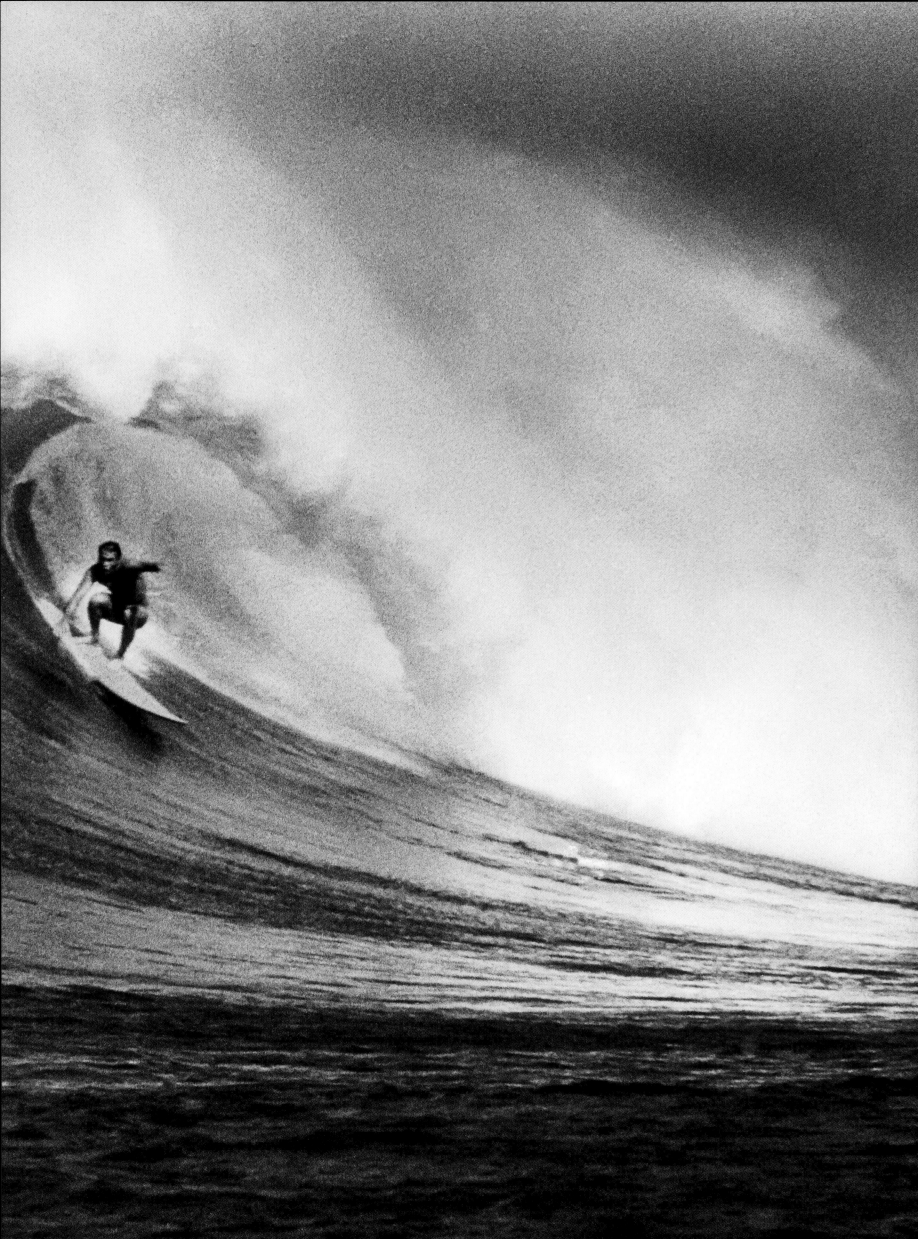

1970-1986

CONTESTING EDEN

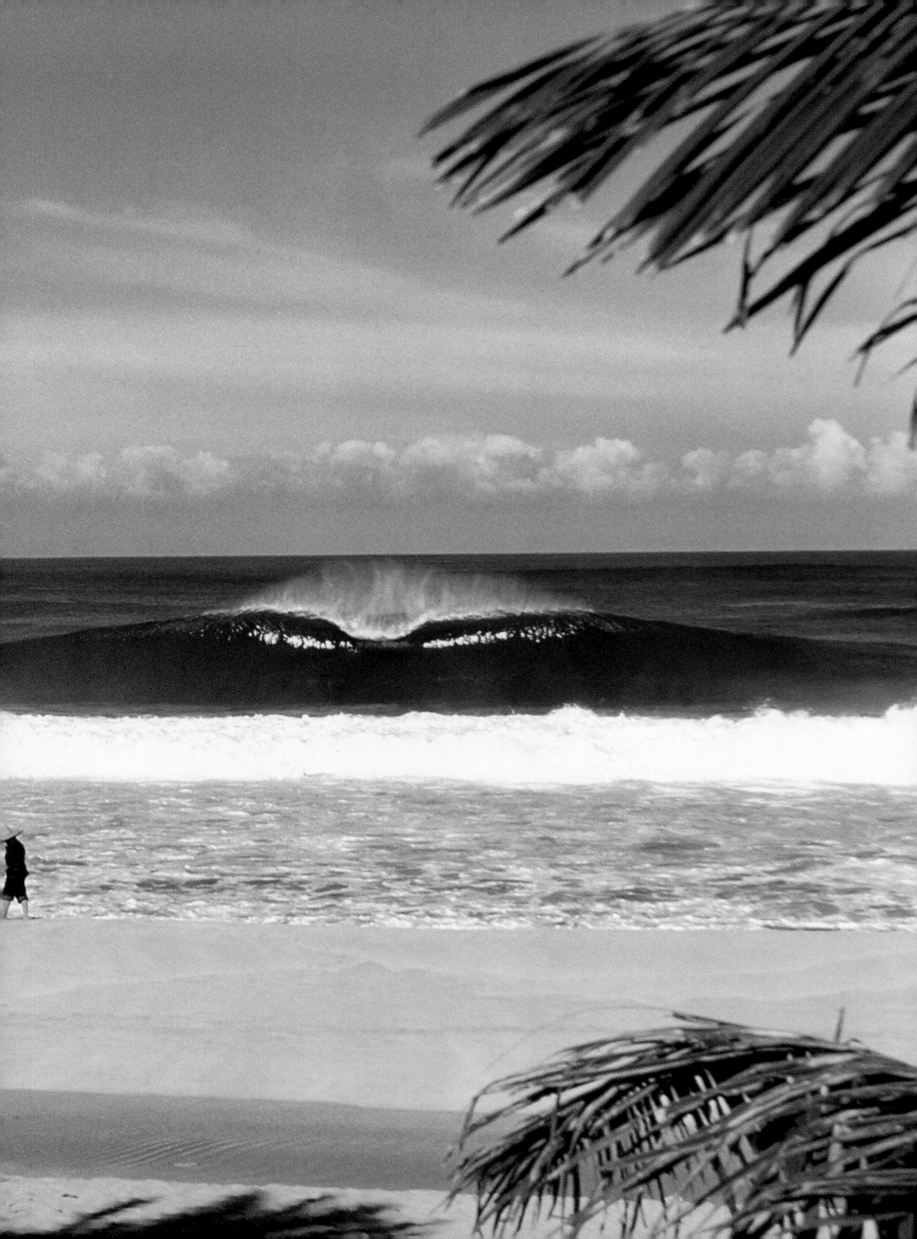

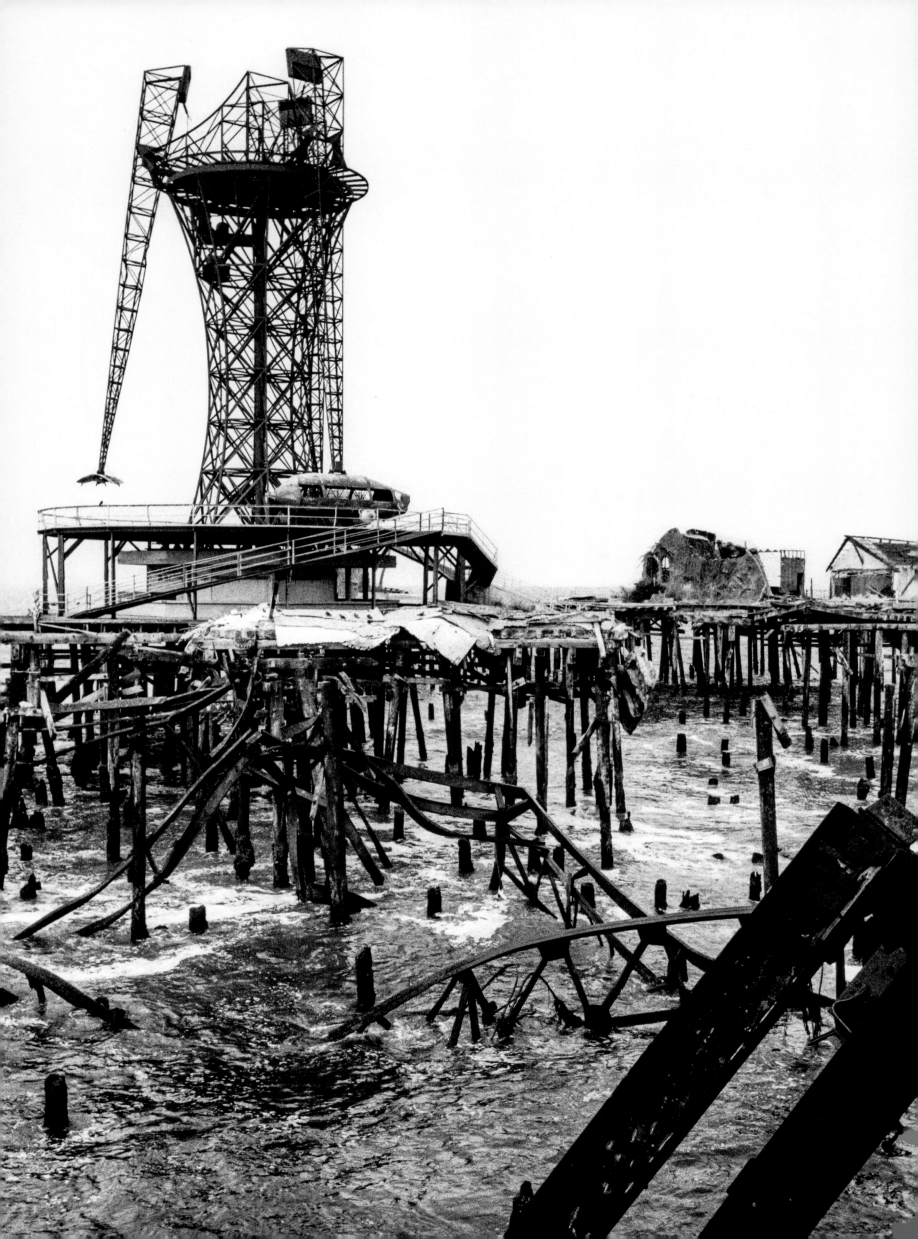

1970-1986
THE LEASH, THE LORD, AND THE INDUSTRY

DREW KAMPION

The paroxysms of the world aside, the microcosm of surf culture was in full-stage mitosis by 1970 as the ripening pop-and-sport paradigm was cross-pollinated with the counterculture's coalescing rejection of the Establishment and its twin scions of war and capitalism.

These were the twilight years during which it was hard to tell if things were getting better or worse for surfing. The intrusion of President Richard Milhous Nixon into the Southern California surf scene with the acquisition of the Cotton Estate as the site of his administration's "Western White House" (aka Casa Pacifica) was not only symbolic but also disruptive. Cotton's Point was a fine SoCal surf spot and gateway to a series of excellent right-hand point breaks at the northern corner of San Diego County on the Camp Pendleton U.S. Marine base.

Sneaking into that off-limits "Trestles" surf area (so named for the railroad trestles spanning the sloughs that helped create the sand and cobble "points" and the resulting wrapping waves) had become a right of passage for area surfers, and now heightened security during Nixon's visits completely cut off access to those coveted waves. Since *SURFER* magazine founder John Severson lived (literally) next door to Casa Pacifica, the entire surfing world got the picture via the magazine's pages.

Meanwhile, the Vietnam War and accompanying protests crowded into every evening news broadcast on all three networks. In 1970, Hawaiian local Jock Sutherland, perhaps the best surfer in the world, enlisted in the U.S. Army, while most surfers did whatever they had to do to avoid the draft. A year or two earlier, surf champion Mark Martinson excused himself to use the men's room during his induction process, crawled out the window, and took flight to Europe, South America, and beyond. Thus the parallel realities: Some surfers were exported to distant lands of lethal waste, while others surfed on in exotic bubbles of waves, beaches, and travel.

Part and parcel of the cultural transformations that had been at work in the '60s was a creative storm that rearranged a lot of what surfing was about: first, in an attitudinal shift exemplified in the concept "total involvement surfing," which called for greater commitment to riding in the most critical part of the wave; second, the shakeup in surfboard design that became known as the "shortboard revolution." Surfboards shrank from an average of 10 feet long to about eight feet—and then kept going. By 1970 the top Australian competitors were surfing on boards in the five- to six-foot range, with American shapers adapting their own designs to the new metric.

With the change in boards came a complete change in how boards were ridden. Gone were the fancy footwork and much of the stylish posturing in so-called "hood ornament" poses. Gone was the ultimate and definitive surf maneuver of all time: hanging 10. Although pockets of retro stylists continued to exist, the accepted surfer's stance changed virtually overnight from walking the board to maneuvering from a fixed and generally central position. In other words, surfing went from riding the board to riding the wave.

TETHERED AT LAST

Hard on the heels of the revolution that rendered worldwide surf shop inventories obsolete overnight came possibly the most revolutionary development in surfing history—the leash. In 1970, in Santa Cruz, California, inspired by a knee-boarder who used a length of line to attach the board to his wrist, Pat O'Neill (son of wetsuit pioneer Jack O'Neill) stuck a suction cup to the nose of his surfboard and tied a length of surgical tubing to his wrist, thus launching the era of the surf leash. In a brief flurry of conceptual and design modification, the leash emerged as a tether that connected a surfer's ankle to the tail end of his or her surfboard.

PIPELINE, HAWAII, 1975 *(Pages 308–309)* With the development of hard-edged shortboards that could hold tight to Pipeline's steep hollow face, riding inside the tube became surfing's new frontier. *Photo, Jeff Divine*

PACIFIC OCEAN PARK PIER; VENICE, CALIFORNIA; 1972 *(Page 310)* By the mid-'70s, after bankruptcy and a series of fires, P.O.P. became a monument to Los Angeles's urban decay and surfing's transition from clean-cut to gritty. *Photo, Anthony Friedkin*

TRESTLES; SAN DIEGO COUNTY, CALIFORNIA; C. 1971 The trail to Trestles is a legendary half-mile trek from the main highway along a seasonal creek. *Photo, Jeff Divine*

TRESTLES; SAN DIEGO COUNTY, CALIFORNIA; 1970 Until Trestles was made a state park in 1971, surfers played cat and mouse with the U.S. Marines who sometimes shot live bullets over the surfers' heads. *Photo, Drew Kampion*

BARRY KANAIAUPUNI; SUNSET BEACH, HAWAII; C. 1971 *(Pages 314–315)* "BK" defined the term "power surfing" with radical full-rail bottom turns. *Photo, Jeff Divine*

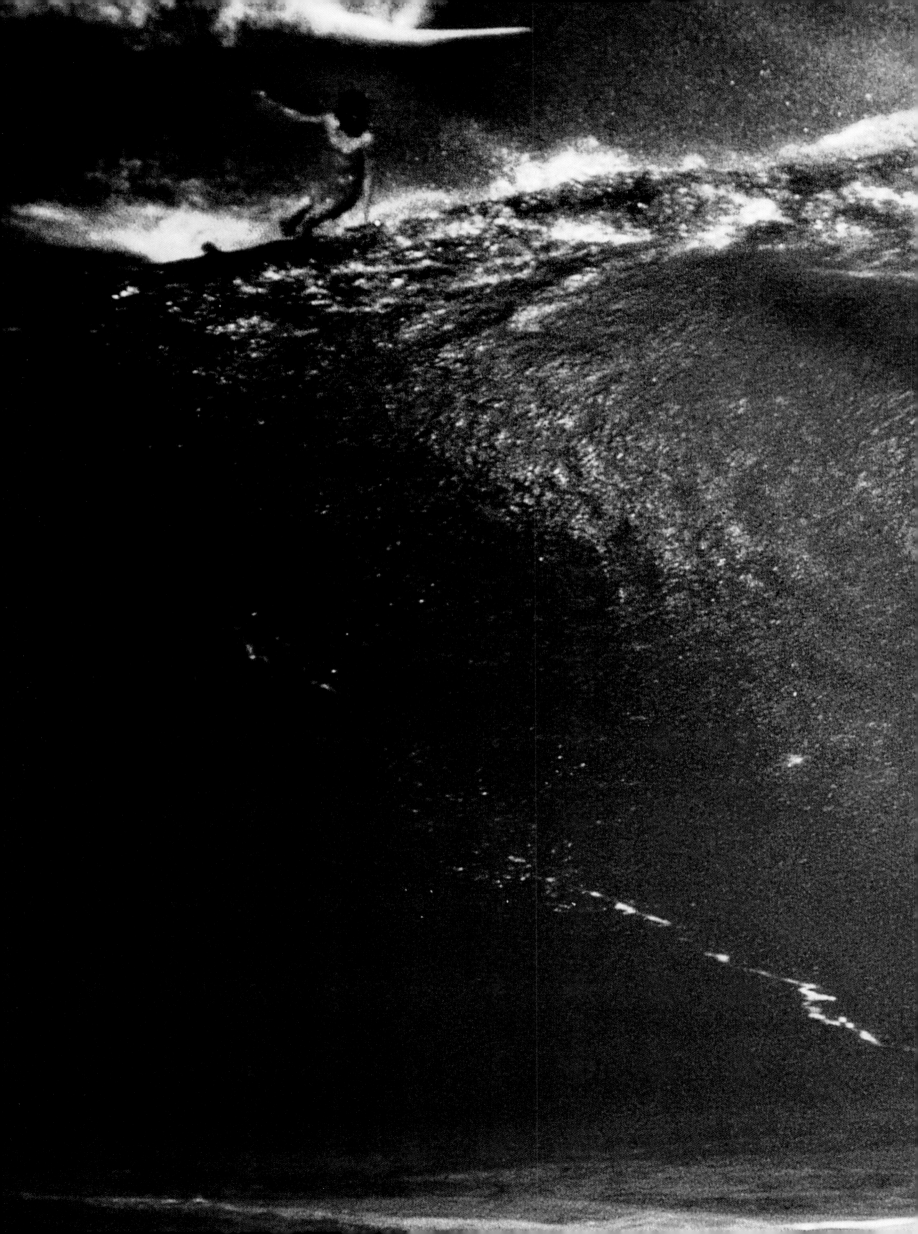

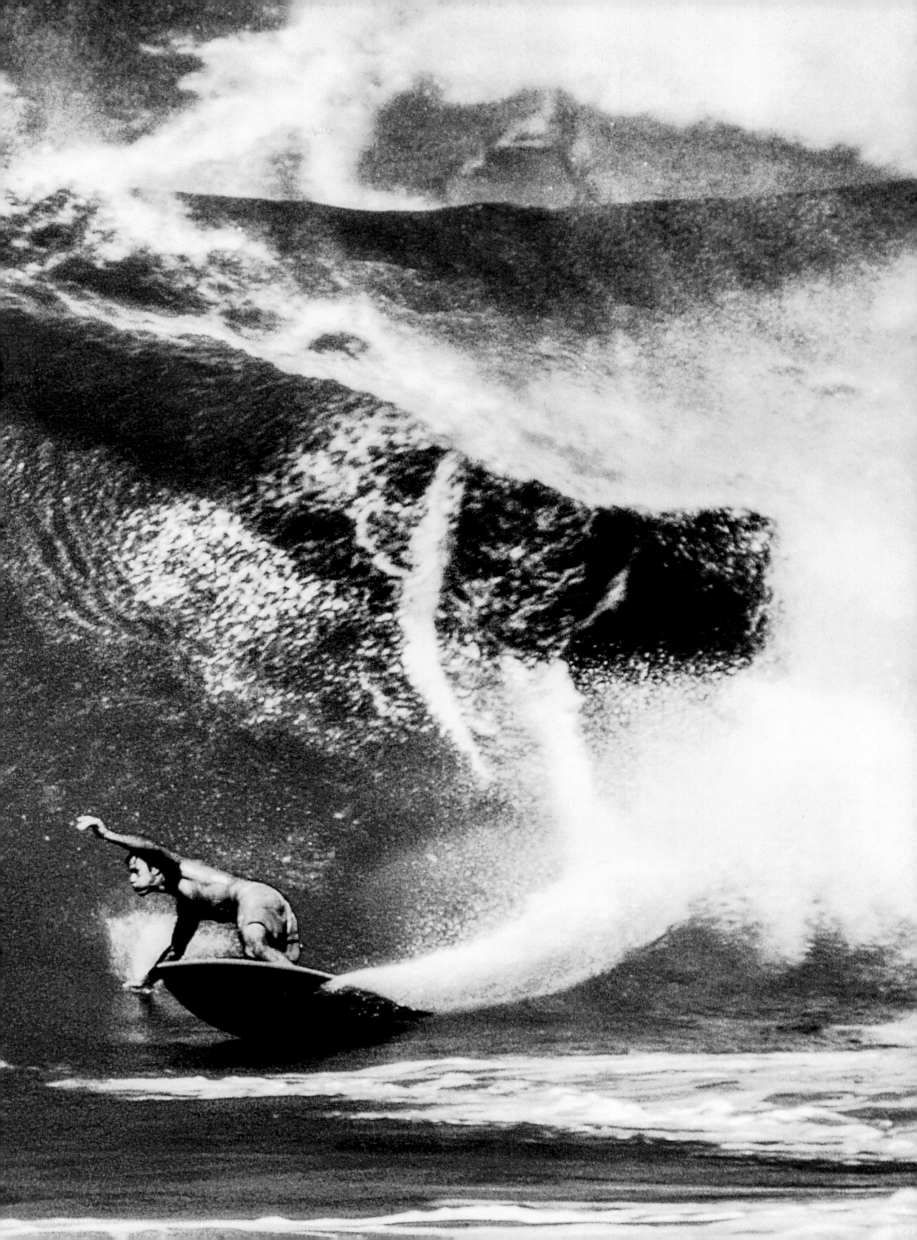

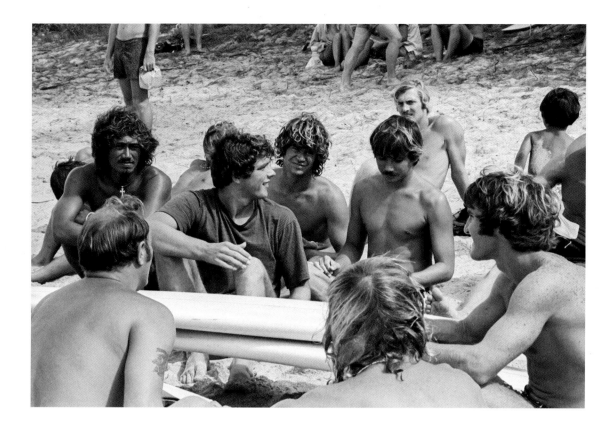

At first mocked as a "kook cord," the device virtually eliminated one of the fundamental problems of surfing: losing control of the surfboard and having to chase after it. Also the leash virtually eliminated an ambient hazard of the surf zone: getting struck by another surfer's lost board. Within a year or two of the innovation, surfboards were typically manufactured with built-in attachments for a variety of manufactured leash systems.

By eliminating frequent long swims between waves, the leash allowed surfers to spend more time in the lineup waiting for waves (aka socializing) or riding them. The net impact was increased crowding. Surfers could now explore and ride more treacherous coastlines resulting in plenty of newly discovered or rarely surfed areas.

Perhaps the most invigorating result of the leash was its impact on the performance spectrum of the physical act of surfing. Surfers en masse were now attempting maneuvers that were rarely tried before. Whereas a typical carving turn off the bottom of a wave would send the surfer into a complementary banking turn off the upper lip of the wave, now the surfer could contemplate blasting straight up through crest and into the air, hoping to reenter the wave from above. Bottom line: With the invention of the leash, the 1970s and '80s became the most innovative era *by far* in the history of wave-riding.

PRAISE THE LORD!

The very nature of surfing—its spare, elemental essence—gives it resonance with a pantheistic philosophy and worldview. So just as the early Malibu scene grooved with the outlaw stance of the Beats, the California culture of the '60s jibed with the altered states of consciousness that came in with Zen and psychedelics that followed. The surfing way of life (literally on the fringe and essentially tuned into nature) easily drifted toward a sensibility that rejected competition and commercialization in favor of a free-spirited reverence for values like brotherhood and pacifism.

This spiritual and even animistic underpinning of the culture had infused surfing with a unique tribal vibration by the 1970s. Following a brief romance with a sharing and generous community spirit ("Your wave!" … "No, after you!"), however, an all-too-human factionalism began to emerge. The low-key, anti-commercial vein spawned pockets of surfers (notably in the Santa Barbara area, north of Ventura County) who rejected colored wetsuits in favor of sober black neoprene uniforms. A brightly colored suit proclaimed you

EXPRESSION SESSION PARTICIPANTS; NORTH SHORE, HAWAII; 1970 The Expression Session was designed as a low-key "anti-contest" that sought to bring out the best in surfing performance without judges, scores, winners, or losers. Among those in attendance were Tiger Espere, Greg Tucker, Ryan Dotson, Gerry Lopez, Jeff Hakman, Richard Graham, and Jimmy Blears. *Photo, Ed Greevy*

BLAINE WEBBER, WAIKIKI, 1970 Random oil spills sparked outrage and a growing surfer's environmental movement.

LAGUNA BEACH, CALIFORNIA, 1970 *Photo, Slim Aaron*

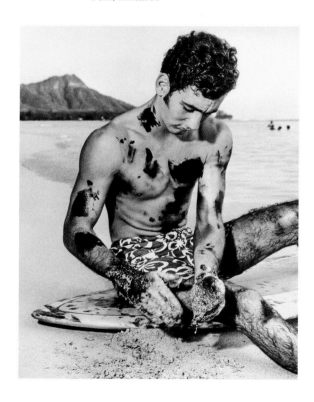

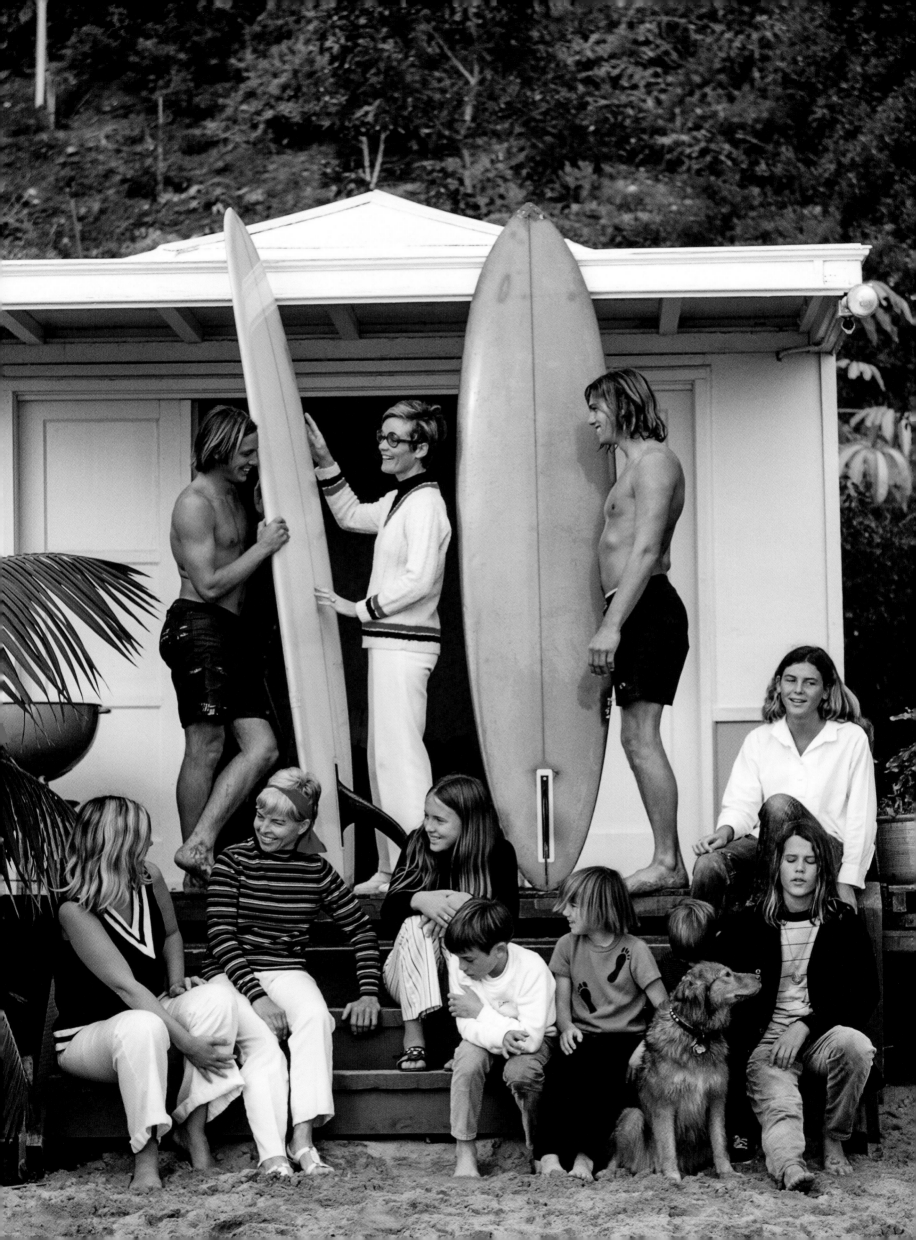

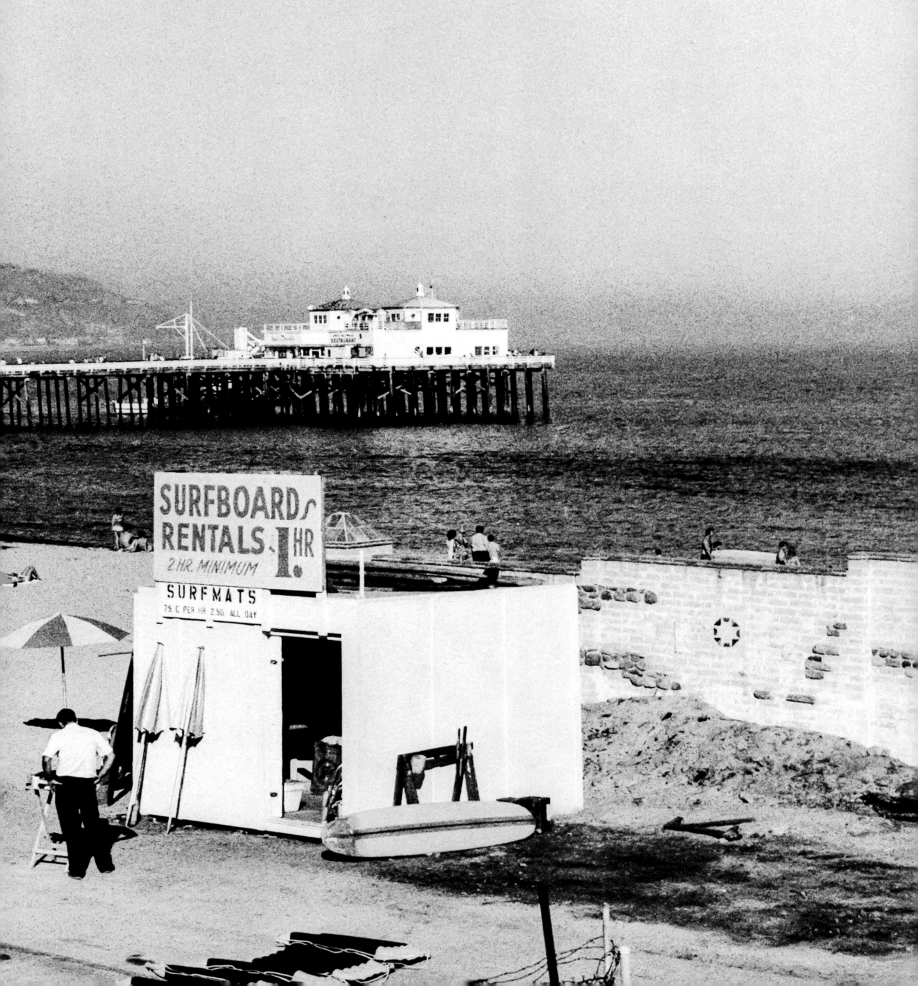

were from out of the area, identifying you as an interloper and marking you for exclusion. Surfboards were made in small garage shops that shunned any sticker or logo aside from the maker's small, hand-printed name along the centerline of the bottom of the board.

Elsewhere (notably in San Diego and Orange Counties) the aroused spiritual consciousness looped back toward its European origins (most surfers coming out of relatively affluent white communities) in the ascent of a Christian colonization of the surfing sub-culture. One of the earliest and foremost synthesizers of Christ and surf was the gifted artist Rick Griffin. Griffin, who created the iconic Murphy character in his 1960s cartoon strips in *SURFER* magazine, had gone on to have psychedelic adventures in the San Francisco music scene. By the time he came back for a guest-artist stint at *SURFER* circa 1969–70, his art was imbued with transcendent Christian messaging of considerable power and effect. Very quickly Christian surfing communities coalesced along both the East and West coasts, spawning a Christian Surfing Association and congregations of prosely-tizing believers who carried both Bible and surfboard with them into the world's most remote wave meccas.

Meanwhile, the current that ran from Tom Blake through the 1960s—the almost religious native and tribal aspects of surf culture—pushed forward through psychedelic experiments and into the budding surf industry. In the 1970s, marijuana, hashish, cocaine, and heroin trafficking manufactured hundreds of thousands of dollars in need of laundering, some of which found a place in this emerging lifestyle marketplace.

EVOLUTION AT WARP SPEED

The shortboard revolution of the late 1960s ushered in an era of unprecedented experi-mentation with surfboards. It was clear from the start that lopping two or three feet off the vehicle opened up vast new performance opportunities. Turning arcs became substan-tially tighter. The shorter boards were much lighter and offered far less flotation, but the whole performance repertoire was changed. Not walking the board and noseriding was just part of it. The classic style of paddling on the knees was almost eliminated overnight; instead, surfers almost literally "swam" their boards out to the waves.

Sometimes called "pocket rockets," the little boards fit neatly into the pitching tube of the wave. The elegant stylists of the mid-'60s (David Nuuhiwa and Miki Dora, for

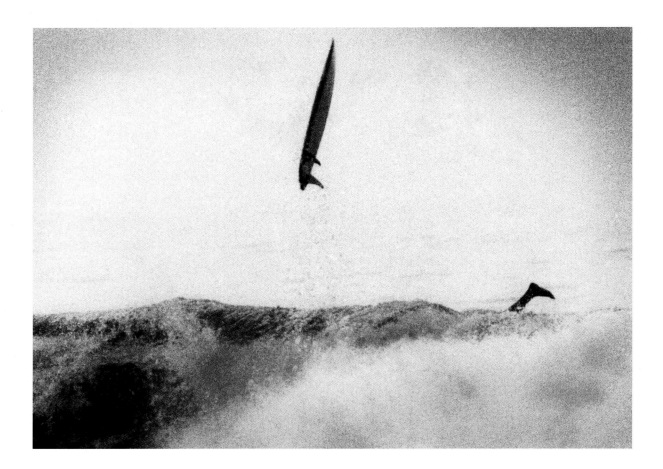

instance) gave way to the poised and committed tube riders of the '70s (like Gerry Lopez and Shaun Tomson). Further, surfers on short boards could carve even modest-sized waves with rail-to-rail S-turns that looked and felt like slalom skiing.

But still the new boards had issues; like the longboards of the previous decade, they didn't work equally well for everyone, so right out of the gate there was experimentation, invention, development, and change. The 1970s saw several significant developments in twin-fin shortboards, from Californian Charles "Corky" Carroll's wide-tailed models (c. 1972) to Australian Mark Richards's twinners on which he won four consecutive World Championship titles from 1979–82.

Other experiments touched on the idea of a central fin augmented with a pair of side fins. Early designs by shaper Dick Brewer with gifted rider Reno Abellira were sufficient to inspire the "bonzer" surfboards of California brothers Duncan and Malcolm Campbell (larger single fin with two angled keel-like wedges off to the sides). But it was the three-fin "thruster" of Australian Simon Anderson in 1980 that finally caught the imagination of the sport: three conventional (but smaller) shark-like fins of equal size, triangulated near the tail of the board, yielded increased speed and power (thrust) with solid bite on the wave face. Anderson proved his point with a dominating and timely victory in solid 15-foot surf at the 1981 Rip Curl–sponsored pro contest at Bells Beach, Australia.

Since then, despite variations on the theme and retro longboard resurrections, three-fin thruster-style surfboards have been the standard performance tool of the sport of surfing. Typically the thruster surfboards are in the 5'6" to 6'2" range and weigh less than 10 pounds, even with the three fins.

Due to the compact lightness of these new-generation surfboards, the barriers to younger surfers and women quickly receded. Whereas the big redwood planks and hollow paddleboards of the '20s, '30s, and '40s required a generally large-framed surfer, and even the balsa and foam boards of the '50s and '60s were not comfortably light for most women or young people, these small ultra light thrusters opened the way to all-ages participation by either sex.

As with every step in the evolution of the wave-riding vehicle, there was a period of dramatic escalation in performance in the early 1980s. Just as the shortboards initially redefined the actual shape of surfing in the late '60s, the even smaller, lighter tri-fins

TWIN-FIN, CALIFORNIA, 1971 While twin-fins dated back to the 1950s with Bob Simmons, they weren't used widely until the late '70s, when Australian Mark Richards began winning world championships riding twin-fins in small and mid-sized surf. *Photo, Michael Haering*

NORTH SHORE, HAWAII, C. 1978 The introduction of the surf leash in the early 1970s was a mixed blessing. While it saved surfers swimming after lost boards, many felt it flattened the learning curve in favor of the less-experienced surfers, leading to more crowded lineups. *Photo, Steve Wilkings*

P.O.P. PIER; VENICE, CALIFORNIA; 1971 *(Pages 324–325)* The ruins of the P.O.P. pier hid a secret gem of a wave that was fiercely protected by the Dogtown locals from outside surfers. *Photo, Bob Steiner*

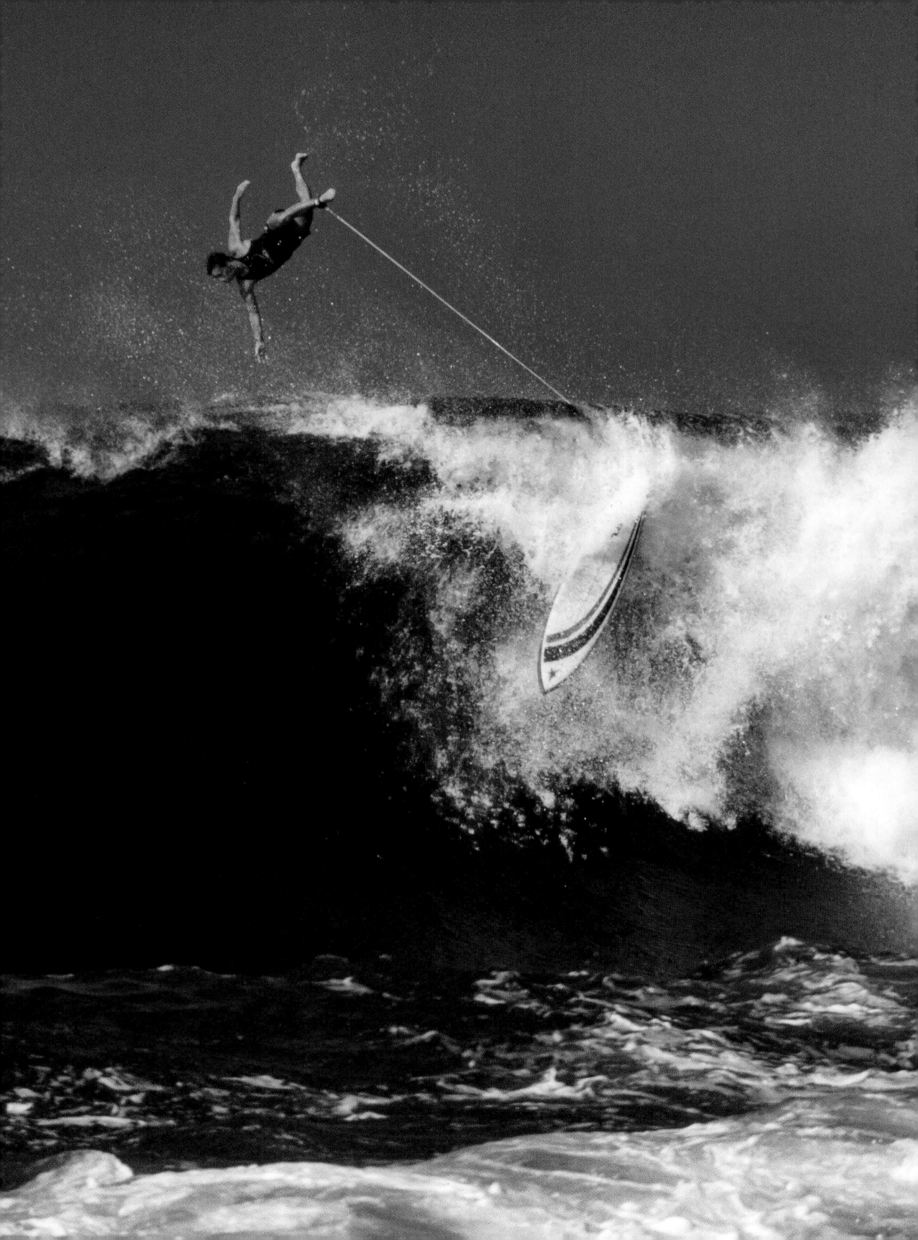

lifted the game again. The pivotal power of the fin configuration combined with a thin nose and squash-tail outline made for ever tighter and more positive arcs on the wave faces, as well as better traction in the hollow parts of the wave, which meant ever more committed barrel riding.

As surfboards got smaller and lighter, riding them became increasingly similar to the style and maneuvers practiced by skateboarders and snowboarders (both offshoots of surfing and surf culture). It was only a matter of time before surfers began to leave the wave and take to the air.

Pioneered by a known lineage of high-performance surfers led by Hawaiian Larry Bertlemann, Australian Cheyne Horan, and Californians Christian Fletcher (San Clemente), Kevin Reed (Santa Cruz), and Davey Smith (Santa Barbara), by the late 1980s the "air game" was a vital part of the success of most professional surfers.

EARTH OCEAN

Perhaps no other human activity puts a person into a more intimate relationship with nature than surfing. Engaged with the dynamic forces of tide and swell, the power of the surf, the sun and wind, the near-shore aquatic, avian, and terrestrial life—the surfer is continually reminded of the fact that he or she inhabits a living system that does things on its own irresistible terms. Wilderness begins at the edge of the sea, and committed wave riders come to an acute understanding of the greater forces at work on the planet. Some of them ultimately espouse a pantheistic philosophy perhaps best expressed by surf culture pioneer Tom Blake in the 1940s: Nature = God.

The first Earth Day was celebrated in 1970, within a year of a massive oil spill off the California coast. That blowout during an offshore drilling operation released some 90,000 barrels of crude, which blackened the beaches of Santa Barbara, killing marine and bird life, and awakening surfers' awareness to the potential environmental consequences of mining the sea.

Synchronous with that first Earth Day, plans to extend the beach at Waikiki some 385 feet, obliterating the culturally sacred Queen's surf spot (and opening the way to countless other engineering boondoggles), met with some 2,000 demonstrators from the Save Our Surf organization, who flooded into the Hawaii capitol courtyard, successfully petitioning the government to halt the project.

WAYNE LYNCH; VICTORIA, AUSTRALIA; 1978 Although raised in isolation on Australia's rugged southern coast, Lynch was a six-time Victorian junior champion who quickly mastered the short-board's potential by the late '60s. *Photo, Art Brewer*

GEORGE GREENOUGH, AUSTRALIA, 1970 In the mid-1960s, Greenough introduced a long tapering fin modeled off a bluefin tuna. It provided incredible directional control and drive and helped propel the shortboard revolution. *Photo, John Witzig*

PROGRAM, WORLD SURFING CHAMPION-SHIPS, 1970 Plagued by rainy weather, small waves, and raging anti-contest sentiment, the 1970 event was called a "complete fiasco." Despite the difficulties, Californian Rolf Aurness parlayed a smooth backside performance into a world championship and then promptly retired from further competition.

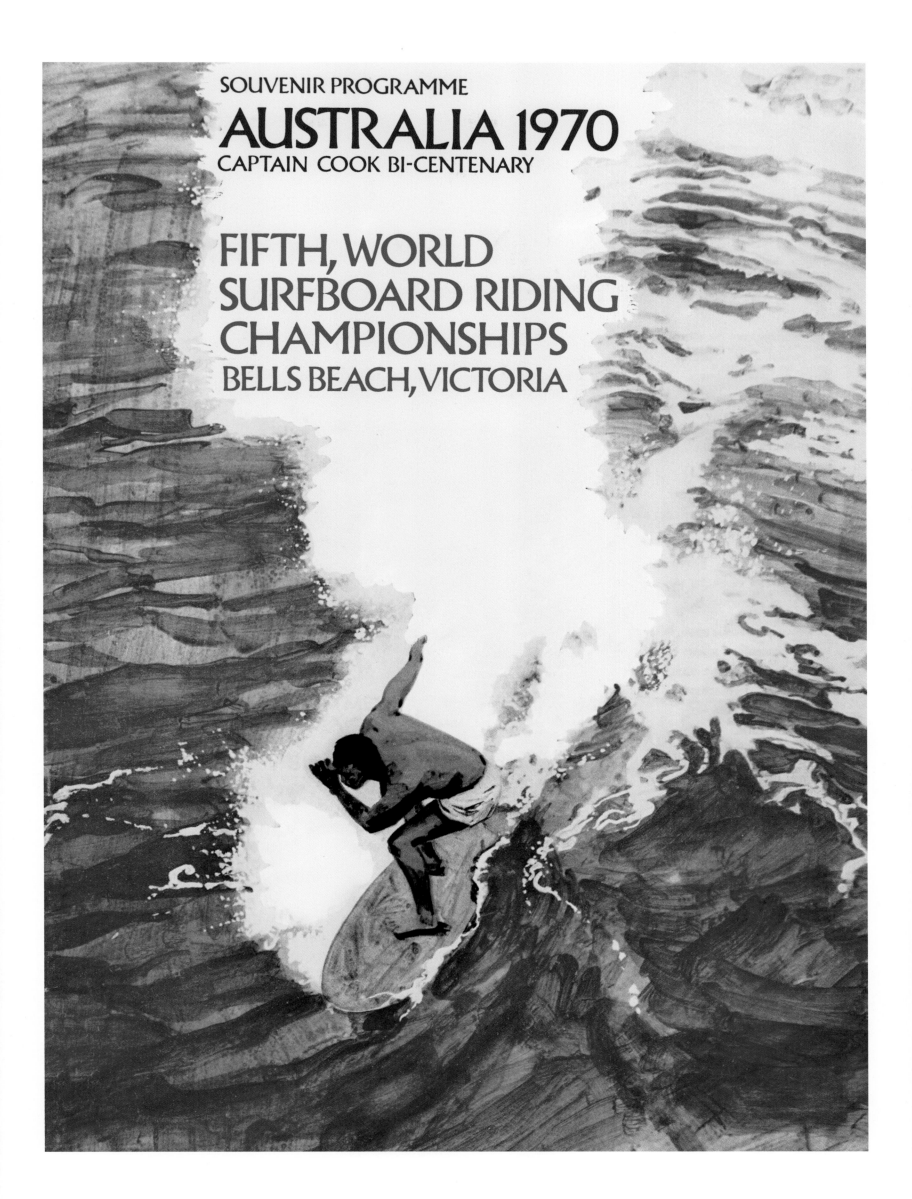

SOUVENIR PROGRAMME
AUSTRALIA 1970
CAPTAIN COOK BI-CENTENARY

FIFTH, WORLD SURFBOARD RIDING CHAMPIONSHIPS
BELLS BEACH, VICTORIA

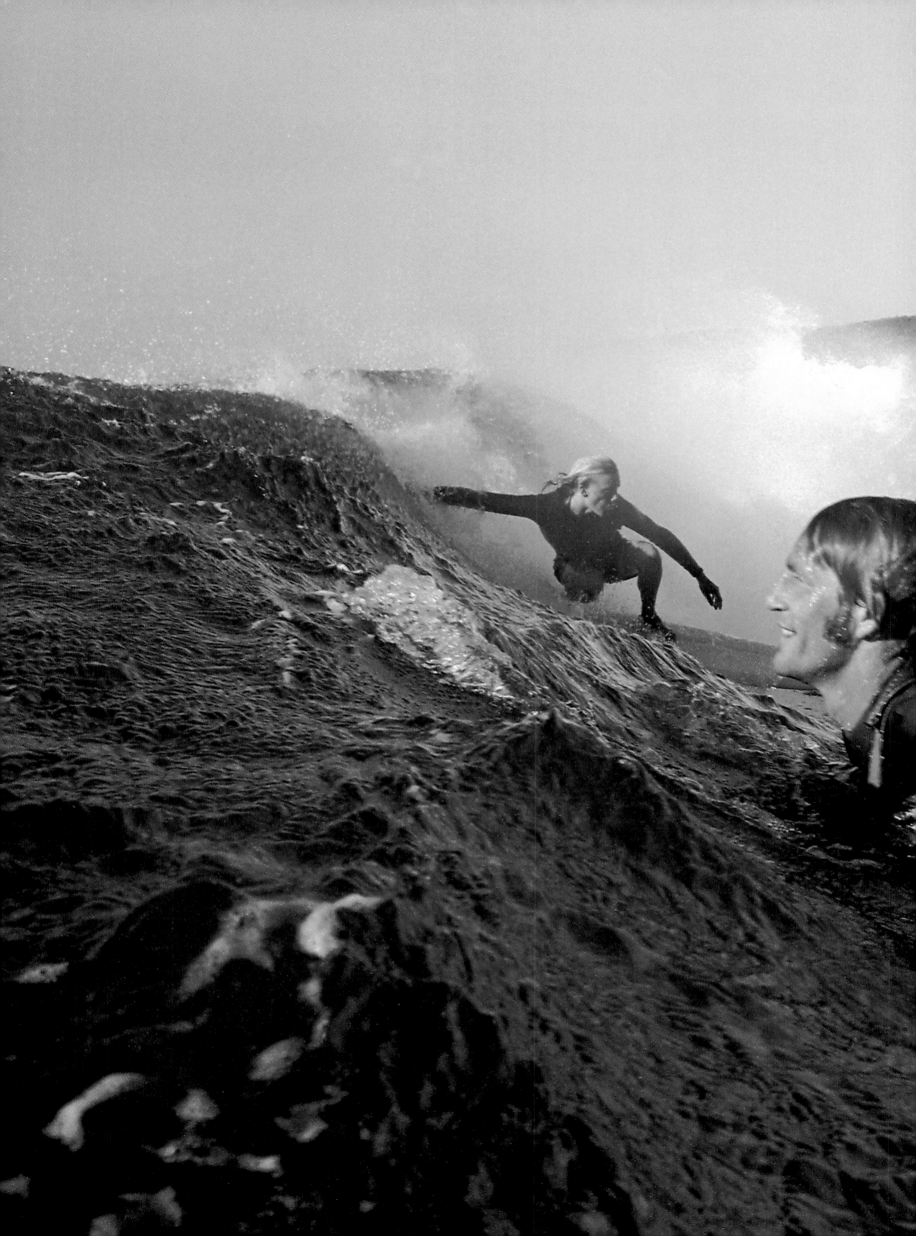

In California, public coastal access became a volatile and popular issue as a historically unique "coastal alliance" of surfers and other community and environmental entities championed the voter initiative Proposition 20, which led to the establishment of a California Coastal Commission. The passing of the California Coastal Act of 1976 extended the authority of the commission and was a major victory for surfers and other "green" organizations.

Over the course of the next decade a small group of surfers periodically rallied to defend the waves and coastlines from a succession of threats, natural and manmade. Then, in 1984, responding to development plans at Malibu's iconic Surfrider Beach, a trio of surfers (environmentalist Tom Pratte, aerospace engineer Glenn Hening, and legendary Malibu surfer Lance Carson) and their allies created the Surfrider Foundation, modeling their vision on the fledgling environmental group Greenpeace. Over time, other surf- and beach-oriented environmental and access organizations emerged globally, and surf literature (in magazines, books, and now websites) developed a rich vein of environmental consciousness, which continues to be a centerpiece of the culture's core values.

SURFING THE WORLD

Building on the template prototyped by decades of seasonal migration to Hawaii, and inspired by adventurous American Bob Cooper (who first left Malibu for Australia in 1959), Bruce Brown and his revelatory *Endless Summer* film, and prototypical Australian traveler Peter Troy (who visited more than a hundred countries in the 1960s, almost always with a surfboard under his arm), the '70s inaugurated an era of surf travel that soon made surfing the ultimate global lifestyle sport.

The search for perfect, uncrowded waves led to the discovery of a pantheon of "new" spots that redrew the surf map of the world: Uluwatu (Bali), Grajagan (Java), Lagundri Bay (Nias), Tabuaeran (Kingdom of Kiribati), Tavarua and Namotu (Fiji), Isla Natividad (Baja, California), various parts of the Maldives in the Indian Ocean, Tamarin Bay (Mauritius), and on and on. There were also discoveries in Australia, the Americas, the Caribbean, Europe, Africa, and Asia.

The longstanding and simple map of the surfing world was rendered obsolete in one short decade of exploration as each new surf spot in turn became a hub of expansion. Surfers

NIGEL COATES AND MURRAY SMITH; SMITHS BEACH, WESTERN AUSTRALIA; C. 1972 *(Pages 328–329)* *Photo, John Witzig*

FLYER, CHRISTMAS CONCERT, 1970 *Art, Bill Ogden*

CHRISTMAS CONCERT; LAGUNA CANYON, CALIFORNIA; 1970 The Christmas concert was a free event hosted by the Laguna Beach–based Brotherhood of Eternal Love. More than 20,000 people attended the two-day event, during which a helicopter flew over and dropped thousands of Christmas cards, each one containing a dose of LSD. *Photo, Dion Wright*

PIPELINE HOUSE, HAWAII, C. 1975 In the mid-1970s, Gerry Lopez built a three-level house overlooking the Pipeline that became the unofficial contest headquarters for the best surfers in the world. *Photo, Dan Merkel*

JOHN SEVERSON AND BRAD BARRETT; HOLLISTER RANCH, CALIFORNIA; 1970 Severson, left, and *SURFER* photo editor Barrett film part of *Pacific Vibrations*. *Photo, Art Brewer*

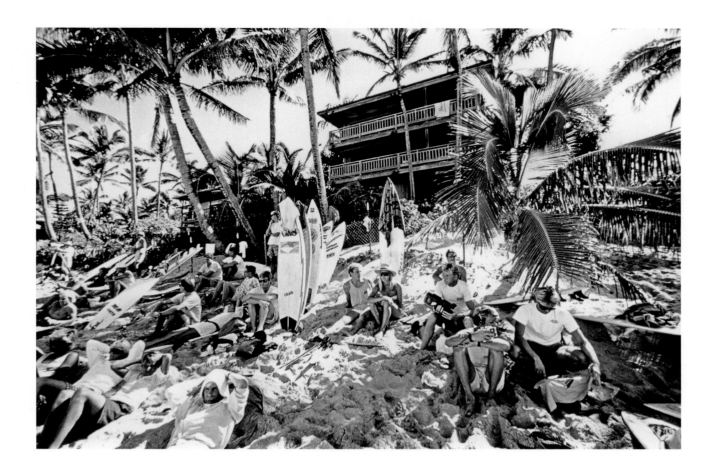

from the southwest coast of France wore a path to Morocco and beyond. Wave riders from England headed over to Ireland and up to Scotland. Californians headed beyond Mexico to Central America. Hawaiians brought their sport to Peru, where the ancient Peruvians had fished and ridden waves on their *caballitos de totora*. Brazilians and Argentinians brought the sport home from Hawaii. Pioneering surfers in South Africa discovered some of the finest waves on the planet not far from their urban homes. As each surfing hub spoked out into its surrounds, wave-riding became one of the most ubiquitous coastal activities on the planet, and the culture of surfing increasingly transcended political and social divides.

The genre of "surf travel writing" that emerged quickly became a staple of the surf magazines (*SURFER* and *SURFING* being the dominant titles of the period, along with the very popular Australian surf rag, *Tracks*) and in turn encouraged ever more surf travel, leading to ever more discoveries, and ever more surfers.

COMPETITION HEATS UP

Despite the infinite variables involved in surfing ocean waves, contests have been a part of the game from the beginning. The flowering of inter-club competition in the '60s served up a sufficient model for sponsorship appeal to attract the attention of Heublein Inc., which sponsored the Santa Cruz Pro-Am Surfing Invitational at Steamer Lane in Santa Cruz (first place got $300) in 1967, and again in 1968 (first place got $400). In the third Smirnoff Pro-Am at Steamer Lane (1969), Corky Carroll won the pro division, taking $1,500 of the $4,350 purse.

Apparently Heublein liked this quirky niche but felt that Santa Cruz was a little off the beaten surf path, so they moved the contest to Hawaii for 1970, putting up a record $4,600 purse for the first Smirnoff International Pro-Am Surfing Invitational. The contest was held in classic eight- to 18-foot point surf at Makaha (site of the traditional Makaha International amateur event) with the 90-minute final pitting 1965 World Champ (amateur in those days) Felipe Pomar of Peru against 1966 World Champ Nat Young of Australia. Tied on their best five waves, the judges had to go nine waves deep to arrive at a winner. Young collected the $2,000 first-place money, the richest prize to date in surfing.

Most top-level surfing contests were still amateur affairs in 1970, and the apex of all competitions was the now biannual World Contest, scheduled for Bells Beach in May—solidly

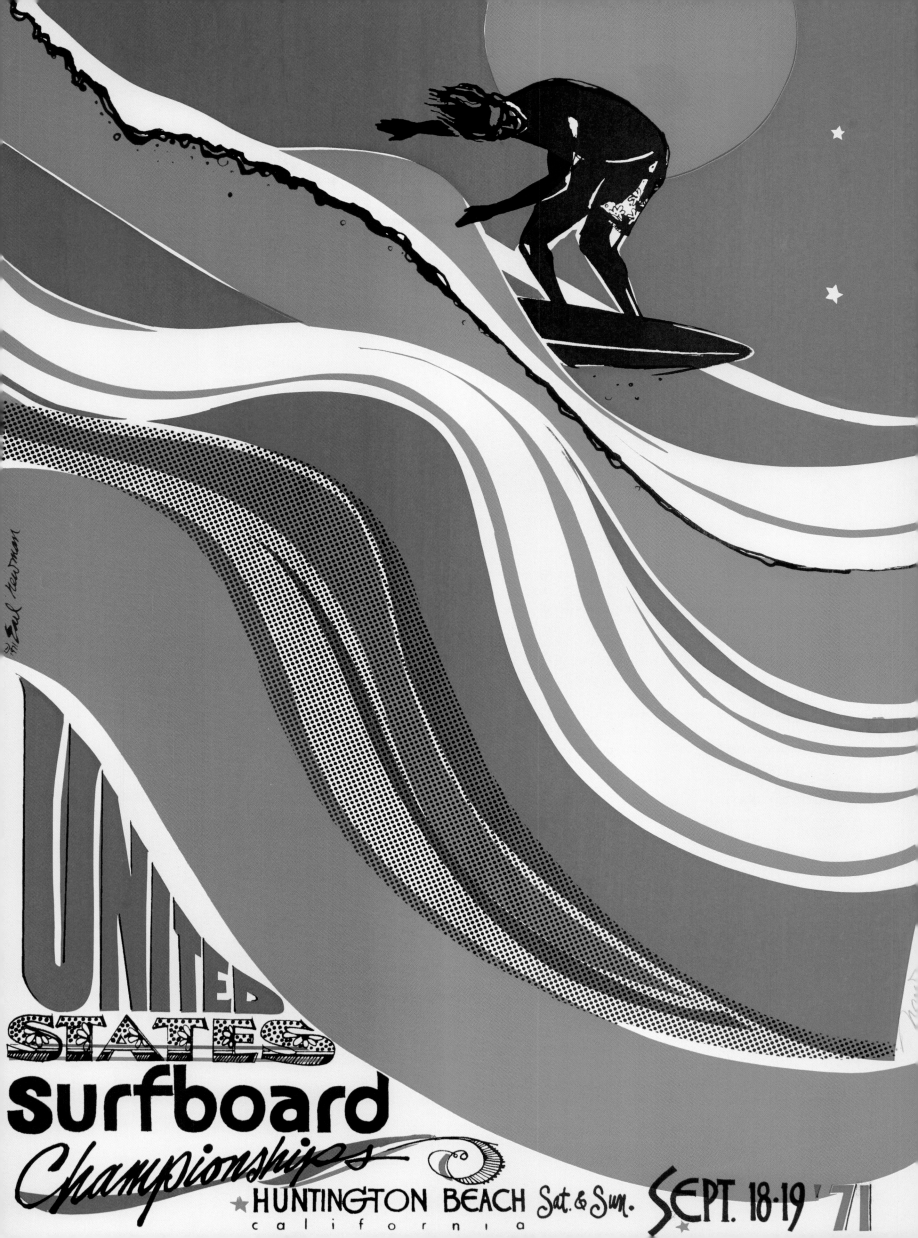

POSTER, U.S. SURFING CHAMPIONSHIP, 1971 *Art, Earl Newman*

"COUNTRY SOUL" SURFERS; NEW SOUTH WALES, AUSTRALIA; 1970 Australian surfers looking to escape crowded city beaches would move to remote stretches of the rural New South Wales and Victoria coast, often renting old farmhouses and vacation homes while living on "the dole." *Photo, John Witzig*

NAT YOUNG; SYDNEY, AUSTRALIA; 1972 Young, center, poses with women surfers at the Australian Surfing Championships in Sydney. From left to right: Kim McKenzie, Micha Mueller, Phyllis O'Donell, Judy Trim, Carol Watts, and Alison Cheyne. *Photo, John Witzig*

in the window for the high-powered winter storms that brew in the Roaring Forties off Antarctica. Teams from around the world (at least insofar as there was a surfing world at the time: United States, Puerto Rico, Peru, South Africa, and Great Britain) converged on Australia and proceeded to wait for waves that wouldn't come. Meanwhile there was unrest among the competitors, poor behavior in the local town of Torquay, a couple of marijuana busts, a boycott of the opening ceremonies, and so on—and still no waves. Finally, the men's event was moved 90 miles west to a remote beach located below farms, where a handful of local folks were the only witnesses (apart from those in the show) to Californian Rolf Aurness's World Title victory at a place called Johanna.

Amateur surfing competition was in decline, however, and the established contest infrastructure was widely ignored in the politically charged and psychotropically fueled atmosphere of the late 1960s, a decade that ended with the Altamont Free Concert and the fatal violence of the Hell's Angels. That event seemed a barometer of the times, and, indeed, surfing was entering a kind of cultural twilight. For one thing, competition in general was not so cool anymore.

Two years later, the 1972 World Contest at San Diego put the final nail in the coffin of high-end amateur competition. It was a lackluster event, marginally funded by an unmotivated California surfing establishment, and fraught with questionable calls and selfish behavior on all sides. On the morning of the finals, a twin-fin surfboard stolen from heavily favored stylist David Nuuhiwa appeared hanging from the Oceanside pier with "Good Luck, Dave!" painted on it and a very large knife embedded in it.

Although amateur competition seemed to be going out of fashion, for those who had devoted their lives to surfing, there was practical value in devising a pathway to making it a viable career choice. Among some of the most talented and pragmatic, there was powerful motivation to conjure ways of bringing more money into the competitive side of the sport.

During the Hawaiian contest seasons of '70 and '71, a philosophical split revealed itself: Even as sponsors of the main events were beginning to elevate prize money in order to attract the biggest names and more media, an experiment dubbed the Golden Breed Invitational Expression Session at Pipeline emerged, reflecting and culminating in societal vectors growing out of the peace-and-love values of the 1960s. The concept was designed to

MONTGOMERY "BUTTONS" KALUHIO-
KALANI; NORTH SHORE, HAWAII; 1972
Kaluhiokalani, who described himself as "half-Hawaiian, half-black, and a little bit Chinese," surfed with a genius sense of fluid style and crowd-pleasing showmanship. *Photo, Jeff Divine*

ADVERTISEMENT, JANTZEN, 1972–1973
Art, Bill Ogden

ADVERTISEMENT, HOBIE, 1970
Art, Bill Ogden

LARRY "RUBBERMAN" BERTLEMANN;
SUNSET BEACH, HAWAII; C. 1976
(Pages 336–337) Bertlemann synthesized fast, radical skateboard moves into surfing by using the wave face as he would a skate pool. *Photo, Dan Merkel*

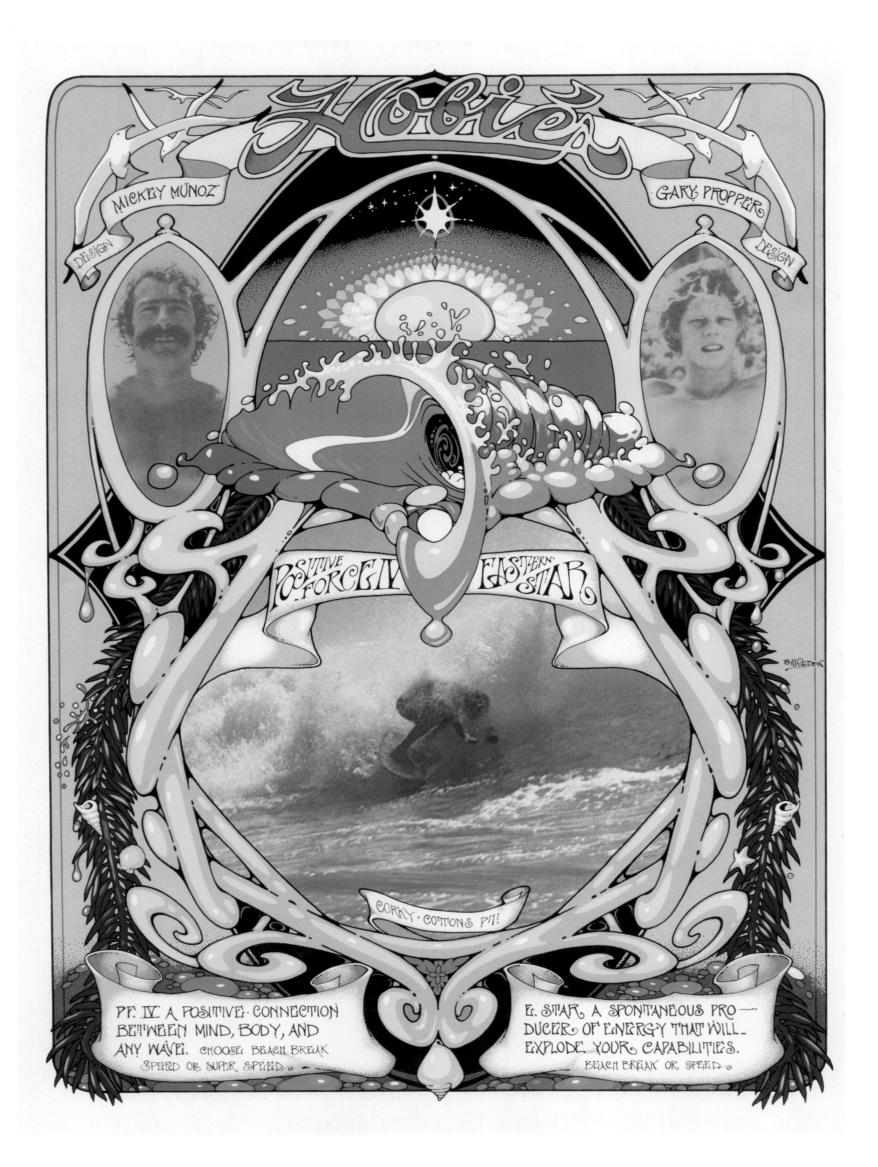

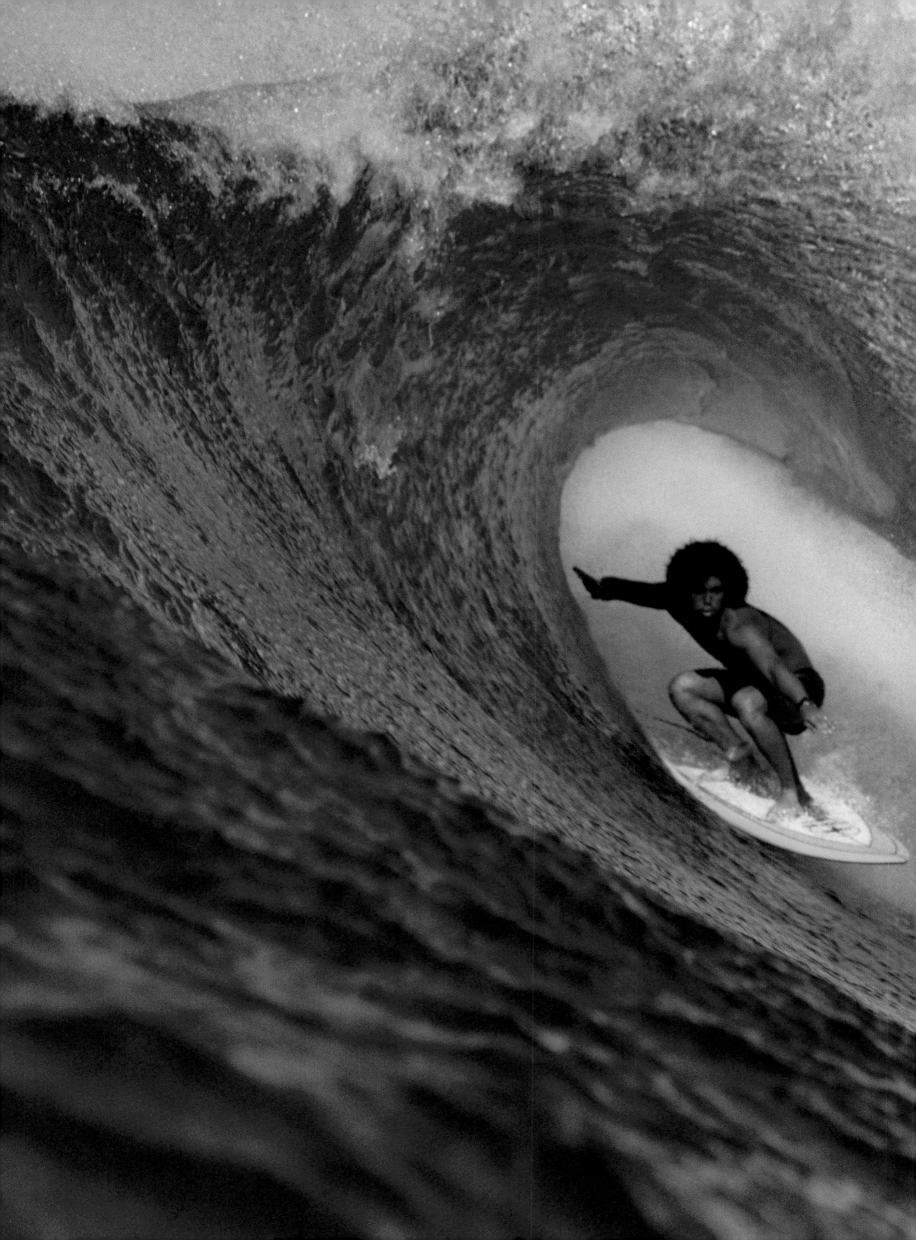

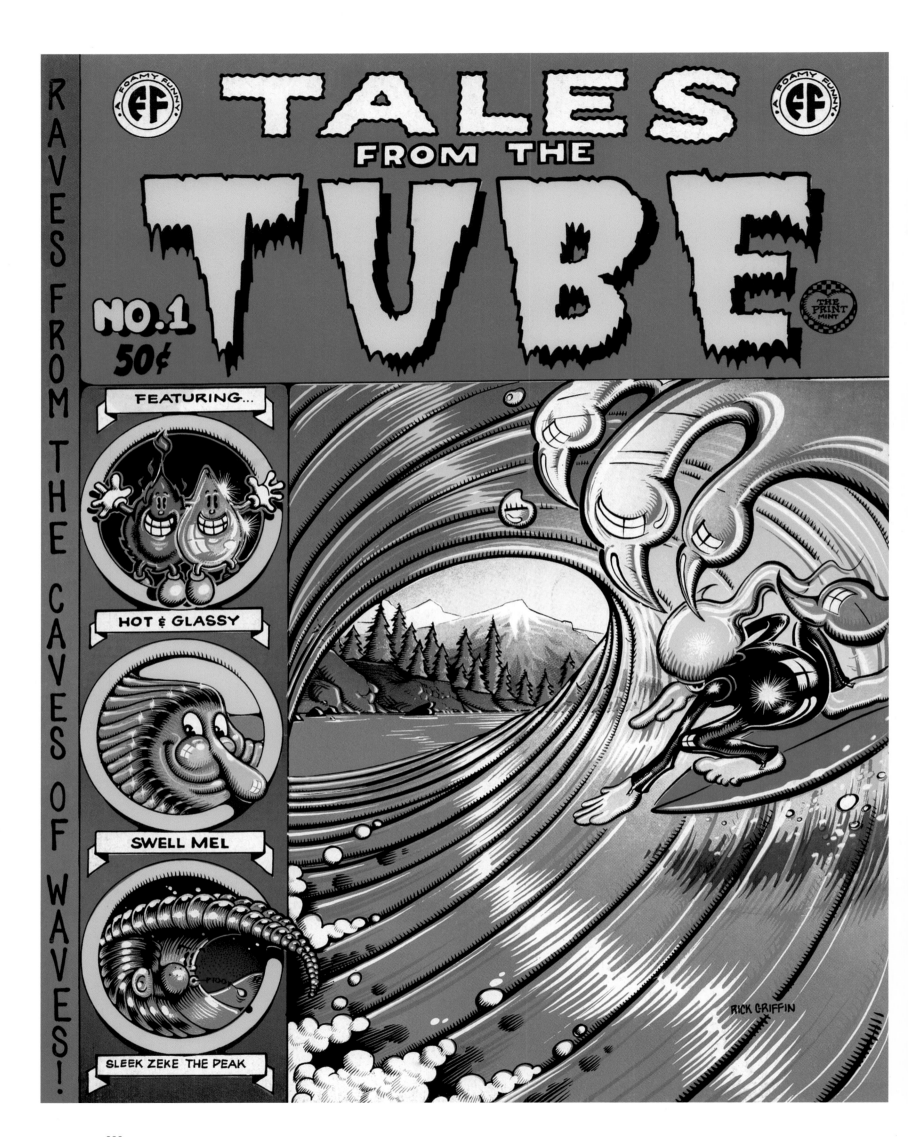

minimize competition and maximize aesthetic sharing. At the end of the day the prize money would be divided evenly among the participants. Unfortunately, the thing got off to a rocky start with an altercation between local Hawaiians and event organizers over the exclusion of a particular surfer from the event. The situation turned violent, the roster was modified, but the waves failed to arrive, and the event had to be relocated to less celebrated waves.

For the second running of the Expression Session (winter 1971–72), the waves were great and the event was run by a respected local surfer; the new format was fun for participants, revelatory for aesthetics, but unsatisfying for results-oriented media. Enthusiasm for the concept quickly faded, and there was no third running.

On the other hand, the rising prize money at the three or four major Hawaiian contests was whetting career appetites. Amateur World Champ (1968) Fred Hemmings had wrangled $1,000 out of Continental Airlines to fund the prize money for a six-man experiment at Pipeline he called the Hawaiian Masters Surfing Championship (it would soon become the Pipeline Masters), while the Smirnoff Pro event was now paying its winner $5,000. So there was blood in the water when, during the annual migration in December of 1972, top surfers gathered on the North Shore to express their mutual desire for a professional surfers union and a world competition circuit modeled on golf or tennis. The appeal of such a concept was reflected in the diversity of the assemblage, which included Hemmings, influential surfboard designer Dick Brewer, popular stylist Bill Hamilton, women's champ Margo Godfrey, surfboard designer and *Endless Summer* star Mike Hynson, and politic Hawaiian surfer Paul Strauch. All had been involved in the amateur surfing scene of the 1960s, but now they were looking to move the sport forward—and their livelihoods with it.

While the competitive edge had been dulling among most surfers, things were just getting going in the Southern Hemisphere, where more businesses were stepping up to sponsor surfing contests.

The year 1976 was when all this Southern Hemi momentum really crystallized. The previous November and December had seen the celebrated "backside attack" at Pipeline and the "bustin' down the door" approach to surfing, in which a handful of young Australians and South Africans, sensing their moment had arrived, charged the North Shore waves with a braggadocio and determined frenzy that earned lots of pages in the surfing press.

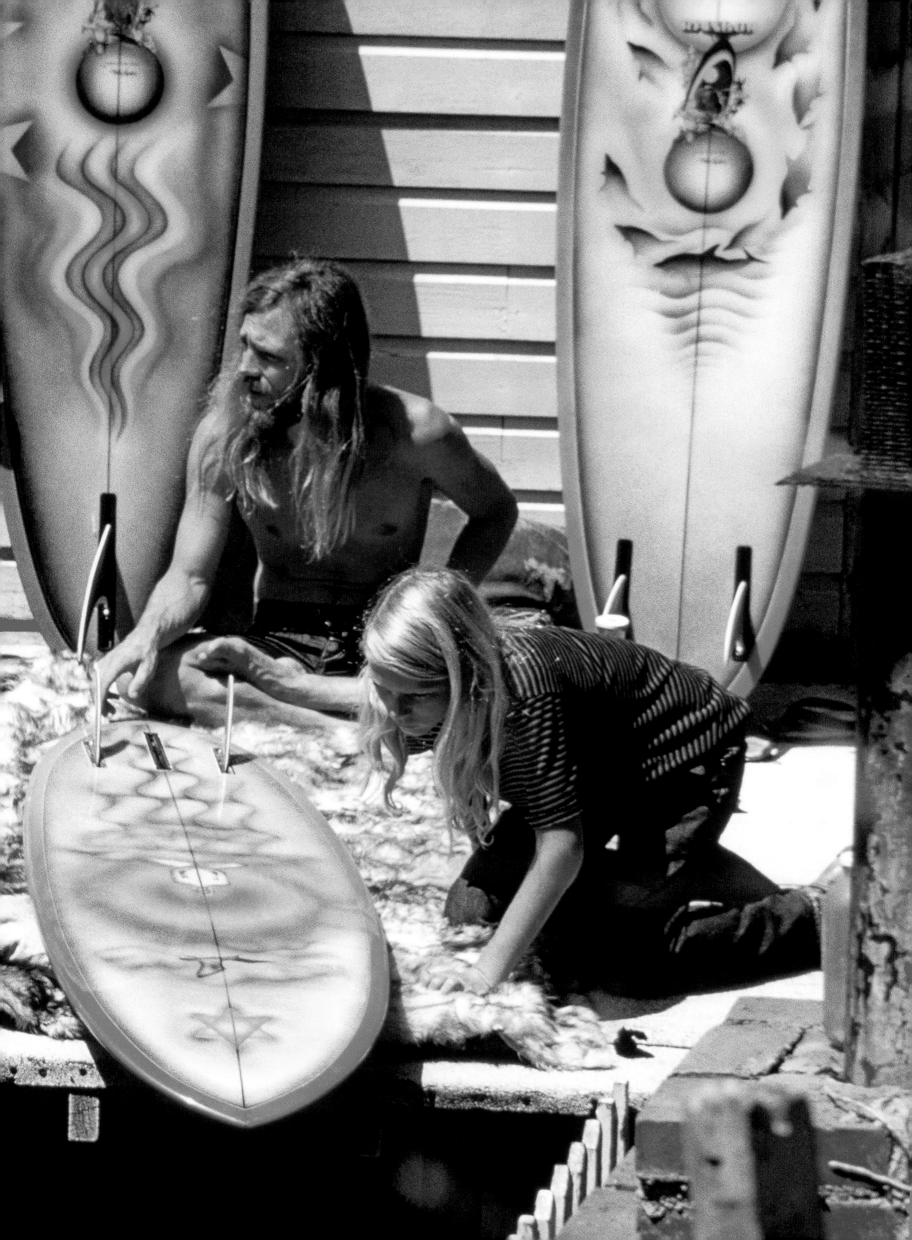

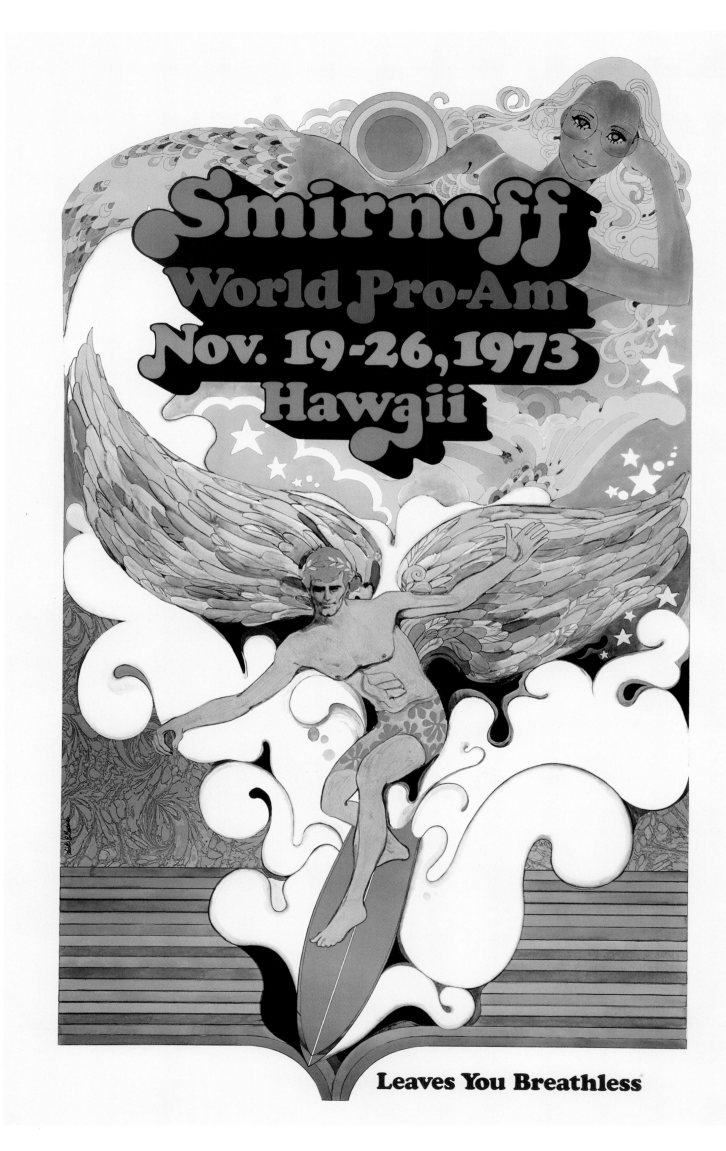

That winter, Aussie Ian Cairns won the Duke Kahanamoku Classic at Sunset Beach, South African Shaun Tomson won the Primo Masters at Pipeline, and Aussie Mark Richards won both the Smirnoff at Waimea Bay and the Lancers World Cup at Haleiwa. They took it all.

The lads from down under parlayed this momentum into the new year, winning the lion's share of pro events throughout 1976. That fall, just before the pros converged on the North Shore, Fred Hemmings registered the name International Professional Surfers (IPS), thus creating the sport's first professional governing body. And so the IPS 1976 world tour was born — retroactive to the beginning of the year! Peter Townend and Ian Cairns, who had diligently competed in every pro event around the world, finished first and second respectively.

Attempting to capitalize on what they saw as an inevitable trend and galvanized by Sydney journalist Mike Hurst, in the midst of that first nascent "tour," Cairns, Townend, and Mark Warren had packaged themselves as a new style of professional surf team futuristically geared to emerging consumer marketing trends. Wearing matching warm-up suits and tidy haircuts, they called themselves the Bronzed Aussies.

That concept failed to take hold; however, certain self-aggrandizing statements made by some of the Aussies did. Articles in surf magazines (most notably teenager Wayne "Rabbit" Bartholomew's over-the-top "Bustin' Down the Door" in *SURFER*) asserting Australian prowess earned the enmity of Hawaiian surfers and other locals, outraged that their own beaches were being used as a stage for disrespectful claims. As a result, the following winter ('76–'77) was punctuated by violence, narrow escapes, and difficult negotiations, all of which framed the first two months of the IPS's reality.

Although it was the iconic Hawaiian surfer Hemmings who created the mold for the new pro tour and elected himself executive director, it was clear that much of the impetus (and talent, including the tour's first champion) came from Australia.

Clearly, a new world order had solidly emerged, and it was only a matter of time before the Australians (who won eight of the first nine world titles!) owned the show. In 1982, in a true coup d'état, former Bronzed Aussie Ian Cairns created a new sanctioning body called the Association of Surfing Professionals (ASP), effectively snatching control of pro surfing from the IPS and out of the grasp of Hemmings. Soon the administration of

POSTER, SMIRNOFF PRO-AM, 1973
Held from 1969 to 1977, the Smirnoff Pro-Am was the world's premier big-wave event that saw its largest waves during the 1974 Thanksgiving Day contest. Hawaiian Reno Abellira won in waves averaging 25 feet or more at Waimea Bay.

DAVID NUUHIWA AND JOHN GALE, PACIFIC COAST HIGHWAY; CALIFORNIA; 1971 By the early 1970s, Gale and other members of the Brotherhood were under constant surveillance by the Drug Enforcement Agency (DEA) and local police. Many were arrested and others went into hiding for years. *Photo, Jeff Divine*

MIKE HYNSON, RAINBOW JUICE BAR ; LA JOLLA, CALIFORNIA; C. 1973
With financing from the Brotherhood of Eternal Love, Mike Hynson opened a surfboard showroom selling his custom-made Rainbow surfboards. Hynson shaped while John Bredin, aka "Starman," created the artwork.

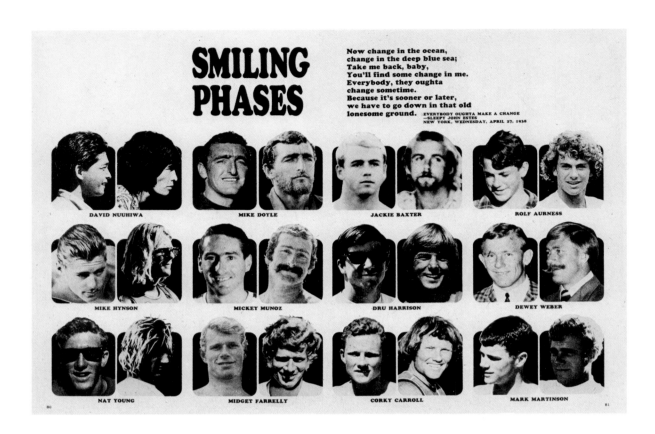

SMILING PHASES

Now change in the ocean,
change in the deep blue sea;
Take me back, baby,
You'll find some change in me.
Everybody, they oughta
change sometime.
Because it's sooner or later,
we have to go down in that old
lonesome ground.
—SLEEPY JOHN ESTES MAKE A CHANGE
NEW YORK, WEDNESDAY, APRIL 27, 1938

DAVID NUUHIWA · MIKE DOYLE · JACKIE BAXTER · ROLF AURNESS

MIKE HYNSON · MICKEY MUNOZ · DRU HARRISON · DEWEY WEBER

NAT YOUNG · MIDGET FARRELLY · CORKY CARROLL · MARK MARTINSON

the complex events that made up and supported the elite world tour (including women's, juniors, and masters events) was coming out of Australia.

FASHIONING A SPORT

Back in 1970 the concept of a "surf industry" could only pass for an oxymoron. Though there did exist a robust niche manufacturing and grassroots economy based around surfing and, mostly, the California beach iconography, any characterization of the whole thing as an industry could only be met with a quizzical look or a guffaw. Sure, the early icons of the surf-based economy (Hobie, Weber, Jacobs, O'Neill, Hansen, Gordon & Smith, Noll, etc.) had shaped and glassed their way to enviable if hardworking lifestyles, but it was all based on piecework. There was little leverage in the system. They'd all had their silk-screened T-shirts, largely to stoke and promote their team riders, and O'Neill and Body Glove were making wetsuits, but the prospects of surfing becoming big business were so slim that Hang Ten founder Duke Boyd sold off his original surf brand in 1970. But even as he did so, the seeds of a new era were starting to crack open, and not in the established surf capital of Southern California.

As winter began in Torquay, Australia, in May of 1969, surfboard builders Doug "Claw" Warbrick and Brian Singer began making wetsuits in Claw's spare old flat on Zeally Bay Road, The wetsuits were "Made by Surfers for Surfers," and the demand for a locally made product was immediate.

Shortly thereafter, Alan Green (an early Rip Curl employee) and John Law started up a little operation they called "Quiksilver." They too were in Torquay, which was nearby the iconic Victoria surf spot, Bells Beach. Quiksilver's first product, and still its flagship, was the "boardshort"—the essential surfing garment. The founders, in part because they were hardcore surfers, were committed to making the best boardshorts on the market.

Spotting a trend, Australian clothing manufacturer Edward Fletcher and Co. created a new line of "Stubbies" fashion shorts in 1972. After selling three-quarters of a million pairs that first year, they changed their company's name to Stubbies. That same year, Jim Jenks launched surfboard brand Ocean Pacific into the rag race in California, bucking the trend.

In 1973, Australian surfer/shaper Gordon Merchant and his wife, Rena, began producing handmade triple-stitched boardshorts at their Burleigh Heads flat; the following

MAGAZINE INTERIOR, *SURFER*, 1970
Within five years, surfing's public face—and mind—had transformed radically.

MAGAZINE COVER, *ROLLING STONE*, 1976
After battling depression and drug addiction for years, the Beach Boys' Brian Wilson made a short-lived but celebrated comeback on *Saturday Night Live*, where John Belushi and Dan Akroyd, playing state troopers, forced a pale, overweight Wilson to go surfing near Malibu.

PAUL NEILSEN, BARRY KANAIAUPUNI, AND TERRY FITZGERALD; SUNSET BEACH, HAWAII; 1974 By the mid-1970s, the Australians (Neilsen and Fitzgerald flanking Hawaiian Kanaiaupuni) and South Africans were dominating most of the major pro contests. At the 1974 Hang Ten American Pro, South African Shaun Tomson won the contest in the challenging 10- to 12-foot waves of Sunset Beach. *Photo, Jeff Divine*

344

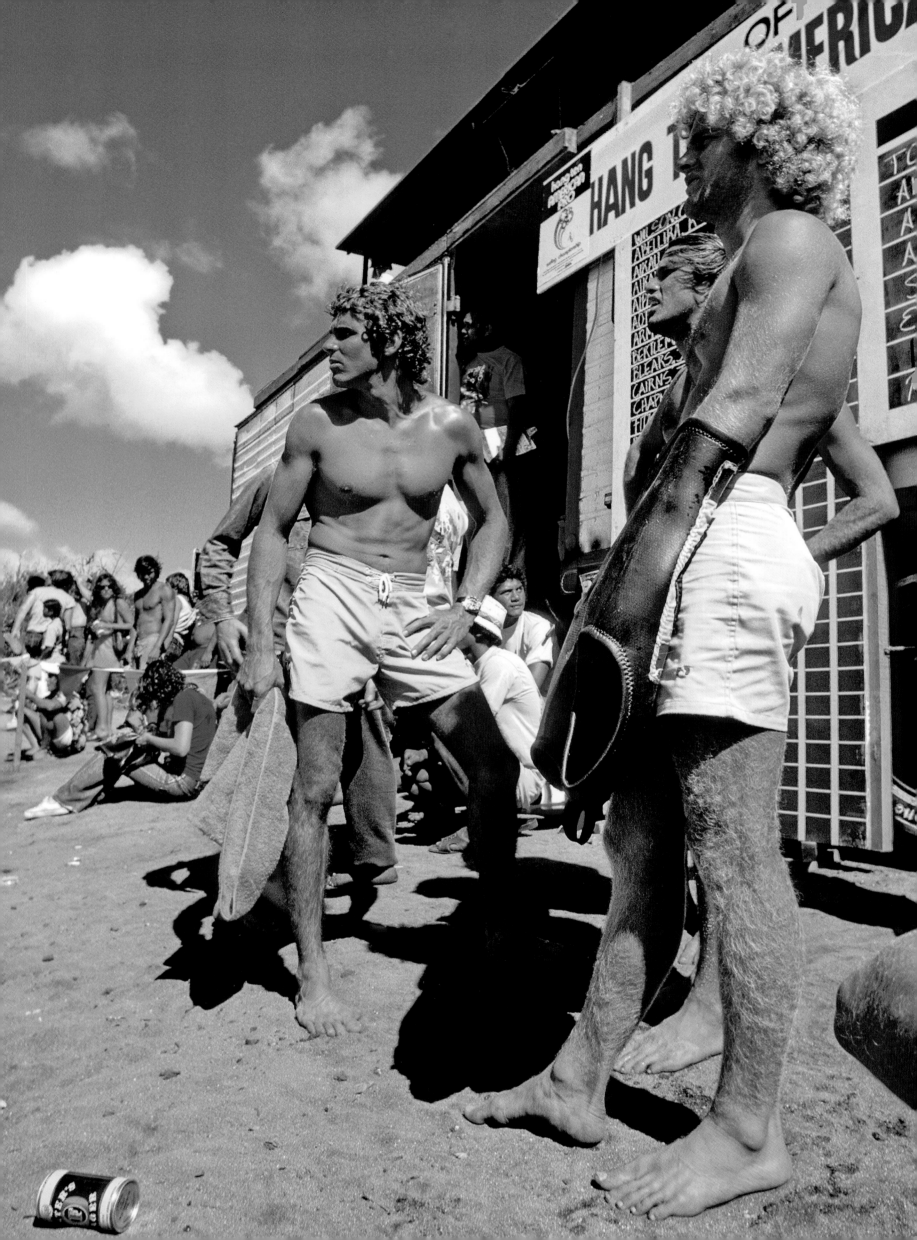

a surf film by john bennett

blue cool

blue cool is all new blue cool is rolf aurness
big matt dillon wayne lynch vic champs 72
terry fitzgerald hot girl surfers john law
bells open 72 keith paul & top interstate
and world surfers plus scramble short

year, Billabong was born. Then, in 1978, South African pro surfer Michael Tomson and longtime friend Joel Cooper founded Gotcha Sportswear. Before long, Michael's cousin Shaun launched his own brand, Instinct. It was only a matter of time before Rip Curl, too, got into the "rag business."

The irony was fascinating—an industry born and branded in (mostly Southern) California was soon dominated by Southern Hemisphere businesses. Furthermore, each of these new companies soon had bases in California and elsewhere around the world. Within a few years they were international businesses generating millions of dollars in annual sales. With this money they were able to sponsor a rising tide of talented young surfers, not to mention fund the contests that became their showcases. The meteoric rise in the profitability of these companies fueled advertising in the surf media, which ran the ads and promoted the surfers in those ads, plus, covered the contests that those advertisers were supporting or even creating. Many new companies subsequently entering the lucrative surf market worldwide were either started by these large brands or were soon acquired by them. And as their liquidity and commitment to professional surfing developed, most of the major surf brands became title sponsors of events on the professional world tour.

Surfing is sometimes described as a "gravity" sport, as it takes advantage of this primal force in generating a controlled fall ahead of a steadily forming wave face. The 1970s saw a branching out of gravity sports and elements of the surfing lifestyle. Michigan engineer Sherman Poppen's "Snurfer" (snow + surfer) invention spawned the modern snowboard with bindings and other modifications. Meanwhile, the steel- or clay-wheeled "sidewalk surfer" morphed into the polyurethane-wheeled high-performance skateboard. The Wind-surfer® (a large surfboard with a sail, a universal joint, and a daggerboard) evolved into a lightweight high-performance vehicle that rode waves and vaulted high into the air, in turn inspiring kitesurfing. Since each of these were essentially inspired by the surfboard, the effect of the growth of these sports and others further fueled the success of the surf brands, which also made products explicitly for these expanding lifestyle sports.

FLUORESCENCE

Concurrent with the growth and expansion of the surfing universe came waves of new media—magazines (fed images by a proliferating network of world-class photographers)

POSTER, *BLUE COOL*, 1972

MAGAZINE INTERIOR, *SURFER*, 1977
Wayne Bartholomew's inflammatory comments in his article so infuriated the Hawaiians that he and his fellow Australians were badly beaten and received a death threat when they returned to Hawaii the following year. *Photos, Art Brewer and Steve Wilkings*

WAYNE "RABBIT" BARTHOLOMEW; NORTH SHORE, HAWAII; 1975 Bartholomew, from Australia's Gold Coast, was determined to make surfing a professional spectator sport on the level of Grand Prix racing or World Cup Tennis. *Photo, Jeff Divine*

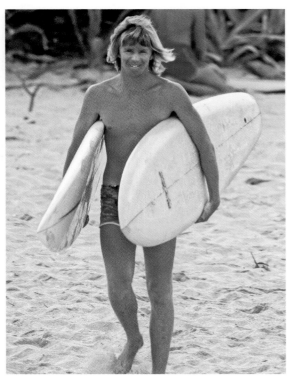

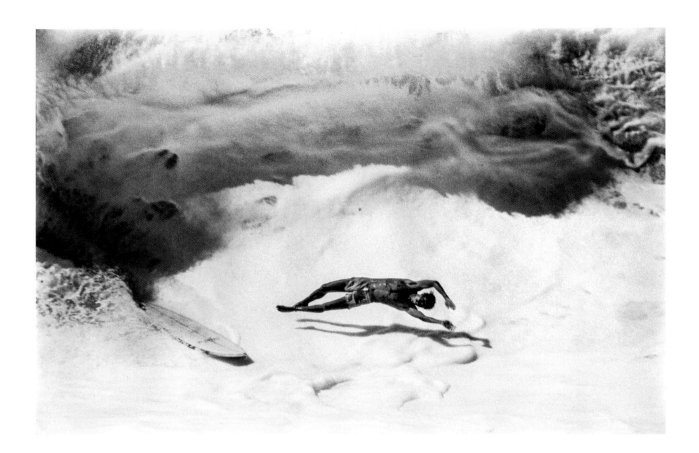

and cinema. The traditional four-wall approach of surf film pioneers like Bud Browne, Bruce Brown, and John Severson continued to pull in large crowds in every surf town on the planet. Some of the films like Hal Jepsen's action-oriented *Cosmic Children* and *Sea for Yourself* were new but basic and formulaic, some extolled new values that emerged out of the shortboard era (like Albert Falzon's *Morning of the Earth*), others reflected new currents in surfing that came out of new aesthetics like disco and punk. Each found their celebrants in the surfing world, including the surf films produced by top surfer Herbie Fletcher in the early 1980s). The concept of "surf punk" was at once resonant with the outlaw roots of the sport and totally oxymoronic; the midnight smack aesthetic of the punk was hard to reconcile with all that sun, saltwater, and urban crank, but it was tried and celebrated, for a while.

Though most surf films played in high school auditoriums or small venues, there were some forays into big-screen theaters, too. While John Severson's *Pacific Vibrations* and MacGillivray-Freeman's *Waves of Change* pioneered 35mm theater showings with slim success, John Milius's much-publicized *Big Wednesday* (which took its title from an early '60s Severson film) raised the bar when it came out in 1978 after dropping into the North Shore to shoot its cast in action. (Filming it on location in Hawaii created subtext and made it more authentic in the eyes of the surf community, including surf magazines.) The following year *Apocalypse Now*'s Colonel Kilgore (played by Robert Duvall) reminded us that "Charlie don't surf"—a short scene that made a big impression.

Clearly, the lid was off and the genie was out of the bottle. The down-home impulses of the late '60s, which hoped to dampen the growing popularity of surfing and thereby keep it more in a low-down, tribal style that would mean less crowds, less commercialism, less conformity, was largely relegated to just another past era. Or at least the media and the industry and the competition scene thought so. By the mid-'80s, surfing magazines had exploded with color and glitz; it seemed that everything was not just new, but newer than new. And if that newness, that almost cartoonish fluorescence, invited a gaudy superficiality that attracted more posers than ever into surfing's big tent, well, at least burning cop cars and frenzied rioters gave the magazines fresh topics in the rush toward edgy currency.

What brought things back to center, yet ironically pushed them even further to the edges that high-performance surfing was always pushing, was a quiet, shy, second-generation

PIPELINE, HAWAII, C. 1973 Pipeline breaks over a shallow, unforgiving rock reef. Wipeouts like this can easily cause lasting injury, even death. *Photo, Jeff Divine*

ADVERTISEMENT, SEX WAX, 1972 Rick "Zog" Herzog started making surf wax in a shed in Isla Vista, California, using recycled tuna cans for wax molds. He called it "Sex Wax" because "sex sells!"

PIPELINE, HAWAII, C. 1971 *Photo, Jeff Divine*

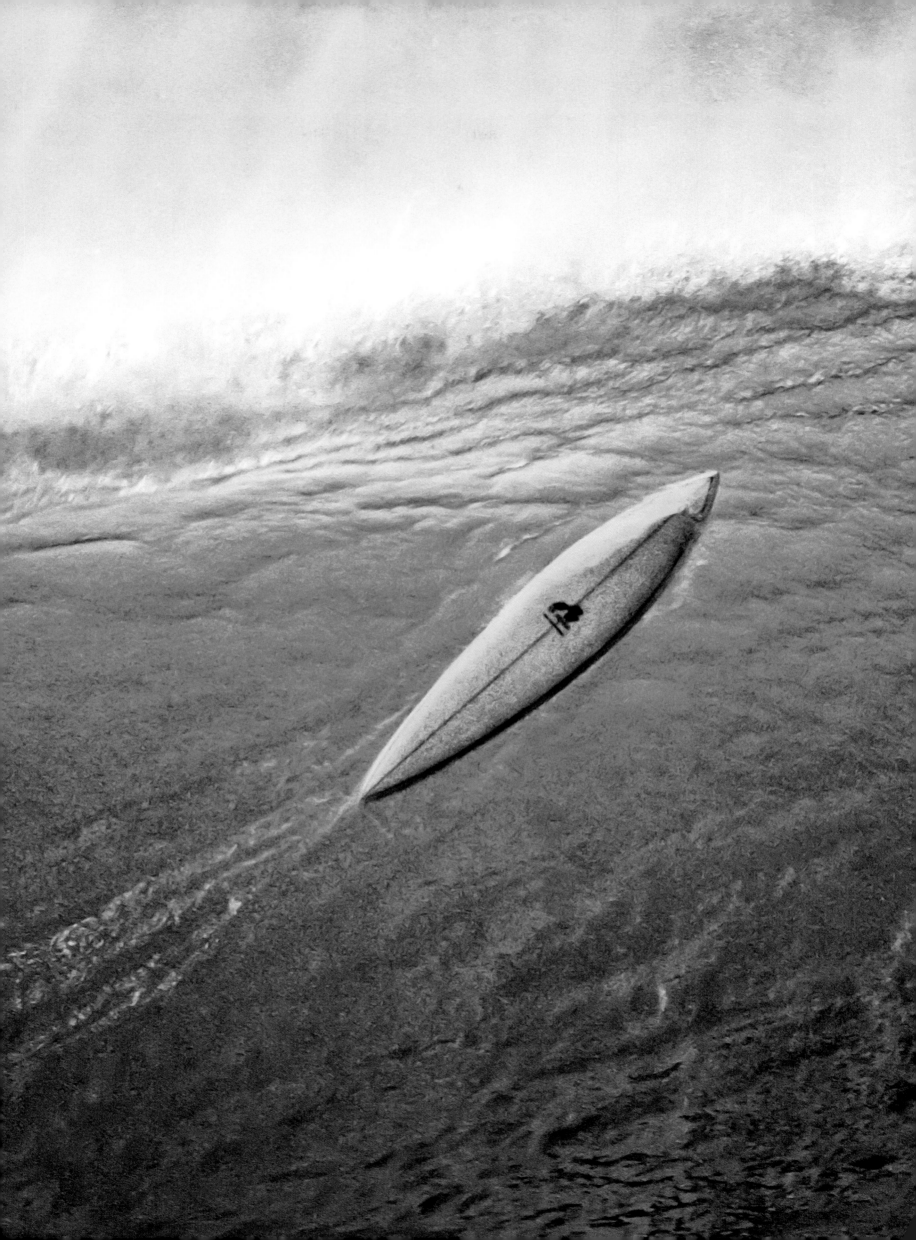

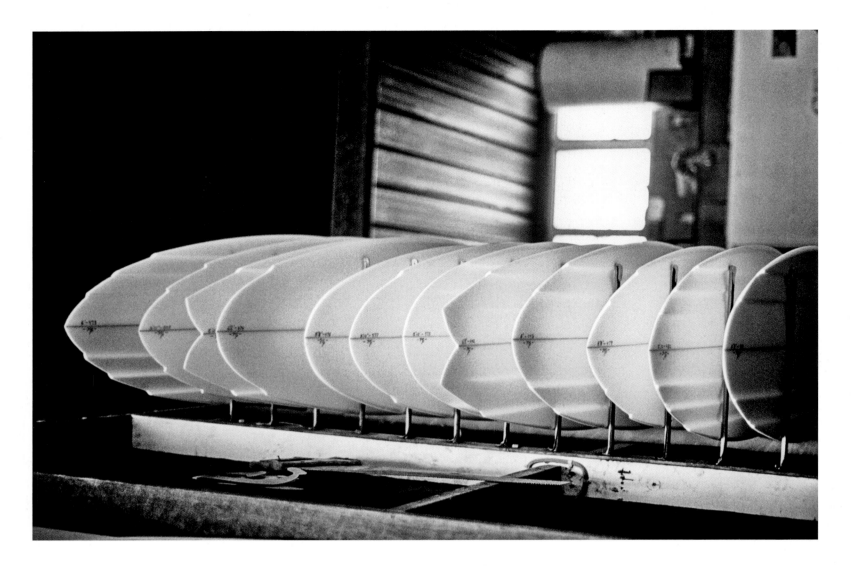

lad from Santa Barbara. Son of the iconic and reclusive Pat Curren, builder of prototypical "big gun" surfboards, and rider of those big guns on big waves in the late 1950s and early '60s, Tom was an unlikely successor to the mantle. Exquisitely perceptive, almost cosmically intuitive, and elastically creative in the water, the younger Curren famously refused prize money in early contest victories until he won the amateur world title at Burleigh Heads in 1982. From then on he stormed through world tour events to win back-to-back world titles in the mid-'80s, finally breaking the hold that Southern Hemi surfers had held on pro surfing for a decade.

What was different about Tom Curren was...everything. Despite his old-school pedigree, despite the fact that he was a quiet force in an ostentatious era, and despite his self-effacing modesty, he rose to the top. In doing so, he single-handedly redefined surfing by creating a heroic blend of respect for the forms of the past with an audacious willingness to redefine the present in terms straight out of the future.

As modern surfing moved toward the end of its first century, what was becoming clear was that all eras continued to exist simultaneously, somewhere. In 1986, a longboarding division was added to the ASP's World Tour. That same year the United States Surfing Championships (amateur) were held in Florida, where Kelly Slater won his first U.S. title, in the boys' division.

SHAPING ROOM, C. 1979 A good production shaper was expected to handcraft 10 to 12 boards a day.

SKIP FRYE, 1972 Frye, a California surf star and shaper, was part of the 1967 Windansea team that went to Sydney to compete against the Australians. Once back in California, he quickly adapted the Australian shortboard development to board design at the Gordon & Smith Surfboards factory. *Photo, Lee Peterson*

CHANNEL-BOTTOM SURFBOARD BLANKS, CALIFORNIA, C. 1978 Australia's shapers Jim Pollard and Allen Byrne produced the first channel-bottom surfboards in the mid-1970s. Difficult to shape and glass, the lengthwise slots were thought to enhance overall board speed. *Photo, C.R. Stecyk III*

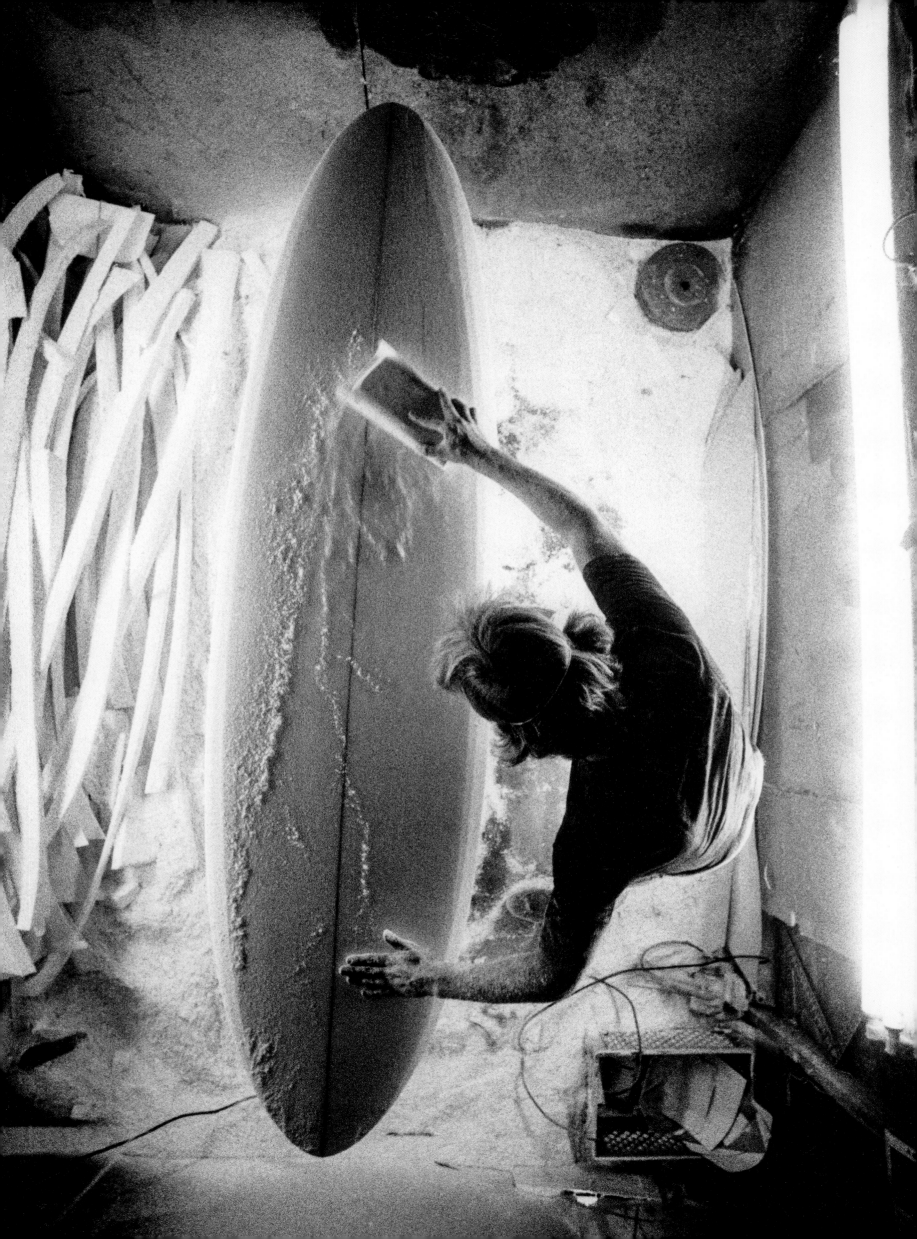

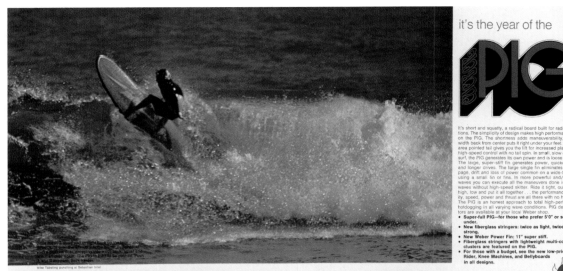

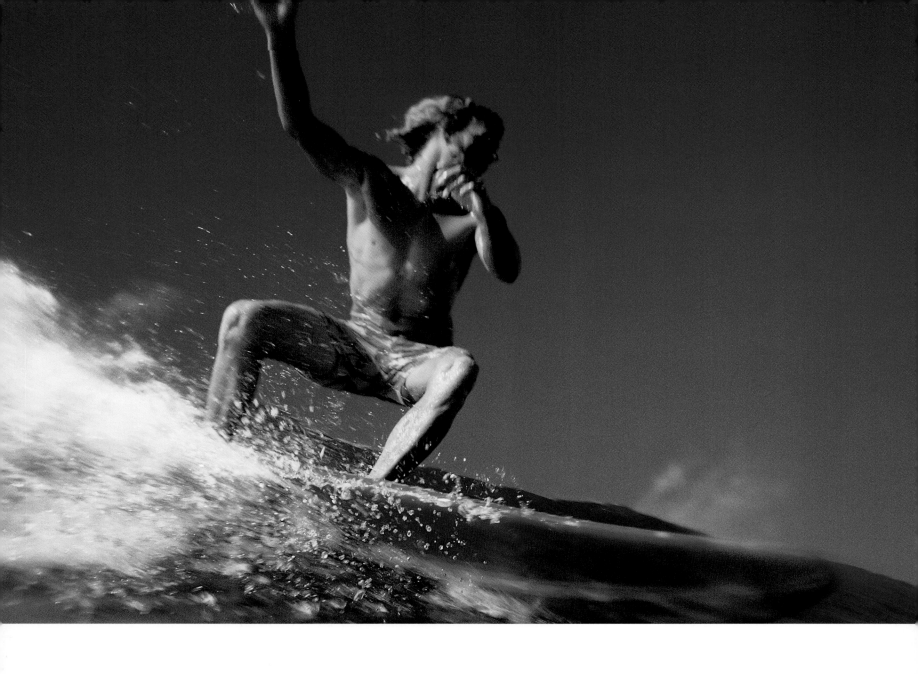

ADVERTISEMENT, WEBER SURFBOARDS, 1971 The Weber Pig was actually an update of Dale Velzy's 1955 "pig," a wide-hipped board that offered remarkable speed and agility.

SHAUN TOMSON; PIPELINE, HAWAII; 1977 Tomson partnered with Durban surfboard shaper Matthew "Spider" Murphy to produce specialized boards that enabled Tomson to successfully make the steep, dangerous drop at Pipeline in the mid-1970s. *Photo, LeRoy Grannis*

MIDGET FARRELLY; PUPUKEA, NORTH SHORE, HAWAII; 1970 Although Farrelly came out of the late-1950s longboard era, he moved readily with the times as a progressive short-board surfer and shaper. *Photo, LeRoy Grannis*

DUNCAN AND MALCOLM CAMPBELL; OXNARD, CALIFORNIA; 1970 Using their dad's garage and borrowed books on hydrodynamic hull theory, the teenage Campbell brothers invented the "bonzer," a revolutionary tri-fin system that paved the road to later tri-fin designs. *Photo, Jack Campbell*

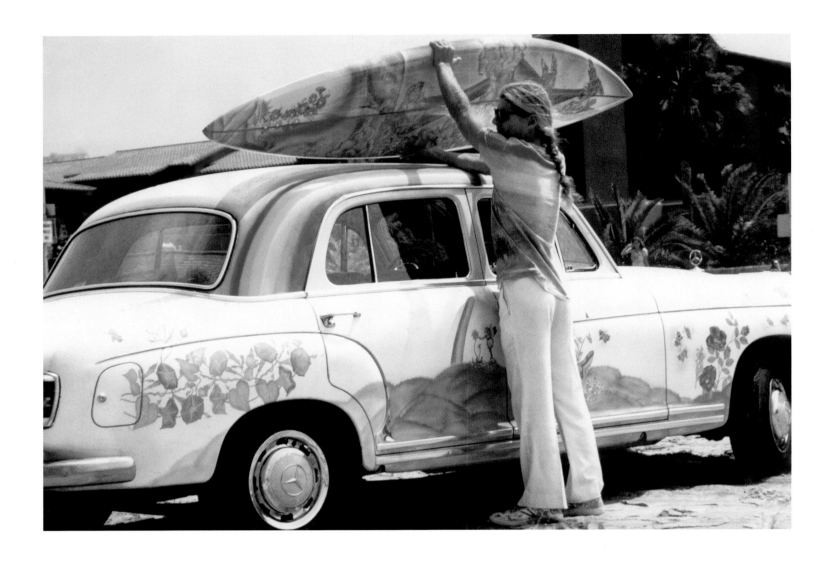

MIKE HYNSON, LA JOLLA BEACH CLUB; LA JOLLA, CALIFORNIA; C. 1971 Hynson loaned this psychedelic Mercedes to the Brotherhood's John Gale, who was decapitated after a high-speed pursuit by either Drug Enforcement Administration agents or the Mexican Mafia. Hynson once remarked to *SURFER* magazine: "by the time acid was against the law, we were way beyond saving."

MIKE DIFFENDERFER, HAWAII, C. 1971 Diffenderfer was a 1950s La Jolla surfer renowned for shaping beautifully foiled "guns" for the Hawaiian big-wave elite. He was called the "Michelangelo of shapers." *Photo, Art Brewer*

PHIL "BONUS" STYES; PUPUKEA, NORTH SHORE, HAWAII; 1974 In the 1970s the economy of the North Shore was based on real estate, surfboards, and *pakalolo* (Hawaiian for marijuana.) *Photo, Art Brewer*

DRUG SEARCH; BAJA CALIFORNIA, MEXICO; C. 1972 Surf trips south of the border invariably included an encounter with the *Federales* (Federal Police) looking for some added income via a *mordita* (bribe). *Photo, Jeff Divine*

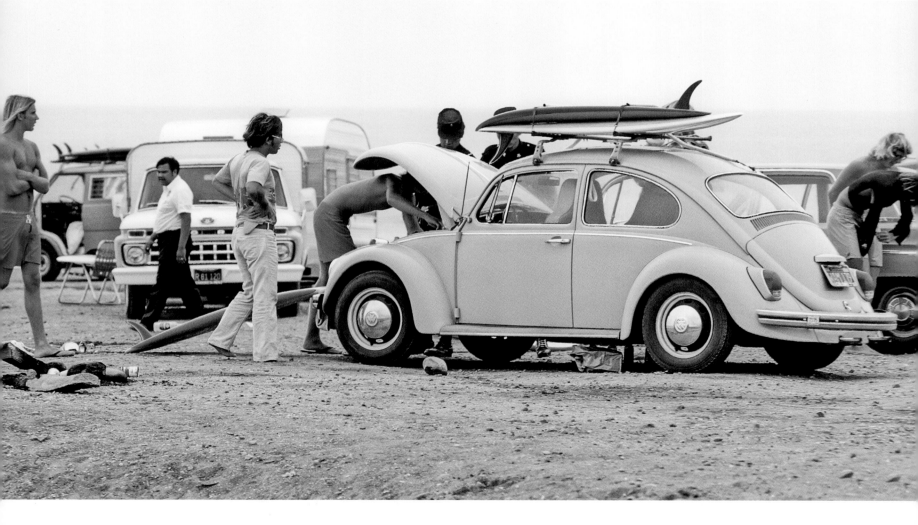

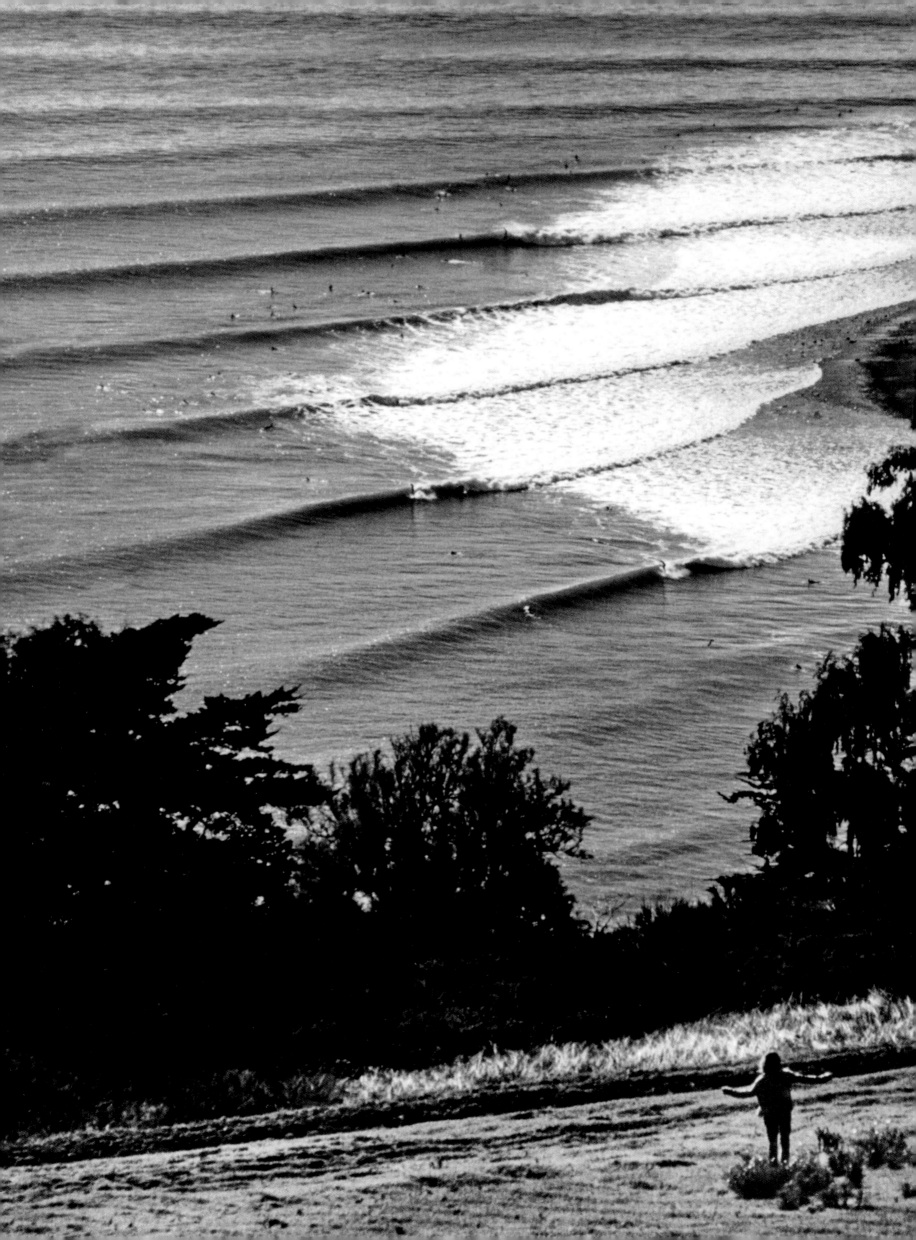

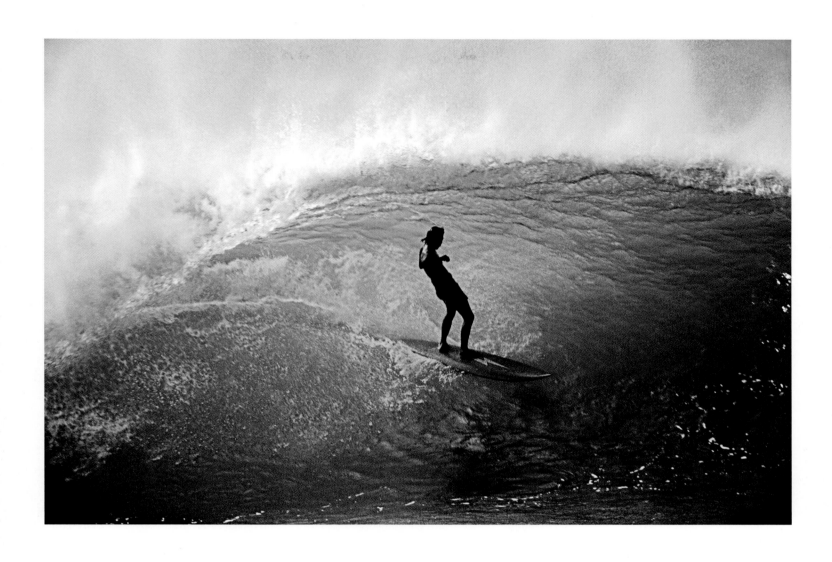

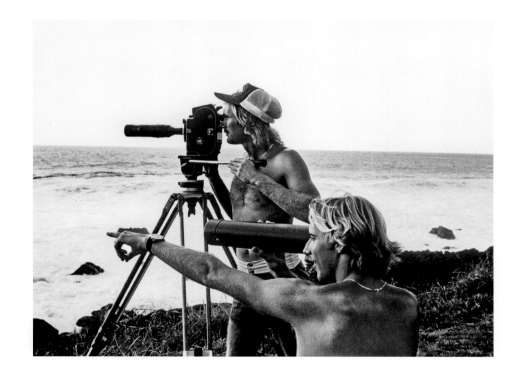

RINCON; VENTURA COUNTY, CALIFORNIA;
C. 1975 *Photo, Steve Bissell*

GERRY LOPEZ; PIPELINE, HAWAII; C. 1971
Despite Pipeline's fearsome reputation, Lopez's
style was about making the ride look as effortless as
possible. "It's a cakewalk, when you know how," said
Lopez. *Photo, Jeff Divine*

HAWAII, C. 1975 During the '70s there was a
glut of low-budget surf films from around the world
whose quality ranged from "Stoked!" to "Give me
my money back!" Many showed once and were never
seen again.

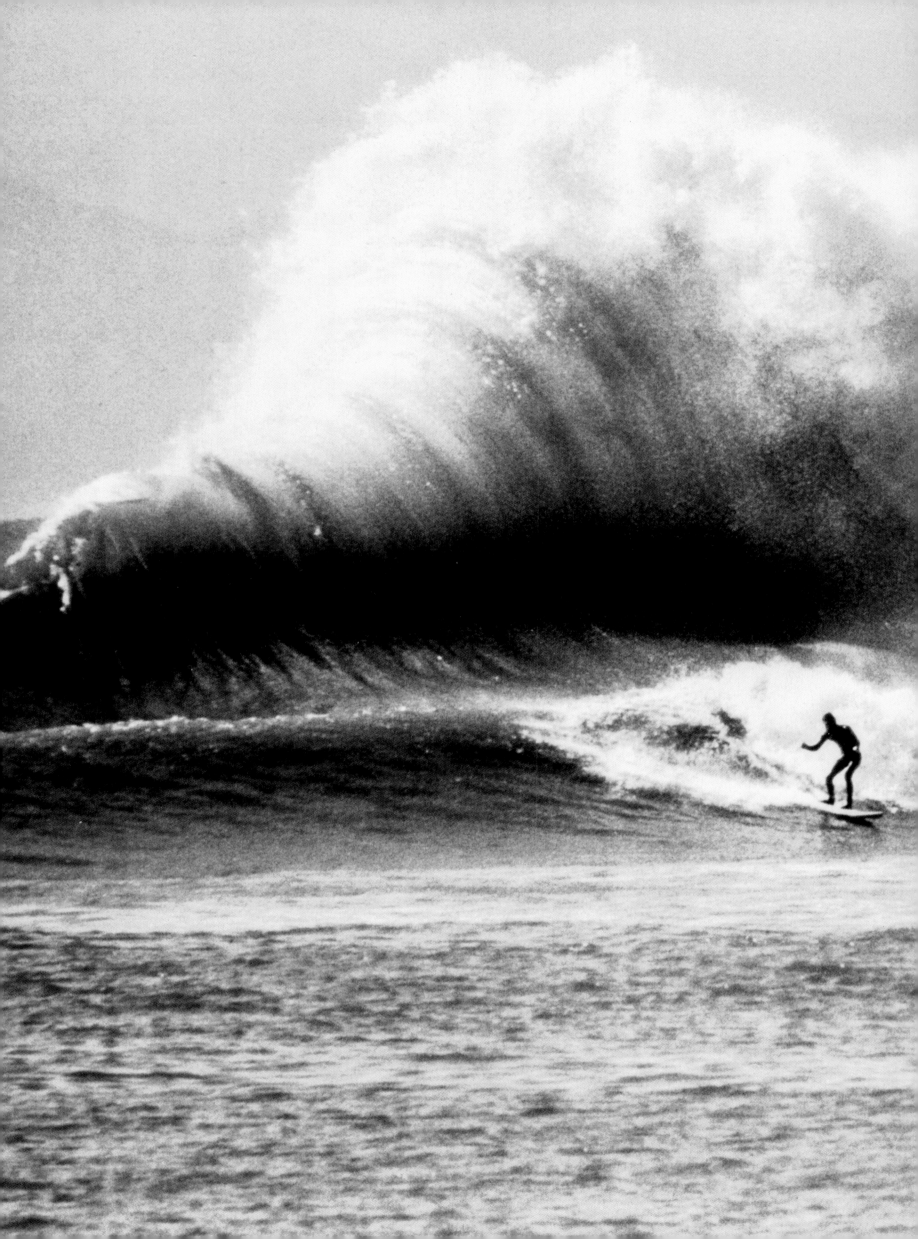

SANDSPIT; SANTA BARBARA, CALIFORNIA; C. 1975 *(Pages 358–359)* When the U.S. Army Corps of Engineers built the Santa Barbara Harbor, the jetty immediately accumulated sand and created a dredging barrel during a big northwest swell that terrified boaters but delighted surfers.

WINDANSEA PUMP HOUSE; LA JOLLA, CALIFORNIA; 1971 La Jolla surfers share their opinion of Tom Wolfe, author of *The Pump House Gang. Photo, Jeff Divine*

SKIP ENGBLOM, CRAIG STECYK, AND JEFF HO AT ZEPHYR SURFBOARDS; OCEAN PARK, CALIFORNIA; C. 1974 Zephyr Surfboards was founded by shaper Jeff Ho in Venice Beach. Stecyk designed the artwork, and Engblom shaped and ran the showroom. *Photo, Anthony Friedkin*

CRAIG STECYK; VENICE, CALIFORNIA; 1974 Stecyk brought a gritty urban aesthetic to surfing that reflected Venice's decline from idyllic seaside resort into a crime-ridden "surf ghetto." *Photo, Anthony Friedkin*

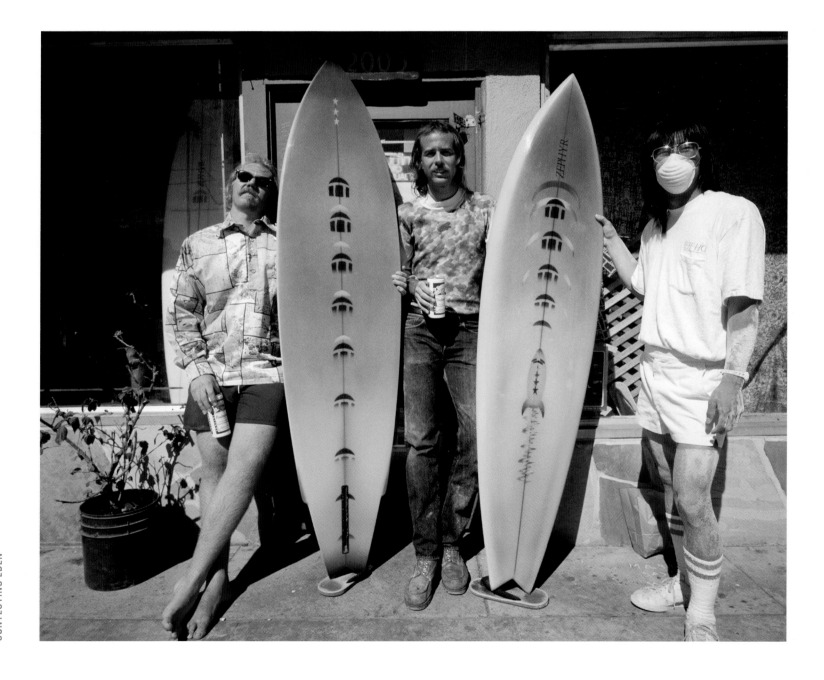

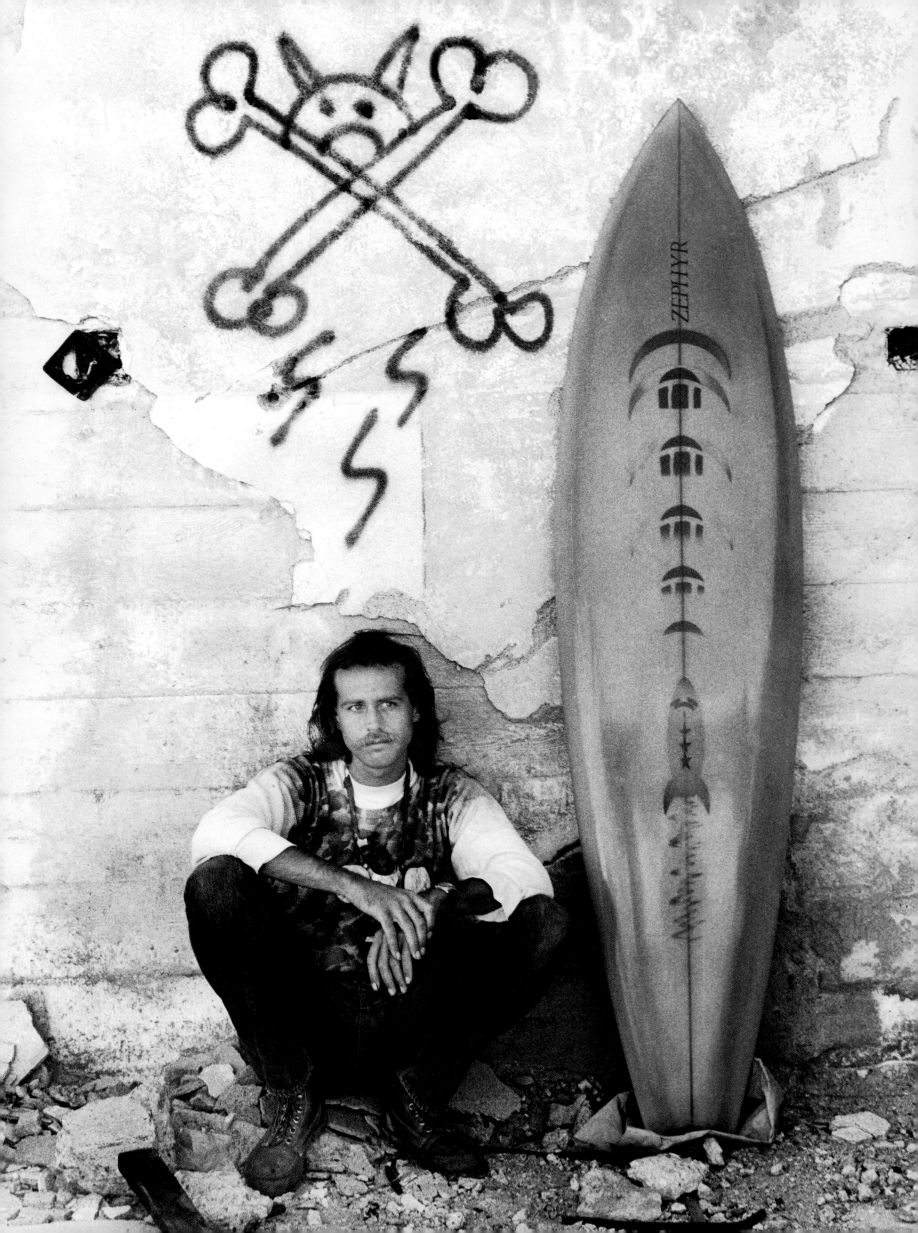

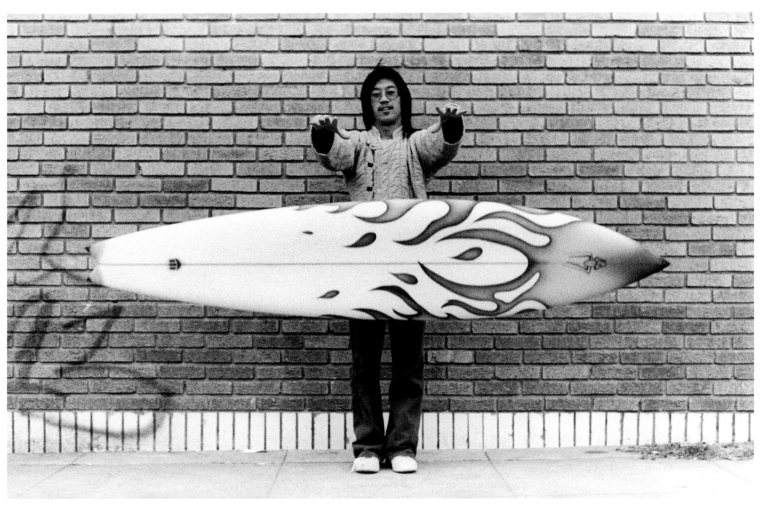

JEFF HO; VENICE, CALIFORNIA; 1975
As a young teen in the 1960s, Ho would hitchhike down to Santa Monica and borrow surfboards until one day he decided to build his own. Soon he was selling them under the name Jeff Ho Surfboards and later Zephyr. *Photo, C.R. Stecyk III*

JAY ADAMS; SANTA MONICA, CALIFORNIA; 1975 "When God invented skateboarding, he said, 'Let there be Jay Adams.'" — Stacy Peralta in *Dogtown and Z-Boys*. *Photo, C.R. Stecyk III*

TONY ALVA, DOGTOWN; VENICE, CALIFORNIA; C. 1975 Alva, along with Jay Adams, Stacy Peralta, Nathan Pratt, Peggy Oki, and others, were young surfer kids who would ride skateboards for fun and to improve their surfing. But their skating talents were so advanced they soon formed the Zephyr skateboard team. They eventually became renowned as "The Z-Boys." *Photo, C.R. Stecyk III*

STACY PERALTA; SANTA MONICA, CALIFORNIA; C. 1975 Peralta, of all the Zephyr skateboard team, took the most professional approach to his career. He later became an award-winning documentary filmmaker, best known for *Dogtown and Z-Boys* and *Riding Giants*. *Photo, C.R. Stecyk III*

BUNKER SPRECKELS; NORTH SHORE, HAWAII; 1976 For all of his outrageous quirks, Spreckels was a gutsy, talented surfer who helped test and popularize several influential shortboard designs. *Photo, C.R. Stecyk III*

BUNKER SPRECKELS AND RORY RUSSELL; DURBAN, SOUTH AFRICA; 1975 Shortly after his 21st birthday, Adolph B. "Bunker" Spreckels III, heir to his family's sugar fortune and later stepson to motion picture star Clark Gable, inherited the family fortune and used it to fund a lavish, drug-fueled international surf lifestyle. He died of an overdose at age 27. *Photo, Art Brewer*

364

ADVERTISEMENT, JANTZEN, 1972–1973
Art, Bill Ogden

LARRY BERTLEMANN; SYDNEY, AUSTRALIA; C. 1978 *Photo, Art Brewer*

TERRY FITZGERALD; SUNSET BEACH, HAWAII; 1976 *(Pages 366–367)* Throughout the '70s, most of the top surfers such as Fitzgerald (nicknamed the "Sultan of Speed") shaped and rode their own boards. Every season "Fitz" brought over a full quiver of his Hot Buttered surfboards custom airbrushed by Sydney artist Martin Worthington. *Photo, Jeff Divine*

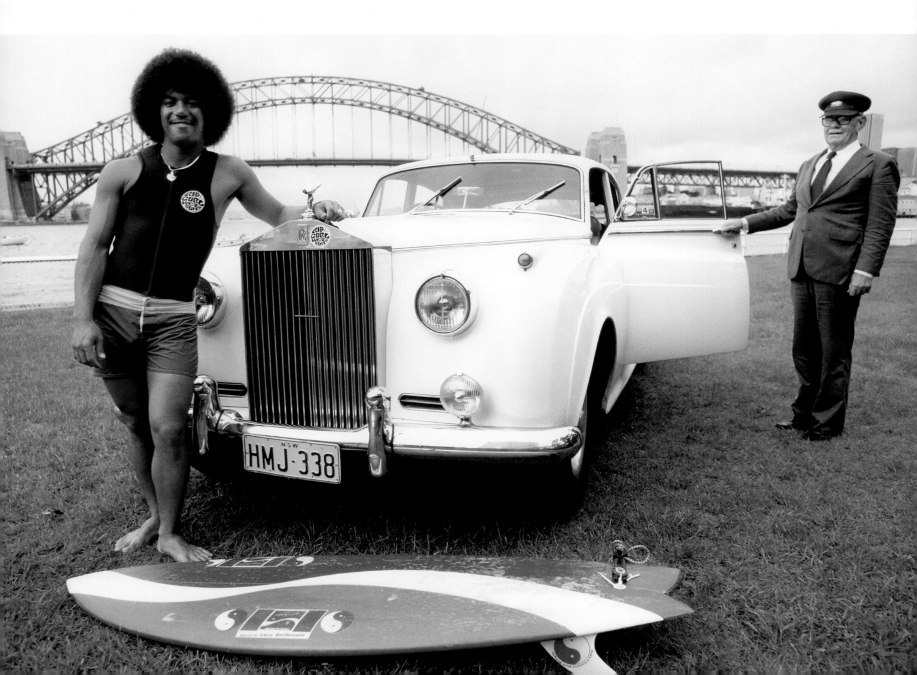

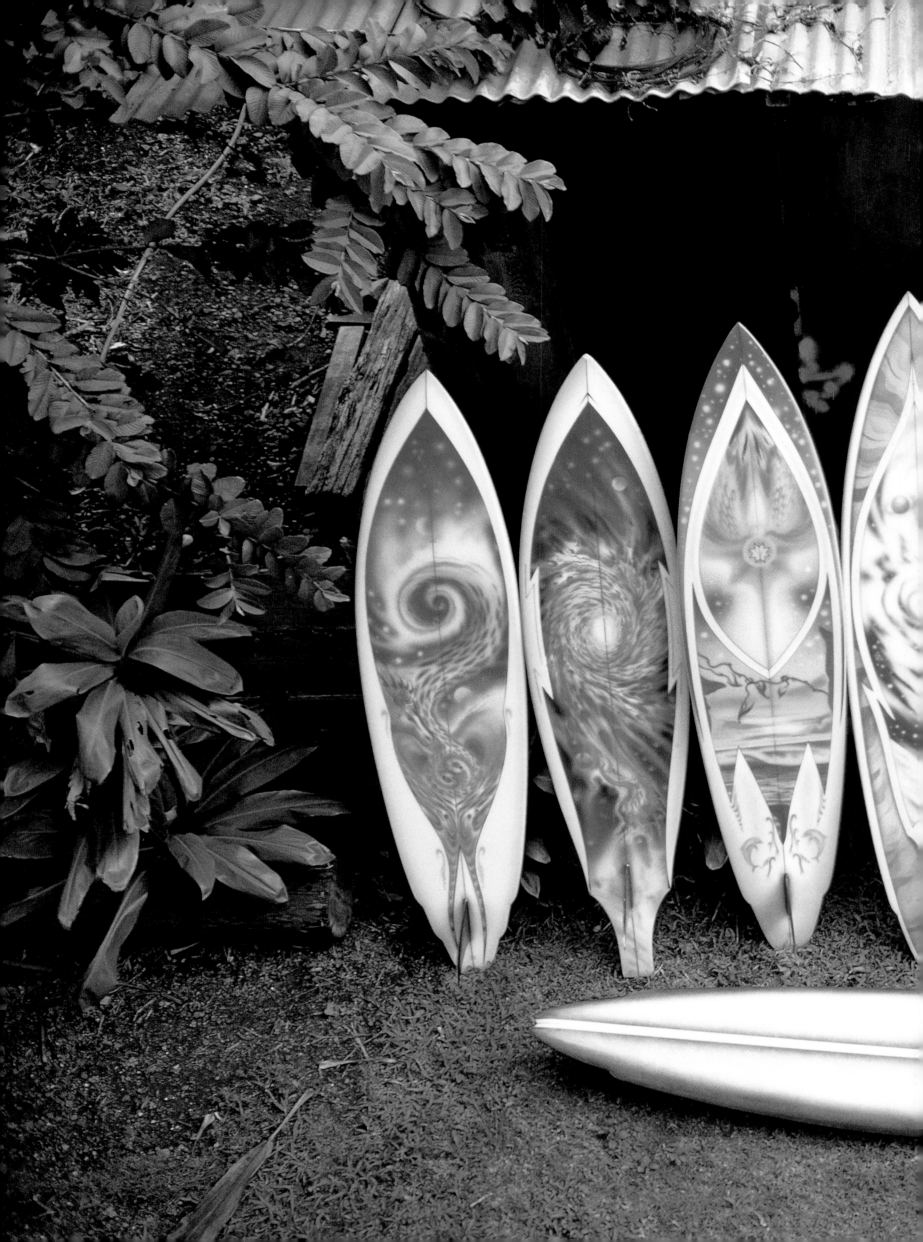

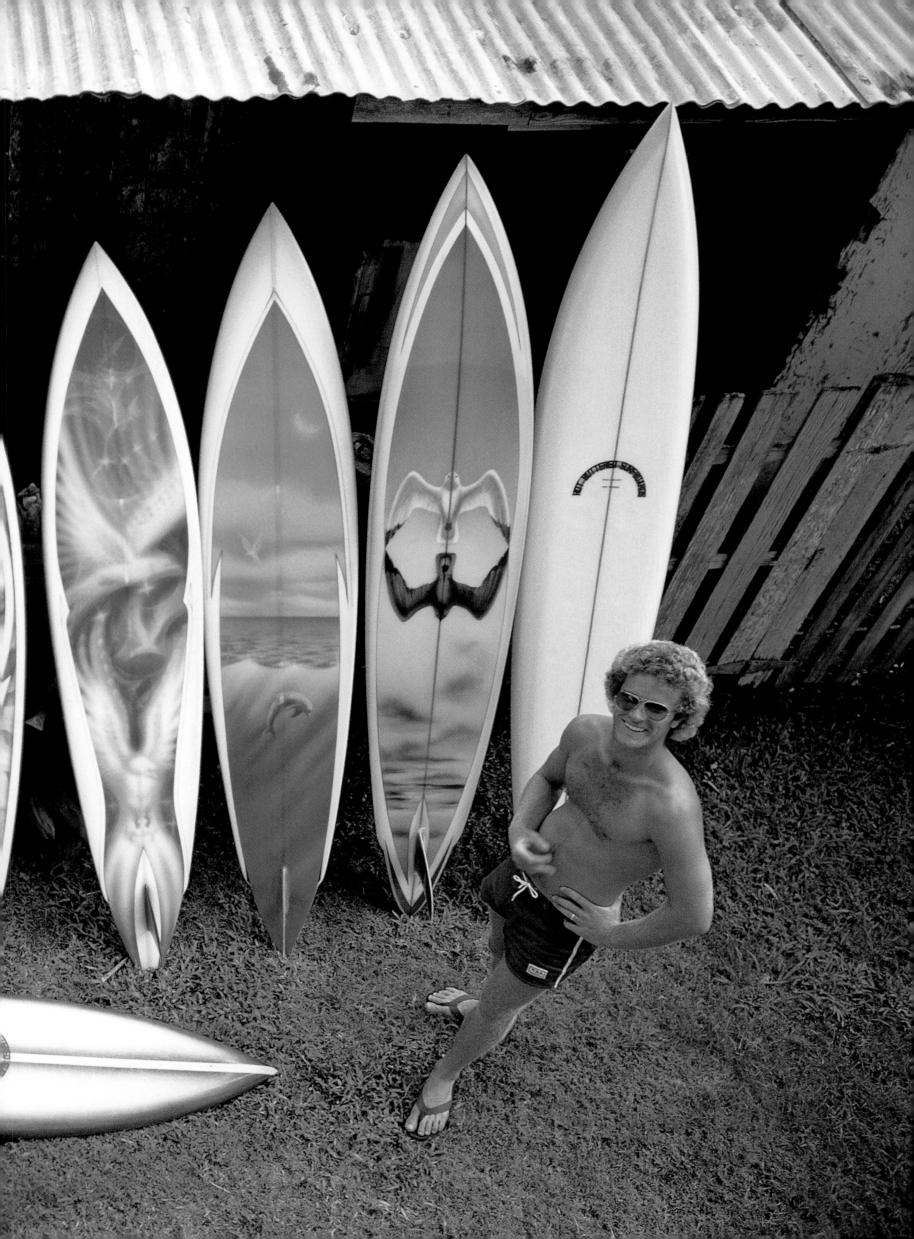

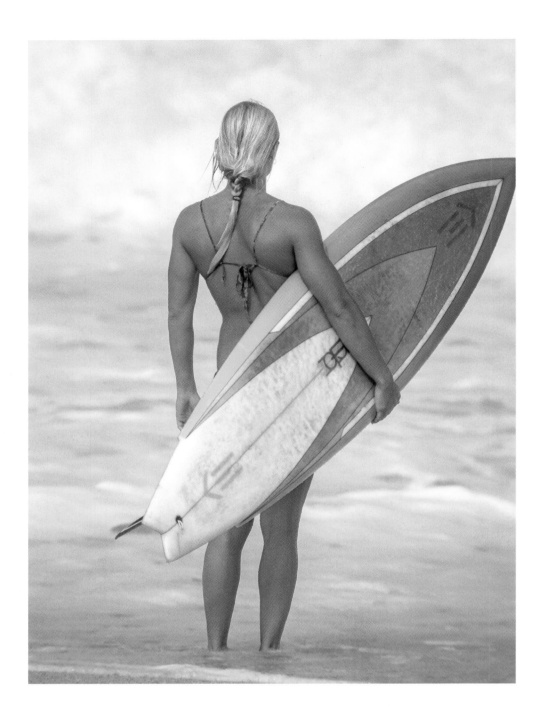

ELAINE DAVIS; NORTH SHORE, HAWAII; C. 1975 *Photo, Dan Merkel*

JERICHO POPPLER; SUNSET BEACH, HAWAII; 1976 Poppler smiles after winning the Smirnoff Pro-Am women's division. She brought an athletic grace to surfing, stating that while men look to conquer waves, women prefer to "dance, and just be part of this kingdom." *Photo, Warren Bolster*

LAURA BLEARS; SUNSET BEACH, HAWAII; C. 1976 The daughter of professional wrestler Lord James "Tally Ho" Blears and a champion level competitive surfer, Laura created a sensation by surfing and posing nude for a six-page *Playboy* pictorial. *Photo, Dan Merkel*

WAVE CAR; DANA POINT, CALIFORNIA;
C. 1975 Surf vehicles come in all shapes, sizes,
and colors. But the best are the ones that you can
inhabit for cheap, what surfers call "hermit-crab-
bing." *Photo, Pierre Van Swae*

BUNKER SPRECKELS AND DAVID
LANDSLEY, SOUTH AFRICA, 1975
Spreckels, driving, bought a pair of Mercedes
touring sedans to explore the South African coast
for waves. With weapons in tow, he stopped at a
reserve to hunt big game on the way to Jeffreys Bay.
Photo, Art Brewer

HUNTINGTON BEACH, CALIFORNIA,
C. 1978 A couple of hippie surfers and a VW
with an impossible stack of surfboards are catnip
for the Huntington Beach police.

CALIFORNIA, C. 1977

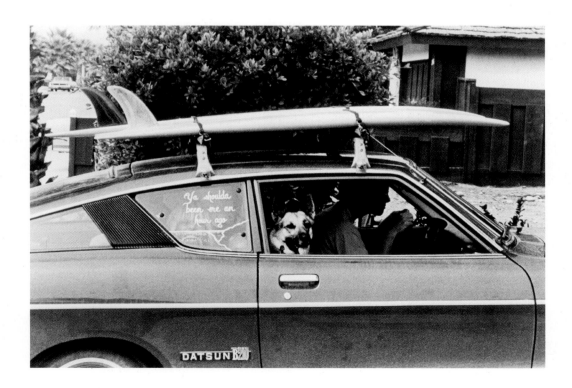

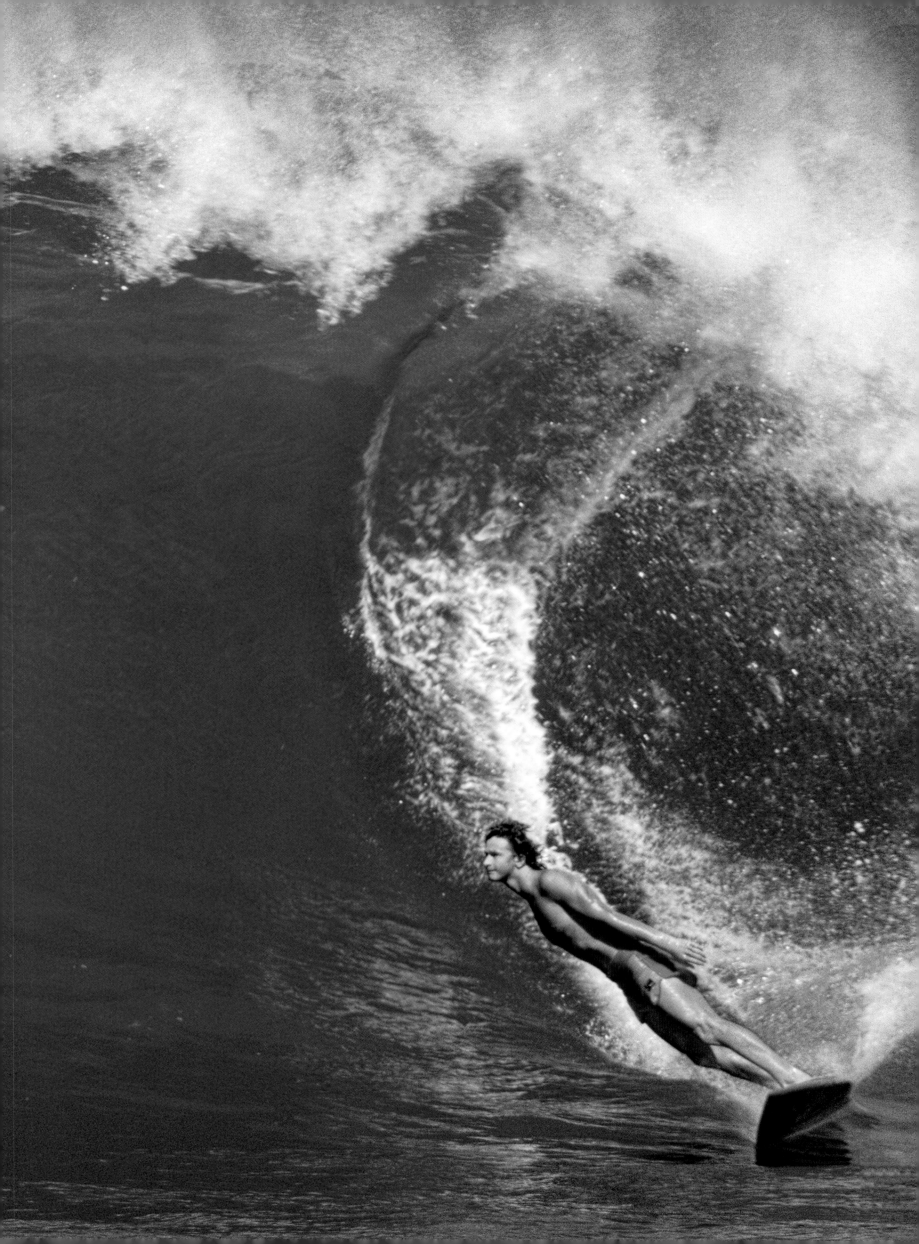

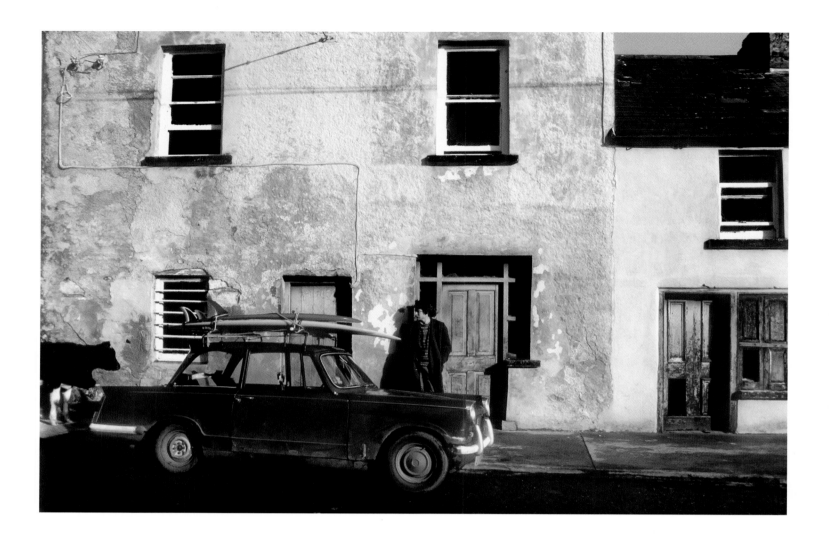

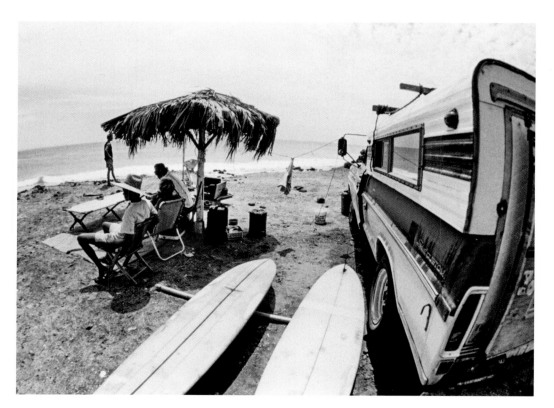

MARK RICHARDS, OFF THE WALL; NORTH SHORE, HAWAII; C. 1975
(Pages 372–373) Photo, Dan Merkel

KEVIN NAUGHTON; EASKEY, IRELAND; 1977 Starting in 1973, Southern California natives Naughton and Craig Peterson went on a global surfari for 11 years. They discovered several new surf spots and were considered the Lewis and Clark of '70s surf exploration. *Photo, Craig Peterson*

SCORPION BAY; BAJA CALIFORNIA, MEXICO; C. 1984 Surfers seeking sanctuary from crowded urban lineups traveled by car, plane, and boat to pitch camp on the most remote beaches in the world. *Photo, Sonny Miller*

DAVE TERRY AND KEVIN NAUGHTON; WEST AFRICA; 1974 *Photo, Craig Peterson*

GROMMETS; BURLEIGH HEADS, QUEENSLAND, AUSTRALIA; 1979
(Pages 376–377) Australian "grommets" were young surfers who were zealously loyal to their beach and favorite surf stars. *Photo, Rennie Ellis*

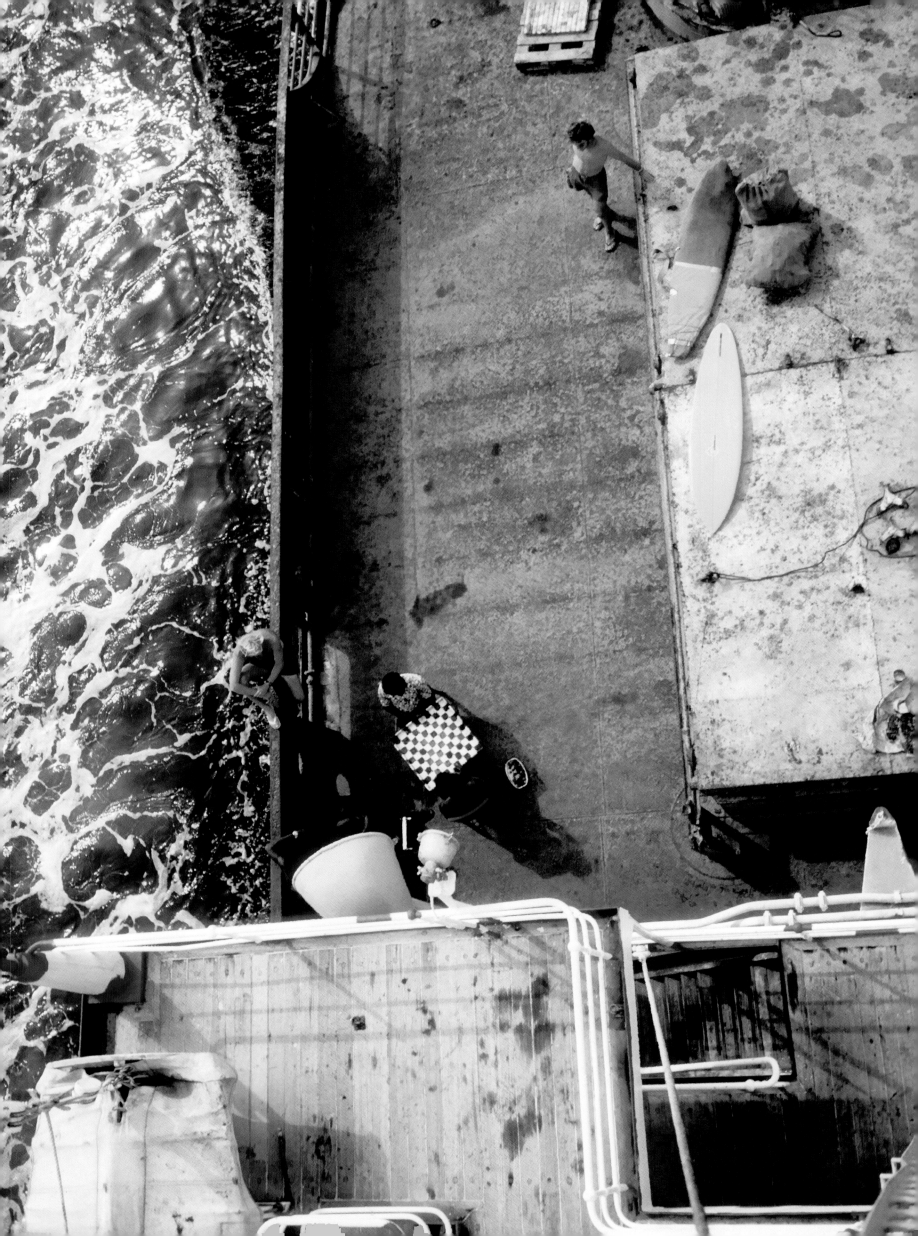

QUIKSILVER ADVERTISING SHOOT; NEWPORT BEACH, CALIFORNIA; CA. 1982
The Echo Beach surfers from affluent Newport Beach embraced a party-hard philosophy crossed with a New Wave aesthetic. Their Quiksilver slogan was "If you can't rock and roll, don't fuckin' come!" From left to right: Craig Brazda, Preston Murray, Tom Carroll, and Danny Kwock. *Photo, Jack McCoy*

MEN'S SURF TRUNKS *(Clockwise from top left)*
Quiksilver, c. 1981; Kanvas by Katin, c. 1978; Hang Ten, c. 1976; Surf Line Hawaii, c. 1972; Quiksilver, c. 1981; Reyn Spooner, c. 1974

MEN'S SHIRTS *(Clockwise from top left)* Malihini, c. 1974; c. 1984; c. 1978; Landmark, c. 1988; c. 1977; c. 1974

ADVERTISEMENT, O'NEILL, 1970 Indicative of the time by exploiting liberalized nudity, O'Neill sparked a minor storm of controversy with this ad, which was banned from some libraries, and raised sales of O'Neill wetsuits remarkably.

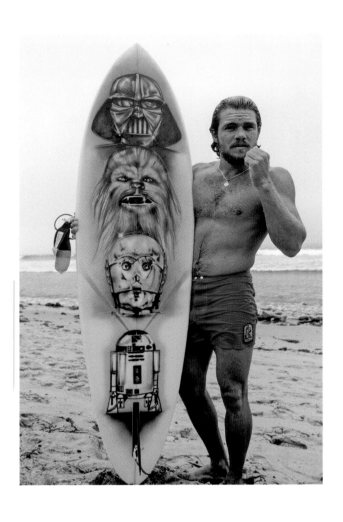

GREG MUNGALL, FLORIDA, 1979 Mungall of Cocoa Beach, Florida, specialized in small waves and a big, sometimes intimidating presence. *Photo, Jeff Divine*

DAVID NUUHIWA; SALT CREEK, CALIFORNIA; C. 1972 Born in Hawaii but raised in California, Nuuhiwa, left, combined rock-star glamour with an effortless-looking style. In the mid-'60s Nuuhiwa was considered one of the world's best young competitive surfers renowned for his long noserides. A few years later he transitioned easily into the shortboard era as a psychedelic soul surfer. *Photo, Jeff Divine*

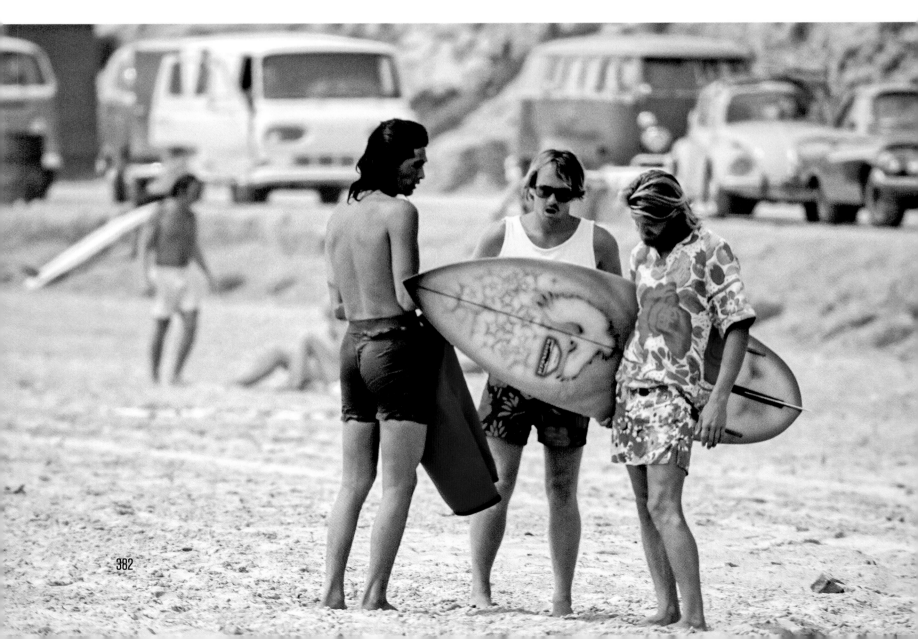

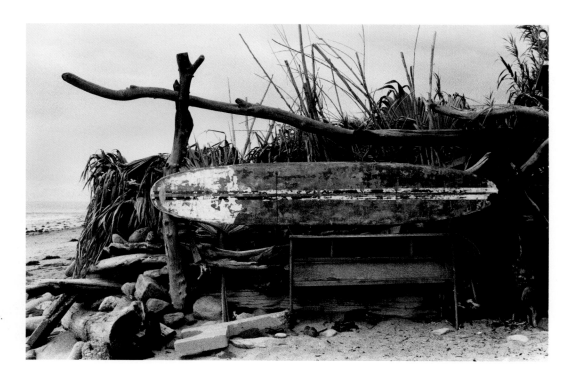

MIKE PURPUS; NORTH SHORE, HAWAII; C. 1976 Surfboard art has always been a reliable and sometimes dubious indicator of popular culture. *Photo, Dan Merkel*

TOPANGA BEACH, LOS ANGELES, 1977 *Photo, Anthony Friedkin*

TIMOTHY LEARY; SAN CLEMENTE, CALIFORNIA; 1977 LSD guru Leary appeared on the beaches of Southern California after years as an international fugitive. His odd relationship with the sport was solidified in a *SURFER* interview in which he declared that surfers were "evolutionary throw-aheads." *Photo, Art Brewer*

RICK GRIFFIN; SAN CLEMENTE, CALIFORNIA; 1976 *Photo, Art Brewer*

POSTER, *PACIFIC VIBRATIONS*, 1970
Rick Griffin's seminal poster was commissioned by John Severson for his epic film. *Art, Rick Griffin*

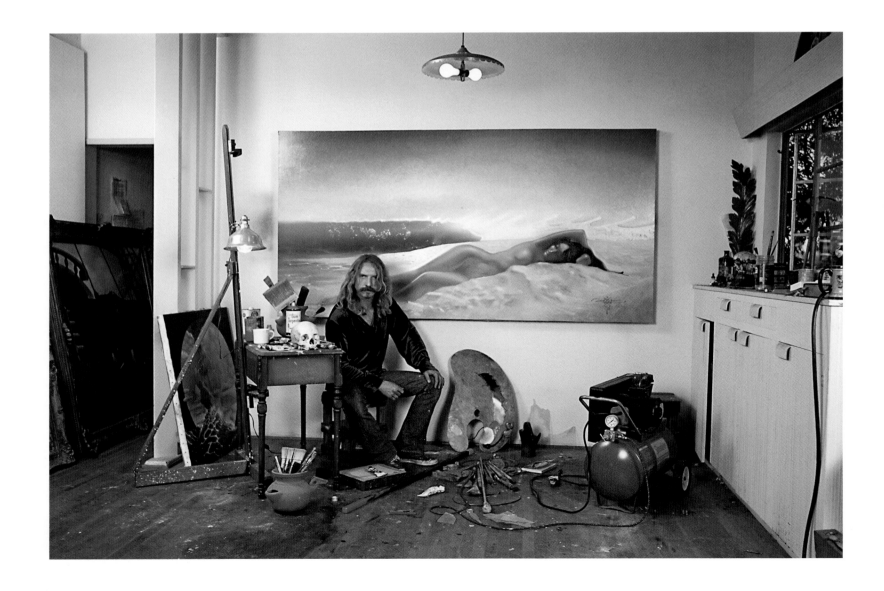

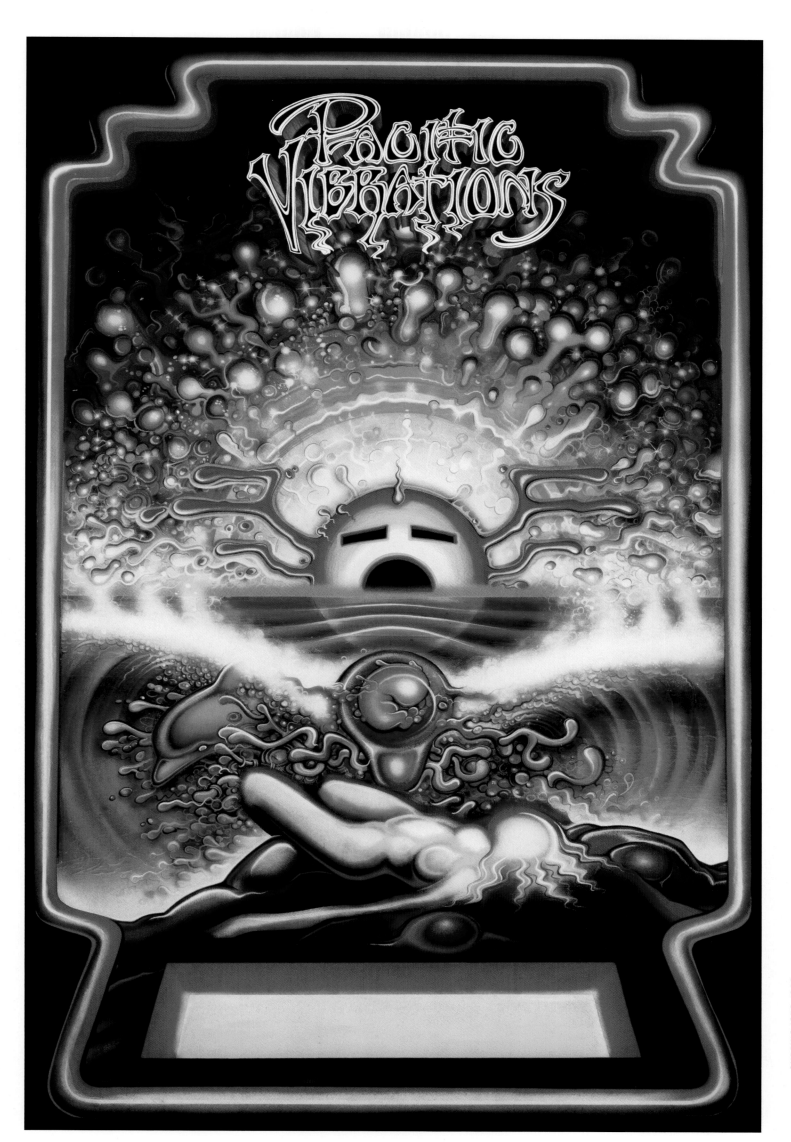

PIPELINE, HAWAII, 1979 *(Pages 388–389)*
Photo, Jeff Divine

ILLUSTRATION, 1983 Journalist Hunter S.
Thompson gave the gonzo treatment to Hawaii
and the surf scene in *The Curse of Lono. Art, Ralph
Steadman*

**ADVERTISEMENT, SUNSHINE SURF-
BOARDS, 1971** Appropriating underground
comic art coupled with a psychedelic vibe was a
popular way to sell to a "turned-on" generation of
surfers. *Art, Jim Evans*

**COMIC BOOK INTERIOR; "SALTY DOG
SAM GOES SURFIN'," *TALES FROM THE
TUBE*; 1971** Underground artist Robert Crumb's
ode to surfing in the comic book *Tales from the
Tube* addressed racism and environmental issues.
Art, Robert Crumb

PASKOWITZ FAMILY; SAN ONOFRE, CALIFORNIA; C. 1976 The two parents and nine kids of the Paskowitz family lived in a 26-foot camper, embodying surfing's gypsy soul. From left to right: Dorian, Juliette, Salvador, Joshua, Navah, Adam, Moses, Israel, Abraham, Jonathan, and David Paskowitz.

CARDIFF REEF; SAN DIEGO COUNTY, CALIFORNIA; 1981 Enthusiasts attempt to set the Guinness World Record for most surfers on a single wave. The current world record is 110 surfers on one wave, set in 2012 in Anglesea, Australia. *Photo, Jeff Divine*

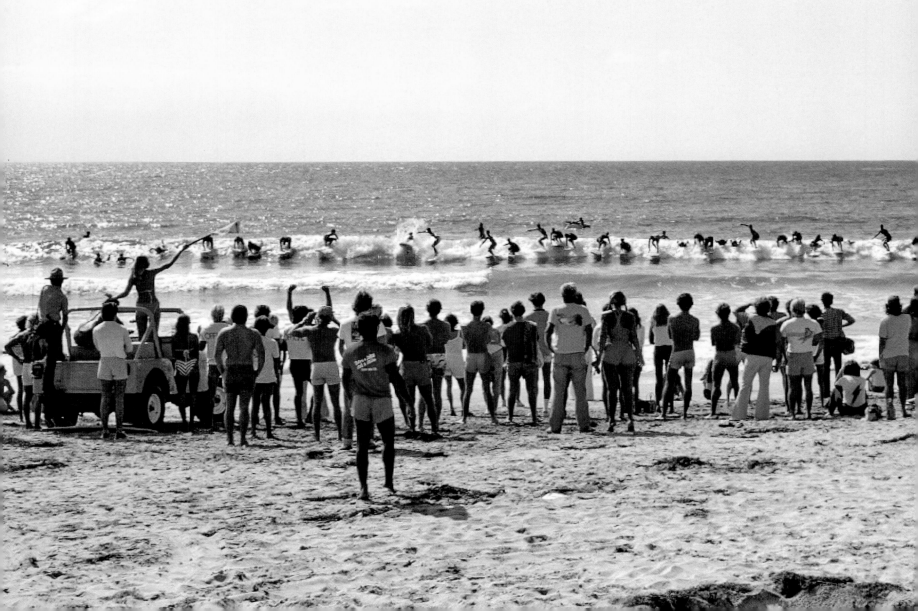

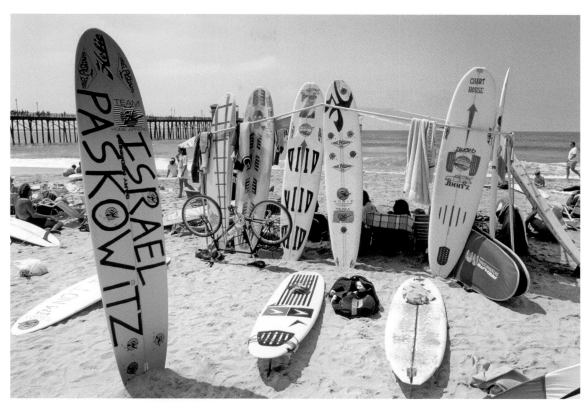

OCEANSIDE, CALIFORNIA, 1988 The Paskowitz family intuitively positioned their boards to block the morning sun at an impromptu beach encampment during a longboard competition. Israel "Izzy" Paskowitz identified his board to distinguish it from other clan members'. *Photo, Jeff Divine*

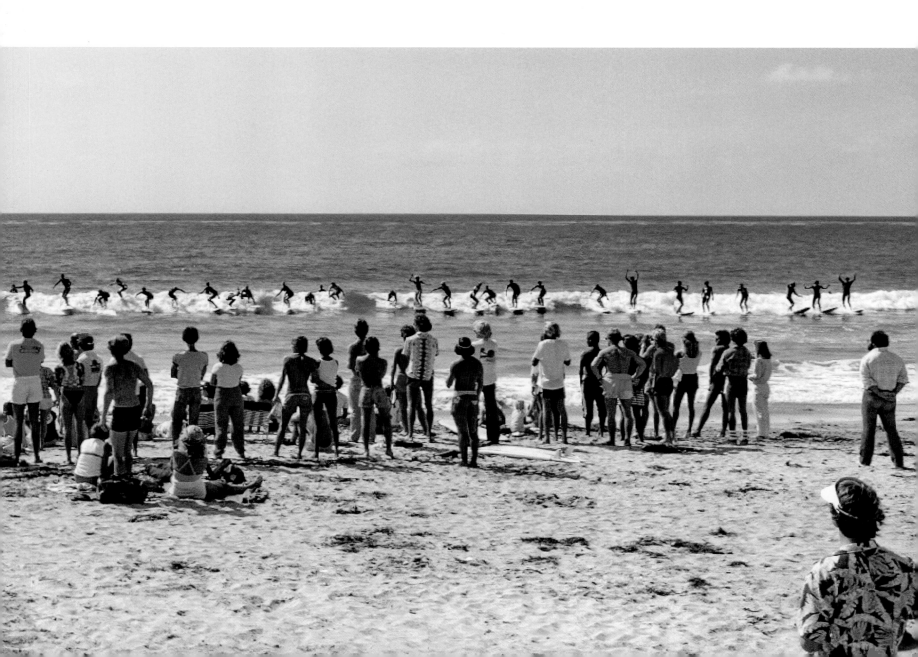

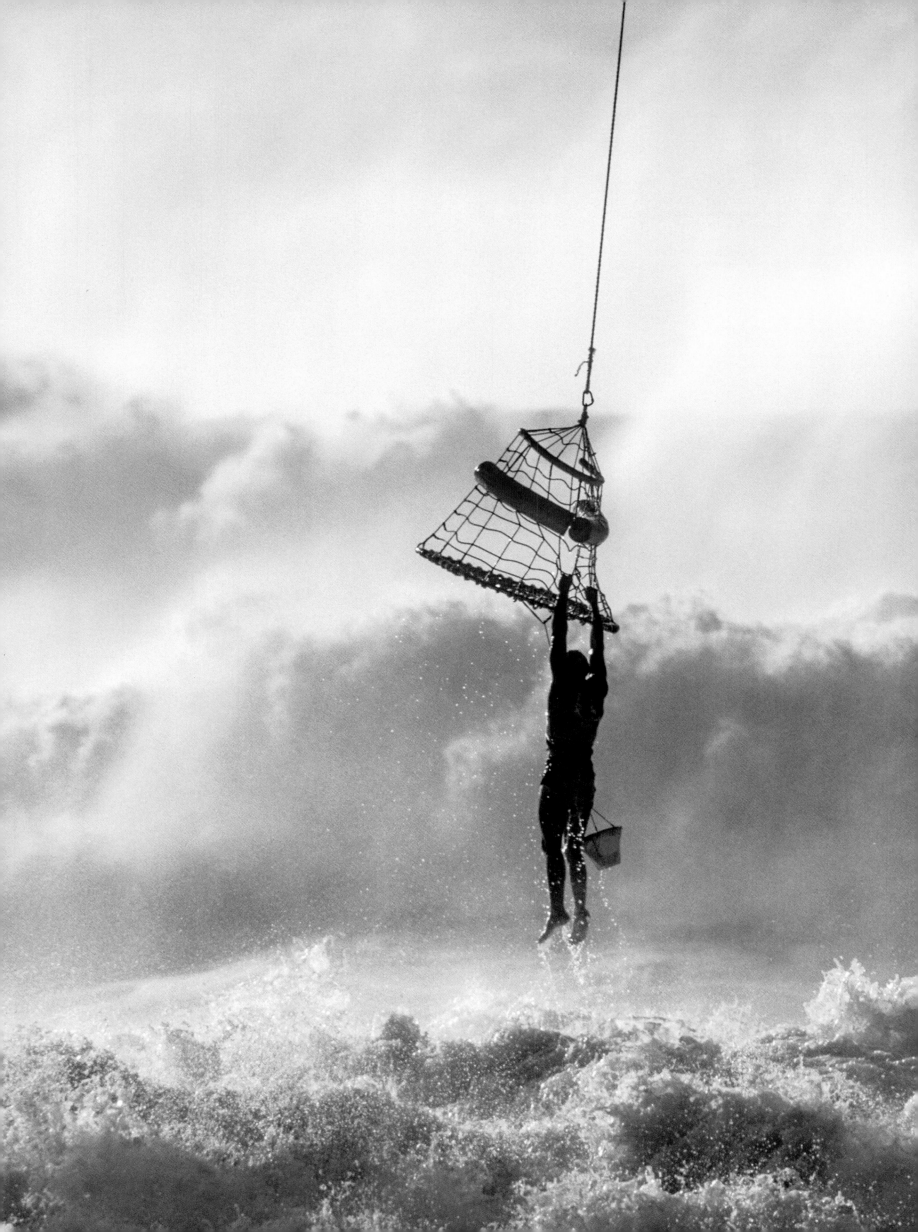

ALEC "ACE COOL" COOKE; WAIMEA BAY, HAWAII; 1985 Big-wave surfers Cooke, Mark Foo, James "Booby" Jones, and J. P. Patterson paddled out to Waimea on a huge swell later described by Foo as "the unridden realm." They got caught inside and were being swept out to sea when they were rescued by helicopter. *Photo, Darrell Jones*

GEORGE GREENOUGH, *BIG WEDNESDAY* SET, C. 1977 Greenough created special water housings to shoot amazing small- and big-wave 35mm surfing footage for the film. *Photo, Dan Merkel*

MARK LIDDELL AND CLINTON BLEARS; ALA MOANA, HAWAII; C. 1977 With more surfers in lineups competing for waves, critical conditions could lead to injury. Blears in the tube has priority, but he is being "burned" by Liddell in front. *Photo, Dan Merkel*

WAIMEA BAY, HAWAII, C. 1985 *(Pages 396–397) Photo, Jeff Divine*

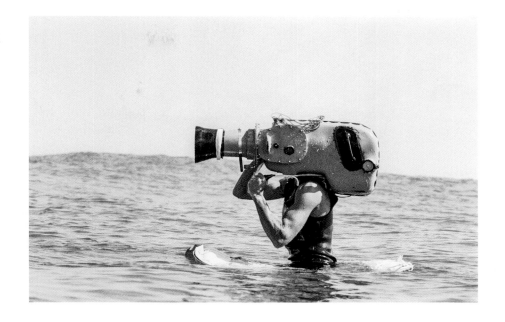

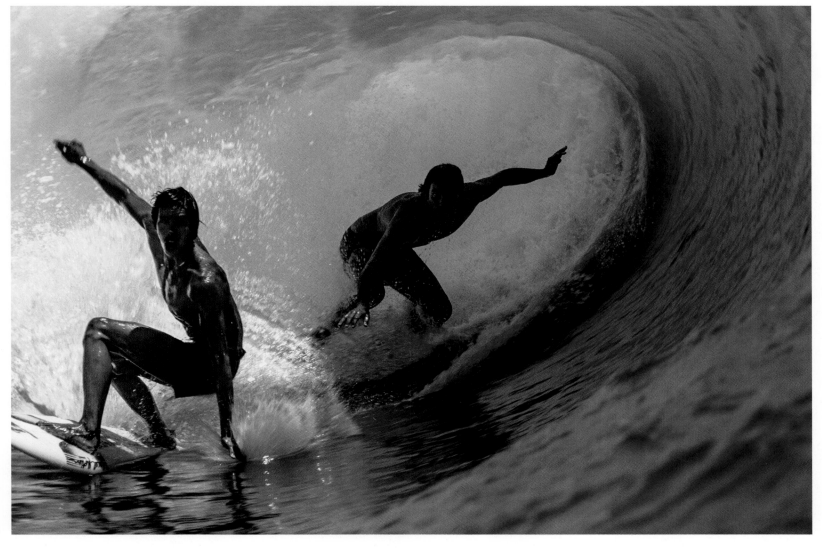

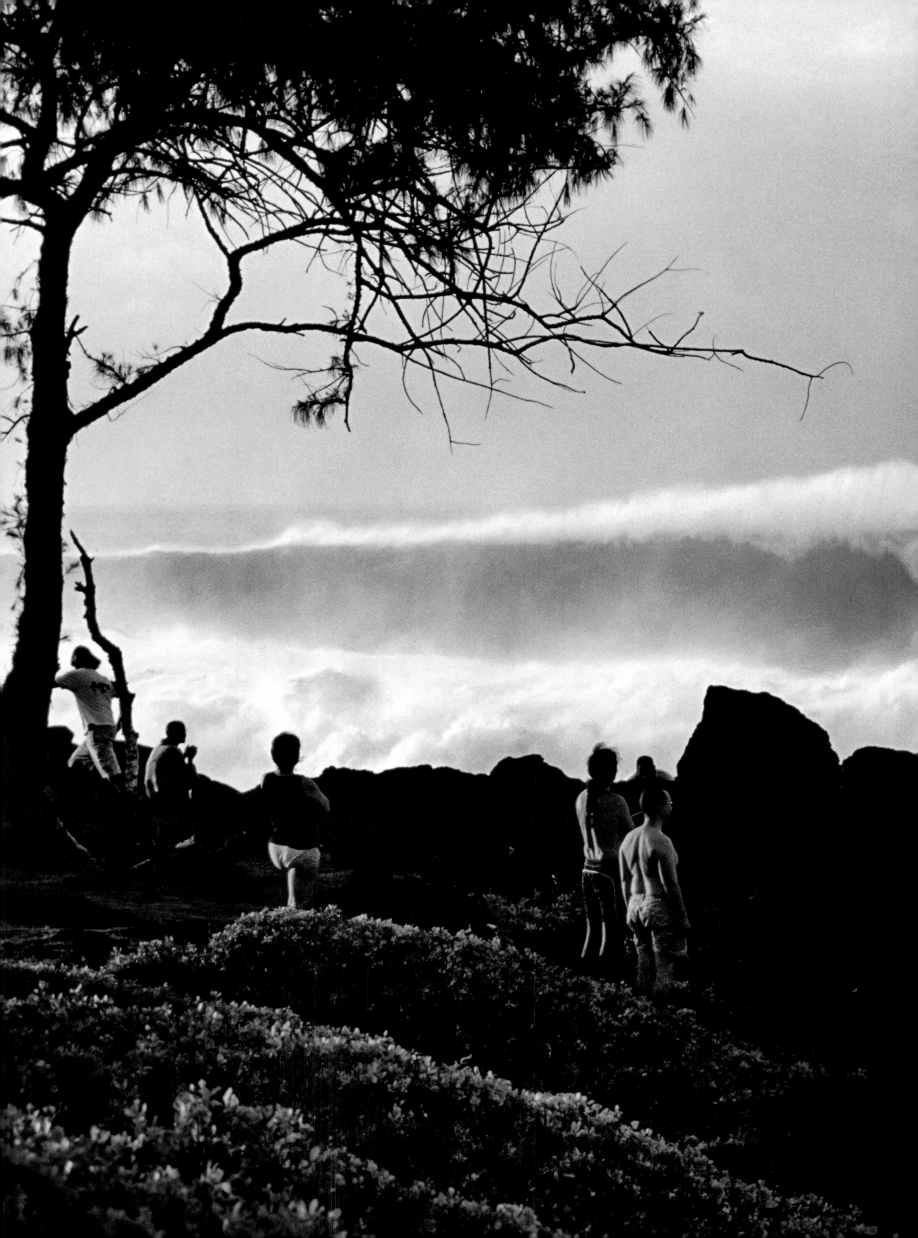

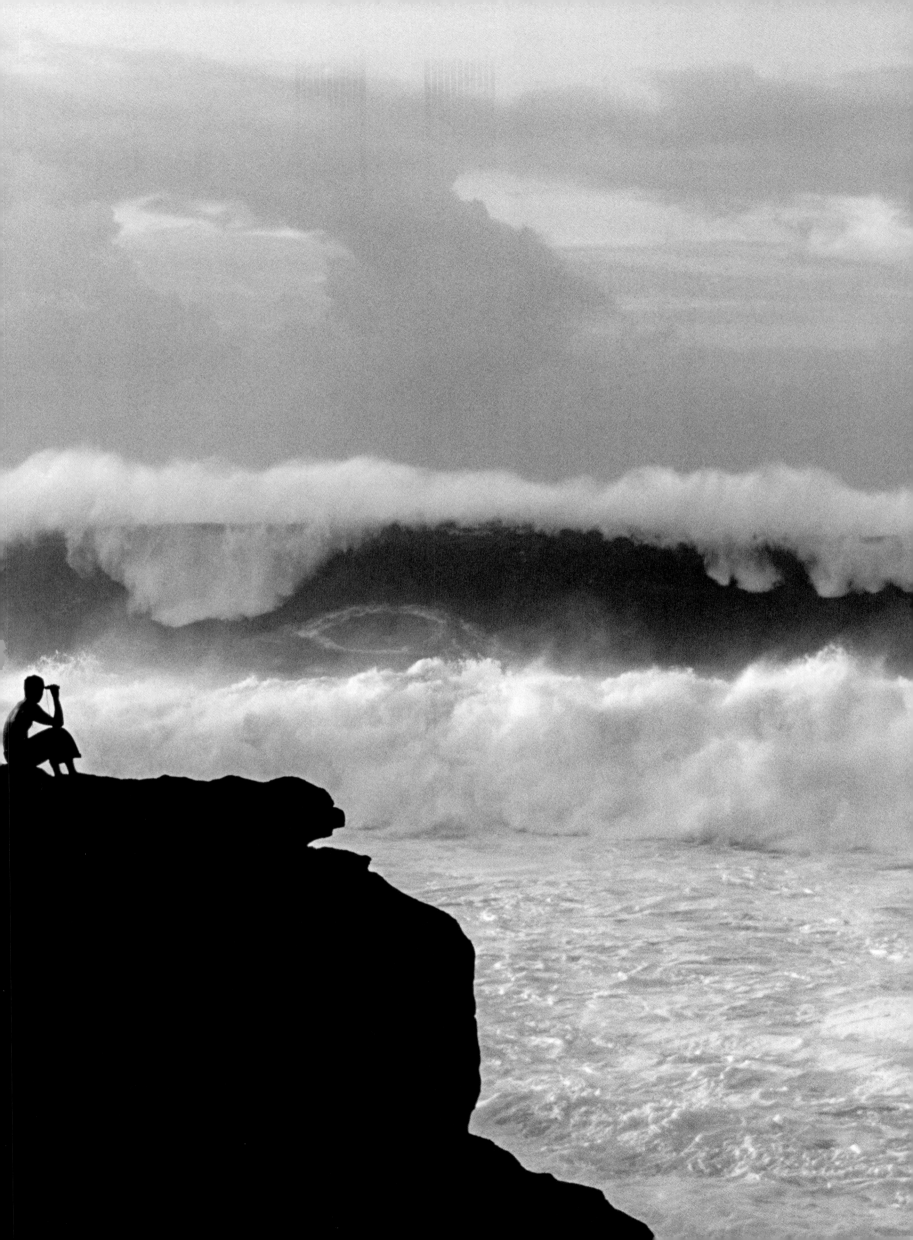

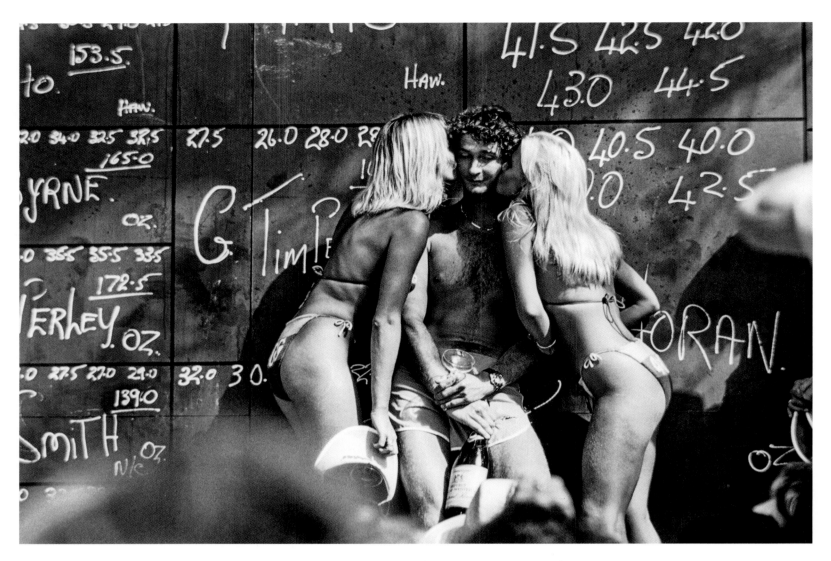

MARK RICHARDS; BURLEIGH HEADS, AUSTRALIA; 1981 After winning the 1981 Stubbies Surf Classic, Richards would go on to clinch two more back-to-back world championships. When asked what made him happy he replied, "sex and tube rides."

FILM STILL, *FAST TIMES AT RIDGEMONT HIGH*, 1982 As character Jeff Spicoli, played by Sean Penn, said, "All I need are some tasty waves, a cool buzz, and I'm fine."

POSTER, *FAST TIMES AT RIDGEMONT HIGH*, 1982 Though mostly a coming-of-age story about suburban Southern California teens, *Fast Times at Ridgemont High* featured Sean Penn's iconic portrayal of Jeff Spicoli as the prototypical stoner surf dude.

ADVERTISEMENT, 1985
Maui and Sons

NORTH SHORE, HAWAII, 1985
Photo, Jeff Divine

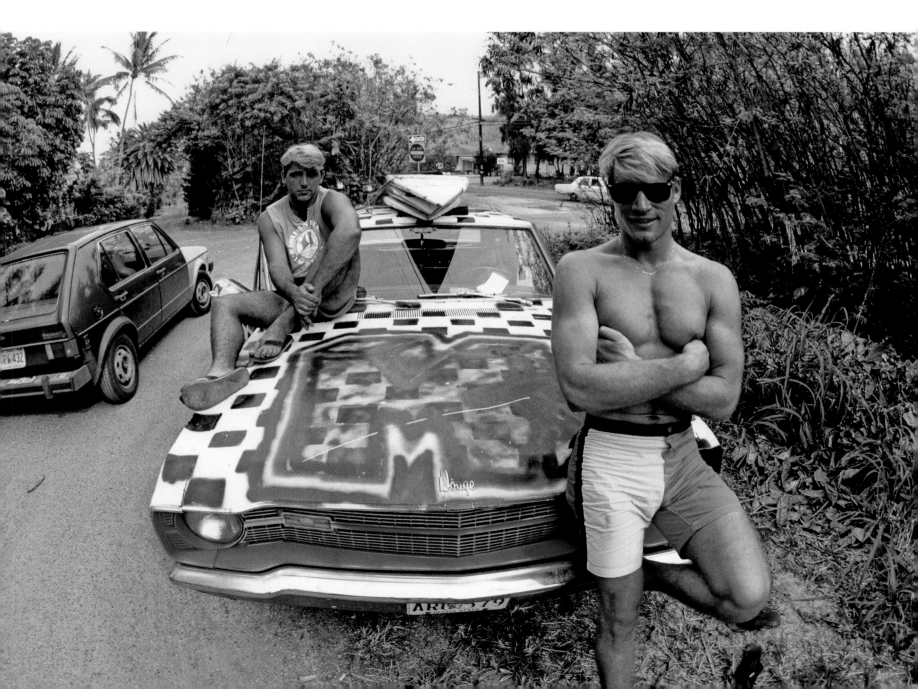

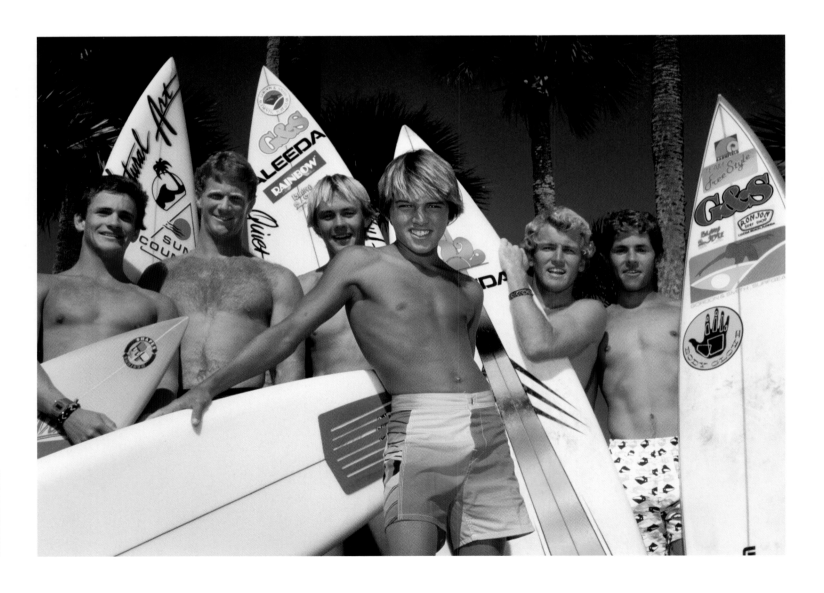

© Ocean Pacific 1986

Surfrider Foundation

LANCE CARSON, MALIBU, 1977 Carson was a master of Malibu and a surf star throughout the 1960s. He later cofounded the Surfrider Foundation with fellow surfers Glenn Hening and Tom Pratte in 1984. *Photo, Art Brewer*

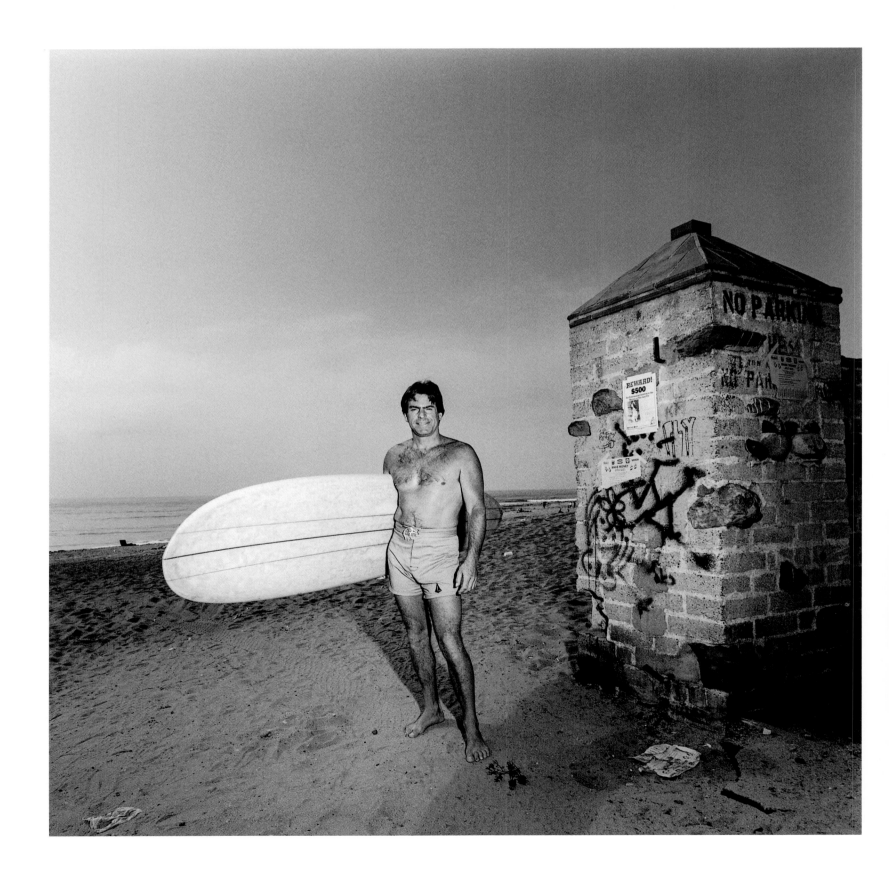

DECALS Astrodeck, Gotcha, ca. 1986

SURFER PROTEST; SAN ONOFRE, CALIFORNIA; C. 1985

SEAN ROSS; PIPELINE, HAWAII; 1977
(Pages 404–405) Surfing futurist Tom Morey created the "boogie board" in 1973 using a slab of refrigerator insulation carved with an electric turkey knife. By the mid-'80s there were millions of bodyboards in the waves, making it the most popular form of surfing in the world. *Photo, LeRoy Grannis*

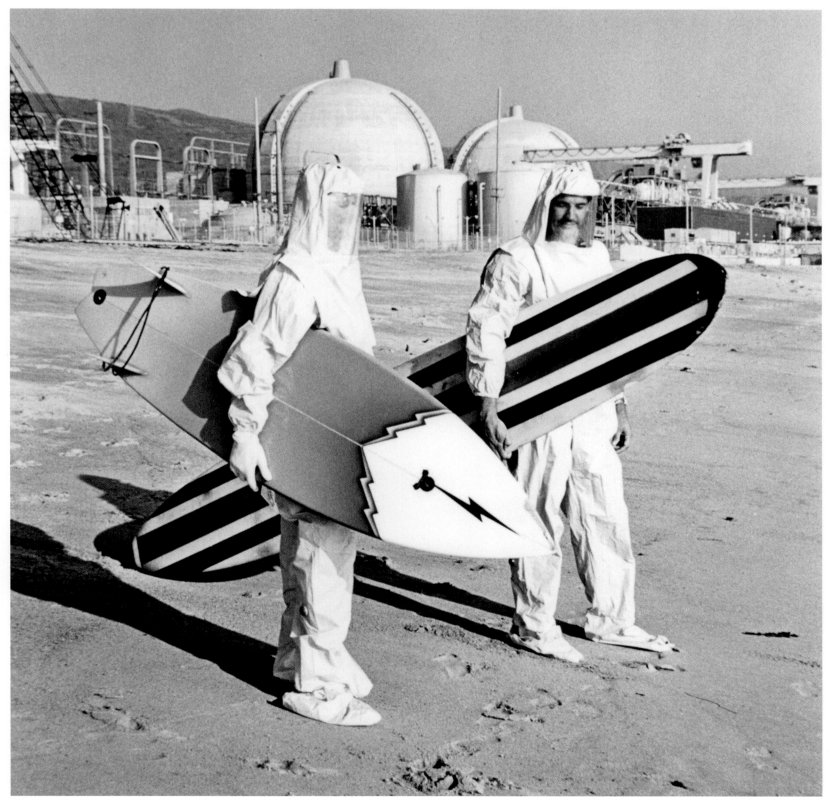

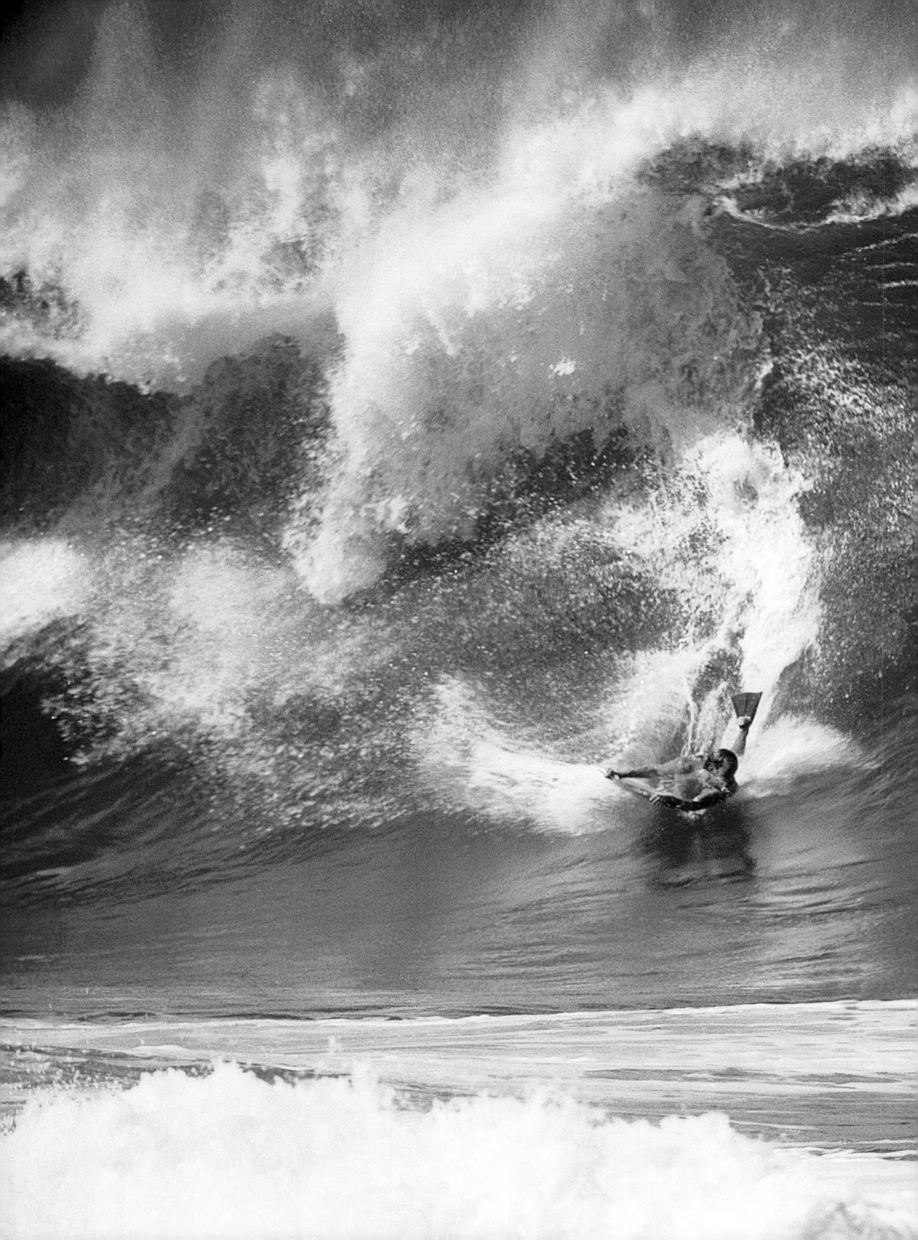

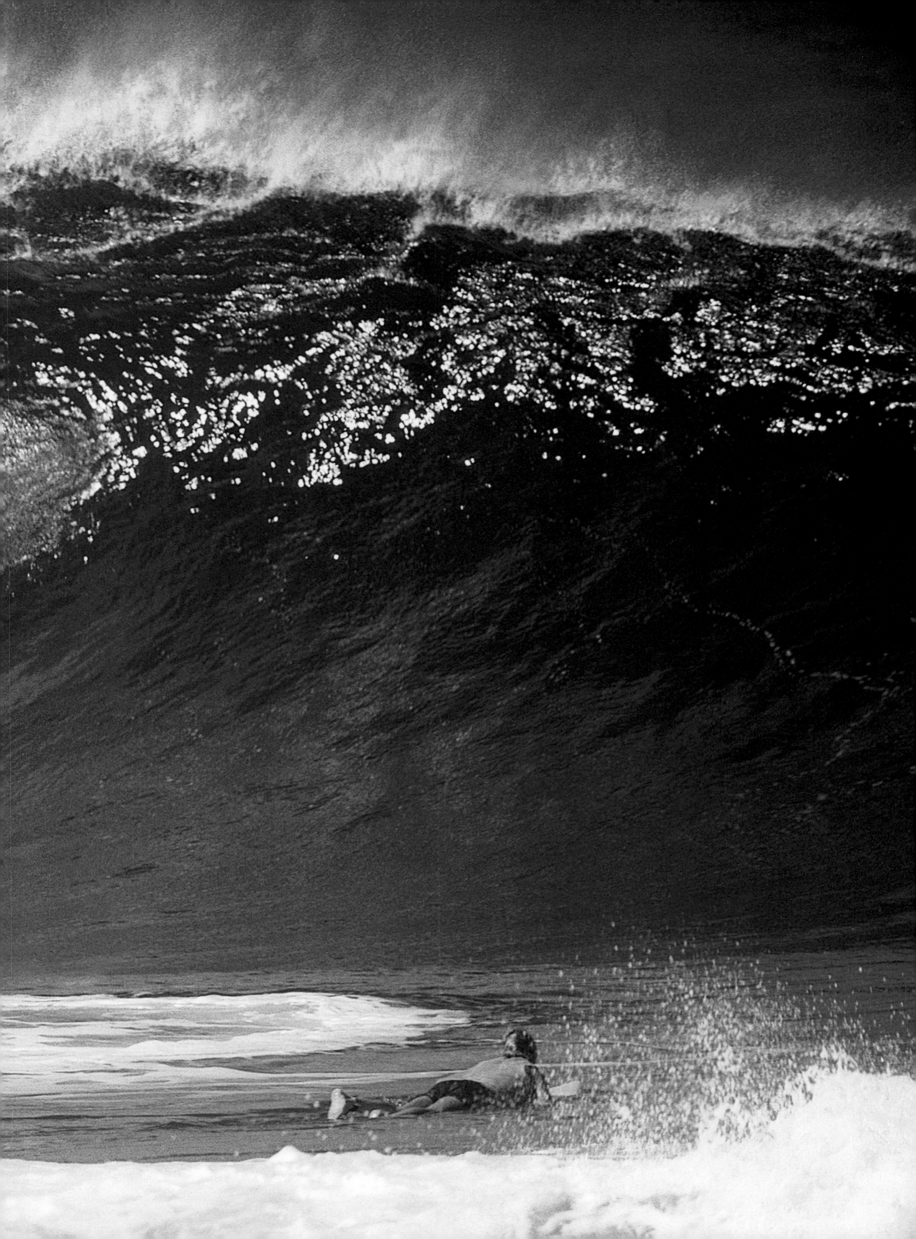

DANNY KWOCK; NEWPORT BEACH, CALIFORNIA; 1979 Hawaii-born Kwock moved to Newport Beach in the early 1970s and became a team rider for the newly formed Quiksilver in 1977. His flair for self-promotion and bright fashion was a perfect fit for the surf brand, and he eventually became vice president of the company. *Photo, Mike Moir*

NEWPORT BEACH, CALIFORNIA, 1979 Bright neon and 1,000-watt attitude, the boys of Echo Beach brought an edgy pop aesthetic to surfing. From left to right: Preston Murray, Jeff Parker, and Danny Kwock. *Photo, Mike Moir*

PIPELINE, HAWAII, C. 1982 Surfers scramble to either catch the wave or get out of the way. *Photo, Jeff Divine*

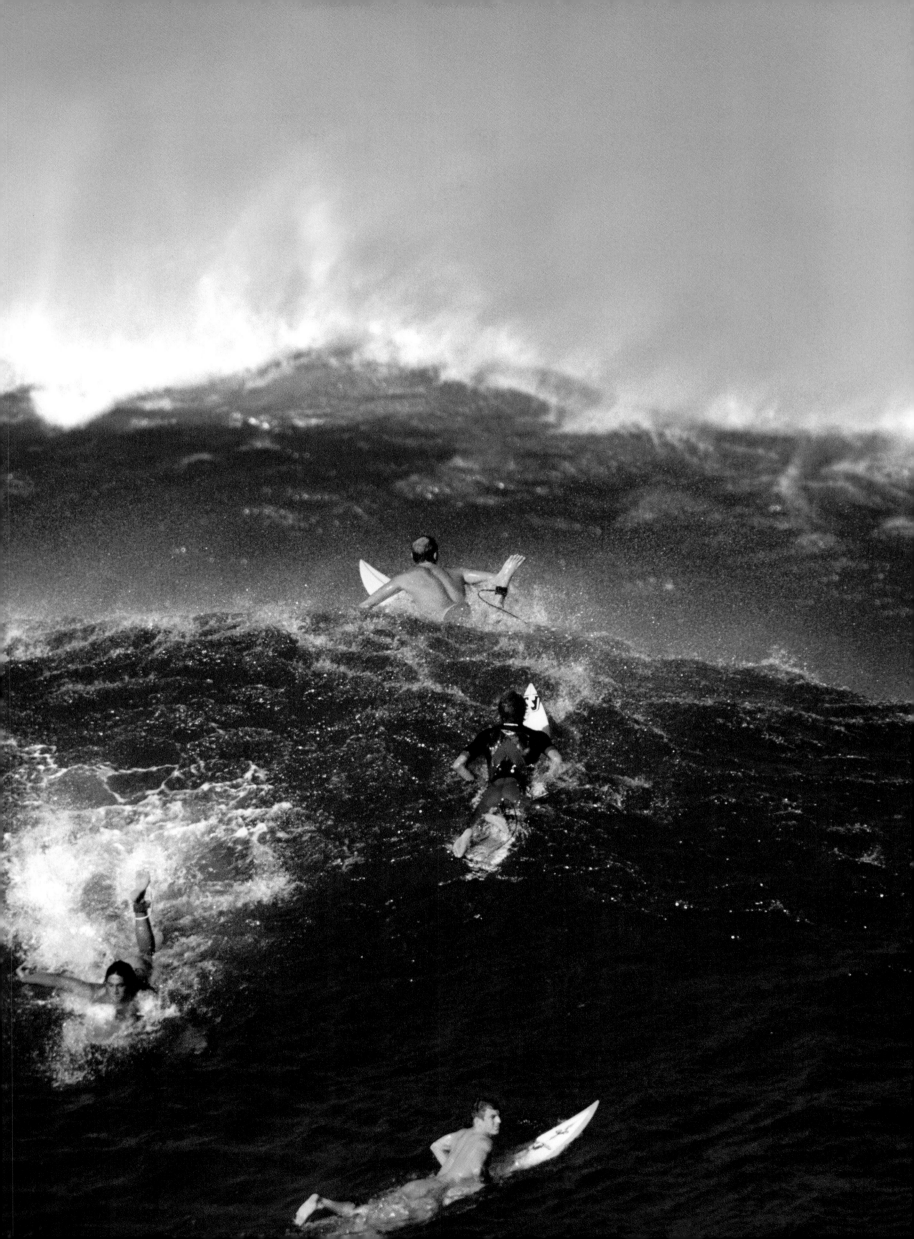

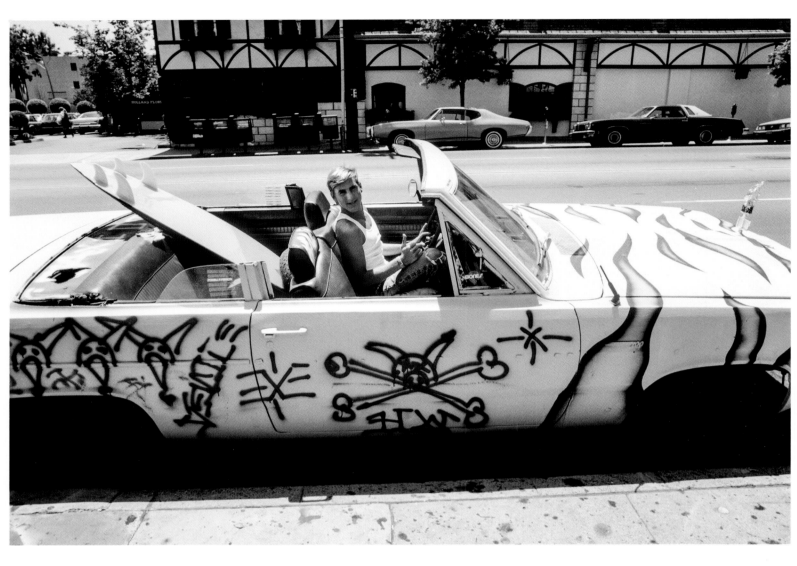

JOHN MCCLURE, LOS ANGELES, C. 1985
McClure shows off his surf vehicle tagged by Venice's Dogtown surfers. *Photo, Steve Sakamoto*

POSTER, *SURF NAZIS MUST DIE*, **1987**

ALBUM ART; *MY BEACH*, **SURF PUNKS;**
1980 While mostly a satirical act, the Surf Punks from Malibu reflected the growing aggressiveness and surf rage found on California's urban beaches, reflected in such song titles as "My Beach," "Punch Out at Malibu," and "Somebody Ripped My Stick." *Photo, Richard Upper*

OP PRO RIOT, HUNTINGTON BEACH, 1986
(Pages 410–411) During the finals of the 1986 Op Pro, a riot broke out when police attempted to arrest a handful of women who had flashed their breasts to the beer-soaked crowd. More than a hundred riot police were brought in and the beach erupted in flames and arrests, signaling the end of an era. *Photo, Mike Balzer*

408

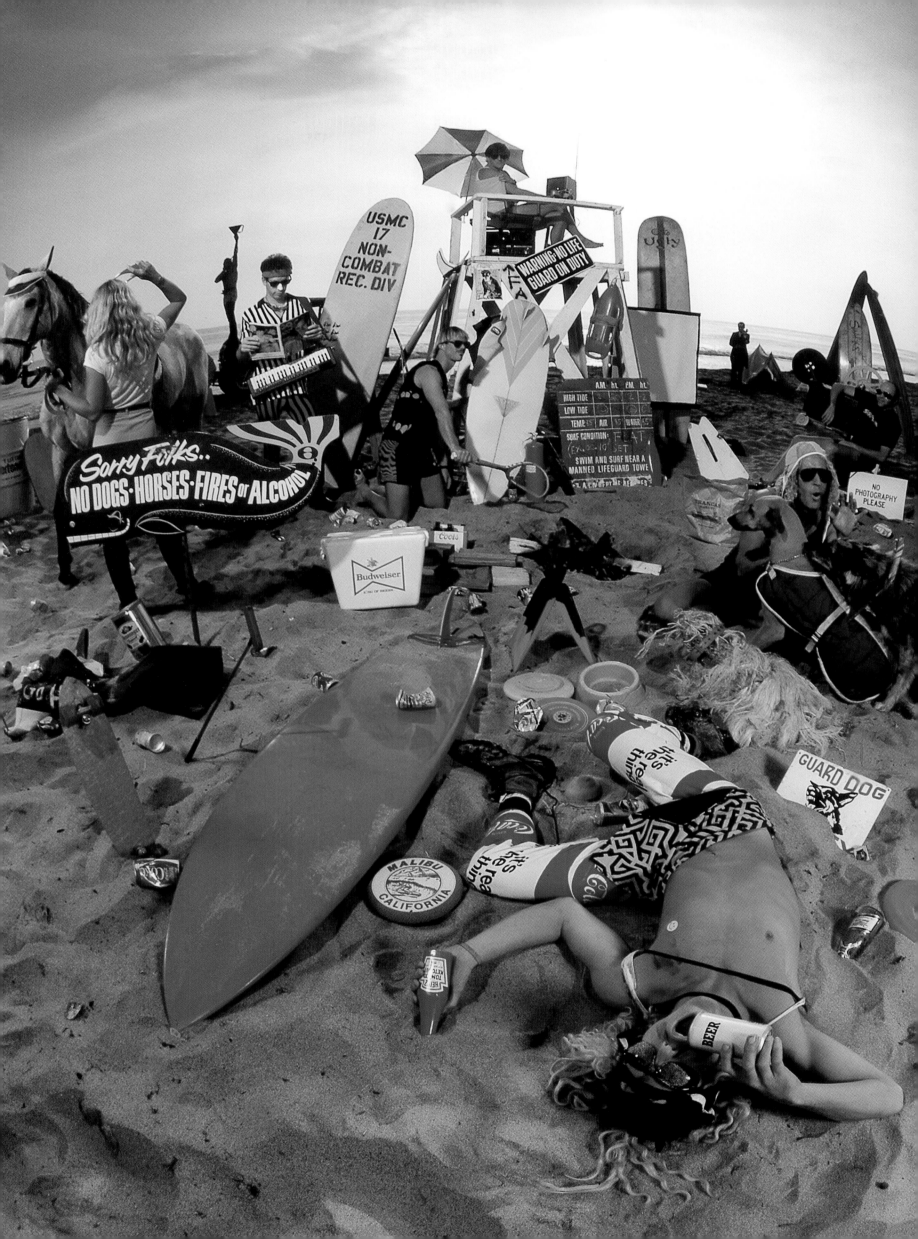

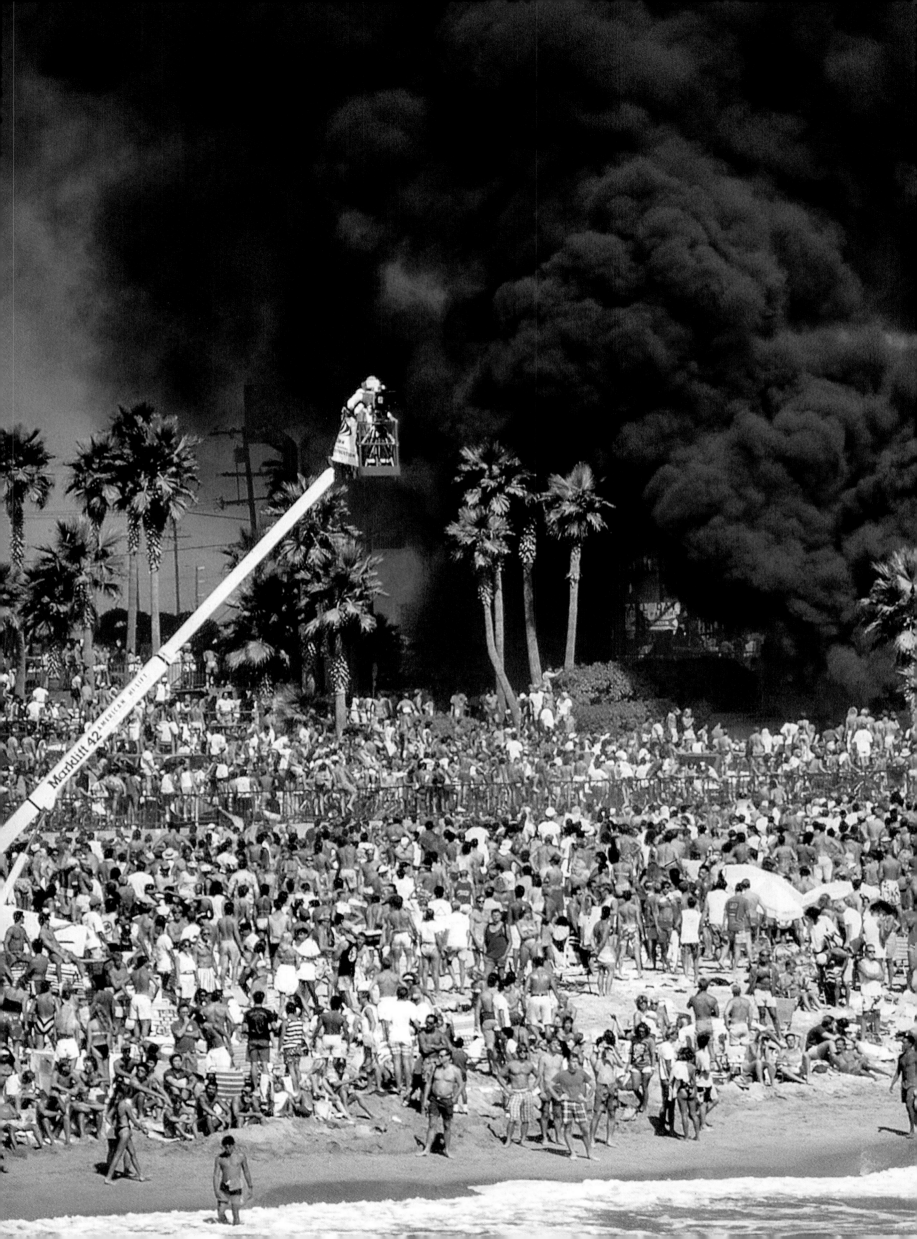

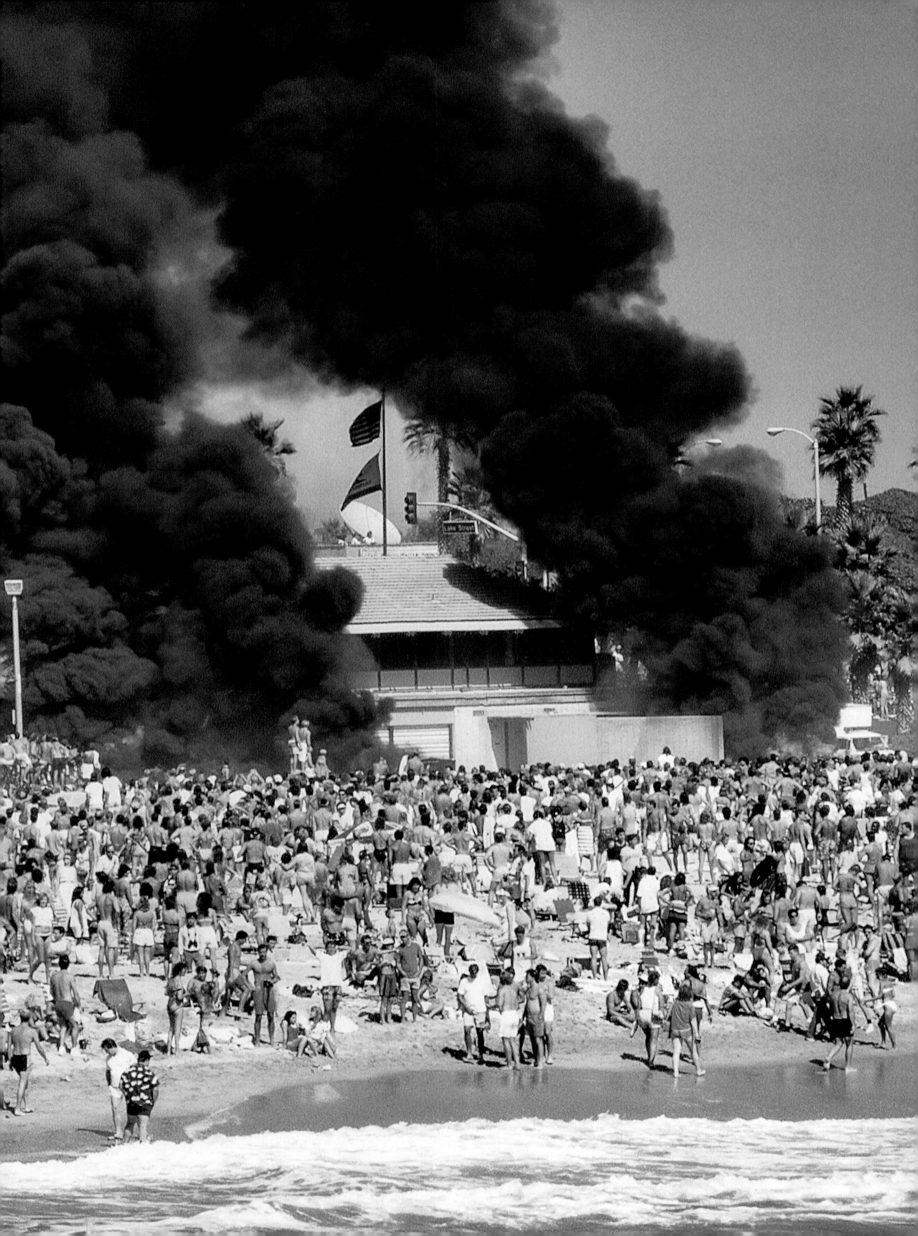

1987–TODAY
SURFING TAKES OFF

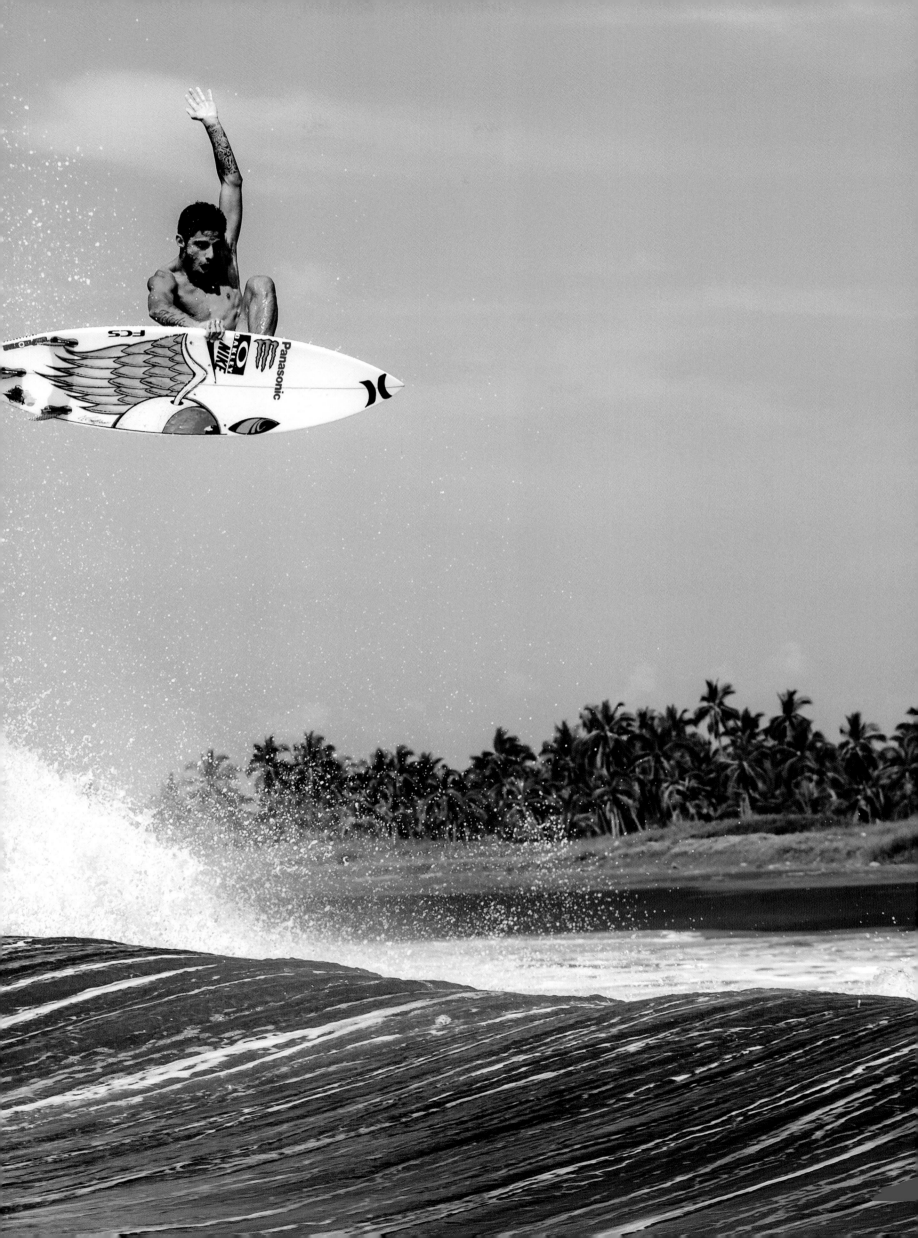

1987-TODAY
THE BOYS (AND GIRLS) OF SUMMER

BY PETER WESTWICK & PETER NEUSHUL

Starting in the 1980s, surfing underwent another wave of pop-culture revival, as the mainstream masses, primed by economic recovery, clamored for the lifestyle marketed by pro surfing and the growing surf industry. In 1985, *Rolling Stone* ran a photo spread titled "The Boys of Summer," featuring Madonna cavorting with "six hunky surfers." Surf-themed nightclubs opened in New York, the *The Village Voice* ran surfwear ads, and *Time* magazine and the *The Wall Street Journal* rushed to cover the new "surfing chic." *Time* estimated that Americans would spend $1 billion on surfwear in 1986, and Quiksilver brought surfing to Wall Street in a public stock offering. That summer surfing appeared poised, as *SURFING* magazine put it, to "take off like a rocket."

The Op Pro contest that summer at Huntington Beach had everything going for it. Thirty thousand spectators thronged the beach on Labor Day weekend, enjoying sunny skies and the best south swell of the summer. But as the finals hit the water, a crowd behind the contest grandstands turned ugly and a full-fledged riot broke out.

Drunken revelers overwhelmed police officers, burned several police and lifeguard vehicles, and drove off a police helicopter with a barrage of beer bottles; a lifeguard captain had to fire warning shots to keep rioters from storming the lifeguard headquarters. This did not exactly fit the public image of laid-back surfers, and the riot attracted sensational news coverage. As the smell of burning squad cars wafted across the beach, the future of pro surfing threatened to go up in smoke.

SELLING STOKE

The Op Pro riot symbolized broader issues for pro surfing. Contest promoters wanted spectacle: grandstands, TV cameras, and big crowds on the beach. But that meant contests had to be held near cities and on well-defined dates—which often meant lousy waves. In 1984, tour officials at the Wave Wizards Challenge in Florida hired a large powerboat to motor up and down the coast so that contestants could at least surf the boat wake. Four-time world champ Mark Richards took one look at the flat ocean and said, "Take me to the airport."

Small-wave follies and the hangover from the Op Pro riot fed a general disillusion-ment among pro surfers. Only a handful of surfers at the top of the tour were making six figures; most were barely covering their travel costs. The travel grind of a sponsor-driven 20-event, five-continent, eight-month tour sucked the joy out of the sport as surfers realized that making surfing into a profession meant no longer just surfing whenever and wherever they wanted.

Pro surfing continued to clash with the romantic belief that surfing was about more than making money—it was an idealistic, even spiritual pursuit. How, then, did the best surfer in the world end up as an actor on television's *Baywatch*, wrestling an octopus in a cave? Hollywood had continued to tap surfing as a pop-culture touchstone since the *Beach Blanket Bingo/Gidget* days, with surfers usually cast as one of two types: surf bum or spiritual guru. The apotheosis of the first was Sean Penn's brilliant turn as surfer-stoner Jeff Spicoli—

FILIPE TOLEDO; MEXICO; 2015
(Pages 412–413) As part of the pro tour contingent known as "The Brazilian Storm," the diminutive but brilliantly talented Toledo is predicted by many to be the next Brazilian world champ. *Photo, Jason Kenworthy*

PALM BEACH, FLORIDA, 1995 *(Page 414)*
Photo, Bruce Weber

VINCENT "SUNNY" GARCIA, OP PRO; HUNTINGTON BEACH, CALIFORNIA; 1987
The annual Huntington contest was generally held in hot weather and poor conditions but drew a huge beach crowd. Surf journalist Nick Carroll wrote that for the contestants the options were "suffer, or win." *Photo, Jeff Divine*

"all I need are some tasty waves and a cool buzz and I'm fine"—in 1982's *Fast Times at Ridgemont High*. For the second, there was 1991's *Point Break*, featuring Patrick Swayze as a surfer whose name, Bodhi, unsubtly suggested his mysto soulfulness.

Kelly Slater's role on *Baywatch* represented the return of the clean-cut heartthrob, the wholesome middle-class jock—in other words, the renewed triumph of *Gidget*'s Moondoggie over Kahuna. *Baywatch* first aired in 1989 and quickly became the world's most popular TV show, once again conveying California's beach lifestyle to landlocked masses on several continents. Slater joined the cast in 1992 as Jimmy Slade, a surfer from Malibu High, and appeared in 10 episodes, including the regrettable octopus cave match.

Slater had turned pro at 18 in 1990, his gymnastic mix of aerial acrobatics and tailsliding cutbacks soon becoming known as New School surfing. He won his first pro contest and signed an exclusive six-figure deal with Quiksilver that ballooned to a million a year after the first three of his unprecedented 11 world titles. Quiksilver could afford it; its sales had tripled in the late 1980s, approaching $100 million, largely by following Hang Ten's formula: selling T-shirts and shorts through department stores to teenagers who never set foot on a beach. Quiksilver and other firms like Ocean Pacific, Billabong, and Gotcha added armies of accountants and lawyers who talked less of waves and more of dividends, shareholder value, and quarterly goals. As business suits replaced board shorts in the offices of surfwear firms, some surfers wondered whether the industry was losing touch with its roots.

Popular interest in surfing continued to swell into the new millennium. "Alternative," "extreme" sports began supplanting traditional sports, led by two surfing spinoffs, skateboarding and snowboarding, that fed the ESPN X Games juggernaut. Surf firms began selling snow and skate gear, and surfers embraced aerial tricks popularized by their skate/snowboard brethren. By 2005, Quiksilver was grossing $2 billion annually, and surfwear executives joined the multimillionaire jet set. Some of this money found its way into the pro tour and individual surfers. Even amid the ensuing recession, some contests were

JOEL PARKINSON AND MICHEL BOUREZ, SUPERTUBOS; PENICHE, PORTUGAL; 2011 Although surfing on Europe's Atlantic coast dates back to the late 1950s, it was virgin territory until the early '70s. Now there are thousands of local wave-riders as well as the summer-long "European leg" of the professional world tour. *Photo, Peter "Joli" Wilson*

KELLY SLATER AND PAMELA ANDERSON, C. 1996 Slater's *Baywatch* TV role garnered mostly negative reviews by fellow surfers who resented his "going to the other side." *Photo, Marc Kozai*

417

awarding six-figure checks to winners, and top surfers were making a million dollars a year, seeming to validate the vision of the Free Ride generation.

Some of this money came from a graying demographic, the baby boomers who took up surfing as teenagers and now were decades older with disposable income to burn. Boomers helped fuel the longboard revival as well as a growing memorabilia market, where vintage surfboards fetched tens of thousands of dollars. Much more money, however, flowed into the surf industry from youth. With sponsors paying school-aged kids six-figure salaries for riding waves, children became "pro surfers," and the surf industry joined the general commodification of childhood. Such early investments were justified by the occasional success story, such as that of Hawaiian John John Florence, born in October 1992, who competed in pro contests on the North Shore at age 13, and by 20 was recognized as one of the best in the world.

Far more numerous, however, were the starry-eyed youngsters who made money in the short run but soon found themselves cast aside for the next hot crop, meanwhile having skipped college and other possible routes to a real-world career. There were even more spectacular flameouts, can't-miss kids who signed with sponsors in their midteens and quickly went out in a blaze of drugs and partying. The opposite danger was that kids would succeed as pro surfers, but still hurt surfing in the long run by becoming contest clones. The very source of surfing's mass-market appeal was its countercultural, nonconformist image. How could young surfers rebel against authority with corporate minders overseeing their careers? In 2010, Kolohe Andino, a 16-year-old hotshot, signed sponsorship deals with Target, Nike, and Red Bull; his friends mocked him with the nickname "Corporate."

Surfing's countercultural credibility claimed steeper casualties. In November 2010, Andy Irons, who was headed home to Hawaii, died alone in a Dallas airport hotel room while on a layover. Irons, a three-time world champ, was one of the few of his generation to challenge Slater. Journalists eventually connected the tragedy to his well-known partying streak, including drug abuse, which apparently exacerbated an undetected heart condition. Irons's lifestyle was not an isolated example. Recreational drugs pervaded pro surfing (in 2013, former world champion Tom Carroll spoke publicly about his longstanding addiction to methamphetamine), but the surf media and industry had studiously ignored the problem. As with Michael Peterson and Jeff Hakman, two top surfers in the 1970s with heroin addictions, surfing distinguished itself for its apparent tolerance of drugs. What other sport

STEAMER LANE; SANTA CRUZ, CALIFORNIA; 1988 The rise of professional surfing in 1980s meant more beaches were closed off to recreational surfers during prime swell days. *Photo, Jeff Divine*

ADVERTISEMENT, SURFRIDER FOUNDATION, 1990 Advocacy by surfers accompanied the deplorable conditions of a late 20th-century environmental debasement of California's coastline.

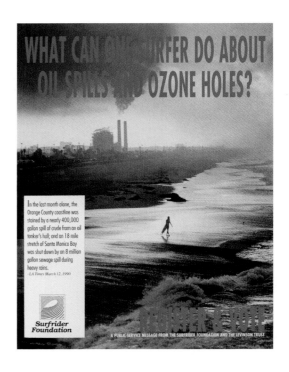

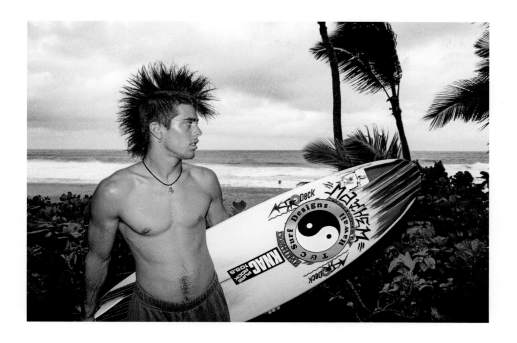

CHRISTIAN FLETCHER, C. 1988 Fletcher, grandson of Walter Hoffman and eldest son of '70s legend Herbie Fletcher, became a professional "anti-pro" surfer renowned for his revolutionary aerial style and punk attitude. *Photo, Tom Servais*

FLETCHER FAMILY; SAN CLEMENTE, CALIFORNIA; 1992 Colorful, outrageous, and brutally honest, the Fletchers became "First Family of Surfing" through sheer talent and self-promotion. From left to right: Christian, Herbie, Nathan, and Dibi Fletcher. *Photo, Art Brewer*

CHRISTIAN FLETCHER, 1982 *(Pages 420–421)* Fletcher's "aerial attack" defined his radical approach to surfing and life. *Photo, Erich Schlegel*

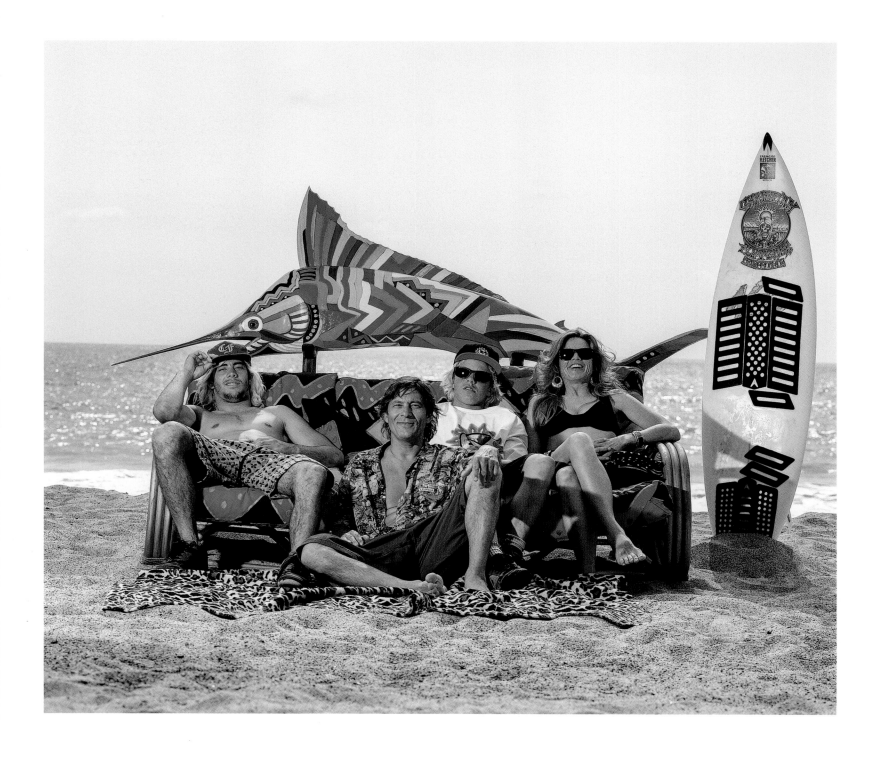

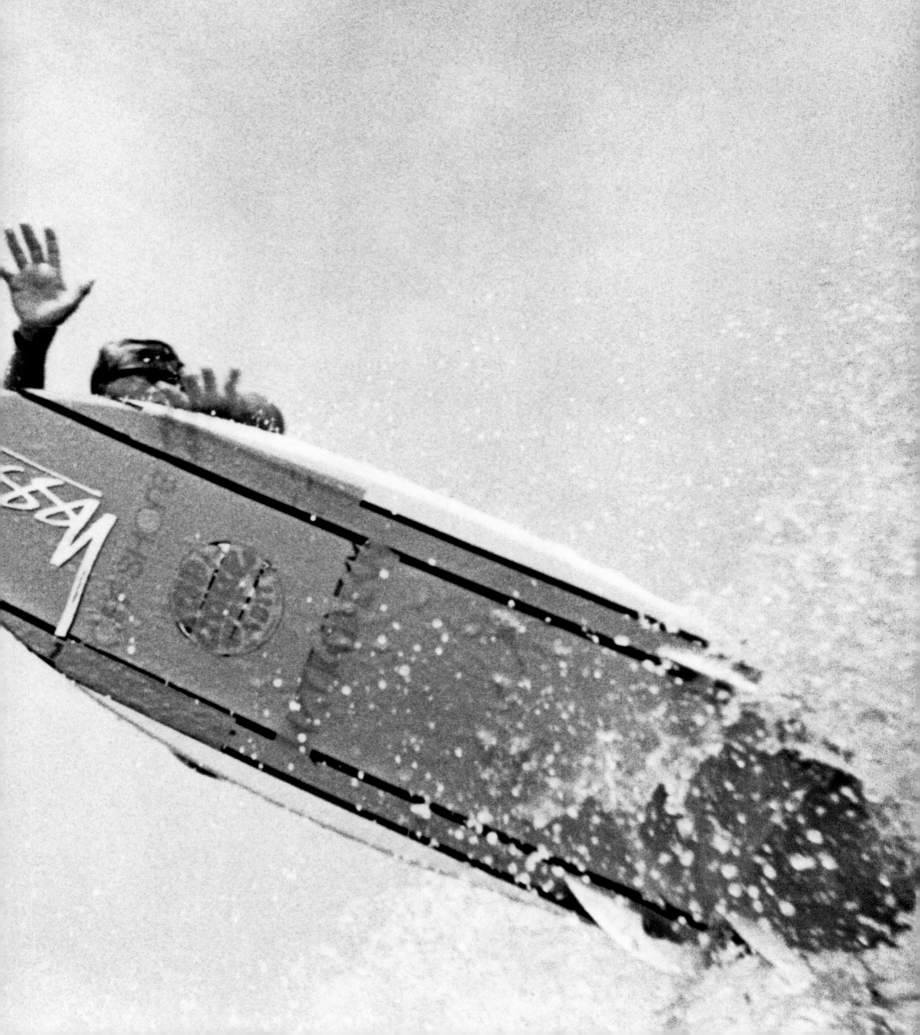

MY ROAD HOMEWARDS LAY THROUGH
WAIMEA BAY

DRAWING, *NO TITLE (MY ROAD HOME-WARDS)*, 1995 Surf art, long influenced by cartoons and comics, was rebooted in the 1980s by artists such as Raymond Pettibon, who had a sophisticated style and point of view. *Art, Raymond Pettibon*

DRAWING, *NO TITLE (JACOBS SURF TEAM)*, 1985 Raymond Pettibon grew up in Hermosa Beach, California, thoroughly immersed in the Southern California surf and skate scene. He gained fame for his album and poster work for such bands as Black Flag and Sonic Youth. *Art, Raymond Pettibon*

GERRY LOPEZ AND DAVID KALAMA; PEAHI, HAWAII; 1996 *(Pages 424–425)* Kalama pulls Lopez at the popular big-wave surf destination Jaws. *Photo, Erik Aeder*

KATIN PRO-AM TEAM CHALLENGE; HUNTINGTON BEACH, CALIFORNIA; 1986 *(Page 426) Photo, Bruce Weber*

stood by while its best athletes spiraled into drug abuse? The pro tour finally announced in 2012 that it would begin drug testing. Irons's death was a tragic reminder of the costs of pro surfing, lost amid the general celebration of the fact that young men were getting paid to ride good waves all over the world. It also highlighted the tension between maintaining surfing's countercultural image and chasing the commercial mainstream.

THE SPORT OF QUEENS

Another source of surfing's growth in this period came from the other half of the global population: women. When the movie *Blue Crush* came out during the summer of 2002, featuring pro surfers like Hawaii's supremely confident big-wave charger Keala Kennelly, a new generation of young girls flocked from theaters to the beach in search of waves. Women's surfing grew exponentially during the 1990s and onwards. The main impetus was Title IX, a federal law passed in 1972 that mandated equal opportunity for women to participate in federally funded education programs, including intercollegiate sports. Title IX caused a surge in the number of female athletes: from 300,000 high school athletes to over two million by 1980, what *Time* magazine called a "revolution" in sports. And the legislation's impact was reflected in the results of the 2012 Olympics, with the U.S. women's medal count exceeding that of the men's for the first time. Title IX programs and scholarships created millions of female athletes capable of paddling out at local breaks.

Title IX helped the number of women surfers rise from 5 to 8 percent of all surfers to 15 to 20 percent a decade later. Lisa Andersen, who came out of Florida with a remarkable combination of athleticism and surfing skill, emerged as the standard-bearer of the movement. In 1996, Andersen became the first woman to appear on the cover of *SURFER* in 15 years, with a caption challenging the men: "Lisa Andersen surfs better than you." Andersen's meteoric career helped fuel Quiksilver's Roxy brand, based on surf trunks tailored for women.

Andersen's rise brought more attention to women's surfing, but the women's side of the pro tour remained in a sort of purgatory. The women's 1987 champion made less than the number 16 men's finisher, and even after Andersen it continued to lag behind the men. Some contests offered women half the prize money given to the men, and women's

POLAROID, BLIND GIRL SURF CLUB, MONTAUK, 2002 The Blind Girl Surf Club was a collaboration that emerged from the 40-plus-year friendship between surfer artists Herbie Fletcher and Julian Schnabel. *Photo, Julian Schnabel*

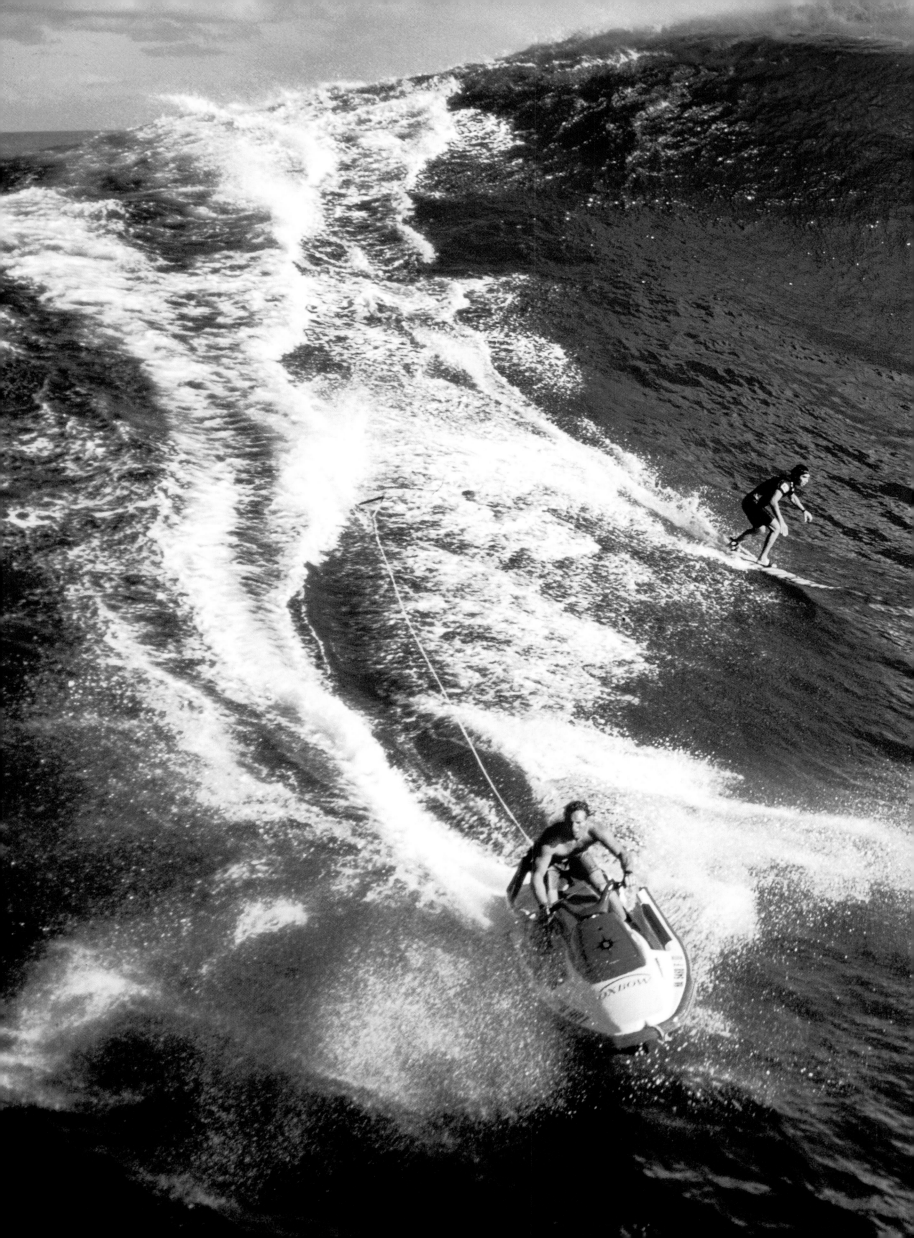

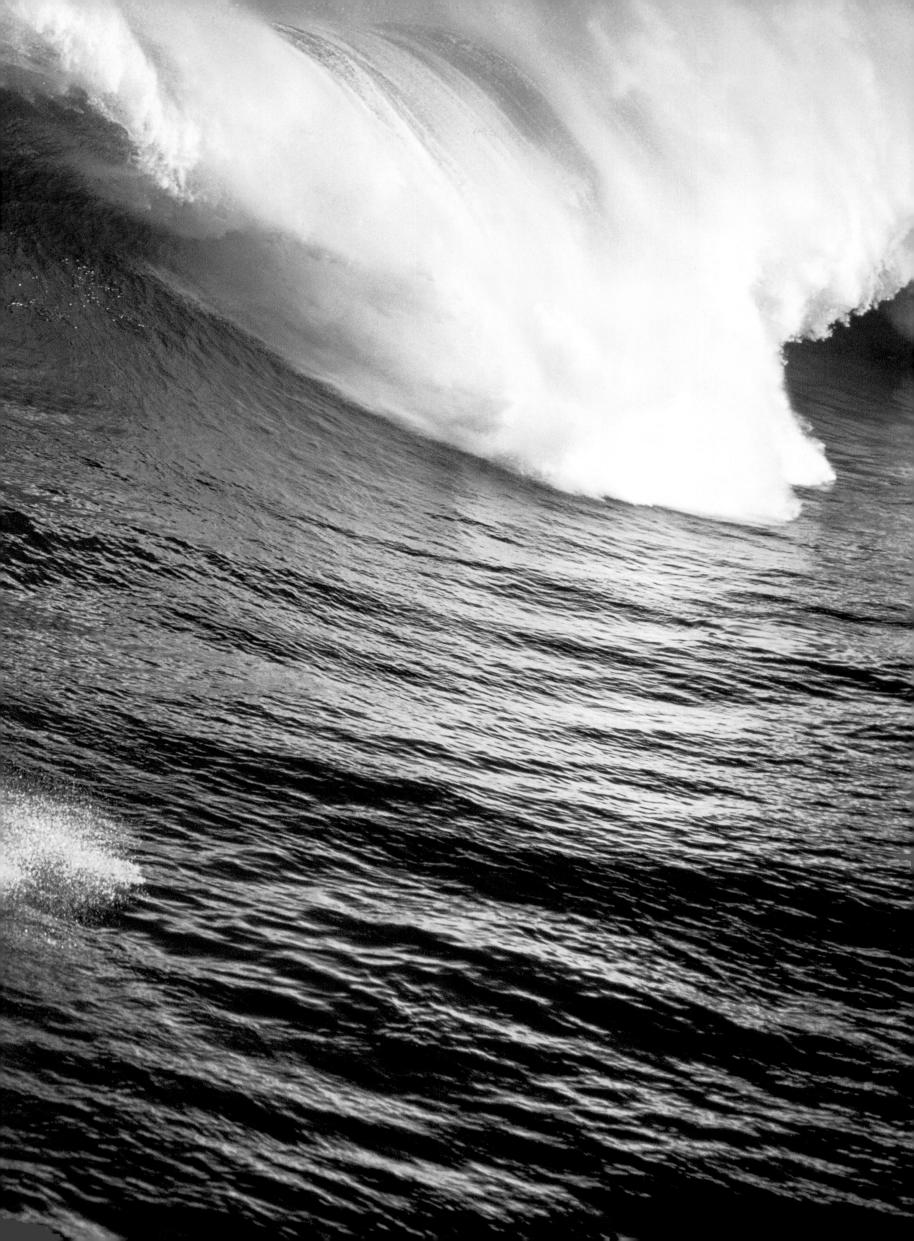

contests were occasionally cancelled altogether for lack of sponsors, with the entire tour itself truncated in 2013.

Part of the trouble with the women's tour was that sponsors and the surf media often treated women more as sex objects than athletes, favoring racy photos and backhanded coverage to serious consideration. After towing into a monster wave at Teahupo'o in Tahiti, Kennelly made the cover of Australia's *Surfing Life*, which she laughingly described as "the most chauvinistic magazine in the world." It had competition. *TransWorld SURF*'s 2012 "Women's Issue?" featured a male surfer on the cover and, inside, a reader poll on "the hottest female surfer"—hotness being defined by looks, not skill; another *TransWorld* issue polled top women surfers with such enlightening questions as "Is it hard to surf with boobs?" Eventually, if only for a short time, magazines like *Surfing Girl*, *Surf Life for Women*, and *Wahine* offered women an alternative to the established male-dominated surf media and an outlet for the thousands of female athletes attracted to the ancient Hawaiian sport of queens. Despite the obvious abilities of Anderson, Kennelly, and a host of other superb athletes, however, the women's pro tour struggled to find sponsors and survive. Women's surfing remains mired in a sexist limbo created by surf journalists and corporate marketers, who are seemingly unable to resolve whether women surfers should be regarded as athletes or as objects.

REVIVAL OF THE FITTEST

In 1983, *SURFER* magazine pronounced big-wave surfing dead and asked, "Have surfers turned into candyasses?" As the pro tour increasingly focused on small-wave exploits, however, some surfers revived the lost art of big-wave riding. In years to come, the big-wave revival was aided by the discovery of several new big-wave spots outside of Hawaii. These included an isolated spot in Northern California named Mavericks, surfed for years by a lone local, Jeff Clark, until it burst on the surf world in the early '90s, especially after the death there of Hawaiian big-wave veteran Mark Foo; and the shallow offshore reef in Tahiti called Teahupo'o, or "broken skulls" in the local language, a heaving, warping mutant with awesome power. Teahupo'o acquired legendary status for one wave, involving a particular surfer, Laird Hamilton, and a new technology. Surfers had always paddled themselves into waves, but they had also dreamed of easier ways of catching them. In the

PAINTING, *CHAMPAGNE SUNSET*, 1997
Bill Ogden's ability to capture truth and fantasy in his paintings has led to a successful, decades-long art career. *Art, Bill Ogden*

MAGAZINE COVER, *BEACH CULTURE*, 1991 *Beach Culture* was first launched through *SURFER* as an experiment in examining mass youth culture. It proved so unique that it won more than 100 awards for groundbreaking design, photos, and content. *Art, Gary Baseman*

LAIRD HAMILTON; NORTH SHORE, HAWAII; C. 1994 *(Pages 428–429)* When big-wave tow-in surfing started in the early 1990s, the surfers were so far offshore nobody could see what they were doing or how big the waves truly were. Enterprising helicopter pilots like Don Shearer became experts at getting the photographer perilously close to the action. *Photo, Sylvain Cazenave*

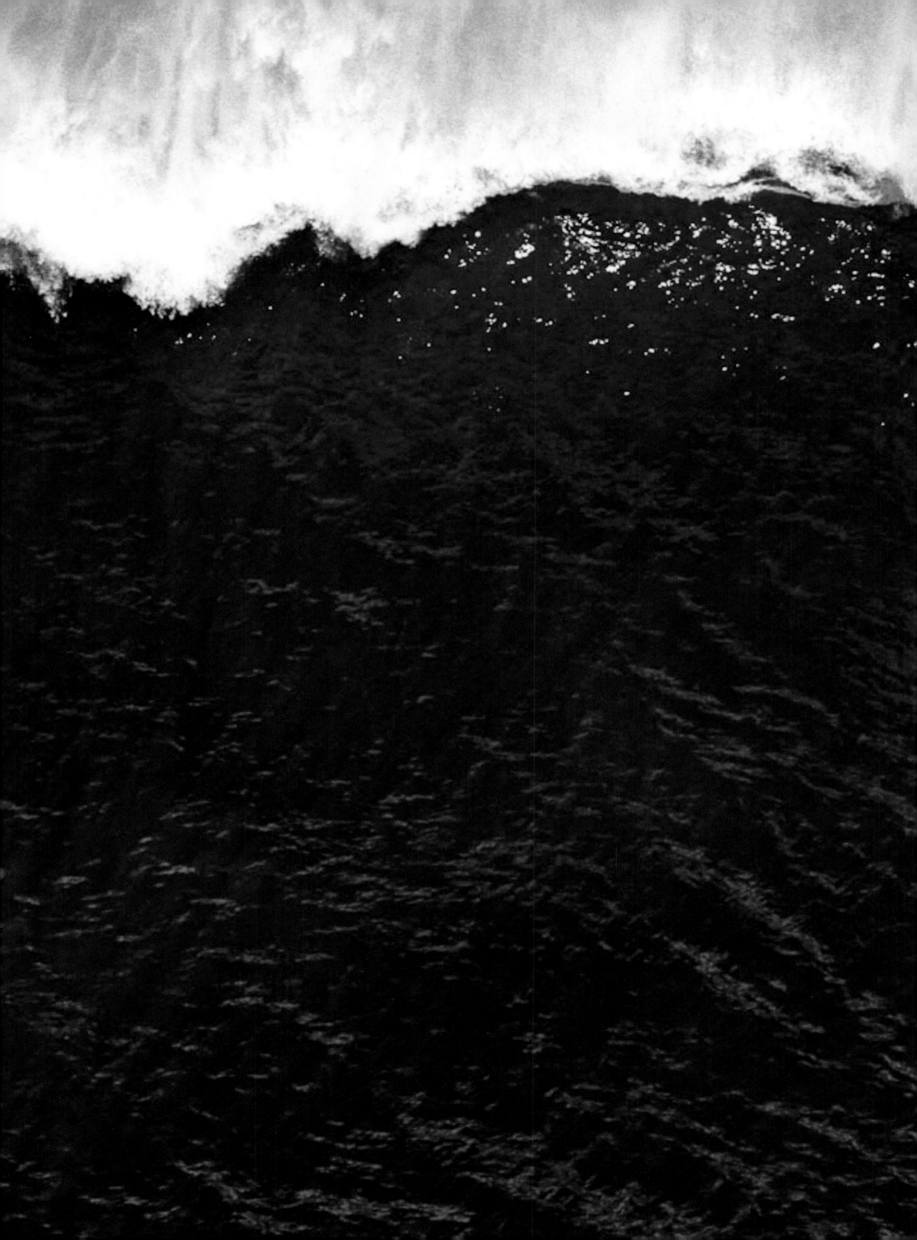

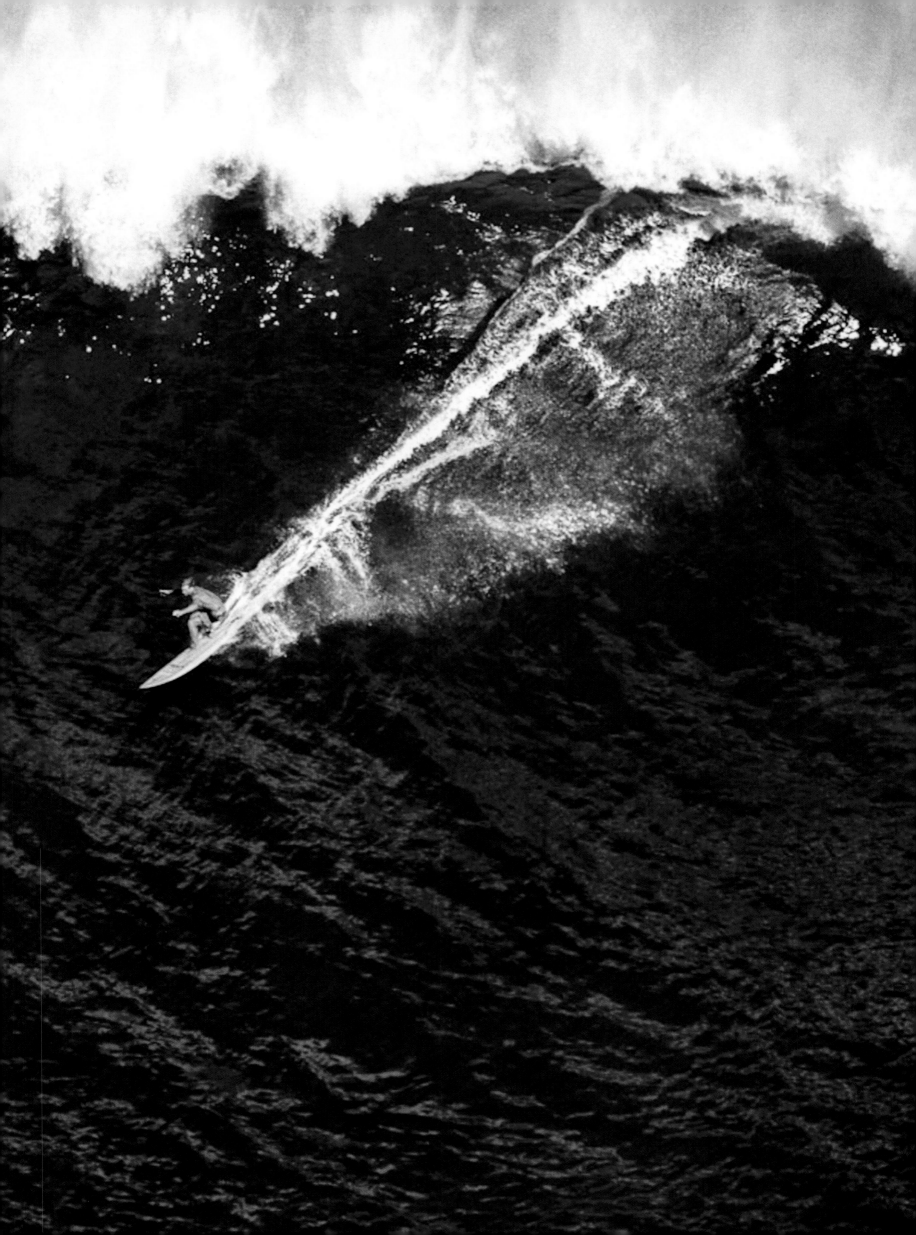

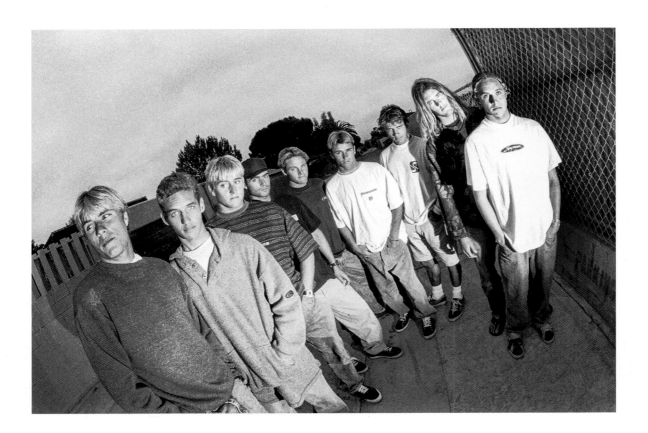

1980s, a number of top Hawaiian surfers had taken up windsurfing and found they could zip into big waves at twenty knots on a windsurfer far more easily than paddling into waves at just a few knots. Led by Hamilton, Burton "Buzzy" Kerbox, and Darrick Doerner, Hawaiian surfers took to towing each other into 50-foot waves, first behind an inflatable Zodiac and then on jet skis.

The result was a quantum jump in big-wave surfing that allowed Hamilton and his friends to ride ever bigger waves at outer reefs, especially a break on Maui known as Peahi or, more menacingly, Jaws. They borrowed foot straps from windsurfing to keep their feet locked onto their boards, allowing them to launch looping aerials and hop casually over chop in the wave face. Tow-in also meant they didn't need long boards for paddling speed, and they cut their boards down to the six-foot range for easier turning. Instead of angling across the face and racing for the safety of the shoulder, previously the main approach of big-wave riders, they carved turns across huge wave faces, arcing under (and sometimes over) the pitching lip. In essence, they took small-wave surfing to a vastly greater canvas. Peter Cole, a big-wave legend from the 1950s, declared, "This tow-in surfing has made regular surfing look like a Model T."

Some purists resisted tow-in, saying that if you didn't paddle into the wave yourself, it wasn't surfing; you were just waterskiing. Hamilton silenced many critics in 2000 with a mutant wave at Teahupo'o that reared up over the reef, warped, and then doubled over with a lip nearly as thick as the wave was high. Hamilton somehow steered a course through the heaving belly of the beast and shot through the barrel, coasted to a stop past the shoulder, sat down on his board, and wept. A photo of it ran on the cover of *SURFER* with a simple caption: "Oh my god…"

The Teahupo'o wave capped the tow-in revolution and boosted Hamilton's already formidable celebrity—he won mainstream sponsors such as Nike and American Express—and established big-wave surfing as an alternate career path to the pro tour. It also opened up even more spots around the world previously judged unrideable, including waves in Australia, South Africa, Ireland, and Portugal. Surf forecasting—computer-based swell models, crunching weather data fed by a global network of electronic buoys and satellite sensors—enabled surfers to chase waves around the world, booking last-minute plane tickets to show up at remote waves at the eve of a major swell.

MOMENTUM **CREW, 1992** Named the "Momentum Generation" after Taylor Steele's low-grade but energetic debut movie, *Momentum*, this core group of young Americans became the celebrated "New School" of 1990s pro surfing. From left to right: Benji Weatherly, Rob Machado, Ross Williams, Greg Browning, Taylor Knox, Shane Dorian, Kelly Slater, Donavon Frankenreiter, and Conan Hayes. *Photo, Steve Sherman*

POSTER, *POINT BREAK*, **1991** The Hollywood action thriller *Point Break*, which featured big-wave surfing and skydiving, became a cult classic.

MARK FOO, MAVERICK'S; HALF MOON BAY, CALIFORNIA; 1994 Foo surfed his last wave on December 23, 1994. *Photo, Bob Barbour*

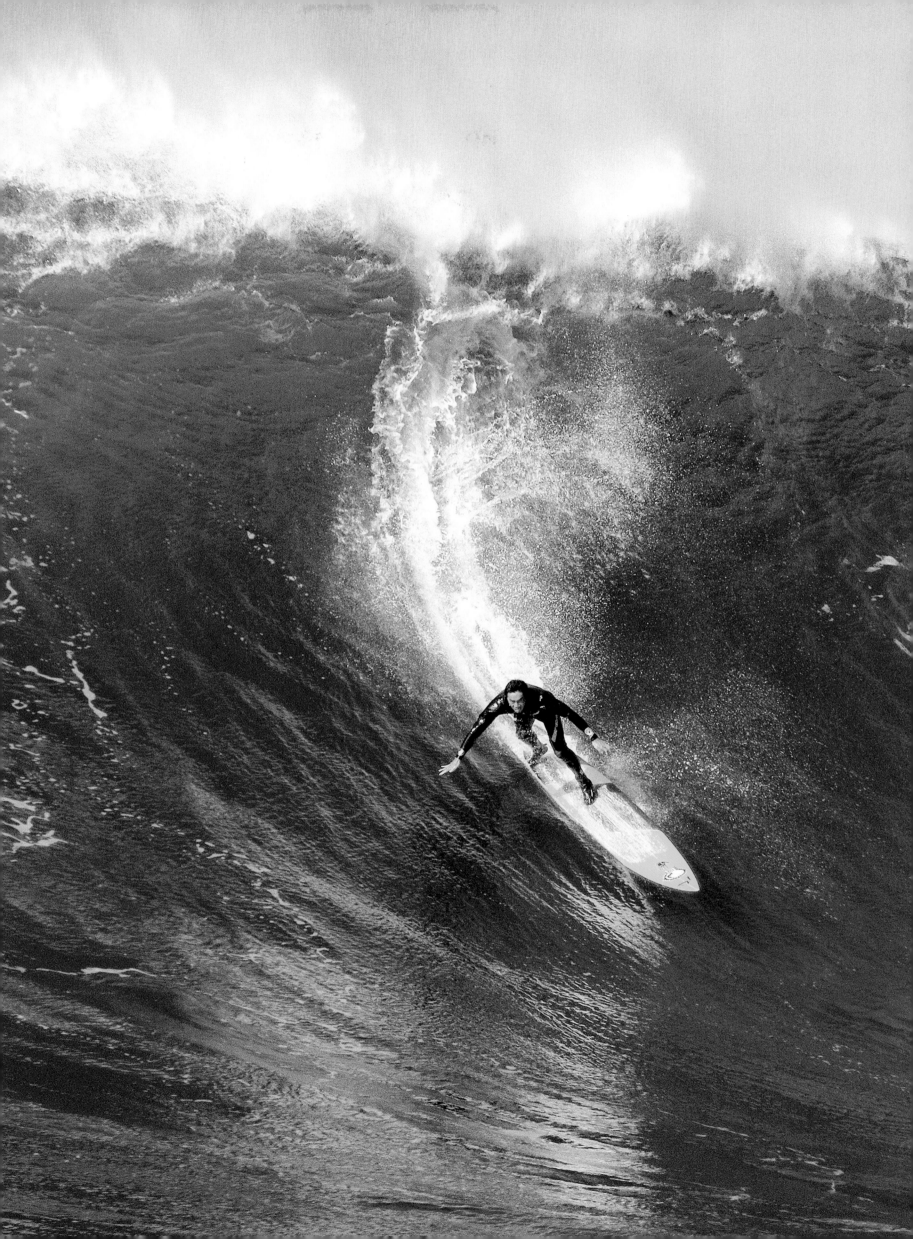

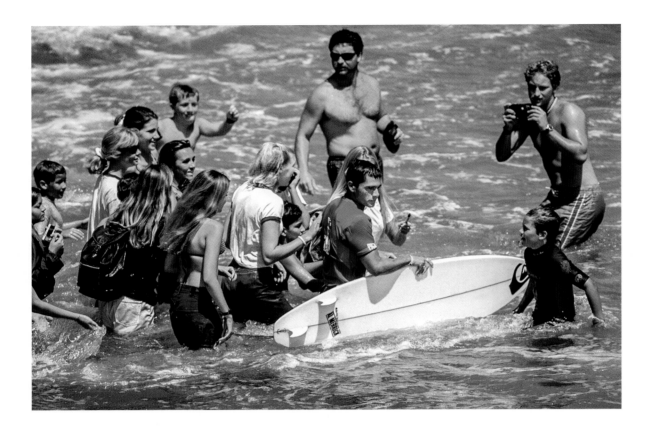

Tow-in surfing also, however, raised environmental questions, since jet skis were noisy and polluting and several big-wave reefs were environmentally sensitive. Tow-in surfers were also making it look too easy. One Aussie rider was filmed guzzling a can of beer in a massive barrel, while another towed in wearing a Santa suit. The appeal of big-wave surfing had always been the sheer physical challenge and fear factor. For that reason, in the last decade, a growing cadre rejected tow-in surfing and returned to paddling themselves into big waves. *SURFER* in 2013 proclaimed "the end of the machine" and added, "in the eyes of the big-wave vanguard, a towrope has become the equivalent of training wheels."

MAKING BOARDS, MAKING WAVES

Although tow-in surfing infused new technologies, including experiments with exotic hydrofoil surfboards, surfboard design remained mostly conservative and three-fin thrusters prevailed. Perhaps the most significant change in surfboard technology was the source of basic materials. By 2000, Grubby Clark, owner of Clark Foam, had an iron grip on 90 percent of the $200 million U.S. market and 60 percent of the world market for polyurethane blanks. Three years earlier, *SURFER* heralded Clark as the second most powerful man in surfing (after Bob McKnight, CEO of Quiksilver).

Over the years Clark regaled his customers with annual letters describing the state of the surfboard industry, ranging from the introduction of shaping machines during the late 1970s to the need to ventilate glassing shops in the 1990s. In December 2005, surfboard shapers received a rambling fax notifying them that Clark Foam was closing immediately. Dubbed "Blank Monday," Clark's abrupt decision shocked the surfing world. His fax blamed it on government regulators and health-related lawsuits by employees, but the pressure on Clark may have been more economic than environmental. Clark's letter the previous year warned of the emergence of offshore surfboard manufacturers, especially in Asia. Responding to the potential demand of a worldwide market of millions of surfers, a company in Thailand called Cobra International had recently opened a new factory outside Bangkok that dwarfed Clark's operation; the Cobra factory cost $20 million to build, employed 2,800, and could crank out 250,000 boards a year. Chinese manufacturers were similarly tooling up large factories. Clark may have seen the handwriting on the wall, and jumped out of the business before Asian competitors pushed him out.

KELLY SLATER, OP PRO; HUNTINGTON BEACH, CALIFORNIA; 1995 *Photo, Jim Russi*

MAGAZINE COVER, *BEACH CULTURE,* **1990** *Art, Stephen Bykram*

LAIRD HAMILTON; NORTH SHORE,
HAWAII; 1990 *Photo, Walter Iooss*

LAIRD HAMILTON; JAWS, HAWAII;
2004 *Photo, Erik Aeder*

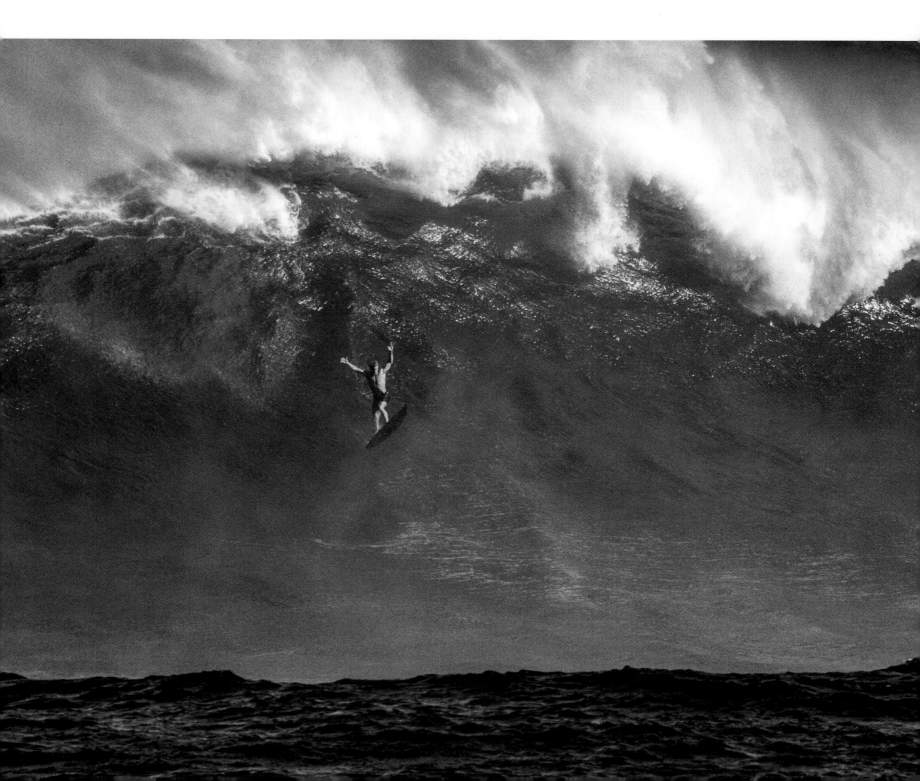

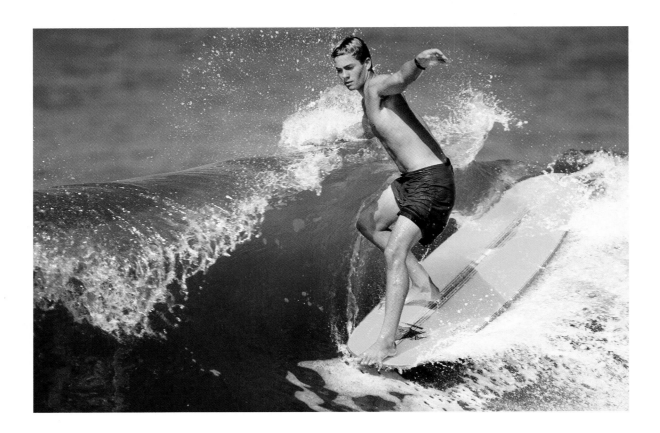

The rise of offshore blank manufacturers sparked fears of the demise of the backyard craftsman and the individual relationship between a surfer and shaper. Some of these fears have been realized, as surfers today can buy Chinese-made pop-out boards at big-box superstores for less than half the price of a custom board. But even local shapers by the 2010s were relying heavily on computerized shaping machines based on standardized templates, with CAD software driving CNC (computerized numerical control) routers; these shapers were more likely to wield a computer mouse than a planer.

Clark's demise led some shapers to pursue alternative materials, including lighter, more buoyant expanded polystyrene/epoxy alternatives and "green" materials such as sugarcane foam instead of polyurethane, and hemp or silk in place of fiberglass. But the overwhelmingly dominant board materials remained polyurethane foam, fiberglass, and polyester resin, as they had been since the late 1950s.

In this period, waves themselves became a sort of technology. Wave pools appeared in such landlocked locales as Las Vegas, Nevada; Memphis, Tennessee; Palm Springs, California; and Allentown, Pennsylvania. Disney World built Typhoon Lagoon, its 2.5-million gallon wave tank with the surreal backdrop of a decrepit fishing boat impaled on a Matterhorn-like mountain. The trend spread abroad, with wave pools at Sun City, South Africa; Edmonton, Canada; and Bandar Sunway, Malaysia. The apex arrived in Japan, with the construction of the world's largest water park in Miyazaki. Called the Ocean Dome, the $300-million indoor park, opened in 1993, could accommodate over 6,000 people. Twenty massive pumps lofted 1,800 tons of water and flushed it like a toilet, generating a head-high wave over the contoured pool bottom.

Not everyone viewed this with enthusiasm. Surf writers predicted that "purists will undoubtedly cringe, [as] wave pools represent exactly what they seek to escape from by surfing: machinery, technology, computers, plastic, [and] metal." Others recoiled from the notion of paying to surf: "Wave pools suggest elitism. They make me think of green fees and country club dues." But those fees themselves suggested the limits to wave pools, which were not because of aesthetics or ideals, but simple economics. Wave pools cost about $80 per square foot to build. An eight-foot wave needed a 20,000-square-foot pool, with millions of gallons of water and elaborate pumps, filters, and chlorinators, which meant a couple million dollars minimum. The only way to recoup this investment was to pack

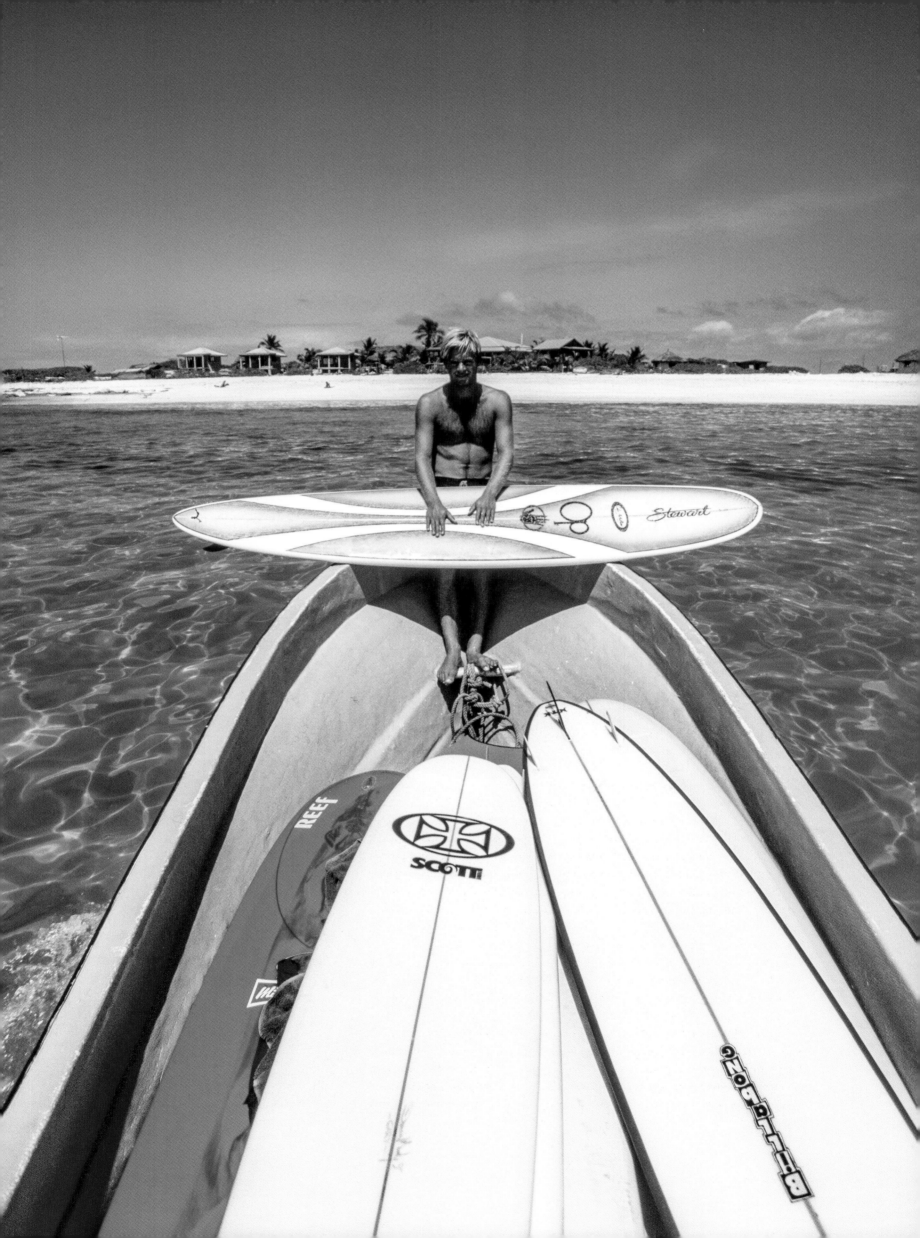

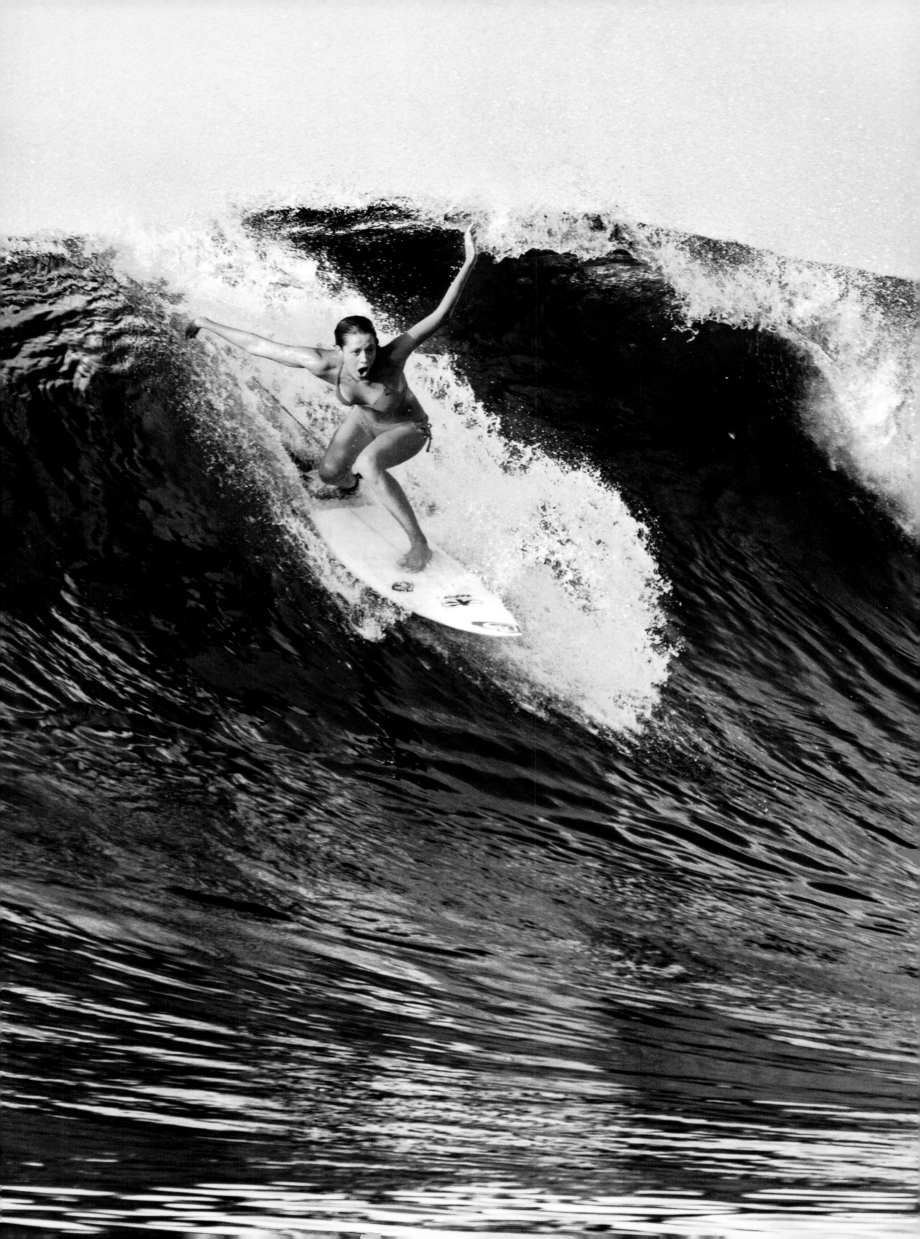

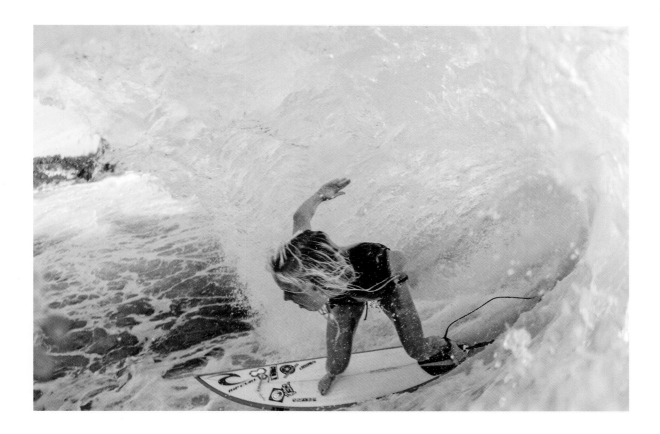

people in for swimming and wading. The economics of wave pools help explain why the Ocean Dome, whose best waves broke in treacherously shallow water over concrete, never turned a profit. It shut down for good in 2007.

But surfers were just then reconsidering their attitude toward wave pools—particularly among professionals. Pro surfing had always been limited by the lack of an arena and the fickleness of Mother Nature. With a wave pool, contest organizers, spectators, and TV crews need not wait around for waves. You could build stadium seating around the pool, charge for seating, ensure excellent viewing angles for TV cameras, and broadcast live because waves arrived on demand.

In 1985, the pro tour arrived in that noted surf town of Allentown, where the surf media scorned the knee-high, gutless waves as "pathetic," "an abomination." Wave-pool contests nevertheless followed at Palm Springs in 1987, Miyazaki in 1993, and Disney World in 1997, where Kelly Slater won the inaugural Typhoon Lagoon contest. The pros complained of the monotonous waves, but third-place finisher Rob Machado, whose dreadlocked, ultra-mellow image was the epitome of the soul surfer, said, "I'd much rather surf here than Huntington. At least I know I'll get my wave count."

Artificial surfing reefs off natural beaches also emerged with varied success in the United States, Australia, New Zealand, and England. Pratte's Reef, installed in 2000 by the Surfrider Foundation at El Segundo, near Los Angeles, for $850,000, was an abysmal failure that required removal eight years later. Amalgamate Solutions and Research (ASR) meanwhile built surfing reefs in Australia, New Zealand, and at Boscombe Beach in Dorset, England. Boscombe's reef was the size of a soccer field, cost £3.2 million, and consisted of geotextile bags filled with sand. At Boscombe, the bags were exposed at low tide and resembled a beached whale. Surfers were underwhelmed. But while artificial reefs designed for surfing often failed, rising sea levels may mean more will be built as shore protection for expensive coastal real estate.

OUR FILTHY SEAS: SURFERS AND THE ENVIRONMENT

As some surfers sought to build better waves, others began to consider preserving the natural ones they already had. Surfers occupy the edge of the oceanic frontier, that interface between civilization and the marine wilderness that fascinated Rachel Carson, the 20th

MONYCA ELEOGRAM; MENTAWAI ISLANDS, INDONESIA; 2011 With the explosion of women's surfing in the late 1990s, sponsors like Roxy began sending crews of women surfers on paid photo trips to exotic wave locales. *Photo, Jim Russi*

BETHANY HAMILTON, C. 2014 While surfing her local spot on Kauai, Hawaii in 2003, 13-year-old Hamilton was attacked by a tiger shark that tore her arm off. After recovering, she returned to surfing, winning competitions and worldwide acclaim. *Photo, Damea Dorsey*

POSTER, *BLUE CRUSH*, 2002 Made for $35 million, the female surf film *Blue Crush* was the surprise breakout hit of the summer. One critic described the film as "Gidget Kicks Ass."

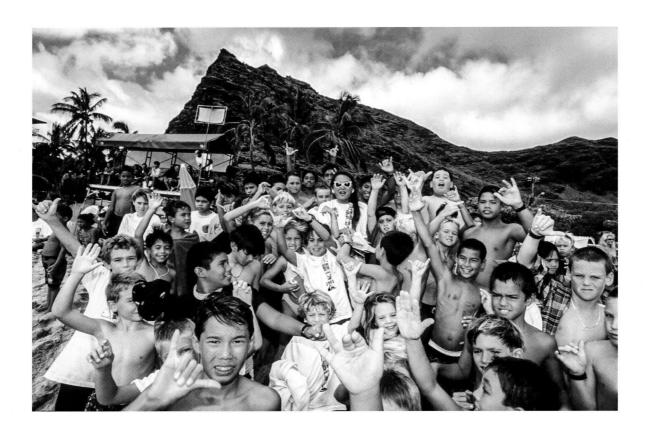

century's most significant environmental scribe. In 1988, almost 40 years after Carson's 1951 classic, *The Sea Around Us*, *Time* magazine ran a cover story on "Our Filthy Seas." The immediate occasion was a sewage spill that polluted New York and New Jersey lineups with colostomy bags, used bandages, and syringes during one of the summer's best swells. The nauseating waste included balls of sewage two inches thick and blood vials tainted with hepatitis B and AIDS. Between 1940 and 1980 America's coastal population more than doubled from 42 to 89 million people. The average 150-pound human produces 1.5 pounds of solid effluent every day, which when multiplied by 89 million makes for a mind-boggling amount of offal. Although many coastal cities installed sewage treatment plants, the treated waste-water and the solid leftovers known as "sludge" all ended up in the ocean—raising fecal coliform counts in surf lineups. Some coastal communities, such as the North Shore of Oahu, have no sewage treatment facilities at all, instead relying on cesspools and septic tanks to filter effluent on its inevitable path to the ocean. And those are the best-case scenarios in the developed world—and they do not account for the untreated runoff from animal and livestock waste or pesticides.

Despite their direct experience of swimming in sewage, surfers were not in the vanguard of environmental activism. With the environmental movement well underway, the Surfrider Foundation, established in 1984, had won small victories, starting with a successful campaign to prevent channeling the Malibu lagoon. Despite growing concern for the ocean environment, by 1990 total membership amounted to less than 4,000, a pitiful percentage of the two-million-plus surf community. *SURFER* declared such apathy "an absolute disgrace." In 1991, Surfrider received $200,000 in cash donations, perhaps $20,000 of that from surf companies. For an industry with sales of nearly $2 billion, that amounted to a pathetic contribution. Surfrider eventually found its feet, as the surf industry and surf community finally stepped up financial support, and as human assaults on the surf environment became ever harder to ignore.

Surfrider flexed its muscles in 2008, after developers campaigned for a toll road that would block access to Trestles, an exceedingly popular Southern California break. Hundreds of members spoke in defense of Trestles, along with celebrities ranging from Kelly Slater to Eddie Vedder and Clint Eastwood. The California Coastal Commission had cognizance, since the proposed road crossed the coastal zone, and held a series of boisterous public

RELL SUNN; MAKAHA, HAWAII; 1993
Known as "Auntie Rell" to the beach kids of Makaha, Sunn worked tirelessly to keep them out of trouble through community work and events like her annual Rell Sunn Menehune Contest. *Photo, Jim Russi*

POSTER, QUIKSILVER EDITION MOLOKAI–OAHU PADDLEBOARD RACE, 2006

OUTER REEF; NORTH SHORE, HAWAII; C. 2008 *Photo, Ed Freeman*

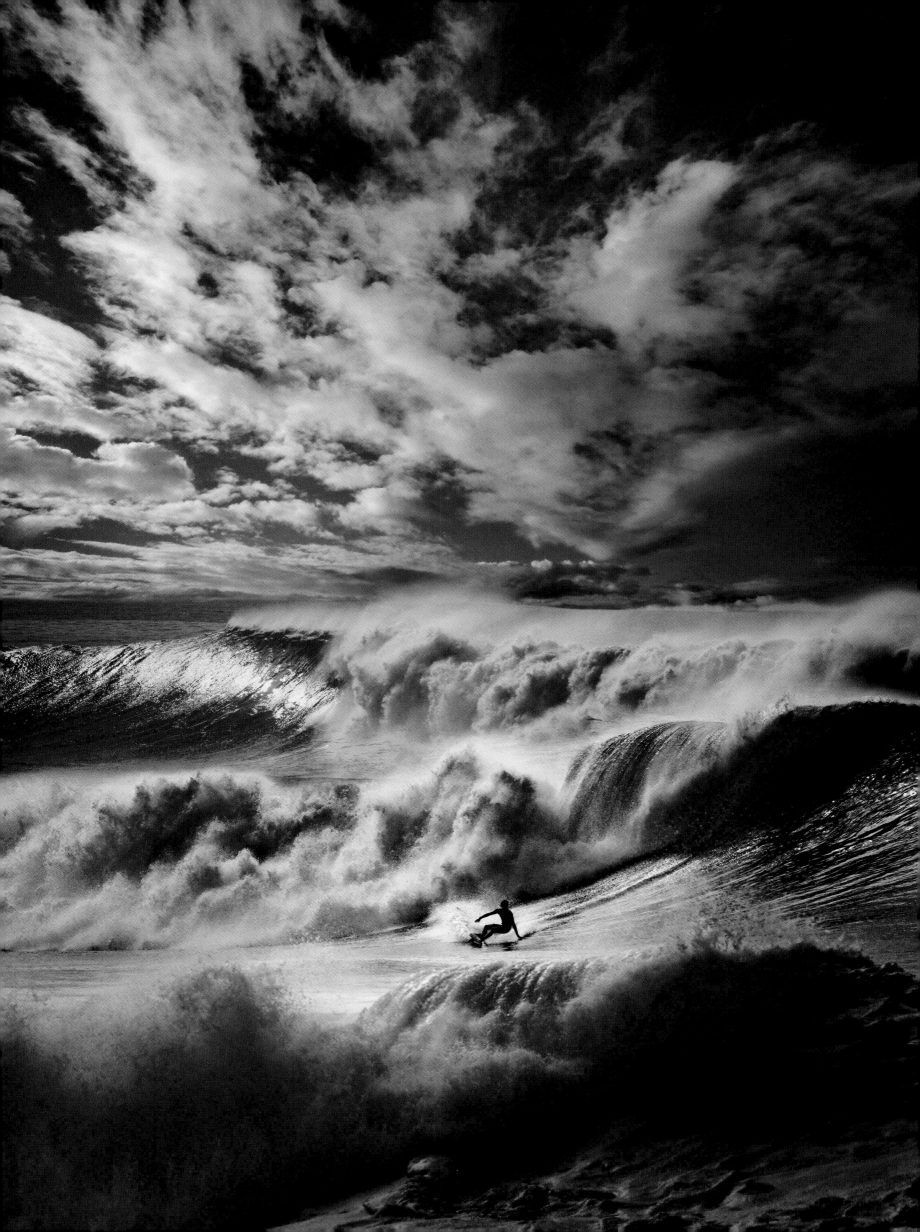

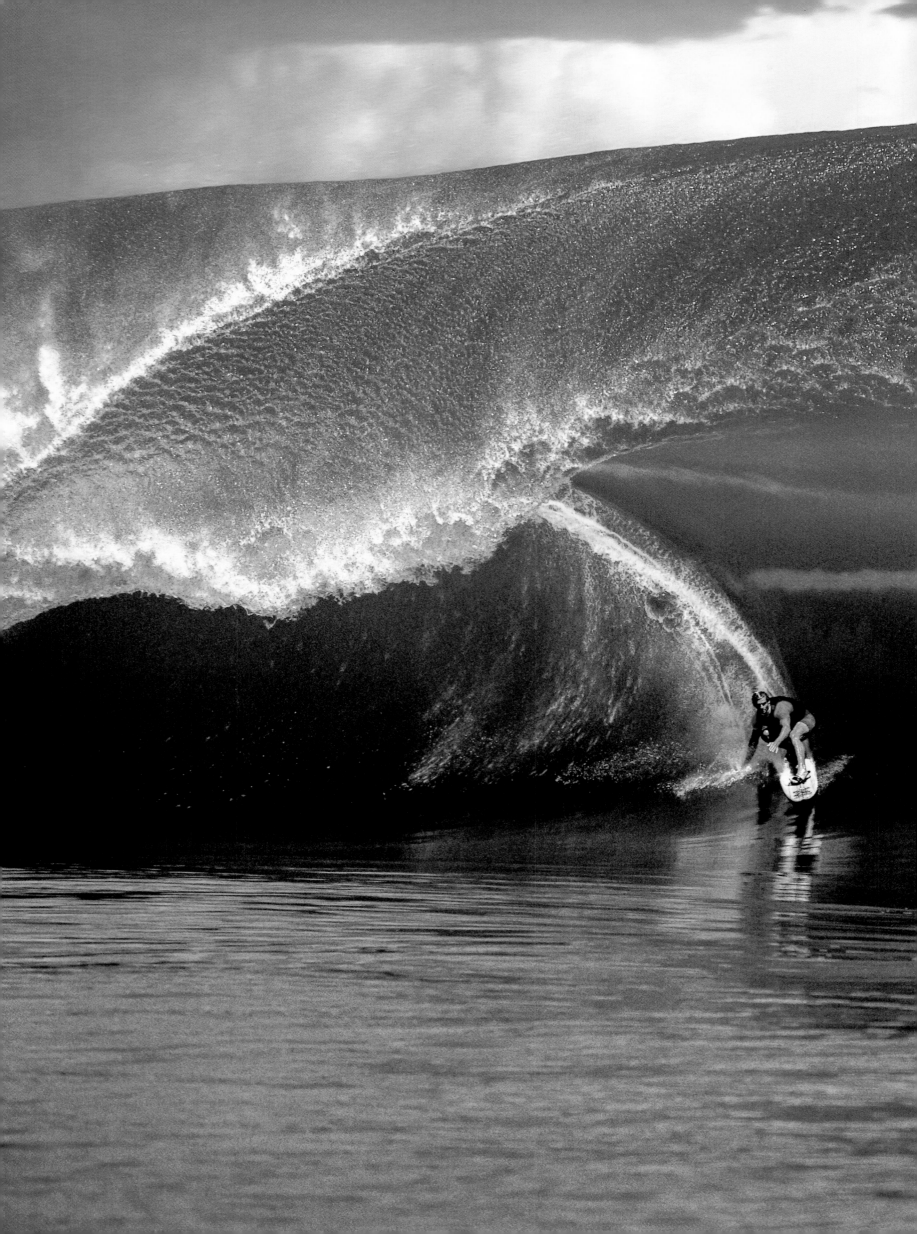

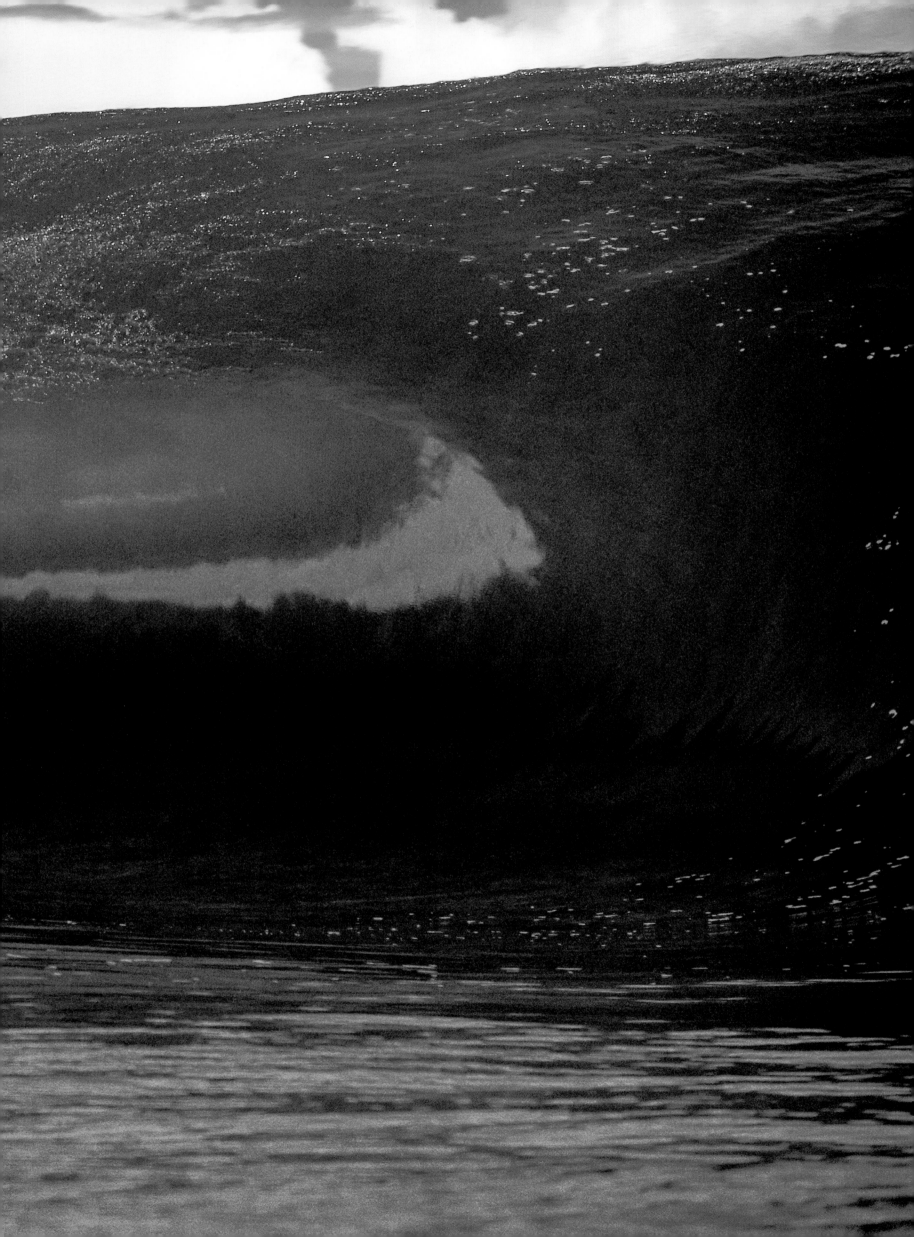

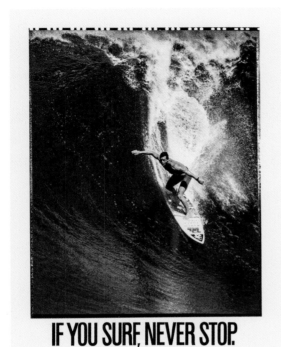

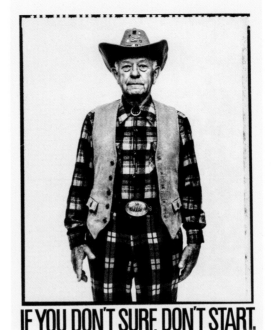

IF YOU SURF, NEVER STOP.

IF YOU DON'T SURF, DON'T START.

ADVERTISEMENTS, GOTCHA, 1989 AND 1988 Gotcha Sportswear, cofounded by '70s pro surfer Michael Tomson, produced provocative ads created by legendary designer (and one time *SURFER* cartoonist) Mike Salisbury.

LAIRD HAMILTON; TEAHUPO'O, TAHITI; 2000 *(Pages 440–441)* Hamilton's groundbreaking tow-in ride at Teahupo'o on August 17, 2000 earned him the *SURFER* cover ("Oh My God…") and worldwide recognition for surfing the "Millennium Wave." *Photo, Tim McKenna*

meetings. After the commission rejected the road in an 8–2 vote, the developer appealed to the U.S. Commerce Department, which upheld the decision. The well-publicized episode suggested that surfers might have finally found their political voice. Global warming is now presenting surfers with more difficult environmental challenges. Much of the world's wealth is concentrated in coastal cities that use breakwaters and jetties to protect the shoreline from erosion—and which help generate some of the most popular waves in the world. Most of the Southern California coast is engineered to prevent the ocean from enveloping expensive real estate. These measures are already being tested by higher tides, storms, and waves, and, at some point, they will fail the test.

In October 2012, Superstorm Sandy gave the northeastern United States a glimpse of what larger storms and bigger waves will mean. Sandy made landfall with a record low pressure of 940 millibars, and the oceanographic buoy at New York Harbor registered wave heights of 32.5 feet. In the late 1960s the Army Corps of Engineers developed a plan for protecting against such a storm, but it was deemed too expensive. Instead Sandy inflicted billions of dollars in damage.

Global warming is narrowing the benefit–cost ratios used to determine the need for new shore protection measures. If surfers wish to preserve existing breaks, they must demand a place at the planning table. Meanwhile, rising ocean temperatures and acidity pose a dire threat to the world's coral reefs, over which many of the world's best waves break. This includes the cradle of surfing itself, Waikiki, whose hallowed reefs may eventually succumb to global warming.

GOING GLOBAL

Surfing rode the wave of another late 20th-century phenomenon, globalization. The surf industry increasingly depended on Asian factories for manufacturing surfboards and foam blanks, wetsuits, and, above all, the surf trunks and T-shirts that underpinned the industry. Meanwhile, thanks to international air travel, wave forecasting, and global communications, surfers and surfing spread to every continent, including Antarctica.

In addition to proliferating surf camps on the model of G-Land on Java, a new mode of surf tourism, the boat trip, emerged. In the early 1990s, Martin Daly and his boat, the *Indies Trader*, began ferrying surfers to remote reefs in the Mentawais, an island chain off

MAGAZINE COVER, *THE SURFER'S JOURNAL*, 1992 The launch of *The Surfer's Journal* in 1992 by former *SURFER* publisher Steve Pezman revealed a large, older surf demographic willing to pay a premium for quality surf journalism.

MAGAZINE COVER, *THE SURFER'S PATH*, 2013 *The Surfer's Path* out of the United Kingdom offers thoughtful essays and critiques focusing on travel, culture, and ocean environmental issues. *Design, David Carson*

BOB PEARSON; SANTA CRUZ, CALIFORNIA; 1993 After stints in Hawaii and Australia, California shaper Pearson settled back in Santa Cruz for the next 20-plus years creating boards for locals and touring professionals alike. *Photo, Bob Barbour*

the coast of Sumatra, Indonesia. As word got out, Daly expanded into a whole fleet, trailed by a pack of copycats, and soon surf charters were swarming around the Mentawais and other Indonesian islands. These trips further removed surfers from the early, feral mode of dirtbag travel, as trips often ran several thousand dollars and featured gourmet chefs and well-stocked bars. Surf tourism in general also roused local resentment from villagers who noted that most of the profits went to American and Australian tour operators.

With surfers came surf culture and surf industry. Surf towns such as Biarritz in France and Newquay in Britain became almost indistinguishable from their counterparts in California or Australia. A surfer from anywhere on the planet could paddle out in one of these places and fit in. And as surfers carried their culture to new hosts, localism often appeared as an ugly symptom of infection. Localism appeared in such unlikely, isolated places as Mauritius, the Canary Islands, and Alaska. Some Bali locals mimicked Hawaii's Da Hui with their own violent version of the North Shore "Black Shorts" enforcers. Stories circulated about surfers at the Eisbach, a man-made channel off the Isar River in Germany, throwing rocks at visiting photographers, apparently out of fear that touring surfers would be soon be swarming to Munich. The surf industry's insatiable search for markets helped propagate the sport—half of Quiksilver's sales came from the international market—and surf firms began seeking out young stars in new markets. Quiksilver's Roxy brand, for example, signed Peru's Sofia Mulanovich when she was 15, and was rewarded in 2004 when she won the women's world title and became a national hero; Roxy sales in some parts of Latin America jumped 50 percent. By 2011, *SURFER*'s "Hot 100" list of up-and-coming youngsters included surfers from the usual suspects—Hawaii, California, Australia, and

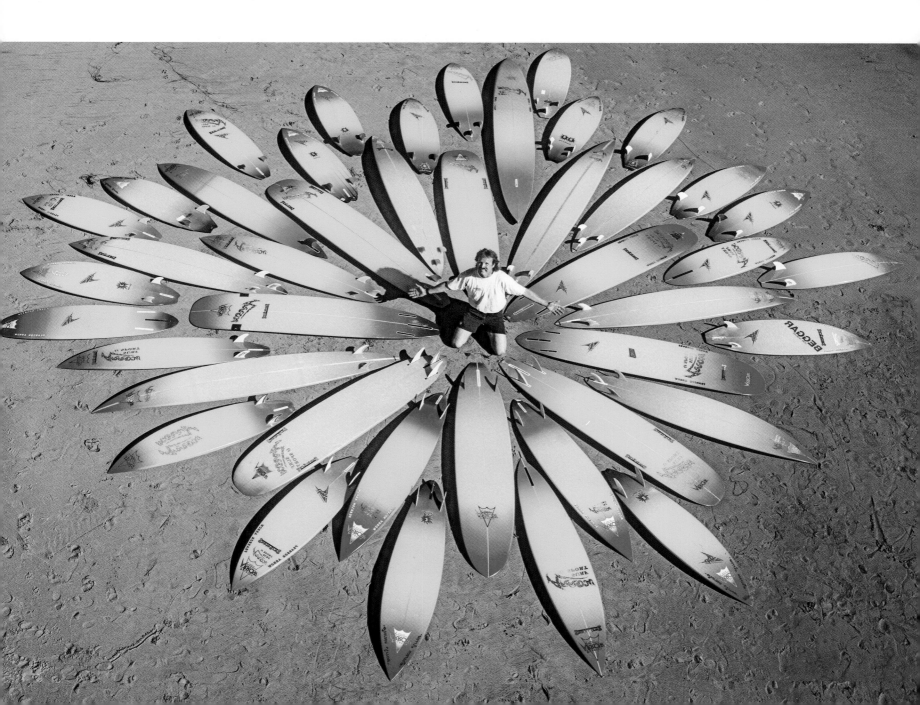

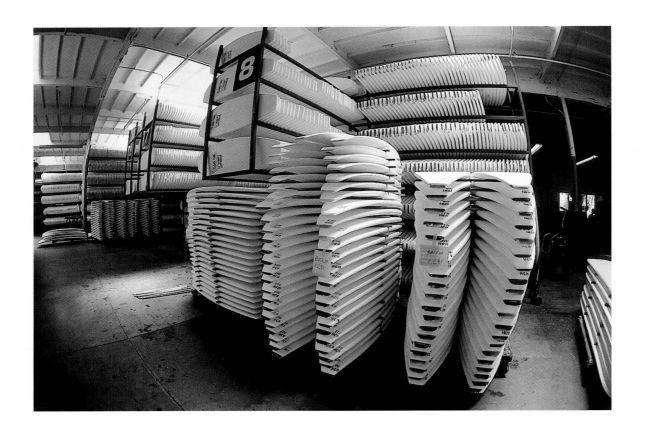

South Africa—but also France, Italy, Mexico, Costa Rica, Peru, the French West Indies, Réunion Island, Tahiti, and New Zealand, plus a slew from Brazil. By 2014, one of those Brazilians, Gabriel Medina, was a leading contender for the world title.

Globalization meanwhile expanded surfing's ethnic horizons. The sport had shed the uglier racist overtones of the "Surf Nazis" and Miki Dora's outright bigotry, although traces persisted: In 1984, *SURFER* published a photo of dark-skinned Hawaiian surfer Montgomery "Buttons" Kaluhiokalani juxtaposed with an image of an orangutan. The pro tour also continued to visit South Africa, even after several Hawaiian pros, including Dane Kealoha in the 1980s, faced outright discrimination under apartheid laws.

Many surfers could plausibly deny that they were racist—the sport, after all, first came from Polynesians, and Hawaiians had always played a central role in its history. But surfing in many countries remained an overwhelmingly white domain. One reason was

CLARK FOAM; LAGUNA NIGUEL, CALIFORNIA; C. 2000

"BLANK MONDAY," SOUTHERN CALIFORNIA, 2005 *Photo, Grant Ellis*

SAN JUAN CAPISTRANO, CALIFORNIA, 2005 After nearly 50 years of producing the bulk of the world's surfboard blanks, Gordon Clark abruptly shut down production of Clark Foam, citing impending lawsuits and governmental crackdowns. The closure sent the global surfboard manufacturing industry into a temporary panic. *Photo, Jeff Divine*

ALEX KNOST'S SURFBOARD, C. 2012 *Photo, Grant Ellis*

JACK MCCOY, TAHITI, C. 2010 *(Pages 446–447)* Using a custom-rigged underwater Jet Ski, surf filmmaker McCoy was able to get for the first time unprecedented "backstage" footage of breaking waves over the shallow, dangerously sharp coral reef at Teahupo'o. *Photo, Tim McKenna*

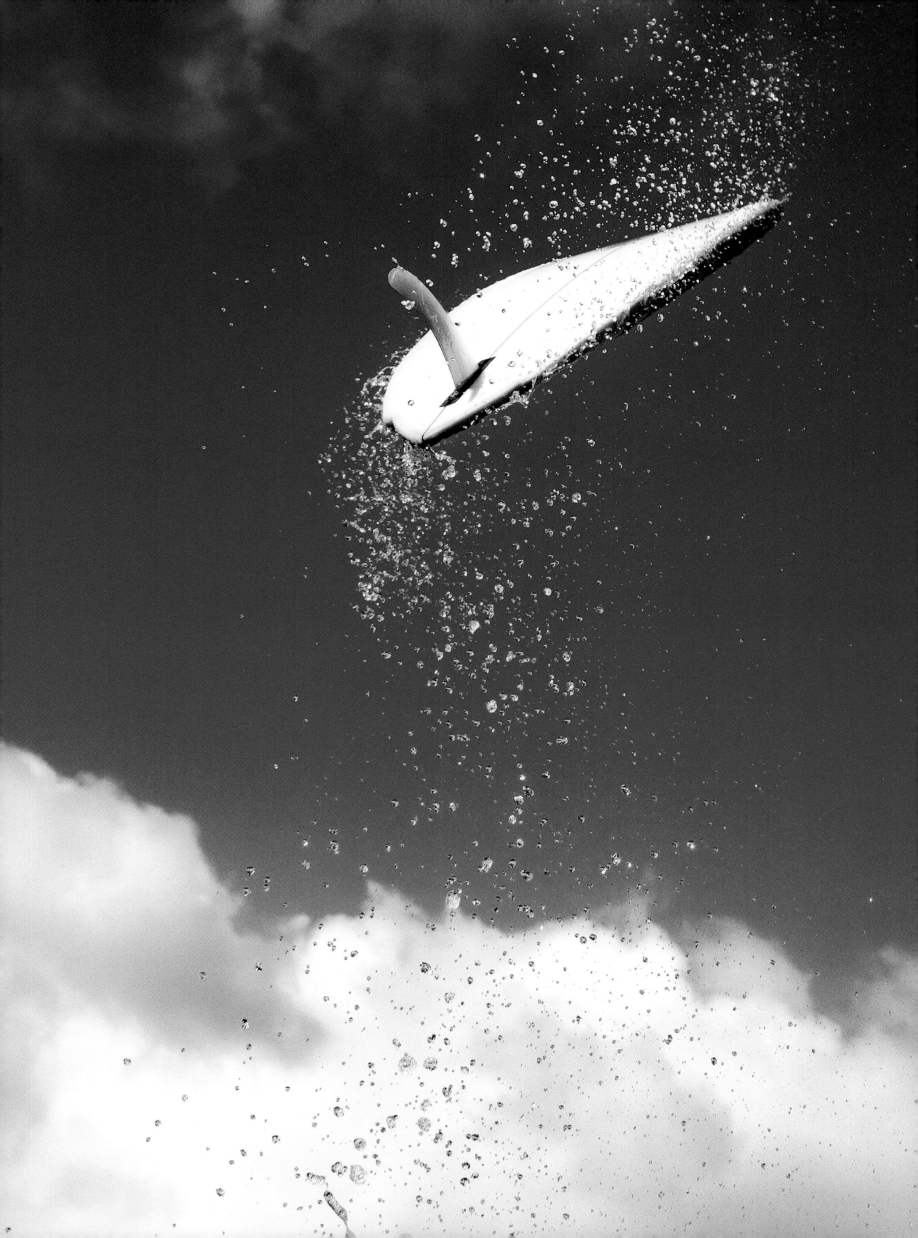

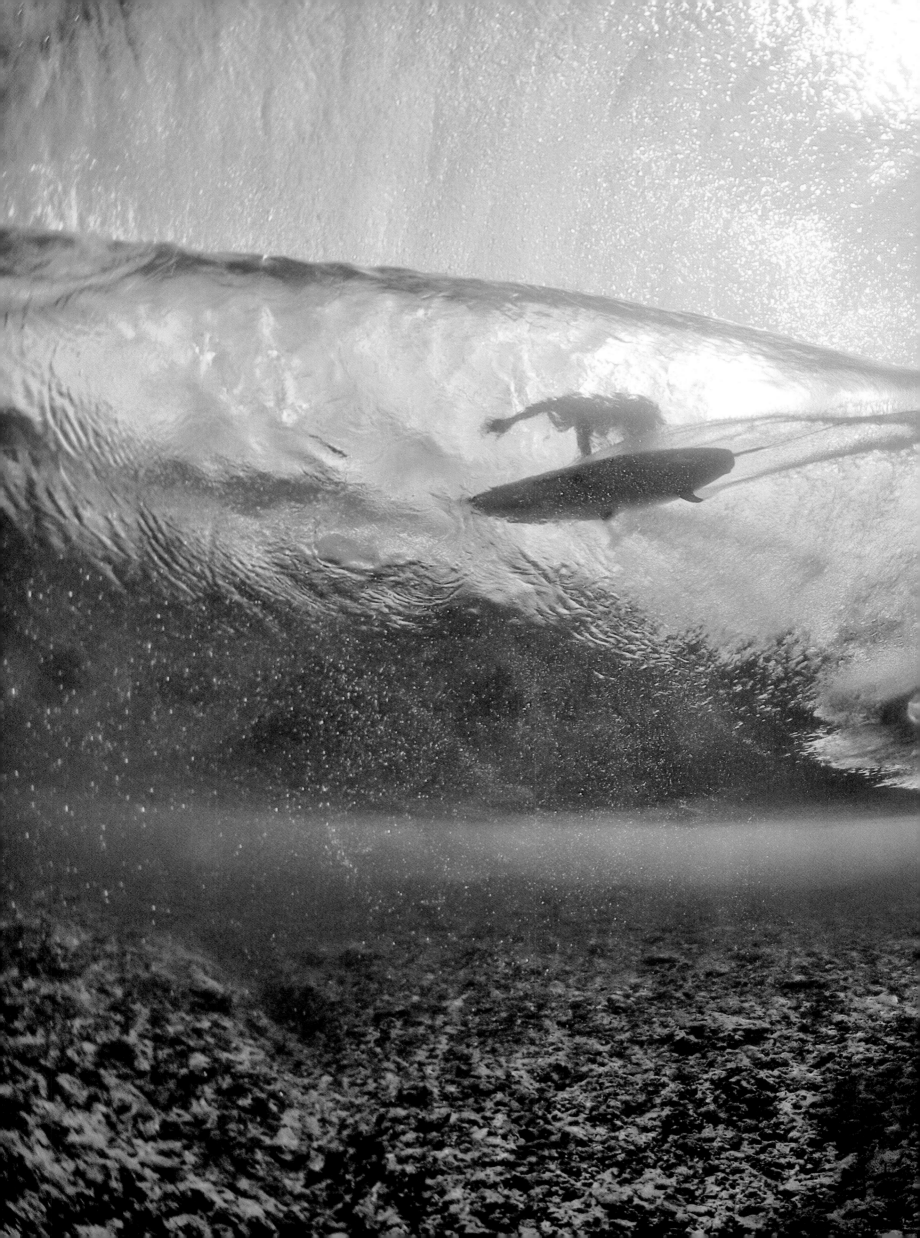

socioeconomic. While surfing was not as expensive as, say, skiing or golf, surfboards and wetsuits weren't cheap, and most beach communities were expensive places to live. The other main reason was that many minorities did not learn to swim. A 2008 study by USA Swimming found that Hispanics and African Americans were far less likely to know how to swim than whites, in part the result of the long American history of segregating public pools. You can't surf if you can't swim, so many surf lineups remained mostly white.

But in the new millennium that slowly began changing. Globalization brought more diversity to surf lineups. Surf firms recognized—as they had with women—that an easy way to expand their markets was to attract more minorities to surfing. And, finally, changing social attitudes in the wider world were eroding, though perhaps not erasing, the underpinnings of racism in the surf community.

WAVES ON THE HORIZON

The story of surfing over the last 30 years was one of growth: in cultural presence, numbers of surfers, amounts of money to be made, and places on the surfing map. Perhaps 20 million people surf worldwide and the global surf industry has topped $10 billion in sales. The ancient Polynesian pastime has become a global commercial and cultural phenomenon.

The more mainstream surfing got, the more surfers hearkened to its countercultural roots. Surfing existed in tension between the romantic and modern, the natural, subversive lifestyle and artificial, commercial, middle-class sport. So, for every new high-tech development, there was a retro backlash: Surfers rejected jet-ski tow-ins for old-fashioned paddling into big waves, abandoned chlorinated wave pools for ever more remote tropical reefs or arctic cobblestone points, and shunned the latest CNC-shaped chemical contraption for a wooden alaia plank modeled on ancient Hawaiian boards. Surfing's romantic roots—derived, ultimately, from Hawaii—seemed to provide a built-in governor on how fast surfing could grow. What other sports so self-consciously revives centuries-old equipment? Hawaii, the birthplace of surfing, may still provide the way for surfing to save its soul.

PAINTING, *CHOPPER,* 1999
Art, Don Ed Hardy

COMIC BOOK COVER, *ZAP COMIX,* 1994
Artist Victor Moscoso created a tribute cover in his friend Rick Griffin's signature style showing Griffin's conflicted nature of an angel on one side and a demon on the other. *Art, Victor Moscoso*

PAINTING, MOBY SESSIONS, 2003
Fanciful and surrealistic, Rick Rietveld's masterful work is a swirling mass of surf iconography and pop cultural references making him one of surfing's artistic geniuses. *Art, Rick Rietveld*

fig.1-
JOHNNY BOY GOMES:
Known for high-end,
unrelenting
performance. Tough,
durable, virtually
indestructible.
Incites envy.
Dries quickly in
sunlight, looks
good wet or dry.

fig.2-
LIFE'S A BEACH™
BOARD SHORTS:
See fig.1.

LIFE'S A BEACH. SURFWEAR. PURPOSE BUILT.™
Available exclusively at surf-speciality stores.

ADVERTISEMENT, LIFE'S A BEACH, 1995
Johnny-Boy Gomes was called the "Corporate Badass of Surfing."

ADVERTISEMENTS, JIMMY'Z 1988; HOBIE, 1987

MAGAZINE COVER, *SURFER STYLE*, 1988
SURFER Style, an annual trade publication put out by *SURFER*, announced the coming-of-age of the surf industry. It eventually morphed into *Beach Culture* in 1990.

LAGUNA BEACH, CALIFORNIA, 1998
(Pages 452–453) Photo, Bruce Weber

SURFER STYLE

DUKE

PREVIEW '88

STYLE CHECK

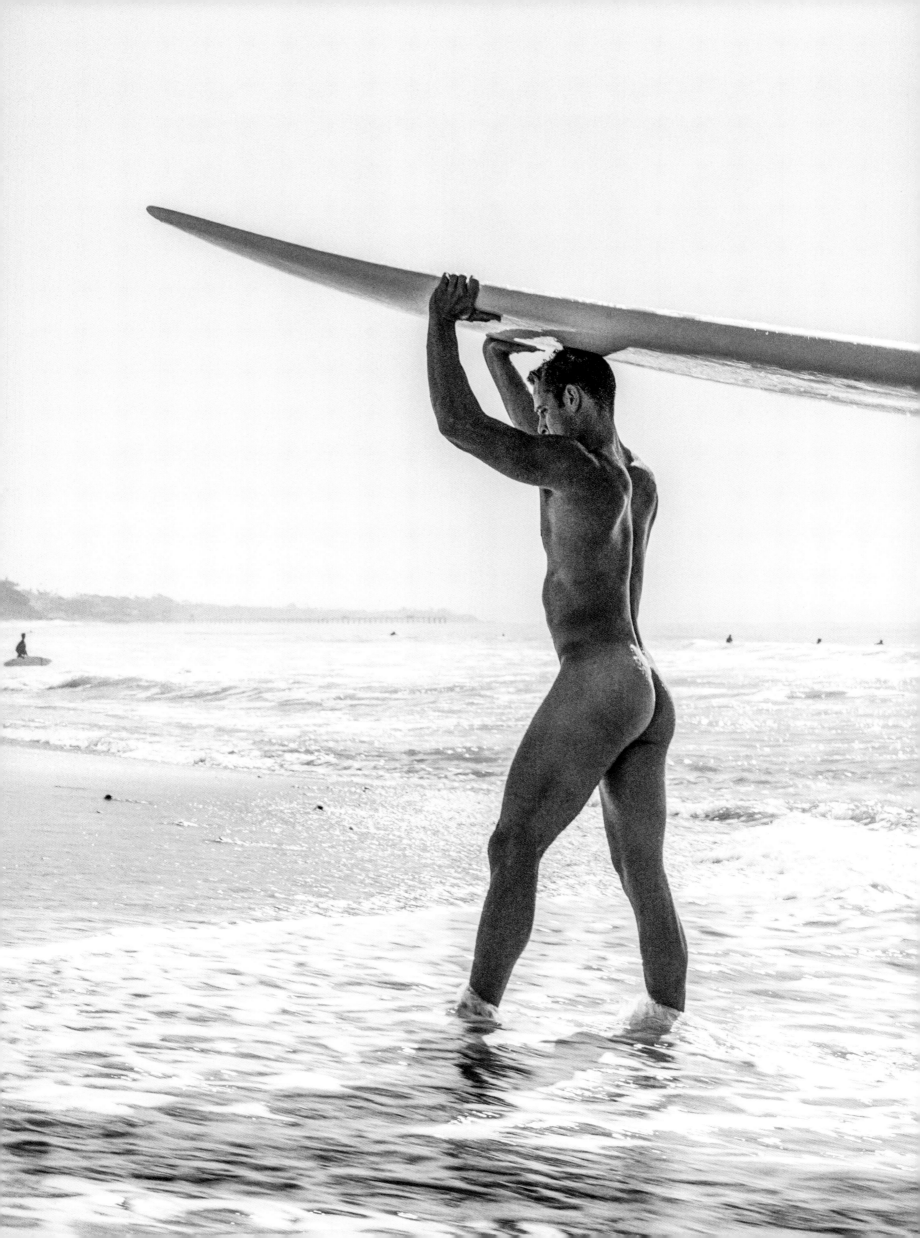

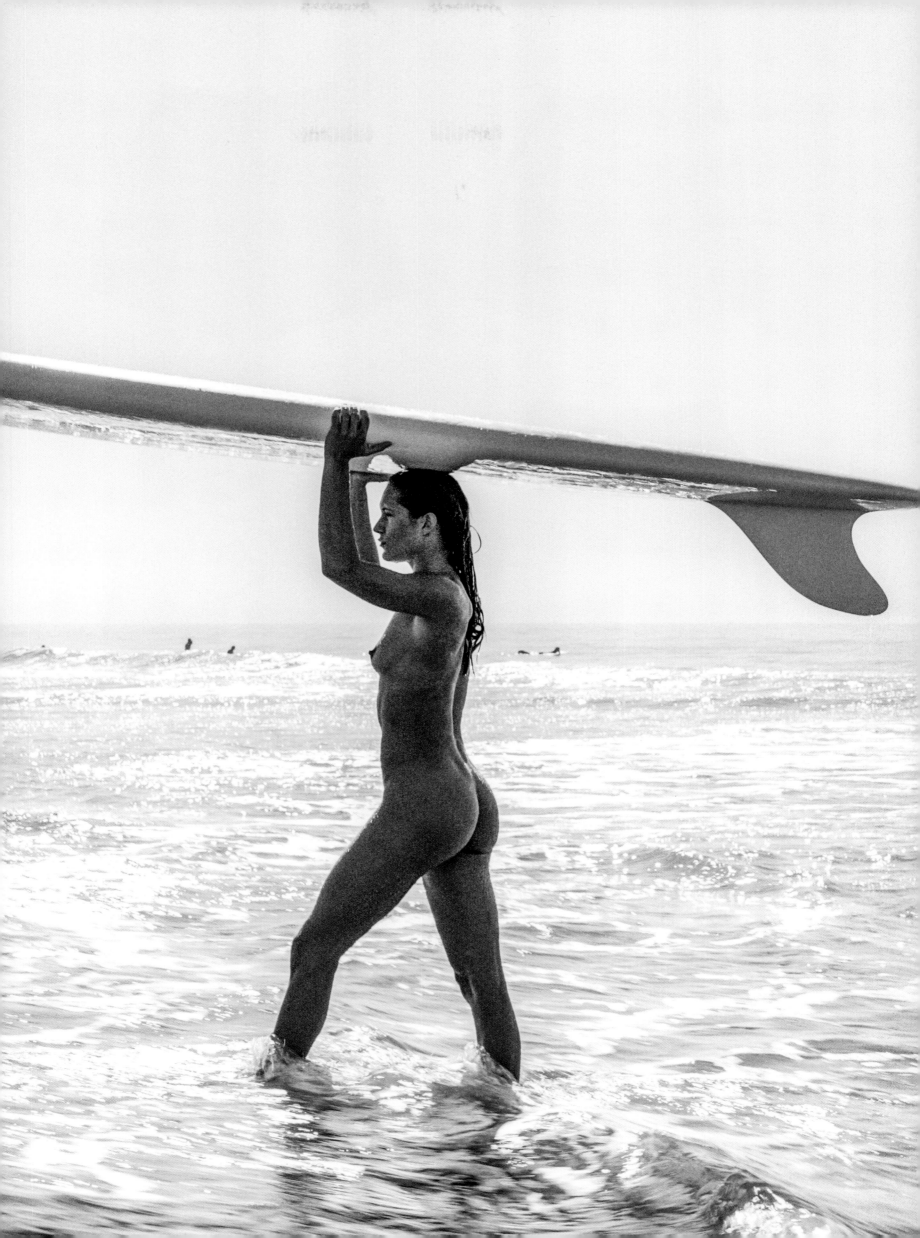

SURF TRUNKS *(Clockwise from top left)* O'Neill, 1989; Billabong, 1998; Quiksilver, 1995; Volcom, 2005; Barry McGee for RVCA, 2013; Quiksilver, 1998

BUZZY KERBOX; KONA, HAWAII; 1982 *Photo, Bruce Weber*

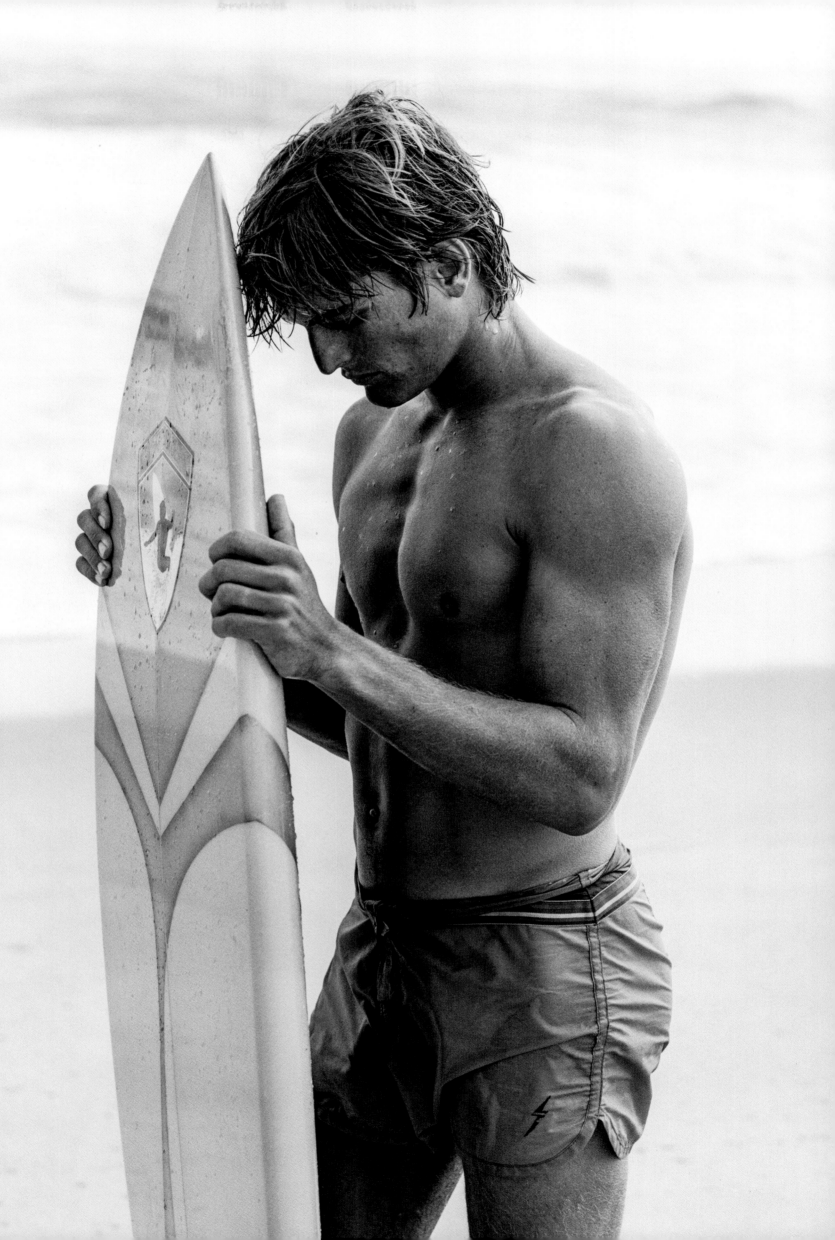

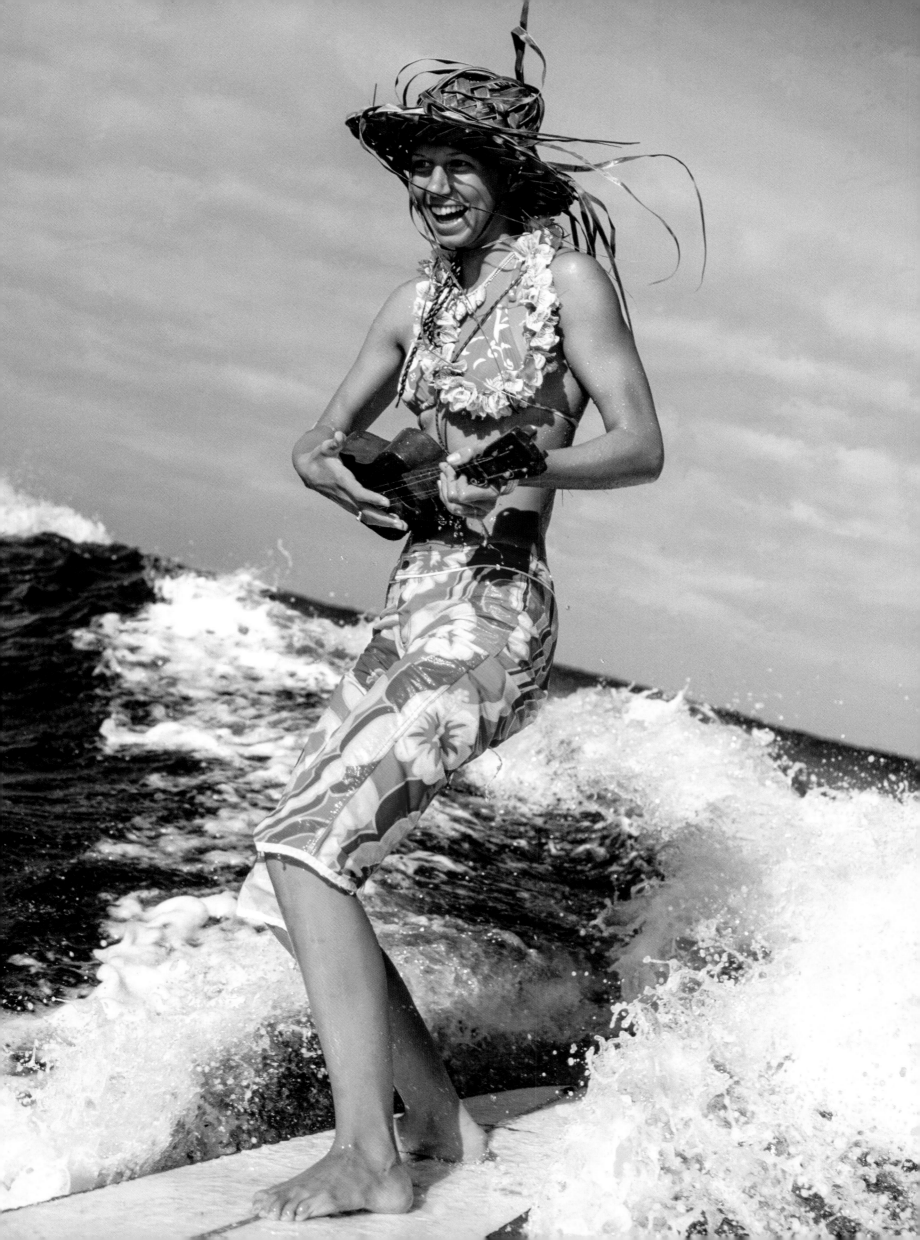

VERONICA KAY, ROXY ADVERTISING SHOOT; WAIKIKI; C. 2001 Riding on the popularity of a new breed of professional women surfers such as Lisa Andersen, surf-wear companies tapped into a huge emerging fashion market. Quiksilver was the first brand to launch a successful women's clothing line with the introduction of Roxy in 1990. *Photo, Jeff Hornbaker*

WOMEN'S SWIMSUITS *(Top and bottom left)* NÜERA, 2015; Body Glove, c. 1992

WOMEN'S BOARDSHORTS *(Top, center, and bottom right)* Roxy, 1999; Roxy, c. 2002; Roxy, c. 2000

SURF APPAREL *(Clockwise from top left)* Toes on the Nose, c. 2000; Op, c. 1989; Quiksilver, 1995; c. 2001; Off Shore, c. 1989; Hang Ten, c. 1987

ADVERTISEMENT, NIKE, 1991 By the early '90s, many mainstream sports-apparel companies were looking for a way to integrate surfing and ocean-related sports. Laird Hamilton's smoldering looks, beefcake physique, and near-superhuman surfing feats quickly made him a global surf celebrity.

4.0 Neoprene Vest

Tavarua
Tunic Top

4.0 Neoprene
Spring Suit

Hood River III
Long Short

Fiji Surf Short

Aqua Thong

Aqua Sock Plus

Aqua Sock Classic

LET X=LAIRD, SUCH THAT X WEARS REALLY COOL NIKE AQUA GEAR.

Assume a 20' wave, a 10' board, and a 6'3" surfer. If the surfer travels at a constant rate of 16 m.p.h. (sideways), registers a 96% increase in blood-adrenaline level, and somehow ignores the gnawing fear in the pit of his stomach, what color will his Fiji shorts be? Right. Just do it.

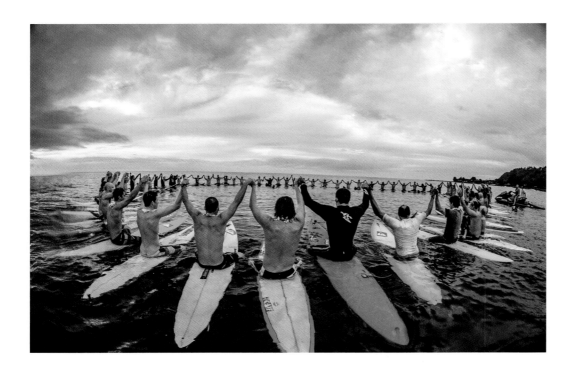

WAIMEA BAY, HAWAII, 2012 Surfers hold a pre-contest memorial paddle out in memory of fallen big-wave rider Eddie Aikau at a Quiksilver event. *Photo, Brent Bielmann*

ANDY IRONS; NORTH SHORE, HAWAII; C. 2006 Irons was a phenomenally gifted and charismatic Hawaiian surfer who won three world championships from 2002 to 2004. Off the beach, however, he struggled with bipolar disorder and drug addiction. In 2010, Irons was found dead in a hotel room in Dallas, Texas, of cardiac arrest with potentially lethal blood levels of various legal and street drugs. He was 32. *Photo, Grant Ellis*

POSTER, LEROY GRANNIS MEMORIAL PADDLE OUT, 2011 *Art, Phil Roberts*

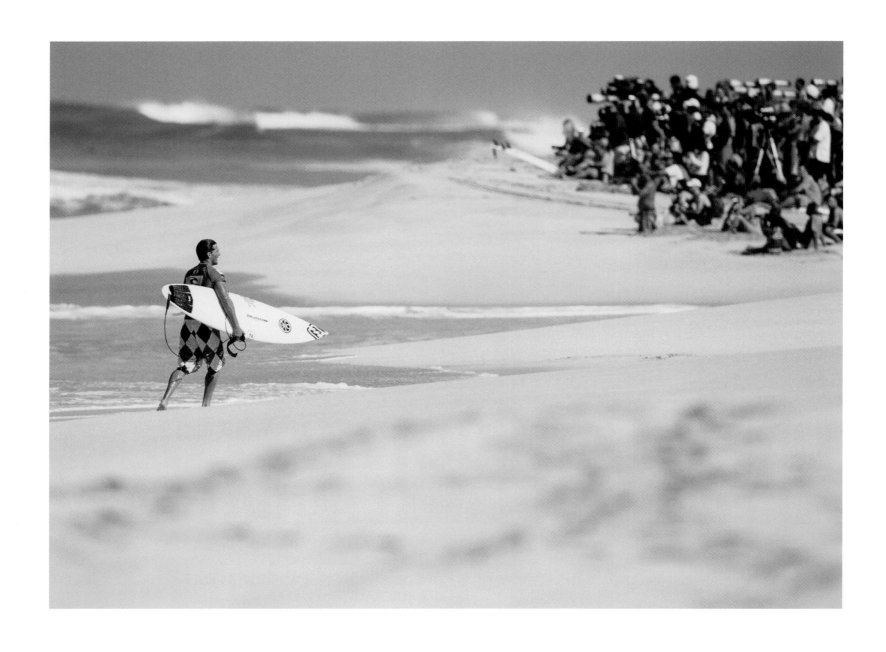

LeRoy Grannis Memorial Paddle Out Hermosa Beach June 25, 2011

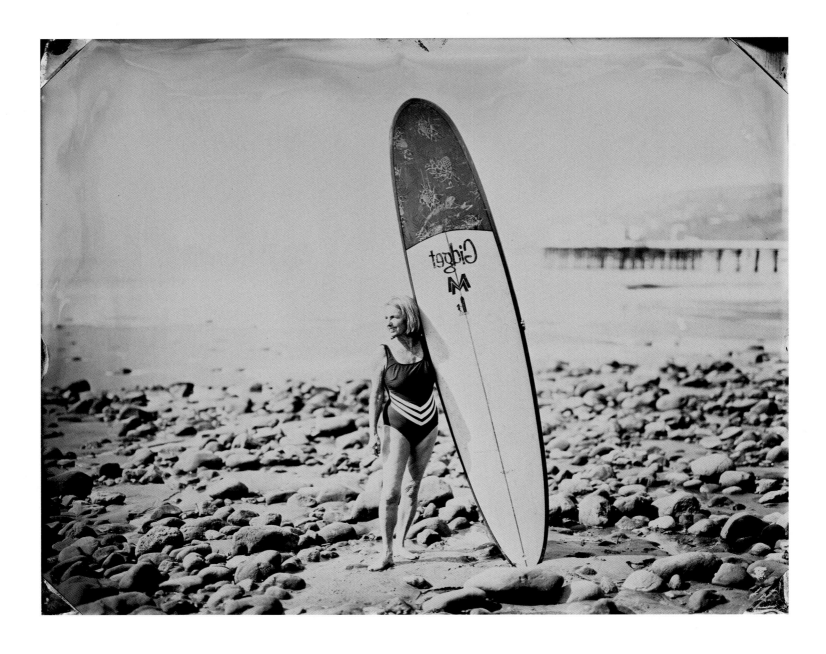

KATHY KOHNER-ZUCKERMAN, MALIBU, 2010 As an adult, Kohner-Zuckerman abandoned her Malibu surfing days, but she still continues to communicate with the waves. "Gidget" appears in reverse on her board due to the technique of the photo-printing process. *Photo, Joni Sternbach*

ADVERTISEMENT, PACIFIC COAST VINTAGE SURF AUCTION, 2005 The emergence of the surfboard as a hot commodity became the basis for lucrative auctions as surfing products and memorabilia became collectible to postwar generations.

POSTER, LUAU & LONGBOARD INVITATIONAL, 2006 *Art, John Van Hamersveld*

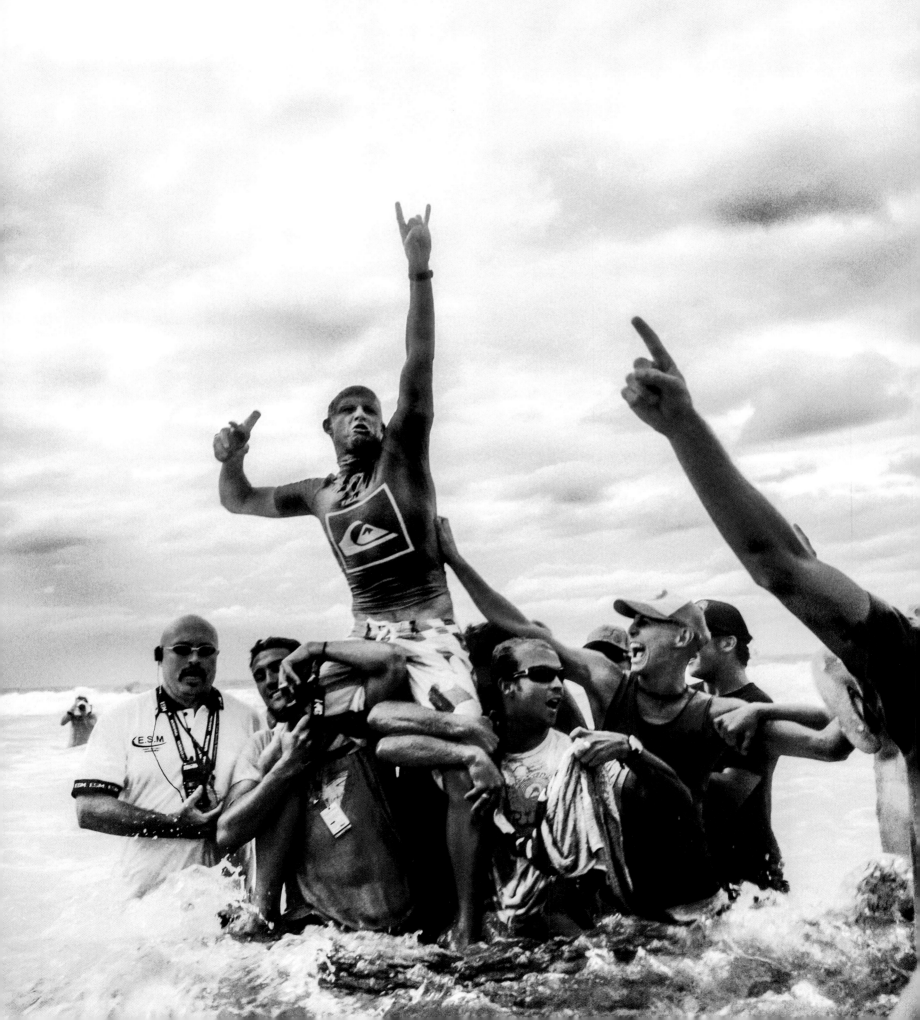

MICK FANNING, QUIKSILVER PRO;
COOLANGATTA, AUSTRALIA; 2007
Photo, Steve Sherman

POSTER, QUIKSILVER EDITION MOLOKAI-
OAHU PADDLEBOARD RACE, 2005
Art, Clive Piercy

MAVERICK'S; HALF MOON BAY, CALIFORNIA;
C. 2009 The remote location of Maverick's makes
it mainly a media event viewed in real-time on the
Internet. *Photo, Vince Street*

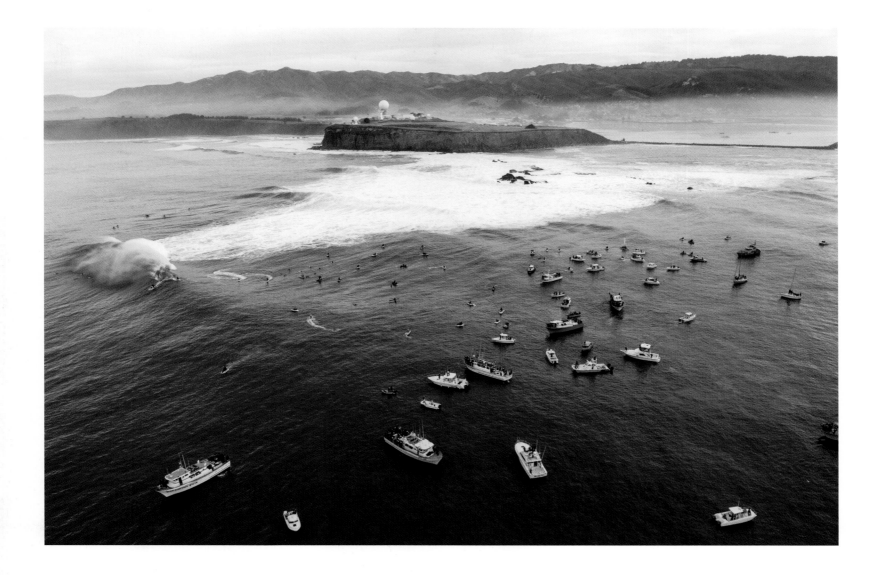

ANDY IRONS AND SHEA LOPEZ, THE SPIT; SOUTH STRADBROKE ISLAND, AUSTRALIA; 1998 Sand is regularly pumped around the entrance to the Gold Coast Seaway to keep it clear for boat traffic. The sand settles onto offshore banks that create excellent surf for local and visiting surfers. *Photo, Jim Russi*

HUNTINGTON CLIFFS, CALIFORNIA, C. 2010 *Photo, Mike Moir*

MARK HEALEY, QIANTANG TIDAL BORE; HANGZHOU, CHINA; 2008 Perhaps the most surreal wave in the world, the "Silver Dragon" tidal bore is formed when the China Sea funnels up the Qiantang River producing a massive wave up to 30 feet high. A surfer must navigate dangerous currents and submerged debris, but rides up to 20 minutes long have been recorded. *Photo, A.J. Neste*

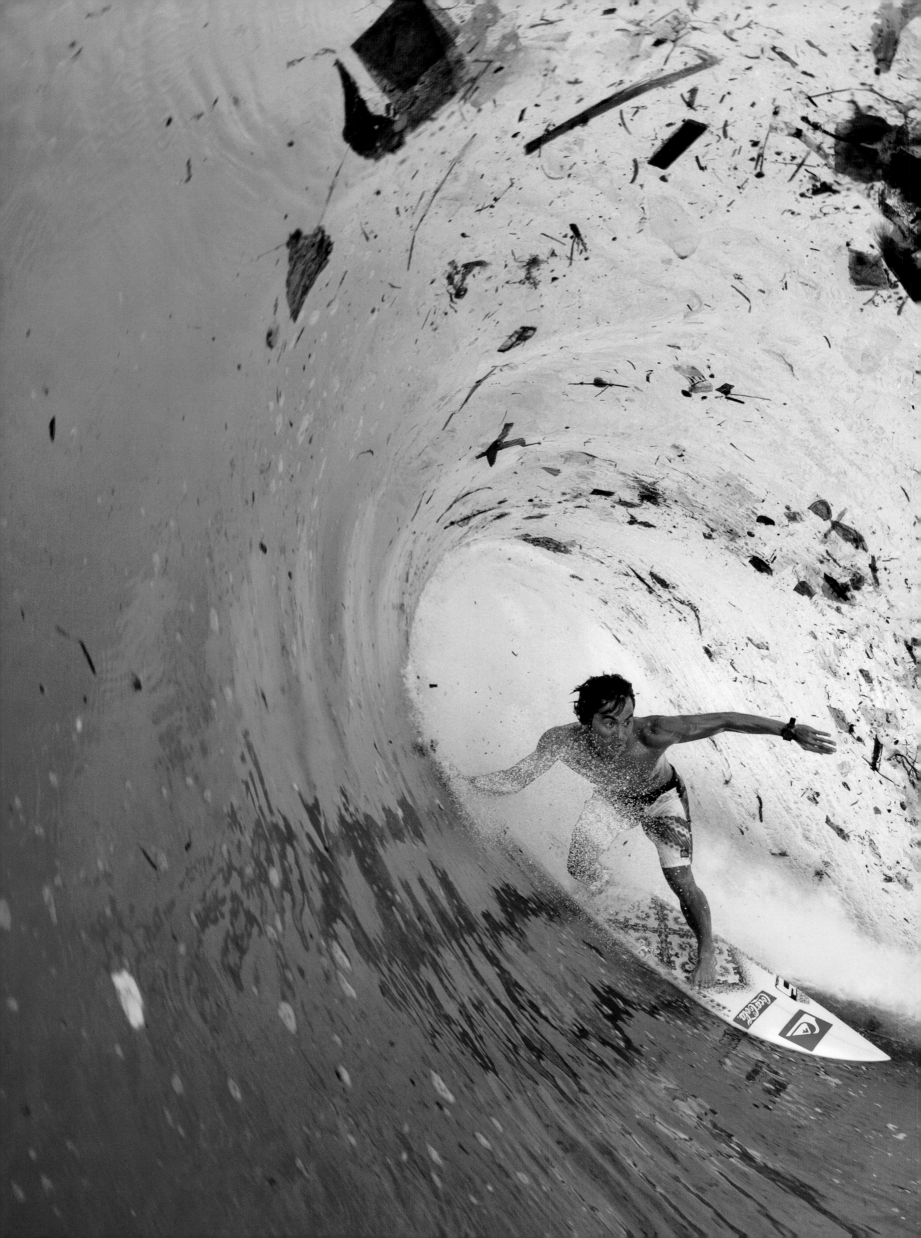

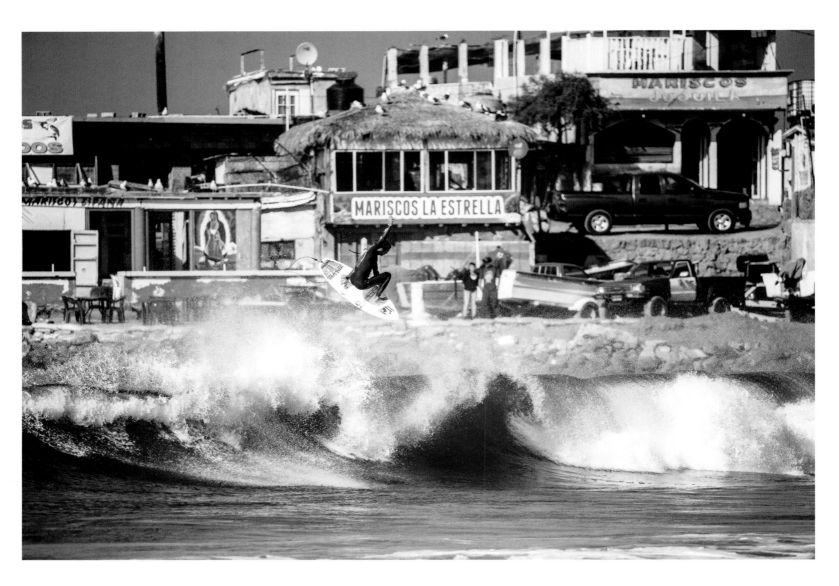

DEDE SURYANA; JAVA, INDONESIA; C. 2013 *(Pages 468–469)* Plastic pollution is a global epidemic, and is most evident in remote corners of the world where impoverished villagers dump their refuse into the sea. *Photo, Zak Noyle*

IAN CRANE; BAJA CALIFORNIA, MEXICO; 2015 Less than an hour's drive south of the border, the surf breaks of northern Baja offer a frontier surf adventure for California surfers. *Photo, Tom Carey*

INDIA, 2011 The Indian subcontinent offers more than 7,500 miles of swell-exposed coastline, yet the surfing possibilities remain virtually unexplored. *Photo, Chris Burkard*

KEITH MALLOY, NORWAY, 2012 *Photo, Chris Burkard*

BRUCE GOLD; JEFFREYS BAY, SOUTH AFRICA; 2013 Former policeman Gold came to Jeffreys Bay in the early 1970s and never left. Pictured at age 66, he is a true throwback to surfing's spiritual roots: lives simply, surfs every day, and lives by his motto, "Surf only for pleasure, never for treasure." *Photo, Grant Ellis*

JOSH MULCOY; ALEUTIAN COASTLINE, ALASKA; 2013 *(Pages 472–473)* *Photo, Chris Burkard*

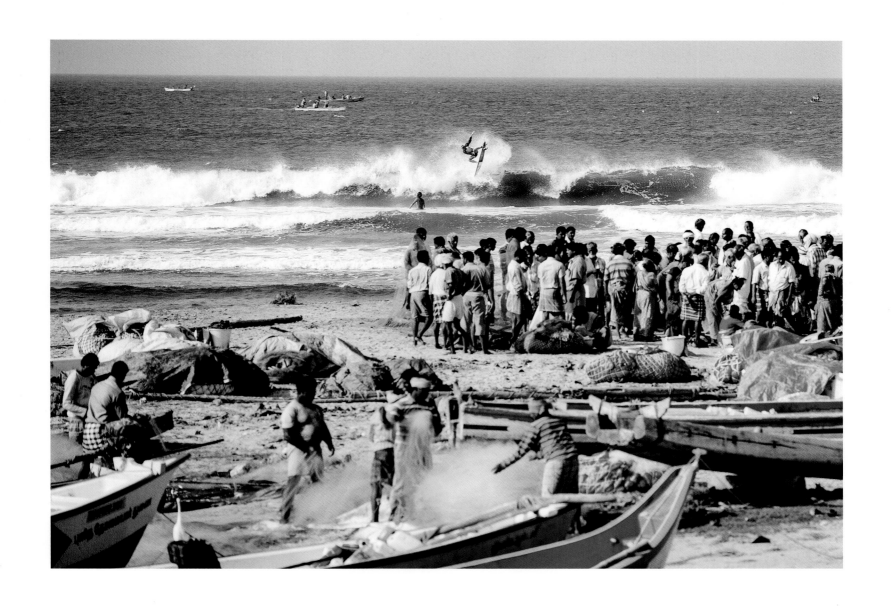

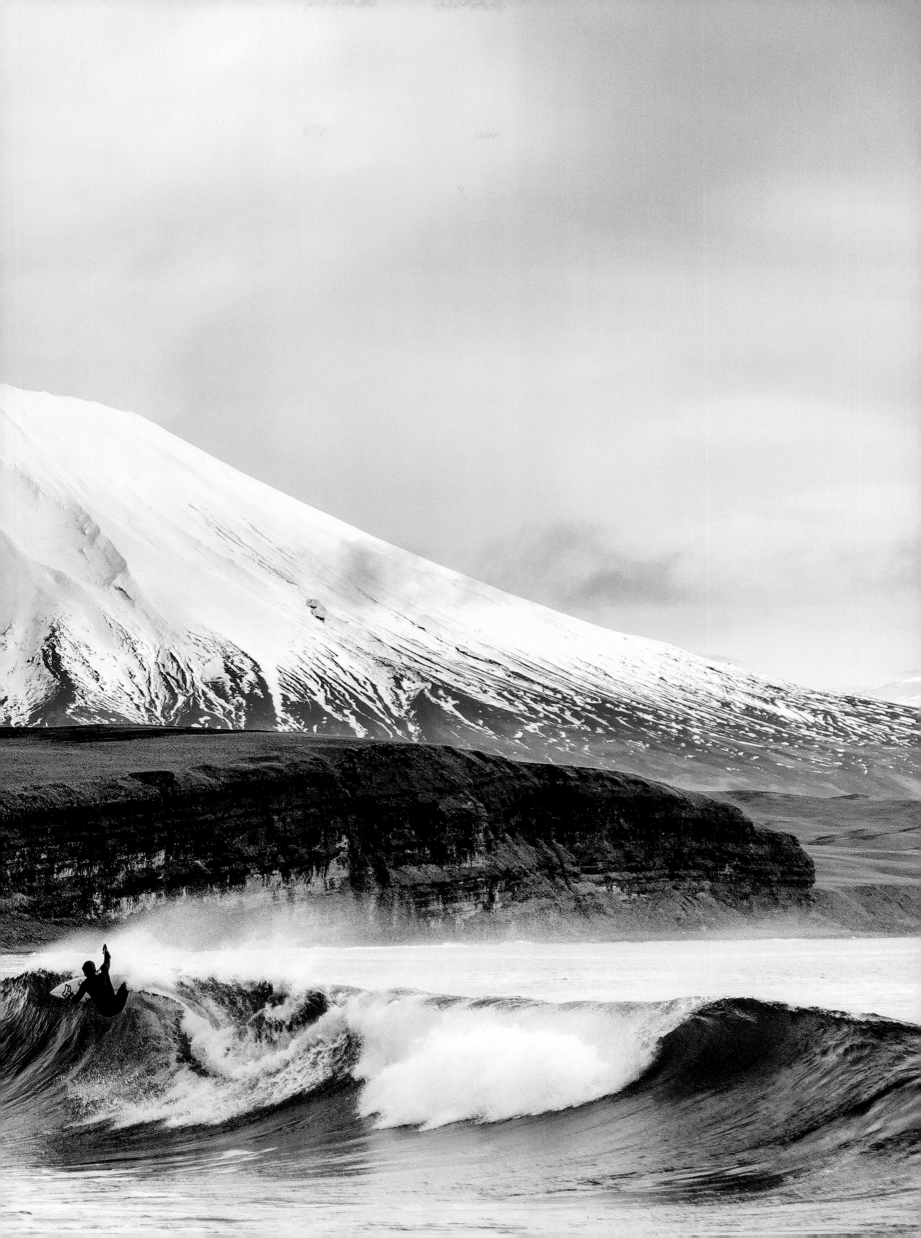

RUSSIA

THE OUTPOST

VOL. 01

ERIC SODERQUIST; JOKULSARLON LAKE, ICELAND; 2013 As the world grows smaller through GPS-mapping technology, a few surfers keep searching out the last remaining wave frontiers. With ultraefficient, modern wetsuits, waves can be ridden in icy waters only a few degrees above freezing. *Photo, Chris Burkard*

BOOK COVER, *RUSSIA*, **2013** Chris Burkard and Ben Weiland traveled into the remote wilderness of the Kamchatka Peninsula resulting in a book and documentary. *Photo, Chris Burkard*

MAGAZINE COVER, *ACID*, **2013**

DANE GUDAUSKAS, NORWAY, 2012
Water and air temperatures hover in the mid-30s Fahrenheit in Norway, leading to the phrase "ice-cube tubes." *Photo, Chris Burkard*

BOOK COVER, *SURFIN' GAZA*, **2011**
With inexpensive printing options, zines, magazines, and books have proliferated in an underground self-publishing environment.

GARRETT MCNAMARA; NAZARÉ, PORTUGAL; 2013 *(Pages 476–477)* On "Big Monday," January 28, 2013, big-wave tow-surfer McNamara broke his own Guinness World Record to successfully ride a wave many measured at 100 feet. *Photo, Tó Mané*

HAWAII, 2013 A high-speed digital strobe photo captures an aerial flip. *Photo, Zak Noyle*

MOROCCO, NORTH AFRICA, C. 2010
Photo, Alan van Gysen

FILM STILLS, *THE PRESENT,* **2009**
(Opposite) From left to right: Dave Rastovich, Michel Junod, Jacob Stuth, Alex Knost, and Shannon Sol Carroll. *Photos, Thomas Campbell*

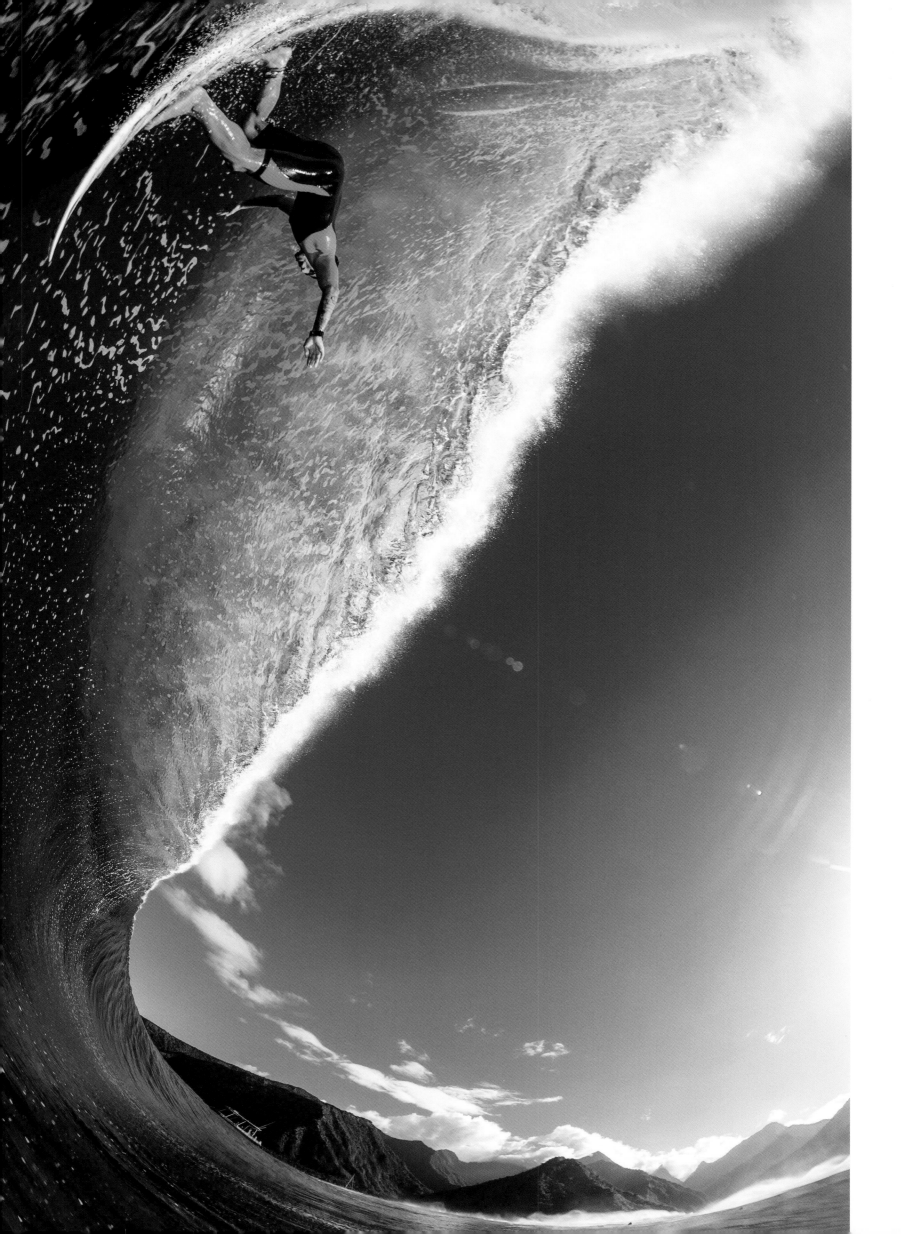

**GABRIEL MEDINA; TEAHUPO'O, TAHITI;
2014** Brazilian Medina began competing at age
nine in San Paolo, turned professional at 17, and
won the world championship at 20. He is the first
Brazilian to win a world title and the second person
in history to successfully land an aerial backflip.
Photo, Ben Thouard

**OSCAR MONCADA; PUERTO ESCONDIDO,
MEXICO; C. 2010** *Photo, Ruben Piña*

**ROBERT HENNESSY; PUERTO ESCONDIDO,
MEXICO; 2007** In what seems to be an impossible
shot, the lip of the wave appears ready to annihilate
the photographer in what became a *SURFER* Poll
Photo of the Year. *Photo, Scott Aichner*

**NATHAN FLETCHER; TEAHUPO'O, TAHITI;
2011** *(Pages 482–483) Photo, Pat Stacy*

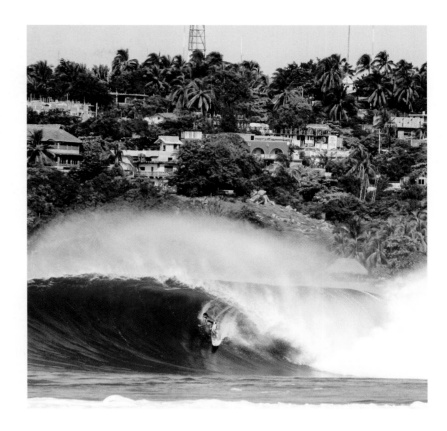

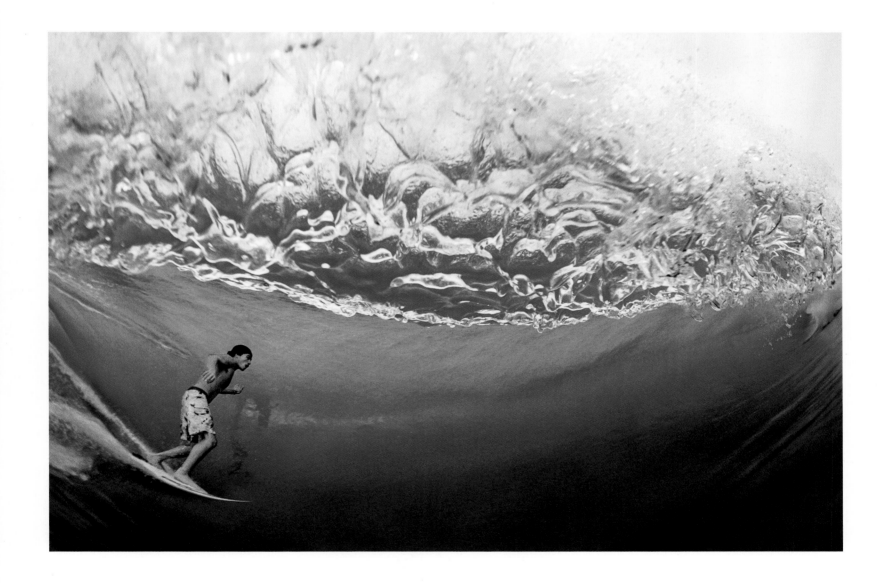

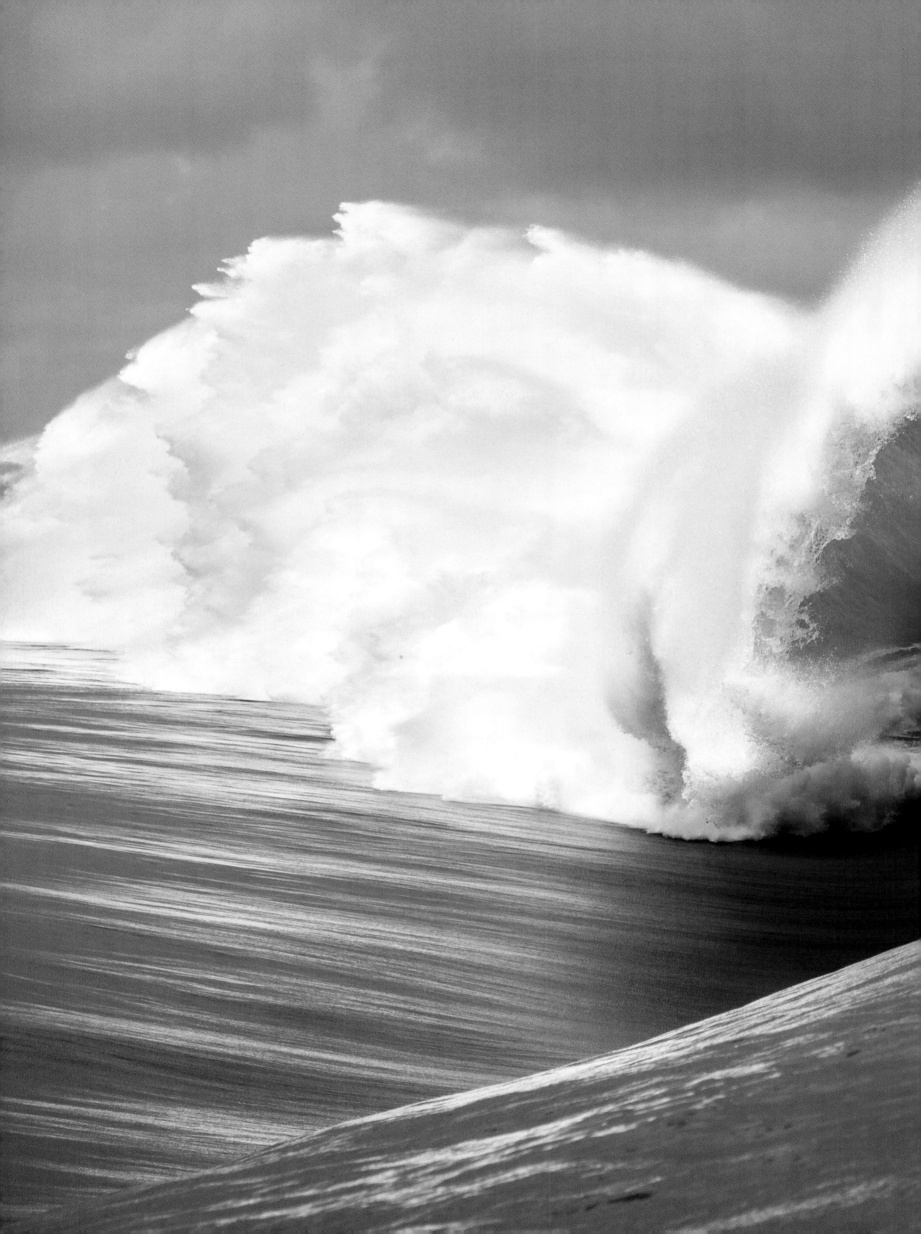

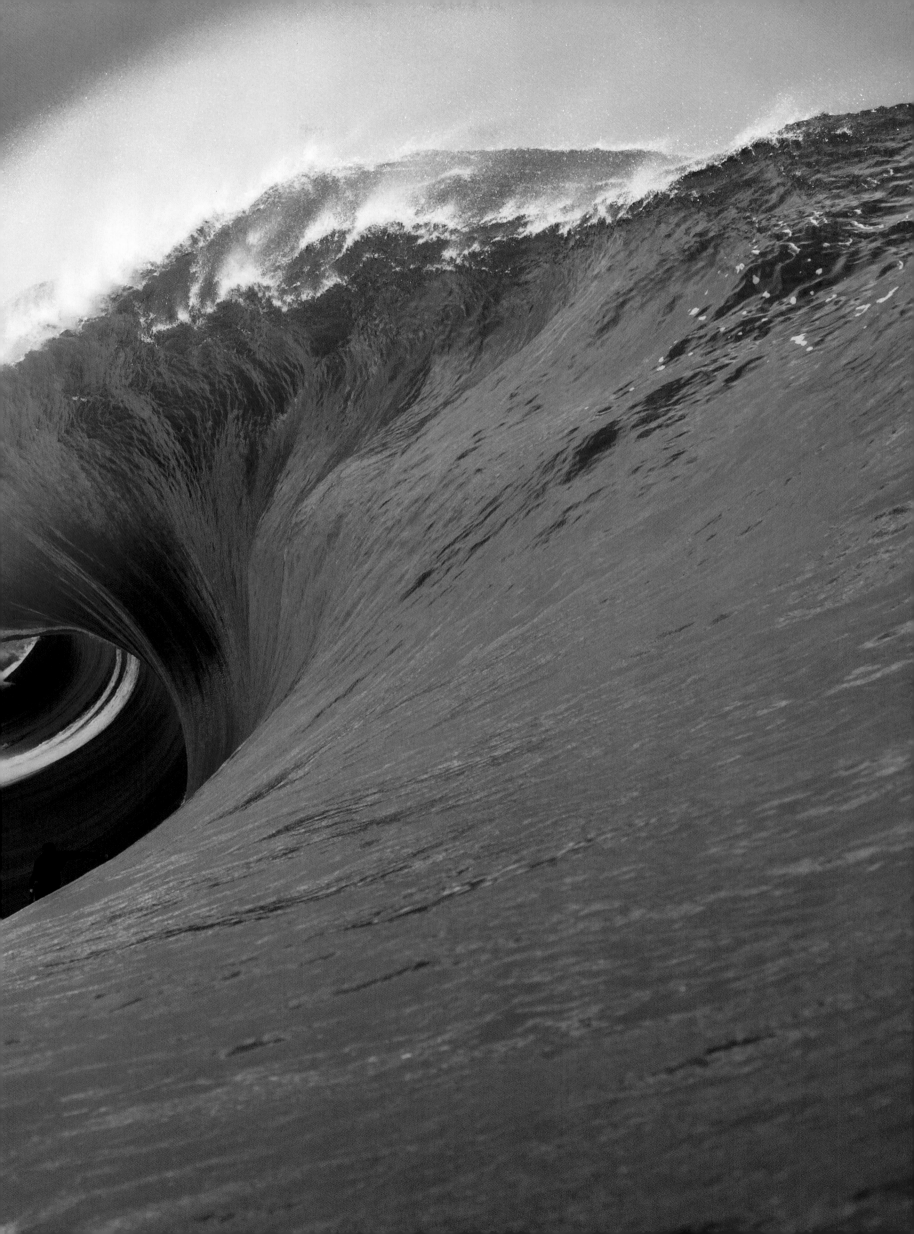

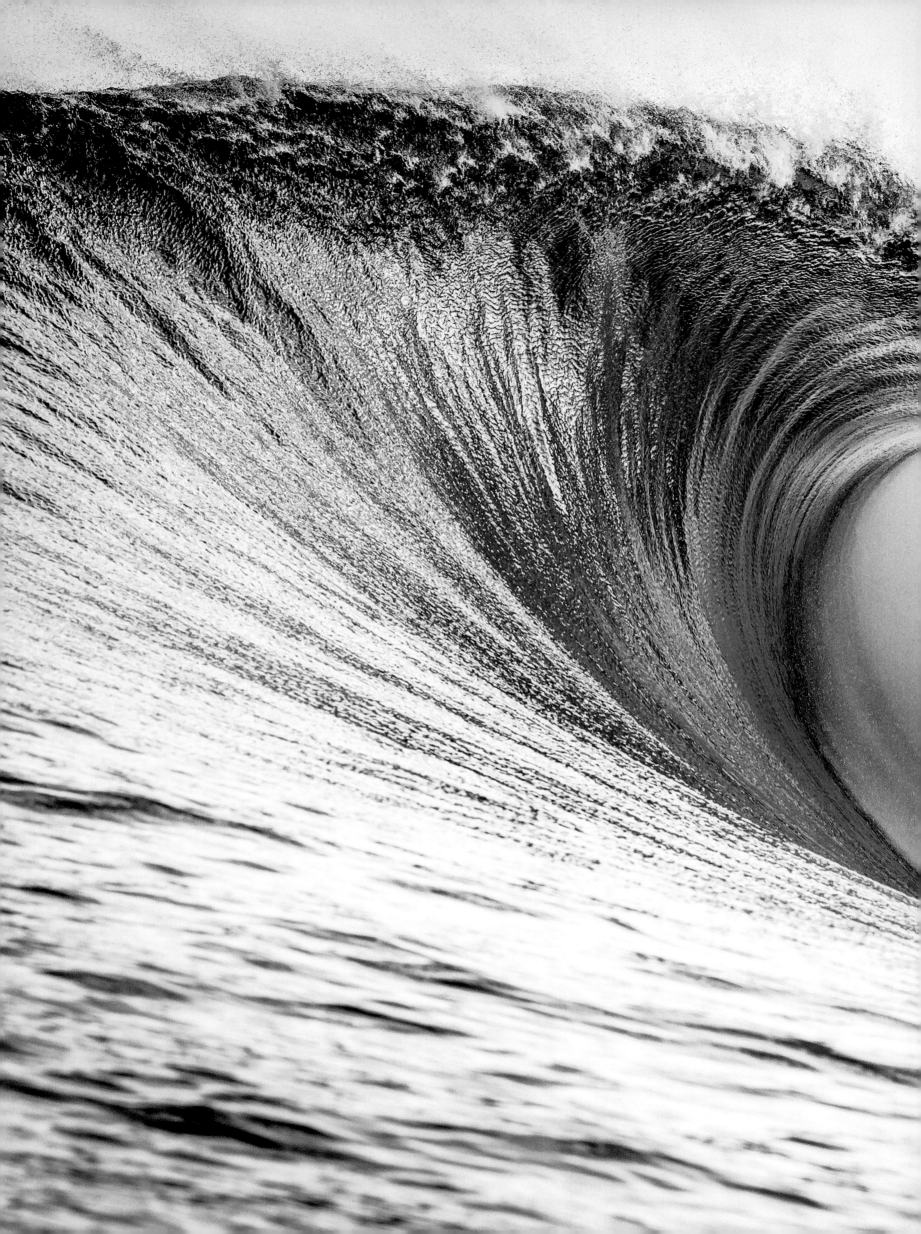

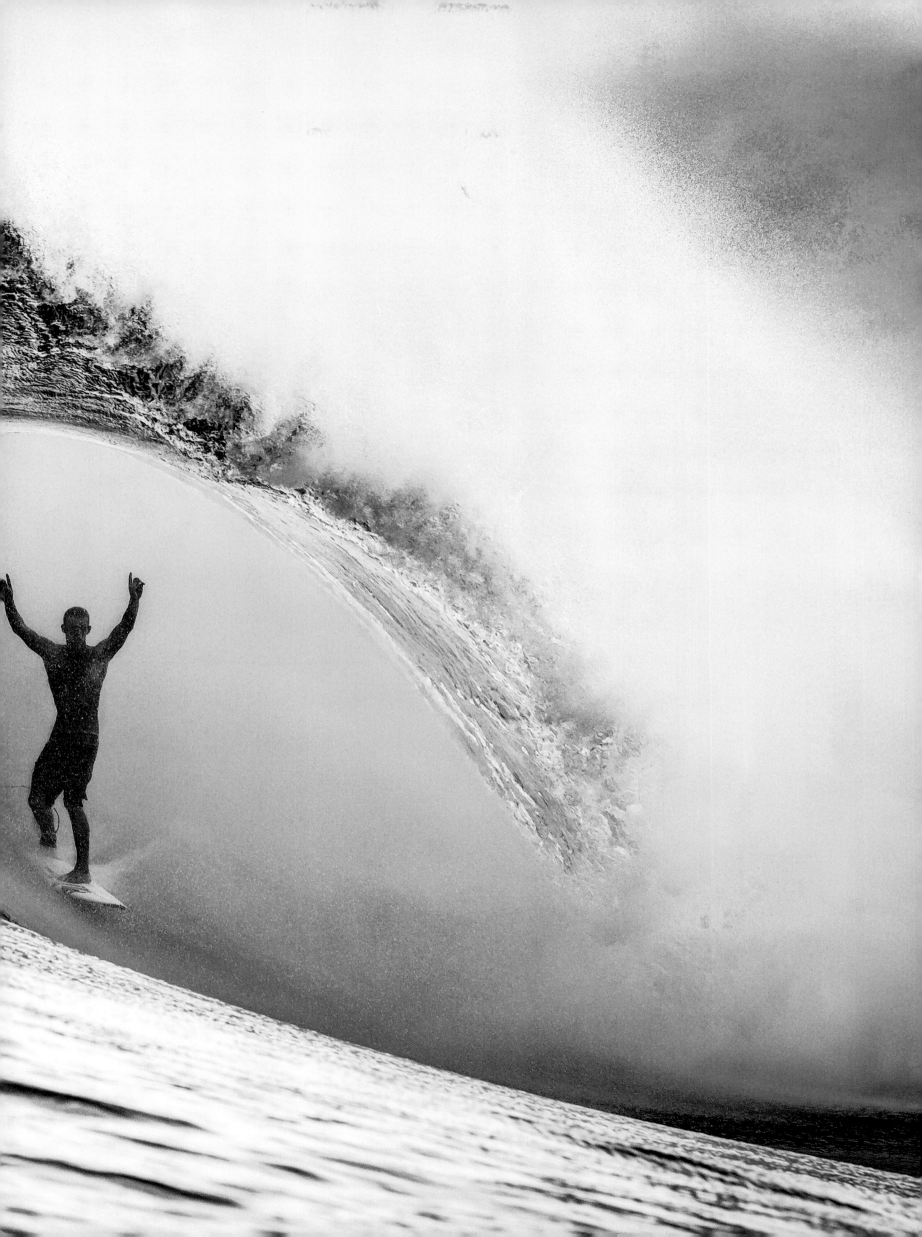

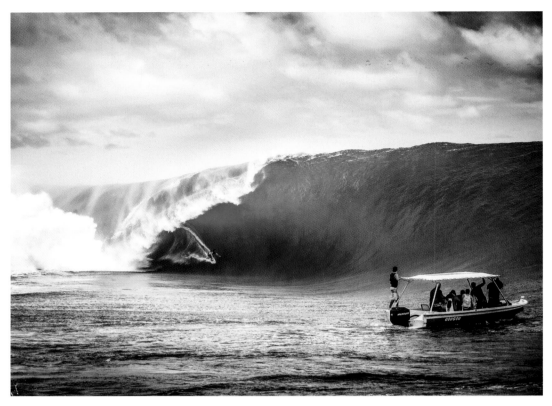

JOHN JOHN FLORENCE; TAHITI; 2012
(Pages 484–485) Top-ranked surfer and Triple Crown champion John John Florence continues to chalk up accolades as one of the best surfers of the new millennium. *Photo, Ben Thouard*

**RAIMANA VAN BASTOLAER;
TEAHUPO'O, TAHITI; 2013**
Photo, Ben Thouard

TEAHUPO'O, TAHITI, C. 2010
Photo, Tyler Cuddy

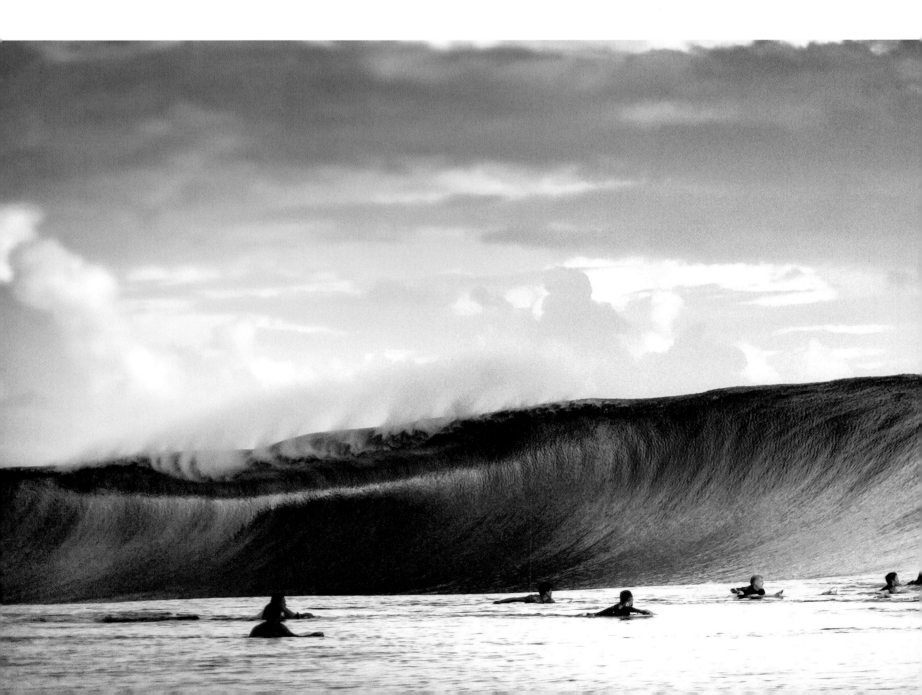

NATHAN FLETCHER; TEAHUPO'O, TAHITI; 2011 Shot during the giant "Code Red" August swell, this monster wave earned Fletcher the Heavy Water Award from *SURFER* and was featured on seven magazine covers. *Photo, Ben Thouard*

NORTH SHORE, HAWAII, C. 2012
(Pages 488–489) A "staircase set" stacks up at Pipeline. *Photo, Aaron Checkwood*

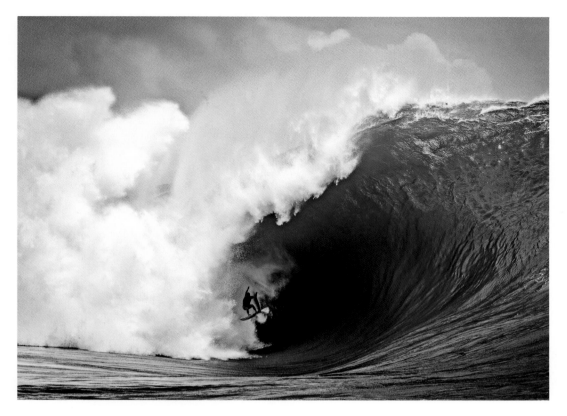

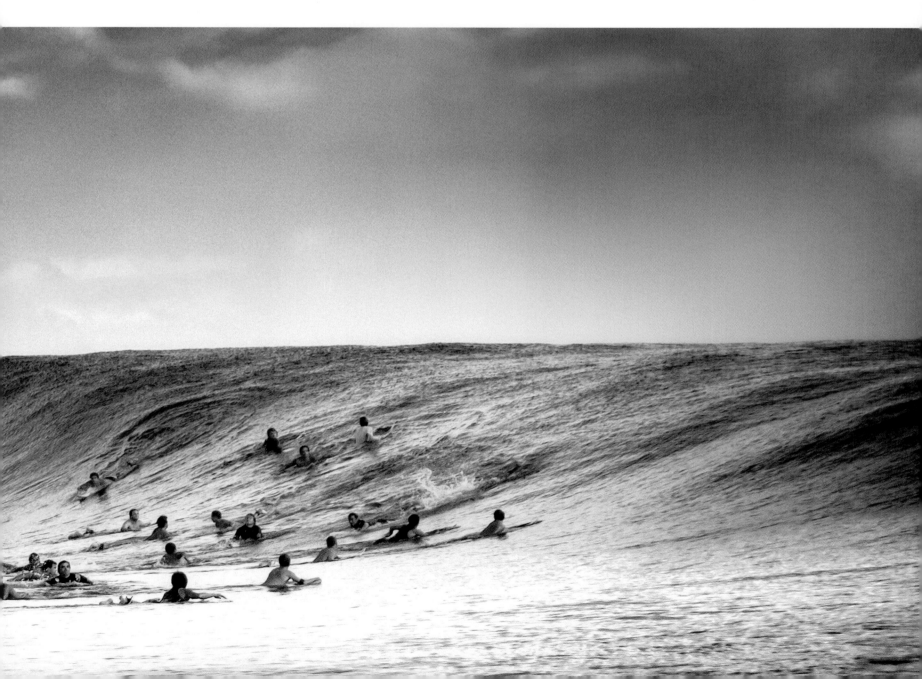

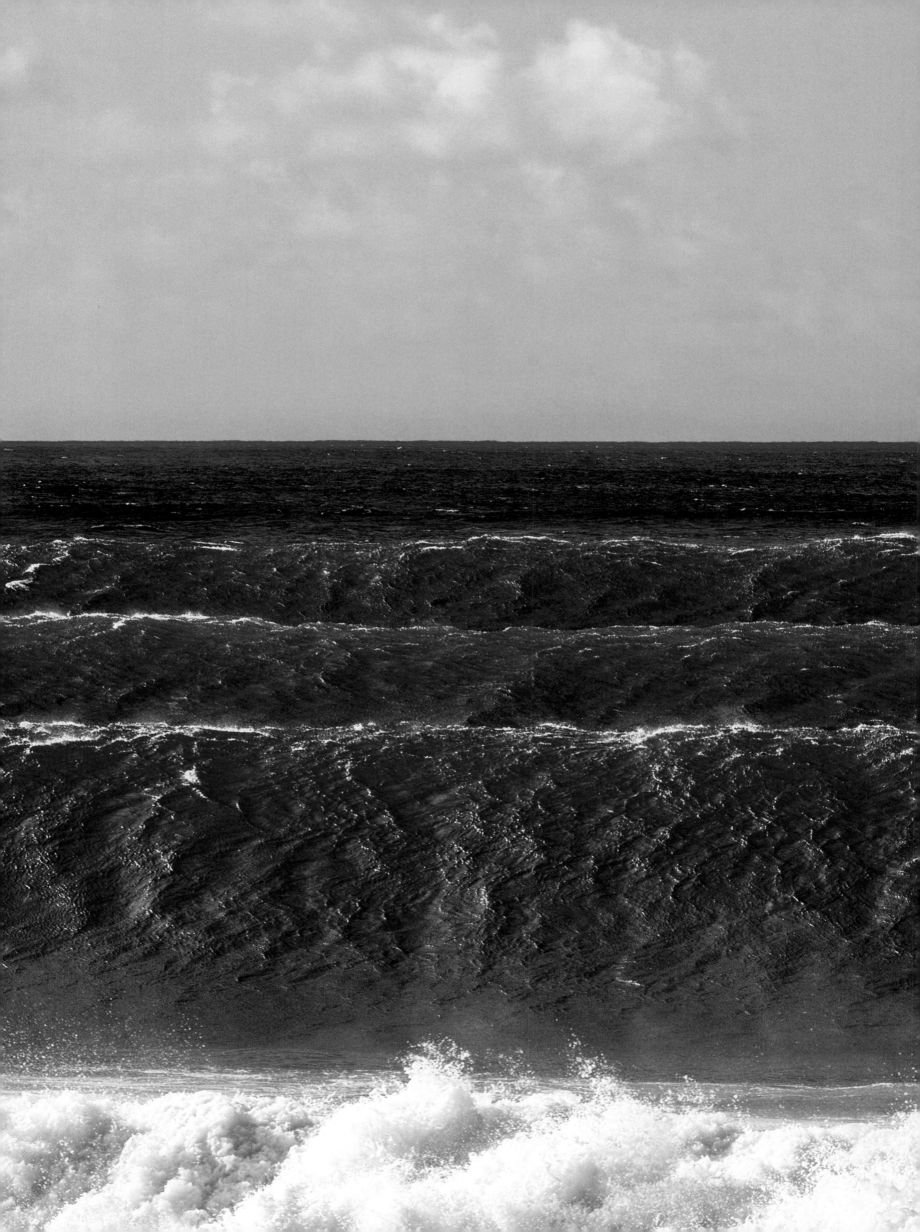

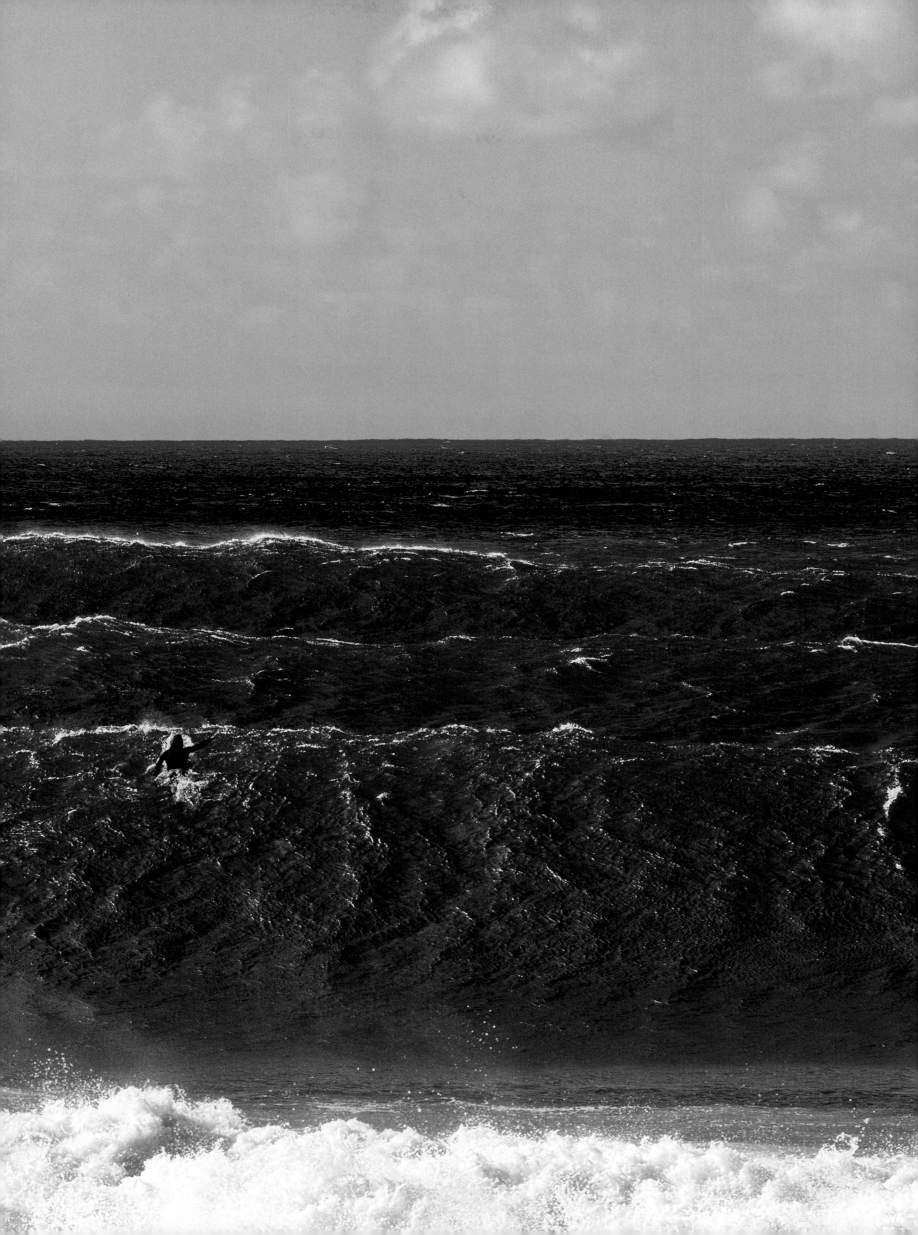

THE EVOLUTION OF THE
SURFBOARD
1900-TODAY

FROM THE COLLECTION OF THE SURFING HERITAGE & CULTURE CENTER

Nothing in the history of sports quite compares to the evolution of the surfboard. From discarded logs to massive redwood planks, to balsa and polyurethane boards, and most recently, the use of environmentally sustainable materials in algae-based blanks, the surfboard—and with it the surfing experience—has been progressively altered for superior speed and performance.

The Surfing Heritage & Culture Center houses a comprehensive representation of the sport's central element: the surfboard. Showcasing not only boards significant in their development, but models that defined the sport by its popularity or notoriety, SHACC's collection reveals the continuous attempt to make the board an extension of the surfer. With more than 500 boards in their possession, the history of the surfboard is secure.

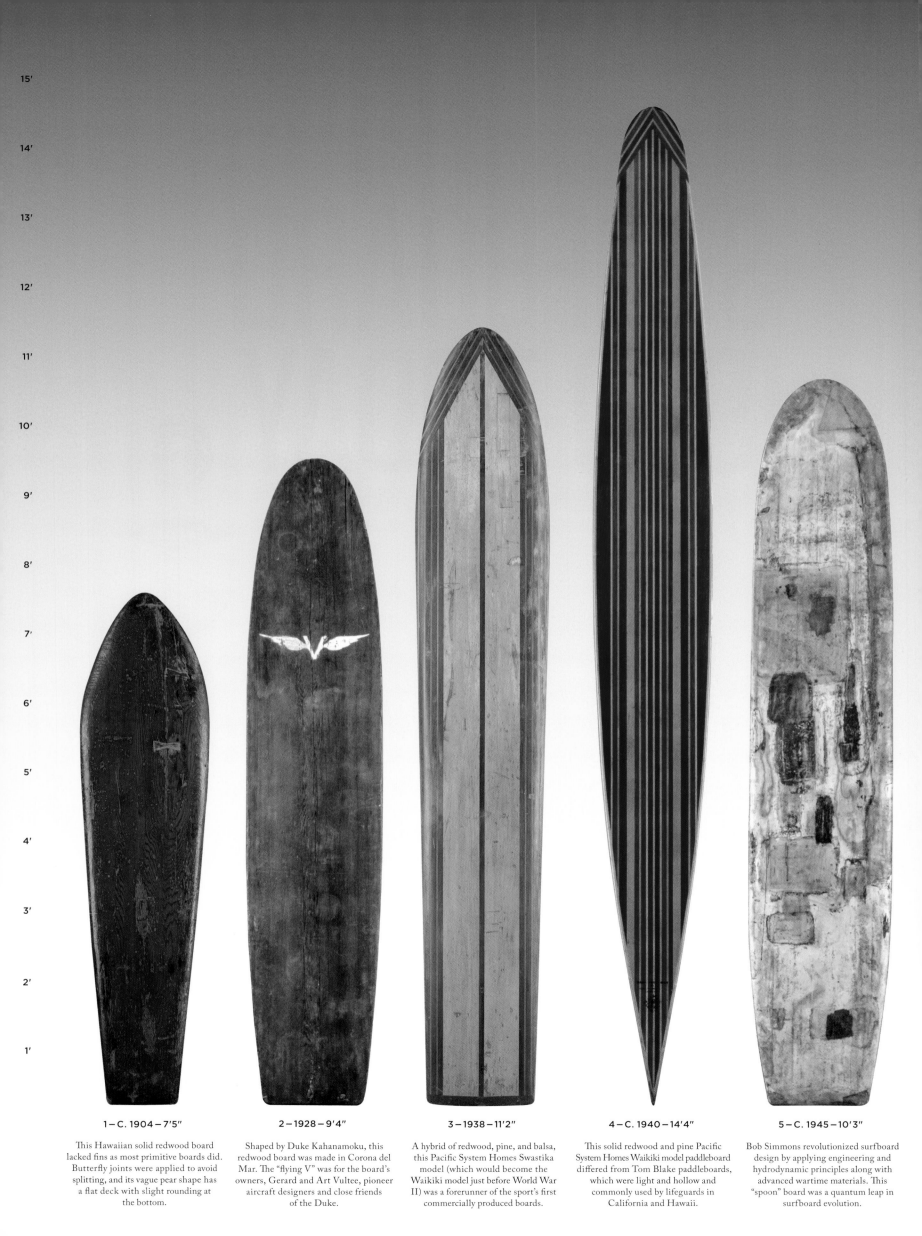

15'
14'
13'
12'
11'
10'
9'
8'
7'
6'
5'
4'
3'
2'
1'

1 – C. 1904 – 7'5"

This Hawaiian solid redwood board lacked fins as most primitive boards did. Butterfly joints were applied to avoid splitting, and its vague pear shape has a flat deck with slight rounding at the bottom.

2 – 1928 – 9'4"

Shaped by Duke Kahanamoku, this redwood board was made in Corona del Mar. The "flying V" was for the board's owners, Gerard and Art Vultee, pioneer aircraft designers and close friends of the Duke.

3 – 1938 – 11'2"

A hybrid of redwood, pine, and balsa, this Pacific System Homes Swastika model (which would become the Waikiki model just before World War II) was a forerunner of the sport's first commercially produced boards.

4 – C. 1940 – 14'4"

This solid redwood and pine Pacific System Homes Waikiki model paddleboard differed from Tom Blake paddleboards, which were light and hollow and commonly used by lifeguards in California and Hawaii.

5 – C. 1945 – 10'3"

Bob Simmons revolutionized surfboard design by applying engineering and hydrodynamic principles along with advanced wartime materials. This "spoon" board was a quantum leap in surfboard evolution.

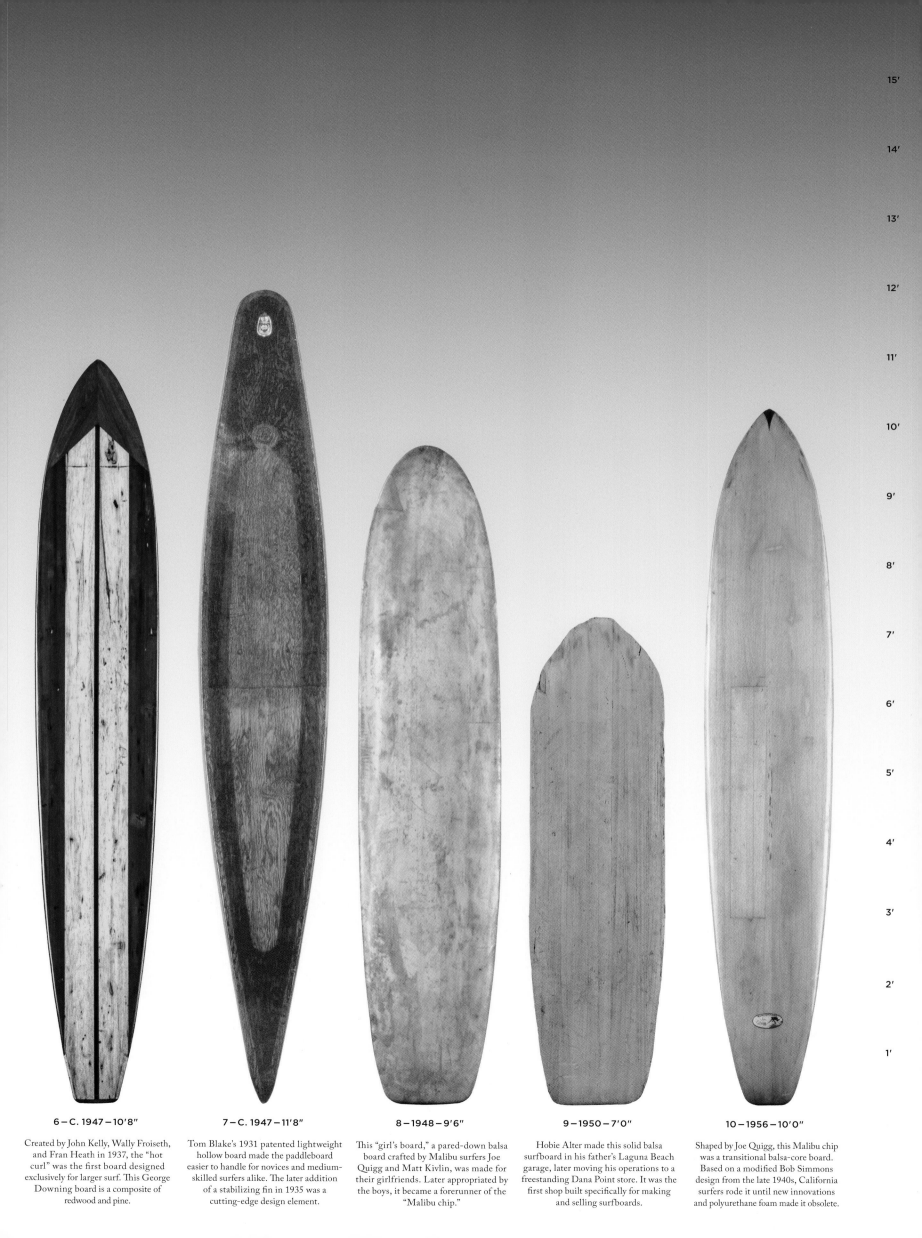

15'

14'

13'

12'

11'

10'

9'

8'

7'

6'

5'

4'

3'

2'

1'

6 – C. 1947 – 10'8"

Created by John Kelly, Wally Froiseth, and Fran Heath in 1937, the "hot curl" was the first board designed exclusively for larger surf. This George Downing board is a composite of redwood and pine.

7 – C. 1947 – 11'8"

Tom Blake's 1931 patented lightweight hollow board made the paddleboard easier to handle for novices and medium-skilled surfers alike. The later addition of a stabilizing fin in 1935 was a cutting-edge design element.

8 – 1948 – 9'6"

This "girl's board," a pared-down balsa board crafted by Malibu surfers Joe Quigg and Matt Kivlin, was made for their girlfriends. Later appropriated by the boys, it became a forerunner of the "Malibu chip."

9 – 1950 – 7'0"

Hobie Alter made this solid balsa surfboard in his father's Laguna Beach garage, later moving his operations to a freestanding Dana Point store. It was the first shop built specifically for making and selling surfboards.

10 – 1956 – 10'0"

Shaped by Joe Quigg, this Malibu chip was a transitional balsa-core board. Based on a modified Bob Simmons design from the late 1940s, California surfers rode it until new innovations and polyurethane foam made it obsolete.

15'

14'

13'

12'

11'

10'

9'

8'

7'

6'

5'

4'

3'

2'

1'

11 – C. 1963 – 9'6"

The switch to polyurethane boards by Hobie Alter, along with foam-blank producer Gordon Clark in 1958, signaled a new era in surfboard manufacturing. This board is from the era after the "Easter egg" models.

12 – C. 1964 – 9'6"

As a prime example of the quintessential style of the early 1960s, this Roberts surfboard displays all the characteristics associated with one of the golden eras of surfing.

13 – 1966 – 9'10"

Miki Dora's signature model was marketed with his nickname, Da Cat. Produced by Greg Noll, this board was highly publicized in a series of controversial advertisements making it highly desirable for collectors.

14 – 1966 – 9'6"

Displaying graphics indicative of the time, this Dewey Weber Performer model is a psychedelic timepiece. Its quintessential longboard shape made it the most popular board ever produced for Weber.

15 – C. 1967 – 8'4"

Assisted by Johnny Fain, this board shows Greg Noll's attempt at transitioning to the shortboard revolution. Production was short-lived and Noll eventually moved to Northern California.

15'

14'

13'

12'

11'

10'

9'

8'

7'

6'

5'

4'

3'

2'

1'

16 — C. 1968 — 7′5″

A master of shortboard design, Dick Brewer left the major surfboard manufacturers to strike out on his own, creating the Hanapepe mini gun. His designs parallel the emergence of the soul surfer.

17 — 1968 — 5′3″

Handmade and experimental, the Velo SS Hull spoon kneeboard accelerated the shortboard revolution. Made by George Greenough, the Velo was molded to fit the wave and flexed just like the fins did.

18 — 1969 — 7′0″

By the late '60s, dramatic changes in the mindset of surfers replaced the longboard overnight. This Surfboards Hawaii board represents that transition. Its removable fin box allowed the changing of fins to fit one's style.

19 — 1969 — 6′7″

With psychedelic decorations by "Starman" and shaped by Mike Hynson for Brotherhood of Eternal Love founder John Gale, this board combined a low rail with a hard edge, and was a significant contribution to the shortboard.

20 — C. 1970 — 8′4″

This Bing board, made during the transitional period from longboard pintails to "pocket rockets," is similar to the Dick Brewer-designed mini guns. Built for speed, it is a forerunner to the Bing Lotus model.

15'

14'

13'

12'

11'

10'

9'

8'

7'

6'

5'

4'

3'

2'

1'

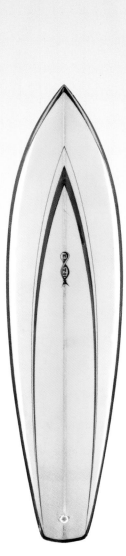

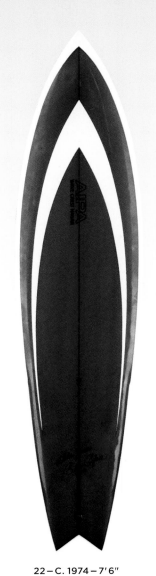

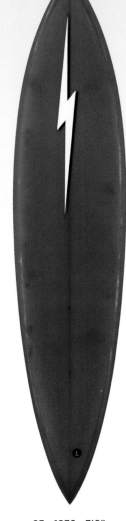

21—1973—6'6"

Inspired by Wayne Lynch's moves in *Evolution*, the Campbell brothers created the "bonzer" in their parents' Oxnard garage. They used George Greenough's kneeboard principles and added three fins to complete the job.

22—C. 1974—7'6"

In an era dominated by Hawaiians, this Ben Aipa–shaped Sting model allowed for skateboard-style moves, opening the door to a new school of surfing.

23—1976—7'8"

Shaped by Gerry Lopez, this rounded pintail was characteristic of his surf company, Lightning Bolt. His casual, Zen-like style and perfectly synchronized moves made him the master of Pipeline.

24—1977—15'0"

Mickey Muñoz built this "Ah-woo" gun for Flippy Hoffman to ride the outer reefs on the North Shore. Built from scrapped Clark Foam blanks with two redwood stringers down the center, this super gun was a futuristic concept.

25—1981—5'9.5"

Built by Simon Anderson, this early tri-fin "thruster" was energetically copied worldwide. It became the performance board of choice for surfers for decades to come.

15'

14'

13'

12'

11'

10'

9'

8'

7'

6'

5'

4'

3'

2'

1'

26 – 1981 – 6' 1"

27 – C.1990 – 8' 0"

28 – 1996 – 7' 0"

29 – 2003 – 7' 6"

30 – 2009 – 6' 9"

The shorter, wider design of this Mark Richards twin-fin model allowed for looser, tighter turns, a design that freed up surfing. Giving way to the thruster, it was short-lived, but had an enormous impact on surfing.

Tom Carroll's personal swallowtail Mini Gun featured a sleek, needle-looking design that worked perfectly for the intense waves of Pipeline and Backdoor.

Tow-in surfing was the logical next step to tackle waves that were too large and too fast to paddle into. Built for Laird Hamilton by Gerry Lopez, this board was specifically designed for tow-ins.

This modern-day "fun board" was produced by *The Endless Summer* standout Robert August and shaped by Mark Martinson for another star of the film, Robert "Wingnut" Weaver.

With four horizontal fins and two holes through the board, the experimental Spitzer Boattail is exemplary of the drive to push boundaries and innovate.

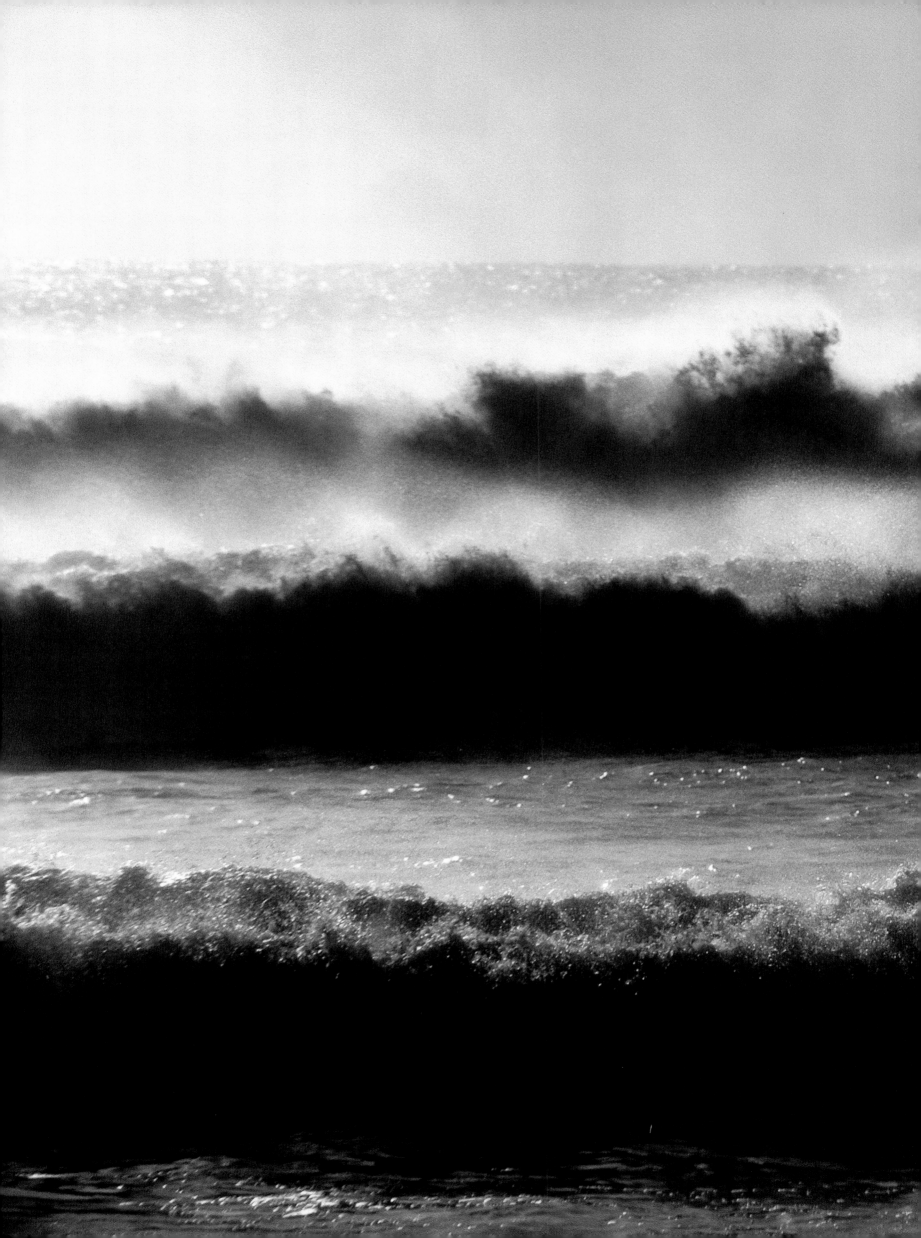

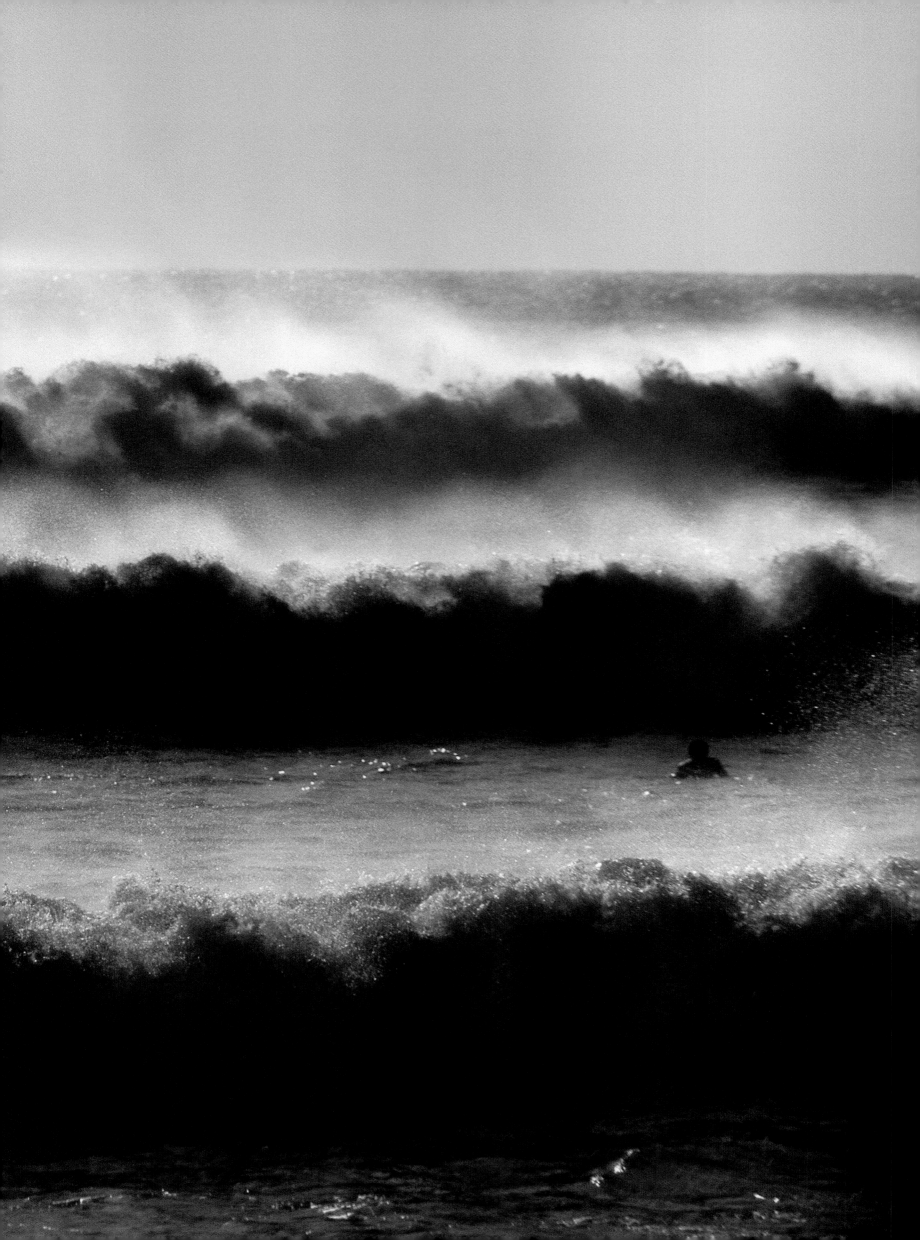

INDEX

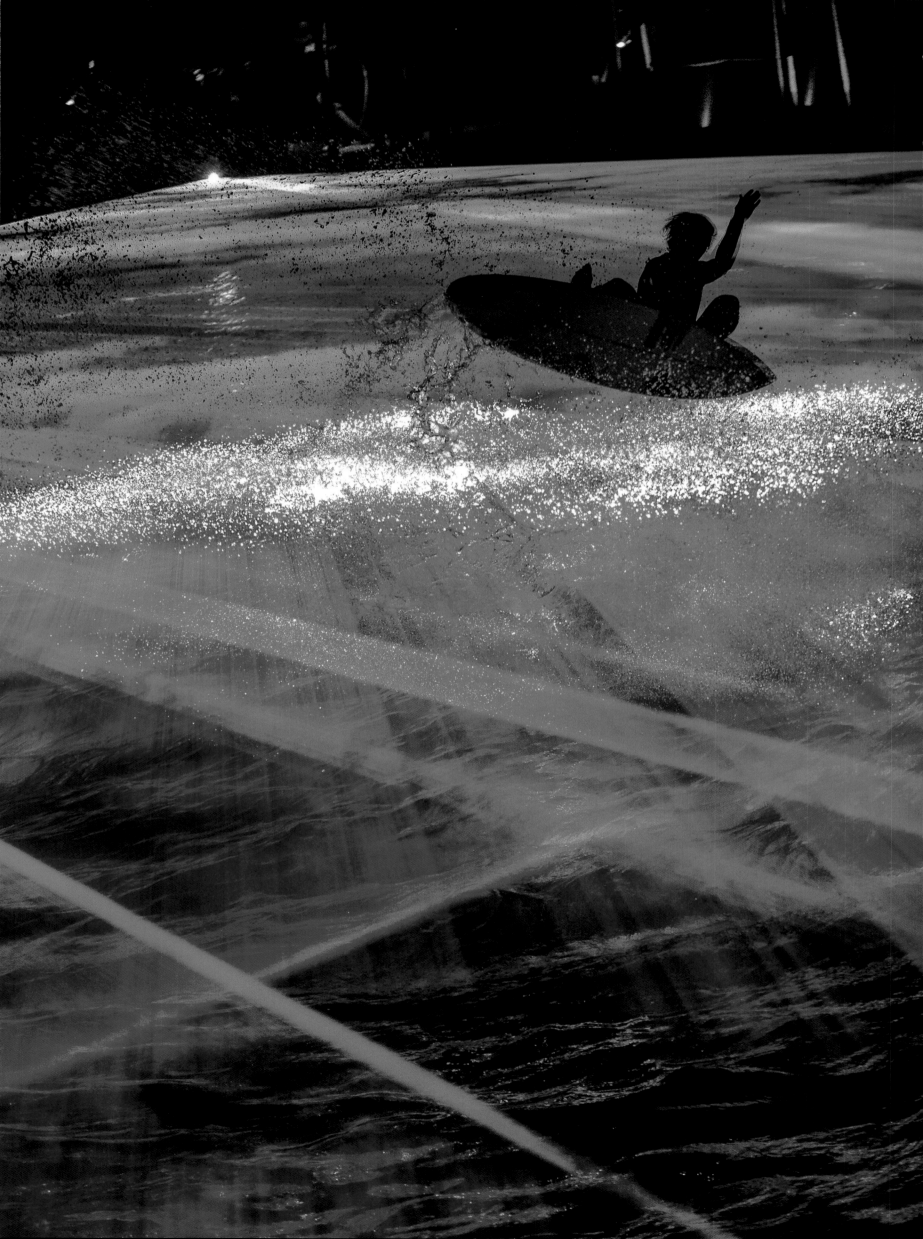

BIBLIOGRAPHY

Adler, Tom, Craig Stecyk, eds., and Sam George. *Surf Life: 32 TO 02*. Santa Barbara: T. Adler Books, 2002.

Adler, Tom, ed. *An Uncommon Archive*. Santa Barbara, CA: T. Adler Books, 2014.

Aguirre, David. *Waterman's Eye: Emil Sigler – Surfing San Diego to San Onofre, 1928–1940*. San Diego: Tabler and Wood, 2007.

Akira, Kobayashi. *P.O.P. from Venice West to Malibu 1969–1974*. Japan: Bueno! Books, 2006.

Anderson, Jerry, et al. *Between the Lines: The True Story of Surfers during the Vietnam War*. Cardiff-by-the-Sea, CA: Headline Graphics, 2008.

Bayless, Kenneth M., ed. *Petersen's Surfing Yearbook, Number Two*. Los Angeles: Petersen Pub., 1965.

Bayless, Kenneth M., ed. *Petersen's Surfing Yearbook, Number Three*. Los Angeles: Petersen Pub., 1966.

Bies, Frank. "Surf Wars." *New West*, May 1981.

Bingham, Hiram. *Sandwich Islands*. New York: Sherman Converse, 1848.

Blackburn, Mark. *Hawaiiana: The Best of Hawaiian Design*. Atglen, PA: Schiffer Pub., 2001.

Blackburn, Mark. *Hula Girls & Surfer Boys, 1870–1940*. Atglen, PA: Schiffer Pub., 2000.

Blackburn, Mark. *Surf's Up: Collecting the Longboard Era*. Atglen, PA: Schiffer Pub., 2001.

Blake, Thomas. "Surfriding in Hawaii." *Paradise of the Pacific*, December 1931.

Blake, Thomas. "Waves and Thrills at Waikiki." *The National Geographic Magazine*, May 1935.

Blake, Thomas. *Hawaiian Surfriding: The Ancient and Royal Pastime*. Flagstaff, AZ: Northland Press, 1963.

Blake, Tom. "Riding the Breakers!" *Popular Mechanics*, July 1937.

Blake, Tom. *Tom Blake Scrapbook*. Newport Beach, CA: Croul Publications, 2014.

Bolster, Warren. *Masters of Surf Photography: Warren Bolster*. San Clemente, CA: Surfer's Journal, 2002.

Booth, Douglas. *Surfing: The Ultimate Guide*. Santa Barbara, CA: Greenwood, 2011.

Boyd, Duke, Jeff Divine, and Steve Pezman. *Legends of Surfing: The Greatest Surfriders from Duke Kahanamoku to Kelly Slater*. Minneapolis, MN: MVP, 2009.

Braun, Kenny, and Stephen Harrigan. *Surf Texas*. Austin, TX: University of Texas Press, 2014.

Brennan, Joe. *Duke of Hawaii*. New York: Ballantine Books, 1968.

Brennan, Joe. *Waikiki Beachboy*. Philadelphia: Chilton, 1962.

Brewer, Art. *Masters of Surf Photography: Art Brewer*. San Clemente, CA: Surfer's Journal, 2001.

Brisick, Jamie. *Have Board, Will Travel: The Definitive History of Surf, Skate, and Snow*. New York: Harper Entertainment, 2004.

Brisick, Jamie. *We Approach Our Martinis with Such High Expectations*. Los Angeles: Consafos, 2002.

Brown, DeSoto. *Surfing: Historic Images from Bishop Museum Archives*. Honolulu, HI: Bishop Museum, 2006.

Burkard, Chris. *Distant Shores Surfing the Ends of the Earth*. Los Angeles: AMMO Books, 2013.

Burnett, Claudine E. *Surfing Newport Beach: The Glory Days of Corona Del Mar*. Charleston, SC: History, 2013.

Campbell, Thomas. *Slide Your Brains Out: Surfing in General 1997–2012*. Davenport, CA: Um Yeah Press, 2012.

Carroll, Nick. *30 Years of Flame: California's Legendary Surf Photographer*. San Clemente, CA: Surfing Magazine, 2005.

Chidester, Brian, and Dominic Priore. *Dumb Angel No. 4: All Summer Long*. San Francisco: Neptune's Kingdom Press, 2005.

Chidester, Brian, and Domenic Priore. *Pop Surf Culture: Music, Design, Film, and Fashion from the Bohemian Surf Boom*. Santa Monica, CA: Santa Monica Press, 2008.

Chouinard, Yvon. *Let My People Go Surfing: The Education of a Reluctant Businessman*. New York: Penguin, 2005.

Chouinard, Yvon, Steve Pezman, and Steve Roper. *California Surfing and Climbing in the Fifties*. Santa Barbara, CA: T. Adler Books, 2013.

Church, Ron, Brad Barrett, and Steve Pezman. *60 to 65: California and Hawaii*. Santa Barbara: Surfer's Journal/T. Adler Books, 2006.

Church, Ron. *Surf Contest*. Santa Barbara, CA: T. Adler Books, 2006.

Clark, John R. K. *Hawaiian Surfing: Traditions from the past*. Honolulu, HI: University of Hawai'i, 2011.

Clark, Rosie Harrison. *Let's Go, Let's Go!: The Biography of Lorrin "Whitey" Harrison: California's Legendary Surf Pioneer*. Choteau, MT: Harrison Clark Pub., 1997.

Colas, Antony, and Bruce Sutherland. *The World Stormrider Guide, Volume Two*. Berkeley, CA: Wilderness Press, 2004.

Colburn, Bolton T. *Surf Culture: The Art History of Surfing*. Laguna Beach, CA: Laguna Art Museum in association with Gingko Press, 2002.

Colburn, Bolton T., Craig Stecyk, and Michael C. McMillen. *Papa Moana: Craig Stecyk*. Laguna Beach, CA: Laguna Art Museum, 1989.

Conner, Daniel, and L. Miller. *Master Mariner, Capt. James Cook and the Peoples of the Pacific*. Seattle, WA: University of Washington, 1978.

Cota, Ignacio Felix. *Tribe of the Waves Memories of Mexican Surfing*. N.p.: N.p., 2011.

Cralle, Trevor. *The Surfin'ary: A Dictionary of Surfing Terms and Surfspeak*. Berkeley, CA: Ten Speed Press, 1991.

Crowley, Kent. *Surf Beat: Rock 'n' Roll's Forgotten Revolution*. New York: Backbeat, 2011.

De Paolo, Tom. "Riding the Big Combs." *Esquire*, December 1949.

Decoster, Gérard, and Alain Gardinier. *Surf Collection*. Paris, France: Aubanel Publishers, 2009.

Decoster, Gérard, and Gibus De Soultrait. *Surfing Visual Arts*. Biarritz, France: Surf Session Editions, 2005.

DeLaVega, Timothy T., Daved Marsh, and A. R. Gurrey. *200 Years of Surfing Literature: An Annotated Bibliography*. N.p.: Timothy T. DeLaVega, 2004.

DeLaVega, Timothy T. *Surfing in Hawai'i, 1778–1930*. Charleston, SC: Arcadia Pub., 2011.

Derloshon, Gerald B. *Little Man on Wheels: Surfing Legend Dewey Weber*. Dana Point, CA: Type-do-dah Media, 2012.

Divine, Jeff, and Scott Hulet. *Surfing Photographs from the Eighties Taken by Jeff Divine*. Santa Barbara, CA: T. Adler, 2011.

Divine, Jeff. *Masters of Surf Photography: Jeff Divine: Thirty Years, 1970–1999*. San Clemente, CA: Surfer's Journal, 2000.

Divine, Jeff. *Surfing Photographs from the Seventies*. Santa Barbara, CA: T. Adler Books, 2005.

Dixon, Chris. *Ghost Wave: The Discovery of Cortes Bank and the Biggest Wave on Earth*. San Francisco: Chronicle Books, 2011.

Dixon, Peter L. *Men and Waves: A Treasury of Surfing*. New York: Coward-McCann, 1966.

Dixon, Peter L. *The Complete Book of Surfing*. New York: Coward-McCann, 1965.

Doyle, Mike, and Steve Sorensen. *Morning Glass: The Adventures of Legendary Waterman Mike Doyle*. Three Rivers, CA: Manzanita Press, 1993.

Dyke, Fred Van. *Once upon Abundance: Coming of Age in California and Hawaii*. Honolulu, HI: Anoai Press, 2001.

Phillips, Jim, Yahya El-Droubie ed., and Ian C. Parliament. *Surf Graphics*. London: Korero Books, 2012.

Elwell, John C., and Jane Schmauss. *Surfing in San Diego*. Charleston, SC: Arcadia Pub., 2007.

Farrelly, Midget, and Craig McGregor. *The Surfing Life*. New York: Arco Pub., 1967.

Fetting, Rainer. *Rainer Fetting: Los Angeles Surfscapes*. Bielefeld, Germany: Kerber Verlag, 2004.

Feuling, Jim. *Early California Surfriders: A Collector's Edition of Rare Photographs Covering Classic California Longboard Surfing in the Thirties and Forties*. Ventura, CA: Pacific Pub., 1995.

Freitas, L.D. "Al Wiemers: A Tribute to a Waterman." *H2O: The Magazine of Waterfront Culture*, Vol. 7, No. 3, 2006.

Friedkin, Anthony. *Timekeeper*. Los Angeles: Enton Publishing, 2003.

Gault-Williams, Malcolm. *Legendary Surfers, Volume One: 2500 B.C. to 1910 A.D.* N.p.: CafePress, 2005

Gault-Williams, Malcolm. *Legendary Surfers, Volume Two: Early 20th Century Surfing and Tom Blake*. N.p.: CafePress, 2007

George, Sam, and Shaun Tomson. *Surfer Magazine: 50 Years*. San Francisco: Chronicle Books, 2010.

George, Sam. *The Perfect Day: 40 Years of Surfer Magazine*. San Francisco: Chronicle Books, 2001.

Grambeau, Ted, Tim Baker, Steve Barilotti, and Steve Pezman. *Masters of Surf Photography: Ted Grambeau*. San Clemente, CA: Surfer's Journal, 2003.

Grannis, LeRoy, and Brad Barrett. *Photo: Grannis: Surfing's Golden Age, 1960–1969*. San Clemente, CA: Surfer's Journal, 1998.

Grannis, LeRoy, Jim Heimann, ed., and Steve Barilotti. *LeRoy Grannis: Surf Photography of the 1960s and 1970s*. Cologne: TASCHEN, 2006.

Grant, Allan. "The Mad Happy Surfers." *LIFE*, September 1, 1961.

Grissim, John. *Pure Stoke*. New York: Harper & Row, 1982.

Gromling, Frank. *Fits Like a Glove: The Bill & Bob Meistrell Story*. Flagler Beach, FL: Ocean Publishing, 2013.

Hall, Sandra Kimberley. *Duke: A Great Hawaiian*. Honolulu, HI: Bess Press, 2004.

Halsband, Michael, and Joel Tudor. *Surf Book*. New York: Channel Photographics LLC, 2004.

Haun, Barry. *Trailblazers in Women's Surfing*. San Clemente, CA: Surfing Heritage & Culture Center, 2015

Havassy, Robb. *Surf Story*. Newport Beach, CA: Havassy Art, 2009.

Hawk, Steve. *Waves*. San Francisco: Chronicle Books, 2005.

Heimann, Jim, ed. *365 Day-by-Day: Surfing*. Cologne: TASCHEN, 2014.

Hemmings, Fred. *The Soul of Surfing Is Hawaiian*. N.p.: Surf Enterprises, 1997.

Hickenbottom, Thomas. *Surfing in Santa Cruz*. Charleston, SC: Arcadia Pub., 2009.

Holmes, Paul. *Bing Surfboards: Fifty Years of Craftsmanship and Innovation*. Laguna Beach, CA: T. Adler Books, 2008.

Holmes, Paul. *Dale Velzy Is Hawk*. Corona Del Mar, CA: Croul Family Foundation, 2006.

Hope, Dale, and Gregory Tozian. *The Aloha Shirt*. London: Thames & Hudson, 2002.

Ito, Tetsuya. "Surfer's Delight." *Brutus*, Vol. 7, No. 15, 2004.

James, Don. *1936–1942 San Onofre to Point Dume*. Santa Barbara, CA: T. Adler Books, 1996.

James, Don. *Prewar Surfing Photographs*. Santa Barbara, CA: T. Adler Books, 2004.

Jarratt, Phil. *Australia's Hottest 100 Surfing Legends*. Melbourne and London: Hardie Grant Books, 2011.

Jarratt, Phil. *The Mountain and the Wave: The Quiksilver Story*. Huntington Beach, CA: Quiksilver Entertainment, 2006.

Kahanamoku, Duke, and Joseph Brennan. *Duke Kahanamoku's World of Surfing*. New York: Grosset & Dunlap, 1968.

Kampion, Drew. *Greg Noll: The Art of the Surfboard*. Salt Lake City, UT: Gibbs Smith, 2007.

Kampion, Drew. *Jack O'Neill: It's Always Summer on the Inside*. San Francisco: Chronicle Books, 2011.

Kampion, Drew. *Stoked: A History of Surf Culture*. Santa Monica, CA: General Pub. Group, 1997.

Kampion, Drew. *The Way of the Surfer: Living It, 1935 to Tomorrow*. New York: Harry N. Abrams, 2003.

Keene, Carolyn. *The Phantom Surfer*. New York: Grosset & Dunlap, 1972.

Kelly, John M. *Surf and Sea*. New York: A.S. Barnes, 1965.

Kempton, Jim. *The San Onofre Surfing Club, 1952–2002: 50th Anniversary Commemorative Album*. San Clemente, CA: San Onofre Surfing Club, 2002.

Kew, Michael. "Hot Curling: Surfing into the Past on a Redwood Plank." *Blue Edge*, December 2006.

Kohner, Frederick. *Gidget*. New York: Bantam Books, 1957.

Kohner, Frederick. *The Gremmie*. New York: Pyramid, 1965.

Leydier, Richard. *La Dernière Vague: Surf, Skateboard & Custom Cultures in Contemporary Art*. Paris, France: 19/80 Editions, 2013.

Lippman, Steven, and Jamie Brisick. "Malibu: The Birth of Legends." *Malibu Magazine*, June/July 2006.

Lockwood, Craig. *Peanuts: An Oral Biography: Exploring Legend, Myth and Archetype in California's Surfing Subculture*. Newport Beach, CA: Croul Family Foundation, 2009.

London, Jack. "Riding the South Sea Surf." *Woman's Home Companion*, October 1907.

London, Jack. *The Cruise of the Snark*. New York: Macmillan, 1911.

Lueras, Leonard. *Surfing, the Ultimate Pleasure*. Honolulu, HI: Emphasis International, 1984.

Lynch, Gary, Malcolm Gault-Williams, and William K. Hoopes. *Tom Blake: The Uncommon Journey of a Pioneer Waterman*. Corona Del Mar, CA: Croul Family Foundation, 2001.

Lynch, Gary. *Tom Blake Surfing: 1922–1932*. Santa Barbara, CA: T. Adler Books, 1999.

Mansfield, Roger. *The Surfing Tribe: A History of Surfing in Britain*. Newquay, United Kingdom: Orca Publications, 2009.

Marcus, Ben, and Jeff Divine. *Surfing and the Meaning of Life*. St. Paul, MN: Voyageur, 2006.

Marcus, Ben, and Pete Noble. *Graphic Surf Decals, Patches, Stickers*. Atglen, PA: Schiffer Pub., 2008.

Marcus, Ben. *365 Surfboards: The Coolest, Raddest, Most Innovative Boards from around the World*. Minneapolis, MN: MVP, 2013.

Marcus, Ben. *Surfing USA!: An Illustrated History of the Coolest Sport of All Time*. St. Paul, MN: Voyageur Press, 2005.

Marcus, Ben. *The Surfboard: Art, Style, Stoke*. St. Paul, MN: MBI Pub., 2007.

Margan, Frank, and Ben R. Finney. *A Pictorial History of Surfing*. Sydney, Australia: Hamlyn, 1970.

Martin, Mary L. *The Ultimate Collector's Guide to Surfing Postcards*. Atglen, PA: Schiffer Pub., 2008.

Masuda, Takuji. *Super X Media Combine*. Malibu, CA: First Point Productions, 2003.

McAloon, Berendan. *To the Four Corners of the World*. Jan Juc, Australia: Flying Pineapple Media Pty Limited, 2010.

McNulty, Patrick. "The Sweet Smell of Surfing Success." *Los Angeles Times West Magazine*, September 11, 1966.

McNulty, Patrick. "World's Best Ride the California Waves." *Los Angeles Times West Magazine*, November 13, 1966.

Moir, Mike, Jamie Brisick, and Joel Patterson. *The Eighties at Echo Beach*. San Francisco: Chronicle Books, 2011.

Moser, Patrick. *Pacific Passages: An Anthology of Surf Writing*. Honolulu, HI: University of Hawai'i Press, 2008.

Muñoz, Mickey, Yvon Chouinard, John Dutton, and Jeff Divine. *No Bad Waves: Talking Story with Mickey Muñoz*. Ventura, CA: Patagonia Books, 2011.

Musick, John R. *Hawaii: Our New Possessions*. New York: Funk & Wagnalls Company, 1898.

Nicks, Dewey. *Surf Girl Oahu*. N.p.: Roxy/Quicksilver, 2002.

Noll, Greg, and Andrea Gabbard. *Da Bull: Life over the Edge*. Berkeley, CA: North Atlantic Books, 1989.

Nordhoff, Charles. "Hawaii-Nei." *Harper's New Monthly Magazine*, August 1873.

Nunn, Kem. "Chairman of the Board." *Rolling Stone*, July 16–30, 1987.

Nunn, Kem. *Tapping the Source*. New York: Delacorte Press, 1984

Nunn, Kem. *The Dogs of Winter*. New York: Scribner, 1997.

O'Connor, Patrick. *South Swell*. New York: Washburn, 1967.

O'Sullivan, Kevin. *Goin' Big: Gotcha and the Evolution of Modern Surf Style*. Irvine, CA: Full Force, 2008.

Orbelian, George. *Essential Surfing*. San Francisco: Orbelian Arts, 1982.

Ornitz, Don. "West Coast Surfers." *LOOK*, June 30, 1964.

Patterson, Otto B. *Surf-riding, Its Thrills and Techniques*. Rutland, VT: C.E. Tuttle, 1960.

Pezman, Steve. "N.Nii." *Man of the World*, Issue No. 8, 2014.

Power, Chris. *Shooting the Curl: The Best Surfers, the Best Waves by 15 of the Best Surf Photographers*. Newquay, United Kingdom: Orca Publications, 2010.

Rebeix, Maurice. *Hawaii Surf Spirit*. Paris, France: Mango-Sport, 2002.

Rensin, David. *All for a Few Perfect Waves: The Audacious Life and Legend of Rebel Surfer Miki Dora*. New York: Harper Entertainment, 2008.

Rensin, David. "The Legend of Miki Dora." *Malibu Magazine*, April/May 2009.

Ritts, Herb, photographer. "Boys of Summer." *Rolling Stone*, May 9, 1985.

Russi, Jim, Tom Adler, and Kate Ruggiero. *Flying through the Clouds*. Atglen, PA: Schiffer Pub., 2011.

Savage, Bruce. "San Onofre's Surfless Summer." *H2O: The Magazine of Waterfront Culture*, Summer 1980.

Schiaffino Cebrián, José Antonio. *Toribio Nitta, Jorge Odriozola y los tablistas de Barranco entre 1920 y 1940*. N.p.: N.p., 2014

Schiffer, Nancy. *Surfing*. Atglen, PA: Schiffer Pub., 1998.

Schou, Nick. *Orange Sunshine: The Brotherhood of Eternal Love and Its Quest to Spread Peace, Love, and Acid to the World*. New York: Thomas Dunne Books, 2010.

Servais, Tom. *Masters of Surf Photography: Tom Servais*. San Clemente, CA: Surfer's Journal, 2005.

Severson, Don. R, Michael D. Horikawa, and Jennifer Saville. *Finding Paradise: Island Art in Private Collections*. Honolulu, HI: Honolulu Academy of Arts, 2002.

Severson, J. *Great Surfing*. New York: Doubleday, 1967.

Severson, John Hugh. *Modern Surfing around the World*. Garden City, NY: Doubleday, 1964.

Severson, John, and Nathan Howe. *John Severson's SURF*. Bologna, Italy/Paia, Hawaii: Damiani/Puka Puka, 2014.

Severson, John. *Surf Fever: Surfer Photography*. San Clemente, CA: Journal Concepts, 2004.

Shiratani, Toshio. *75–85 Surfing Japan*. Japan: Bueno! Books, 2009.

Short, Kevin A., and Mike Evans. *Trestles*. San Juan Capistrano, CA: Puerta Del Cielo Pub., 2007.

Spreckels, Bunker, Craig R. Stecyk, and Art Brewer. *Bunker Spreckels: Surfing's Divine Prince of Decadence*. Cologne: TASCHEN, 2007.

Stecyk III, C.R., and Glen E. Friedman. *Dogtown: The Legend of the Z-Boys*. New York: Burning Flags Press, 2000.

Stecyk, Craig, Drew Kampion, Steve Pezman, and Miki S. Dora. *Dora Lives: The Authorized Story of Miki Dora*. Santa Barbara, CA: T. Adler Books, 2005.

Steele, H. Thomas. *The Hawaiian Shirt: Its Art and History*. New York: Abbeville, 1984.

Sternbach, Joni. *Surf Site Tin Type*. Bologna, Italy: Damiani, 2015.

Tappis, Jordan. "Kelly Slater: A Portrait of a Champion." *Malibu Magazine*, December 2007/January 2008.

Testino, Mario. "The Surf Report." *Harper's BAZAAR*, April 1996.

Timmons, Grady. *Waikiki Beachboy*. Honolulu, HI: Editions, 1989.

Twain, Mark, and A. Grove Day. *Mark Twain's Letters from Hawaii*. New York: Appleton-Century, 1966.

Verge, Arthur C. "George Freeth: King of the Surfers and California's Forgotten Hero." *California History*, Summer/Fall 2001.

Verge, Arthur C. "Protecting Southern California's Treasure." *The Branding Iron*, Fall 2006.

Verge, Arthur C. *Los Angeles County Lifeguards*. Charleston, SC: Arcadia Pub., 2005.

Verge, Arthur C. *Santa Monica Lifeguards*. Charleston, SC: Arcadia Pub., 2007.

Verge, Arthur C. "From the Shores of Hawaii to the Sands of California: The Arrival of Surfing in Southern California." *In the Curl: The Evolution of Surfing in Ventura County*. Ventura, CA: Ventura County Historical Society, 2000.

Douglas, Theo, and Elizabeth Glazner. "The Real Gidget." *Wahine*, Vol. 5, No. 2. 1999.

Walding, Murray. *Surf-o-Rama: Treasures of Australian Surfing*. Carlton, Australia: Melbourne University Pub., 2008.

Waplington, Nick. *Surf Riot*. New York: Little Big Man, 2011.

Warshaw, Matt. *Above the Roar: 50 Surfer Interviews*. Santa Cruz, CA: Waterhouse, 1997.

Warshaw, Matt. *Maverick's: The Story of Big-Wave Surfing*. San Francisco: Chronicle Books, 2000.

Warshaw, Matt. *Surf Movie Tonite!: Surf Movie Poster Art, 1957–2004*. San Francisco: Chronicle Books, 2005.

Warshaw, Matt. *Surfriders: In Search of the Perfect Wave*. New York: Collins Publishers, 1997.

Warshaw, Matt. *The Encyclopedia of Surfing*. Orlando, FL: Harcourt, 2003.

Warshaw, Matt. *The History of Surfing*. San Francisco: Chronicle Books, 2010.

Warshaw, Matt. *Zero Break: An Illustrated Collection of Surf Writing, 1777–2004*. Orlando, FL: Harcourt, 2004.

Weber, Bruce. "Surf Nekkid." *A & F Quarterly*, Spring Break Issue, 1999.

Weber, Bruce, and Herbie Fletcher. "Vintage Surf." *Vogue Sport*, January 2005.

Wehrheim, John. *Taylor Camp*. Chicago: Serindia Publications, 2009.

Weiss, Cary B. *The Early Years: Surfers-Beaches-Boards, 1890–1960*. N.p.: My Publisher, n.d.

Weller, Sheila. "Malibu's Lost Boys." *Vanity Fair*, August 2006.

Westwick, Peter, and Peter Neushul. *The World in the Curl: An Unconventional History of Surfing*. New York: Crown Publishers, 2013.

Williamson, Luke. *Gone Surfing: The Golden Years of Surfing in New Zealand, 1950–1970*. Auckland, New Zealand: Penguin (NZ), 2000.

Winniman, James. *Ultimate Guide to Vintage Surfboards & Collectibles*. N.p.: Usvsa, 2013.

Witzig, John, and Richard Olsen. *A Golden Age: Surfing's Revolutionary 1960s and '70s*. New York: Rizzoli International Publications, 2013.

Wolfe, Tom. *The Pump House Gang*. New York: Farrar, Straus & Giroux, 1968.

Yost, Harold H. "Reeling Hawaii's Royal Sport." *Amateur Movie Makers*, May 1927.

Young, Nat, Craig McGregor, and Rod Holmes. *The History of Surfing*. Angourie, Australia: Palm Beach, 1994.

ADVERTISEMENT, HOBIE, 1977
(Page 490)

SWELL OF '69; EHUKAI BEACH, HAWAII; 1969 *(Pages 498–499)* In late December 1969, three overlapping North Pacific storms combined to create "the swell of the century." *Photo, LeRoy Grannis*

CONNER COFFIN; SUN CITY, SOUTH AFRICA; 2014 *(Page 503)* Chlorinated water, machine-made waves, stage fog, and industrial lasers at a waterpark located 400 miles inland within the South African bush… the future of surfing? *Photo, Tom Carey*

CREDITS

Any omissions for copy or credit are unintentional and appropriate credit will be given in future editions if such copyright holders contact the publisher. The publisher gratefully acknowledges the use of images provided courtesy of the following individuals and institutions:

© 19 / 80 Éditions 474 bottom right, 475 bottom

© ErikAeder.com 424–425, 433 bottom

© Scott Aichner/A-Frame 481 bottom

© Brent Bielmann/A-Frame 460 top

© Tom Carey/A-Frame 470, 503

© Damea Dorsey/A-Frame 437 top

© Jason Kenworthy/A-Frame 412–413

© Dan Merkel/A-Frame 331 top, 336–337, 368 top, 369, 372–373, 383 top, 395 top, 395 bottom

© Zak Noyle/A-Frame 468–469, 478 top

© Tom Servais/A-Frame 419 top

© Pat Stacy/A-Frame 482–483

Fernando Aguerre Collection 18-19, 66 center right

AP Images 316 bottom

© Tony Arruza 400 bottom

© Astrodeck 403 top left

© The Australian Women's Weekly/Bauer Media 280

© Automobile Club of Southern California 84

© Bad Boy Brands International, Inc. 450 top

© Mike Balzer 410–411

© Bob Barbour 431, 434 top, 443 bottom

© George Barris 274 bottom

Bishop Museum 32 top left

Ray Jerome Baker, Bishop Museum 40, 31 top, 97 top left (cropped from original)

Robert Butterfield, Bishop Museum 150–151

Kenneth P. Emory, Bishop Museum (1921) 17 top

N.R. Farbman, Bishop Museum 60

Walery, London; Bishop Museum 31 bottom

© Steve Bissell 356

© Irving Blum 163 top left

© Body Glove/Meistrell Family 139 (all images)

© Rex Brandt Estate – daughter Joan Scarboro 261

© ArtBrewer.com 292, 293, 297, 307–307, 326 top, 331 bottom, 354 bottom, 355 top, 364 bottom, 365 bottom 370 bottom, 385, 386 top, 386 bottom, 402 bottom, 419 bottom

© Bruce Brown Films, LLC 163 top right

© 1964 Bruce Brown Films, LLC 199

DeSoto Brown Collection 42

Bud Browne Film Archives Collection 146 top right

© Chris Burkard/Massif 471 top and bottom left, 472–473, 474 top, 474 bottom left, 475 top

© Duncan Campbell 353 bottom

© Thomas Campbell 479 top, 479 bottom

© Sylvain Cazenave 428–429

© Ron Church 140, 165 bottom, 209 top, 236, 240, 241, 245 top, 246–247, 247, 256, 262–263

ClassicVintagePosters.com 94, 149 top, 291

© Con Surfboards 303 top center

© Hal Conway 160 top

© Coolhous Studio, LLC 463

© Bing Copeland 172 top, 287 top, 303 bottom

© Aladdin Color, Inc./Corbis 214

© Michael Ochs Archives/Corbis 142, 184–185

© Richard Hewitt Stewart/National Geographic Society/Corbis 62–63

© Sunset Boulevard/Corbis 159

Ignacio Felix Cota Collection 305 top

Gary Crockett Collection 124 bottom right

© Tyler Cuddy 486–487 bottom

© Georges Dambier/Courtesy Benrubi Gallery, NYC 130

© David Darling 296 top

© Pat Darrin 270 top left

© Dewey Weber Surfboards 286 top, 287 bottom, 352 top

© Lester R. Dietz 142 top

© Woodward Dike; courtesy of Austin McClelland Photography 76

© Jeff Divine 308–309, 310, 314–315, 321 top left and top right, 334 top, 340–341, 343 top, 345, 347 bottom, 348 top, 349, 355 bottom, 357 top, 360 top, 366–367, 382 bottom and bottom, 388–389, 392–393 bottom, 393 top, 396–397, 399 bottom, 407, 416, 418 top, 444 bottom, 488–489, endpapers

© Grant Ellis 444 center, 445, 460 bottom, 471 bottom right

© Rennie Ellis 198 top, 376–377

© Jim Evans 390 bottom

© Ed Freeman 439

Freshwater Surf Life Saving Club 37 top

© Anthony Friedkin 310, 360 bottom, 361, 383 bottom

The Gallery of Surf Classics, www.surfclassics.com 295 top right, 295 bottom

Getty Images 158

© Slim Aarons/Hulton Archive/Getty Images 317

© Ralph Crane/Time Life Pictures/Getty Images 8

© Loomis Dean/Time Life Pictures/Getty Images 106, 110, 112, 113, 122–123, 145

© Allan Grant/Time Life Pictures/Getty Images 156 top, 200

Keystone/Getty Images 99 bottom

Keystone-France/Gamma-Keystone/Getty Images 136 top

Michael Ochs Archives/Getty Images 183 bottom

Popperfoto/Getty Images 126–127

© GM Holden Ltd. 205 bottom

Golyester.com 67, 131 top left

© Gordon & Smith Surfboards 146 bottom

© Gotcha 403 top right, 442 top left and top right

LeRoy Grannis Collection, LLC 68 top and bottom, 69 bottom, 72 bottom, 72–73 top, 73 bottom, 75 top left and bottom, 77 top, 78 bottom

LeRoy Grannis Collection, LLC 178–179, 188–189, 192–193, 194 bottom, 195, 196, 205 top, 208, 209 bottom, 212 top, 217 top and bottom, 220, 221 top, 224–225, 226, 227 top left, top right, and bottom, 229 top and bottom, 230, 233 bottom, 231 top, 242–243, 250–251, 252–253, 254–255, 257, 264, 266–267, 268–269, 272 top and bottom, 273 bottom, 274 top, 280–281, 288–289, 298–299, 305 bottom, 352 bottom, 322, 353 top, 404–405, 498–499

© Don Ed Hardy 448 top

© Kelly Hart 278–279

Hawaii State Archives 25 bottom, 61 bottom

Hawaii Visitors Bureau, Hawaii State Archives 6–7

Photo Hawaii, Hawaii State Archives 100–101

Jim Heimann Collection 1, 12–13, 14, 20 top left, top right, and bottom, 23 center and bottom, 24 bottom, 29 bottom, 34 top, 35, 37 bottom, 38 top and bottom, 39, 41 bottom, 43 top, 43 bottom, 44, 45 top, 45 bottom, 46 top and bottom, 47, 49, 52 top left, 52 bottom left, and bottom right, 53, 56 top, 56 bottom, 57, 58 top, 58 bottom left, 58 bottom right, 59, 61 top, 64, 65 bottom left, 66 top left, 70 top, bottom left, bottom center, and bottom right, 71,

75 top left, 80 top, 80 bottom, 81, 83 top left and bottom, 85 top, 87, 90–91, 95 right, 96 bottom, 97 top right, 98, 103 bottom, 109 bottom, 114, 115, 116, 117 top, 117 bottom, 118, 124 bottom left, 133 top left, top right, center right, and bottom right, 136 bottom, 137 top left, 137 top right, 149 bottom, 151 bottom, 154 top left, 157, 170, 180 top right, 180 bottom, 182, 183 top left and top right, 197 top left and top right, 201 top, 202 bottom, 216, 234 center right, 235, 256 top, 271, 275, 276 top left, top center, and top right, 276 bottom, 277, 283 top left, top right, and bottom, 284 top right, 303 top left and top right, 400 top left, 427 bottom, 432 bottom, 454 top left, top right, and bottom right, 457 top right, center right, bottom right, and bottom left, 458, top left, top right, center right, center right, bottom left, and bottom right

Heritage Auctions, ha.com 203, 342, 408 bottom, 430 bottom

Randy Hild Collection 16, 17 top and right, 28, 32 top, 36, 41 top left, 66 top left, 66 bottom left, 75 top right and bottom, 99 top left, 131 top right, bottom left, and bottom right, 132 top left, top right, center left, center right, bottom left, and bottom right, 133 center left and bottom left, 134 top right and center right, 232, 233 top, 234 top left, top right, center left, bottom left, and bottom right, 237 top left, top right, center left, center right, bottom left, and bottom right, 284 top left, 284 bottom, 285, 379 top left, top right, center left, center right, bottom left, and bottom right, 380 top left, top right, center left, center right, bottom left, and bottom right, 454 center left, center right, and bottom left

© Hobie 450 bottom right, 490

Honolulu Museum of Art, Gift of Anna Rice Cooke, 1927 (5367) 26–27

Michael Horikawa Collection 4

© Jeff Hornbaker 456

Jack London Collection, The Huntington Library 22–23, 94

© Rob Hutchinson 398 top

Mike Hynson/Melinda Merryweather Private Collection 343 bottom

© Walter Iooss 433 top

© Jacobs Surfboards 147

James Cummins Bookseller, New York City 95 top left

© JIMMY'Z 450 bottom left

© joliphotos 417 top

© Darrell Jones 394

© Drew Kampion 313

© Katin USA, Inc. 180 top left

© 2015 Akira Kobayashi 318–319

© Marc Kozai 417 bottom

Ian Lind Collection 69 top, 86 top

Los Angeles County Lifeguard Association 33 bottom, 95 bottom, 103 top, 108 top and bottom, 109 top

Security Pacific National Bank Collection/ Los Angeles Public Library 25 top

Bob Steiner, Herald-Examiner Collection/ Los Angeles Public Library 324–325

© MacGillivray Freeman Films 295 top left and top right

© Tó Mané, ToManePhotos.com 476–477

© Roger Mansfield – The Surfing Tribe (2009) 128–129

© Neville Masters 222 top

© Maui and Sons 399 top

© Tom McBride 96 top

© Jack McCoy 378

© Tim McCullough 290 top

© Tim McKenna 440–441, 446–447

© Richard C. Miller/Courtesy Craig Krull Gallery 125

© Sonny Miller 374 bottom

© Mike Moir 406 top, 406 bottom, 466 bottom

© 1994 Victor Moscoso. Zap Comix is a registered trademark of Zap Comix. www.victormoscoso.com 448 bottom

Museum of Ventura County 119 top

National Archives of Australia 253

National Library of Australia 82

© A.J. Neste 467

© Earl Newman, earlnewmanprints.com 213, 244, 302, 320, 332

© Nike 459

© Noll Family Archive 146 top left, 270 top right, 290 bottom

Dennis Norton Collection 286 bottom

NÜERA 457 top left

© Off Shore 400 top right

© BILLOGDENARTWORK 330 top left, 334 bottom, 335, 365 top, 427 top

© O'Neill 138 top, bottom left, and bottom right, 141 bottom, 381

© Op 401

Paskowitz Family Archives 392 top

© Lou Perez 403 bottom

© Ron Perrott Estate 223

© Craig Peterson 374 top, 375

© Raymond Pettibon; courtesy Regen Projects, Los Angeles. No Title (Jacob's surf team), 1985, pen and ink on paper, 12 x 9 inches 423 top

© Raymond Pettibon; courtesy Regen Projects, Los Angeles. No Title (My road homewards), 1995, pen and ink on paper, 82 x 60 inches 422

Photofest 202 top, 384 bottom, 398 bottom

© Clive Piercy 465 top

© Ruben Piña 481 top

© Quiksilver 438 bottom

Jack Raglin Collection 83 top right

© Rick Rietveld 449

© Phil Roberts 461

© JimRussi.com 432 top, 435, 436, 438 top, 466 top

© Steve Sakamoto 408 top

San Diego History Center 30

© Erich Schlegel 420–421

© Julian Schnabel 423 bottom

© John Severson, published by SURFER (1957) 164–165

© John Severson, published by SURFER (1959) 160 bottom, 173

© John Severson, published by SURFER (1960) 119 bottom, 166 top, 174–175

© John Severson, published by SURFER (1961) 167, 181

© John Severson, published by SURFER; (1964) 178

© John Severson; Surfer Art (artist Rick Griffin, Pacific Vibrations, 1970, airbrush on board, 36 x 24 in.) 387

© John Severson; Surfer Art (Seal Beach Locals, 1956, oil on masonite, 38 x 28 in.) 148

© John Severson; Surfer Art (Surf Fever, 1959-1960, offset print, 14 x 8½ in.) 162

© John Severson; Surfer Art (The Angry Sea, 1963, offset print, 14 x 8½ in.) 258

© John Severson; Surfer Art (Wild Angels, 2006, watercolor, 15 x 22.5 in.) Cover

© John Severson; Surfer Art (1960) 161

© Louise Severson; Surfer Art (1959) 507

© Sex Wax, Inc. 348 bottom

© Steve Sherman 430 top, 464

© Ralph Steadman 390 top

© C.R. Stecyk III 321 bottom, 351, 362 top, bottom left, and bottom right, 363, 364 top

C.R. Stecyk III Collection 21

Tommy Steele Collection 29 top, 65 center left, 134 top left, center left, and bottom left, 135

© Joni Sternbach 462 top

© Vince Street 465 bottom

© SURFER 245 bottom, 344 top, 347 top, 391, 451

© SURFER/Rick Griffin 186, 187 top, 338, 339 top

© Ron Stoner/SURFER 187 bottom, 259 bottom, 260 top, 273 top, 282, 304

JOHN SEVERSON; SAN ONOFRE, CALIFORNIA; 1959 *SURFER* founder Severson prepares the debut issue of the magazine at "the office." *Photo, Louise Severson*

HERBIE FLETCHER; MONTAUK, NEW YORK; 2003 *(Pages 508–509)* *Photo, Bruce Weber*

ADVERTISEMENT, 1898 *(Page 511)*

WAIMEA BAY, HAWAII, CA. 1973 *(Page 512) Photo, Jeff Divine*

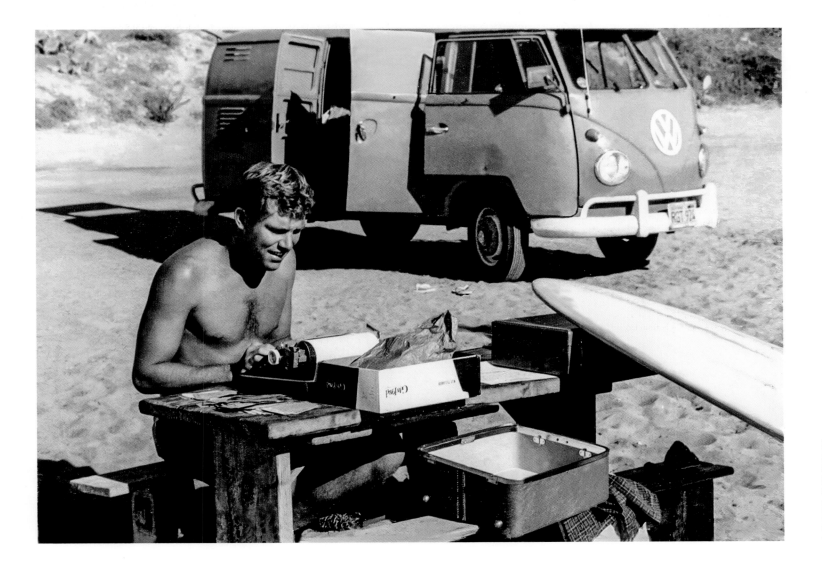

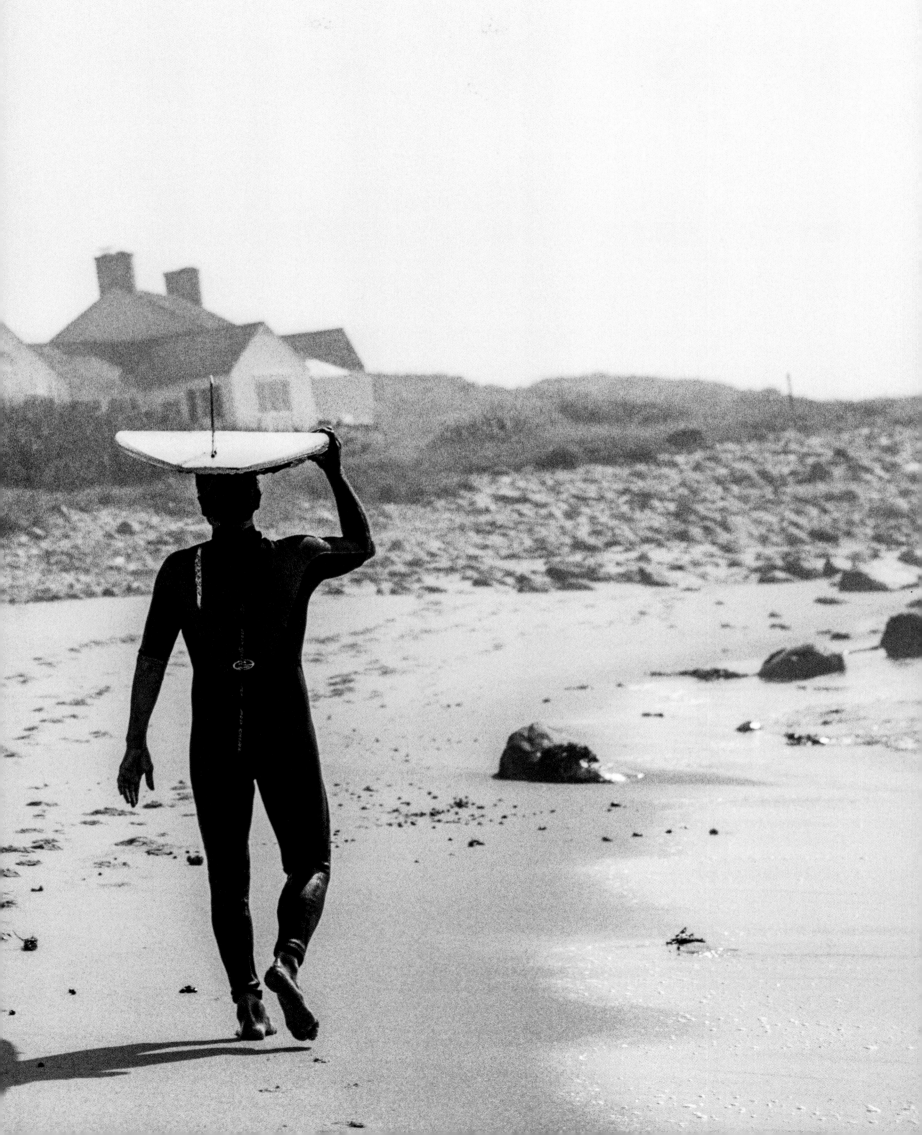

ACKNOWLEDGMENTS

From the start, when the idea for this book was discussed more than a decade ago, Benedikt Taschen never once flinched about producing it, and supported it 100 percent to completion. A true genius, he has paddled his way through the soup of the publishing business into the 21st century and come out of the tube intact, with rough water ahead. To his benefit, he managed to not meddle too much in the process of putting this book together! And to his credit, the guy has been on a board and surfed—a little bit! I have witnessed his mastery of three-footers in Santa Monica and Hanalei Bay, Kauai.

Ryan Mungia devoted three-plus years of his life to coordinate, organize, contemplate, and complete this tome. In the process he has added to his many talents the ability to construct a book from start to finish. With precision and caution, each decision was weighed and calculated so that everything fit precisely the way it should be. As an archivist, researcher, editorial coordinator, negotiator, editor, publisher, designer, artist, employee, friend, and "bud," he is beyond reproach. He also passed a kidney stone in the midst of a stressful negotiation period, downed a Vicodin, and never skipped a beat!

Mick Hodgson of Ph.D was hired on as the initial art director and designer of the book. A seasoned pro, his templates and work on the project were instrumental in its nascent construction. An unfortunate cycling accident sidelined him early in the project, but we have tried to maintain his initial spirit and I think we have succeeded. He continues to regain his health and we wish him well.

Art director Josh Baker has made many of my TASCHEN projects seamless. The consummate pro, I am not sure how he does this! Being an experienced surfer was a plus in working on this project amidst a barrage of other books he was involved with. Having to accommodate a previous design and then weaving it into the TASCHEN style is a skill he is very adept at. It could have been a pain, but he did it!

In any project that is as involved as this one was, you hope you will be visited by an affable concierge who will smooth away any bumps you might encounter and make all the bad go away. Randy Hild was that guy. Generous and influential, I had heard of his reputation among the surf tribes and collectors long before we met. Throughout the project he never uttered a negative word. Completely unselfish with his time and energy, and the use of his collections, I found myself constantly seeking his advice and more typically crying on his shoulder and venting. To say we couldn't have done this book without him is an understatement. He is truly one of the good guys.

I have known Jim Philbin since our days in high school when we made havoc for the Spanish priests who attempted to instill some sense in our still-forming brains. Almost born with a surfboard attached to his feet, he has continued to surf over the last 50-plus years, all the while taking care of business as a Newport Beach fireman. When I approached Jim to assist us in researching certain aspects of the sport, he eagerly jumped on board and continued to help us with all aspects of the project from start to finish. We begged to pay him but he insisted his encyclopedic knowledge was not for sale. Suffice it to say that he is a scholar on the subject and we are proud he was an integral part of the book.

A true legend in the world of surfing, John Severson was ever the gentleman when we met in Maui and on the mainland. As a filmaker, photographer, and creator of SURFER, he has been, and forever remains, an artist. It was an obvious choice to use his artwork for the cover of the book and our limited-edition print. John's extended family has joined him in his current and past ventures through Puka Puka Gallery (www.pukapuka.tv) in Paia, Maui. His granddaughter Alizé de Rosnay, along with Nathan Howe, manages the gallery and bestowed the aloha spirit in our dealings with John's work.

Grant Ellis, who deftly edits the photographs for SURFER, missed our first appointment because he was covering a significant swell in Ventura, California. His absence confirmed we were in the presence of a total pro, and for more than three years thereafter he went way beyond his duties to accommodate our every request, and mentored us on the more contemporary aspects of the surfing world. You couldn't ask for anything more.

Our word wizards: Matt Warshaw, Steve Barilotti, Drew Kampion, Chris Dixon, Peter Neushul, and Peter Westwick nailed the history we were trying to describe. A monumental task, the dilution of more than 200 years of the sport into a compact set of essays was skillfully accomplished by condensing the highlights and obscure moments into a readable narrative. Get the best, if you want the best.

Once we discovered the massive holdings of surfing history's premier depository, we ended up spending an inordinate amount of time sifting through countless images at Surfing Heritage & Culture Center (SHACC). Eventually, with the seemingly endless help of archivist Steve Wilkings and curator Barry Haun, we ended up with the largest stash of images for the book. SHACC's inimitable past and current CEOs, Bolton Colburn and Paul Strauch, along with cofounders Dick Metz and Spencer Croul, supported our book and we in turn continue to support SHACC and their mission.

In addition, the following people helped make this the book that it is. My sincere thanks to the TASCHEN team: Sarah Boyd, Nicholas Cloutman, Noel Daniel, Nemuel DePaula, Lindsey Dole, Ed Fox, Isabelle Gioffredi, Reuel Golden, Dian Hanson, Jonathan Newhall, Jennifer Patrick, Creed Poulson, Amy Quinn, Debra Schram, Jessica Trujillo, and, of course, Nina Wiener, for making this four-year journey fruitful. On the other side of the Atlantic the calming words and suave demeanor of Kathrin Murr got us through the production process together with the help of Juliette Blanchot, Tim Born, Michael Cramm, Petra Frese, Frank Goerhardt, Agnès Guillemot, Stefan Klatte, Florian Kobler, and Ingrid Reuter. Last, but certainly not least, a big thanks to Lisa Bechtold and Lorraine Kirsten for closing the gaps in our editorial process, and our wordsmiths, Teena Apeles and Aaron Bogart.

Locating obscure and hard-to-find surfing imagery has become a challenge with the intense interest the sport has propagated. Luckily, a dedicated group of flea-market vendors, shop owners, and collectors are out there who continually feed my collecting interests, making the eBay quagmire avoidable. Among my regular suppliers, the Damamas, Bob and Rhonda Heintz, Leonard Lightfoot (eBay user: vintagephotograph), and Robin Paeper consistently score the goods for me; along with Bren Bailey-Makani, Jeff Carr, Dan and Danny DePalma, Gary Jenkins, Mike Jipp of Lincoln City Surf Shop, Victoria Leo of Surf 'n Hula, John Jacob Schram, and Don Stewart of Aloha Spirit.

Without the depositories of rare, historical, and contemporary photographic material, many of the key images that depict surfing's history

would be lost to time. Many thanks go to the wards of those collections: DeSoto Brown, Bishop Museum; Genoa Caldwell, The Burton Holmes Archive; Barbara Dunn, Hawaiian Historical Society; Genie Guerard, University of California, Los Angeles, Library Special Collections; Jeff Hall, A-Frame Media; Charles Johnson, Museum of Ventura County; Melissa Shimonishi, Hawaii State Archives; Nancy Thomas, Los Angeles County Museum of Art; Arthur Verge, Los Angeles County Lifeguard Association; and Jenny Watts, The Huntington Library.

Amazingly this sport has produced some of the most generous and giving individuals in the world. Almost everyone was on board. It helped that this is a TASCHEN book. Most everyone knows the brand and the level of commitment and quality that goes into our books. Plus, the fact that books still hold this cache of something tangible and complete, attracted people to be part of this special, one-of-a kind project. We had the opportunity to visit and interact with a group of folks who graciously lent us items; let us into their houses, offices, and studios; and unselfishly spent time helping and guiding us through the project. Among them are Tom Adler, Fernando Aguerre, Art Brewer, Ignacio Felix Cota ("Nacho"), Jeff Divine, Dibi and Herbie Fletcher, Tony Friedkin, Nancy Grannis, Kathy Kohner-Zuckerman ("Gidget"), Victoria Leo, Gordon and Austin McClelland, Earl and Dale Newman, Steve Pezman, Craig Stecyk and Melanie Berry, Tommy Steele, Cary Weiss, Jim Winniman, and Renny Yater.

Additionally, our thanks go out to all of the folks who made this book possible: Erik Aeder, David Alcock, Jerry Anderson, Tony Arruza, Kimberly Ayl, Mike Balzer, Bob Barbour, Marilyn Barilotti, Brett Barris, Danielle Beck, Sandow Birk, Mark Blackburn of Mauna Kea Galleries, Irving Blum, Chris Burkard, Paul Caddy, Duncan Campbell, Thomas Campbell, Tom Carey, Sylvain Cazenave, Tani Church, Shelly Coe, Bing Copeland, Margaret Croft, Laura Crosser, Matthew Crouch, Tyler Cuddy, Adriana Daniels, David Darling, Pat Darrin, Lester Dietz, Woodward Dike, Jack English, Keith Eshelman, Christian Fletcher, Pierce and Lindsey Flynn, Jack Ford, John Frazier, Ed Freeman, Manuela Furci, Malcolm Gault-Williams, Matt George, Brian Gillogly, Esther Ginsberg, Ida Griffin, Kelly Hale, Misato Hamazaki, Don Ed Hardy, Whitey Harrison, Kelly Hart, Aliza Hoffman, Walter Hoffman, Marty Hoffman, Dale Hope, Michael Horikawa, Jeff Hornbaker, Bill Hornstein, Mike Hynson, Walter Iooss, Phil Jarratt, Alison Rose Jefferson, Darrell Jones, Donna Jost, Lee and Whitney Kaplan, Mark Kawakami, Dave and Erin Kennedy, Nathaniel Kilcer, Brian Kilpatrick, Akira Kobayashi, Marc Kozai, Bernard Lassalle, Ian Lind, Paul Maartens, Morgan Maassen, Tó Mané, Roger Mansfield, Ben Marcus, Scott Massey, Neville Masters, William A. Mays, John Mazza, Tom McBride, Jack McCoy, Tim McCullough, Mark McInnis, Tim and Stephanie McKenna, Jenna Meistrell, Eric Middledorp, Margaret Miller, Virginie Miramon, Mike Moir, Anna Moore, Yumi Morimoto, Victor and Justo Moscoso, Guy Motil, Mickey Muñoz, Randy Nauert, A.J. Neste, Greg Noll, Jed Noll, Dennis Norton, Melissa Nykanen, Sean O'Keefe, Hunter Oatman-Stanford, Bill and Toby Ogden, Bowen Ota, Jonathan Paskowitz, Craig Peterson, Lisa Peterson, Clive Piercy, Ruben Piña, Ty Ponder, Marc Prefontaine, Jack Raglin, Tia Reber, Rick Rietveld, Phil Roberts, Chris Rohloff, Matt Roth, Molly Rubick, Jim Russi, Ron Saggers, Mike Salisbury, Fred Salmon, Jim Salvati, Shonn Sanchez, Joan Scarboro, Lawrence Schiller, Erich Schlegel, Jane Schmauss, Joelle Sedlmeyer, Tom Servais, Susan Shamshoian-Sakamoto, Doug Shemer, Steve Sherman, Peter Simons, Joni Sternbach, Vince Street, Matt Stringfellow, Pauline Sugino, Ben Thouard, Blue Trimarchi, Richard Upper, Harry Van Bommel, Alan Van Gysen, John Van Hamersveld, Jan Van Mecl, Pierre Van Swae, Chris Vestal, Chris Vranian, Murray Walding, Bruce Weber, Henry Wessells, Luke Williamson, Peter "Joli" Wilson, John Witzig, Adia Wright, and Dion Wright.

—Jim Heimann, Los Angeles

© 2022 TASCHEN GMBH
Hohenzollernring 53, D-50672 Köln
www.taschen.com

Original edition
© 2016 TASCHEN GmbH

German translation Julia Heller, Munich
French translation Joachim Grenier, Seignosse

Printed in Bosnia-Herzegovina

ISBN 978-3-8365-8328-2

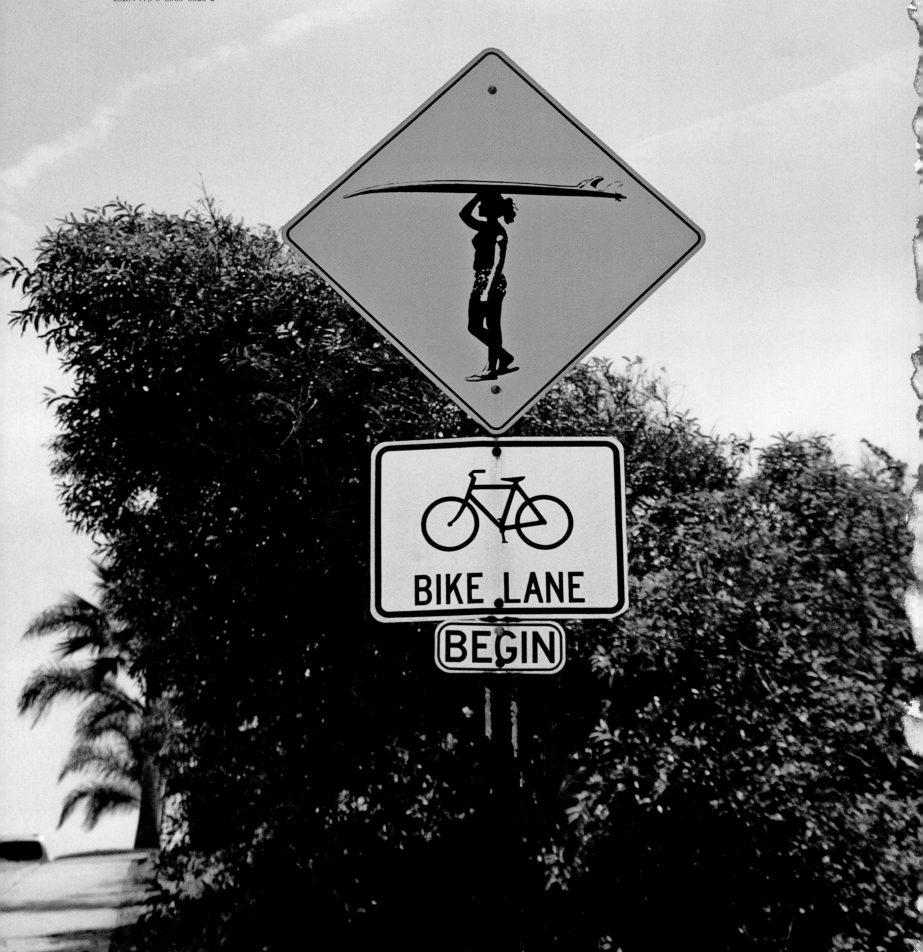